FASHION
A TIMELINE IN PHOTOGRAPHS: 1850 TO TODAY

FASHION
A TIMELINE IN PHOTOGRAPHS: 1850 TO TODAY

CAROLINE RENNOLDS MILBANK

Foreword by Harold Koda

RIZZOLI
NEW YORK

New York · Paris · London · Milan

FOREWORD

HAROLD KODA

In front of the lens, I am at the same time: the one I think I am, the one I want others to think I am,
the one the photographer thinks I am, and the one he makes use of to exhibit his art.

—ROLAND BARTHES

In *Camera Lucida* (1980), Roland Barthes links photography's power to its temporal nature and its ability to tell a story. This uncanny trace of the ephemeral makes photography a medium peculiarly suited to portraiture by not only capturing an individual's physiognomy, but also by arresting fashion's transience and transformations. Apparel—what the sitter wears for this moment dedicated to posterity—is integral to this narrative.

For costume historians—short of surviving examples of actual period garments—the photographic portrait has come closest to substantiating the prevailing attire or mode of any given moment. While written descriptions, paintings, sculptures, and especially fashion publications are essential evidence of how people dressed or aspired to dress in the past, photographs preserve the actuality of period style. The ameliorating eye of the professional portrait painter or sculptor is less evident in a photograph, particularly with "candids" taken outside the studio.

The compilation of images in this book, which illustrate a progression of fashion silhouettes from the mid-19th century to the present, establish a cogent timeline of historic dress. This selection represents not only primary fashion trends of an era, but also nuances of personal style, and, in certain decades, the influence of an individual design, say by Worth, as the dress's details were cited and percolated throughout the fashion system. Certain elusive aspects of historic dress, the sources of trends and the sudden popularity of individual styles, for example, are clarified by the comprehensive nature of the collection and its method of organization.

The amplification of the visual historical record of dress with the photographic portrait begins in the 1840s; and a decade later, at the same moment as the birth of the modern fashion system, photography emerges to document the seasonal evolution of the evolving silhouette. Part of the compelling nature of the photographic portrait is the sense of the authentic: the fashions are shown as they were actually worn on real women rather than represented by an idealized caricature in the fashion plate. Over time, like the corollary shift of the painter from the studio to the outdoors for *plein air* effects, a trickle of non-studio photographic images situates the subjects in a real, or ostensibly realer, context. The selection of a best dress to wear for a sitting for posterity cedes to less formal situations and attire, with day dresses, walking dresses and sports clothes, that suggest life as it was actually lived—categories of dress that often did not warrant extended depiction in the period fashion plates. Historians have often looked to ancillary documentation, especially advertisements, to secure an idea such quotidian types of attire. With the introduction by George Eastman of the Kodak camera with roll film in 1888, photographs by non-professionals begin to account for a widening demographic of subjects and a broader range of social types, seen here to extend from the proletariat, through the bourgeoisie, to the British royals. Surprisingly, the women even in instances of apparently homemade attire suggest the surprising unanimity and democracy of fashionable trends in dress.

Every historic fashion archives, including the holdings of The Costume Institute at the Metropolitan Museum of Art, are filled with atypical and idiosyncratic designs that deviate in some detail, small or large, from the high fashion standards represented in fashion plates and editorial features. A number of forensic techniques—signatures of handiwork, materials, structural idiosyncrasies, etc.—can help situate these anomalous garments to a reasonably secure timeframe. But the photograph, because of its popularity and ubiquity offers the possibility to preserve a period's smallest ancillary taste. Thus, the portrait photograph, whether formal studio sitting or spontaneous candid, invariably conveys the most personal construction of a social or public identity. The sitter and what she wears are inextricably linked, as Barthes describes, in a simultaneity of meanings.

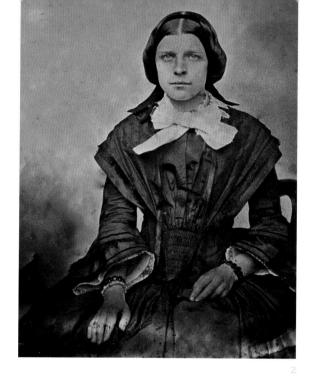

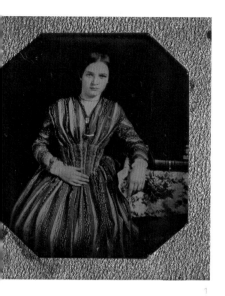

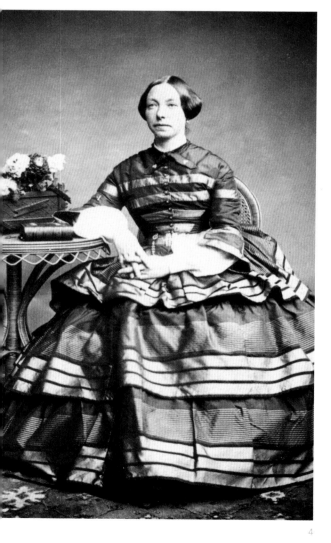

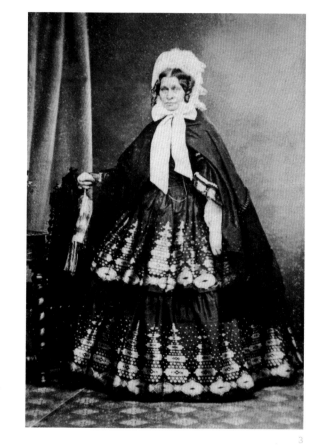

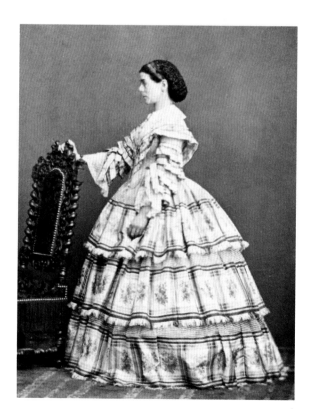

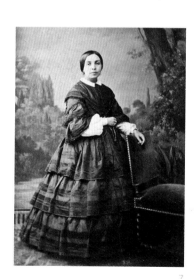

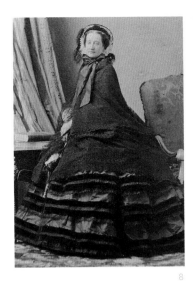 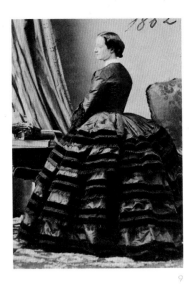 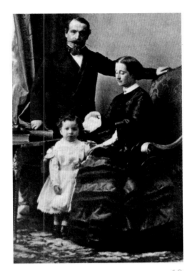

INTRODUCTION

In 1854, French photographer André-Adolphe-Eugène Disdéri introduced something new: a palm-sized image printed on sturdy, inexpensive paper that could be slipped into an envelope to mail to an admirer or pasted into an album. These cartes des visites revolutionized how people depicted and shared images of themselves and launched a craze that has continued to today's new media.

Previously, most photographic portraits depicted the sitter's head and shoulders, or perhaps a seated half figure. Disdéri's cartes des visites usually showed the entire figure and were cut from a sheet of paper that allowed for eight exposures, which let the subject appear in different poses, at different angles.

The new format clearly encouraged fashionable display. It is no coincidence that, just as cartes des visites hit cities, crinoline dresses began sprouting tiered skirts, vestigial tailcoats, mini bustles, bunched apron overskirts, wide sashes with long ties worn at the sides and cascading trains—elements appreciated only when the wearer had turned.

Examining cartes des visites and successors such as large cabinet cards, amateur photography, early fashion photographs and street fashion reportage, one sees how fashion, via its signature silhouette, developed, becoming modern in fits and starts, always true to the human love of adornment and display. The parade commences with the bell-shaped crinoline skirt, its width determined by the supporting structure, followed by the crinoline projectée, the bustle as it grew, shrank, and grew, and the cuirass or narrow hourglass. Long trained skirts, wasp-waists, leg of mutton sleeves, higher than

ever before collars, and the curious pigeon pouter bodice give way to a rebellious exoticism and fluidity during the 'teens and then the sporty simplicity of the flapper age. The 1930s reveal a lean and fluid silhouette sprouting broad shoulders, bustles, and full skirts; some of these elements remained, truncated due to shortages and restrictions, during World War II.

Although a New Look silhouette already existed, couturier Christian Dior gave the style wings after the war and established the notion of introducing a new silhouette with every biannual collection, an idea that impacted fashion coverage and expectations of novelty more than actual silhouettes. From 1947, the gulf widened between the fashion faithful dressed in the latest styles and those who adhered to a prevailing mood and took years to adjust to changing waistline placement, shoulder size or set, or pant leg width. The rebellious attitudes of the 1960s signaled the beginning of the end of a dress code. By the 1980s there was no longer mass conformity to a single standard.

Photographs show what fashion illustrations cannot: what people actually wore, what exaggeration they adopted and the actual prevalence of style. (In fashion plates of the 1850s and early 1860s crinoline skirts are enormous; photographs show a greater range). Trains and steamships had sped up travel during the 19th century, yet it's still remarkable that the same style appeared almost simultaneously in Canada, Europe, India, Argentina, and Algeria. Even across continents, one sees a high level of conformity, a phenomenon that continued for well over a century.

The majority of the aspiring and upper classes obeyed the dictates of fashion; wearing the correct clothes in the correct manner oiled the wheels of upward mobility. Some early feminists adopted pants-based alternative dress in the mid 19th century; photographs show women courageous enough in their convictions to flout convention. There was also an aesthetic dress movement opposed to the restrictiveness of the cuirass and bustle silhouettes. The scarcity of photographic examples suggests that flowing medieval and classical inspired styles were more prevalent in paintings, perhaps appealing primarily to the art world, making aesthetic dress a precursor to early 20th century Bohemianism.

Describing 19th century fashion as Victorian is a misnomer. While Queen Victoria and her consort Albert were fascinated by photography and she and her family dressed to be photogenic in black and white—her white wedding dress, her daughters' graphic Greek key or crenellated borders around the skirts of crinolines—her dress was less influential than reflective of prevailing styles; when she entered her decades of mourning she established a precedent for British royal women in the new century: a style outside fashion.

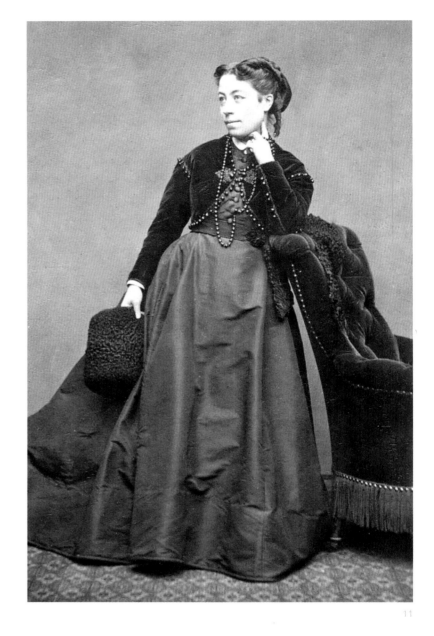

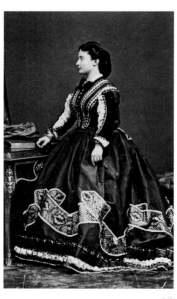

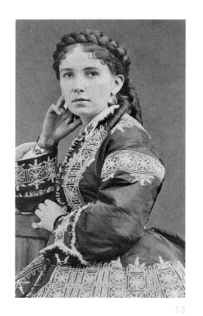

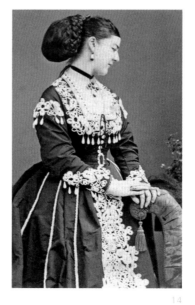

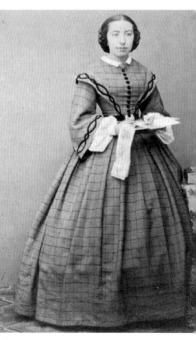

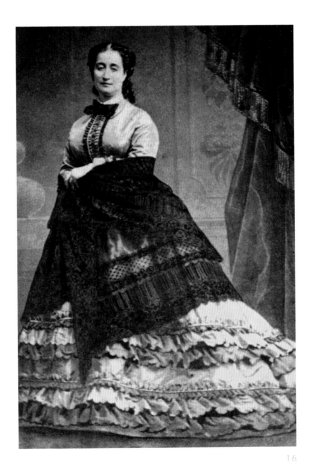

THIS PAGE: Striking similarities among day dresses worn by the Empress Eugenie, members of her family and court and friends of the court from other countries; their crinoline dresses, most likely by her favored couturier Charles Frederick Worth, feature white collars with black bow ties and decorative bands in velvet.

OPPOSITE: Within the context of adherence to the dominant look of the 1860s, photographs reveal the shadings of difference among what was worn by the aristocracy, royal mistresses or courtesans, the upper and middle class, and actresses and other performers.

Mid-19th century photographs indisputably show the influence of the French court. During Empress Eugenie's short time in the public eye (she married Napoleon III in 1853 and their exile began 1870) there was a voracious global desire to know what she and her circle wore to balls at the Tuilleries, the races at Longchamps, and the beach at Biarritz. Beyond descriptions in fashion or gossip columns of newspapers and ladies' magazines and the occasional engraved illustration in a pictorial newspaper, one could see photographs of Eugenie and the ladies of her court in photographers' shop windows. Because it was easier to see the details of a dress in a photograph, cartes des visites facilitated and likely increased the appetite for emulating women of style. Cartes des visites made celebrities of photogenic, well-dressed people and fans of collectors; a beguiling image of the Princess of Wales giving one of her children a piggy-back ride sold more than 300,000 copies.

From the second half of the 19th century to the beginning of the 20th century, the same general silhouette was worn for all activities, give or take a long train or a low décolleté, based on the formality of the occasion. Women wore boned bodices and long skirts to climb trees, hike in the mountains, and play tennis. Not until the 1890s, with the widespread popularity of bicycle riding, did women dress differently for sports, pairing bloomers with the same jacket or shirtwaist they normally wore with a long skirt. As women embraced sports, they wore more sport-specific outfits and casual clothing edged its way into general fashion. And as more relaxed clothing became acceptable, women and men became more playful for the camera.

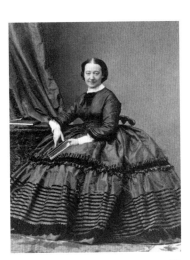

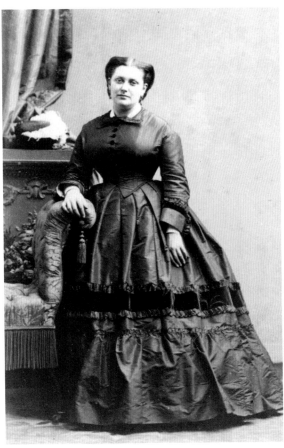

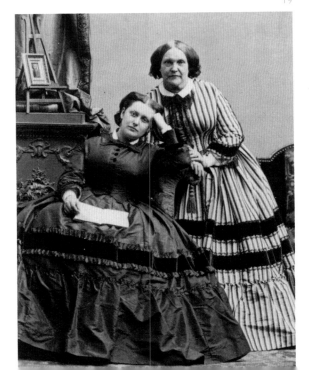

As the 20th century opened, photographers for agencies such as Bain News Service and Séeberger Frères stalked stylish haunts for "street" fashion to entice readers of photograph-illustrated newspapers and magazines; meanwhile, couturiers tried to set styles by sending professional models to the races and resorts in their latest designs. Fashionable types were photographed at Deauville, in Newport or Palm Beach; aboard ships making ocean crossings, strolling in the Bois de Boulogne or along Park Avenue, at races in France, and spilling from churches after society weddings. In 1911 fashion leapt from the rotogravure society section to international front pages when a daring new style, the divided skirt called the jupe-culotte, caused a near riot at Auteuil. For months, jupe-culottes were in newspapers, fashion magazines, and on photo post cards. Then, as now, street photography exerted enormous influence since a style or fad could catch on instantaneously, faster than the fashion cycle of a seasonal couture collection that appeared in a magazine three months after it hit the runway.

Just as fashion has evolved from successive dominant silhouettes to almost innumerable simultaneous looks, photographs reveal an evolution of the stance and the pose. The rigid posture and reserved expression dictated originally by a long shutter time also reflected a desire to comply with standards of behavior that survives only in today's ceremonial photographs.

Nineteenth century poses, comportment, and ensembles, were parsed and the poseur, who posed deliberately for the camera, was considered affected and flamboyant. Today, the Internet has nearly replaced television coverage, bringing the visual language of the runway and fashion magazines into a broader, global culture of nearly two billion smart phones. The red carpet, the grand entrance, even the departure bring out the poseur in everyone. Such a proliferation of highly articulated staged moments has given even greater credence to a counter movement featuring seemingly natural images taken by visionary roving eyes who spot and capture examples of bella figura anytime, anywhere.

In his memoirs, couturier Paul Poiret recalls his days at the house of Doucet around the turn of the 20th century when the staff worked around the clock weekends to prepare and deliver gowns to be worn on Sundays at the French races. Women of fashion (as well as models from couture houses) dressed specifically to attract agency photographers whose images had begun to appear in newspapers and magazines around the world.

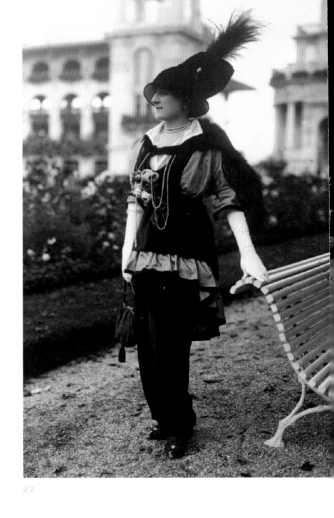

22

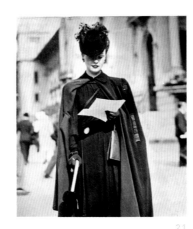

21

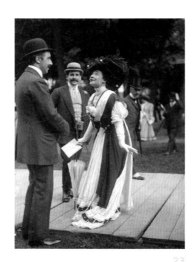

23

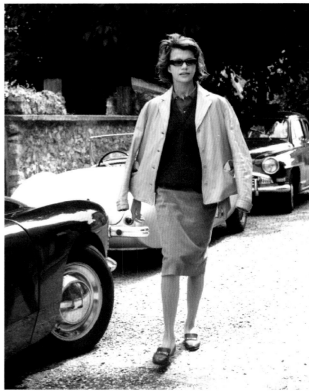

25

24

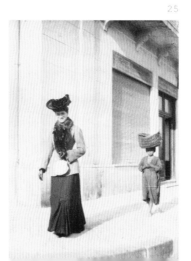

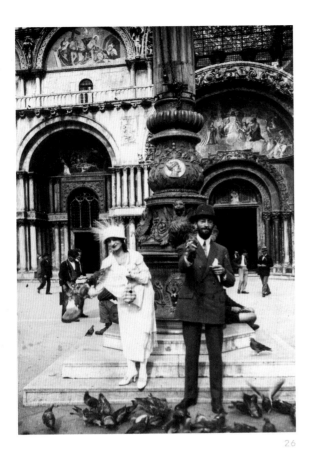

26

The pose and the gaze constantly evolve: everyone is a photographer, a model, a celebrity.

28

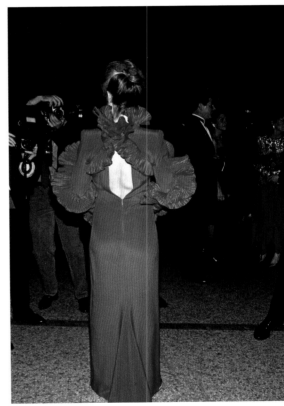

27

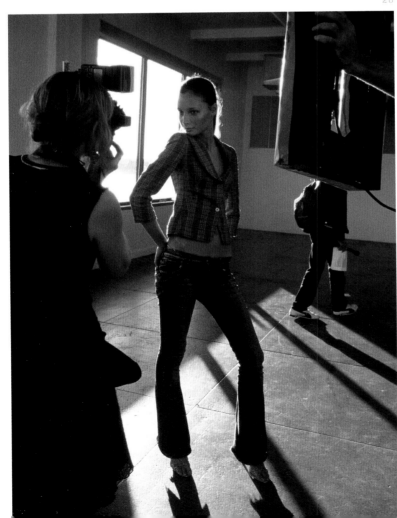

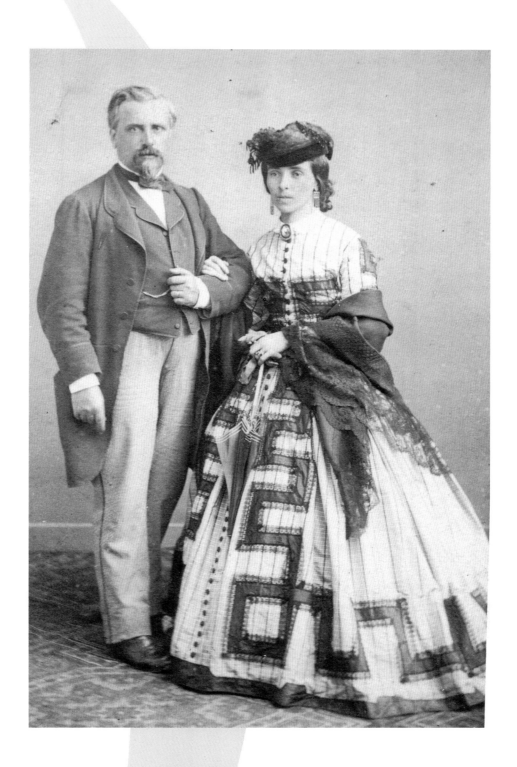

1860s

Being out and about, seeing and being seen was *the* pastime of the mid-nineteenth century. Whether in a park, along an avenue, or at a country location conveniently positioned near one of the new railroad stops, promenading provided many opportunities for display of the latest, or at least the most correct clothes. Although the crinoline supported skirt of the 1850s and 1860s would be the cause of much mirth, there were also those who valued its convenience (the thin steel bands forming a bell-shaped cage were so lightweight compared to layers of petticoats), and there were even those who praised its elegance: On June 3, 1857 a writer for the *Weekly Vincennes Gazette* of Indiana opined: "Show us anything more graceful than the motion of a lady in a well-made hoop! It is not the old fashioned walk. It is an easy, gliding gait, like the motion of a barque upon a quiet sea."

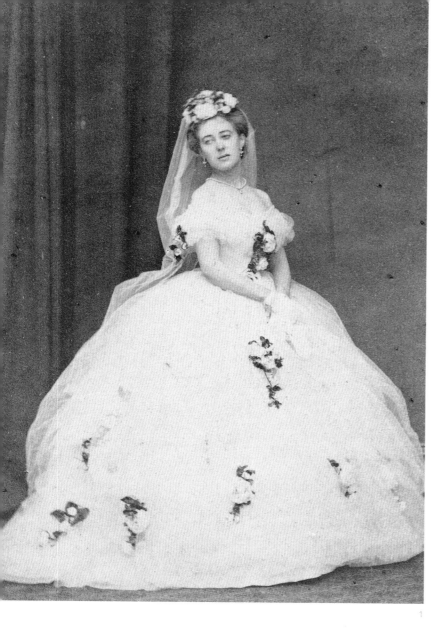

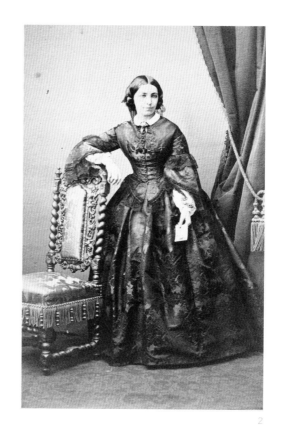

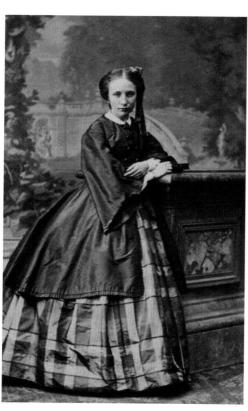

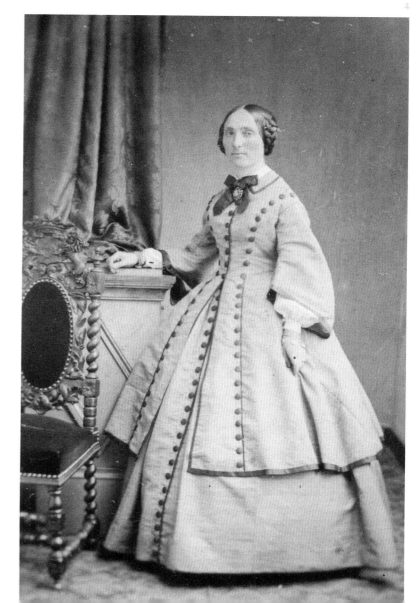

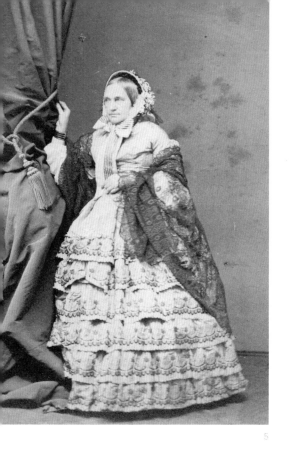

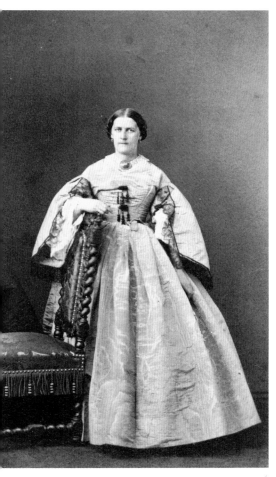

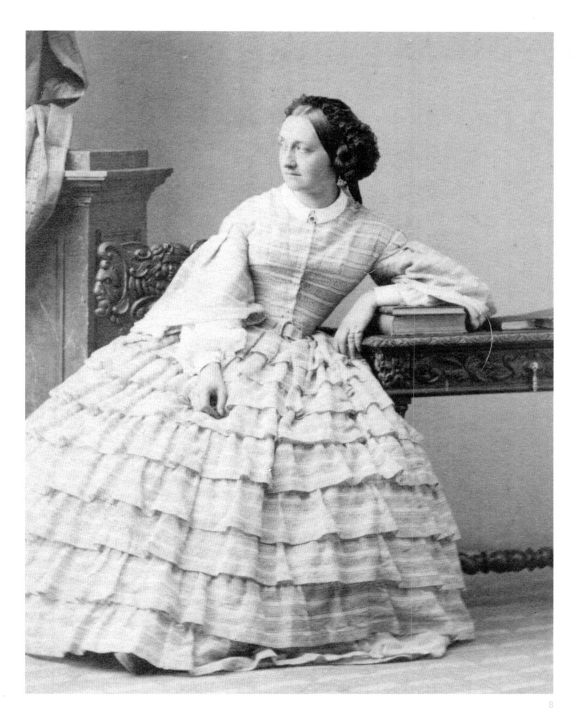

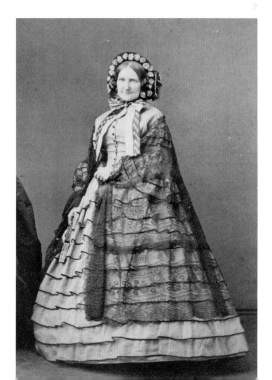

1860

On March 23, 1860, *The New York Times* reports, "the plain skirt and the flounced skirt will be worn, but flounces have the largest choice." Wide crinoline skirts appear in the whole range of feminine attire, but the largest skirt seen here is also the most formal: a ball gown worn for presentation at the English court. The long fitted jacket over a matching dress is something new; it wasn't always referred to as a suit, but it was the forerunner of the woman's skirt suit.

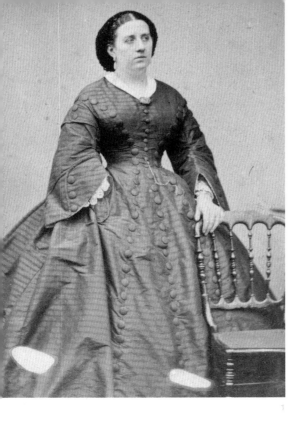

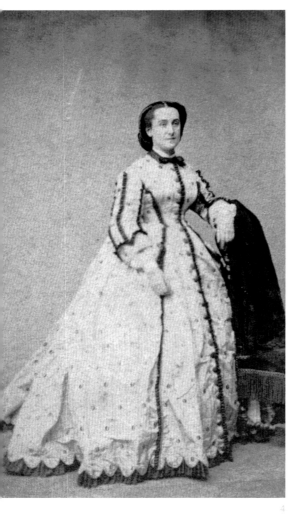

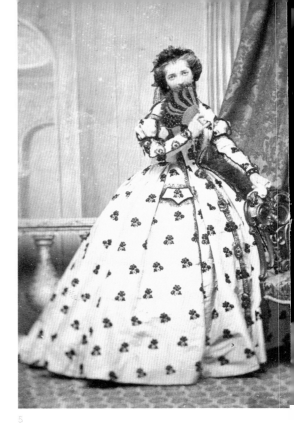

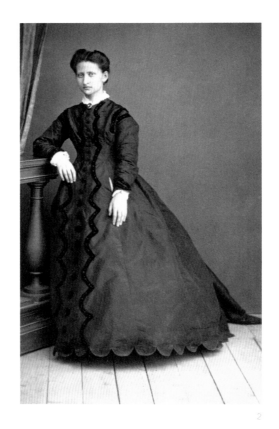

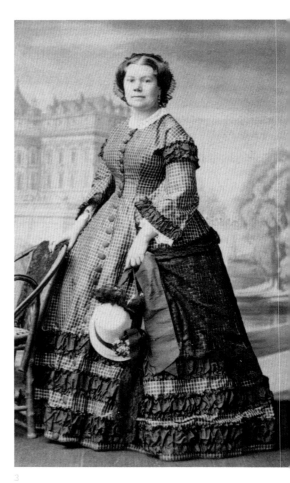

PRINCESS CUT DRESSES

In an 1889 reminiscence published in *Vanity Fair*, Charles Frederick Worth describes one of the first two dresses he made for the Empress Eugenie in late 1860 or early 1861 as "a house dress in black moiré antique, cut princess, that is to say, with skirt and corsage in one piece, the first dress ever made in that style. This was the first order for my imperial custom that I ever filled." Princess cut dresses required particular skill to fit.

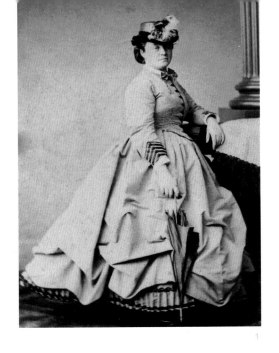

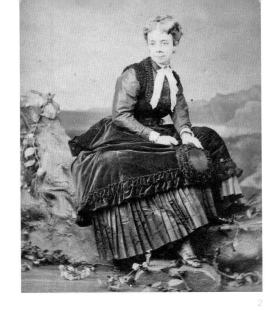

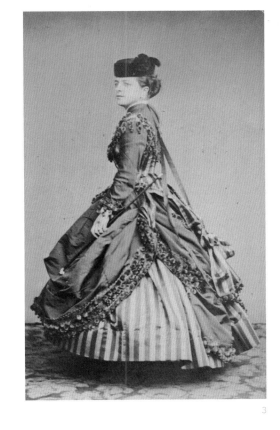

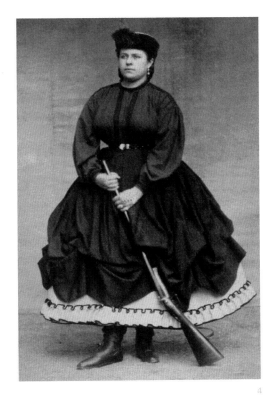

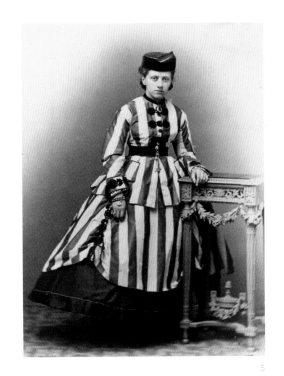

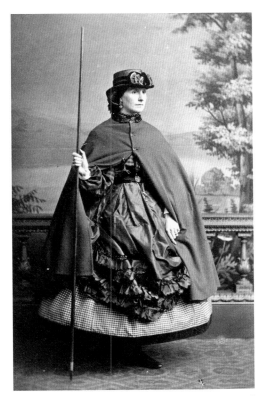

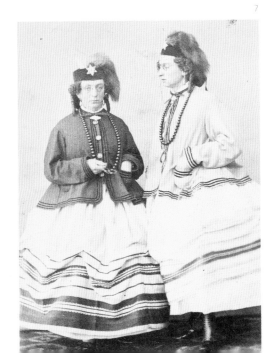

WALKING
SKIRTS

"The ladies of Paris have adopted a fashion for the winter of wearing their dresses drawn up over colored jupons [skirts], light woolen materials of striped patterns, with a band of plaid of a narrow plaited flounces near the edge. They have thus given up sweeping the streets" (Indiana's *Vincennes Gazette*, January 23, 1864). Fashion often changes via innovations led by sports clothes, and the walking skirt may be an early example of this, as the bunched up overskirt morphed into the panniers of the late 1860s.

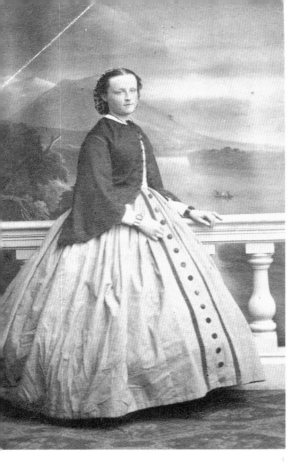

1

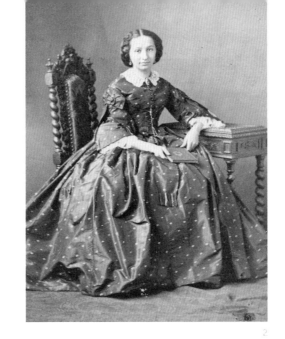

4

18

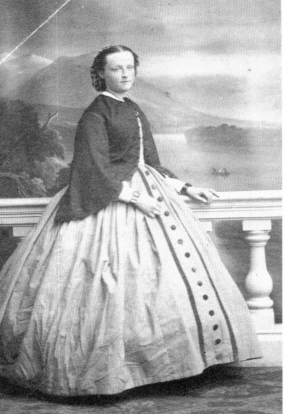

2

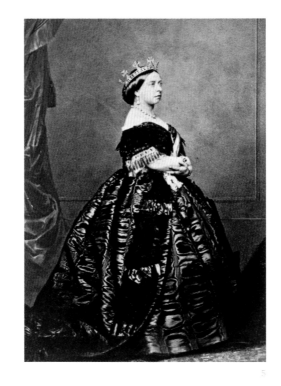

5

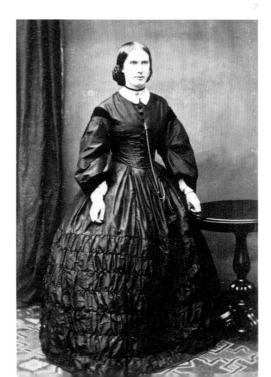

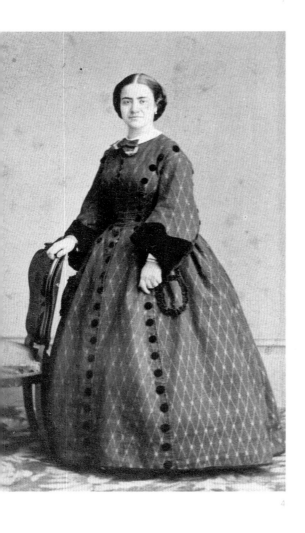

3

7

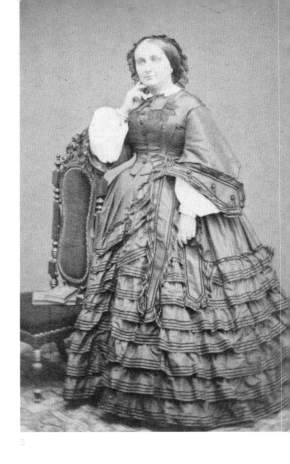

6

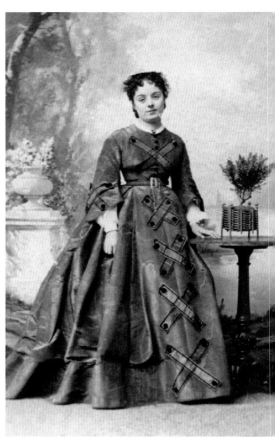

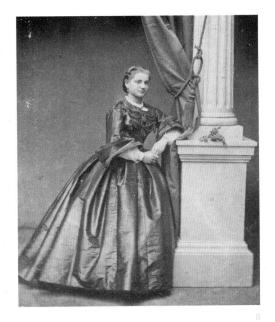

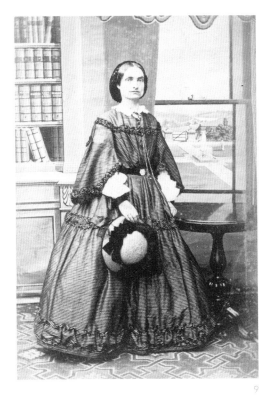

1861

"The most elegant French dresses we saw were not gored, but very full in the skirt and joined to the waist in piles of plaits at the hips, the front and back of the waist and skirt being cut in one piece," reports *The Weekly Vincennes Western Sun*. The skirts shown here range from gathered to softly pleated to gored while the width of the skirts is balanced usually by wide sleeves called pagoda sleeves. Queen Victoria, in mourning for her mother, wears a dress of the era's most luxurious fabric, moiré antique in moderate fullness (she was said to have disapproved of the enormous crinoline dresses like the one worn with a fitted coat by a Viscountess).

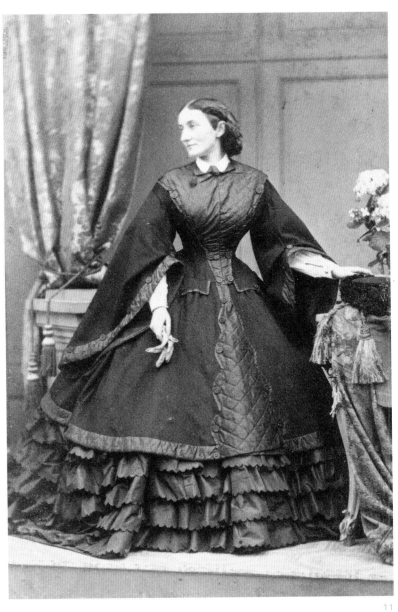

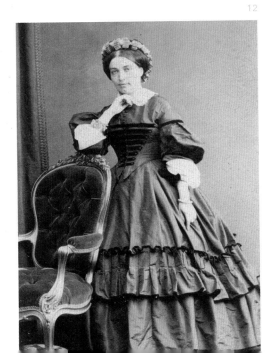

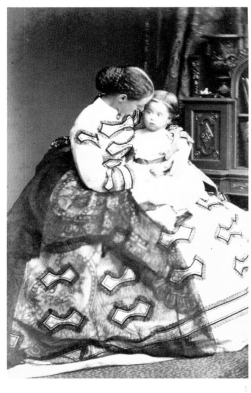

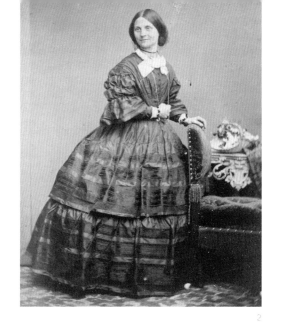

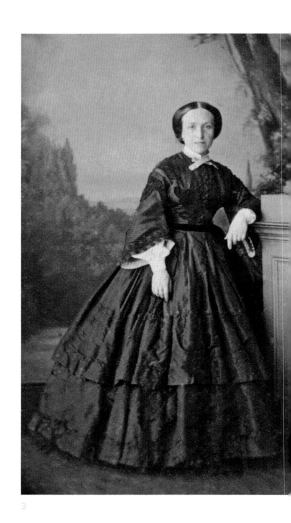

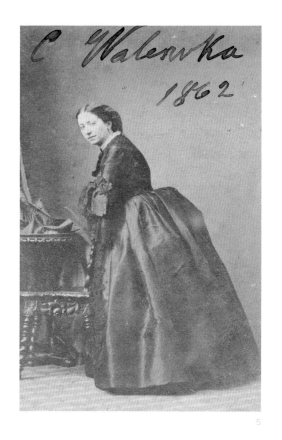

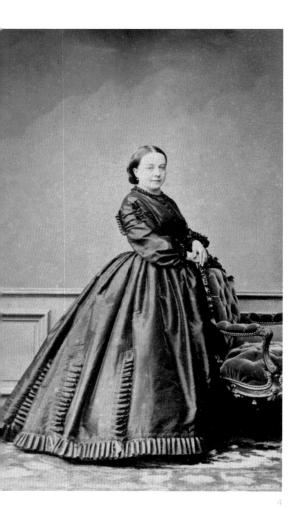

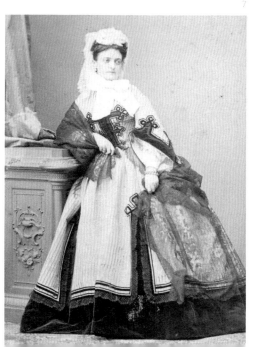

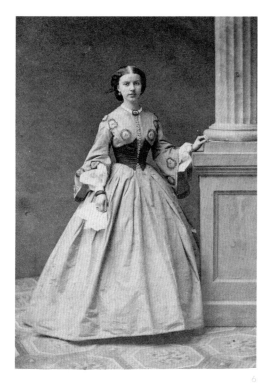

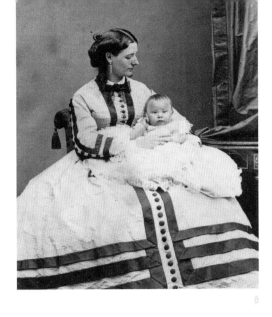

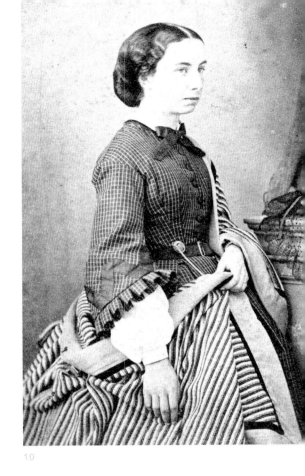

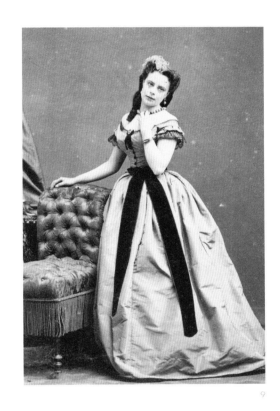

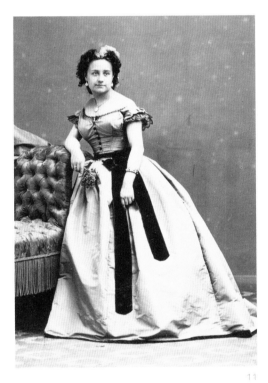

1862

Countess Walewska, one of the inner circle of beauties at Empress Eugenie's court wears a dress with a small but pronounced protuberance (dress improver) at the back of the waist—a harbinger of the bustle to come. The Fiocre sisters, both famed dancers with the Paris Opera, pose for Disdéri in the same ball gown. Eugénie Fiocre, who was a muse to Hilaire-Germain-Edgar Degas (among others) demonstrates a theatrical coquettishness.

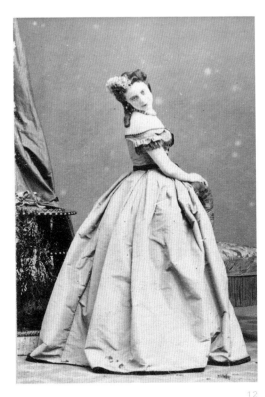

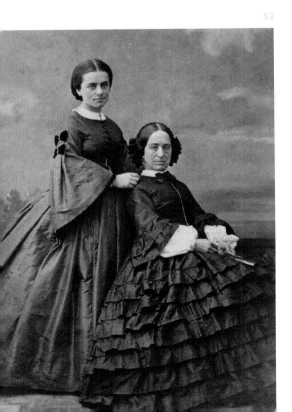

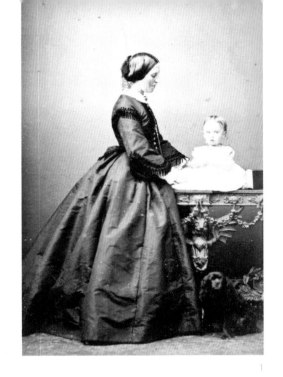

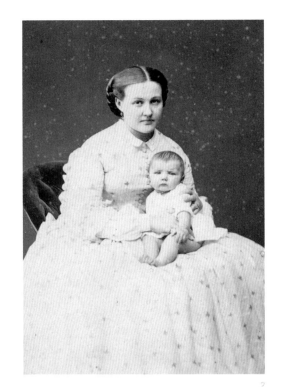

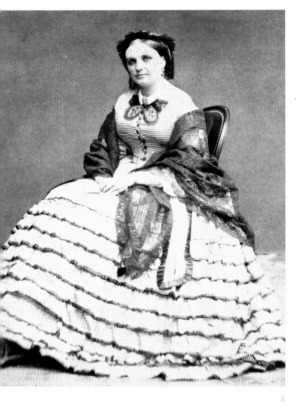

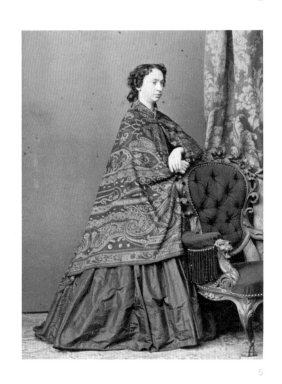

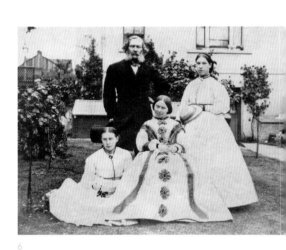

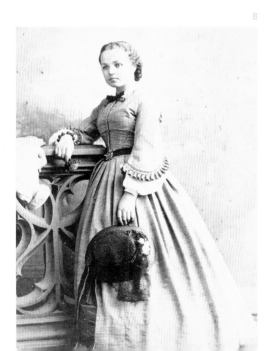

1863

No ensemble was complete without the correct accessories: parasols, hats, and especially shawls. Shawls would eventually be abandoned by women who didn't want to cover up what they were wearing, but they were wildly popular right up to the moment they disappeared. As a status symbol nothing else came close; for the same price as an Indian or handmade lace shawl, one could purchase a small farm according to *The New York Times* in 1862. Alternate wraps shown here include the lace and tulle pelerine worn over a low ball gown and the passementerie-trimmed sacque jacket.

9

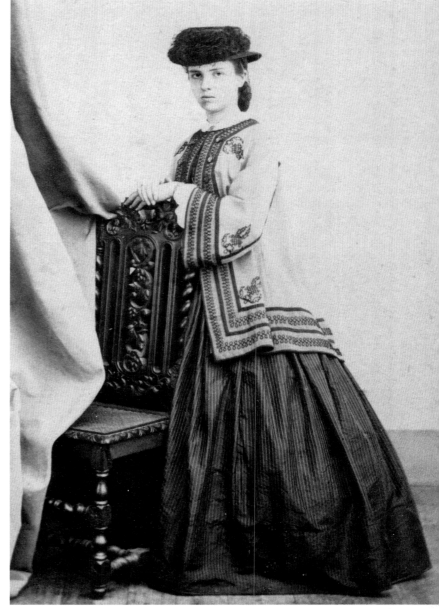

10

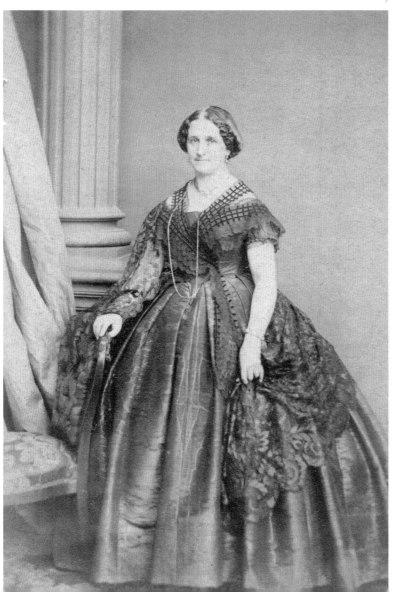

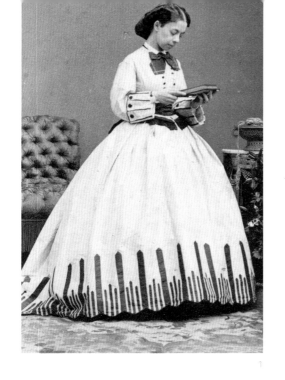

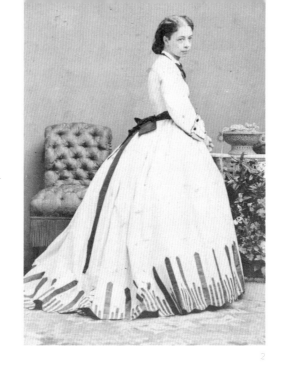

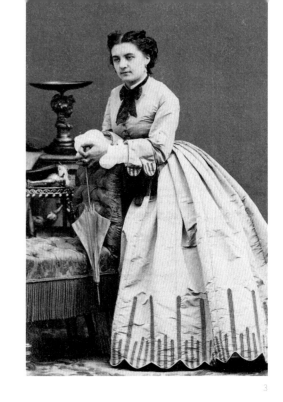

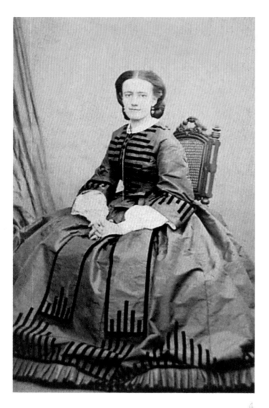

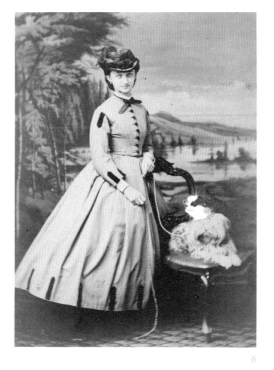

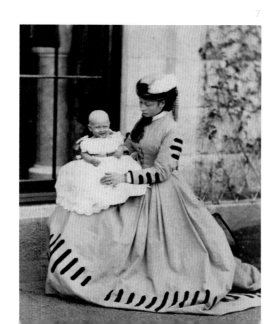

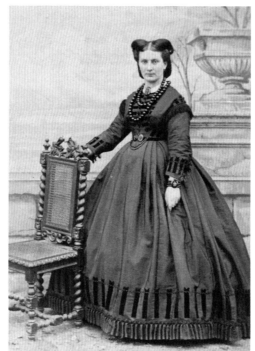

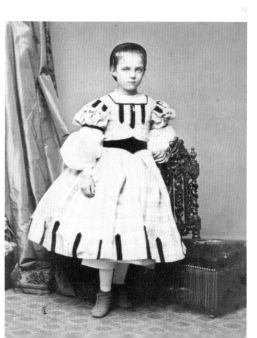

THE WORTH
THAT LAUNCHED A
THOUSAND COPIES

Charles Frederick Worth claimed that his earliest version of this design was the then-new idea of a dress and paletot jacket in gray silk and trimmed in black velvet which was offered to the Empress Eugenie around 1861 (while she was still in demi-mourning for her sister). What is possibly the first of several fashion plates with an unattributed design matching such a description appeared in October 1862. Around this time, the most stylish woman in Paris, Princess Pauline de Metternich, was photographed by Disdéri in the dress version shown here. This image would be used as the basis of her portrait by Hilaire-Germain-Edgar Degas. Although some other versions offered almost identical elements such as the *ancient regime* cuffs and the scalloped hem, most just borrowed the easily copied velvet appliqués.

1864

"Crinolines are very wide round the edge and very narrow round the hips, and dresses are so cut that they require scarcely a plait when mounted to the waistband" (*Godey's Lady's Book*, May 1864). For grand evenings, the open wide neckline was practically universal, and plump shoulders and arms were much admired. Trimmings (ruching, velvet appliqué, passementerie, lace) seem to have taken up the slack where tiers and double skirts once reigned. Croquet would be the first great outdoor sport fad of the nineteenth century, and because it didn't require extreme exertion, it was a proper pastime for ladies.

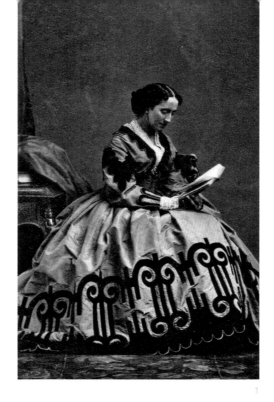

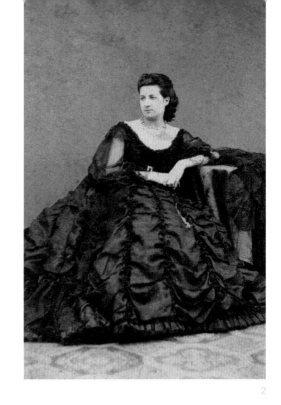

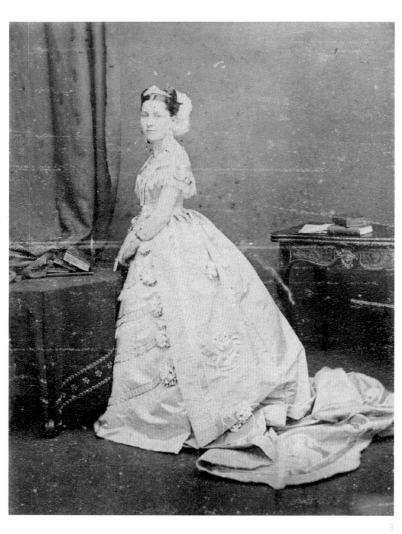

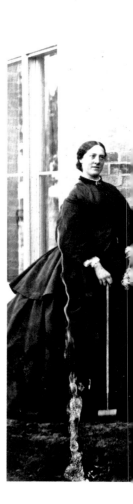

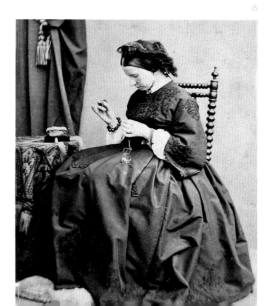

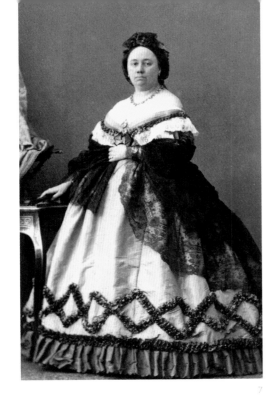

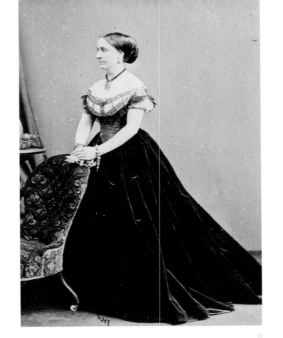

8

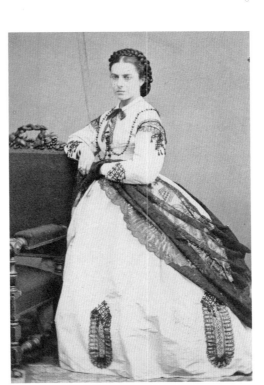

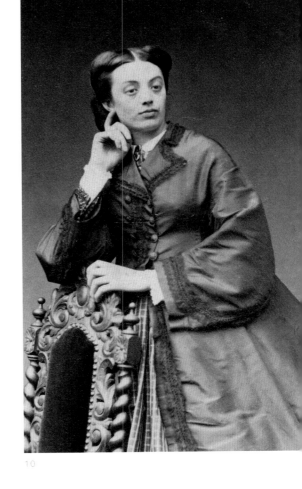

5

7

9

10

11

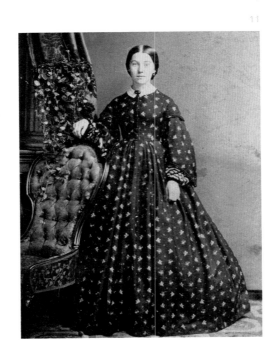

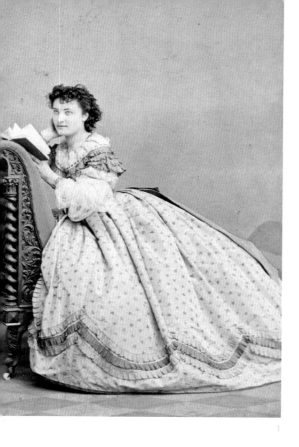

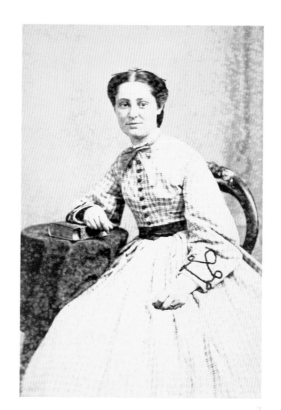

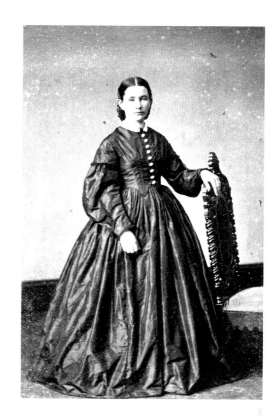

1865

Sleeves are narrower and the skirt continues to fan out in the back in the crinoline projetée. The white linen under sleeve would vanish when the outer sleeve became narrow. "To this day men speak tenderly of their mother's white under-sleeve" (*Godey's Lady's Book*, March 1897).

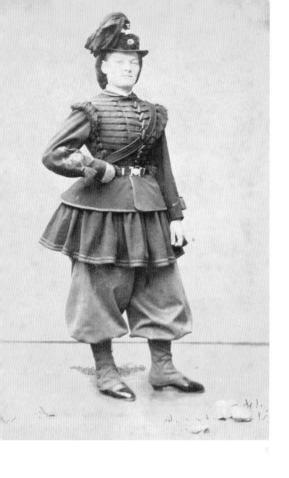

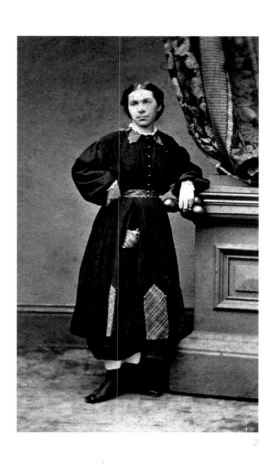

ALTERNATE DRESS

Despite the fact that Amelia Bloomer's namesake dress reform costume is usually considered to have bowed to controversy and faded away, there were examples of women wearing pants and/or bloomers-based ensembles either for sport or in opposition to a system restricting women to elaborate on ornamental attire.

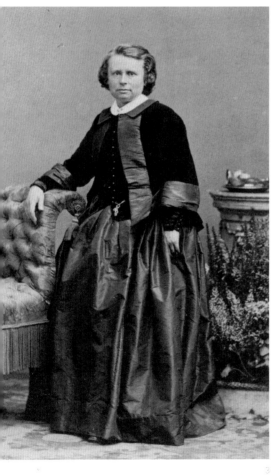

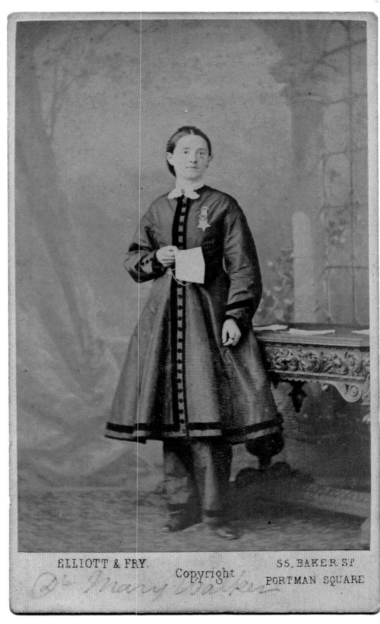

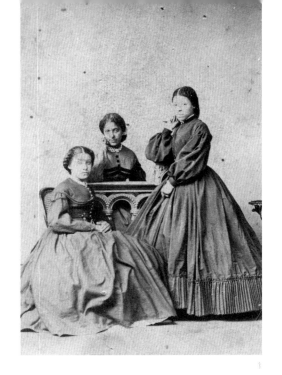

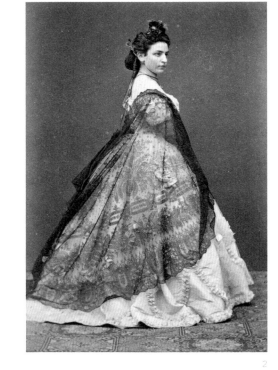

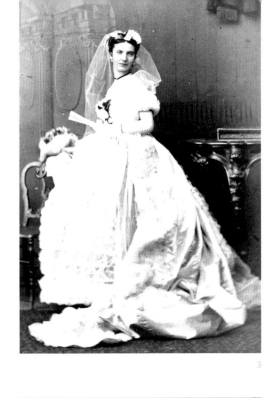

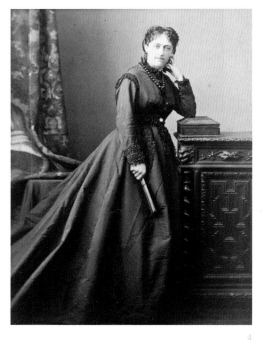

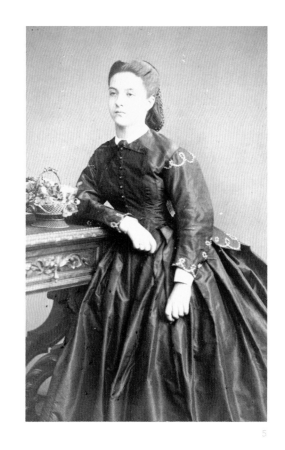

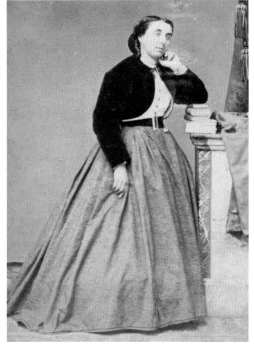

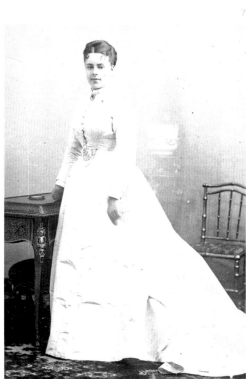

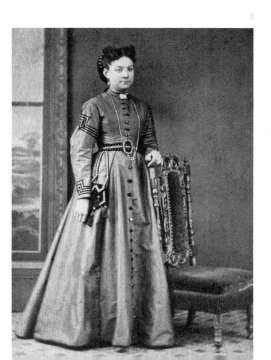

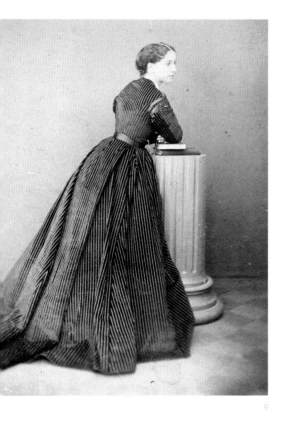

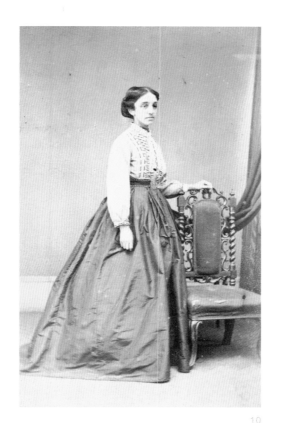

1866

Crinoline *projetée,* as worn in France, England, Germany, and Mexico. Although there are still voluptuous folds of fabric to be seen, particularly in the ball gown worn for presentation at court, gored dresses are looking sleeker with a flatness to the front. Perhaps because a hidden pocket isn't feasible, a decorative purse/pocket appears.

10

9

11

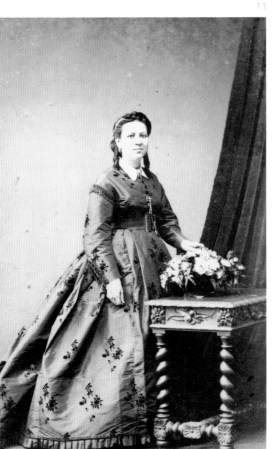

12

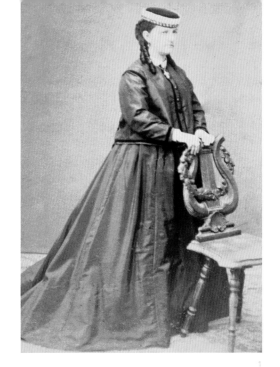

1867

Two views of a Mrs. Bates show her seated in a black silk dress with jet embroidery and also standing dressed for an outing in a short paletot jacket and flat hat worn low on her forehead. A white cotton or linen waist with ribbon and other trimming, worn with a solid or plaid skirt makes an appearance. Christine Nilsson, the blonde and blue-eyed Swedish singing sensation, wears what is being called a suit, a fitted paletot and matching skirt in striped silk.

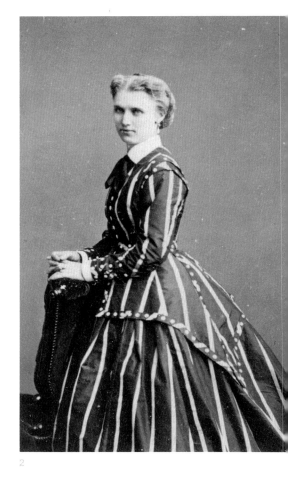

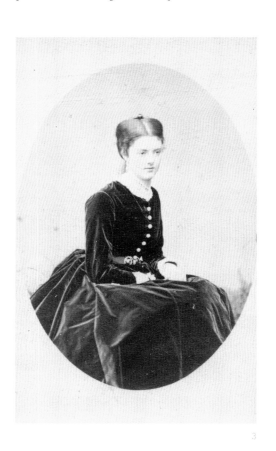

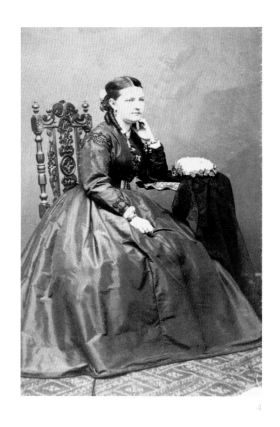

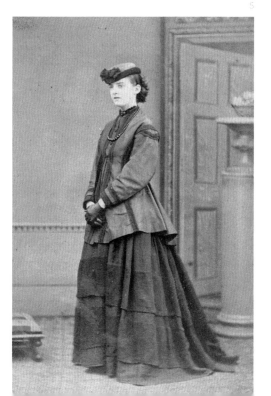

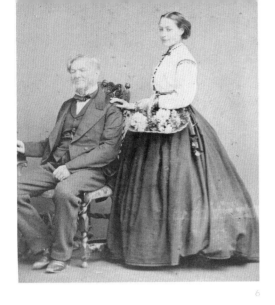

6

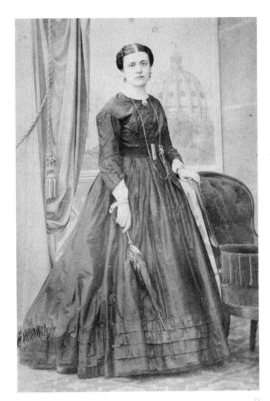

9

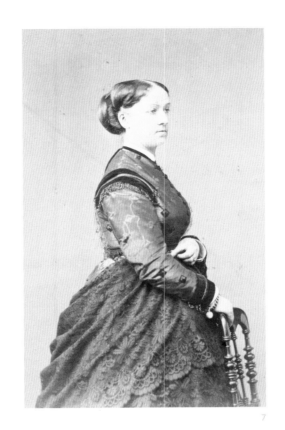

7

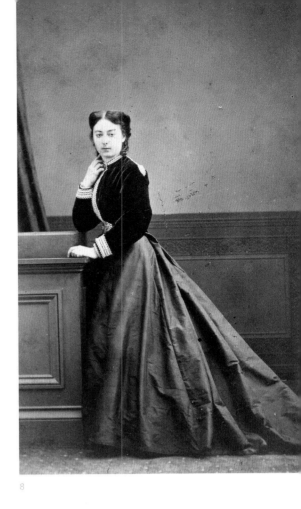

8

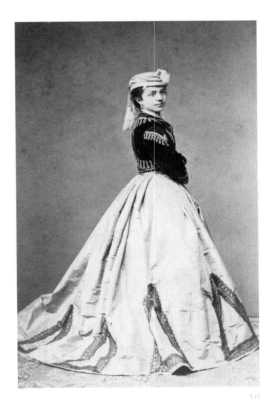

10

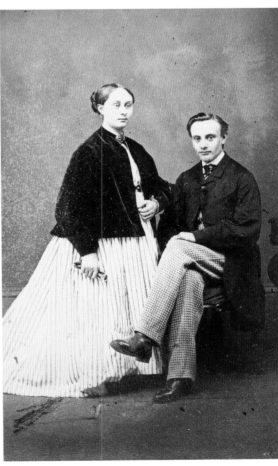

11

12

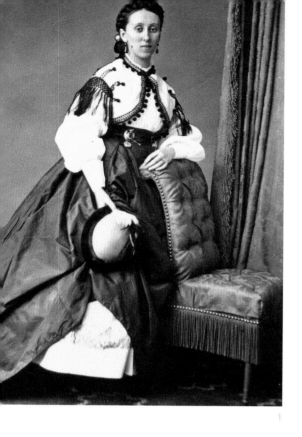

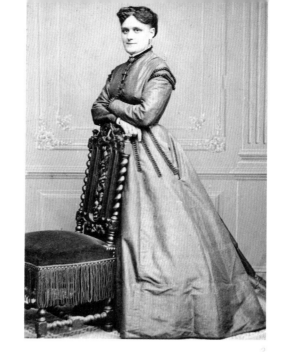

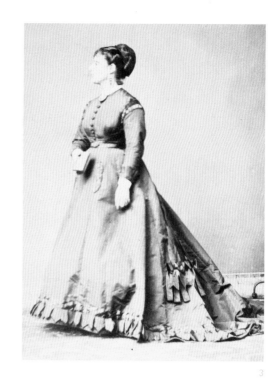

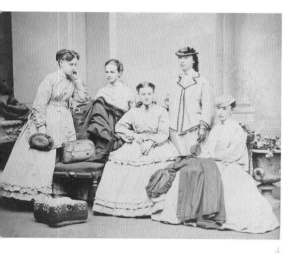

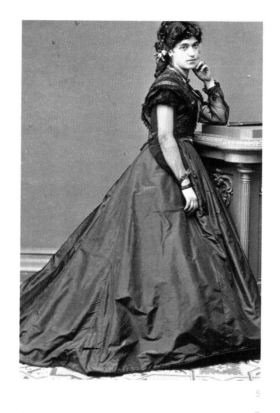

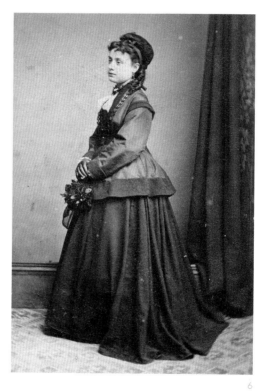

1868

"For visiting and evening toilettes one thing is indispensable and that is a train. Only ignorant women or vulgar now wear crinoline so that it can be detected. Sashes have become the most important accessory of the toilette. No dress is complete without them" (*The New York Times*, March 26, 1868). Well-shaped arms were mid-nineteenth century advantages, and were shown to great effect in the striped and point d'esprit versions of the sheer yoke and sleeve.

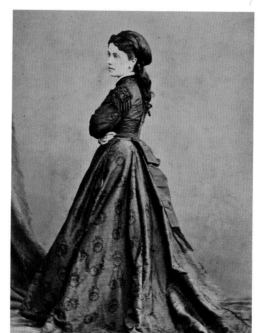

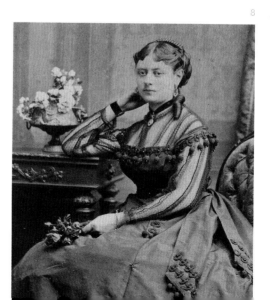

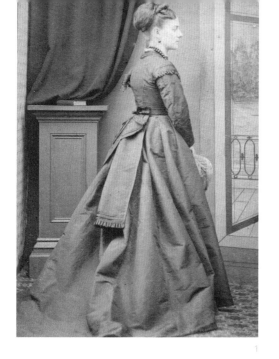

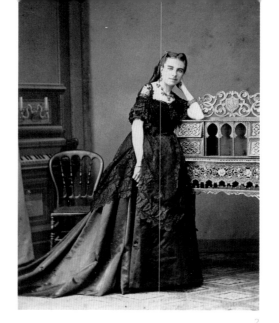

1869

The crinoline projetée recedes and narrower skirts are topped with overskirts and aprons, some in the form of paniers. The bustle makes an appearance. On March 29, 1868, *The New York Times* queried: "What is a panier? Everyone wants to know. It is something invented by Worth, the great French man-milliner, and it makes a 'bustle' or needs a bustle, nobody knows which, and it does away with crinoline."

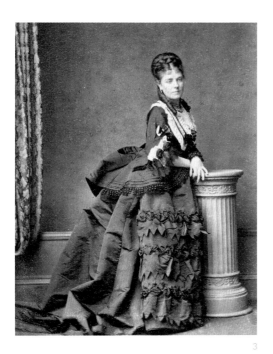

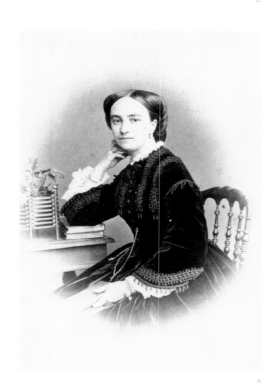

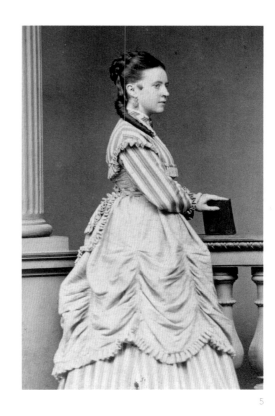

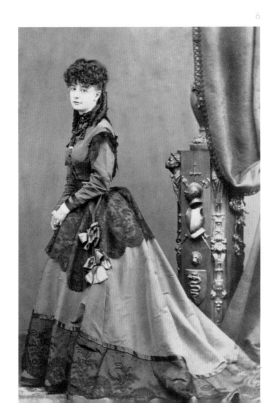

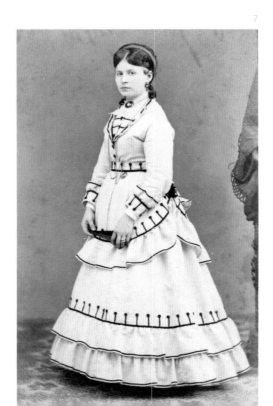

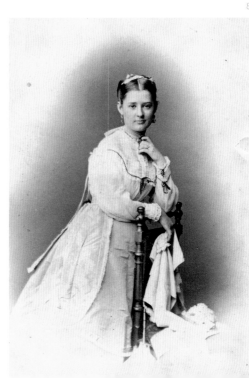

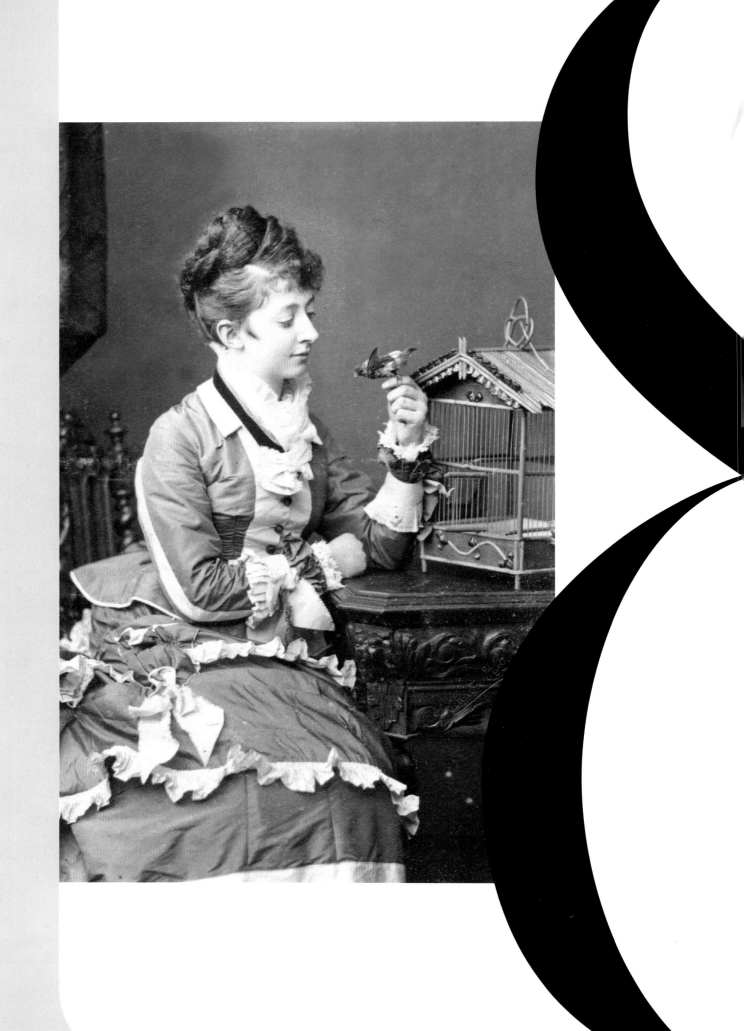

1870s

This would be a decade of two-tone dresses making marvelous use of the saturated and intense shades of analyne dyes (invented the decade before) and, equally popular, black dresses with textural interest from velvet, lace, black layered over white, and especially jet. As the decade progressed, the apron overskirt elongated; eighteenth century touches such as the polonaise and pouf of a bustle ceded to Medici influences; and the basque bodice would morph into the closely fitted cuirass—the narrow, closely-fitting silhouette reaching its zenith with the late 1870s version of the princess dress.

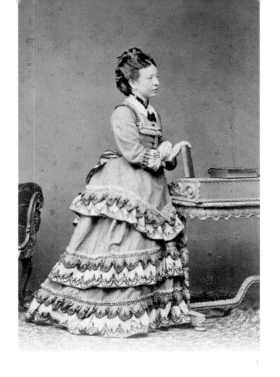

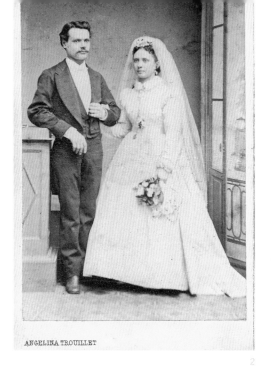

ANGELINA TROUILLET

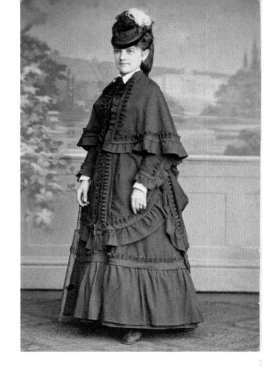

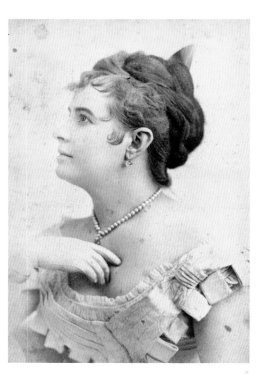

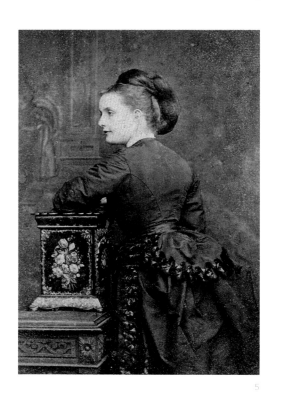

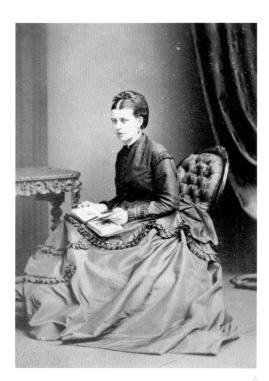

1870

Fashion seemed, if anything, more exuberant during the siege of Paris, the Franco-Prussian War, and following the exile of the Emperor and Empress of France. The 1870s would be a time of elaborate hairstyles, miniature hats, over skirts and under skirts, bustles and panniers, and all manner of ruffles, especially in contrasting tones of silk or black-and-white lace.

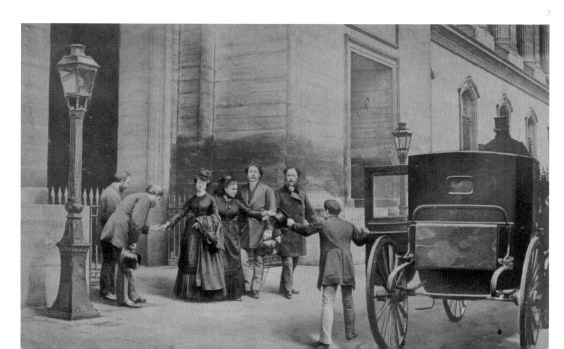

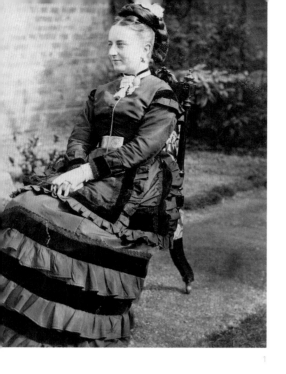

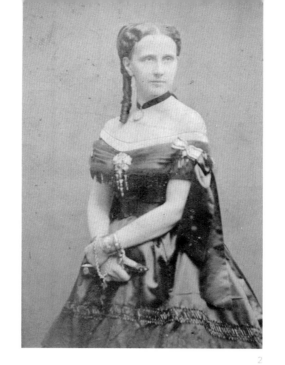

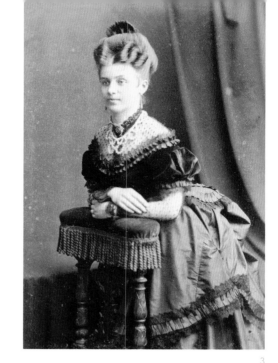

1

2

3

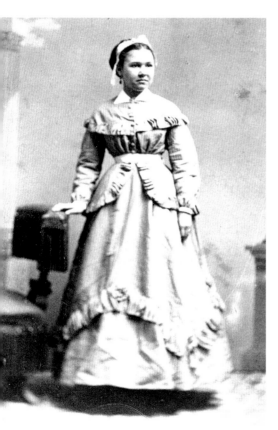

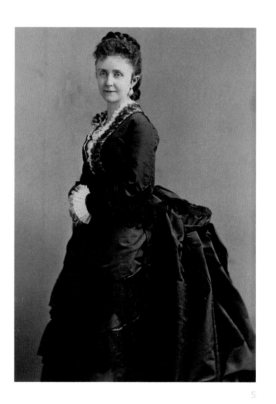

4

5

6

7

8

1871

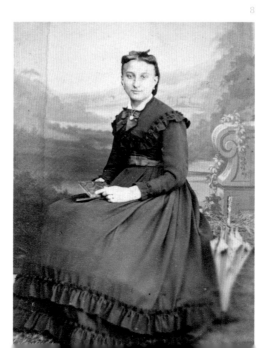

In April, *Godey's Lady's Book* declared, "the Crinoline, or rather the hoop skirt, is superseded by the tournure. This tournure or bridle is made very large, rising high above the hips, and extending the dress skirts to such a size that they hang away from the person, and looks as round as if hips were worn. Dress skirts, to fall gracefully over the tournure, must be made very full behind and at the sides. The tournure is made with hoops, either with muslin or crinoline over them. Persons who do not care to have their dresses stand out so much around the hips still continue to wear a moderate sized hoop skirt, which makes the dress hang more uniform."

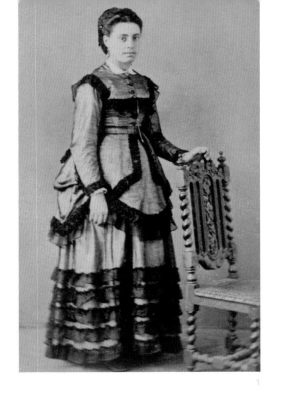

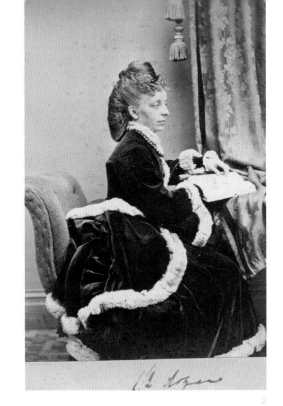

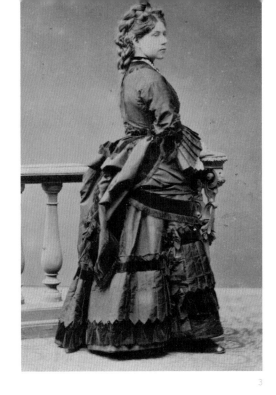

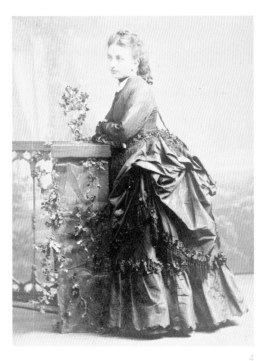

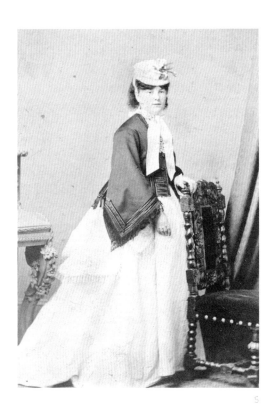

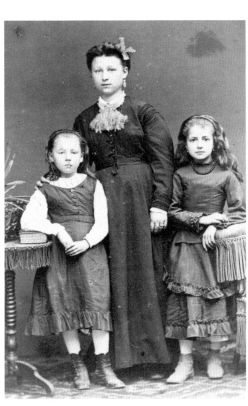

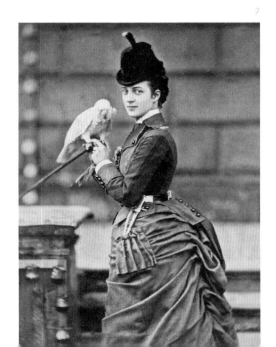

1872

Alexandra, the Princess of Wales, poses with a parrot in a tailored ensemble; her jacket, probably that of a walking suit, features military detailing. Married to the Prince of Wales since 1863, she was elegant with a clotheshorse figure and photogenic. Always impeccably dressed, she added greatly to the allure of the royal family, particularly given that Queen Victoria was in mourning from 1861 to the end of her life in 1901. In the photographic equivalent of a celebrity's face generating newsstand sales of a magazine today, an image of Alexandra giving a piggy back ride to her daughter was the most popular carte de visite ever sold at 300,000 copies.

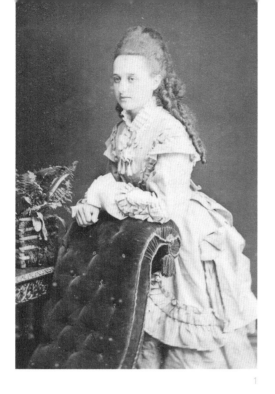

1873

In his book *The History of Fashion in France*, Augustin Challamel describes the scope of the hair industry during the 1870s: Women in Normandy, Auvergne, and Brittany sold their hair or exchanged it for fabrics. Some 51,816 kilos of hair were sold in 1871 with the business roughly doubling by 1873. Most of it seems to have been worn in a high braid at the crown of the head.

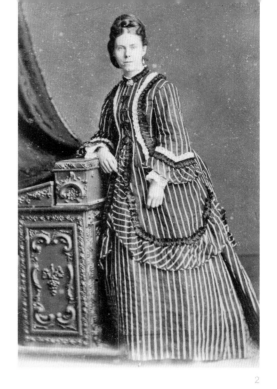

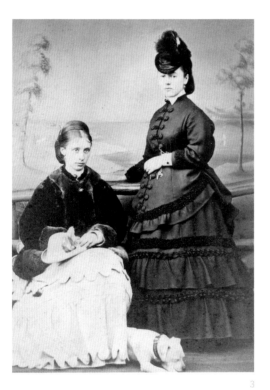

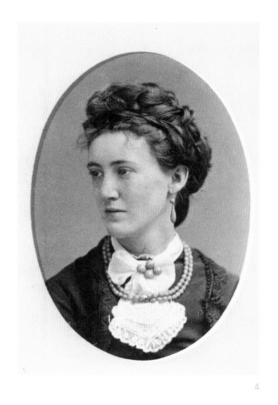

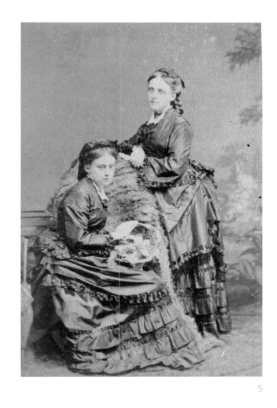

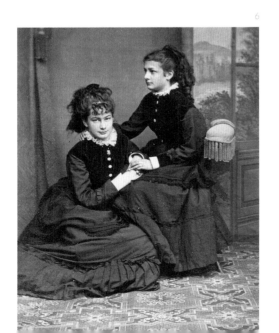

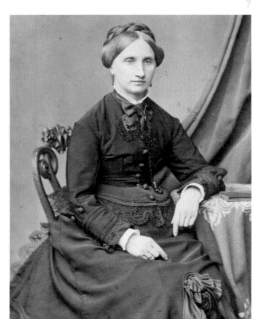

1874

A shift in the silhouette occurs as a longer bodice is introduced: the cuirass/basque bodice is described as tight-fitting (to the hip) long and whale-boned, while the longer bodice emphasizes the waistline. Buttons are becoming more prominent and can be had in dazzling variety—many are used in conjunction with various styles derived from masculine attire, such as redingotes and coachman's coats.

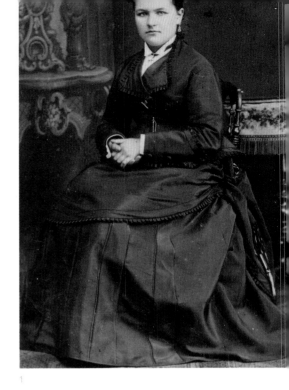

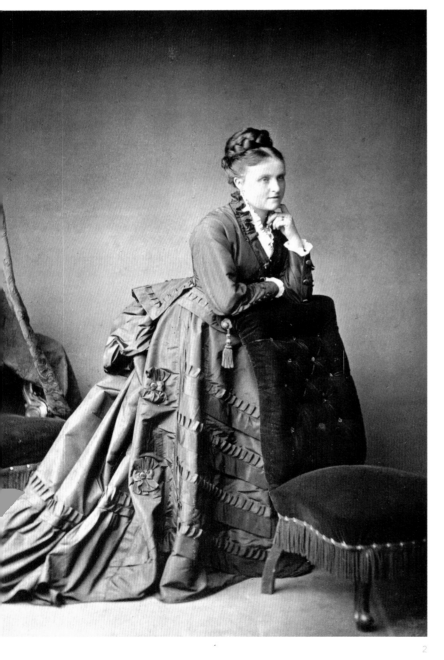

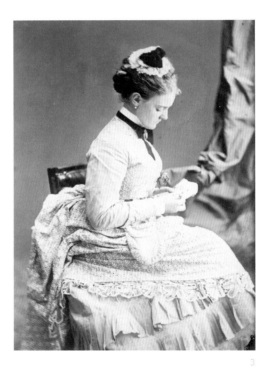

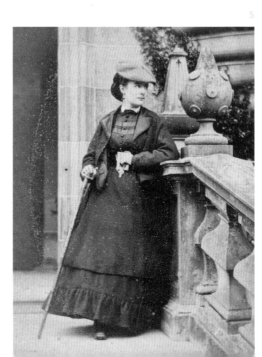

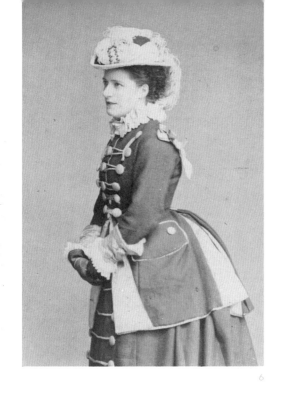

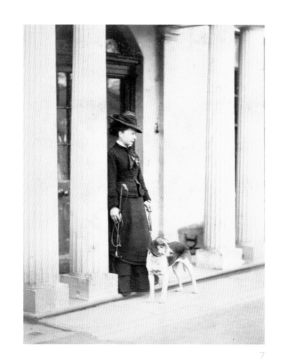

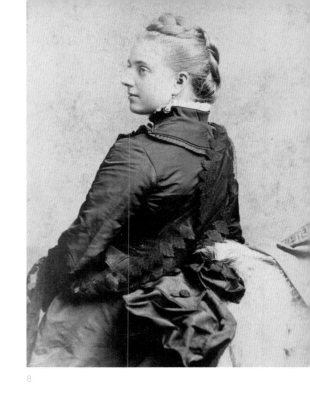

6

7

8

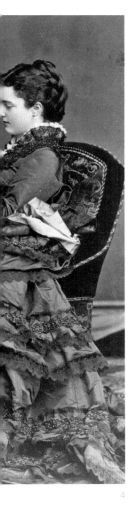

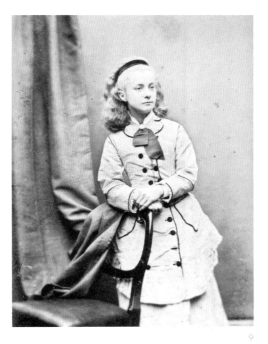

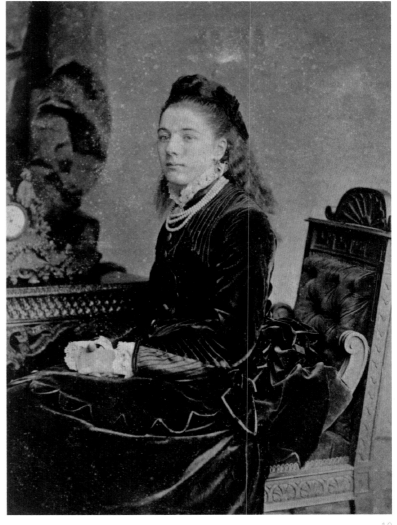

9

11

4

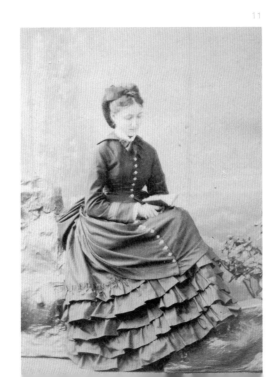

10

43

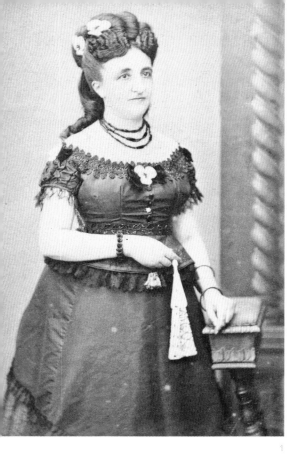

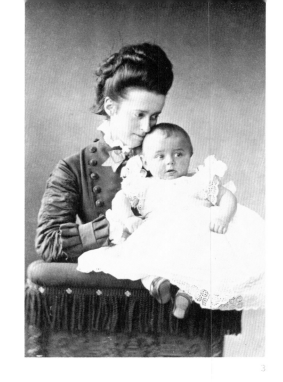

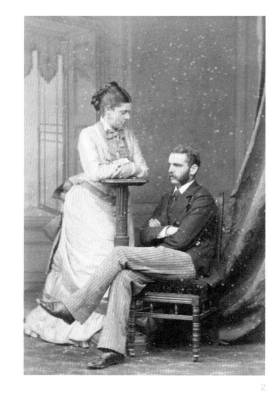

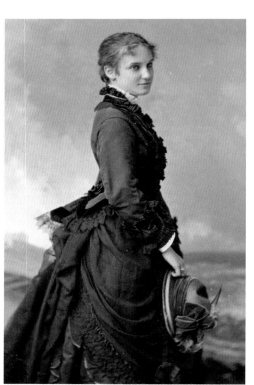

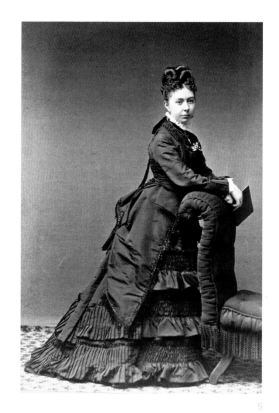

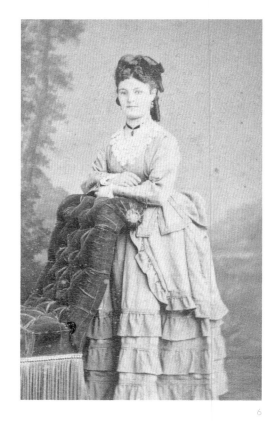

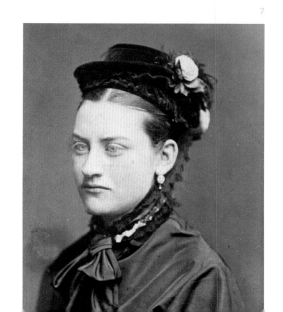

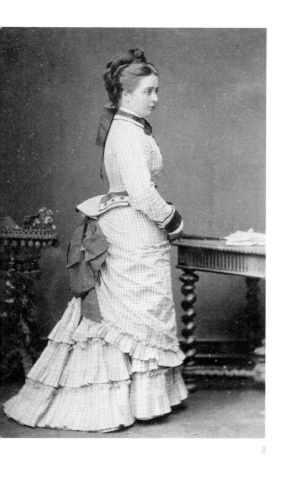

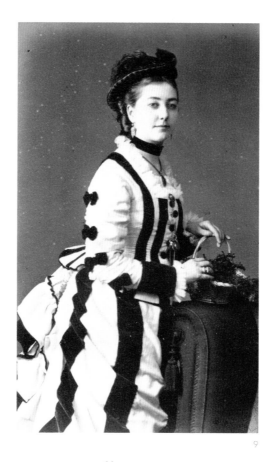

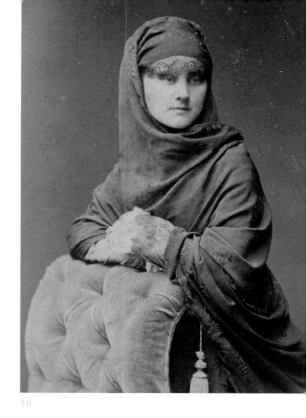

10

11

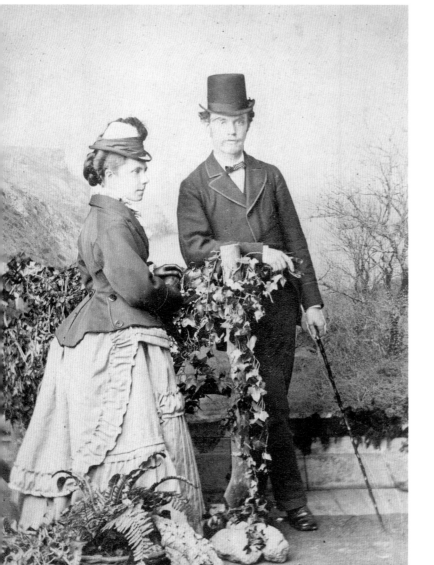

12

1875

The fitted jacket like the cuirass/basque bodice is dominant while skirts take on a narrower look and bustle drapery becomes lower. In March, *Godey's Lady's Book* pronounces: "There is no fashion more popular at the present time than the deep, round apron to be seen on so many dresses. It should be long enough to reach almost to the edge of the skirt, and should curve gracefully up the waistband at the back, where it is hooked or tied across the tournure. The front is sewed plainly to the belt, and its entire fullness consists of four plaits sewn into each side of the belt at the back."

1876

A lady of the house wears a reception gown with jet embroidery, and a chatelaine at her waist suspends several useful objects, including a magnifying glass. The trained evening dress in velvet is in princess style with historical details of obscure origin. A mother's dress features one of the pockets that became popular during the 1870s, and a matelasse wrap has pagoda sleeves and is trimmed with fur.

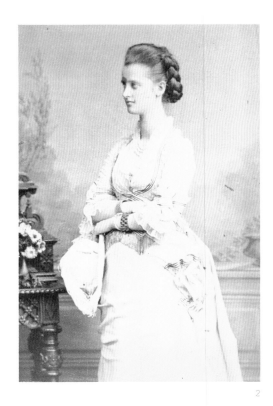

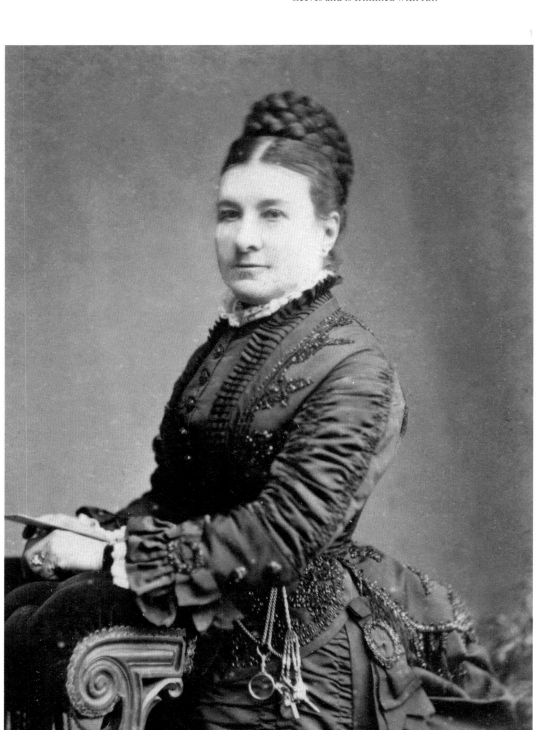

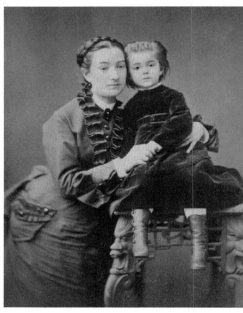

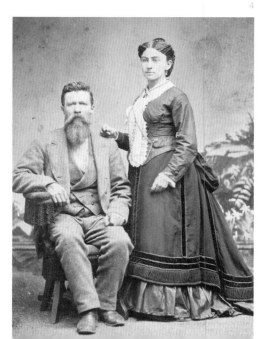

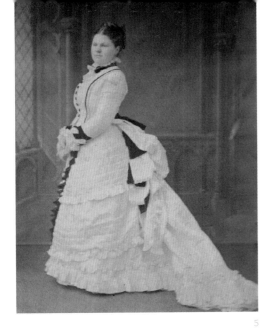

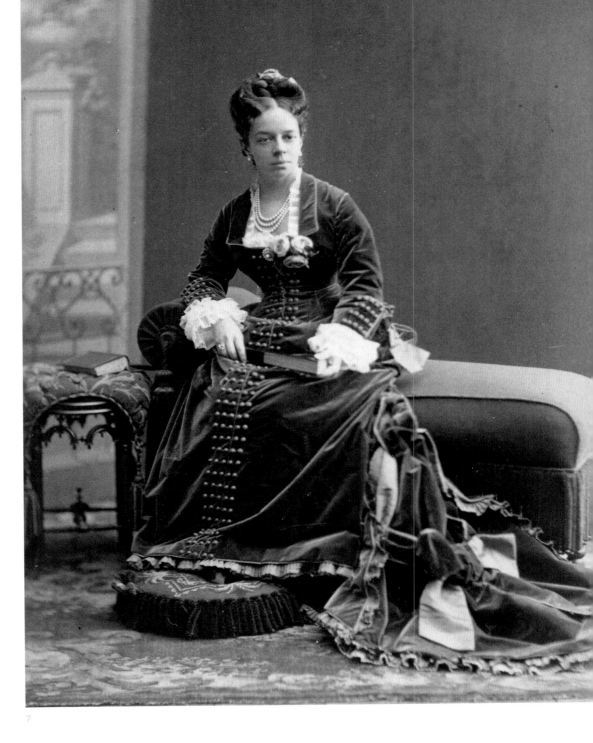

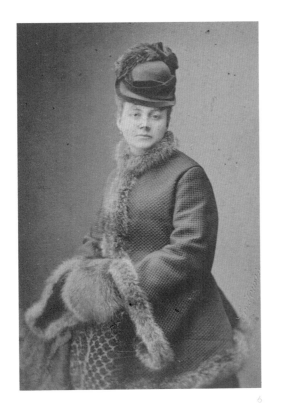

5

6 7

8

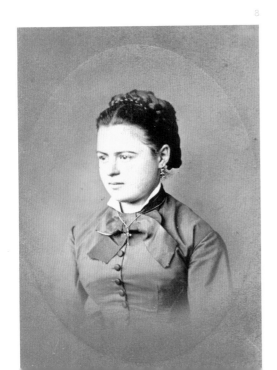

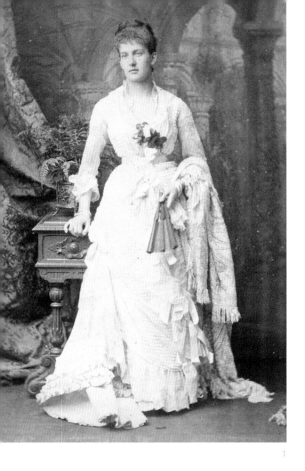

1

2

3

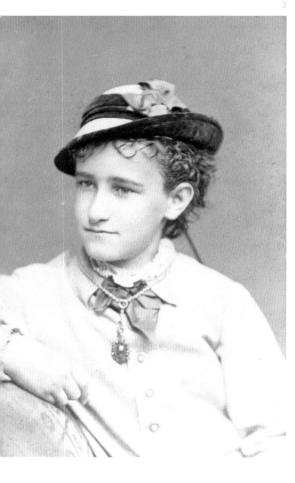

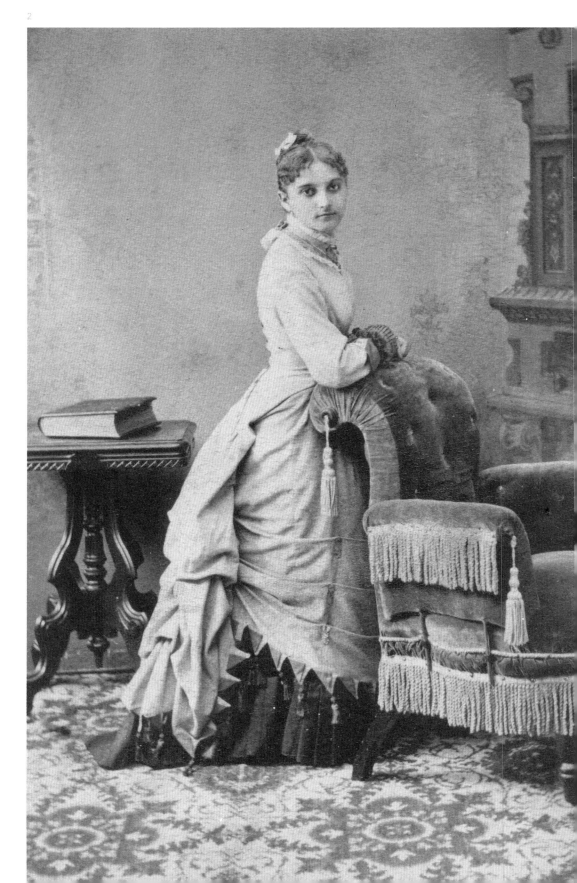

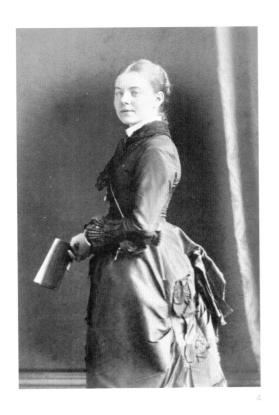

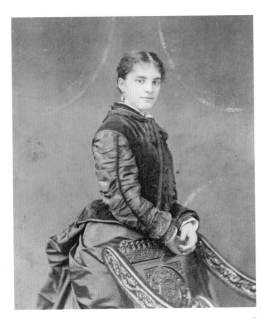

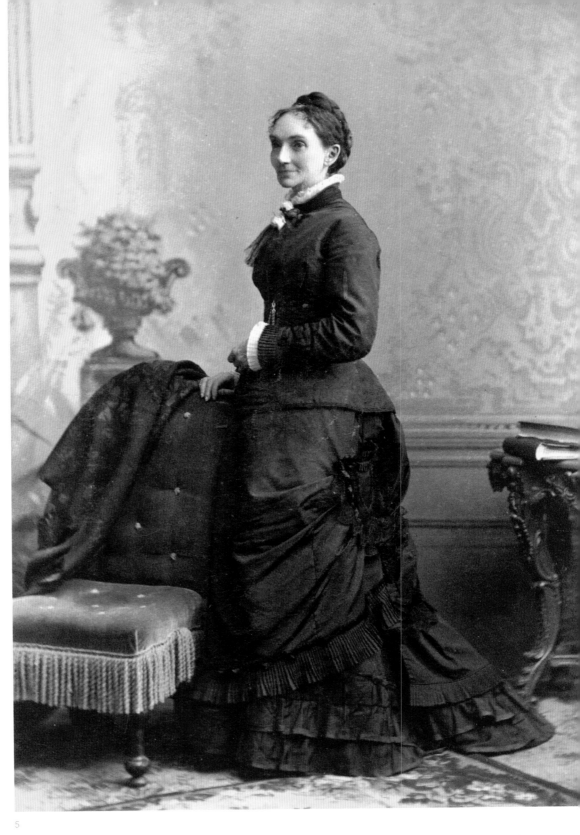

1877

The silhouette is becoming narrower and somewhat elongated. Apron overskirts are getting lower in the front, almost to the floor. A dinner gown in white-on-white striped silk and lace, U neck with ruffles, lace sleeves, paisley wrap and fan is worn by Mrs. Arthur Sassoon, née Louise Perugia, one of the leaders of Anglo-Jewish society. Born into an old Italian-Jewish family, she married Arthur Sassoon in 1873. Her sister married into the Rothschild family in 1881—the first Jewish wedding ceremony attended by the Prince of Wales, who was also a friend and houseguest of the Sassoons. Louise Sassoon's pre-Raphealite beauty was captured by painter George Frederic Watts in 1882.

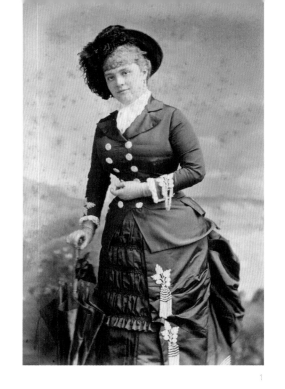

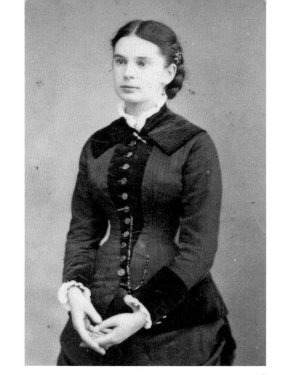

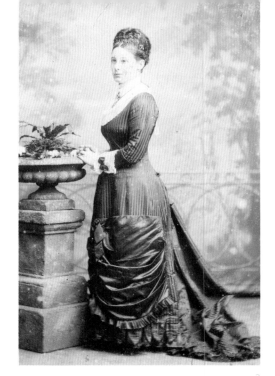

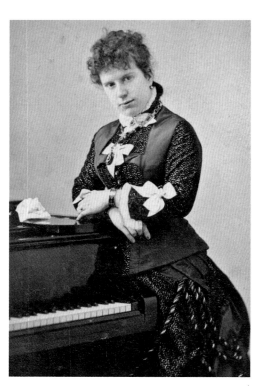

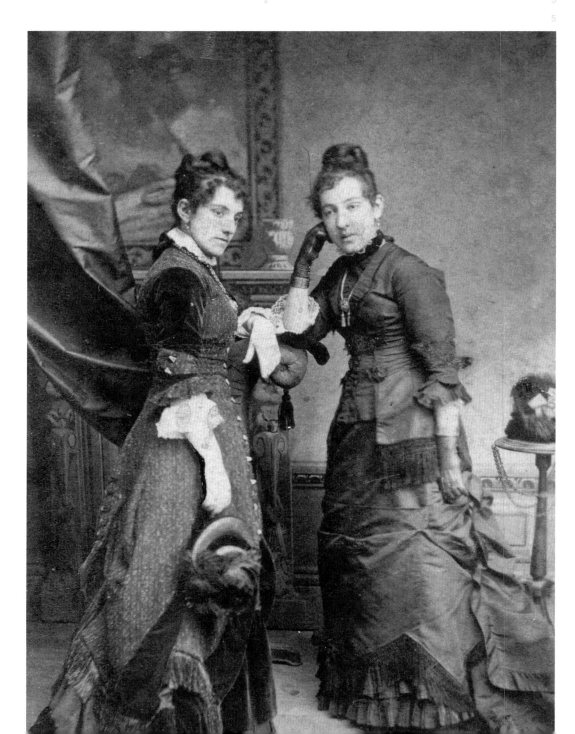

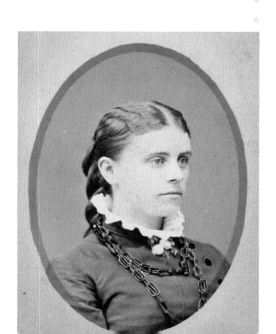

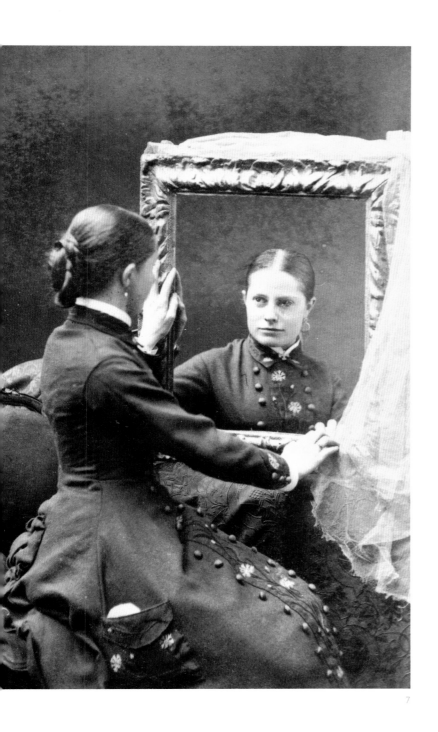

1878

On the right, two views of a princess dress in wool with somewhat Tyrolean embroidery of cornflowers sewn down the front with two rows of buttons. Embroidered to match is the pocket, a must-have feature for several years. Necklaces with pendants are popular, and above left a plume trimmed hat after Gainsborough.

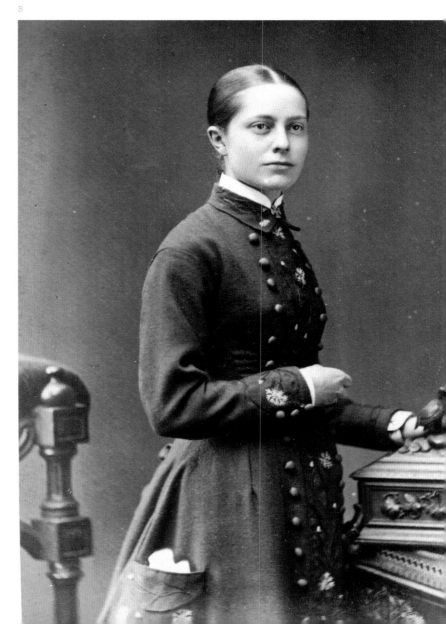

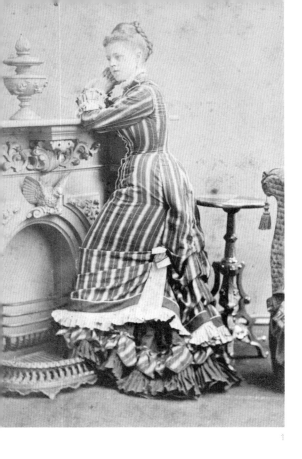

1

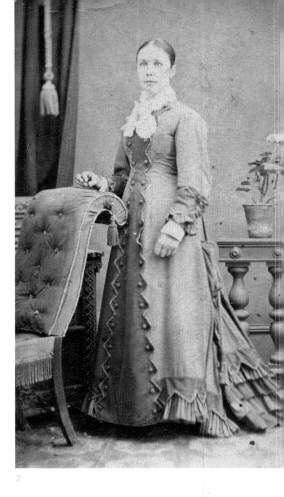

2

PRINCESS DRESSES

Describing princess dresses in September 1878, *Godey's Lady's Book* notes: "Fashion now decides that dresses, or rather sheaths (for skirts are nothing more) should be unprecedentedly narrow. How their wearers get into them is apparently a matter of no import." Such dresses called for different underpinnings: corsets were lengthened above and below the waist, fitting the hips as smoothly as a glove. The narrow silhouette did not leave much room for the usual undergarments, thus the "combinaison"— a camisole attached to drawers—was a novelty.

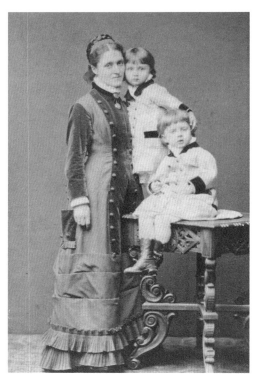

3

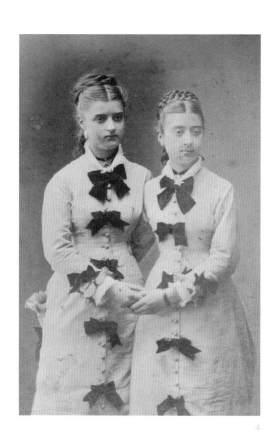

4

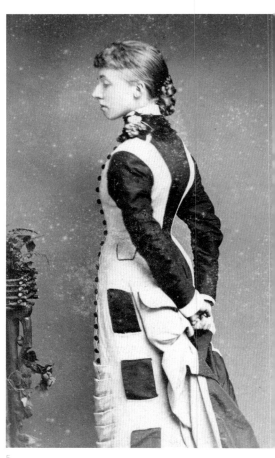

5

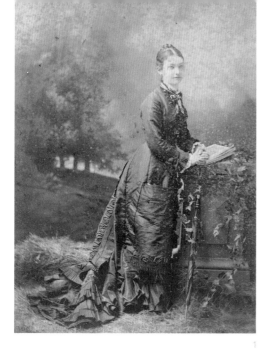

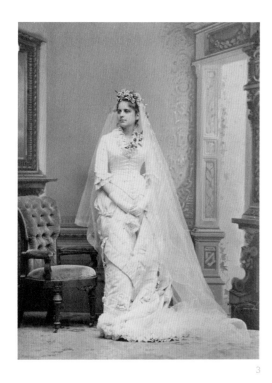

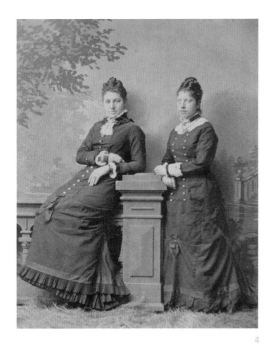

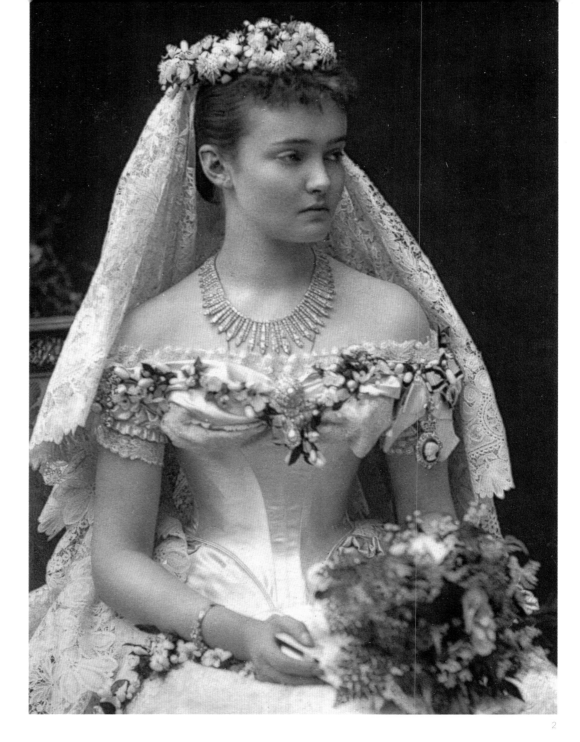

1879

Dark dresses—the most useful item in a woman's wardrobe. Shown here: a reception dress with train and two princess cut dresses with different placement of buttons. The draping of the skirt and hem trim are more *au courant* than either of the luxurious brides' dresses, particularly those worn by Princess Louise Margaret of Prussia, who upon marriage to His Royal Highness Arthur William Patrick Albert became the Duchess of Connaught. Her dress of heavy white satin with pointed waist and ornaments of superb handmade lace, as well as her diamond wedding gifts, were the height of luxury, yet hardly the height of style.

1880s

The constant news in fashion would be the growth and exact shape of the tournure and the methods underneath the skirt to give it the correct shape. This stylish woman wears a quintessential 1880s dress: tailored and closely fitted yet awash with such decorative details as contrasting fabric, panels, tassels, pleats, a shirred plastron, and, not least, a bustle.

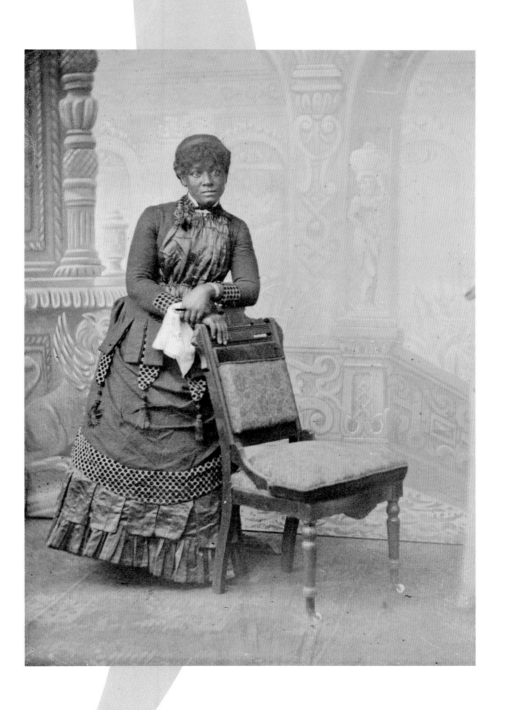

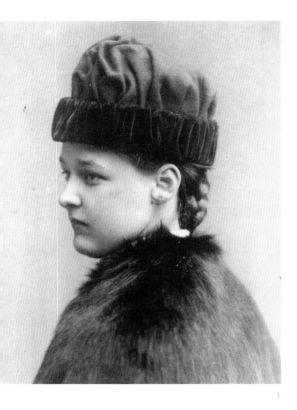

1880

The New York Times declares in September 1880, "Dresses continue to be narrow." There was a tendency for day and street clothing to be relatively simple. A new effect was a drapery around the hips or below, known as a scarf sash. The woman dressed in a feminine version of a jockey's silks is wearing a jockey cap that was ahead of her time. By 1883, jockey caps would be popular for young ladies.

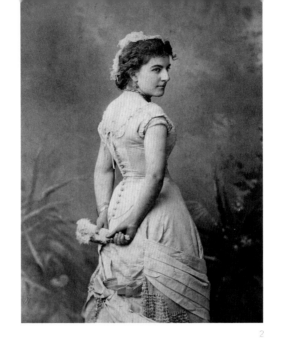

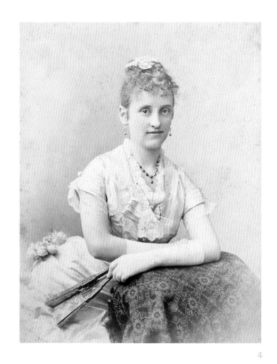

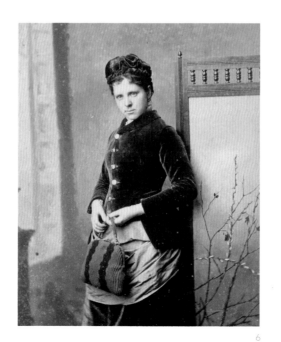

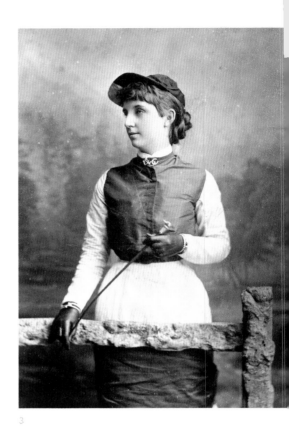

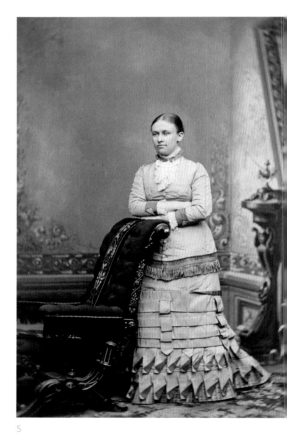

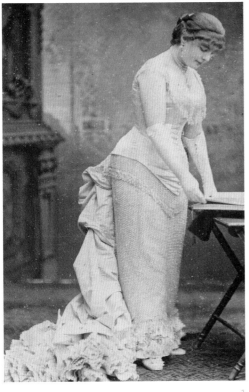

TUMBLING TRAINS

In 1880, *Godey's Lady's Book* reports, "Day dresses were to be made quite short but that toilettes for evening would have long trains." These long extended skirts were lined on the interior with "dust ruffles" known as Balayeuse, or sweepers, generally made of stiffened muslin inset or edged with lace. In 1888, it was reported that muslin versions were out of fashion and that the new treatment was a ruching underneath the hem. Trains were considered to add grace to a dress and were expected to be handled with skill. The French term for the sound of rustling silk was "frou-frou."

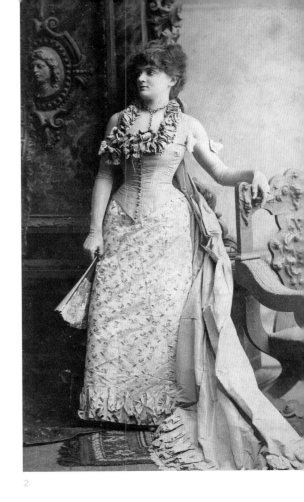

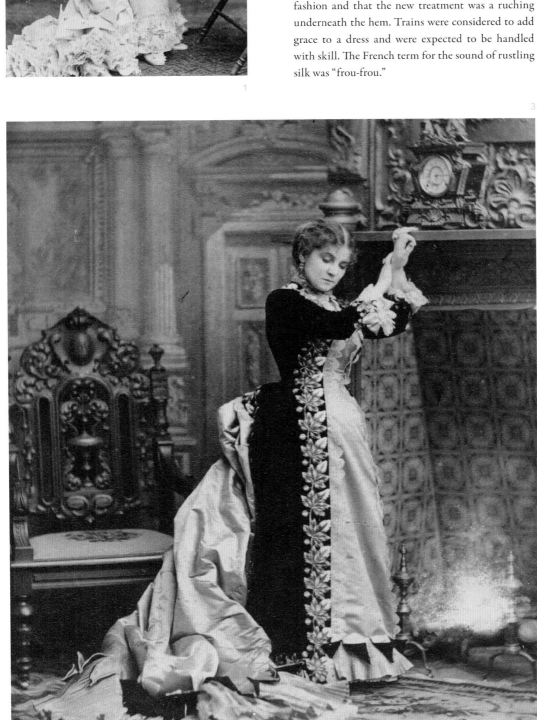

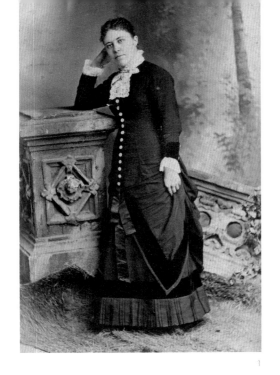

1881

A long fitted basque with a trimmed skirt is the dominant look of 1881, and all manner of frills, jabots, bows, flowers, and pins are worn about the neck. In February, *Godey's Lady's Book* reports: "Evening dresses are very much fuller at the back, a *soupçon* of a tournure being very evident."

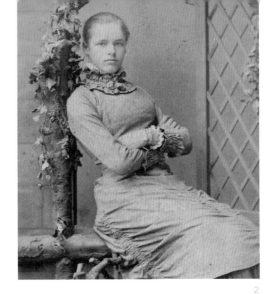

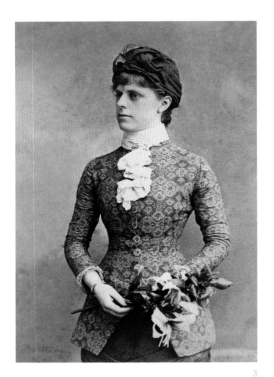

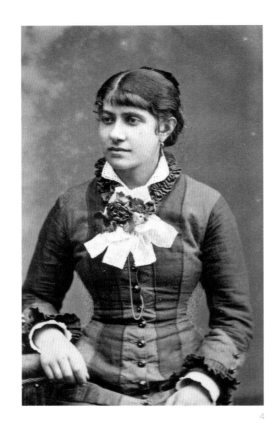

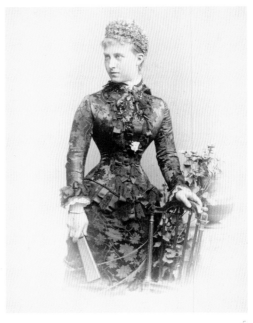

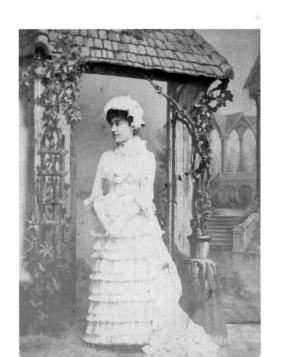

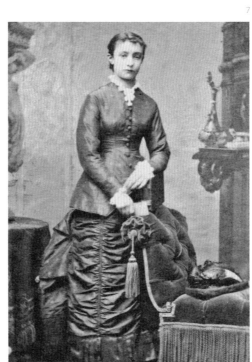

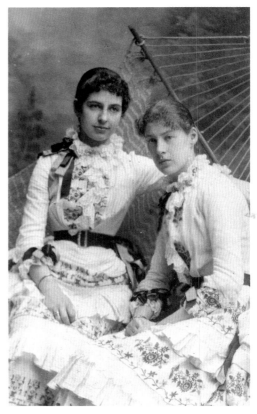

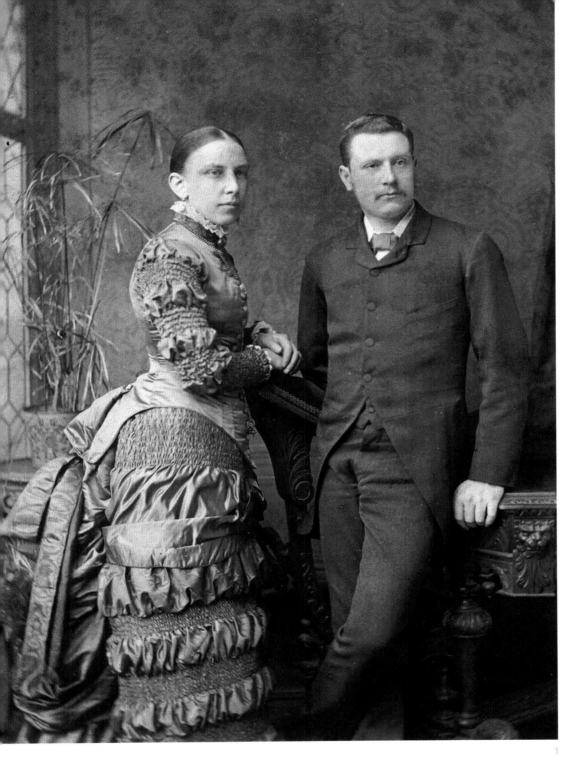

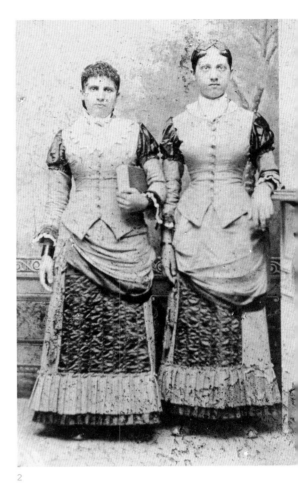

SHIRRING

A favorite form of trimming for about five years beginning in 1879, shirring began with lighter, summer fabrics and by 1880, was used in heavier and more formal materials. Often seen in conjunction with historical details like Elizabethan puffed sleeves, it would go on to be associated with aesthetic movement gowns and with clothes, particularly for children, from Liberty & Co., the London firm who started a costume department in 1884.

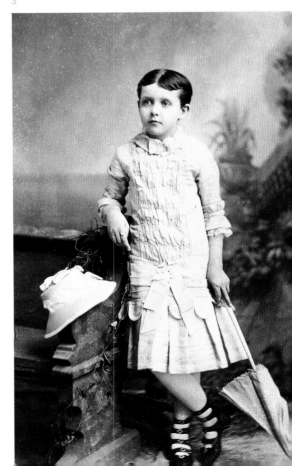

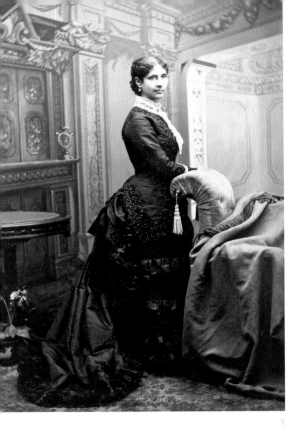

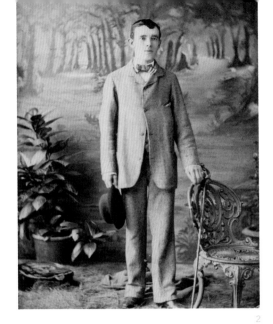

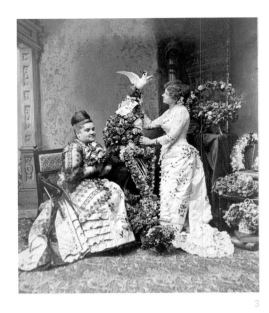

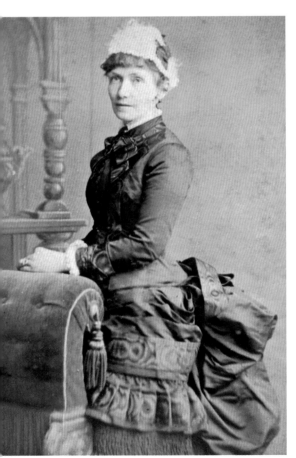

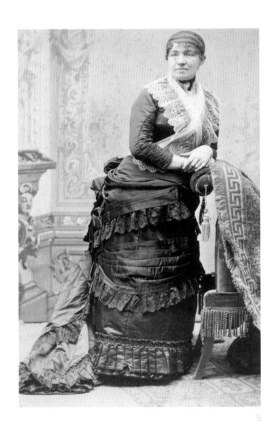

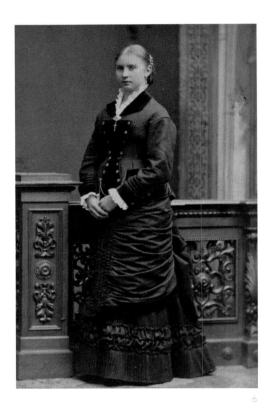

1882

"The mysterious article of the female toilet, which goes by the name of crinoline, bustle or tournure, has for some time been asserting itself again, and is now once more acknowledged as indispensable to the toilet; it appears in various shapes and various dimensions. Each dress, or, to speak more exactly, each style of dress, has its own special tournure, small or large, oval or long, with springs across, or lengthwise, or interlaced" (*Godey's Lady's Book*, July 1882).

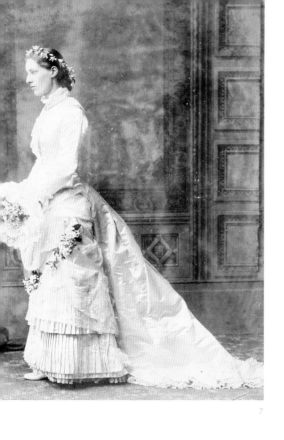

7

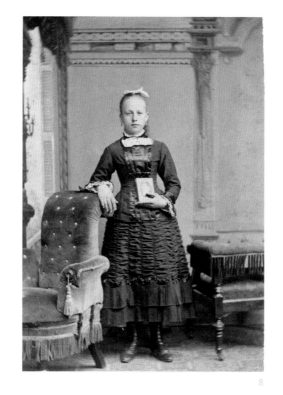

8

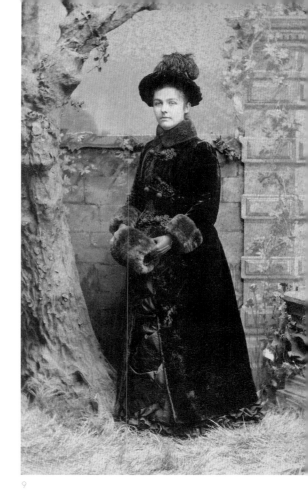

9

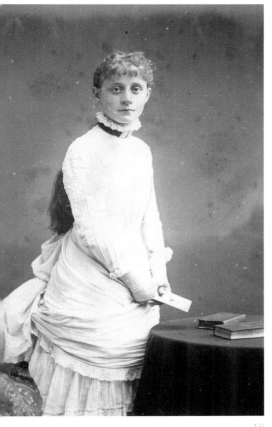

10

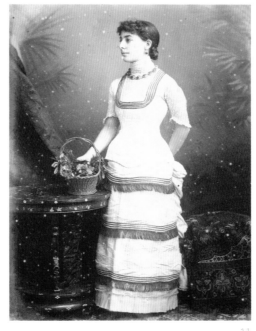

11

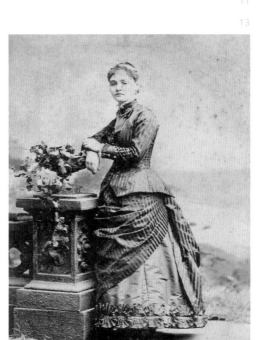

13

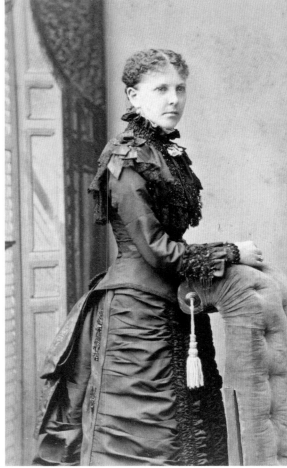

12

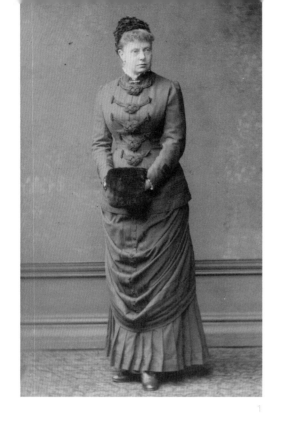

1

Sermaise. 8 Juillet 1883

2

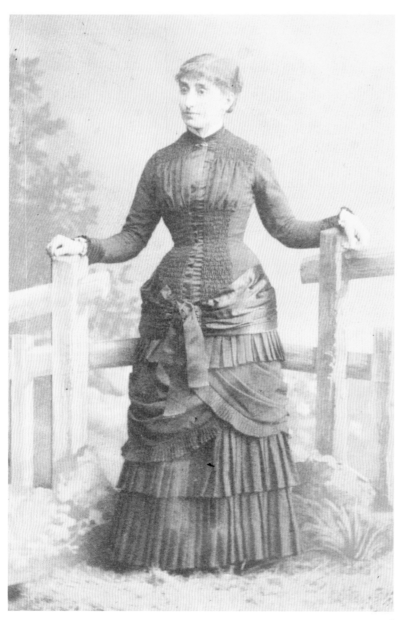

3

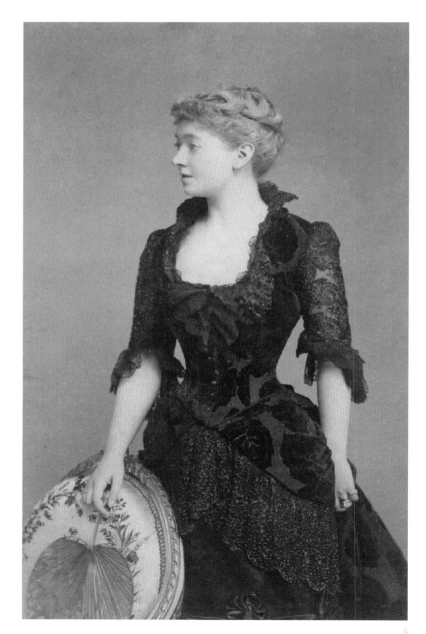

4

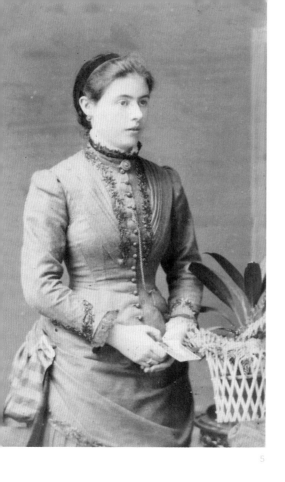

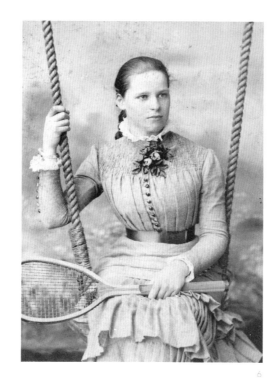

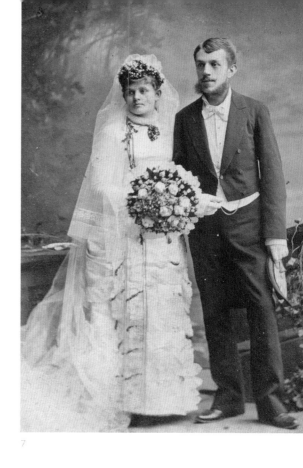

1883

The bustle gains steam, and there's growth in the popularity of the closely-fitted tailor-made garment—often with medium-length jacket, trimmed with braid. In September, *Godey's Lady's Book* reports: "Bustles and crinolettes grow larger, while skirt draperies are being made more ample to accommodate them. A complete revolution in the fashions of ladies' dress and figures; it is predicted to take place thus autumn. Bones, angles, and length without breadth, are out. Roundness, curves and moderate amplitude are coming in. Even a return to the Grecian bend of a few years back is threatened, but sound sense and good taste will probably interfere with that."

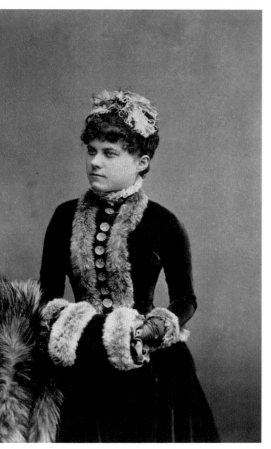

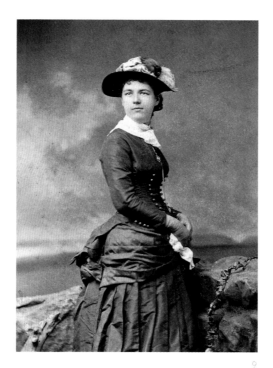

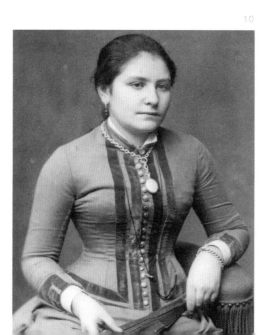

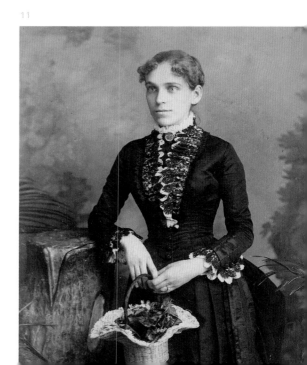

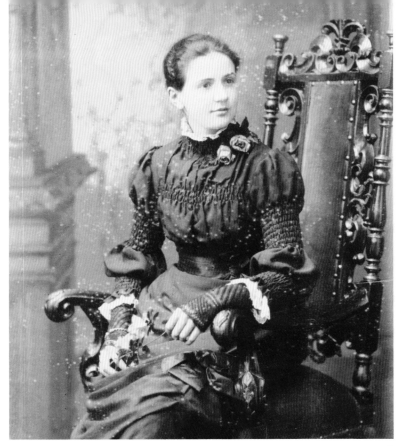

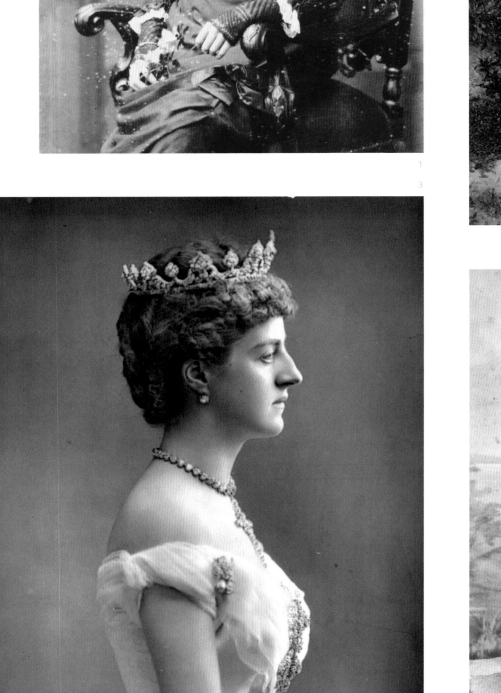

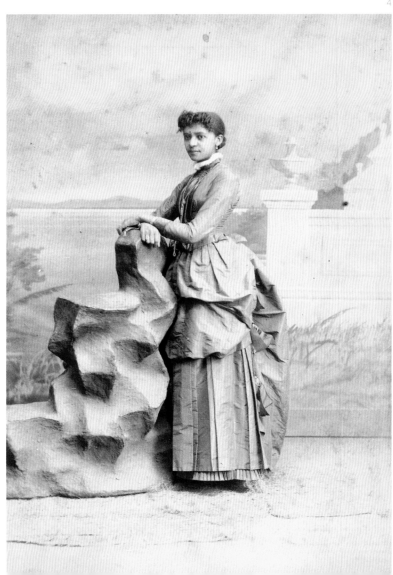

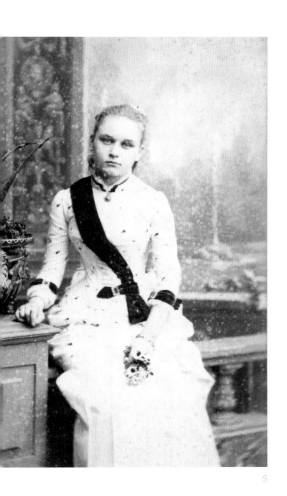

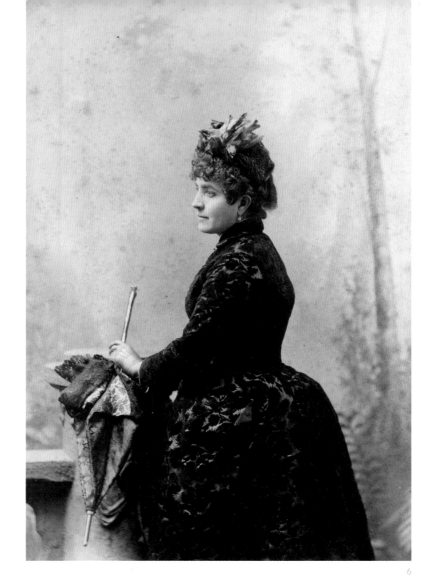

5

6

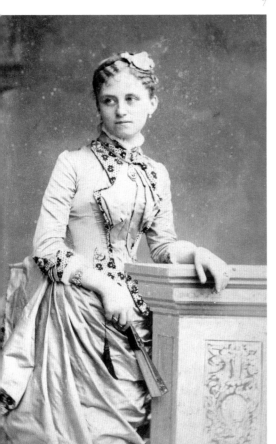

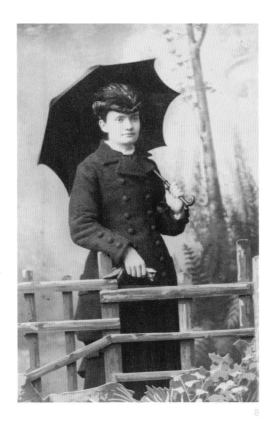

7

8

1884

The parasol vies with the fan for most important accessory. Throughout the nineteenth century, nothing was more formal than a white tulle ball gown worn with a generous supply of diamonds. The Marchioness of Londonderry, Theresa, has pearls sprinkled over her skirt and her diamonds include a stomacher.

1885

Among the narrowly draped silhouettes shown here are a costume for yachting (both the activity and the accompanying way of dressing popularized by the Prince of Wales set) and a textured wool jacket and skirt ensemble. Queen Victoria's youngest daughter, Princess Henry of Batttenberg, wears her satin wedding dress draped in front with the Honiton lace worn by her mother at her wedding. Lily Langtry, an actress and lover of the Prince of Wales, appears in two images—among the styles she popularized was wearing in her hair with a softly curled "fringe" in front.

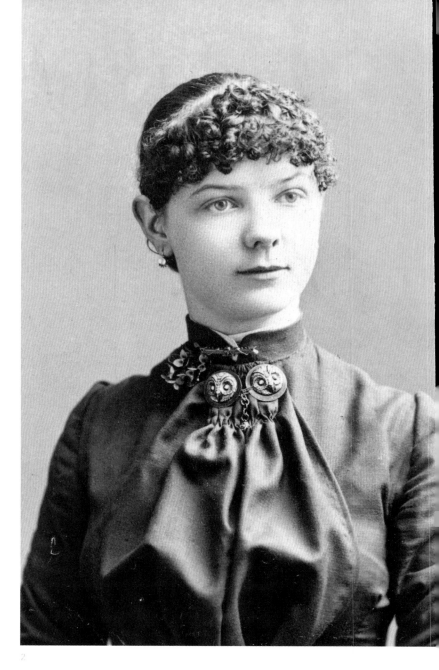

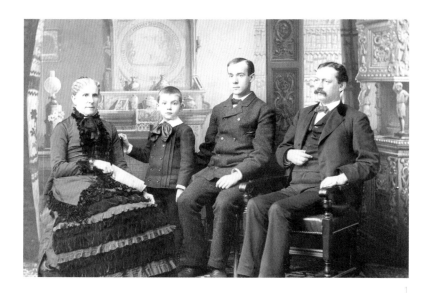

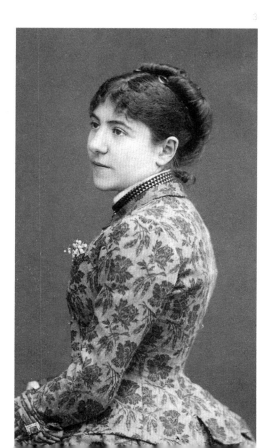

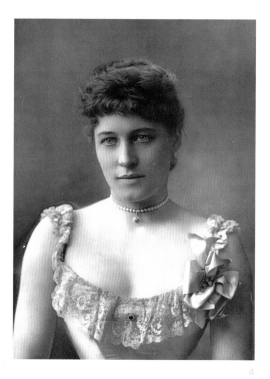

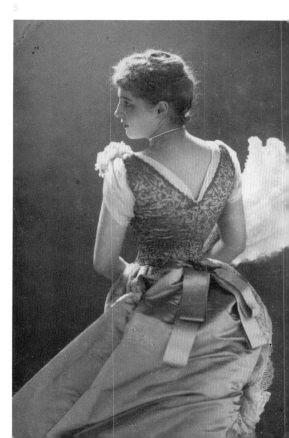

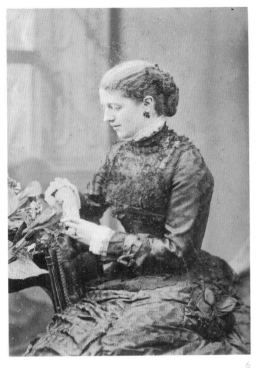

6

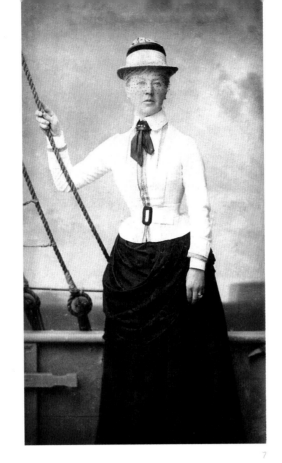

7

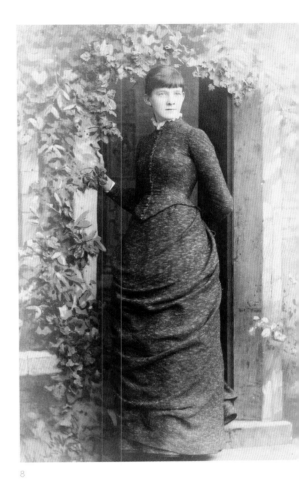

8

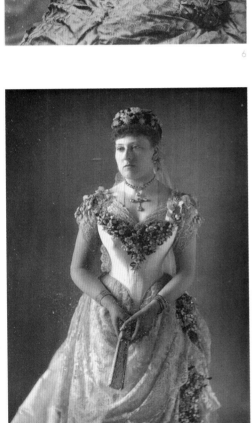

9

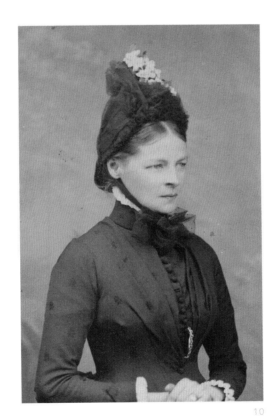

12

10

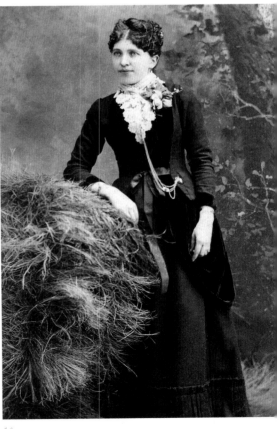

11

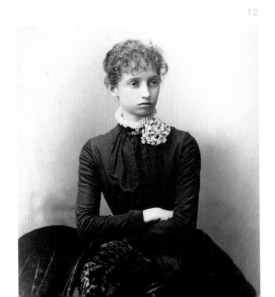

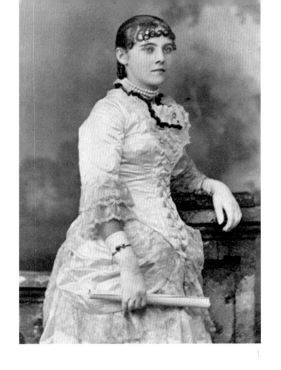

1

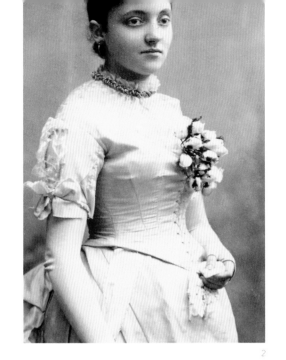

2

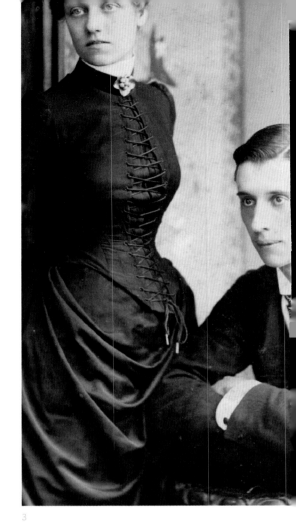

3

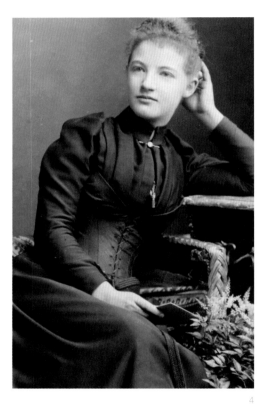

4

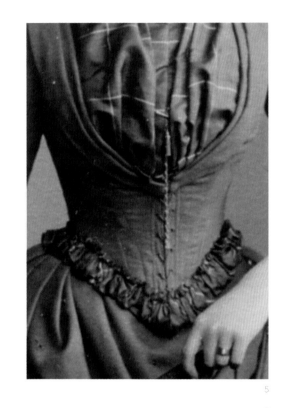

5

6

7

8

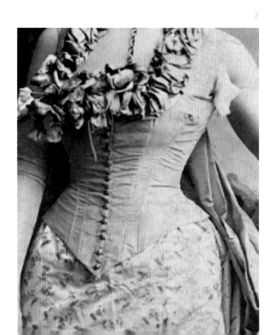

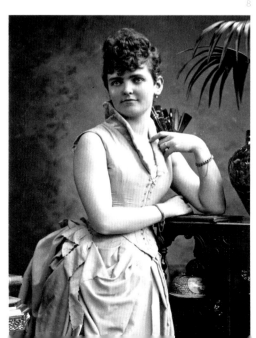

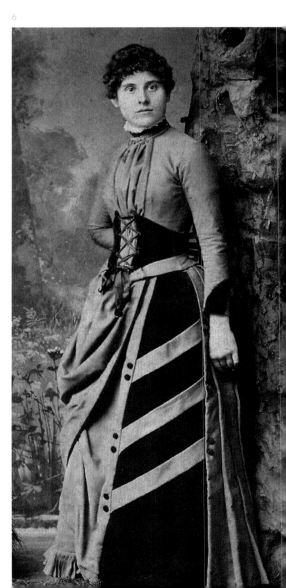

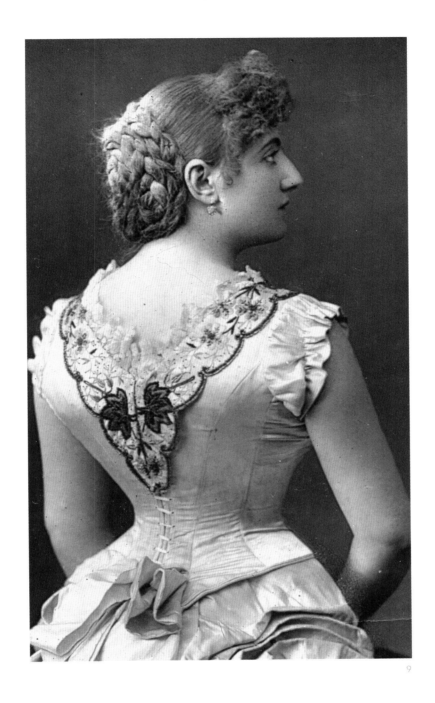

9

CORSET
DETAILING

Corset details, and even a sleeveless dress with a corset bodice, do
not appear to be rare, despite the nineteenth century's reputation for
rigid etiquette and rigorous prudery.

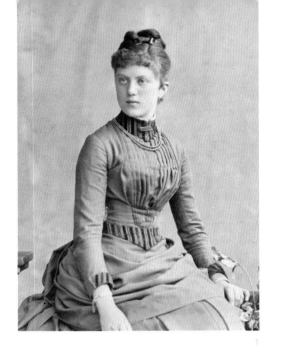

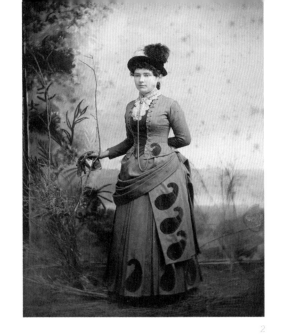

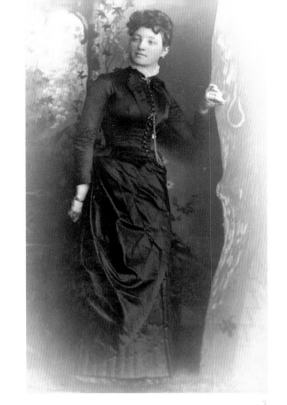

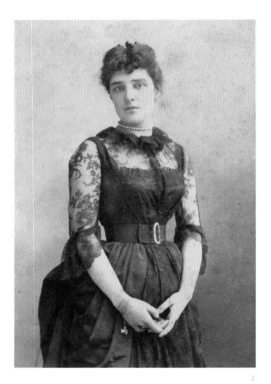

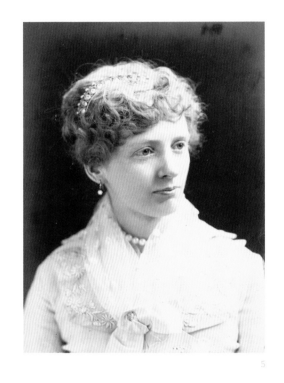

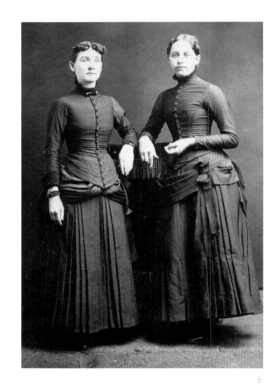

1886

Several skirts feature a narrow polonaise drapery below the basque bodice, and, while the bustle extends, walking skirts are clearing the ground. A tailored costume features velvet appliqués in the shape of paisley botehs. Lady Randolph Churchill wears a black dinner dress with lace bodice and underskirt—the bodice with soft ruffled collar and cuffs at the elbow length sleeves, and a wide belt with a jeweled buckle.

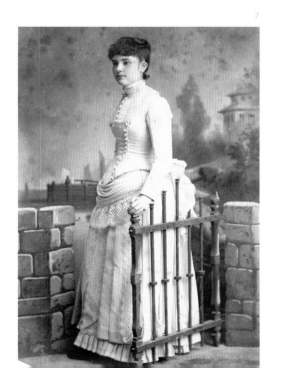

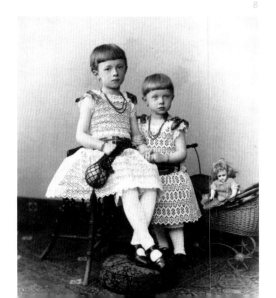

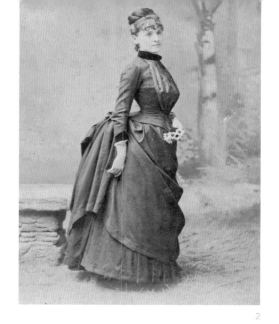

CUL DE PARIS

So associated with French fashion was the bustle that it was known, somewhat naughtily, as the "bottom of Paris." Of the several styles of braided wire bustles advertised in 1886 by Weston & Wells, the biggest and highest health braided wire bustle was called the Paris. "A well-shaped tournure gives a certain degree of elegance to the figure; it makes the waist appear smaller, and takes from the hips when these are too fully developed" (*Godey's Lady Book*, May 1883).

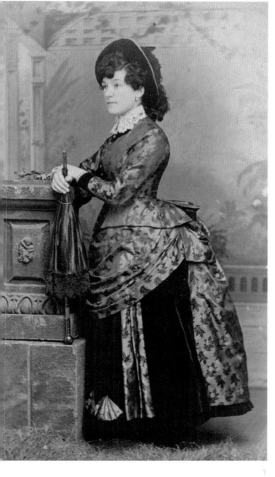

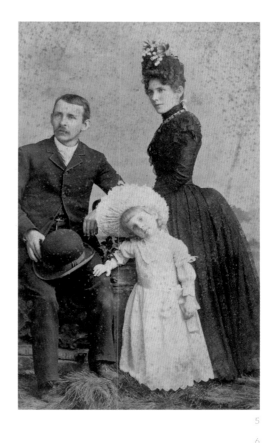

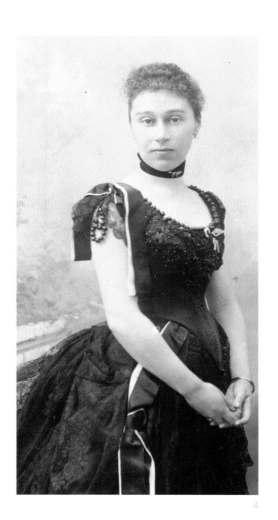

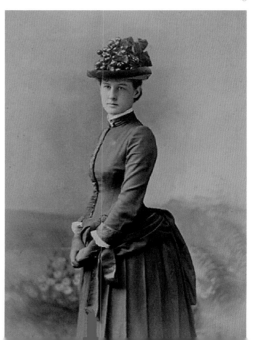

1887

A young scholar wears a lingerie dress in *broderie anglaise* and holds her diploma while an evening dress in Elizabethan taste features a historical detail, a ruff collar, made contemporary (as are most historic details) with a V-neck shape. The bathing costume shown is a relatively simple one: its top is cut almost like a tunic instead of a dress, and, as is true of most seaside-bound attire, it has a sailor collar.

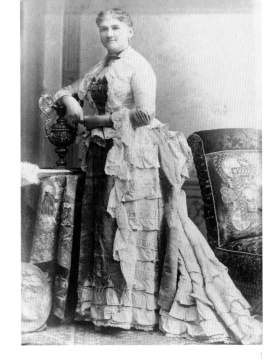

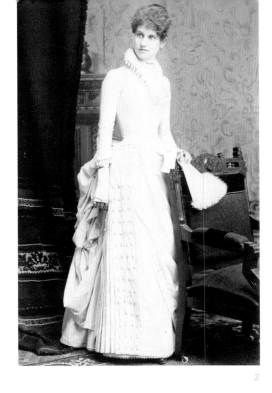

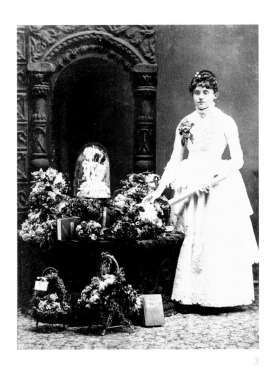

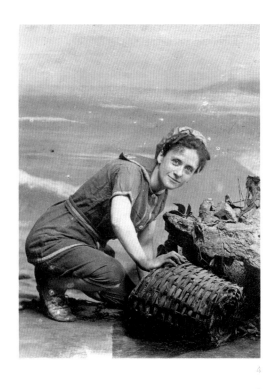

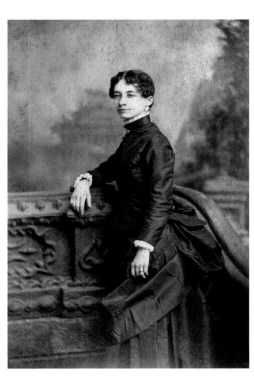

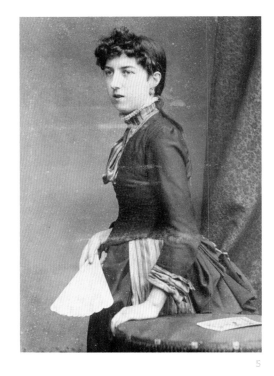

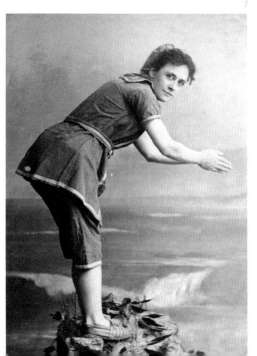

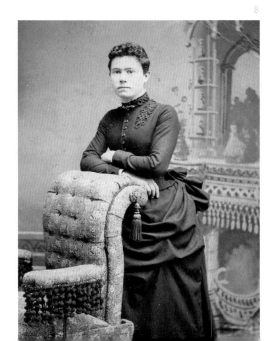

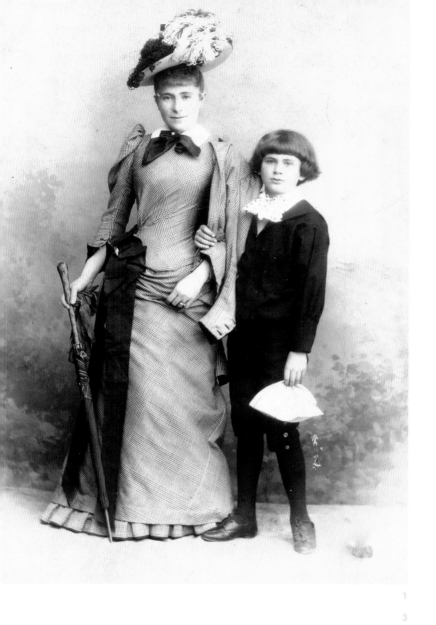

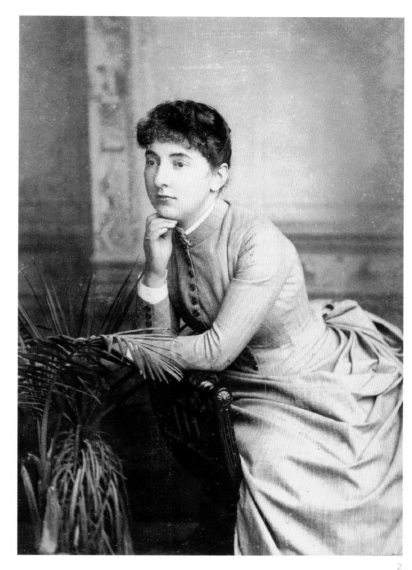

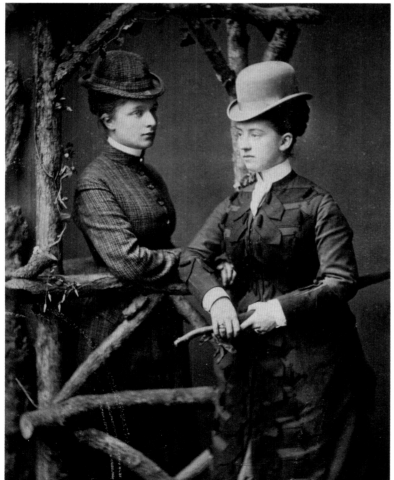

MENSWEAR FABRICS FOR WOMEN

Perfectly fitted tailored costumes made in Glen plaid or pinstriped wool were, like bloomers, considered daringly masculine, and it was Alexandra, Princess of Wales whose imprimatur made them not just acceptable but fashionable. Always impeccable, her yachting and country attire was as influential as any court gown or jewel.

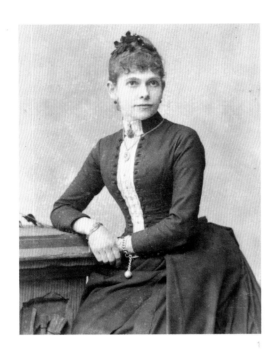

1888

The stripes and large buttons seen in a tailored costume are examples of a Directoire redingote revival. A teacher wears a simple tailored dress and several women sport felt hats with tall crowns. In January, *Godey's Lady's Book* observes that "Black lace dresses have lost none of their popularity."

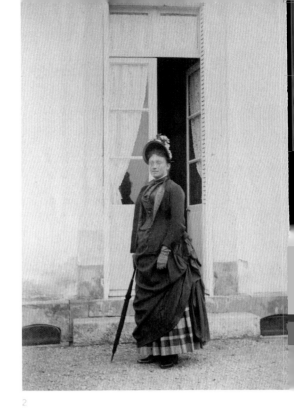

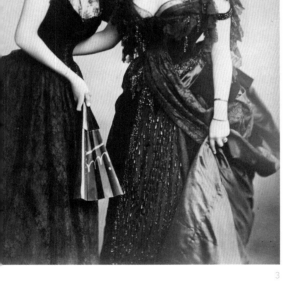

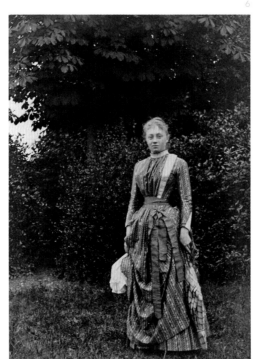

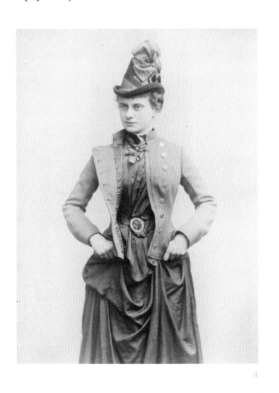

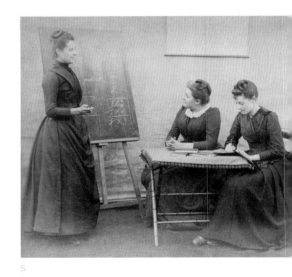

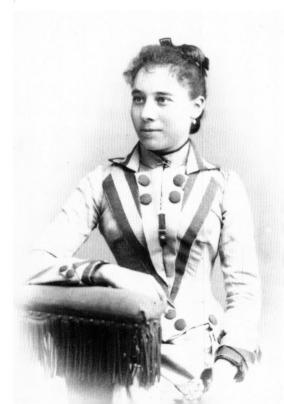

8

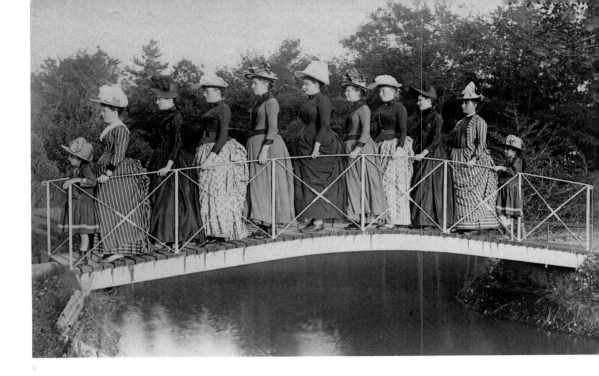

9

10

13

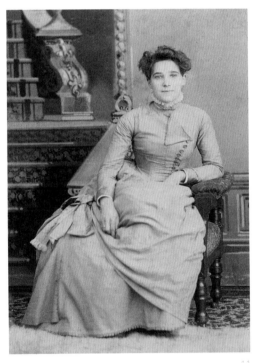

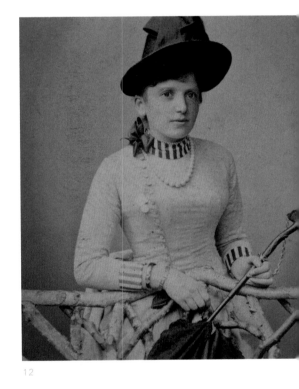

11

12

14

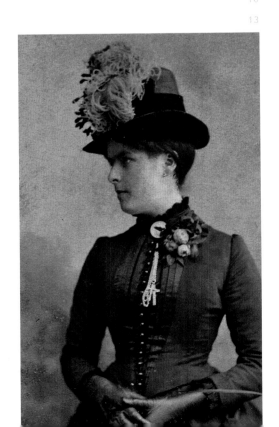

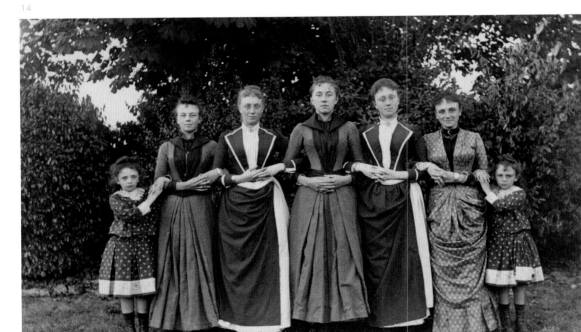

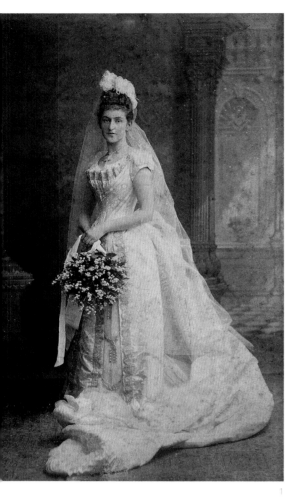

1

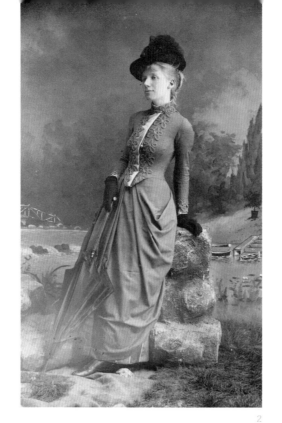

2

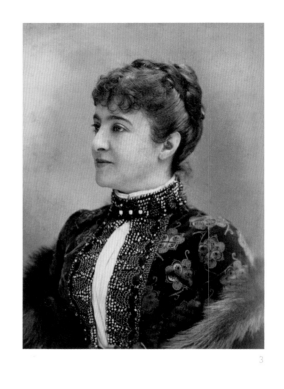

3

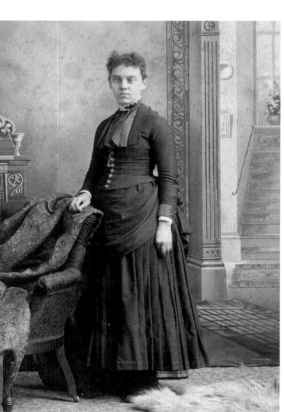

4

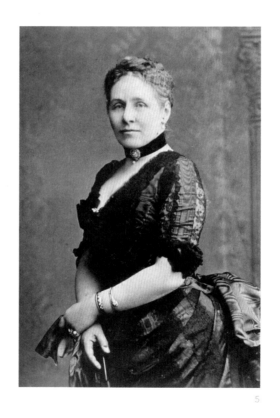

5

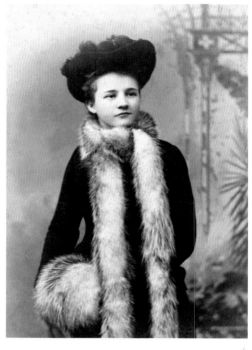

6

7

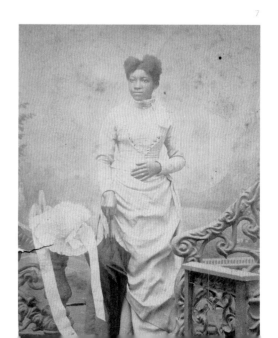

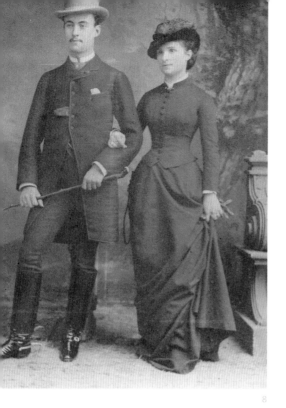

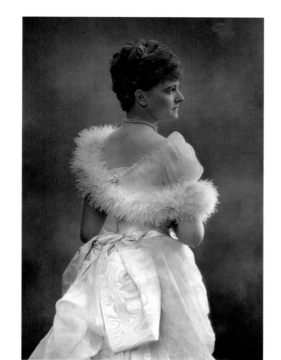

1889

Most skirts feature drapery and pleating, the latter abetted by home pleating machines and ready-made pleating that could be purchased with dress materials. A tailored dress with passementerie is separate at the front and attached in the back. Hats are worn at a slight tilt. A court presentation gown is made in patterned silk trimmed with metallic lace and pearl tassels, and a moiré and lace evening gown is worn by Canada's first lady, Lady Stanley of Preston (the Stanley Cup was named for her husband).

8

9

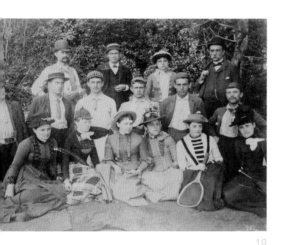

10

13

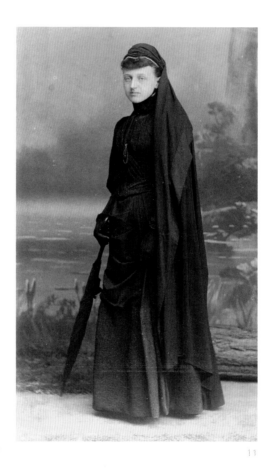

11

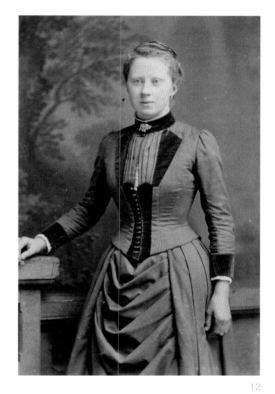

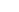

12

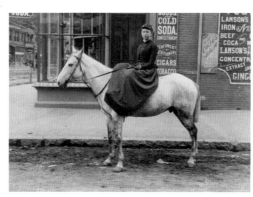

14

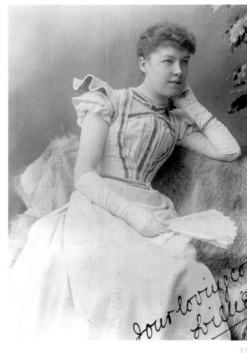

15

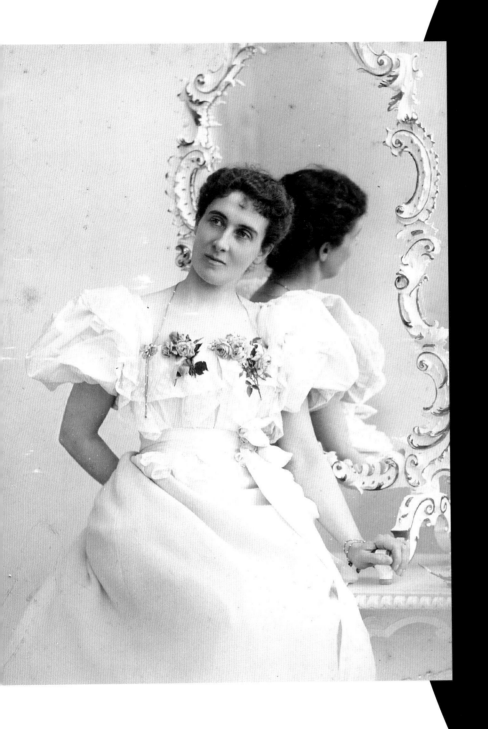

1890s

The 1890s would see most of the attention focused on the head and shoulders. Fairly simple skirts (little "dress improver" will be needed) with a smooth appearance, and flaring as the decade progresses, are in contrast to bodices with gigot sleeves, bertha collars, wide revers, and high collars worn with plateau hats with upright aigrettes (called "panaches") and ribbon bows. A plain, masculine shirtwaist or an ornate bodice worn with a plain and usually dark skirt both become popular.

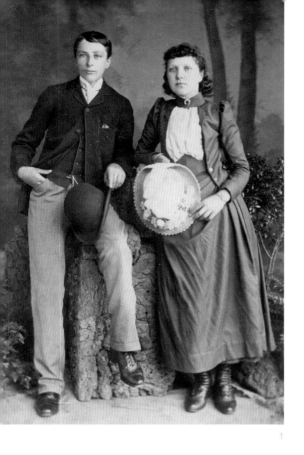

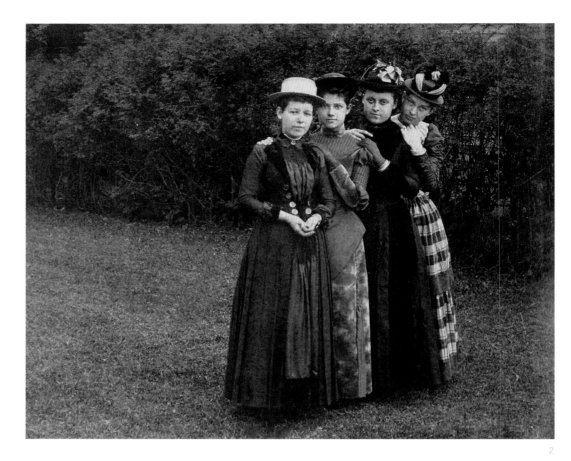

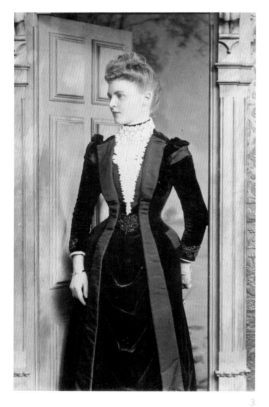

1890

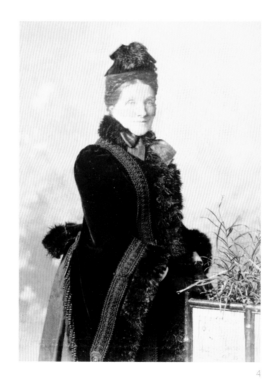

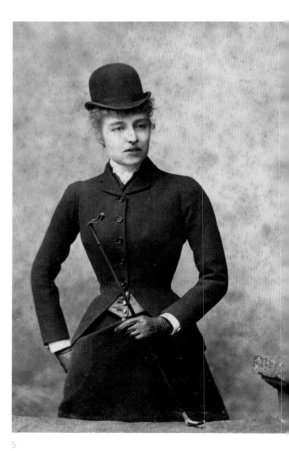

Day clothes often feature vest or open jacket effects. A dinner gown in velvet and faille suggests a man's dinner jacket—just then coming into wide use—while a velvet dolman wrap is edged with braid and ostrich.

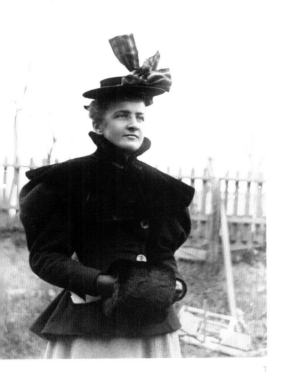

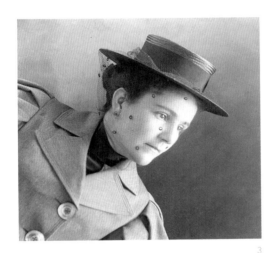

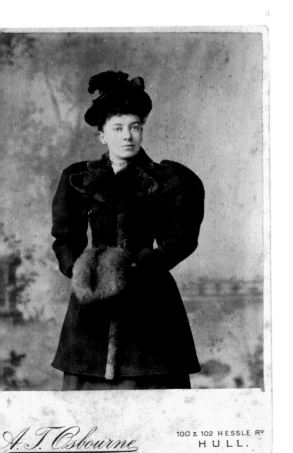

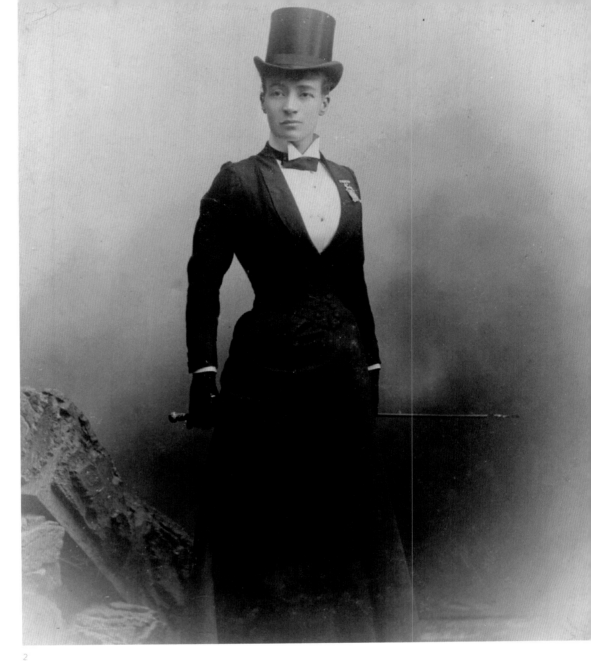

TAILORING

The allure of perfectly tailored clothes was at its most pronounced in the riding habit, amusingly described by Winston Churchill reminiscing about his mother: "My picture of her in Ireland is in a riding habit, fitting like a skin and often beautifully spotted with mud." Although still made exclusively with side-saddle skirts, habits riffed on every possible form of male attire. One shown here is worn with a leather vest and a bowler instead of a top hat—a look that would gain further acceptance the following year when worn onstage by Lily Langtry, while another habit is worn with the wing-collared shirts and black associated worn with a dinner jacket. The best tailored clothes for women, as was true for men, were considered to emanate from England.

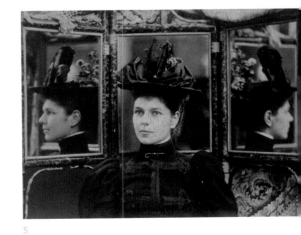

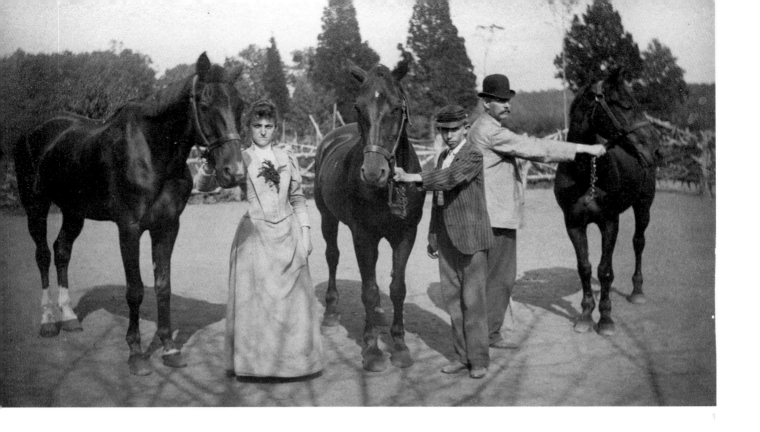

1891

Bodices are fitted to just below the waist, edged sometimes in a point and worn with the edge over the skirt. Although sleeves were already beginning to blossom, in May, Lily Langtry, appearing in the play *Lady Barter*, wears a dress with such enormous sleeves that it makes news as distant as Australia. The play wasn't a hit, but the style would rule for several years.

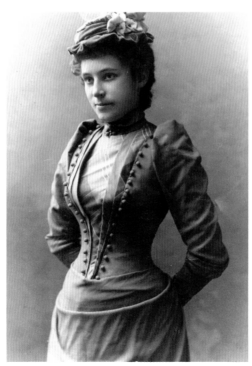

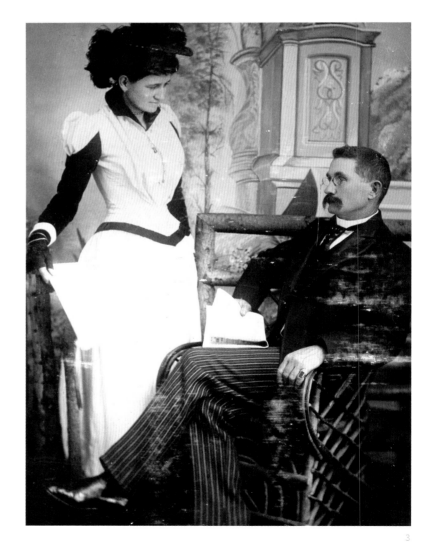

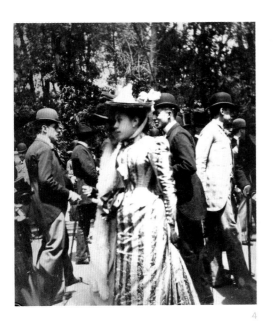

4

Angel — Neosho, Mo.

5

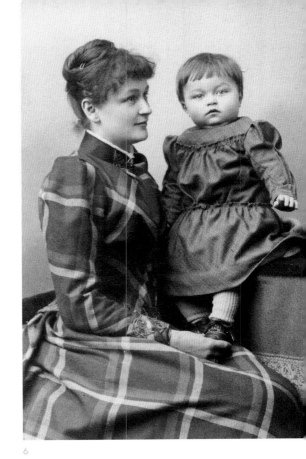

6

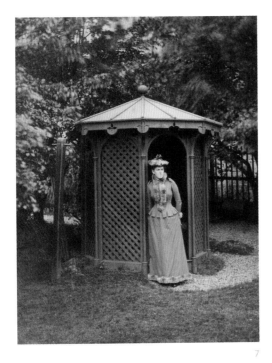

7

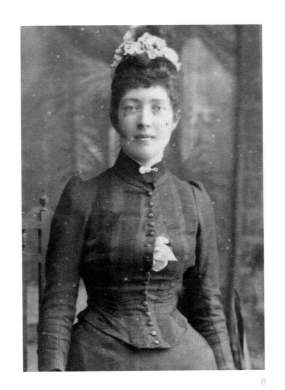

8

11

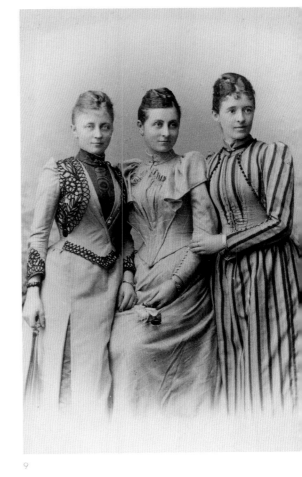

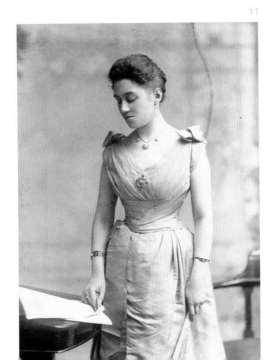

9

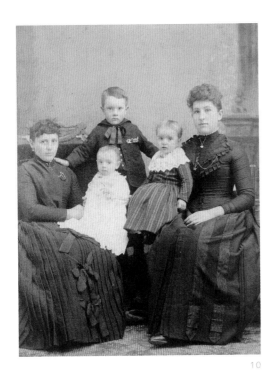

10

83

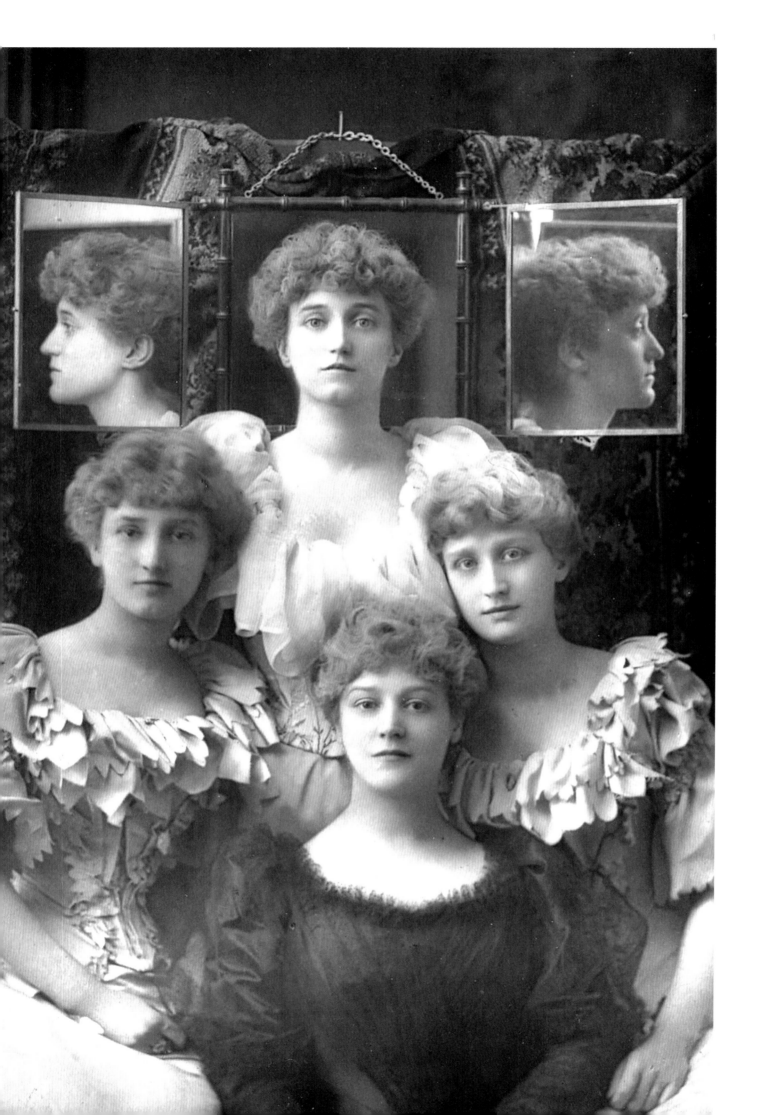

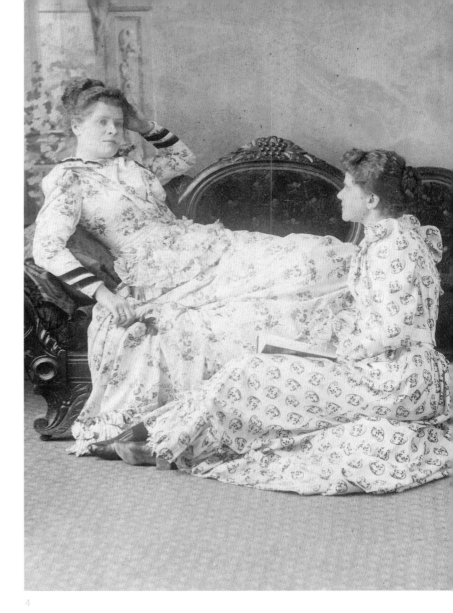

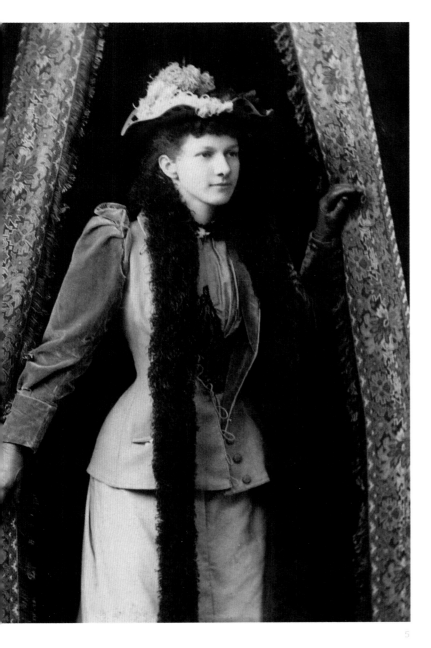

1892

A bevy of pre-Raphealite beauties dressed in the height of fashion for 1892: evening gowns with square or round necks softened with tulle or chiffon and with petalled berthas. At the top—both sides of her renowned profile on view—is Miss Dene, born Ada Pullan, famous beauty and muse to such artists at Frederick Leighton. With her, her sisters who became known for their looks as well. For all styles: tailored clothes, evening gowns, and day dresses, the sleeves are puffed high at the shoulder.

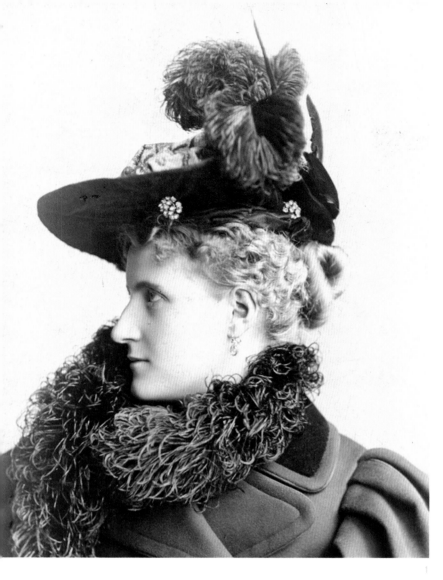
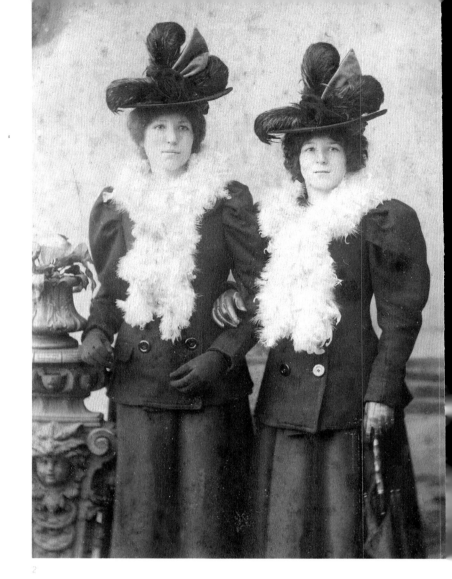

1 2
3 4

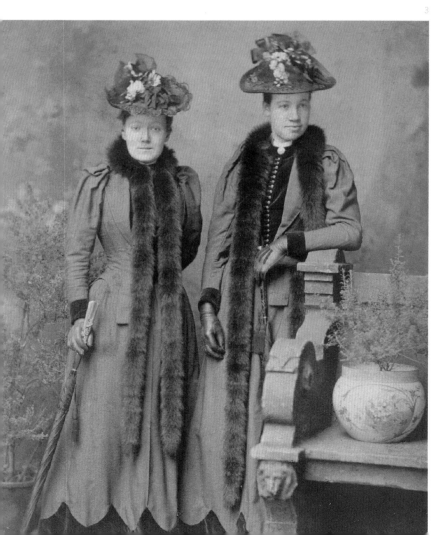
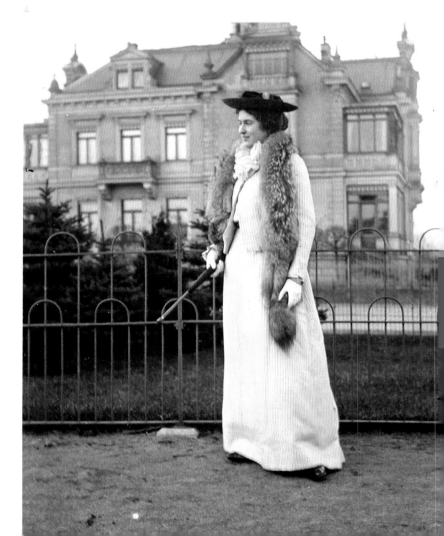

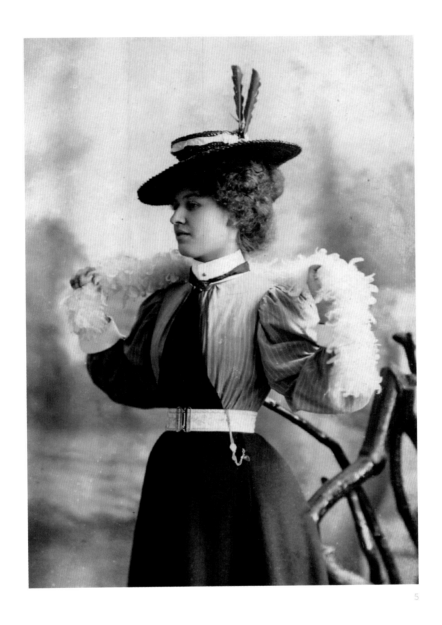

5

BOAS

"Feather boas are as much the rage as ever, black or gray ostrich feathers tightly curled and reaching nearly to the waist. The very long feather boas are no longer in fashion. They were so copied in cheap imitations, that their popularity was short-lived. Fur boas are too warm for wear before December. They will be greatly in fashion this Winter. . . . ," announces *Godey's Lady's Book* in December 1894. They are primarily worn with the dominant tailored day look: walking costumes with long fitted jackets and plain skirts with plateau hats.

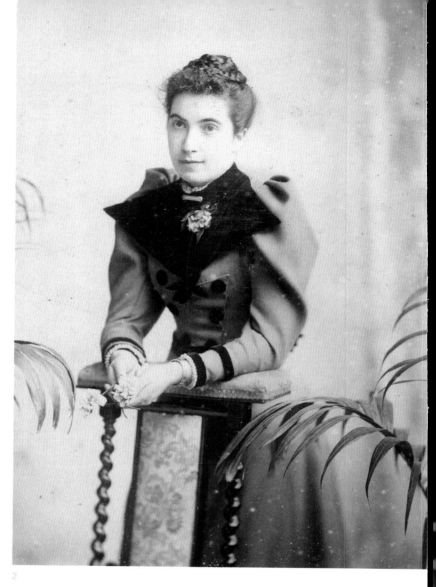

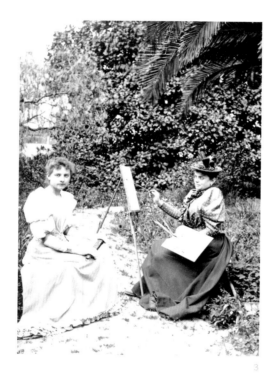

1893

The growing sleeve necessitates a cape as an outer garment; these often have cape collars or yoke ruffles themselves. Bigger sleeves also bring other feminine flourishes, lace, ruching, and embroidery start to supplant more tailored effects.

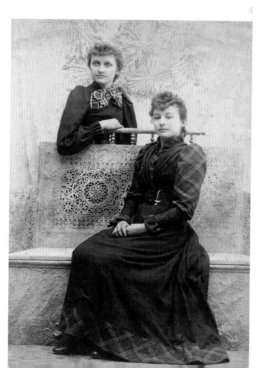

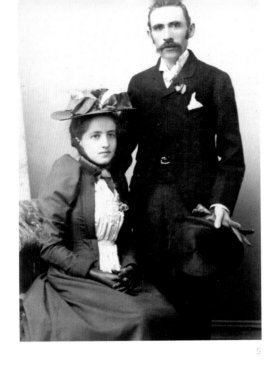

5

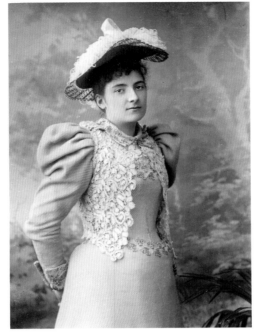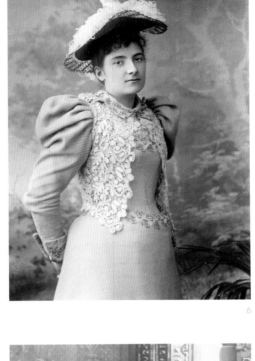

6

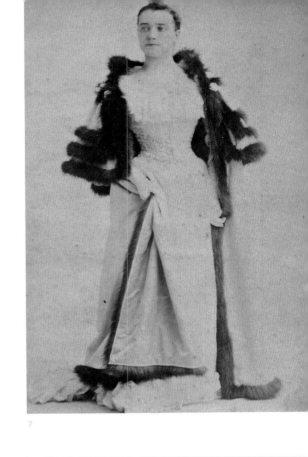

7

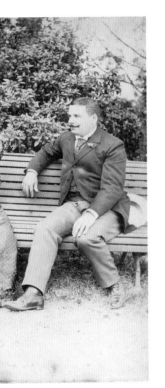

8

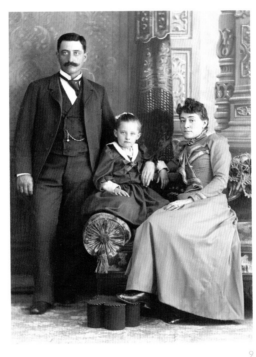

9

11

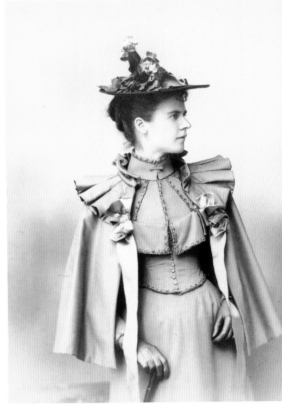

10

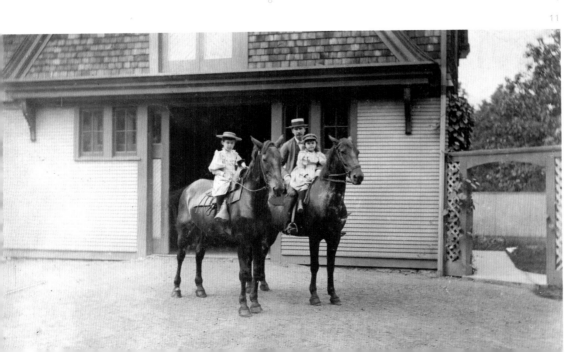

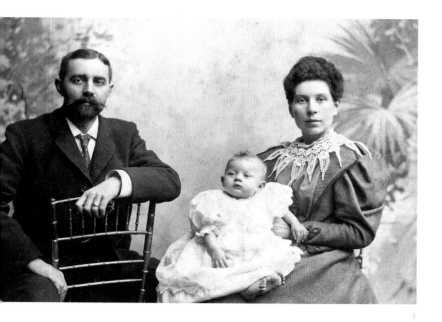

1894

"Sleeves are fairly bewildering; they are all large, even the coat sleeves of cloth, but there are two or three different patterns. From the elbow to the wrist they fit tightly; from the elbow to the shoulder any size is possible," notes *Godey's Lady's Book* in an October article on Paris fashions.

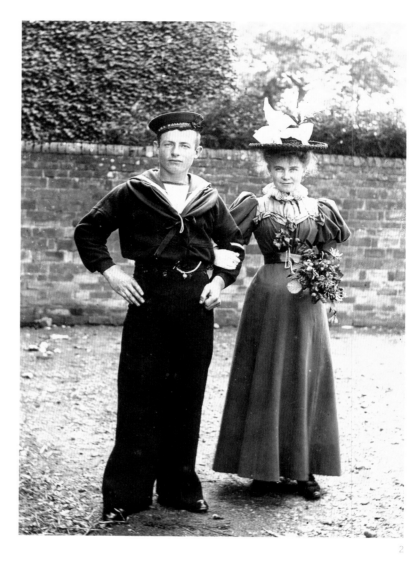

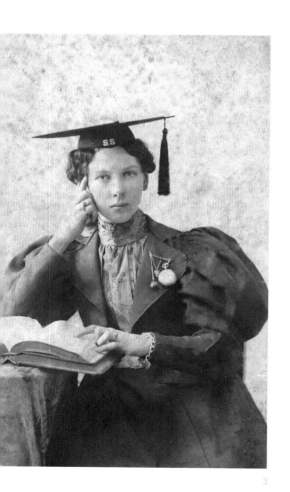

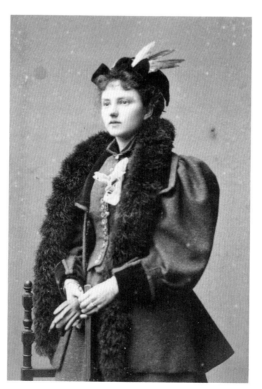

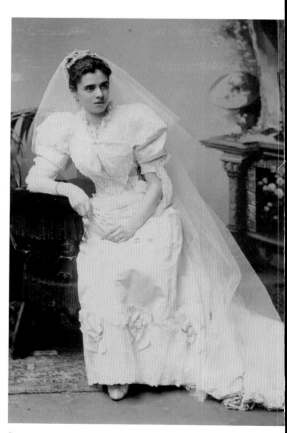

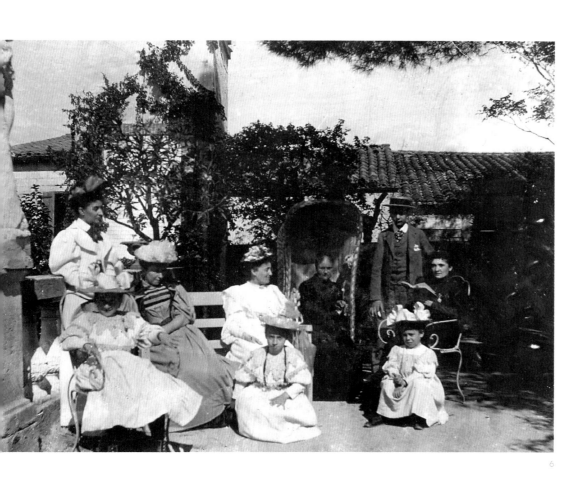

6 7

9

8

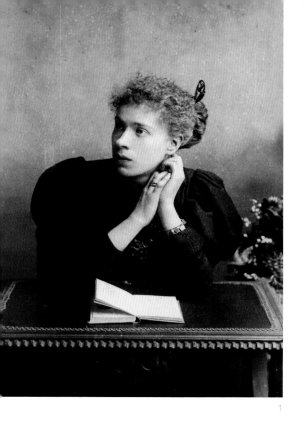

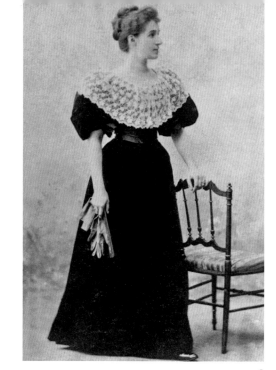

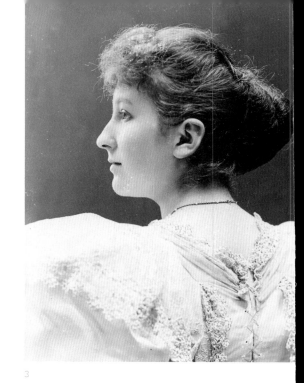

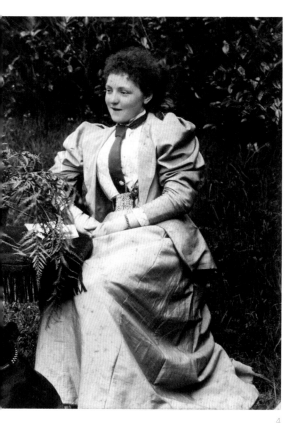

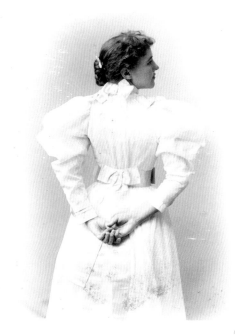

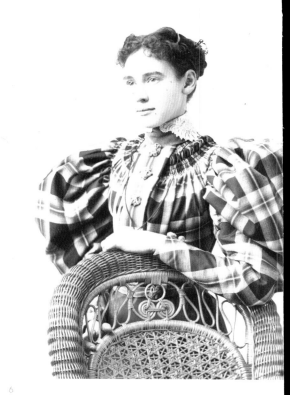

GIGOT
SLEEVES

"The mandolin sleeve, as its name denotes, is shaped like the sweet musical instrument. A good model is cut with five gores, and with no fullness whatever at the shoulders; it is merely held in at the top sufficiently to be easy and graceful; it bulges out roundedly about half-way down the arm, and tapers narrowly at the wrist" (*Godey's Lady's Book*, November 1895).

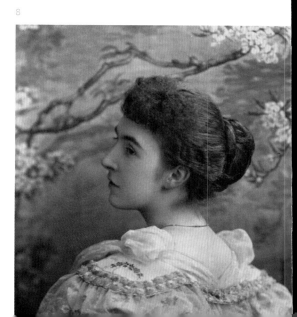

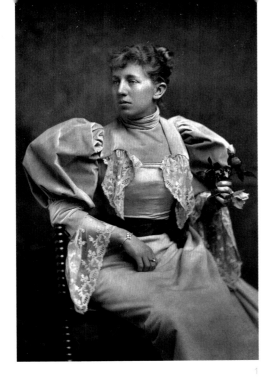

1895

The bicycle has an enormous effect on women's mobility. In July, *Godey's Lady's Book* cautions: "GREAT care should be exercised in the choice of a bicycle suit. A bicycle costume to be successful must be neat and trim. Knickerbockers and divided skirts are as popular for the wheel as for golf. The divided skirt, which is very like Turkish trousers, extends halfway down the leg, where it is met by strapped leggings of either cloth or leather."

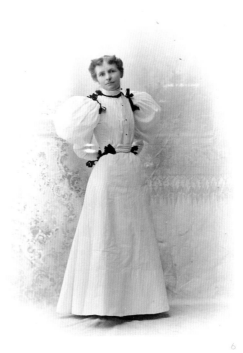

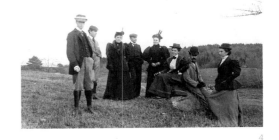

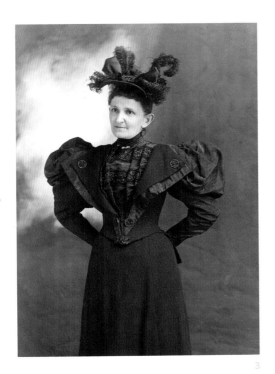

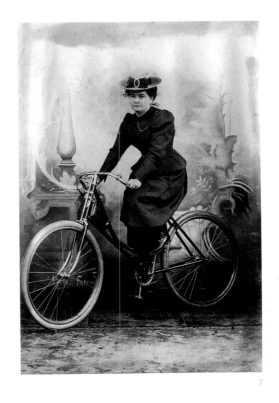

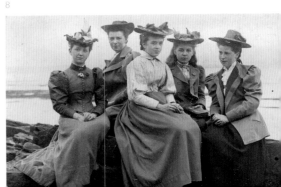

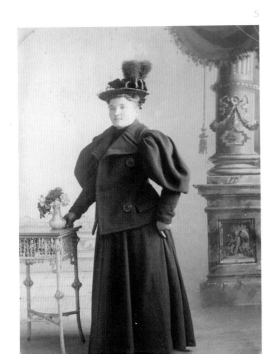

1896

For the most formal clothes, the sleeve deflates rather suddenly, and is narrow almost all the way to the shoulder. The number of gigot sleeves seen at outdoor gatherings suggests older clothes being worn for activities that might require some exertion, like walking or cycling.

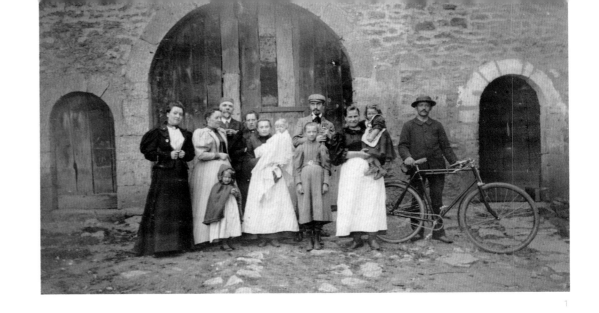

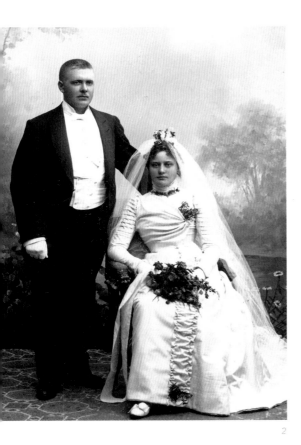

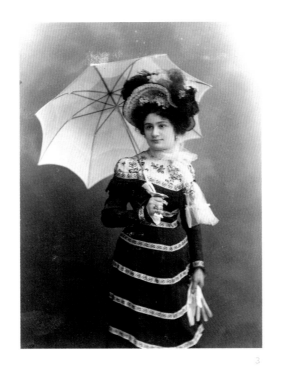

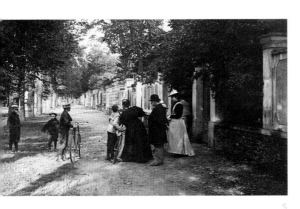

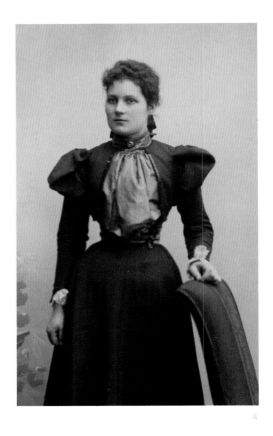

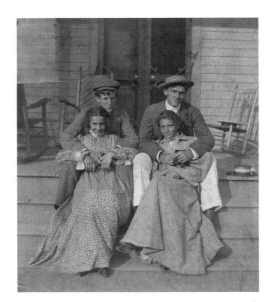

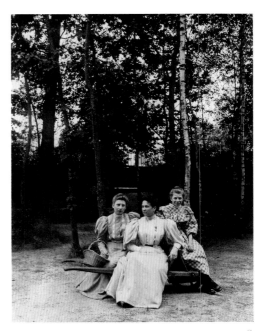

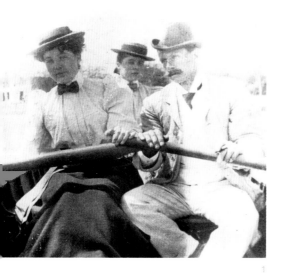

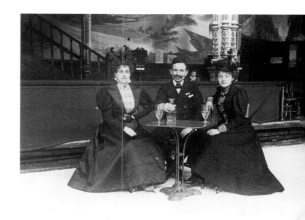

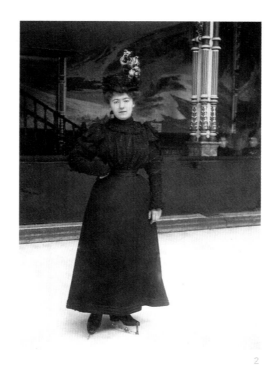

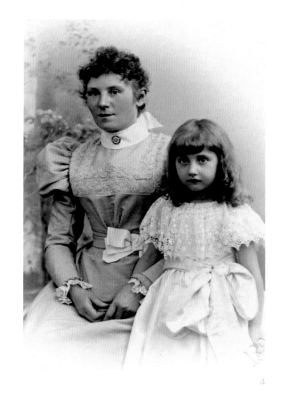

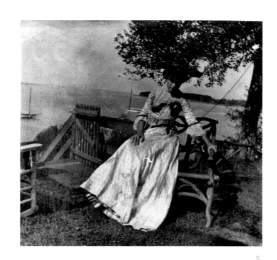

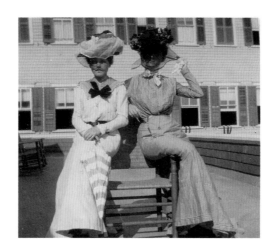

1897

Skirts hover at the top of the foot for cycling and skating. A fullness in the back becomes a train on a ball gown. Bodices are blousing a bit above the waist. The craze for bicycling continues, even apparently at sea, as it was widely reported that William K. Vanderbilt's yacht, "The Valiant," had a cycling track long enough for ten laps. In response to the criticism over bloomer suits, tailoring firms like Redfern devised skirts cut like habit skirts, fitted over the hips and flaring enough to allow for pedaling.

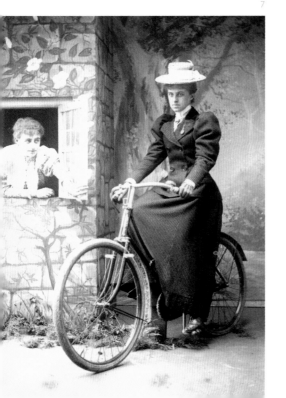

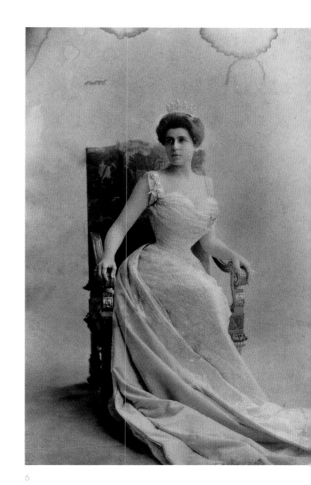

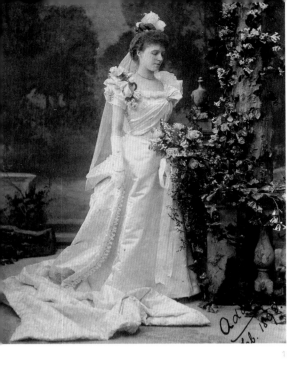

1

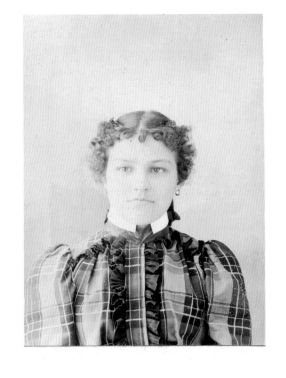

2

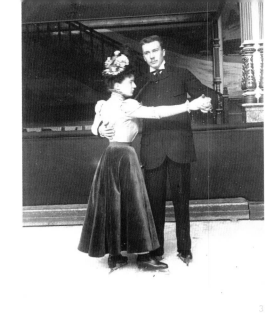

3

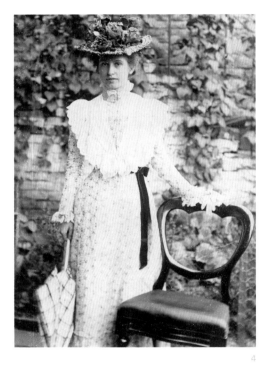

4

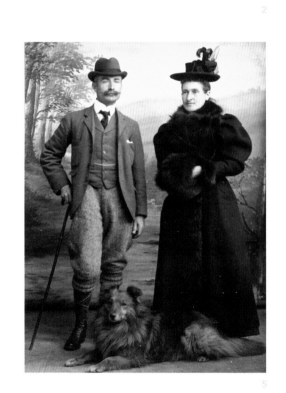

5

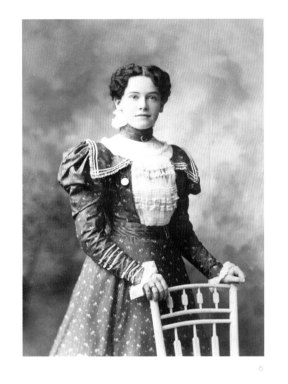

6

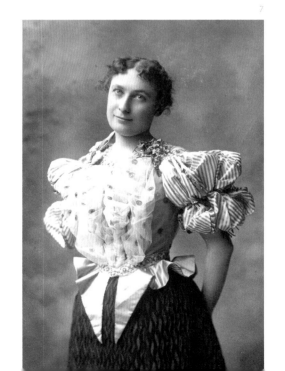

7

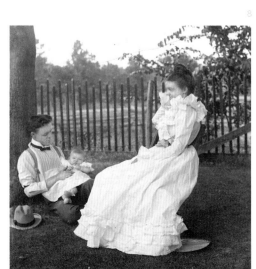

8

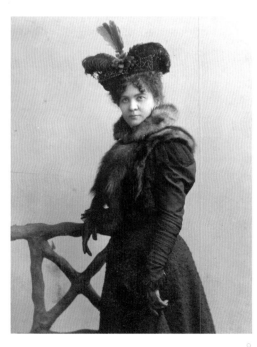

9

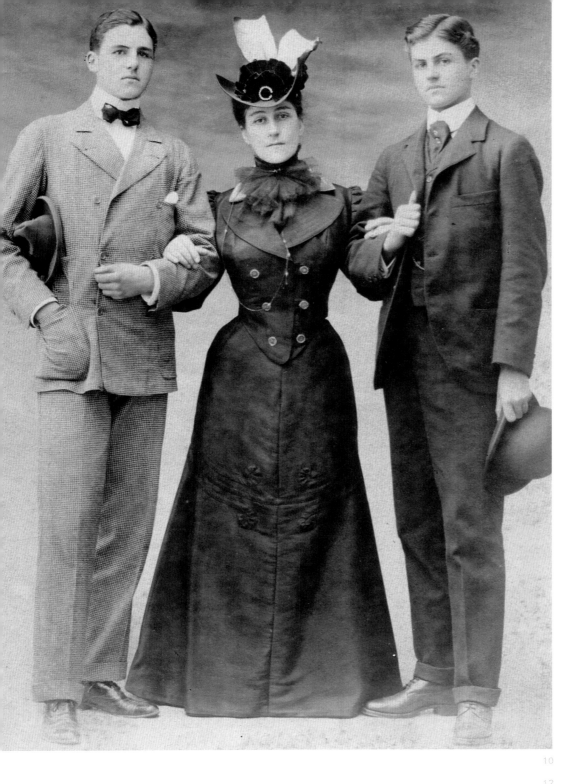

1898

Physical education is given greater emphasis at women's schools and colleges. Elaborate bodices worn with plain skirts have become the norm, for day and evening, even in a court presentation gown with draped bodice and puffed sleeves and paneled skirt reaching just to the floor with separate train.

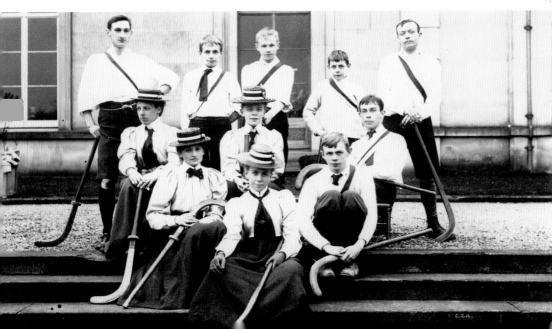

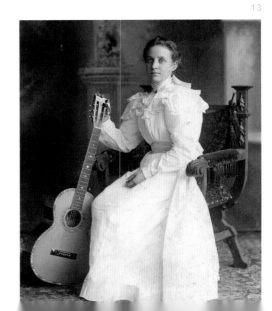

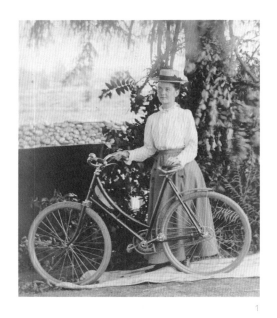

1

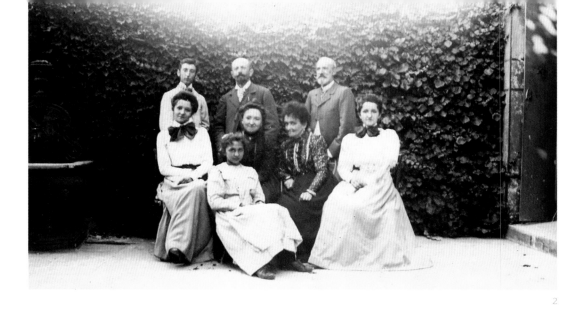

2

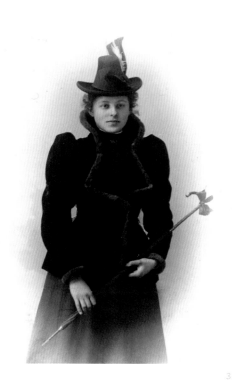

3

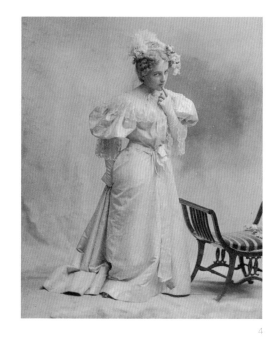

4

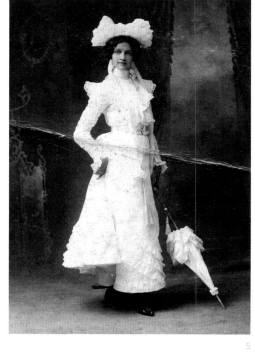

5

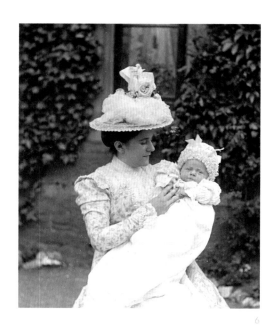

6

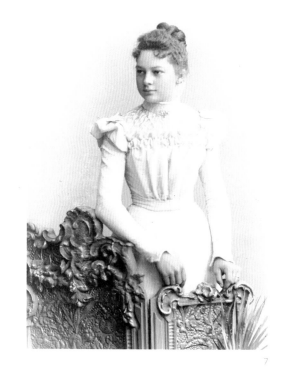

7

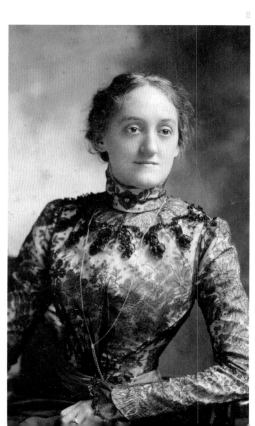

8

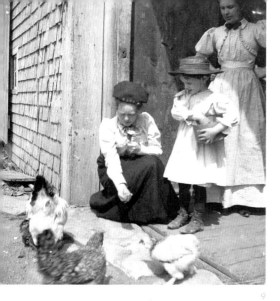

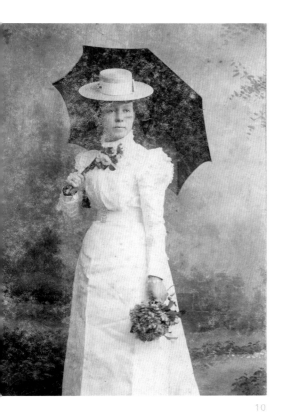

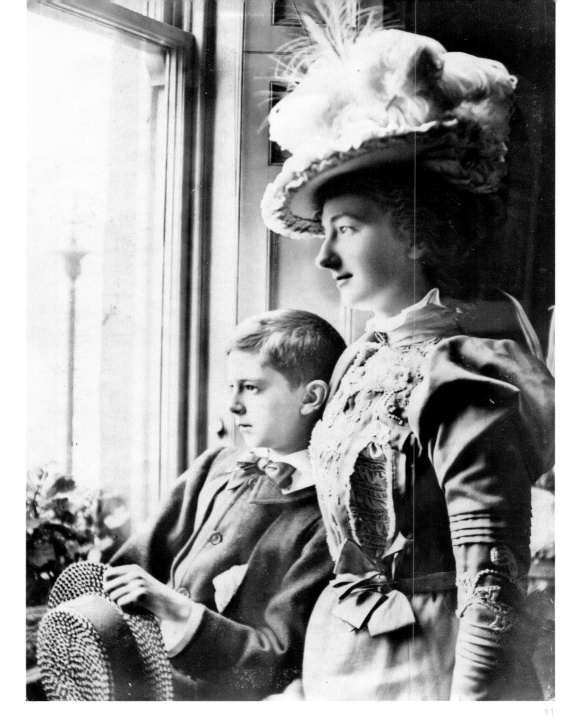

1899

Most sleeves are form fitting with a vestigial puff, ruffle, or decorative detail at the shoulder. The exception, an evening gown that dates from a few years before, is worn by a young man *en travesti* for his school play.

99

1900s

The turn of the twentieth century "S" silhouette is a head to toe affair: a plateau hat perched atop long hair arranged with a chignon high on the head (a coiffure popularized by Charles Dana Gibson's amusing drawings of his idealized American "girl"), a bodice swollen at the waist in front, a handspan "wasp" waist, and a slightly protruding back of the skirt ending on the ground with a slight train.

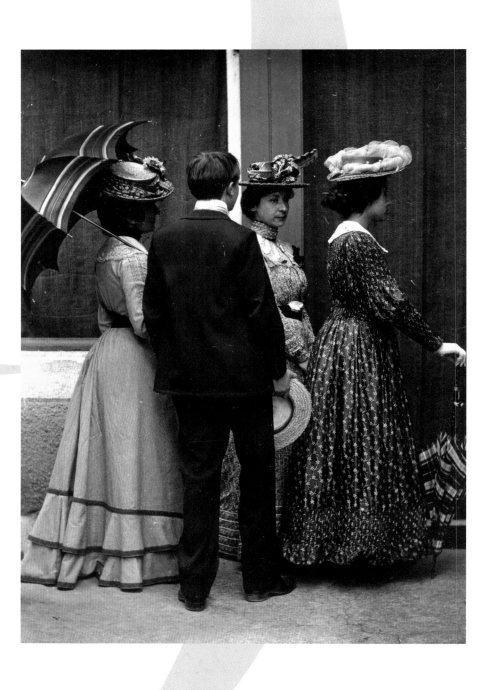

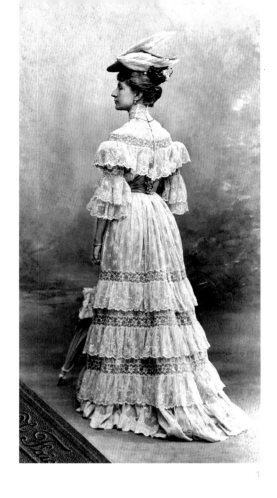

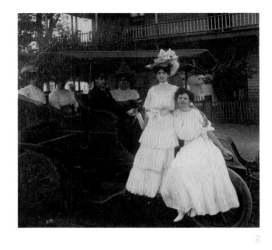

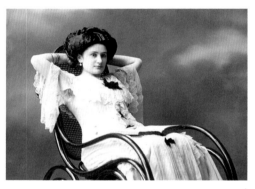

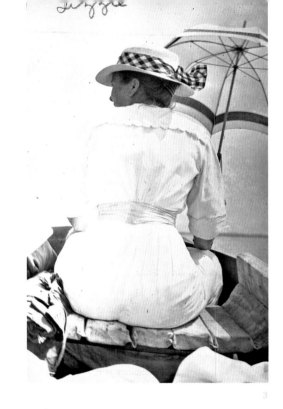

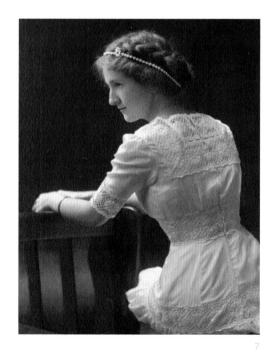

LINGERIE DRESSES

Thanks partly to innovations in washing clothes, lingerie dresses—composed entirely of cotton voile or linen inset with bands of lace or white-on-white embroidery—were ubiquitous. They could be purchased ready-made from mail order catalogues, or custom made entirely in handmade lace by couturiers such as Doucet. The typical turn of the century lingerie dress had a high collar, held up with wire or celluloid supports, and elbow-length to long sleeves. The style grew out of the "wash suit" of the mid-nineteenth century, becoming lacier as it developed, and lasted in chemise versions well into the 1920s.

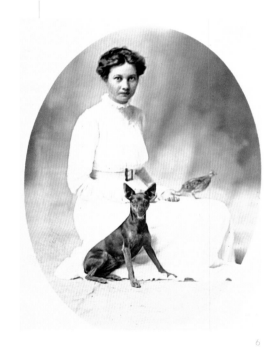

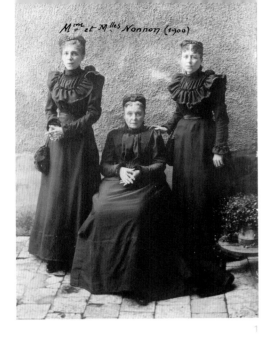

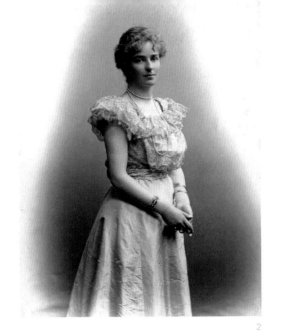

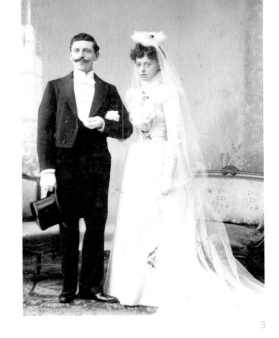

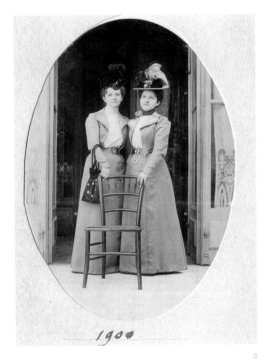

1900

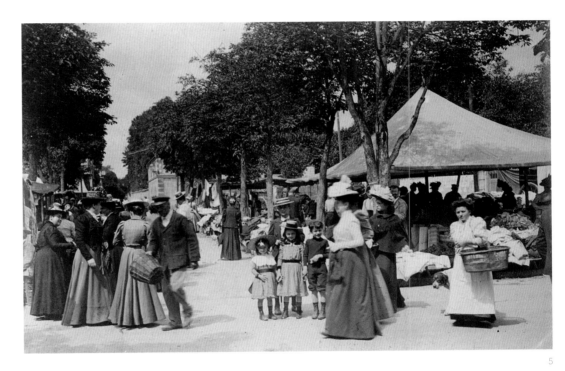

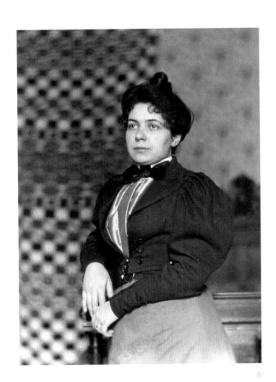

A family in mourning, a bride, a woman dressed in formal evening attire, and a bride all wear ruffles at the yoke and shoulders. Tailored styles include bolero jackets, a new style the previous spring. At bottom left, the top knot of the "Gibson girl" hair style can be seen.

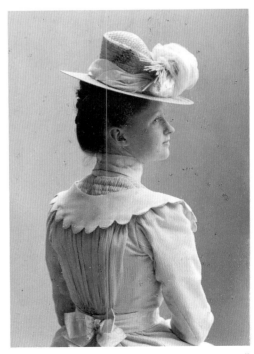

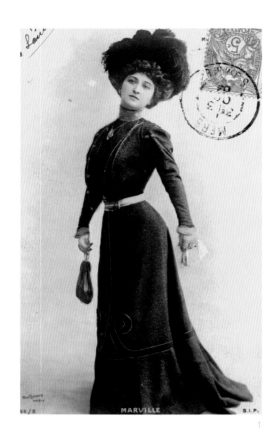

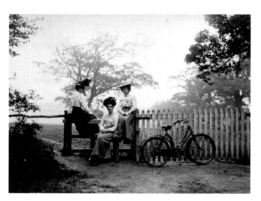

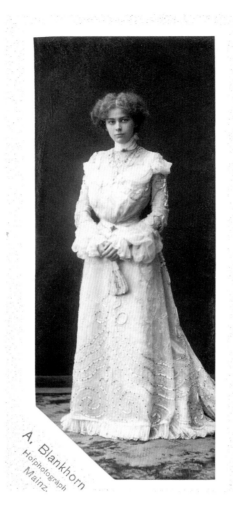

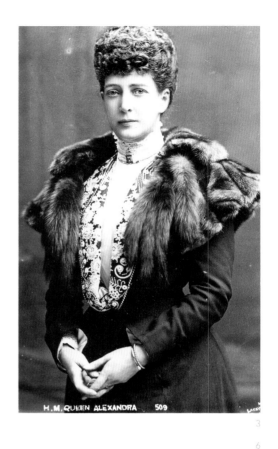

H.M. QUEEN ALEXANDRA 509

MARVILLE

A. Blankhorn
Hofphotograph
Mainz.

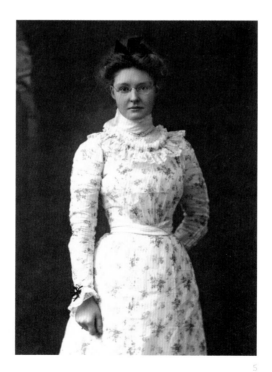

1901

Thanks to technological innovations, photographs began to supplement fashion drawings, and both posed and candid images could be seen in fashion and news publications and were also popular subjects for photo postcards. The term "French postcard" typically summoned up a vision of scantily clad women, but, increasingly, there were images of the latest haute couture styles—usually straightforward, as shown here, but occasionally mocking. Another photo postcard depicts one of the most popular style subjects of the nineteenth and early twentieth century: the ever elegant and *comme il faut* Alexandra, who became the Queen-Empress Consort of England after Queen Victoria's death in 1901.

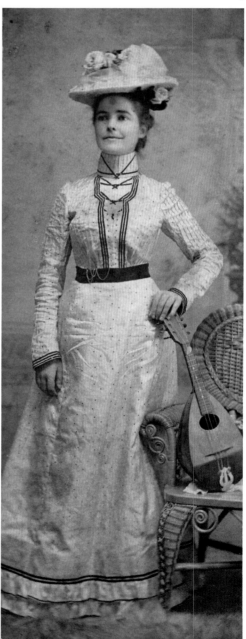

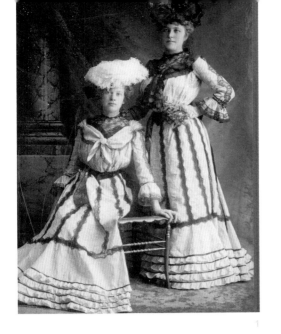

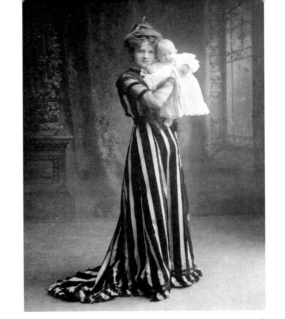

1902

The hems of skirts are becoming a vocal point, especially with flounces set in at a curve that rises in back. White is the ceremonial choice for the graduate holding a diploma and the young woman holding a prayer book. A Wisconsin bride chooses a more practical wool dress, worn with tulle veil for her wedding. In Vienna, a woman poses in a printed shirtwaist against a patterned wallpaper; both prints suggest the designs of the Wiener Werkstätte.

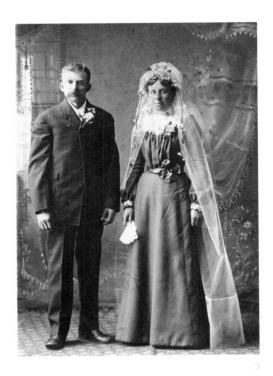

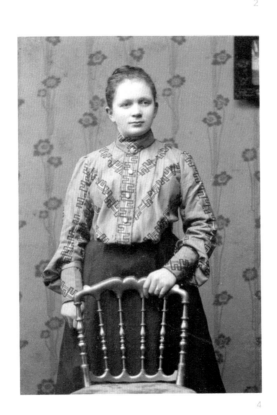

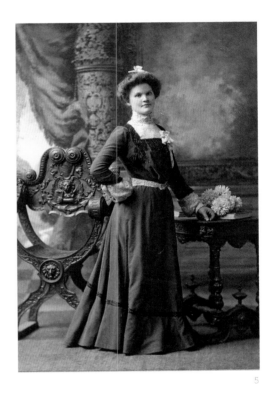

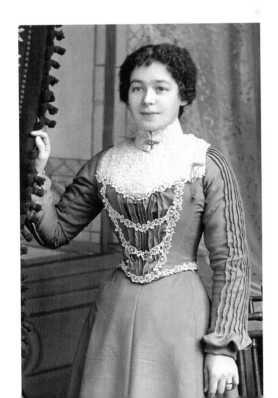

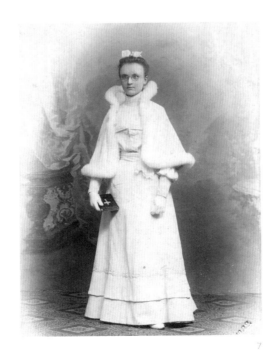

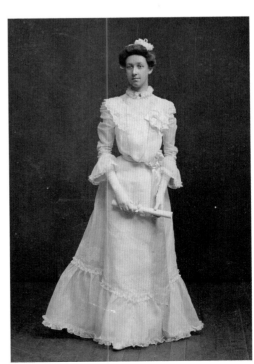

SHIRTWAISTS
AND SKIRTS

The shirtwaist—known in England as a slip—could be made like a man's shirt, complete with starched high collar and worn with a necktie or decorated with lace and embroidery, like the bodice of a lingerie dress. Even at their frothiest, they were worn for activities such as tennis and mountain climbing, as well as by students and working women. The shirtwaist and tailored skirt should be seen as a uniform for increasingly independent women. Interestingly it was derided by a fashion columnist at the British publication *The Bystander* as "the height of fashion, from a lower middle class standpoint" (June 20, 1886), especially when paired with a tweed skirt, scantily pleated and, perhaps causing the worst offence, a woolly Tam o-shanter.

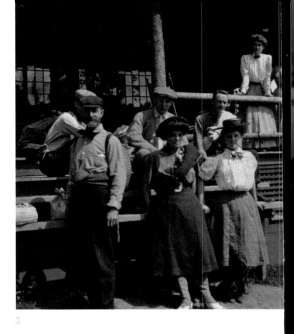

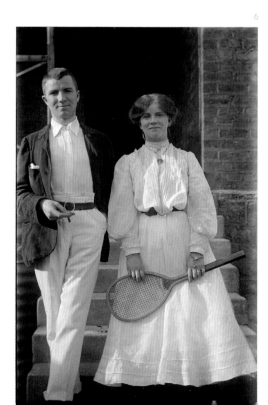

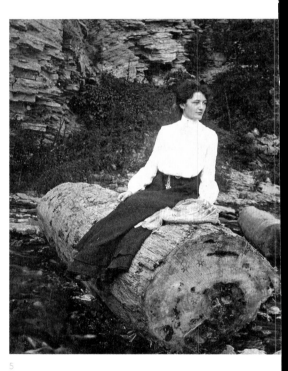

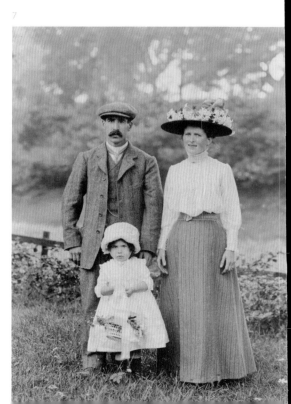

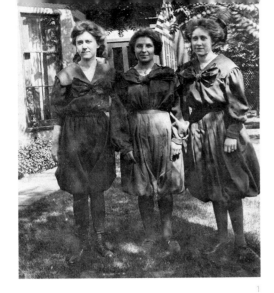

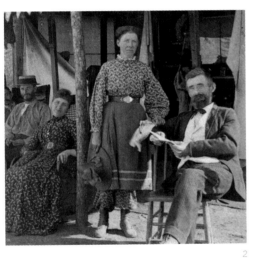

TURN OF THE CENTURY TROUSERS

Bloomers for cycling had made for uncomfortable moments for those who continued to insist that men should wear the pants: deemed suitable to cycle to work wearing them but not to enter a building thus clad, and it was rumored that French policemen watched bloomer-wearing women carefully as the commodious shape made them popular with shoplifters. However, they were worn for active sports as women were becoming more athletic on and off campus. Unusual, long calico bloomers can be seen in a photograph taken in Oregon, perhaps at a camp, where the woman in the belted sweater wears what look like workpants under her long skirt.

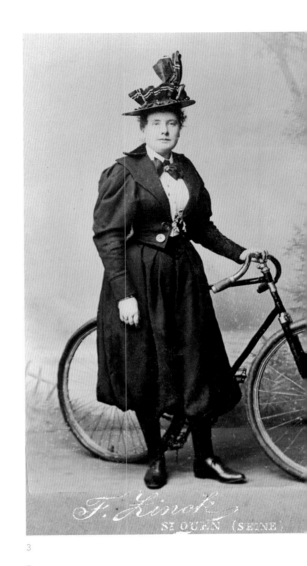

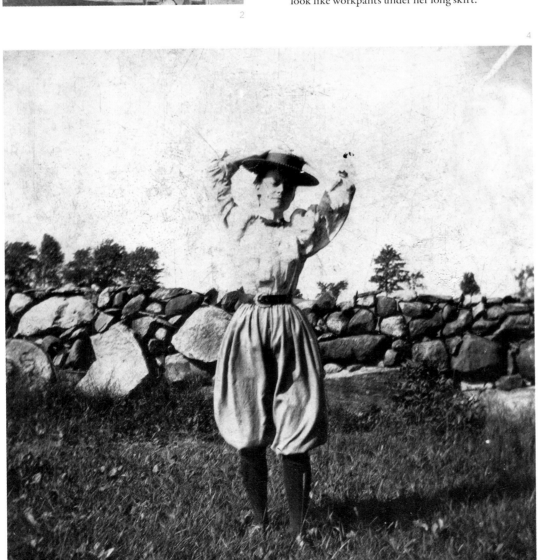

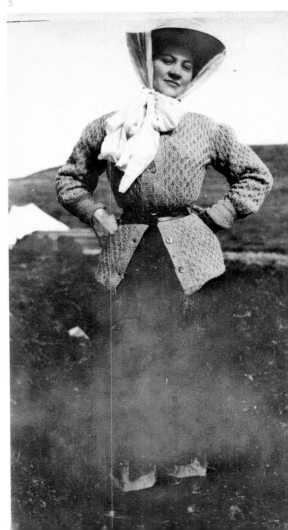

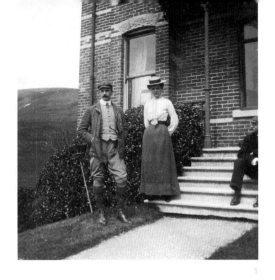

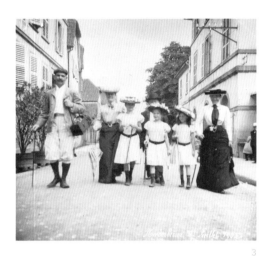

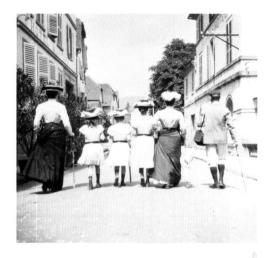

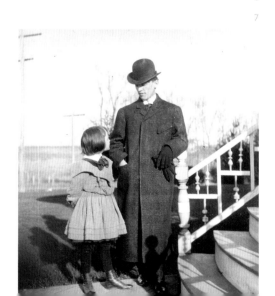

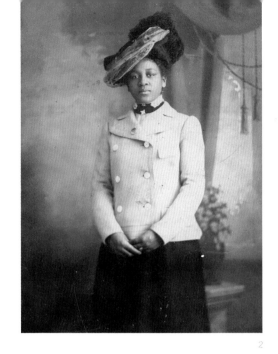

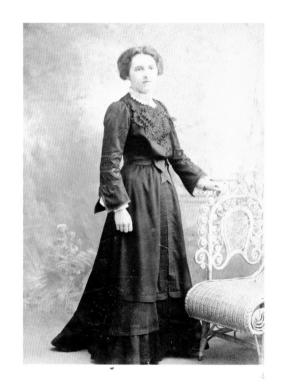

1903

The pigeon pouter bodice still reigns. A woman dressed for the country wears a skirt that clears the ground, as the women out for a stroll in a French town have to hold up their longer skirts. Lace of every type is an important decoration. At bottom right, a tinted fashion plate from *Les Modes* of a frothy dinner gown by Paris couturier Doeuillet.

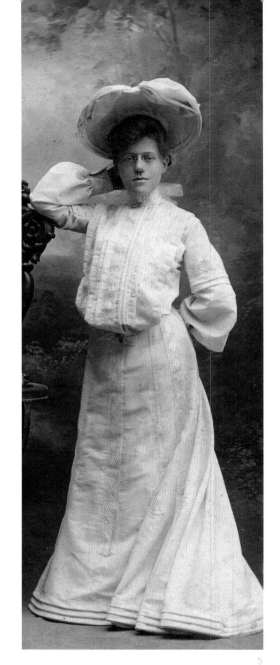

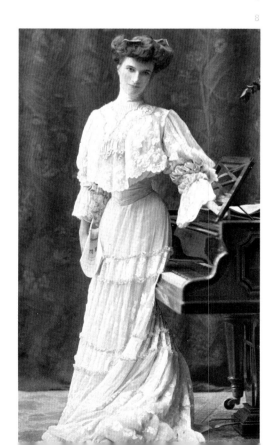

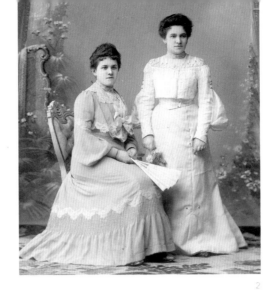

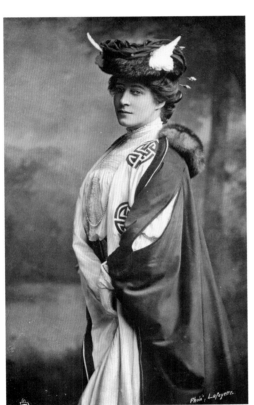

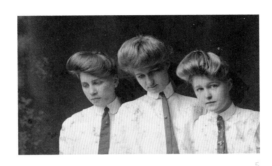

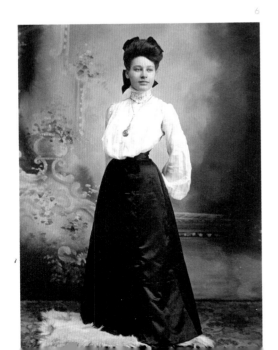

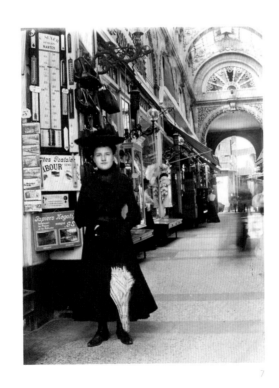

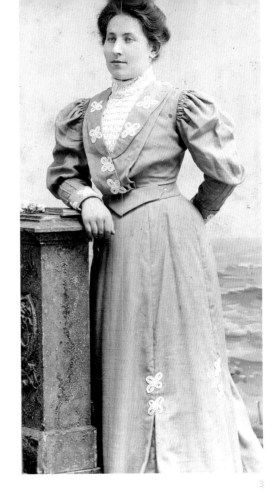

1904

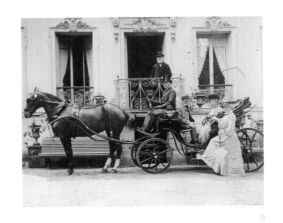

The trio of young girls, perhaps to offset their school uniforms, has achieved the most exaggerated of Gibson Girl hairstyles. Over a fairly mundane lingerie shirtwaist, actress Lily Langtry wears one of Paul Poiret's most significant designs: a Chinoiserie cape—a version of which that landed him in hot water while he worked for the august couture House of Worth but would be one of his best-sellers when he hung out his own shingle in 1903.

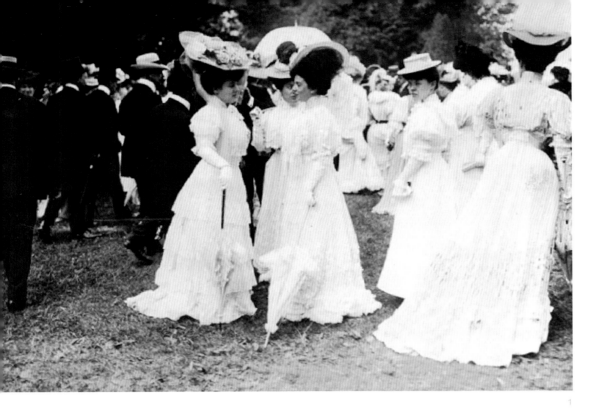

AT THE RACES

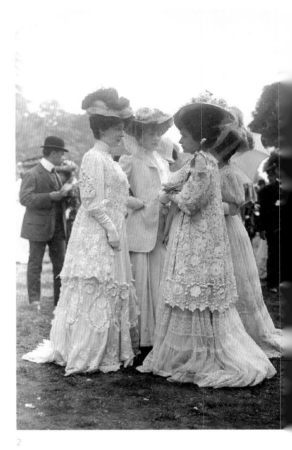

Besides riding, being driven in elegant carriages or promenading, the races were in a category all their own for the degree of sartorial display. Other countries had races, but la crème de la crème were held in the outskirts of Paris. Beginning perhaps with the Empress Eugénie at Vincennes, this is how new styles and the stylish could be observed firsthand. Charles Frederick Worth sent his wife and muse Marie to the races in the 1860s without the standard accessory of the day, a shawl, so as to best show off his latest creation. By the turn of the twentieth century, with the runway show yet to be invented, it was standard practice for couturiers to send mannequins to parade in their new looks. Competing for attention were women of fashion and photographers documented it all for newspapers and magazines around the world.

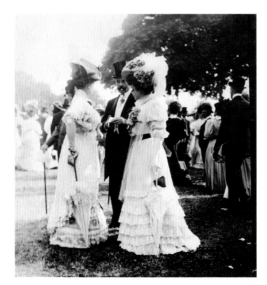

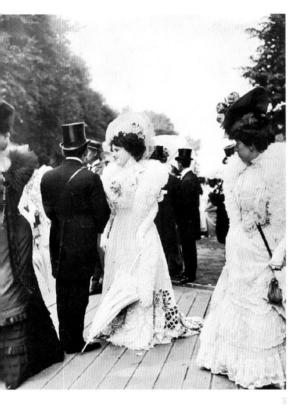

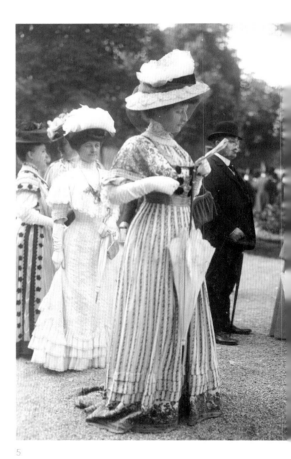

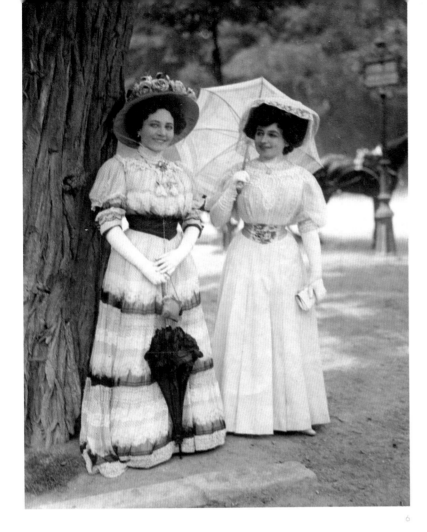

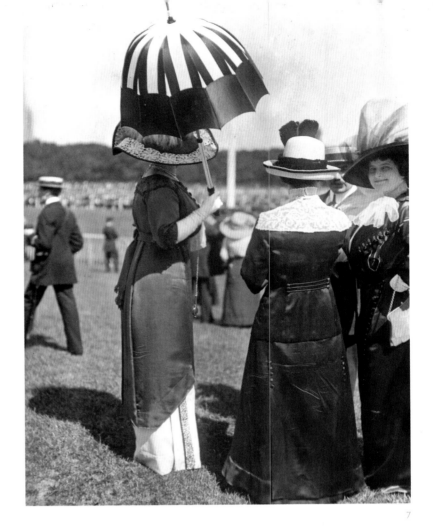

6

7

8

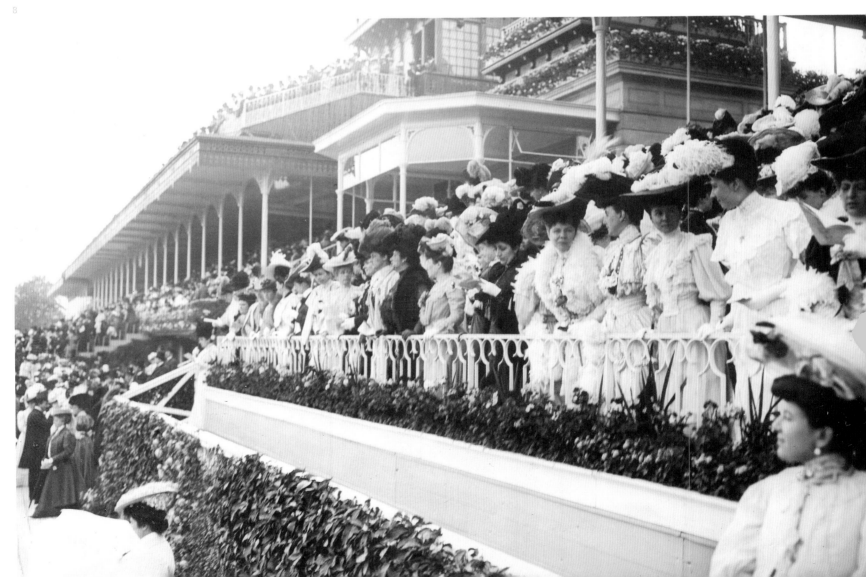

1905

Feminine touches continue to enliven fairly basic styles such as the shirtwaist and skirt and the tailor-made suit. The gored skirt that flares like a trumpet towards the ground is seen to great advantage on an outdoor dancefloor in France.

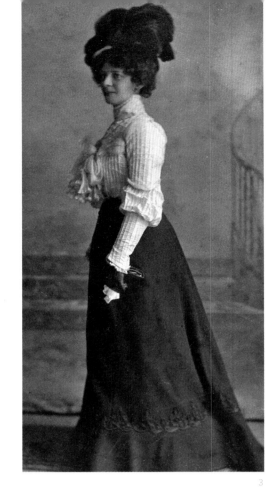

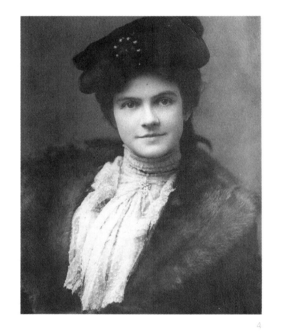

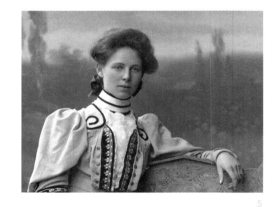

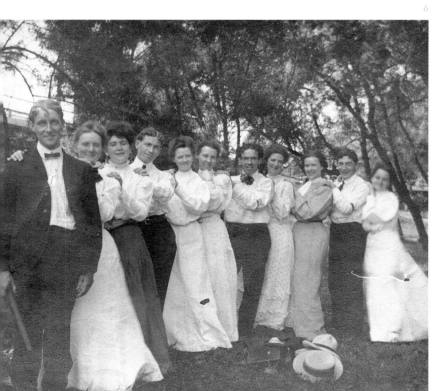

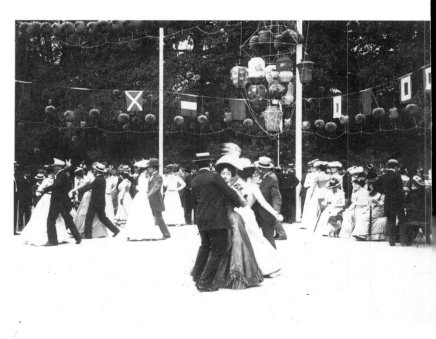

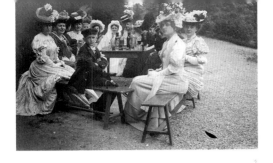

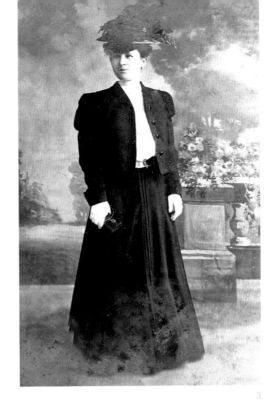

1906

Hats are still being worn like saucers; the young lady in the plaid shirtwaist has abandoned the high collar and the woman paddling in a boat wears one of the sailor-inspired styles associated for several decades with yachting and the seaside.

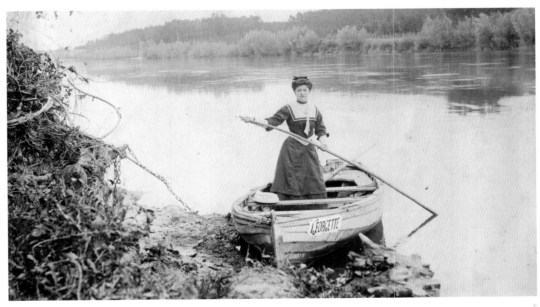

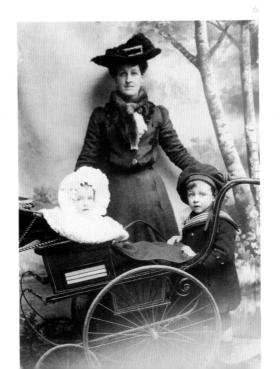

113

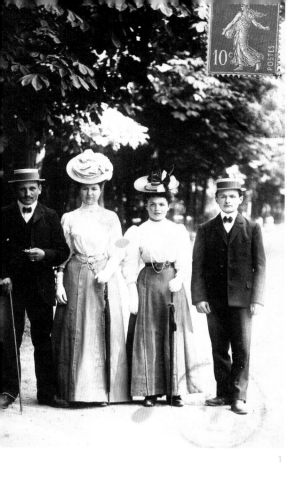

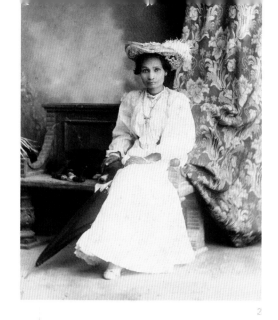

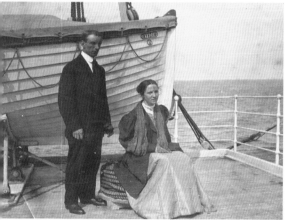

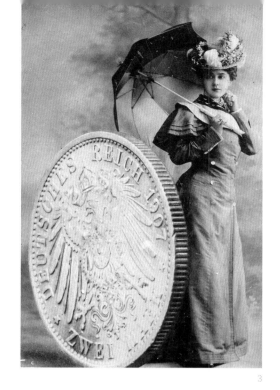

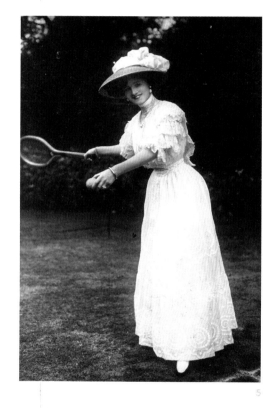

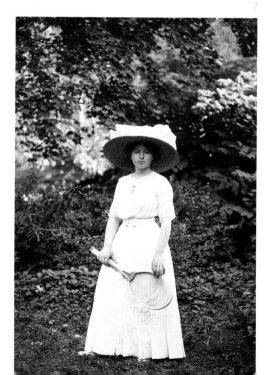

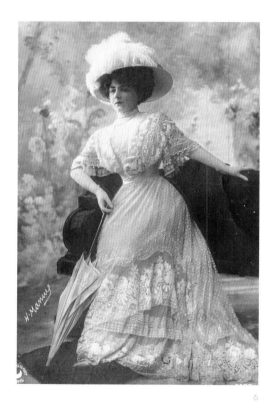

1907

Enormous wide-brimmed hats were seen in 1906, but they didn't catch on until 1907 when previously little known British actress Lily Elsie wore one starring in the first English production of Franz Lehár's operetta *The Merry Widow*, with costumes by British couturiere Lucile. Her hat with plumes became a sensation and would remain the height of fashion until the beginning of World War I in 1914. A British writer describes a trend in which the feet can be seen peeping out from under slightly shorter skirts: "Everyone who comes from Paris has the same story to tell of promenade toilettes. These are all tailor-made, with skirts sufficiently short to show 'the little feet steal in and out'" (*The Bystander*, May 1907).

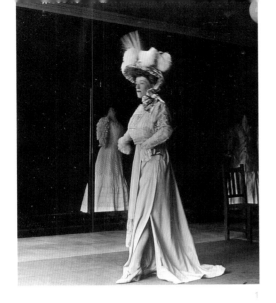

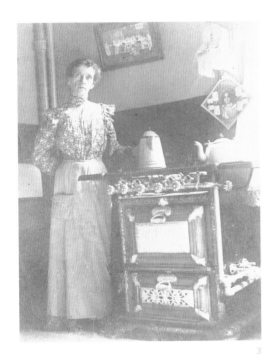

1908

The puff of fabric bloused low at the waist is disappearing, and the bust is still rounded with a hint of a raised waistline as seen in the style modeled in a couture house (top left). A fold just below the shoulder is described as a kimono effect and is often part of a vest over-bodice. The jacket shown bottom left is also kimono-inspired. Tailored suits such as those worn to a vernissage in Paris or at bottom center are made in wool with a soft finish with decorative touches such as appliqué and tucks. Highly unusual is the woman posing in her garden wearing a tea gown or—gasp—a peignoir.

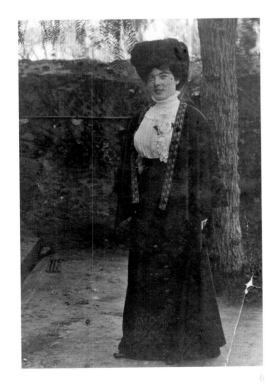

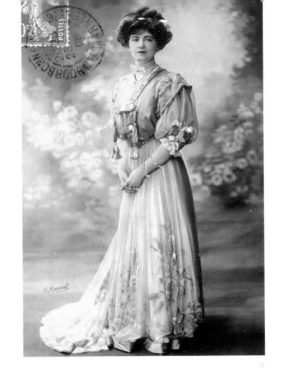

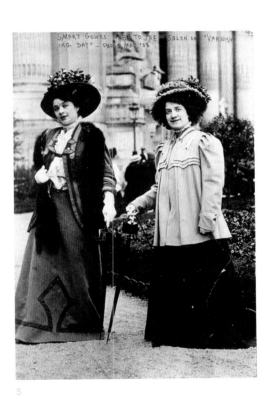

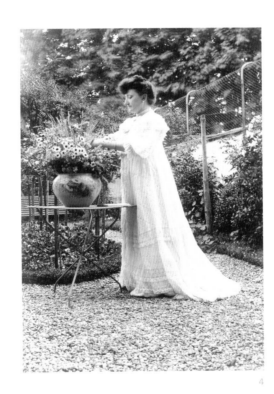

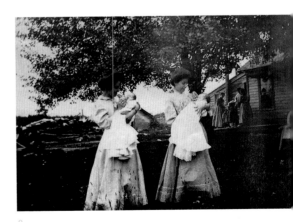

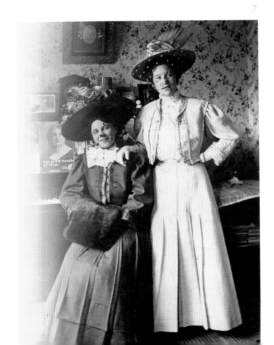

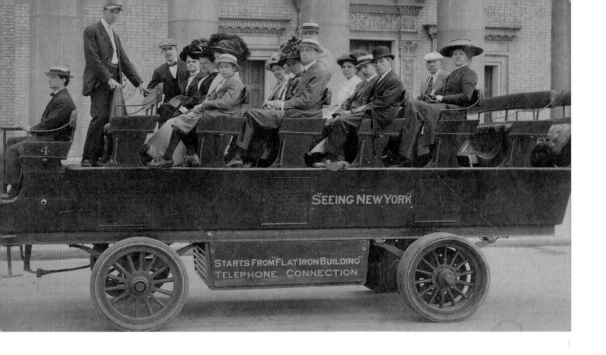

1

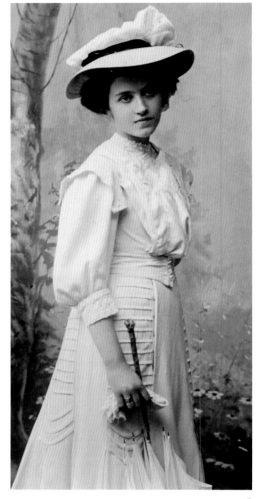

2

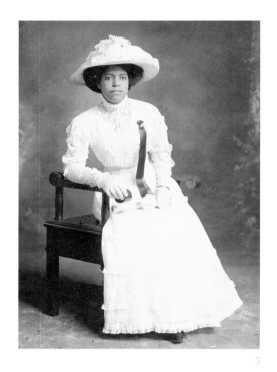

3

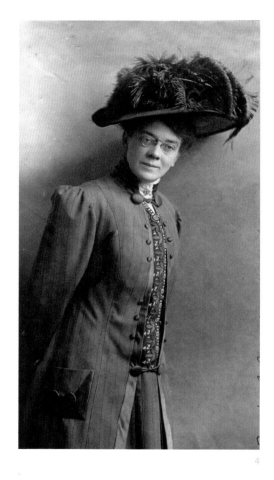

4

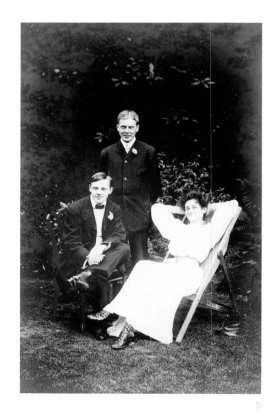

5

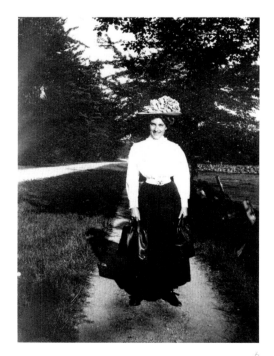

6

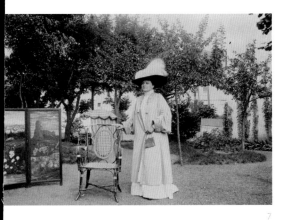

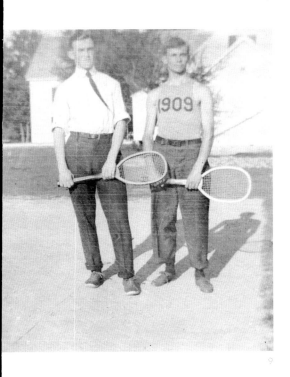

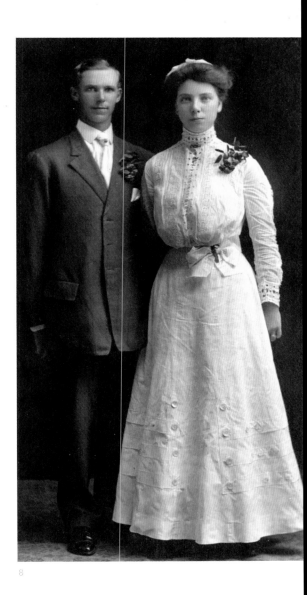

1909

Buttons and tucks are beginning to supplant lacy effects. "Then as to buttons. These are equally prepared to do no wrong, and meander cheerfully down the back of our sleeves and up the sides or back of our skirts" ("Frocks, Frills and Furbelows" by Mrs. Jack May, *The Bystander*, September 16, 1908).

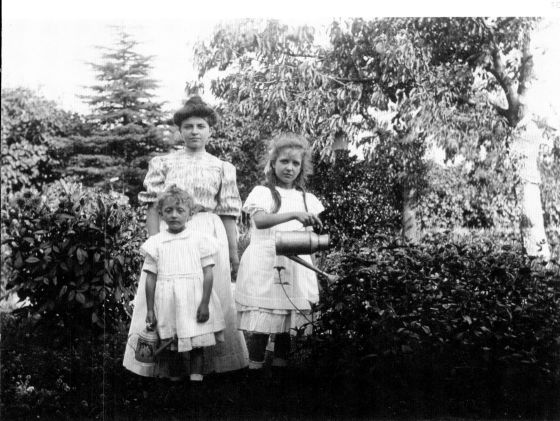

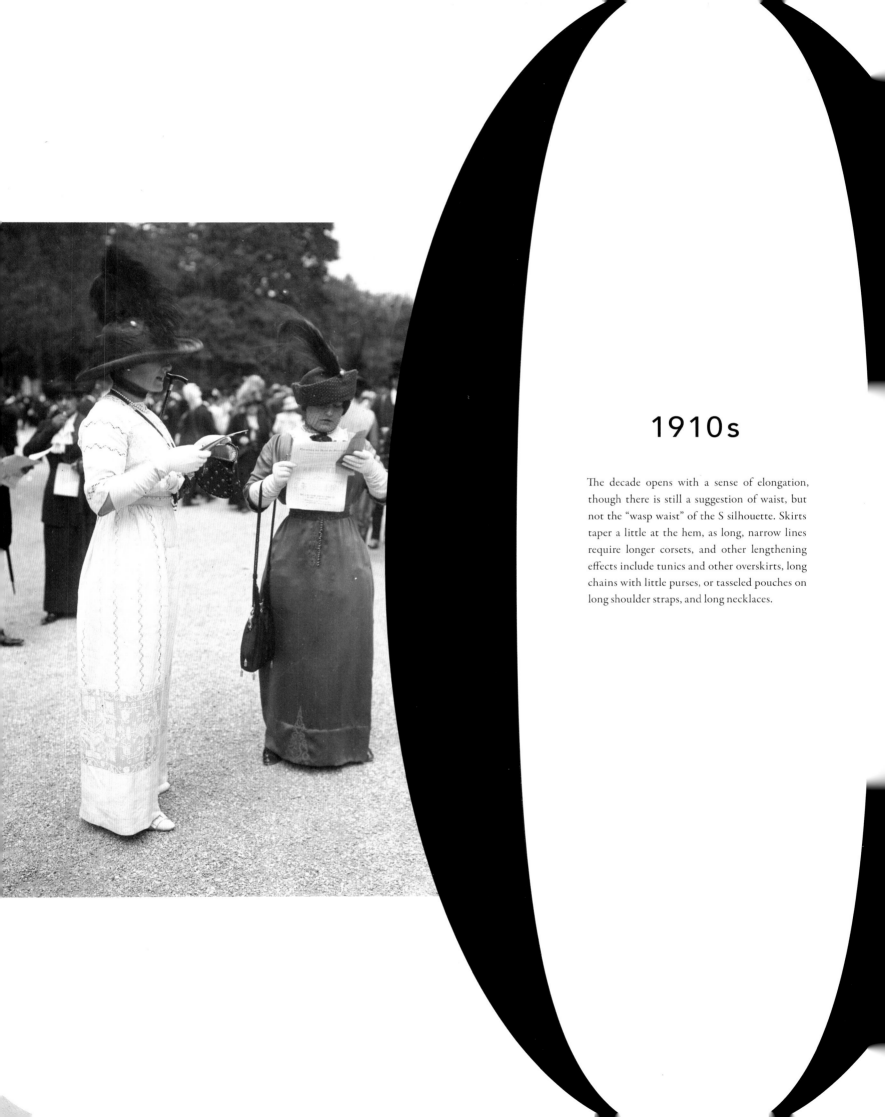

1910s

The decade opens with a sense of elongation, though there is still a suggestion of waist, but not the "wasp waist" of the S silhouette. Skirts taper a little at the hem, as long, narrow lines require longer corsets, and other lengthening effects include tunics and other overskirts, long chains with little purses, or tasseled pouches on long shoulder straps, and long necklaces.

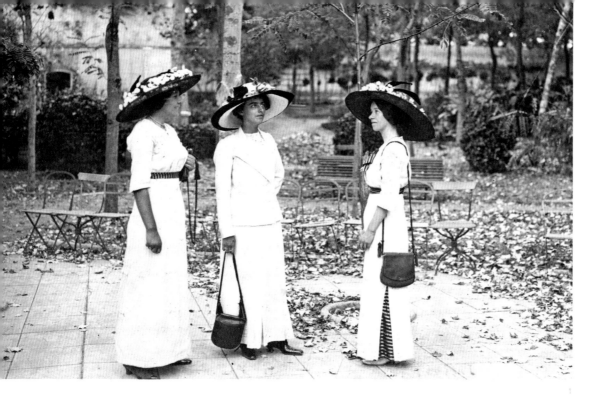

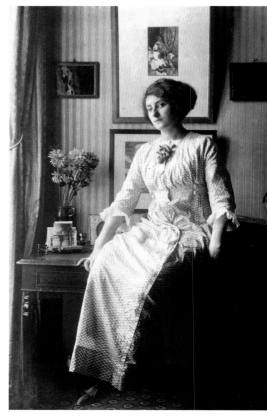

POIRET
LOOK

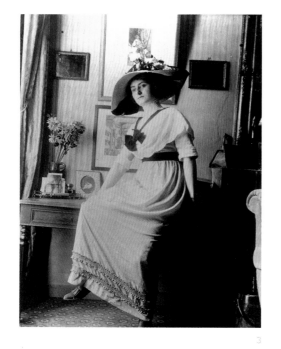

In 1908, Paul Poiret published an exquisite album of pochoir plates by Paul Iribe titled "Les Robes de Paul Poiret." The narrow silhouette featured referenced the Napoleonic era and within a few years would be the dominant look, doing away with the bifurcated S-silhouette. Besides the narrow lines, such Poiret touches as raised waist-lines, soft materials, fichu collars, and tunics over narrow skirts were widely seen.

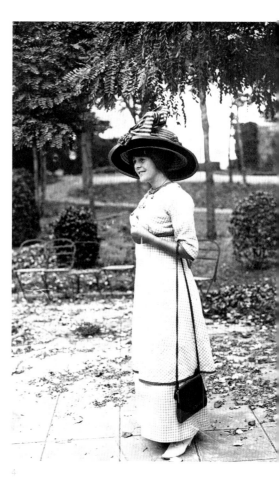

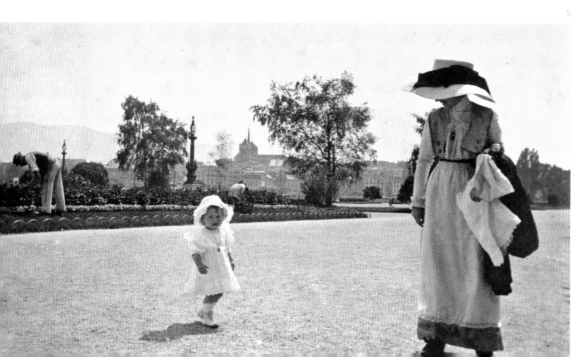

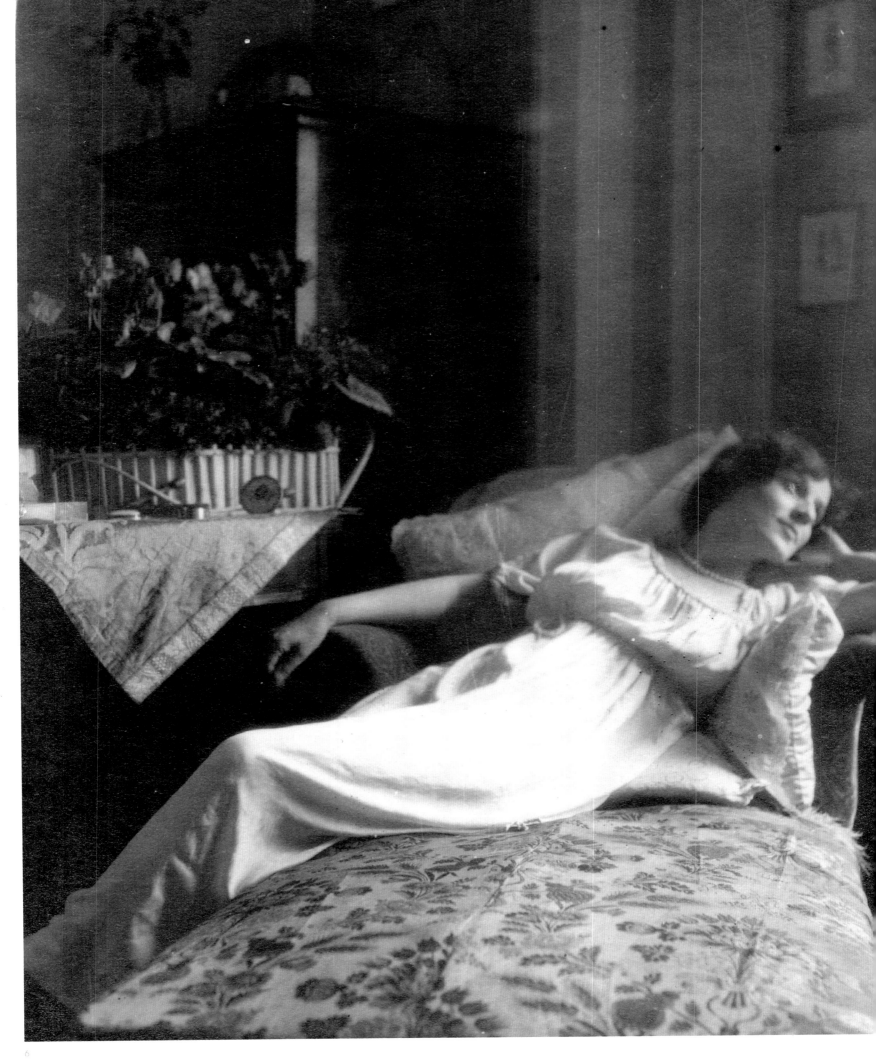

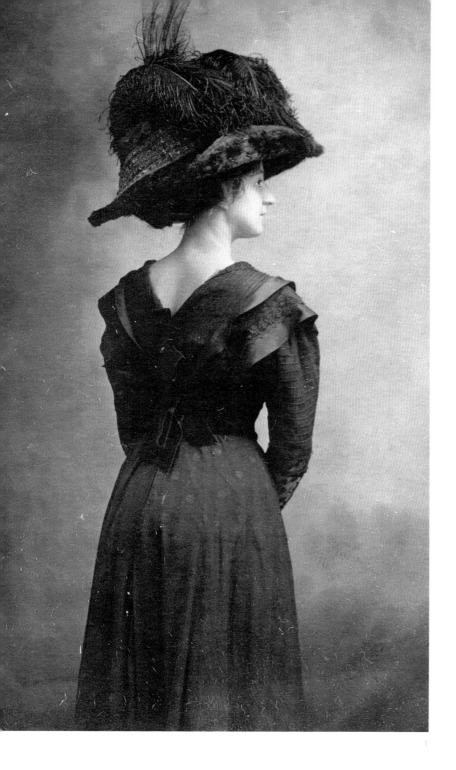

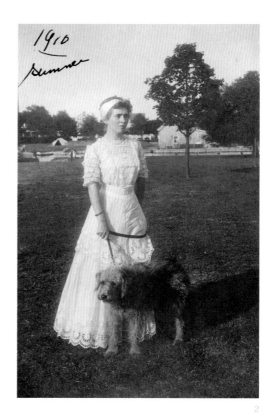

1910

Although the Merry Widow hat continues to dominate, *Vogue* announces (perhaps hopefully): "The diversity of hats is amusing—large and small! The smart bi-corne; close things that resemble Breton caps, of silk, fur and velvet; immense Louis XVI hats, Charlottes and big calottes—all are worn and, speaking generally, they are trimmed with plumes, feathers and fur" (November 15, 1910). The widest hat here is seen in a rare autochrome image, and the only high collar that is still seen is worn by a proper, yet stylish bride.

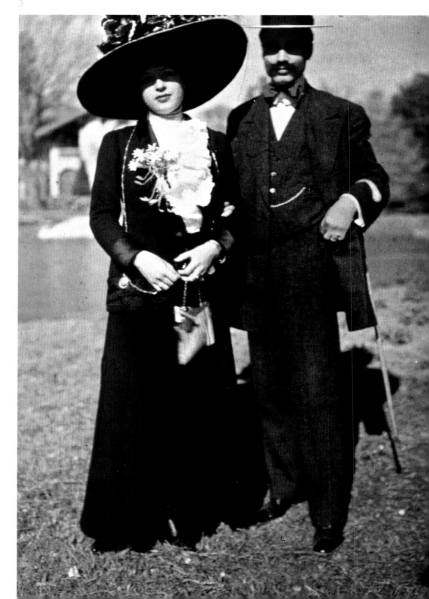

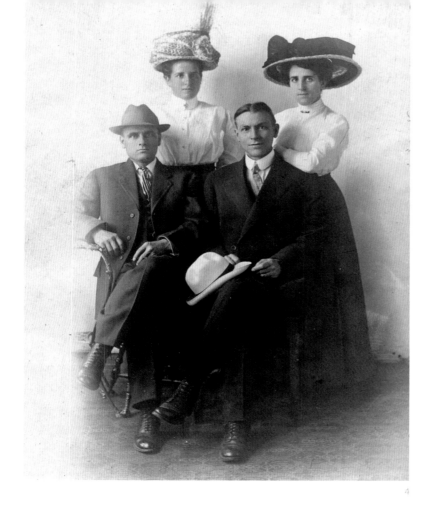

4

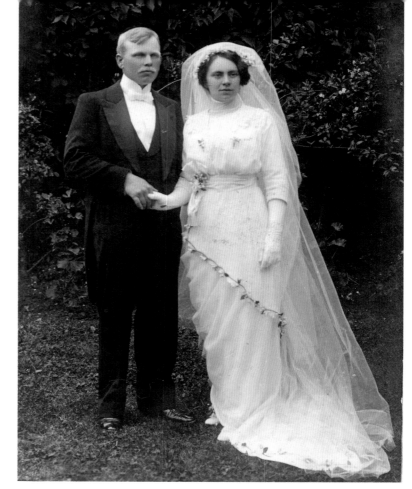

5

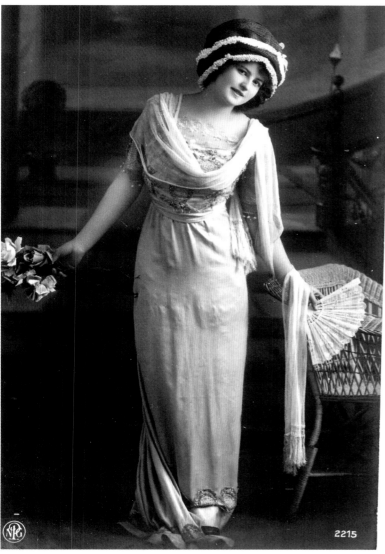

2215

6

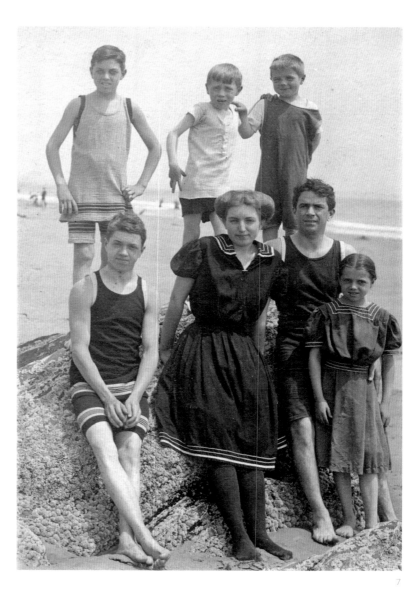

7

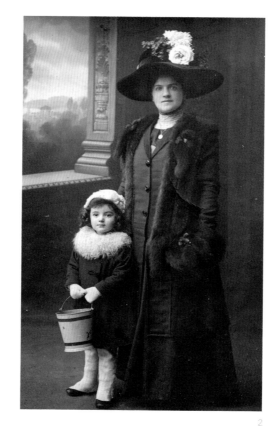

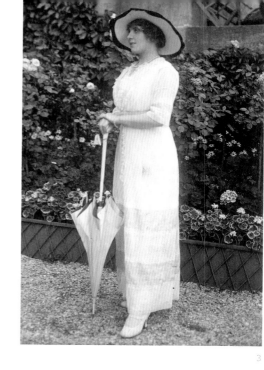

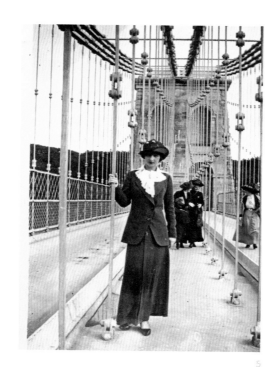

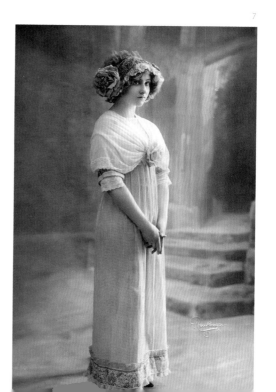

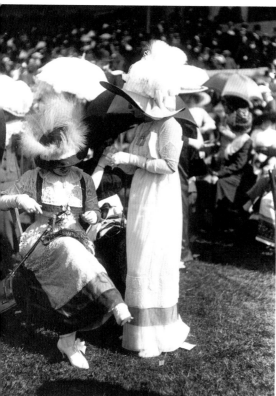

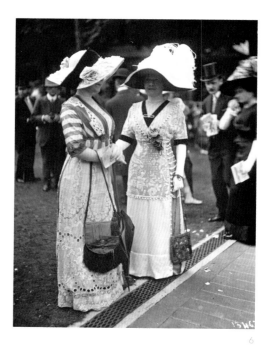

9

1911

The silhouette is narrow, and waistlines range from slightly raised to empire, as in the case of a gown by Buzenet of Paris with a Marie Antoinette fichu. Black and white is popular, and hats are enormous and laden with ostrich or egret feathers.

8

10

11

12

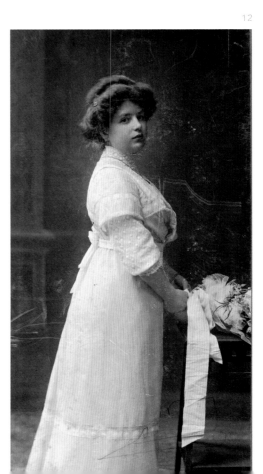

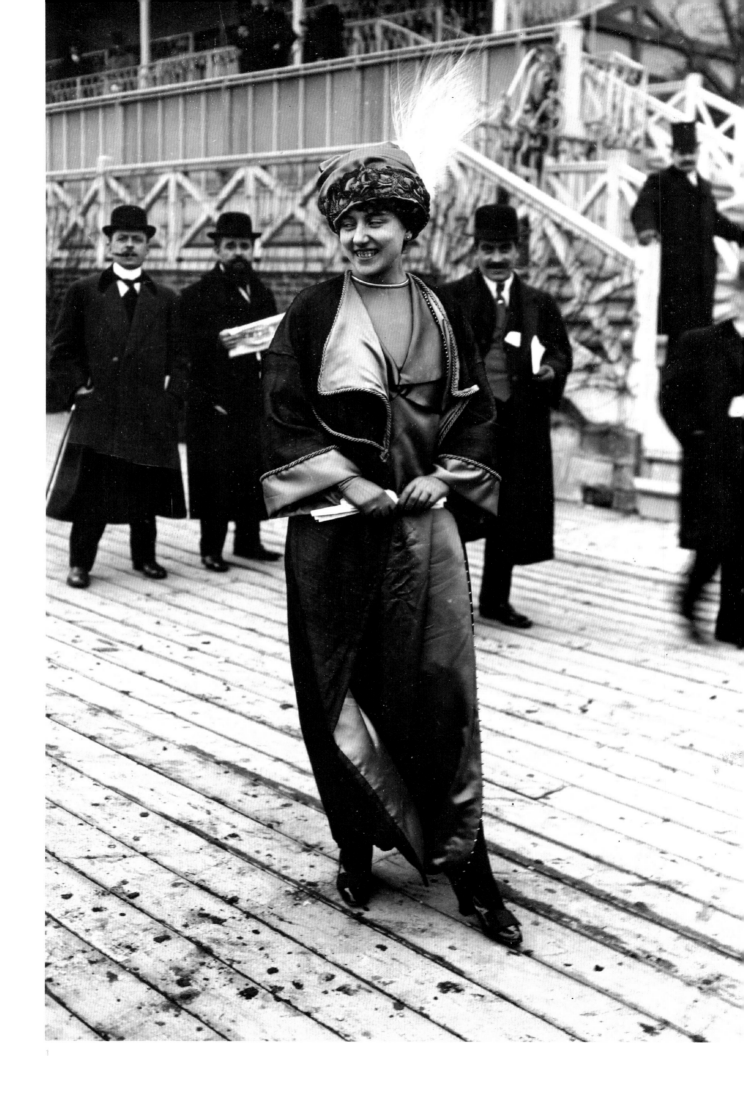

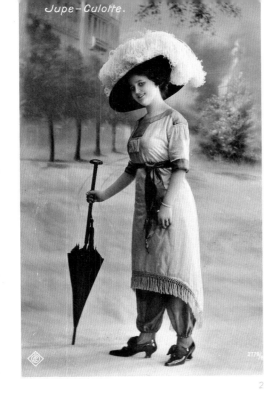

Jupe-Culotte.

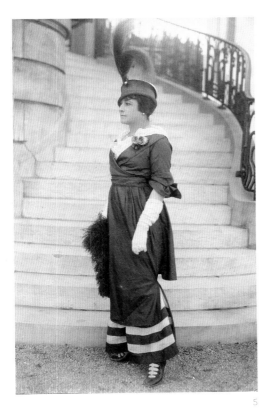

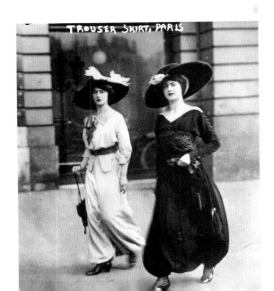

TROUSER SKIRT, PARIS

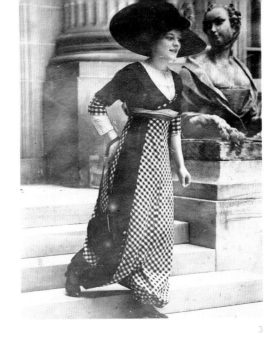

JUPE-CULOTTE

Paul Poiret learned the value of launching fashions at the races when working for Doucet, and in 1911, he created a global stir by sending models to the races wearing pants-based costumes called "jupe-culottes." At far left is the very first to appear in public, at Auteuil, where it made headlines around the world. First presented as an example of "Tomorrow's Fashions," the jupe-culotte was harder to wear than a dress and thus was less of an actual modern advance than a lightning rod for attitudes towards women's abilities and rights. Many sold—Poiret's and others'—and it was a potent visual expression of changes in the air for women.

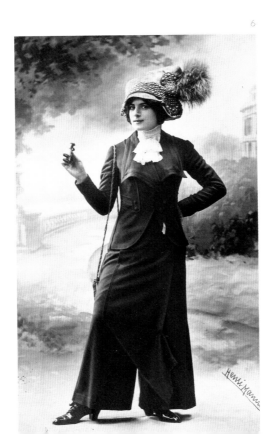

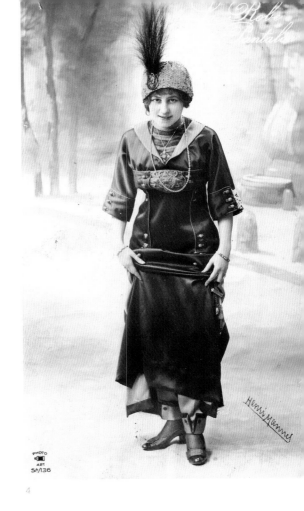

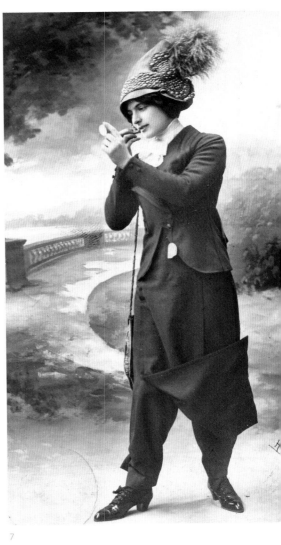

1912

The silhouette is narrow, although not as extremely narrow as the hobble or draped skirt first promoted by Poiret. Elongation is achieved by means of tunic effects and longer jackets, including ones with cut-away hems. Two women wear long chains—one with a miniature mesh purse. Decorations include bobble fringe and tassels. A hat almost tricorne in shape sports a panache, or upright plume. A letter sweater is worn by a Cathedral of the Sacred Heart student.

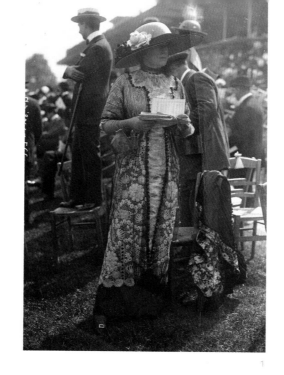

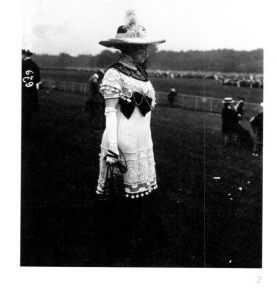

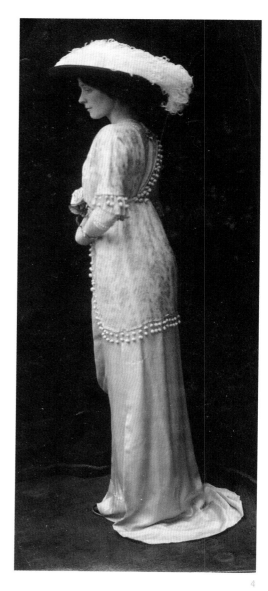

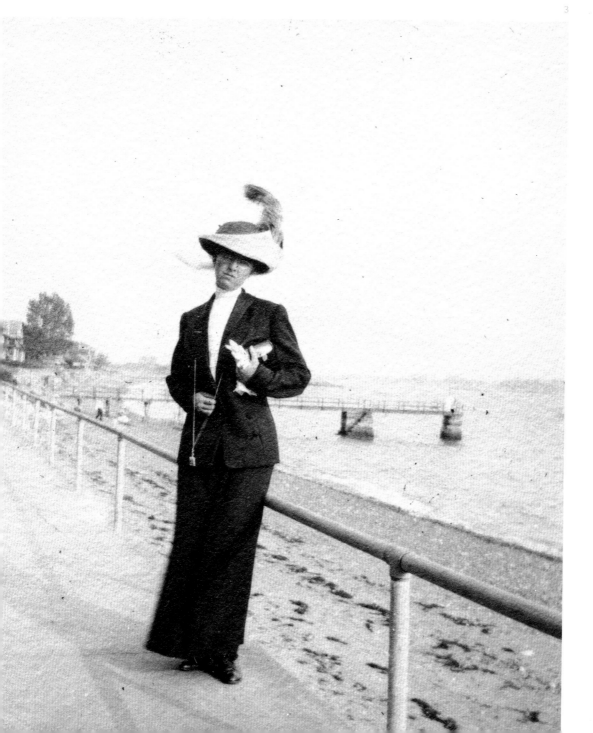

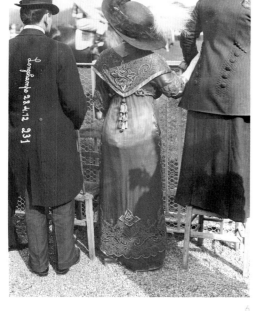

6

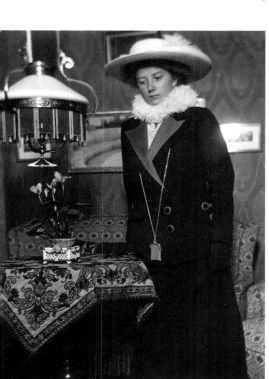

9

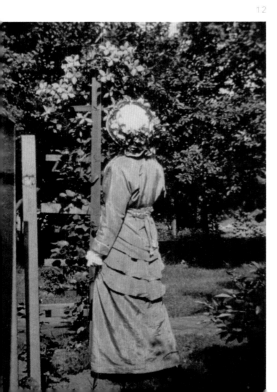

12

7

10

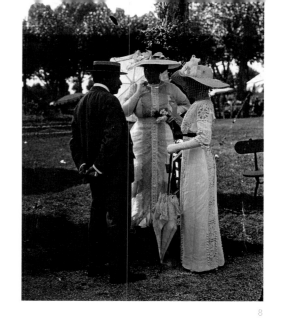

8

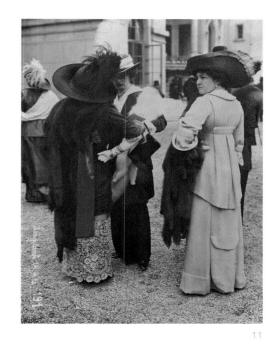

11

13

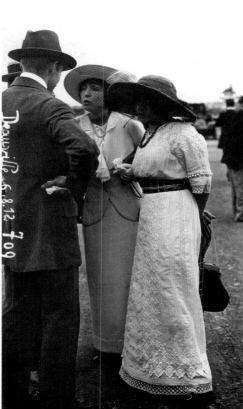

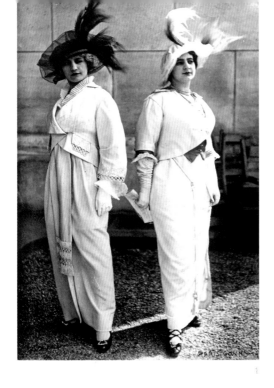

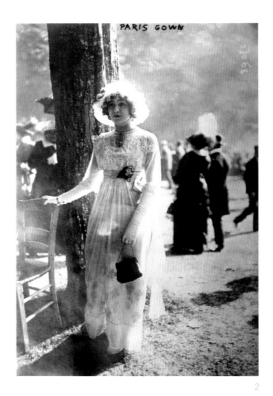

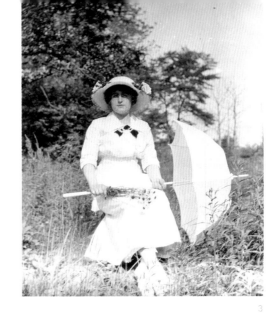

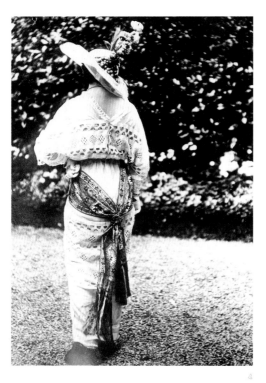

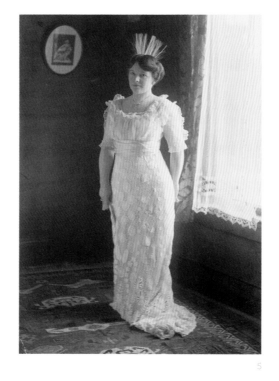

1913

Growing steadily since at least the turn of the twentieth century was the appetite (known in the press as a mania) for lace. Museum-quality antique laces were collected by connoisseurs; whole dresses or trimmings of hand-made lace were instantly recognizable to astute observers (at a time when very little daytime jewelry was worn) as wildly, even shockingly expensive. After World War I, real lace would still be worn by brides, but in general, it would be part of the gilded past.

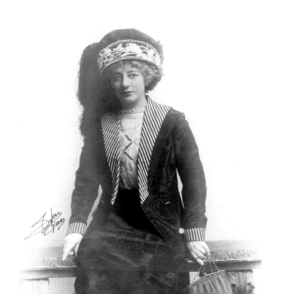

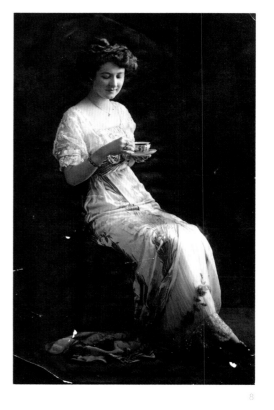

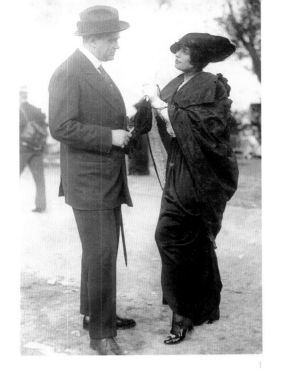

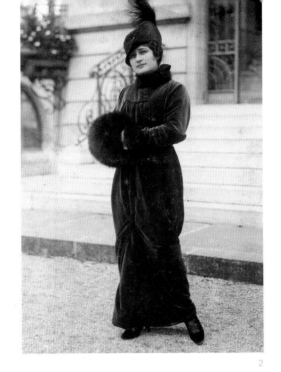

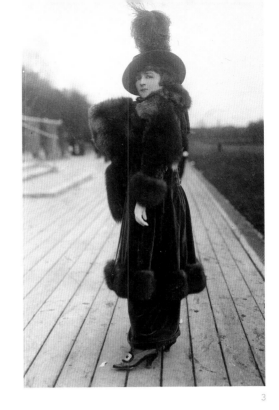

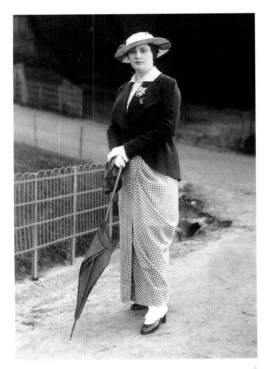

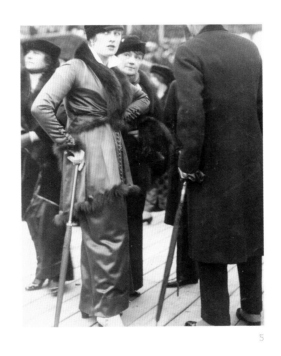

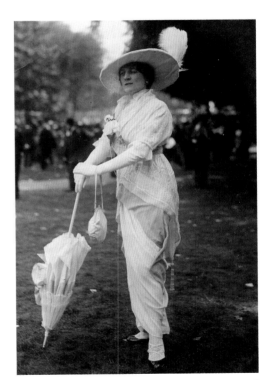

DIRECTOIRE REVIVAL

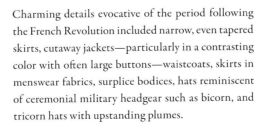

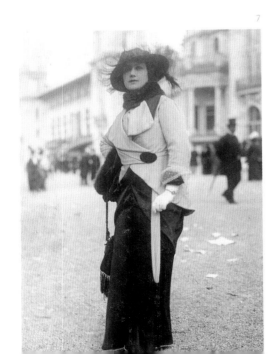

Charming details evocative of the period following the French Revolution included narrow, even tapered skirts, cutaway jackets—particularly in a contrasting color with often large buttons—waistcoats, skirts in menswear fabrics, surplice bodices, hats reminiscent of ceremonial military headgear such as bicorn, and tricorn hats with upstanding plumes.

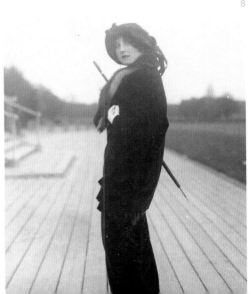

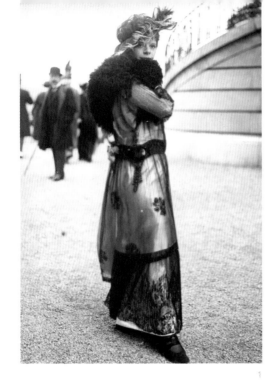

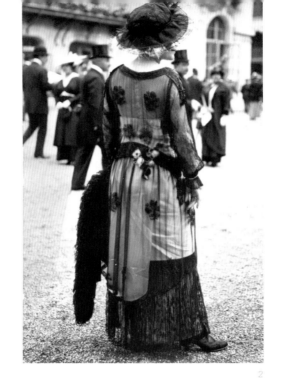

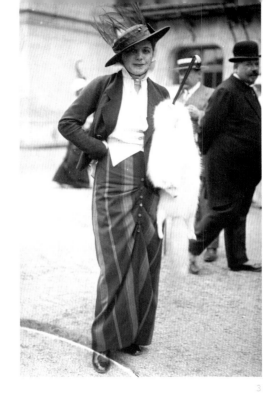

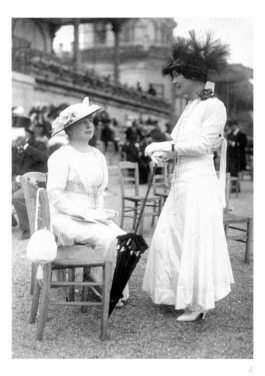

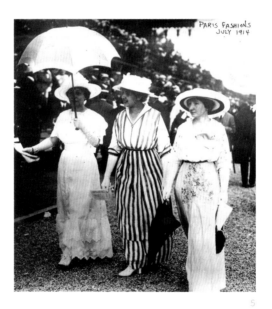

PARIS FASHIONS
JULY 1914

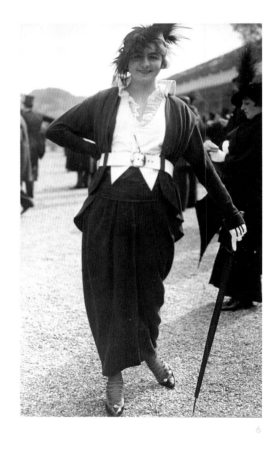

1914

The last gasp of the glamorous habitués decorating race courses before France enters World War I. A few examples of the narrow draped skirt, the remaining legacy of the hobble, a chance to see the side and back of an embroidered sheer silk dress, and a prescient look in white silk by couturier Jenny, shown from the side, featuring a fuller skirt. Most of the hats are worn at a decided angle. Once France entered the war, the horses went to the cavalry, as the male race-goers went into the army, and women joined various war efforts.

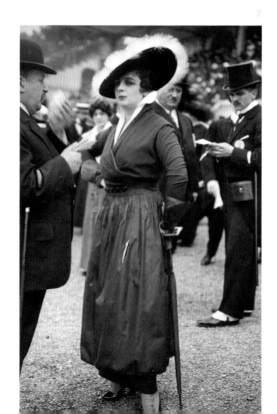

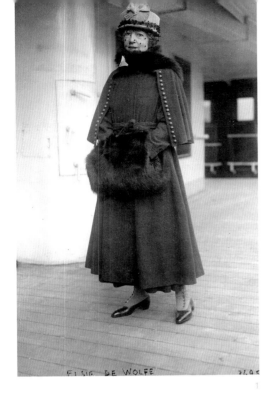

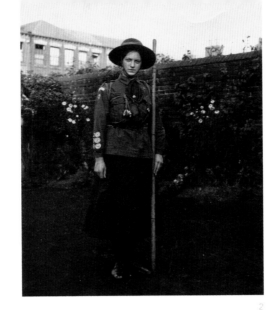

ELSIE DE WOLFE

1915

World War I had begun in Europe in 1914, and a new silhouette emerged almost immediately: the skirts of *crinolines de guerres* were fuller and shorter for ease of movement. Elsie de Wolfe, actress turned decorator and ardent Francophile, was fortunate enough to have an interesting war: her French war work included raising the funds for a fleet of eighteen ambulances and helping with hospitals at Versailles and Compiègne. She was awarded a bronze Croix des Guerre reserved for women near the line of fire, and she was photographed here on her return from an inspection of American Ambulances at Versailles wearing a smart cape coat and toque with cockade and veil, no doubt fresh from Paris.

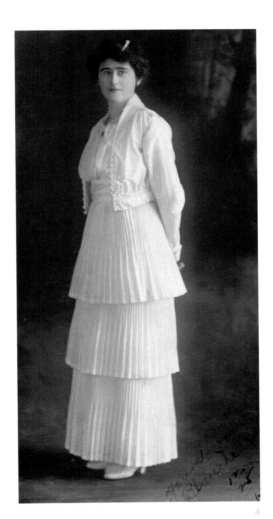

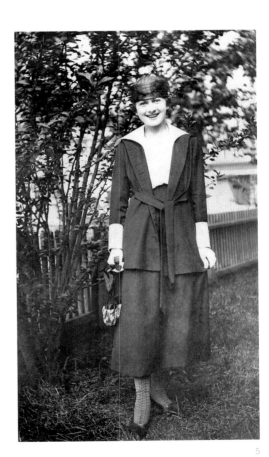

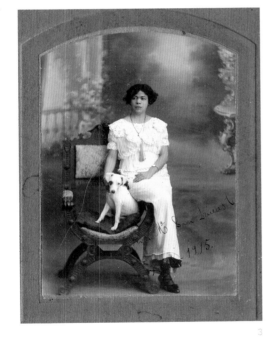

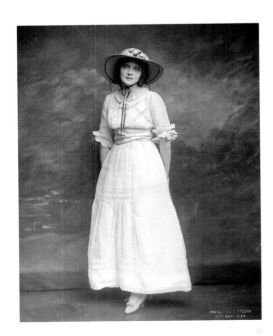

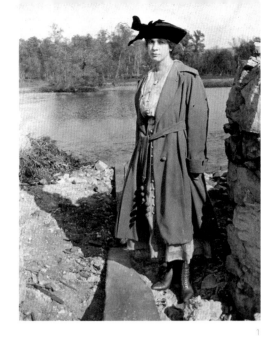

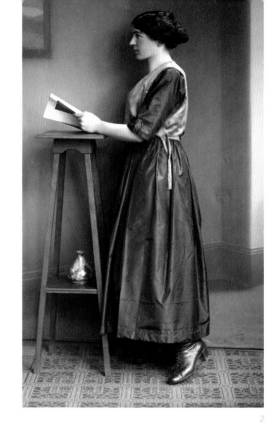

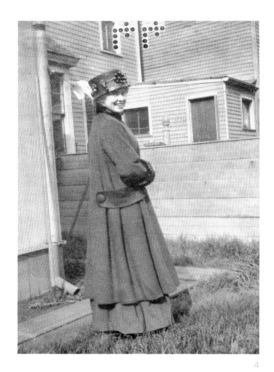

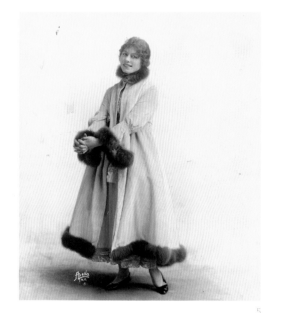

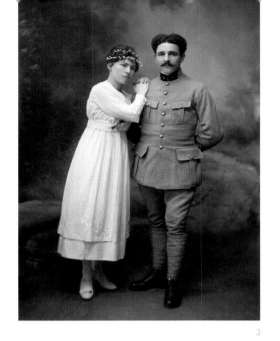

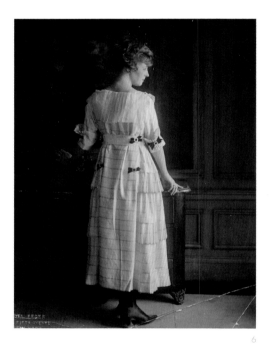

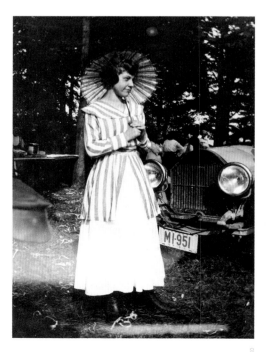

1916

A slightly quaint air to these full-skirted looks was intentional: couturiers were referencing the nineteenth century, specifically the 1830s and the days of Napoleon III.

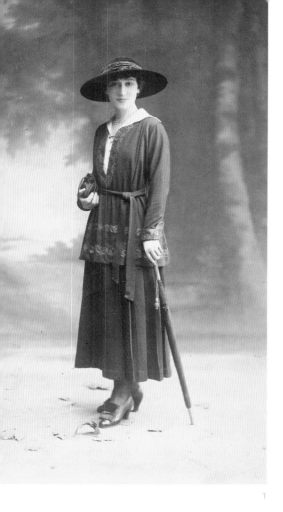

1917

Shown top left, one of Gabrielle Chanel's earliest signature looks—not a suit, but a costume of jersey. Having begun at the resort town of Deauville, her first *success fou* was a heavy knit sports tunic in 1913. As she expanded her business, opening a maison de couture in Paris during World War I, she continued to expand on the idea of elegant comfort. The tunic shown here is almost identical to her first one, rendered in a more supple knit and enlivened with embroidery.

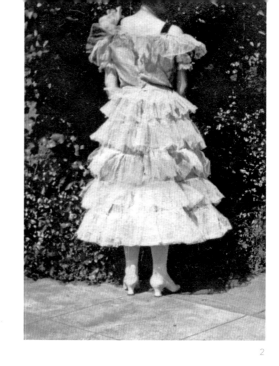

2

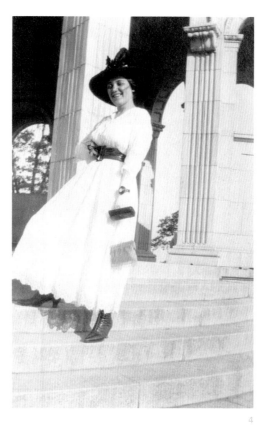

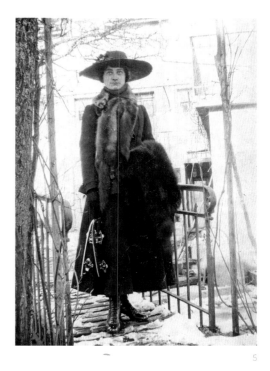

5

7

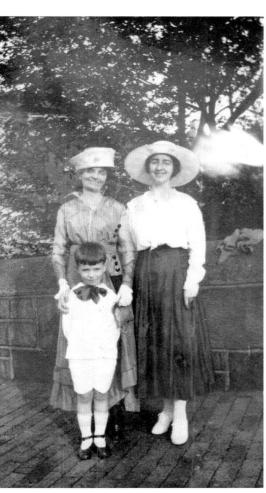

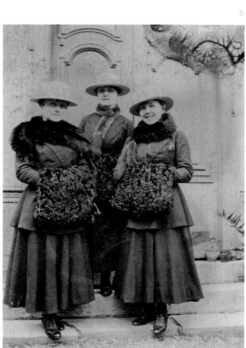

4

6

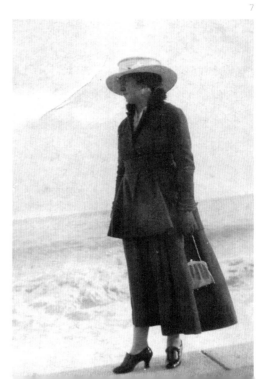

3

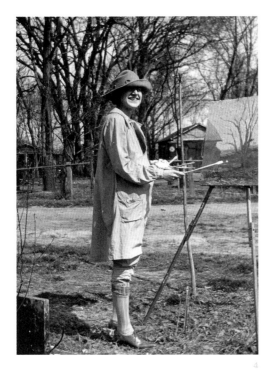

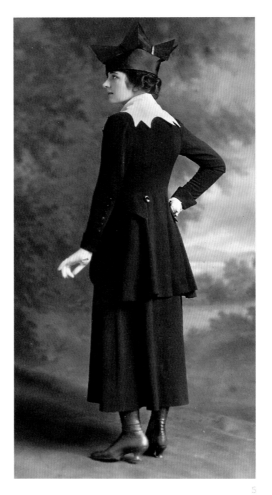

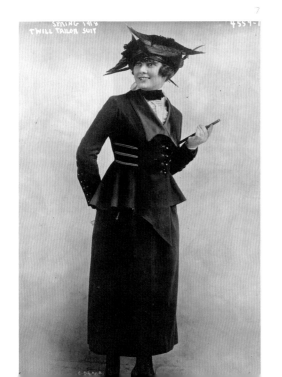

1918

Women had contributed in significant ways to the war effort and in the same year that the armistice was signed (1918), British women achieved the right to vote. (This would happen in the United States in 1920 and in France in 1944.) Reflecting this gravitas was a new daytime uniform of a tailored suit, with face flattering touches, and worn with ankle boots.

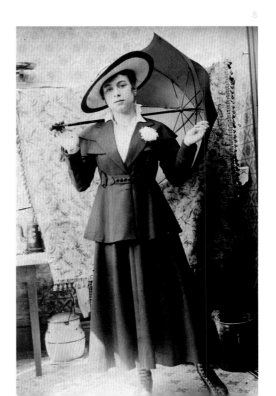

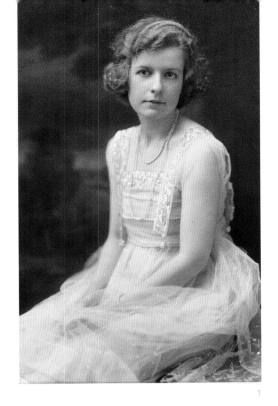

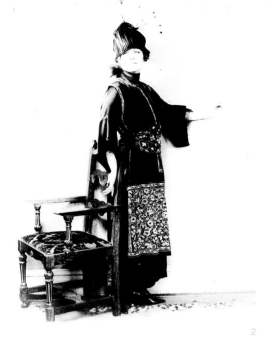

1919

Bathing costumes had become quite revealing and several dresses here display the elaborate surface decorations, in embroidery and particularly in light-reflecting sequins and beads that would characterize the coming decade. The sleeveless evening dress would be a lasting style.

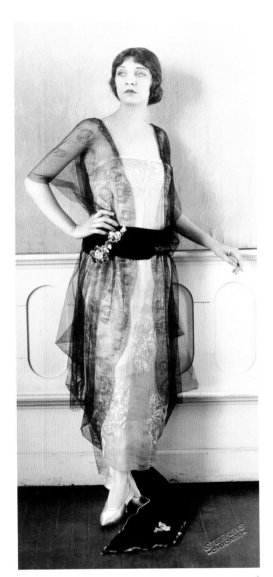

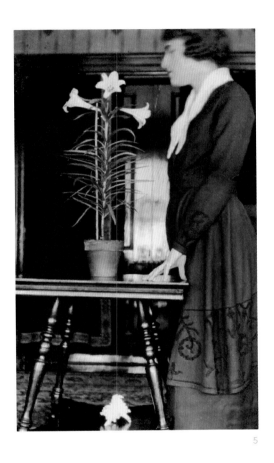

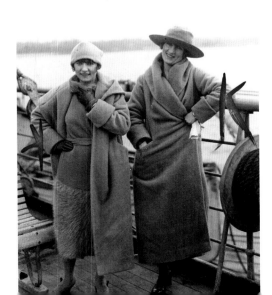

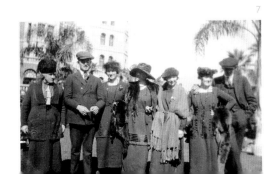

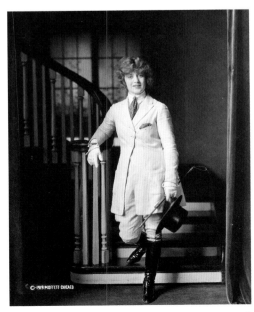

1920s

The 1920s would be synonymous with the flapper and her daring companion the garçonne—youthful creatures who relished every form of breaking with tradition. As the decade opened, however, the look was still girlish, even sweet. Dresses in organdy and lace worn here at the races are not unlike the frocks worn by little girls. Although seen as radical, bobbed hair and heavy lipstick worn in a beestung pout perpetuated this little girl air.

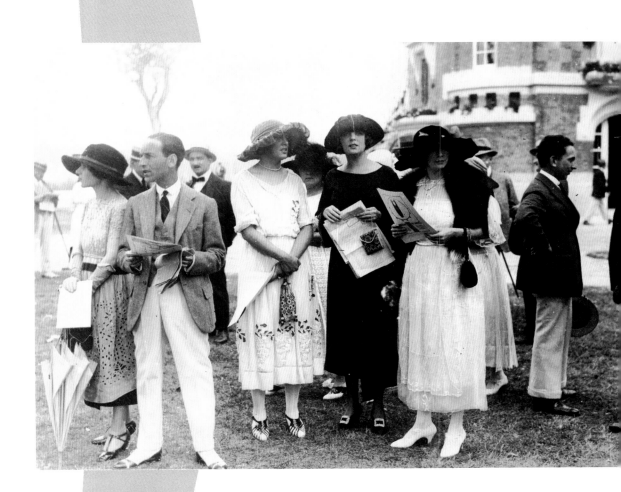

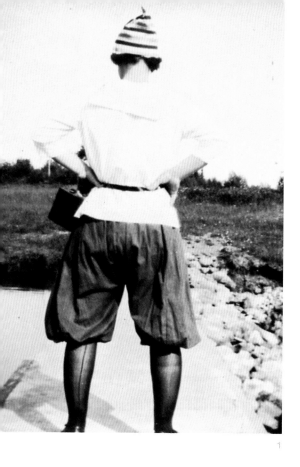

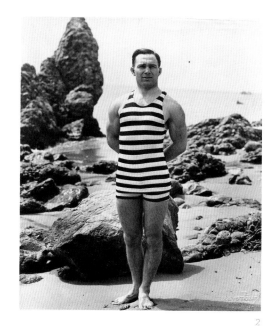

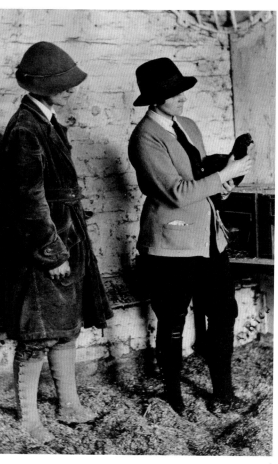

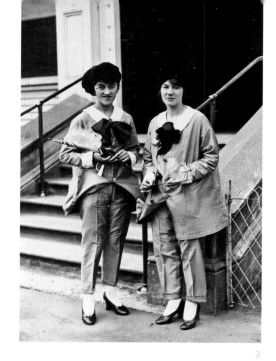

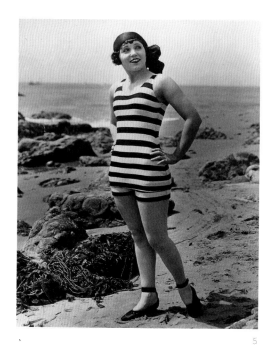

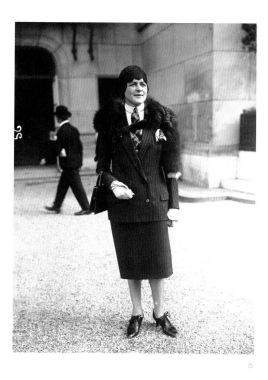

ANDROGYNY

The French word garçonne was a feminized version of the term for boy and it described both a devil-may-care attitude and a look: bobbed hair and the silhouette of flattened chest with no indication of the "natural" waist. At its highest level, androgyny meant haute couture "smokings" and pin-striped tailleurs for women (more masculine than the wasp-waisted suits worn by English Bright Young Things such as Stephen Tennant). Women were now wearing the same sort of swim suit that men had always worn—a wool jersey tank top over shorts, a short-lived similarity that would end with men legally abandoning their tops in the 1930s and women's suits becoming ever barer.

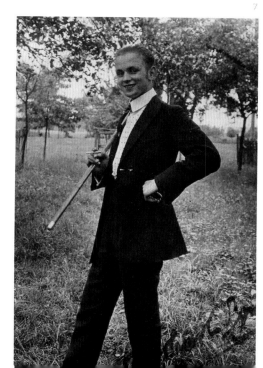

8

9

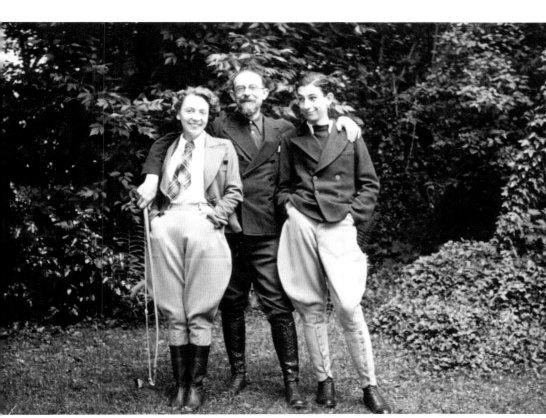

11

12

13

1920

Glamorous lesbian actress Alla Nazimova wears a diaphanous silk mousseline tea gown with metallic embroidery and a large faux pearls necklace. Stylish Rita de Acosta Lydig poses in profile wearing a high, antique lace collar—her attitude prescient of the portrait bust that would be carved in alabaster by Malvina Hoffman in 1928. An early version of what would be a 1920s basic: the little black dress is shown here (bottom left) in satin with a tunic overdress and collar of pin tucked lace from New York ready-to-wear label Rosemary. A new kind of pose (center right) is cheeky while casual.

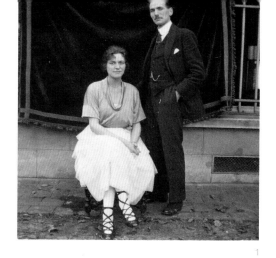

1

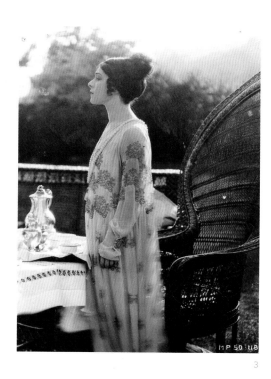

3

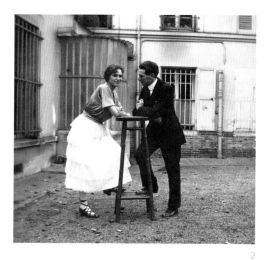

6

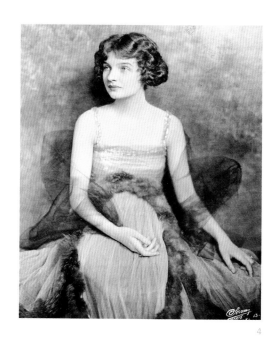

4

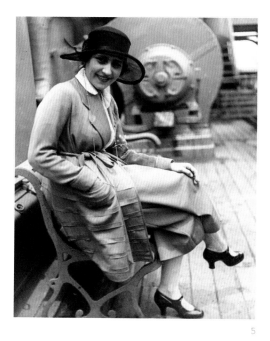

7

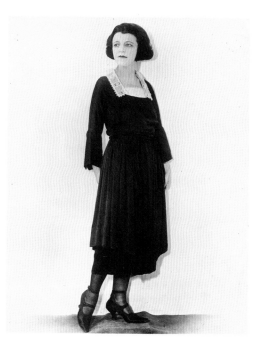

2

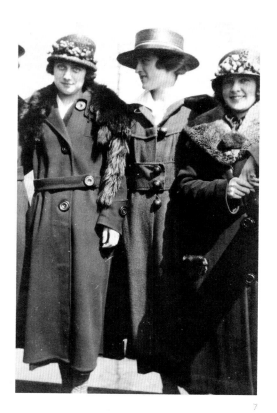

5

8

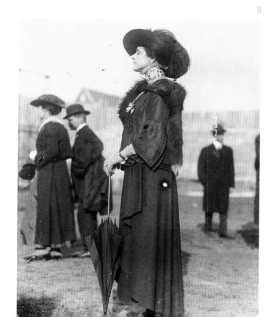

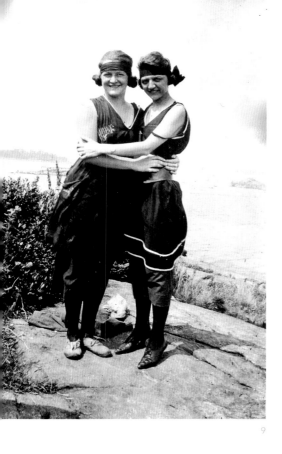

9

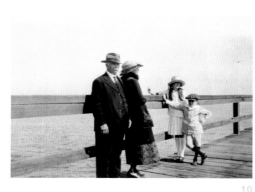

10

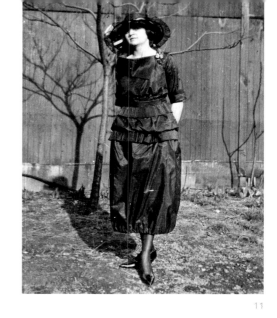

11

12

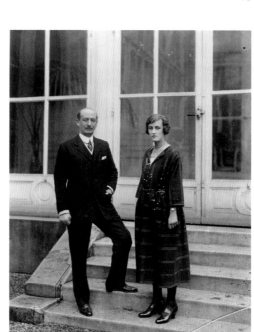

13

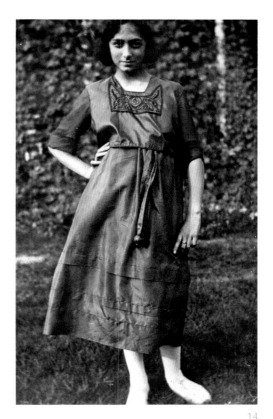

14

16

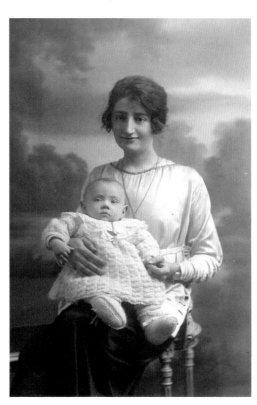

15

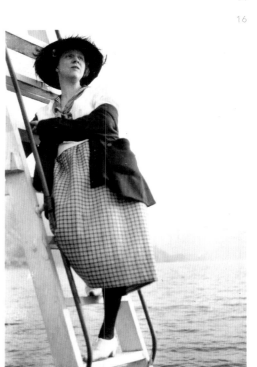

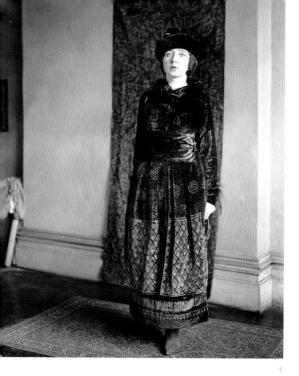

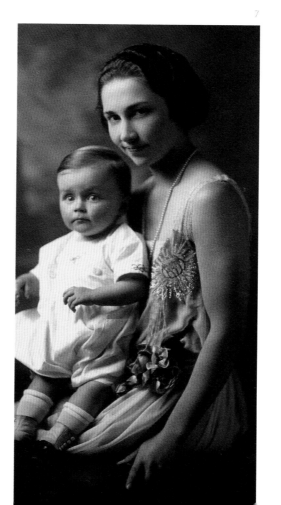

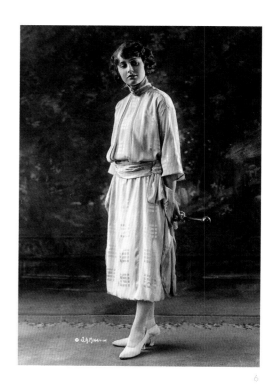

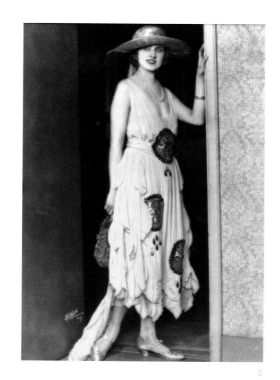

1921

Flouting convention was practically conventional during the 1920s. The homemade batik dress is an example of Bohemian dress associated with the artistic circles in New York who colonized quaint and affordable Greenwich Village. 1921 dresses featured a gently bloused bodice, a natural waist, and soft skirts with striking decorations. Poiret's afternoon frock (bottom right) is black and coral velvet.

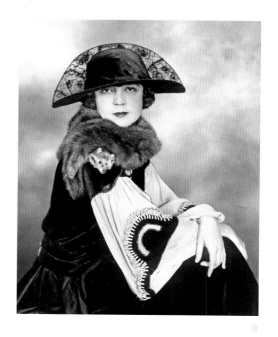

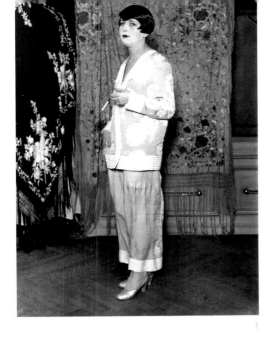

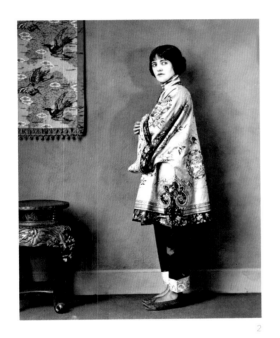

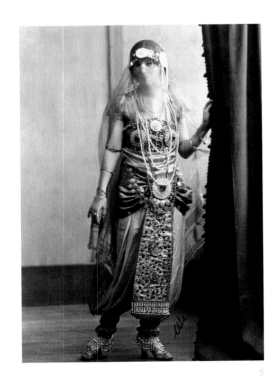

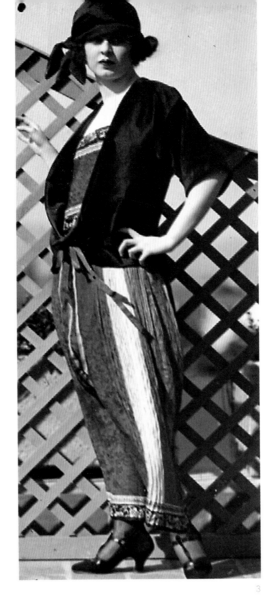

EAST-WEST

European and American women had typically worn Asian looks for fancy dress and costumes as in the two examples of Near Eastern dress shown here. The 1920s however saw actual Asian garments being adopted, as in the Chinese embroidered coat and pants worn at home, the Chinese riding skirt converted into a dress, and the sari worn by Millicent Rogers. A Chinese pajama interpreted in a modern way becomes a "smoking suit" designed in 1927.

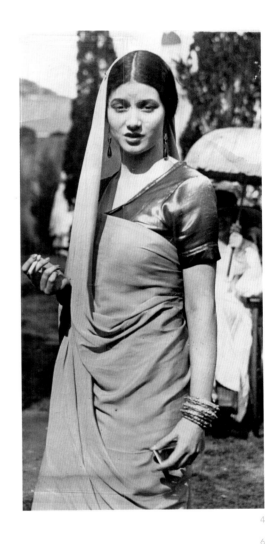

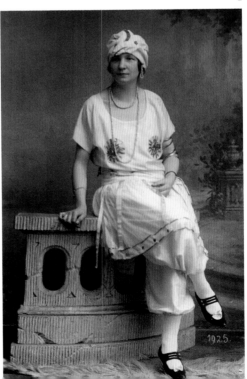

1922

Several haute couture styles shown at the races, along with a New York ready-to-wear ensemble, feature a hem that has dropped just to the top of the ankle. Melnotte Simonin, Paris (a small couture house) shows a modern and simple cape and dress ensemble in white Marocaine and navy satin. Poiret's walking costume is of jade velour, made entirely of straight pieces of material worked with folds, and Mayer of New York presents a three-piece ensemble of black matelasse trimmed with white caracul and Native American inspired beaded fringes.

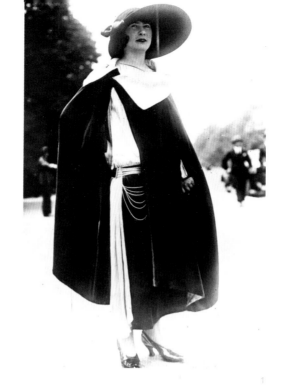

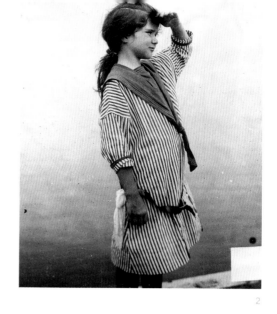

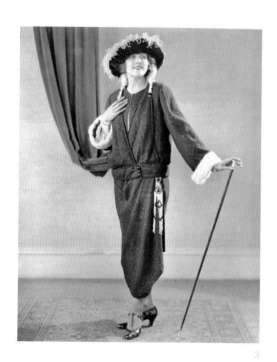

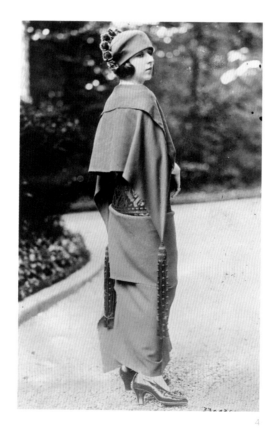

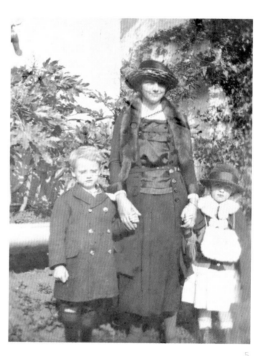

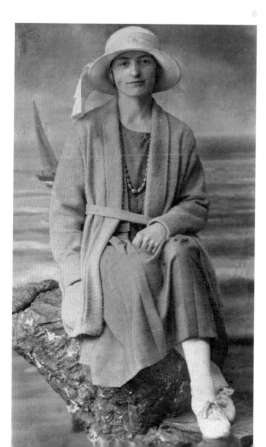

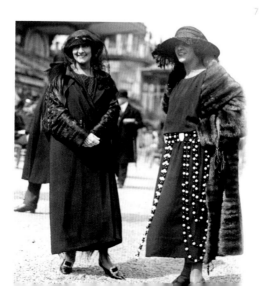

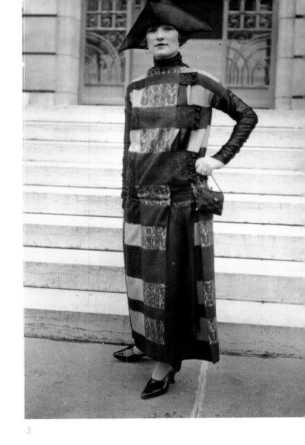

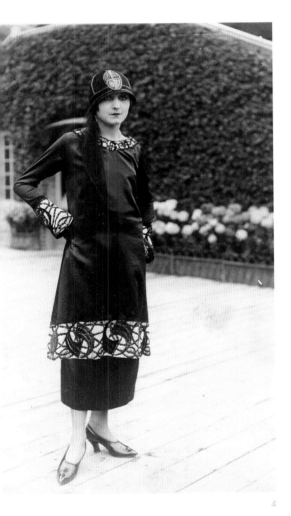

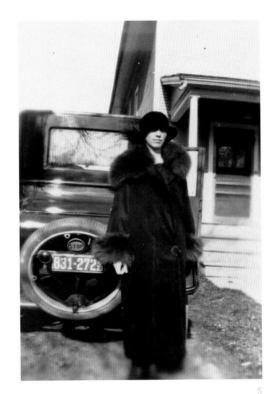

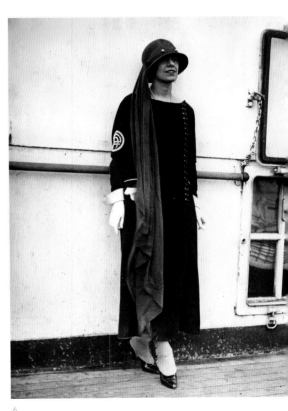

1923

Geometric and modern designs would acquire the nickname Art Deco (attributed to le Corbusier) after the 1925 Paris Exposition des Arts Décoratifs. Examples seen here include the plaid-effect dress composed of overlapping bands of opaque silk and transparent lace, the tunic dress with borders of what looks like stylized sails, and the Jean Patou monogram adorning the sleeve of a dress worn by best-dressed American Peggy Hoyt.

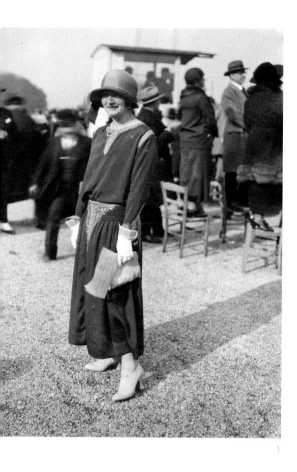

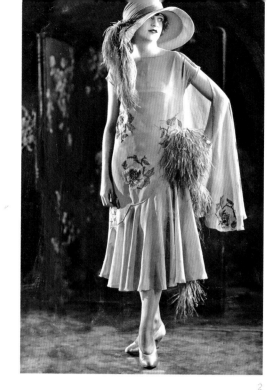

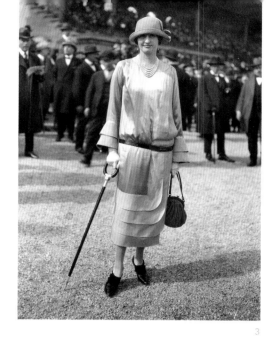

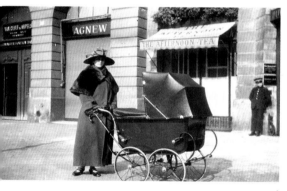

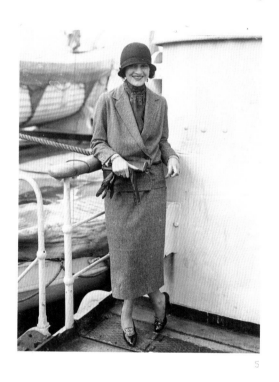

1924

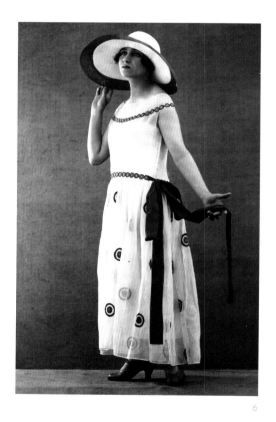

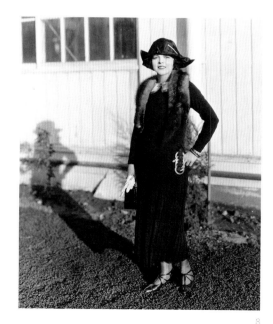

A variety of waistlines are seen here, with most hemlines still just above the ankle. At the races, silk dresses with embroidery reminiscent of a peasant blouse and dresses with geometric with lines are seen. One fashion model wears a dress with floating sleeve and bias cut skirt set in at a slanted scalloped line while another wears a Lanvin full-skirted robe de style—a style for which couturier was particularly known—shown here in white organdy trimmed with concentric circle appliqués.

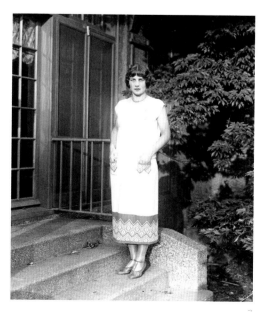

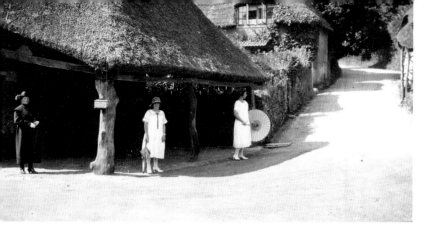

1925

F. Scott Fitzgerald's 1922 collection of short stories, *Tales of the Jazz Age* provided a terrific unofficial title for a decade shaped by a frenzy for music, especially the "new" music from vibrant Harlem and most especially music for dancing. Radios and record players made for dancing anywhere, anytime. Beaded chemise dresses, especially ones with moveable parts like fringe and handkerchief panels, were just the thing for popular moves like the Charleston.

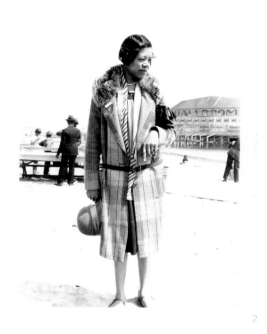

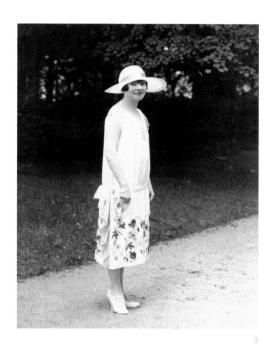

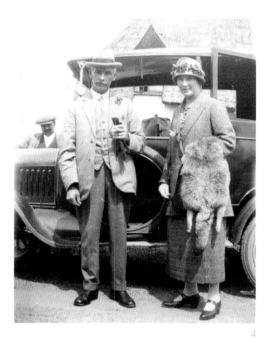

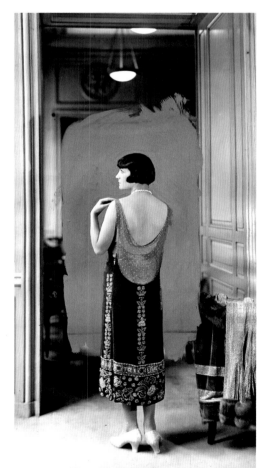

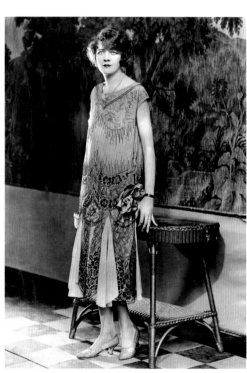

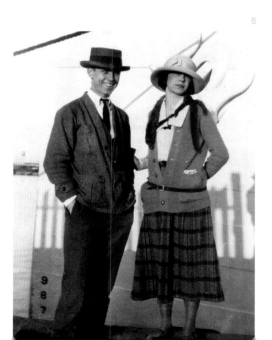

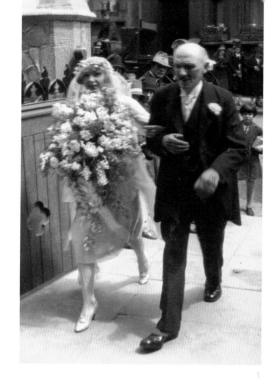

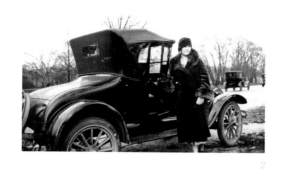

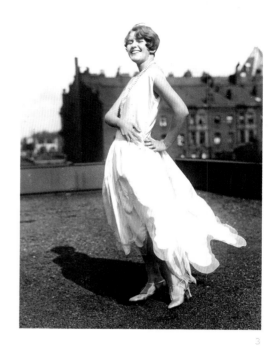

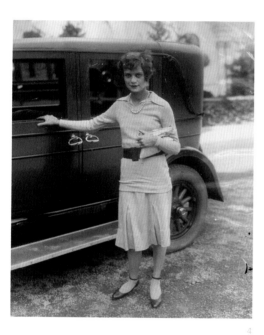

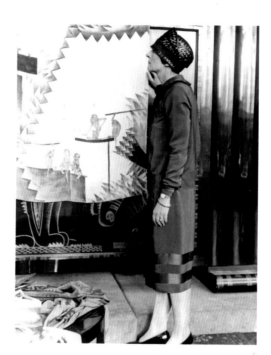

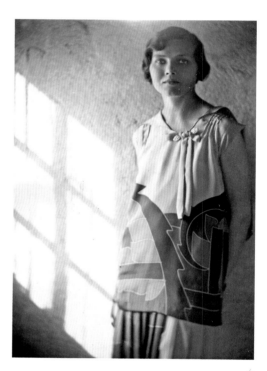

1926

A bride dashes to church; Nancy Hale (future novelist) of Boston smiles bravely despite wearing a detested robe de style by Hickson; a fashion editor poses in front of lacquer artist Jean Dunand's new work on silk, wearing a chemise frock by Lucien Lelong; an avid Communist authority Ruth Epperson Kennell fittingly wears a design by Russian expat artist Sonia Delauney; the most glamorous tennis player in the world, Helen Wills, practices sketching wearing her usual favorite Jean Patou; a socialite is captured at chic resort White Sulphur Spring wearing pearls with the popular sports costume of pullover and pleated skirt.

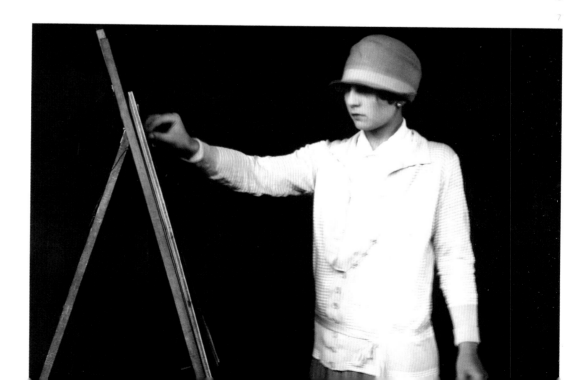

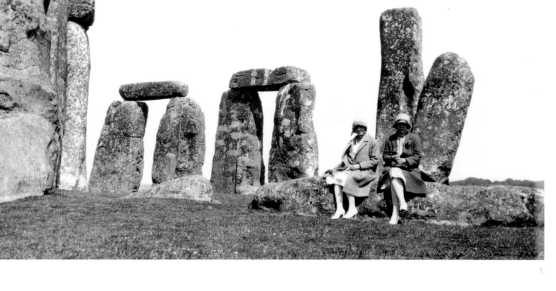

Sporty ensembles include coats with linings that match what was worn underneath, as in the brown and white example by Jeanne Lanvin shown bottom right, and the striped coat with striped pullover worn at the races. Two young ladies wear leather coats to model in a charity fashion show in Greenwich, Connecticut, and Mrs. Freda Dudley Ward, society beauty, sports a Bretonne top—not unlike one worn by her former lover, the Prince of Wales, when yachting.

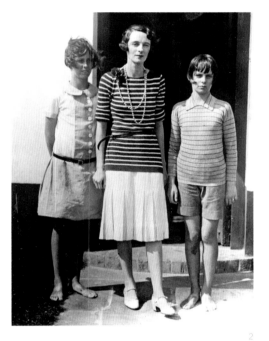

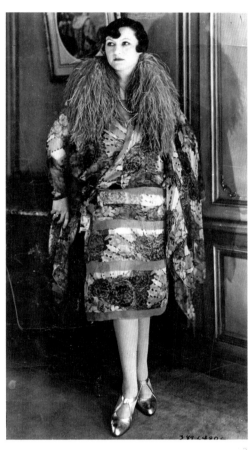

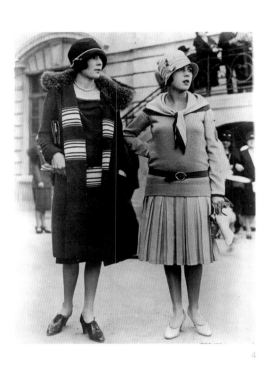

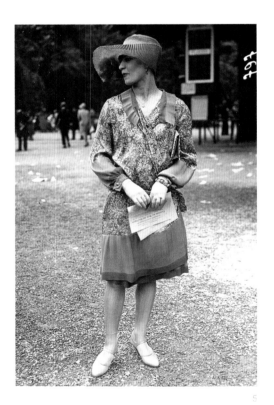

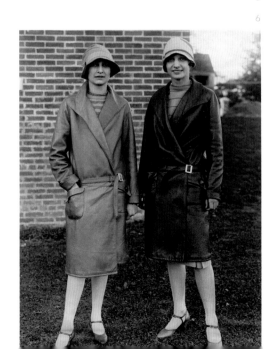

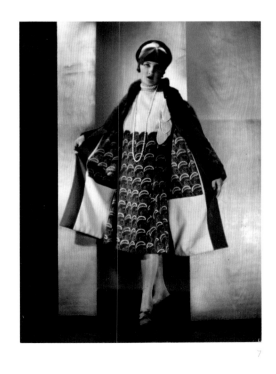

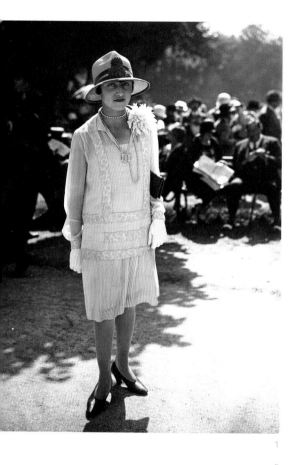

2

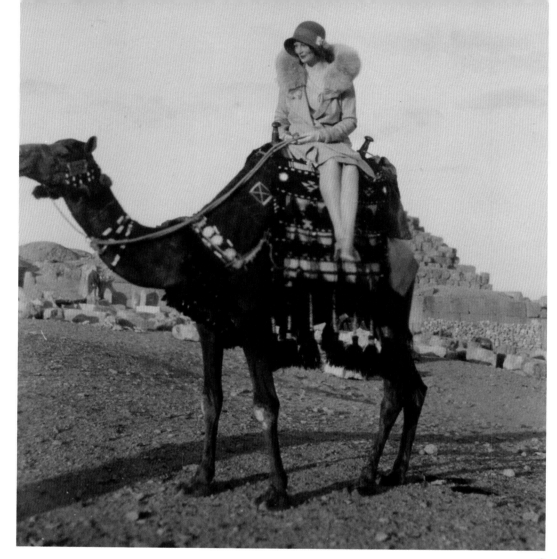

1

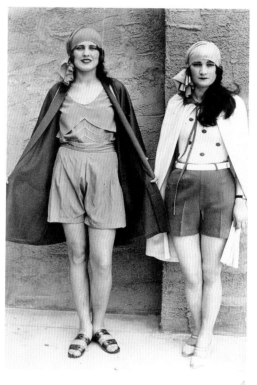

3

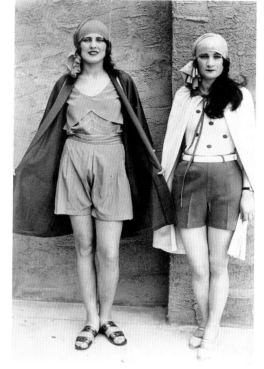

4

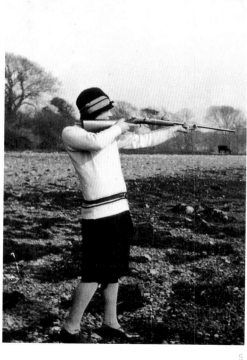

5

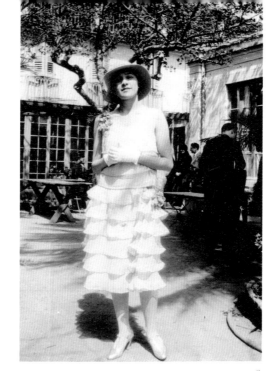

1928

Two quintessential styles of the 1920s: gamine silk dress with white collar and the fur-trimmed coat; examples of the latter here include one worn touring in Egypt, while the leopard coat with sable trim is captured near a car with Wisconsin plates. Hemlines for formal clothes are definitely longer. The wedding dress in silk lace has a hem dipping in back to the floor mirrored by the hemline of the bolero. A new fluttering of the skirt is seen in the tiered dress in white and in the mousseline afternoon dress worn with a wide brimmed straw hat by the wife of the Japanese naval attaché.

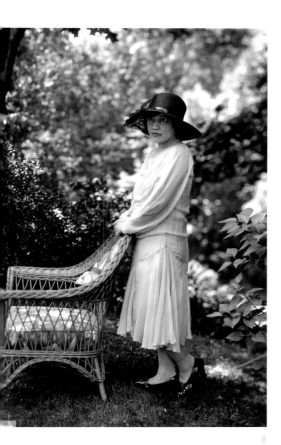

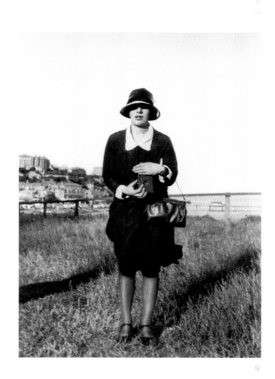

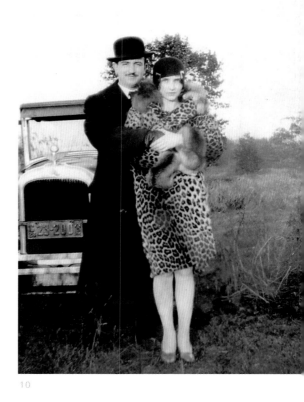

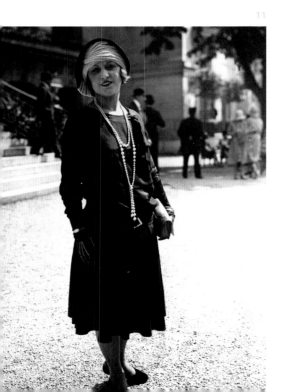

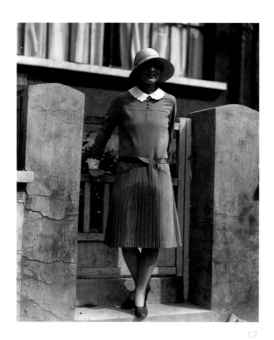

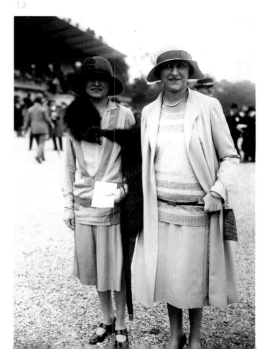

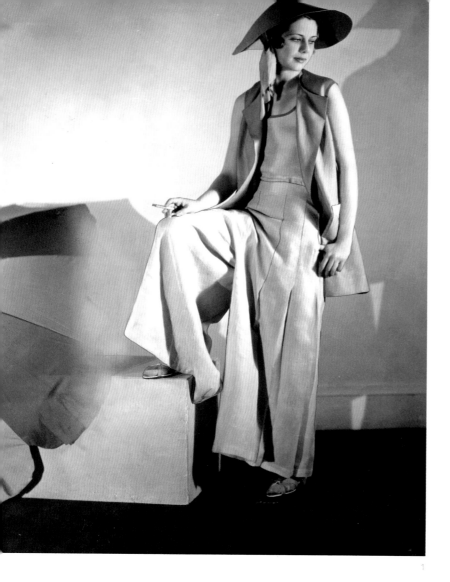

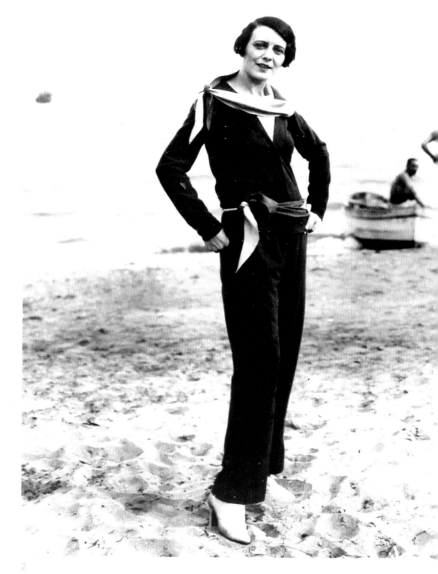

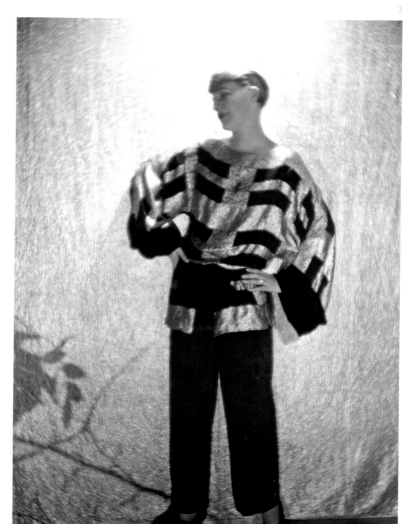

BEACH
AND OTHER
PAJAMAS

Beach pajamas were soft—as opposed to tailored—
pants styles worn first for yachting and promenading
along resort boardwalks; they were then adapted
rather quickly for cocktails and informal dinners.
The beach pajama succeeded where the jupe-culotte
of the teens failed, providing the thin end of the
wedge for wearing pants in public. Here is an ensem-
ble in orange, melon, and lime yellow linen by New
York ready-to-wear label William Bloom. A navy
flannel pajama with two scarves is modeled at the
Lido and evening style "Fonceur" in lamé by Parisian
couturier Lucien Lelong is worn by a model with
unusually short hair for the time.

1929

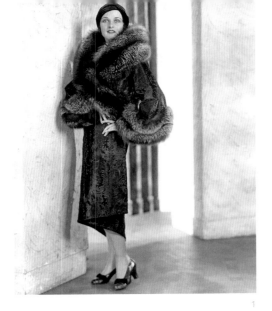

In 1923, American expats Sara and Gerald Murphy rented out the closed-for-the-season Hotel Du Cap in Antibes to live in while their nearby villa was being renovated. Their habit of spending the whole day at the beach, exercising, and sunbathing spread throughout their artistic and fashionable milieu, and soon suntans were the latest thing. Accordingly, bathing suits and evening dresses become more décolleté. Helena Rubinstein debuts new face powders to complement tanned skin, and the white evening dress is popular—examples shown here: two with uneven hems are by Paris couturiers Drecoll-Beer, Lucien Lelong, and Lucille Paray.

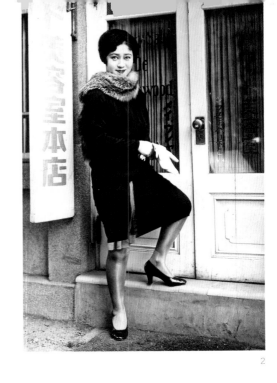

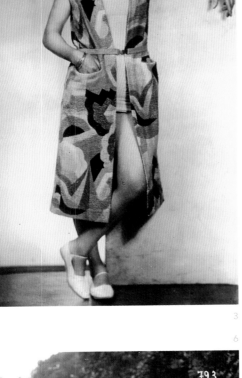

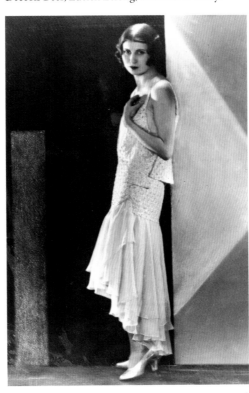

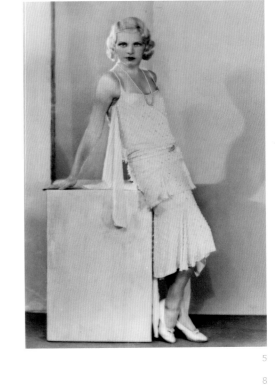

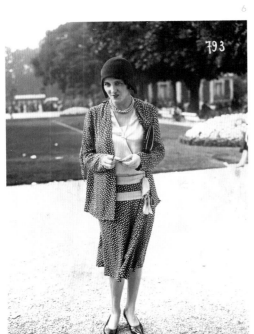

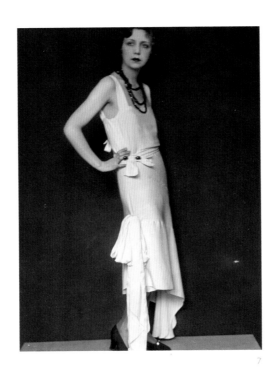

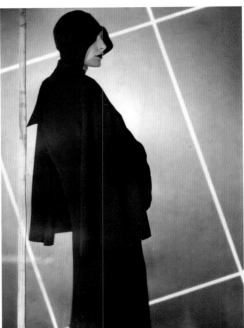

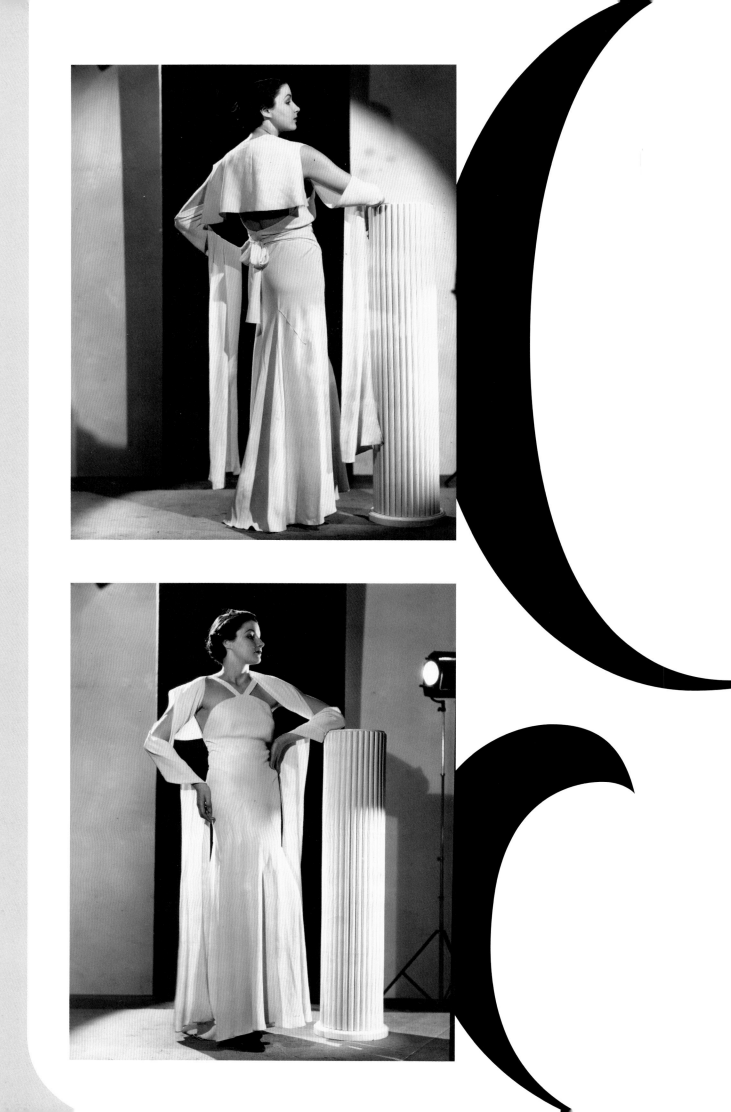

1930s

The 1930s open with a silhouette that is long, lean, natural, and unshaped by major underpinnings. Aspects of modernism such as geometric lines and streamlined simplicity first seen in the 1920s are now found in seams and construction details. Restrained elegance reflects the general sobriety of the Great Depression while glamour provides escape as Hollywood movies become increasingly polished and fascination with the goings-on of celebrities and high society rises.

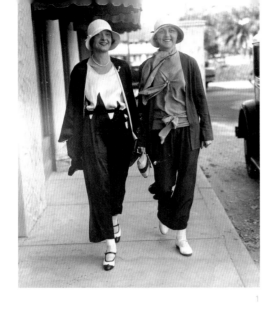

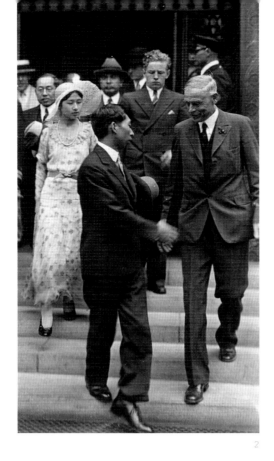

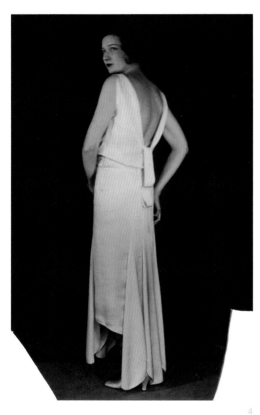

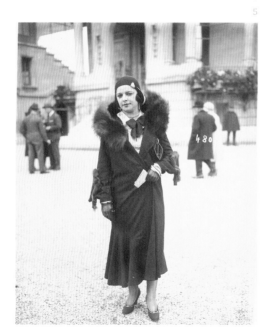

1930

Cloche hats and fur-trimmed coats are still favorites, worn here joy-riding in a rumble seat and at the races at Longchamps. The pajama can now be seen strolling the streets of Palm Beach or listening to the gramophone, and Jean Patou uses the newly invented zipper pull on a suede golf blouson. The sporty ensembles with pleated skirts of the 1920s have been supplanted by more grown-up tailored suits with long narrow skirts, as in the spring suit from the French couture house of Redfern of blue and white tweed in a diagonal stripe, simply cut. The hat is of matching blue felt and the bag of the same material as the ensemble.

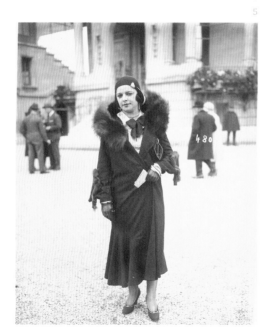

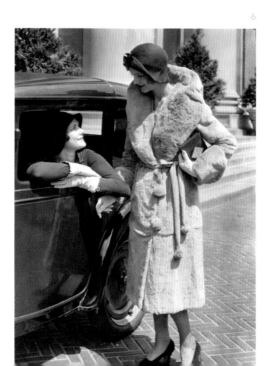

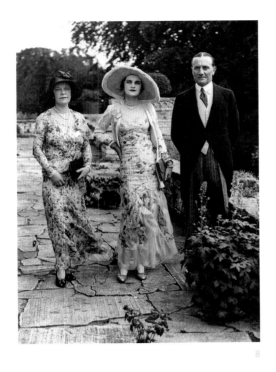

8

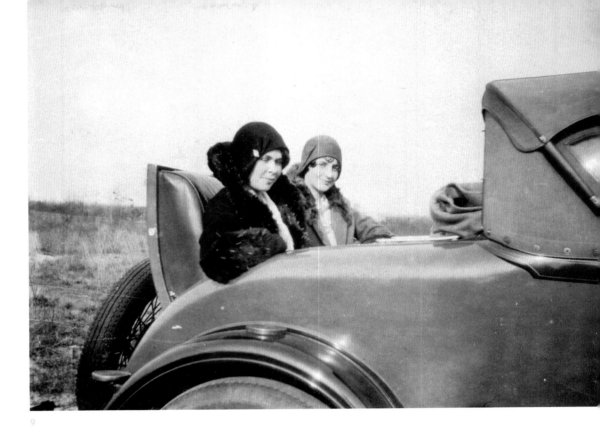

9

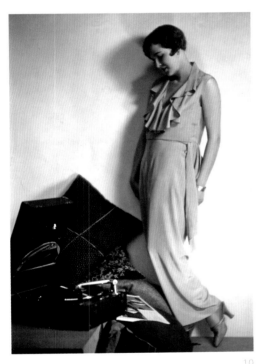

10

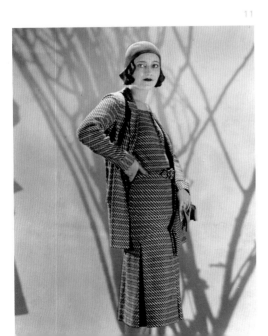

11

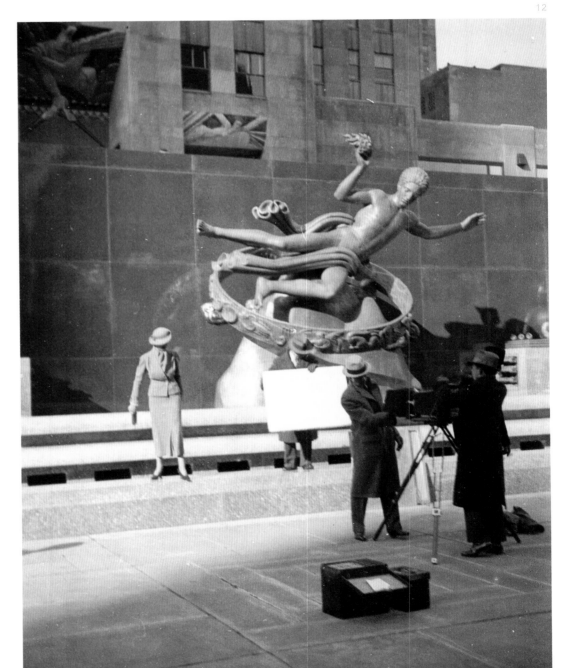

12

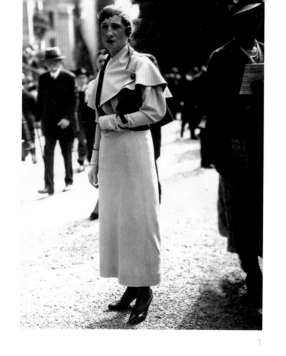

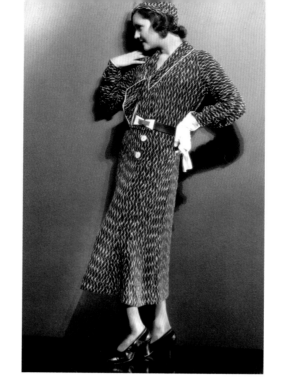

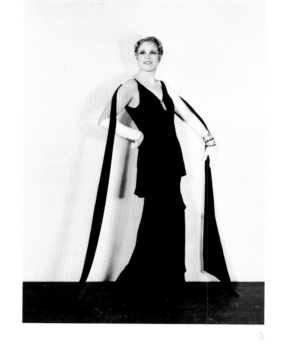

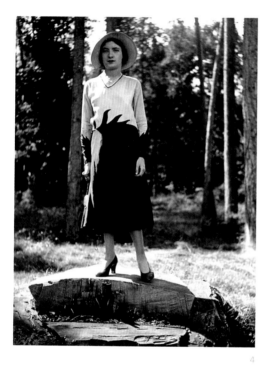

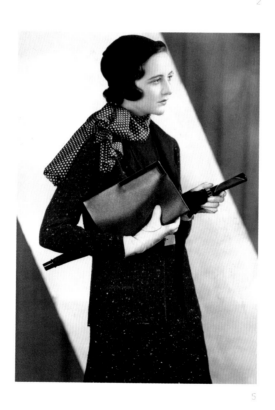

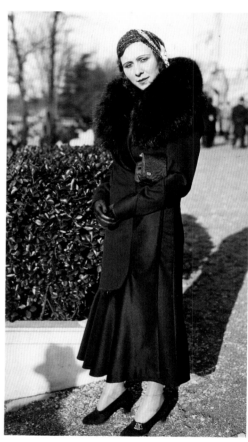

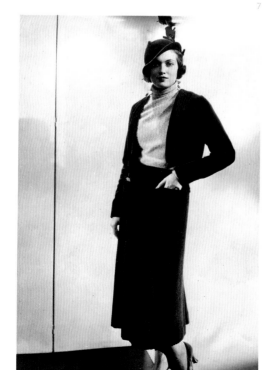

1931

The cloche has disappeared and now hats hug the head and are worn at a distinct slant. New York custom designer (and future rabble-rouser) Elizabeth Hawes designs a suit in brown corduroy with a yellow angora blouse for wear in the country. Hostess gowns have taken up where tea gowns left off and are worn for intimate dinners at home. Here, an example in pale pink lace is from top New York specialty shop Jay-Thorpe.

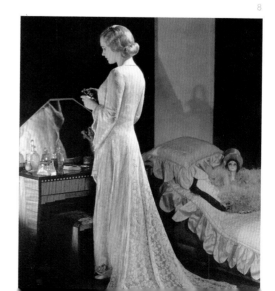

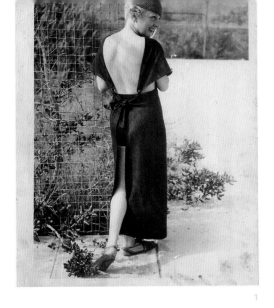

SPORTS CLOTHES

Relaxed attitudes about undress at the beach have changed most sportswear for the sexier. Backless necklines, one-shouldered, camisole necklines, and bare midriffs all came into play. Actress Lilyan Tashman wears a haute couture beach ensemble which includes a backless bathing suit with apron cover-up open in the back, with flat espadrilles and knit cap.

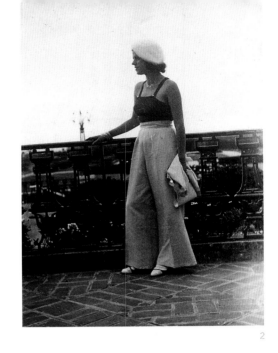

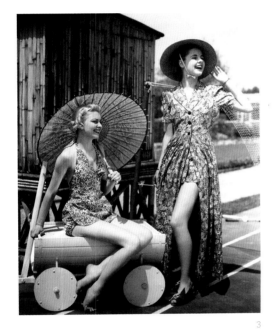

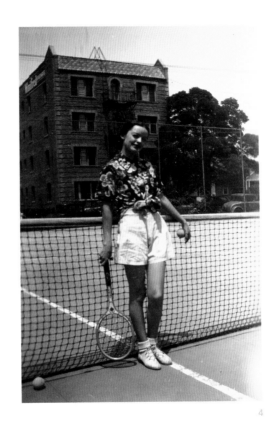

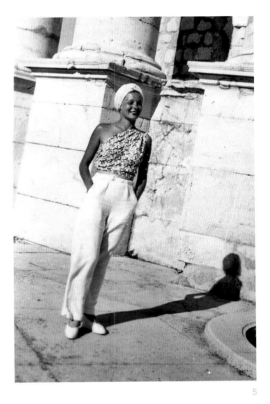

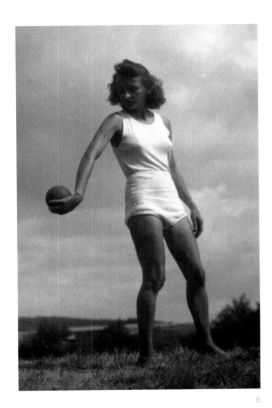

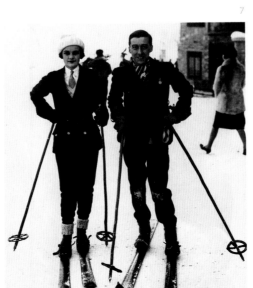

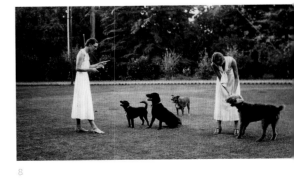

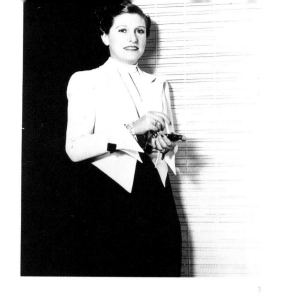

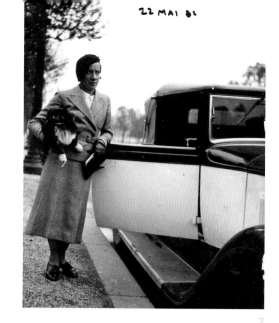

22 MAI 31

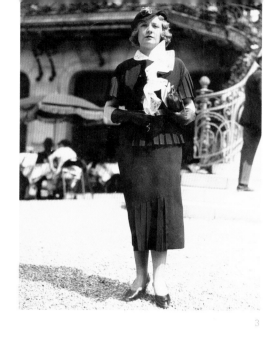

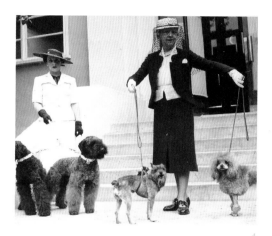

STRICTLY TAILORED

The tailored suit with long, narrow skirt and short fitted jacket was a mainstay for chic 1930s women. For a Paris dog show, Elsie de Wolfe wears a black suit with white vest similar to the Chanel best-selling example in black moiré with vest of white silk piqué. Evening adaptions of men's attire include American designer Sally Milgrim wearing an ensemble based on a mess jacket. French musical comedy star Odette Myrtil wears a "smoking" skirt suit with—in lieu of a bow tie—a diamond and cabochon double clip brooch and carnation boutonnière.

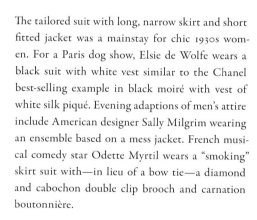

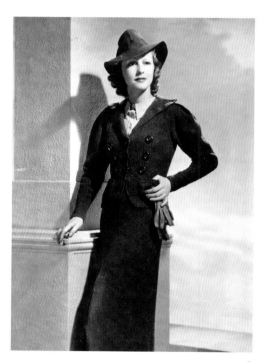

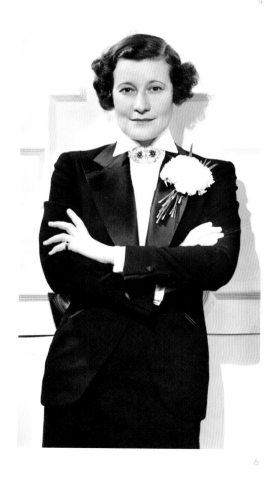

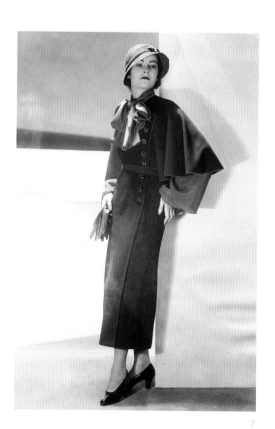

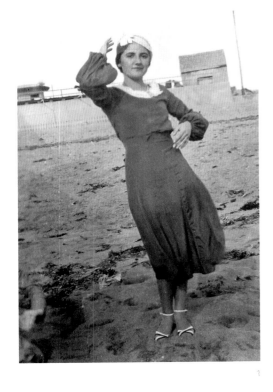

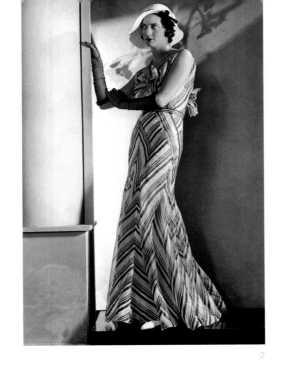

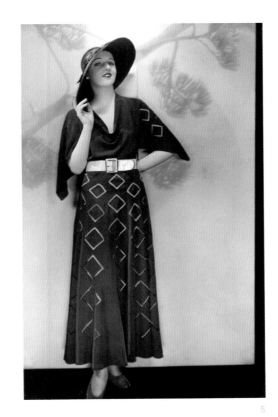

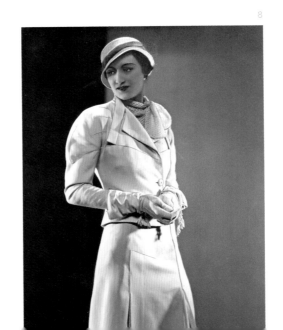

1932

Shown here: Chanel summer evening dress in striped cotton organdy, worn with mesh gloves and a straw hat; Lanvin dinner frock "La Coupole," of black marocain with diamonds cut-out sewn to tulle; wide brimmed hat of black straw with a black peau d'ange ribbon; and dress with ruffled sleeves no doubt inspired by the one worn by Joan Crawford in the 1932 film *Letty Lynton*.

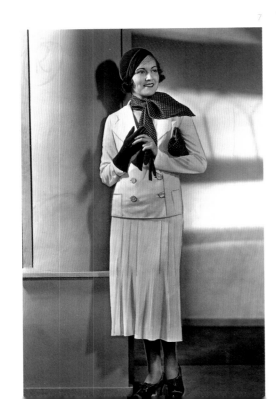

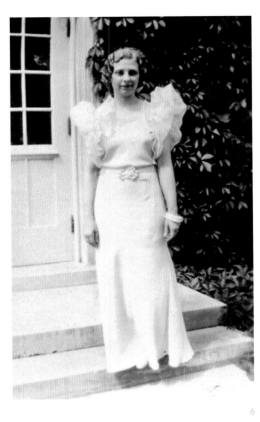

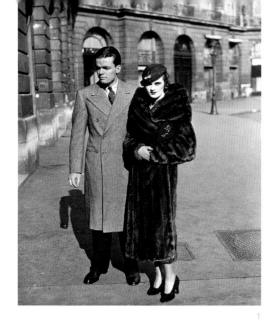

1933

At the height of the depression, the public was captivated by details of one of the grandest of society weddings: traffic slows to a halt for three hours as crowds gather to catch a glimpse of Margaret Whigham who weds Charles Sweeny at the Brompton Oratory wearing a Norman Hartnell white satin wedding gown made in medieval style, embroidered with star shaped flowers outlined in pearls. The dress took thirty-three seamstresses six weeks to make and cost fifty-two pounds, a sum the bride apparently found exorbitant. The sleeves fell to the floor, and the matching veil was held in place by a circlet of wire strung with pearls and wax orange blossoms.

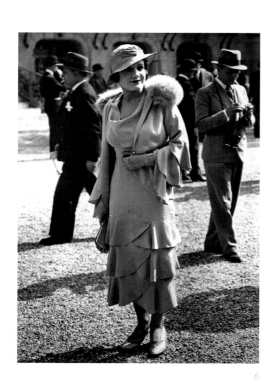

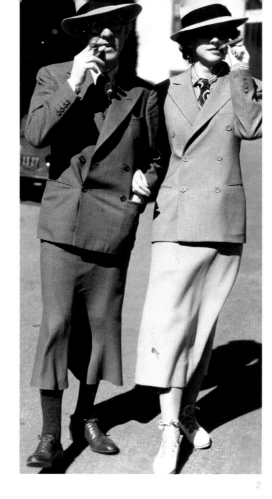

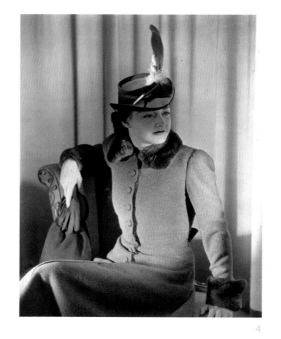

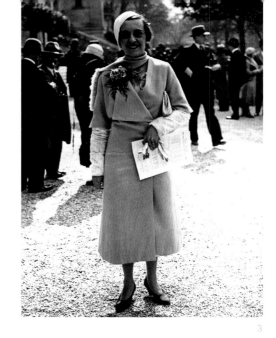

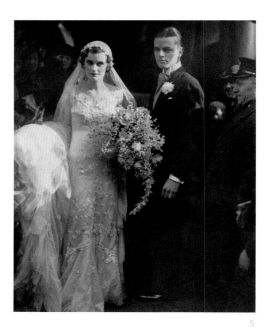

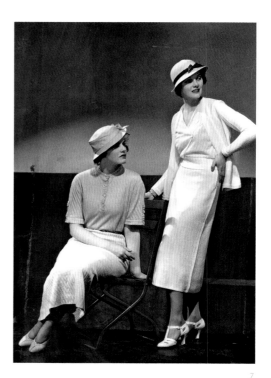

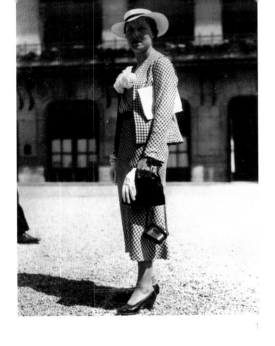

1

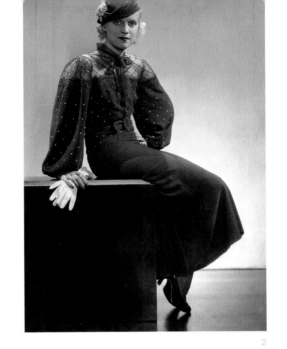

2

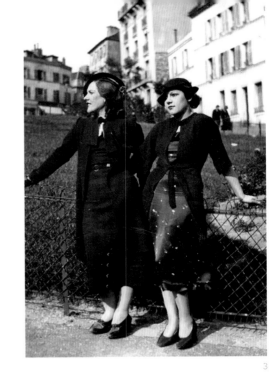

3

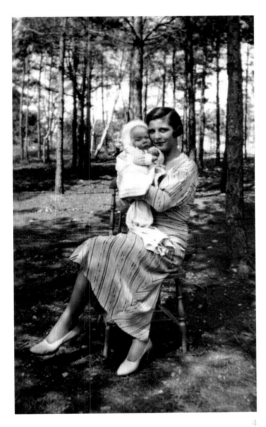

4

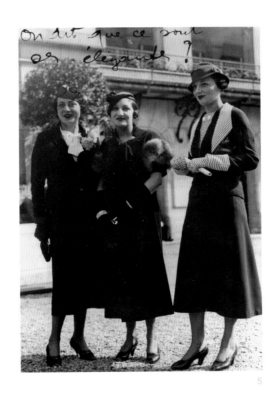

On dit que ce sont si élégante!

5

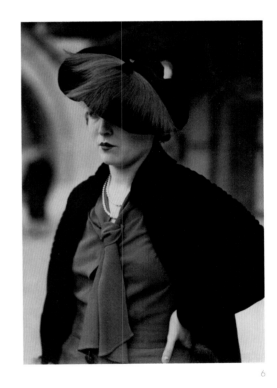

6

7

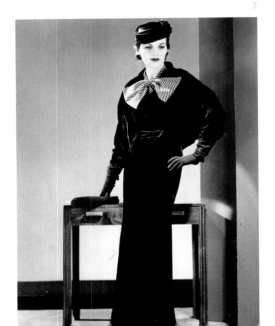

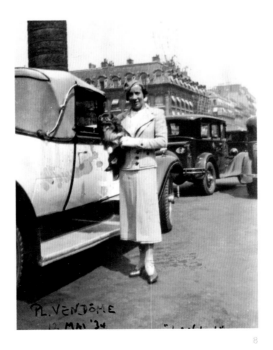

PL. VENDÔME
12 MAI '34

8

1934

Several smart tailored suits are seen at the races and are accessorized with hats and gloves, neat handbags, and simple pumps. A dress in one of DuPont's new rayon materials, called Shangola rayon crepe, shown top, center. A woman poses in the Place Vendome inscribing on the photo that her suit is by Lanvin.

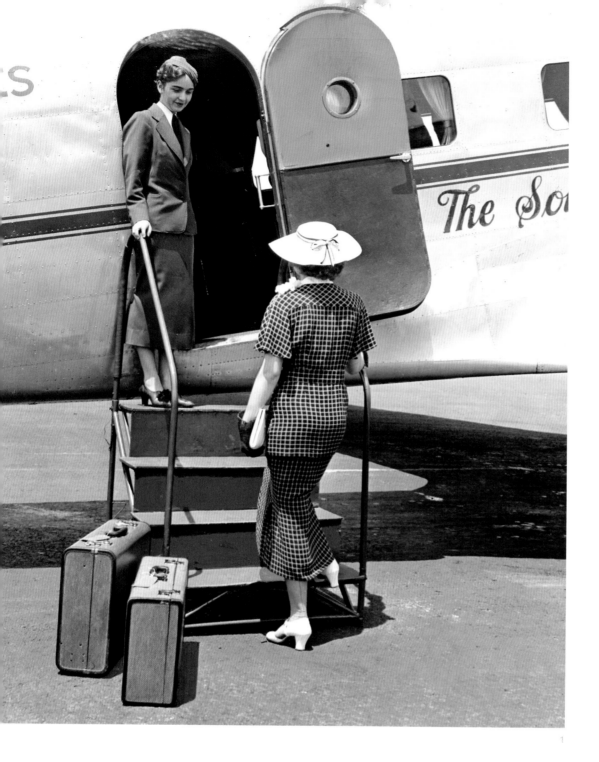

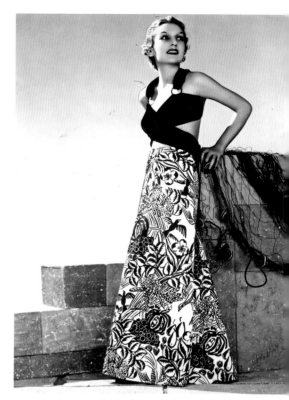

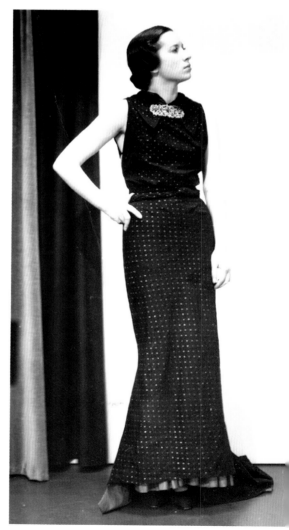

1935

Travel by air is on the rise, a stewardess wears a professional suit complete with neck-tie, and the traveler, heading to a warm climate, is dressed up for the occasion in a grid plaid silk dress, hat, gloves, seamed stockings, and pumps. The daringly bare evening dress, "Pirate," is by couturier Jacques Heim and features a skirt of linen printed with the Raoul Dufy design "les fruits d'Europe" in green and white. At his couture house in Paris, American born Mainbocher is shown with a vendeuse and two models wearing dinner styles—a metallic and specialty crepe jacket over long black dress and specialty crepe dress with draped wrap.

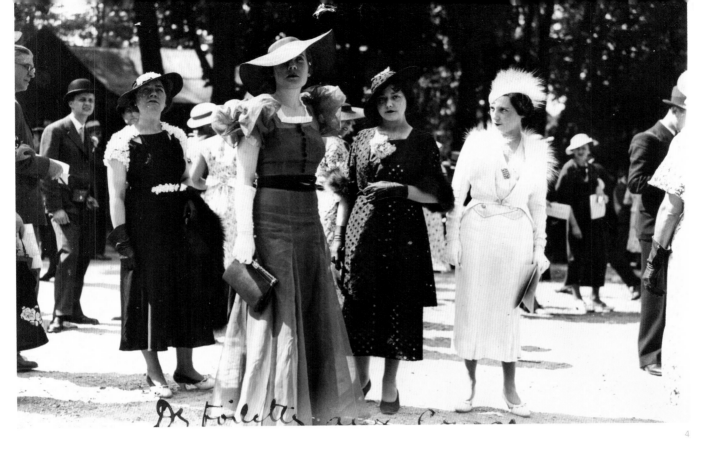

De toilette aux Courses

4

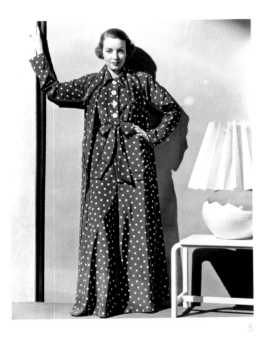

5

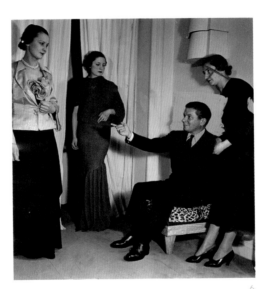

6

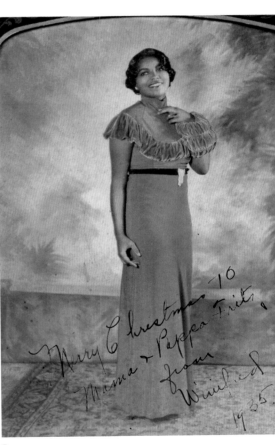

Mery Christmas To
Mama & Pappa Fritz
from
Winifred
1935

7

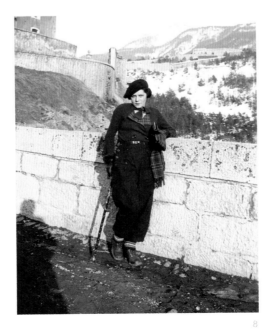

8

1936

Attention is being drawn to the waist in a black wool afternoon dress by Jean Patou with modified gigot sleeves and linen collar; the high-waisted skirt of one of two looks modeled at Rockefeller Center and an afternoon ensemble by British born Paris couturier Molyneux in brown silk with white floral appliqué and diamond grid dress worn with a leather belt, sheared fur coat, tilted beret, and spectacles.

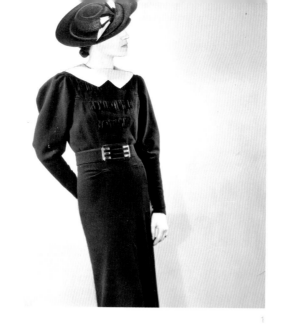

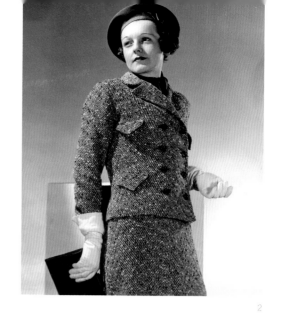

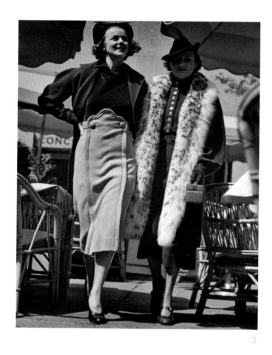

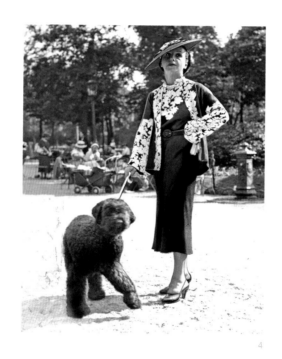

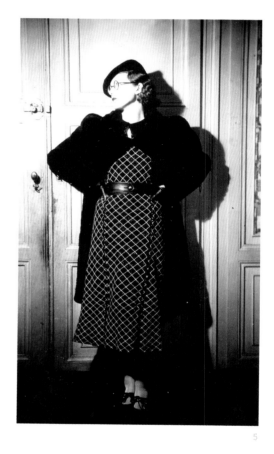

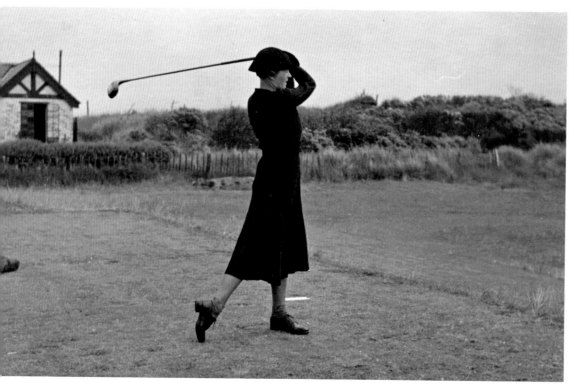

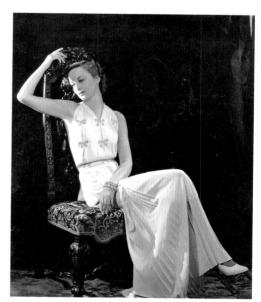

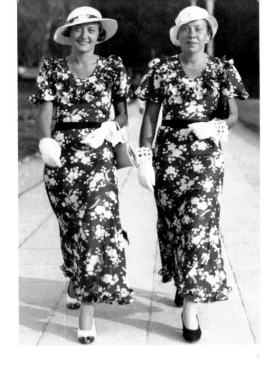

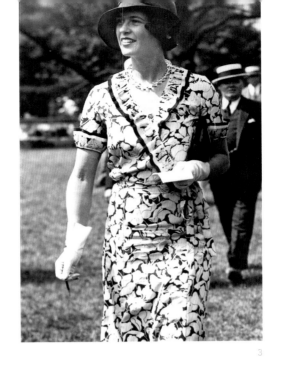

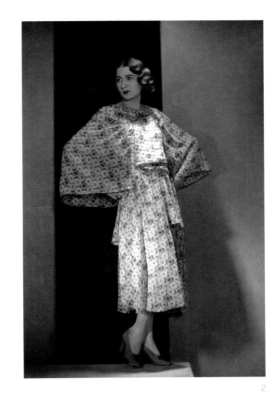

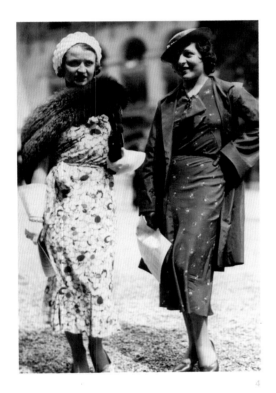

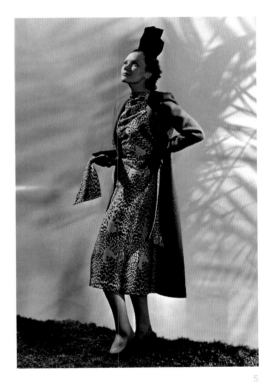

LITTLE PRINTS

Made of silk or the new rayons, print dresses had the depression era virtues of being practical and economical. Examples here include floral print silk dresses with puffed sleeves and self-ruffled hems worn with gauntlet gloves, a formal afternoon ensemble by Paris couturier Louiseboulanger in red, green, and ivory sheer silk, a floral print silk dress with finely pleated self ruffle, and an ensemble by Paris couturier Marcel Rochas—the coat in off-purple wool lined with the same brown and white leopard printed crepe as the dress underneath.

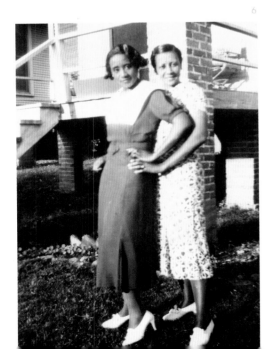

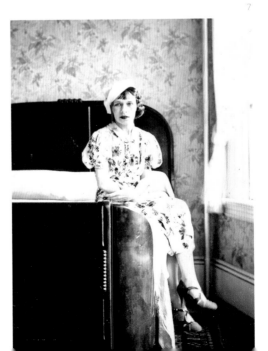

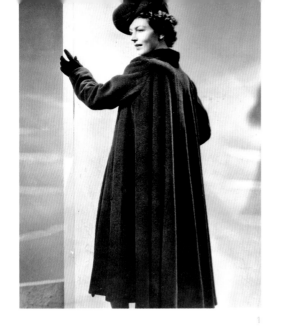

1

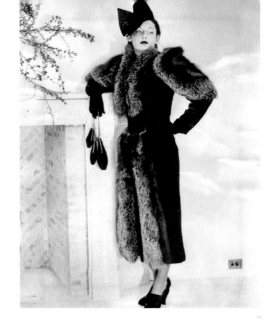

2

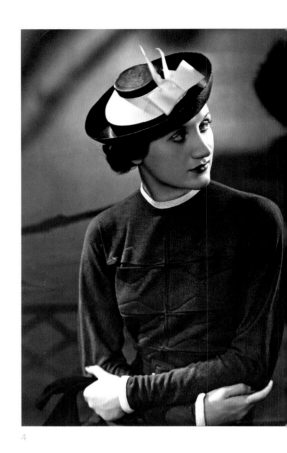

4

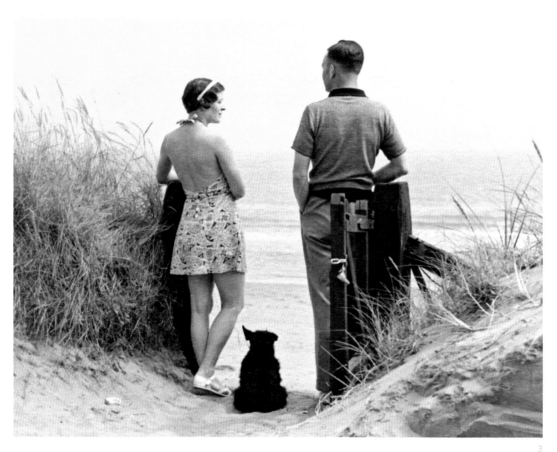

3

5

6

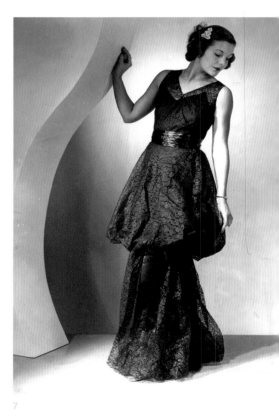

7

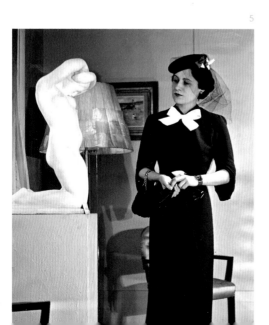

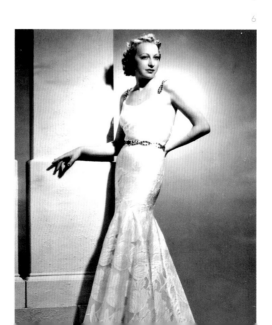

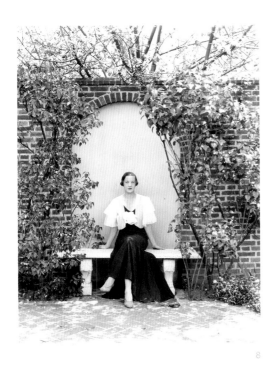

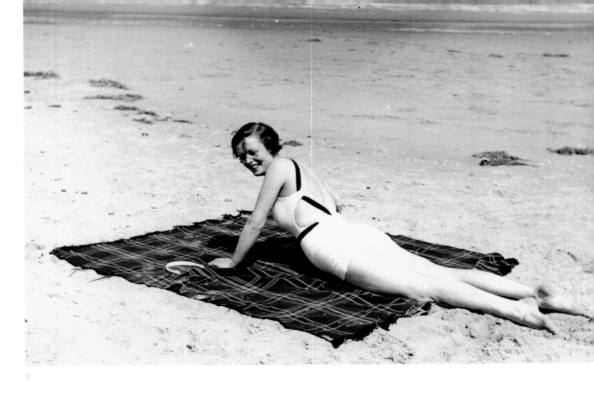

8 9

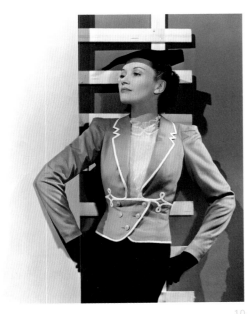

10

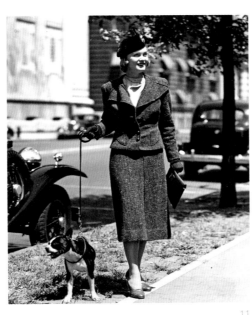

11

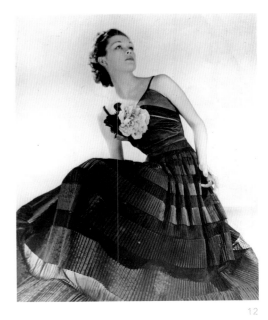

12

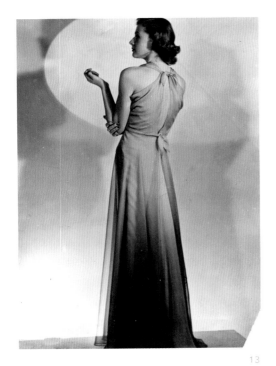

13

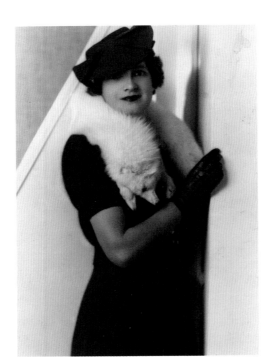

14

1937

The silhouette is shifting. A coat by Francevramant reveals a new fullness in dark green plush wool while a coat by Maggy Rouff is made in black corded silk coat lavishly trimmed with silver fox emphasizing the shoulders. Evening gowns in new shapes include: a black lace dress with bubble overskirt from Balenciaga—a couturier from Spain newly transplanted to Paris—and Germaine Lecomte's evening dress in white floral lace with wide flared skirt.

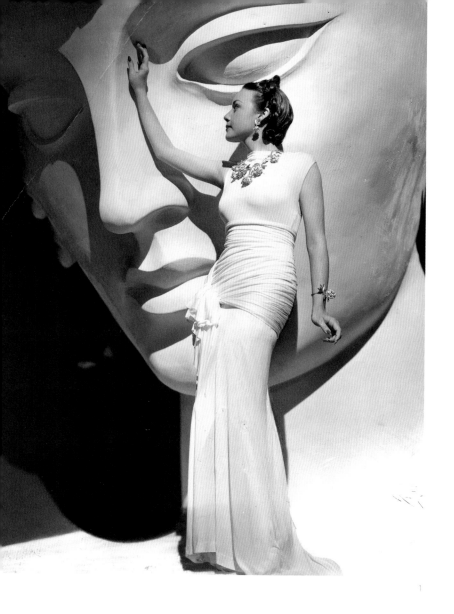

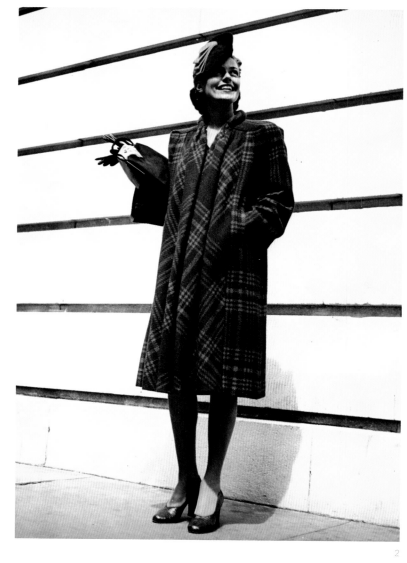

1938

Balenciaga designs a bold striped evening gown, and it is worn by his favorite model, Colette. Tailored styles include: a plaid coat with broad shoulders from Lord & Taylor and a plaid suit from R. H. Macy & Co. Along with a new sense of volume, more drapery emerges: evening dresses in draped white silk jersey by Alix (Mme. Gres), an early example of a strapless dress—this one in emerald green velvet by Jean Patou—and an American ready to wear designer Claire McCardell's white evening pajamas.

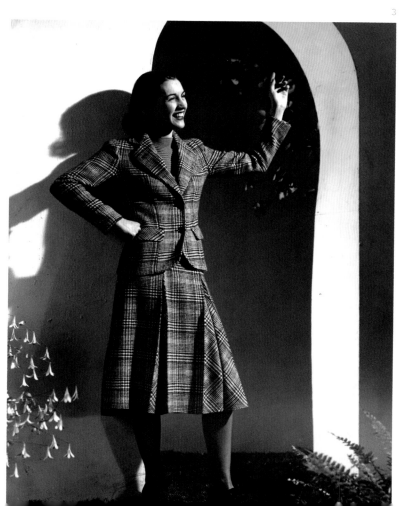

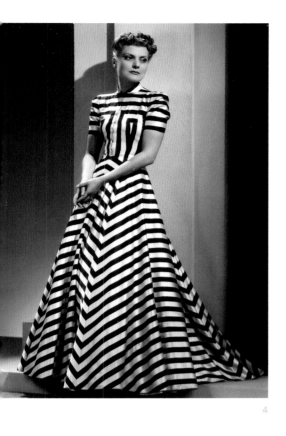

4

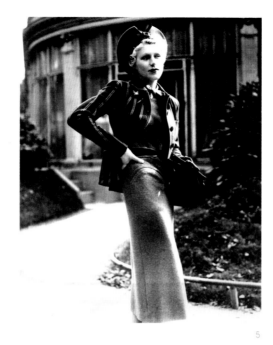

5

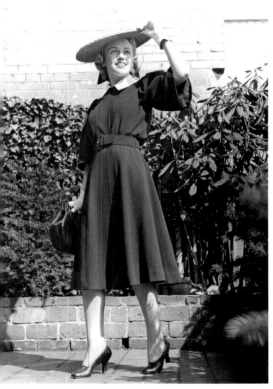

6

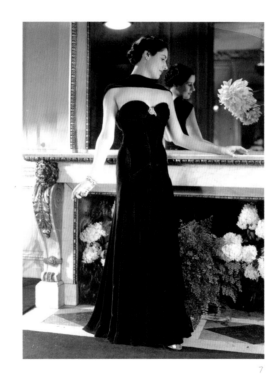

7

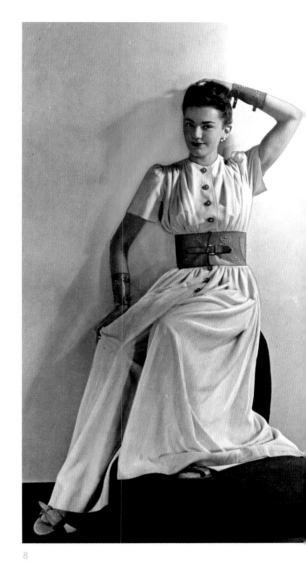

8

10

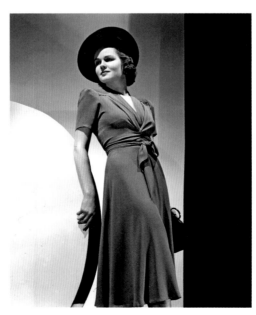

9

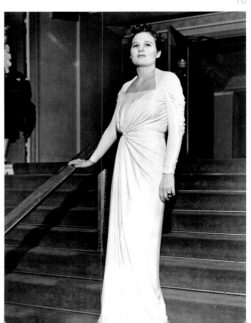

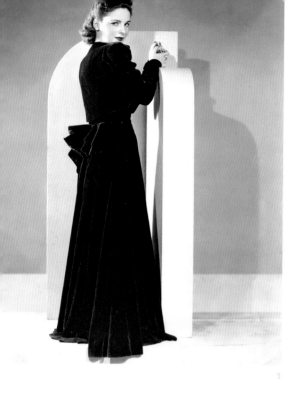

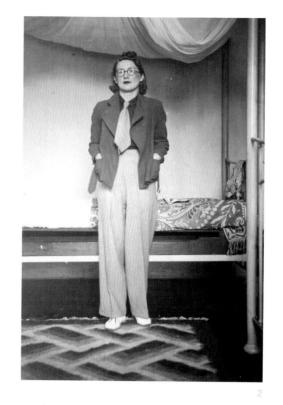

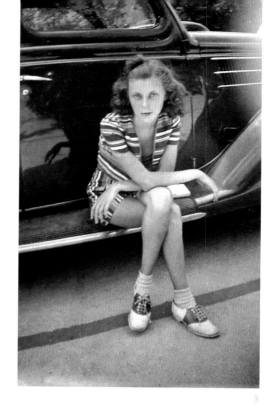

1939

In the last year before World War II, there is tremendous variety in evening clothes. Along with Lucien Lelong's gown with lantern pleated skirt, bustles are seen on a formal dinner suit in velvet from New York store Stein & Blaine as well as a long dress in pink velveteen by American custom designer Muriel King. Pants looks for evening include an at-home look of "harem" pants by Kalmour and an ensemble of tuxedo-striped pants with shirt and cummerbund from Florence Gainor. Broad shoulders feature in the soft chiffon dinner gown by Claire McCardell modeled by ballerina Vera Zorina and a jacket by Mainbocher.

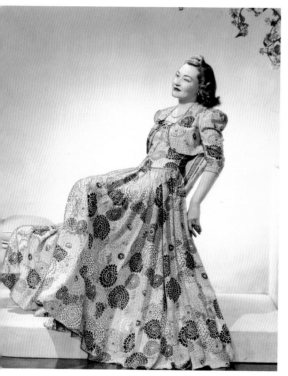

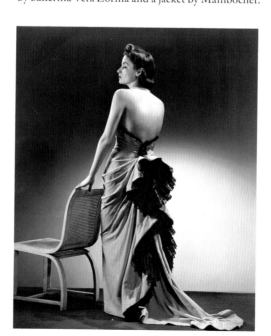

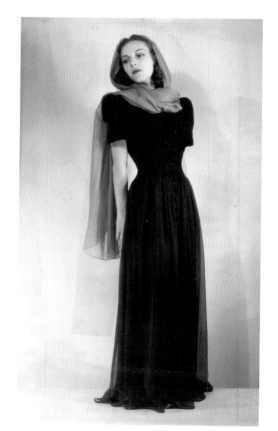

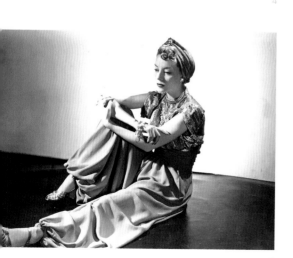

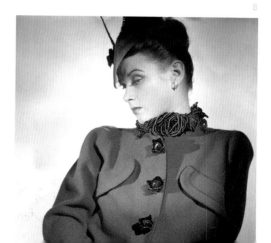

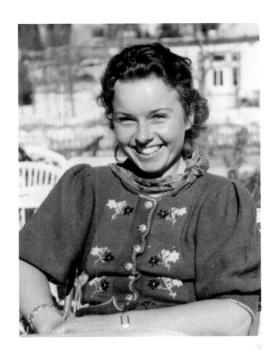

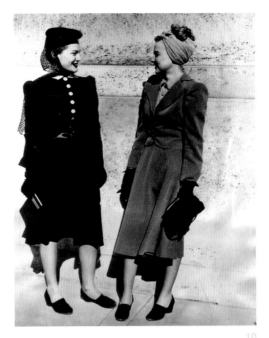

9

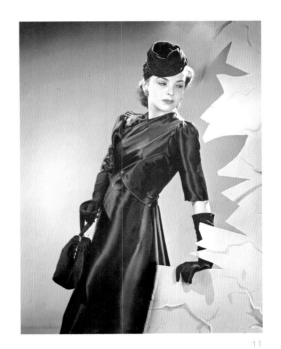

10

11

12

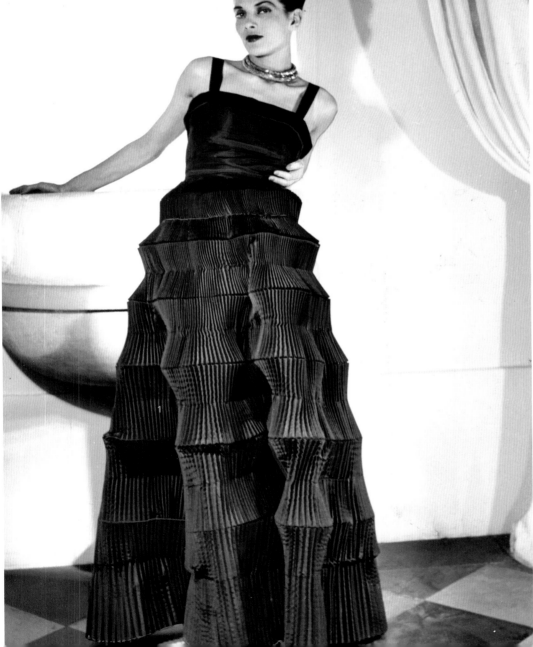

13

14

1940s

World War II impacted fashion in dozens of ways—from specific restrictions of war-necessary materials (as varied as wool, leather, lamb fur, platinum, silk, nylon, and rubber) to government regulations monitoring the amount of yardage and number of pleats, as well as shortages that lingered afterwards. The silhouette most associated with the war years, worn by women in and out of the military, was the narrow skirt suit with strong shoulders often emphasized by a matching coat.

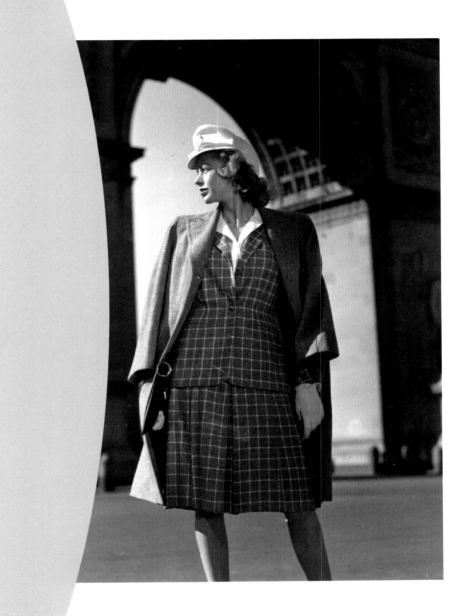

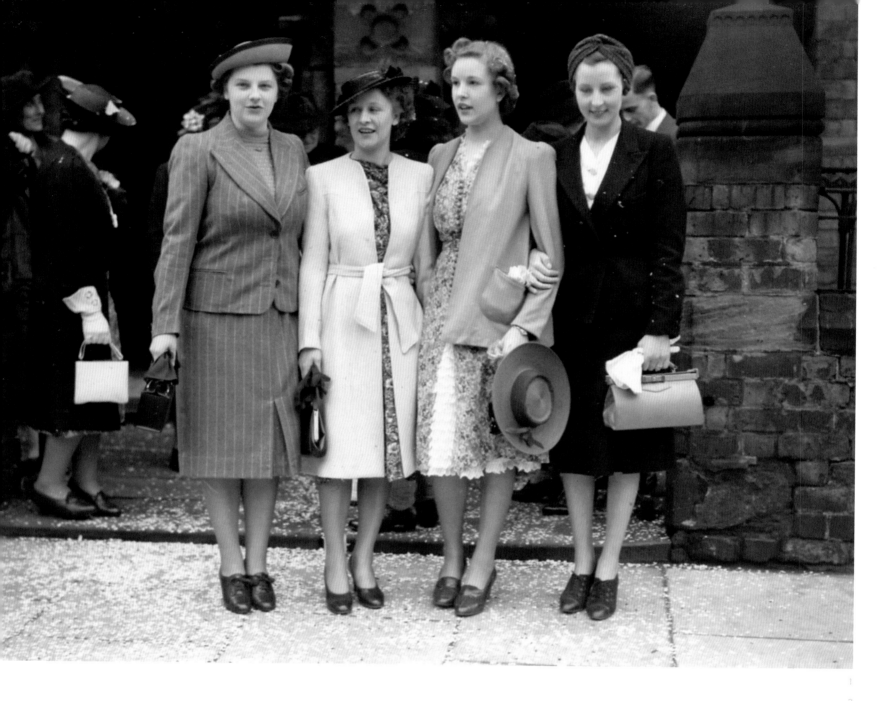

1940

Britain had declared war on Germany in 1939, and in 1940, the Germans entered and occupied Paris. Clothing rationing would not be initiated in England until 1941, and the four women here dressed for spring show no signs of the austerity to come. Despite the variety of their ensembles, their hemlines are remarkably consistent. Styles by New York designers include a bare midriff evening look by Arthur Falkenstein, a sporty ensemble of peacock blue suede jacket over a citron yellow dress in kasha jersey by David M. Goodstein, and a broad-shouldered little black dress by Peg Newton.

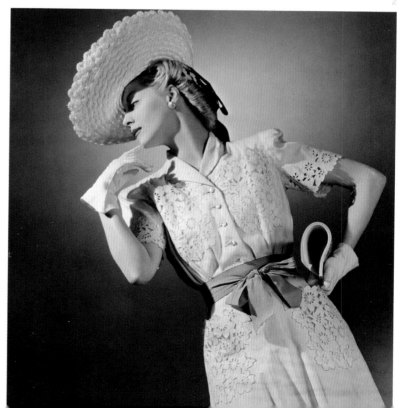

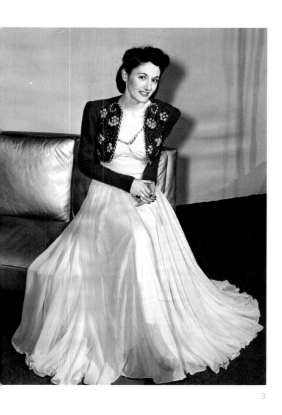

3

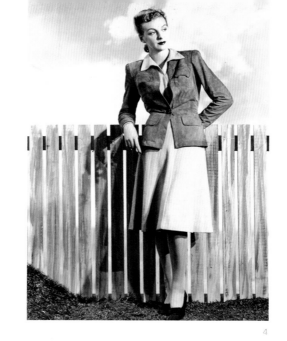

4

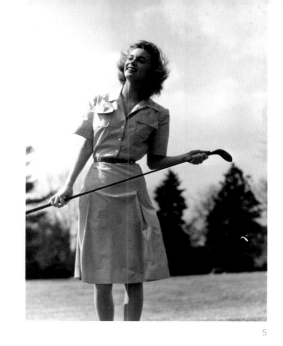

5

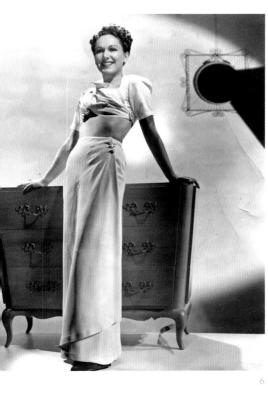

6

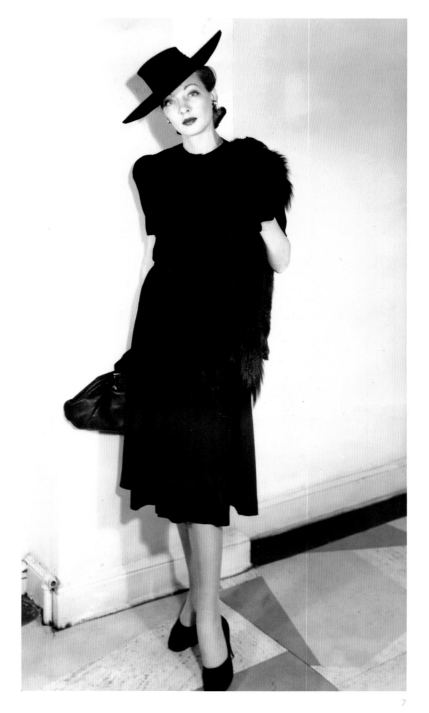

7

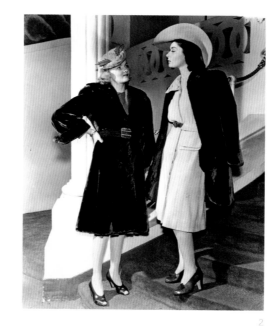

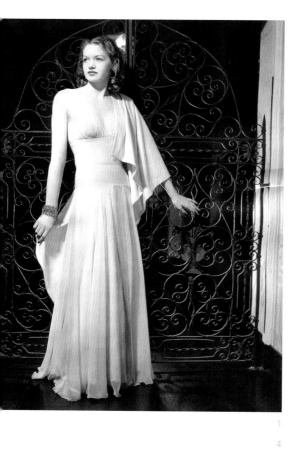

1941

Hems have risen to just below the knee for day dresses, suits, a trench coat, and fur coats—as shown here over suits by B.H. Wragge. For evening, there is a subdued quality to covered-up styles, such as custom dance dress in pale gray silk chiffon by Elinor Jenkins and a white tunic long dinner dress from Bonwit Teller, modeled in a show to benefit the war work of the American Red Cross. Hat styles that would be popular during the beginning of the 1940s include turbans and snoods.

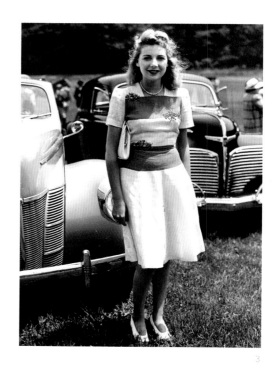

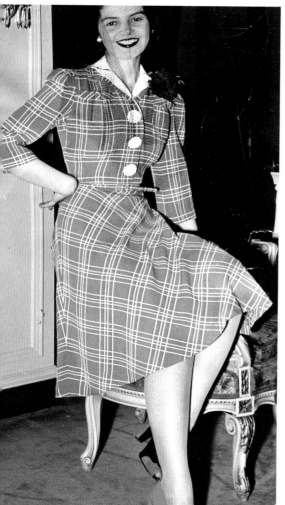

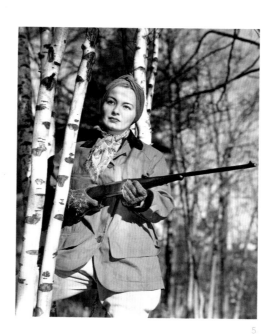

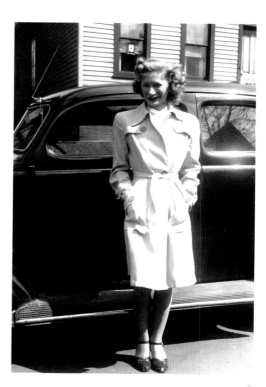

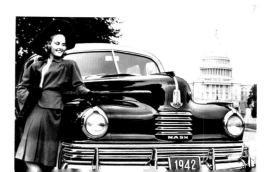

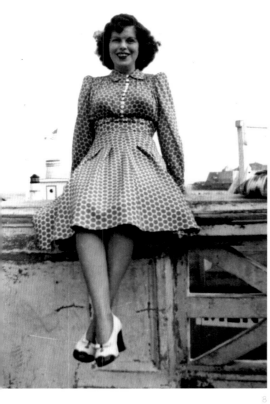

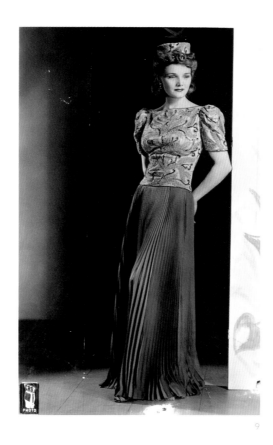

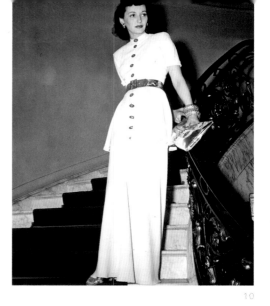

10

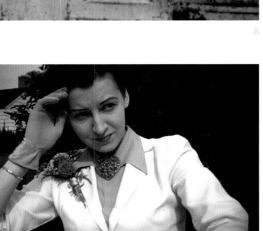

11

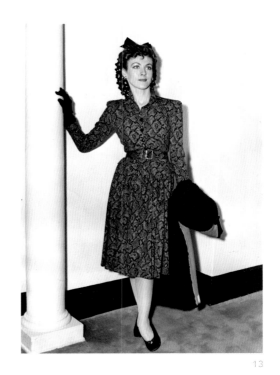

13

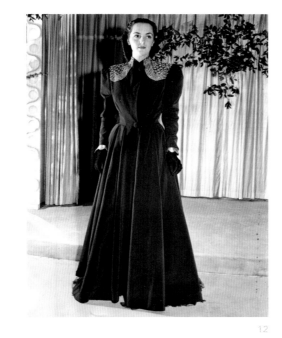

12

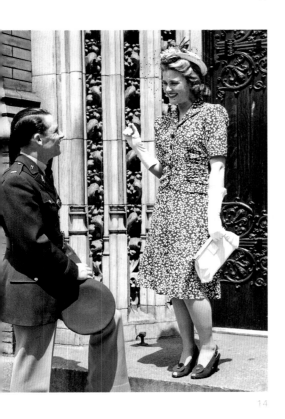

14

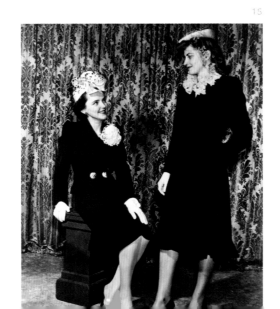

15

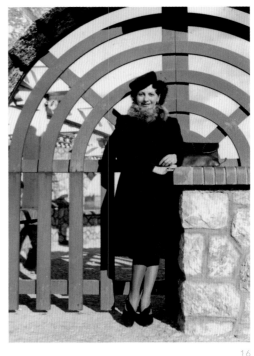

16

1942

The United States enters the war. L-85 regulations are issued: hemlines must be not longer than 17 inches from the floor, natural fibers and leather are rationed, and there are limits for color choices and combinations and circumference of skirts and sleeves. A "Homefront" uniform is modeled by Miss Betty Bond, and radio star Joan Edwards wears a suit made according to the new regulations—the jacket measures twenty-five inches while the skirt—gray and white checked wool with flap pockets and mother-of-pearl buttons—is not more than sixty-four inches around.

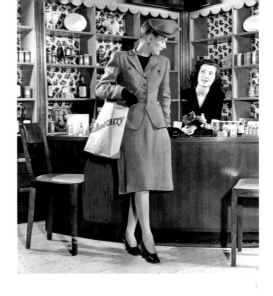

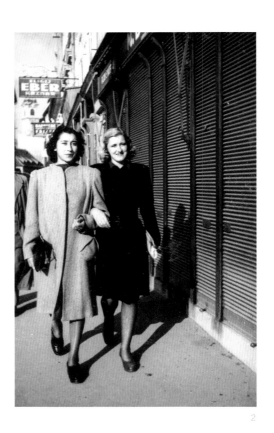

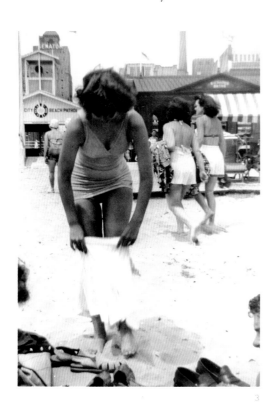

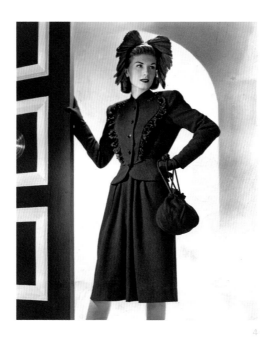

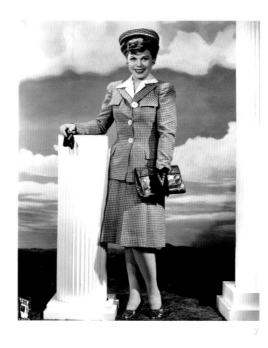

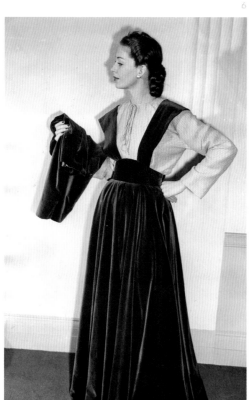

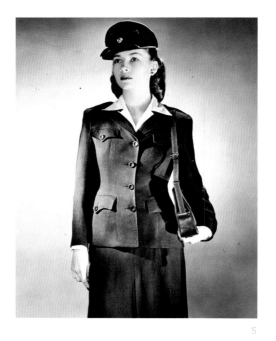

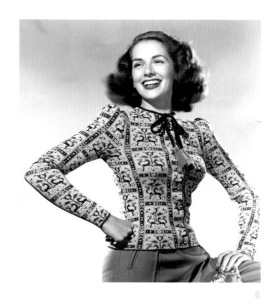

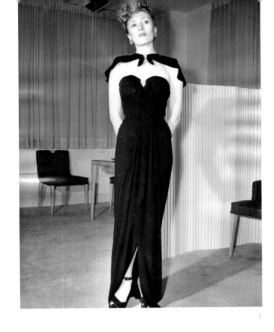

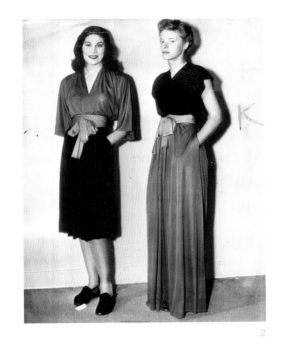

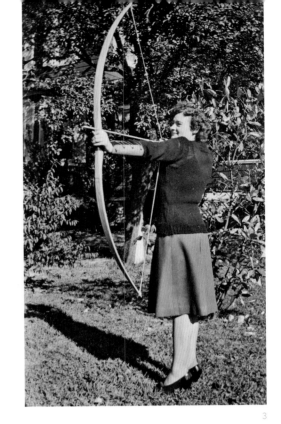

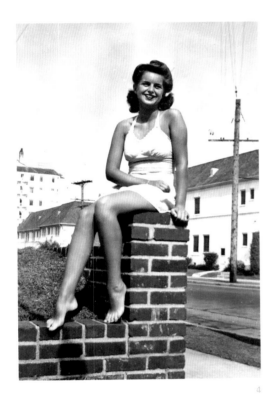

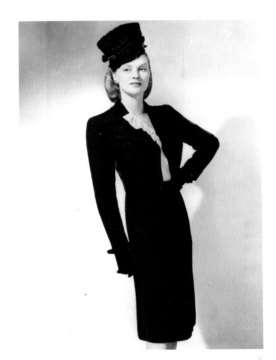

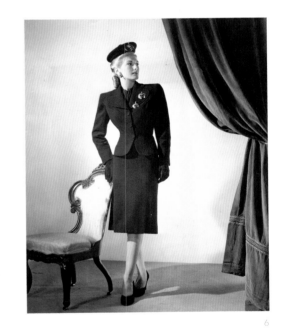

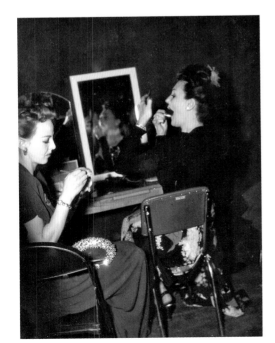

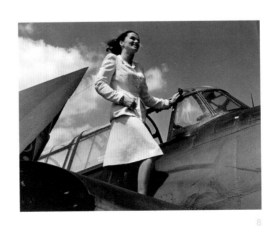

1943

Entertaining the troops is a form of war work. Two actresses primp before going onstage at one of comedian Jack Benny's camp shows while fashion editors promote the wearing of amusing hats as a morale booster. American styles shown here include a suit made in non-rationed rayon, two stylishly accessorized suits by high-end American ready-to-wear designer Nettie Rosenstein, and a problem solving design by Claire McCardell—four separate pieces in black or brown matte jersey that can be combined to make two different day outfits and two different evening looks.

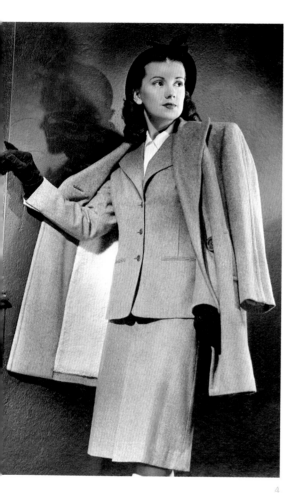

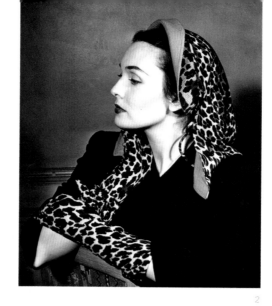

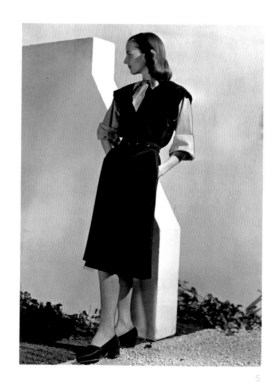

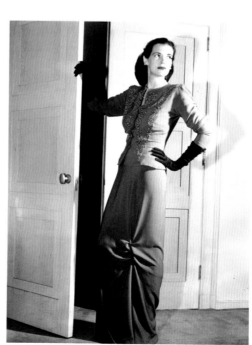

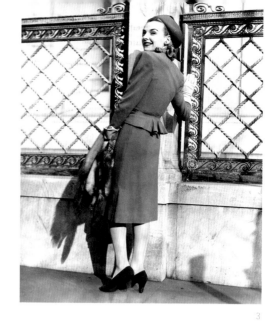

1944

One of the best-sellers in America during the war was Claire McCardell's popover dress, introduced in 1942 and priced at $6.95. The dressier version shown here was available in navy or black wool worn with bow-tied blouse. Retailed by the Town Shop, the dress sold for $25.00 and the blouse for $10.00. Warm evening clothes continue to be needed for heating-oil rationed houses. A dinner dress and jacket in gray wool crepe embroidered with beads is by Fira Benenson, custom designer in New York.

1

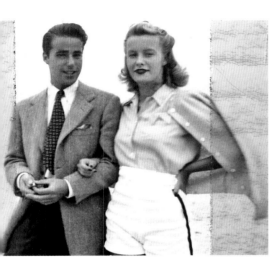

2

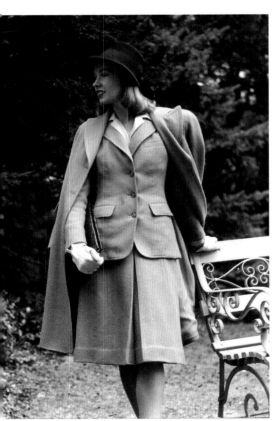

3

CAMPUS STYLE

American college students comprised a market of hundreds of thousands, and since the typical campus was fairly rural, the clothes aimed at coeds had their origins in those worn for British rural pursuits. Separates—and even dresses for dates and parties—were thus made of tweeds, tartan, and corduroy. Fashion magazines and designers marketed directly to students who had a way of thinking for themselves when it came to what they really wanted to wear. There were strong opinions in regards to such elements of attire, including what was the perfect Shetland sweater or saddle shoe, and how much scuff or polish was acceptable for a loafer.

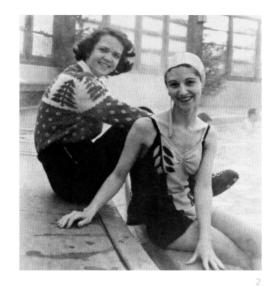

4

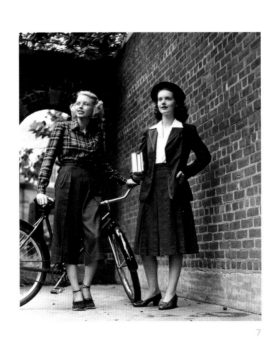

5

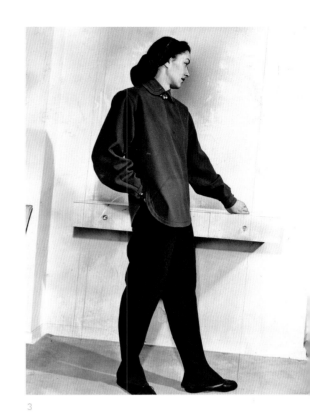

6

7

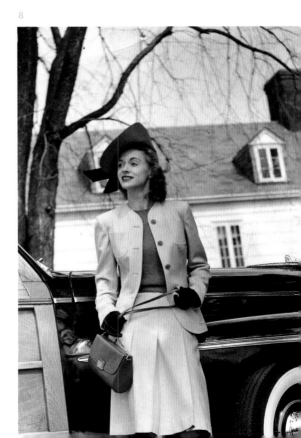

8

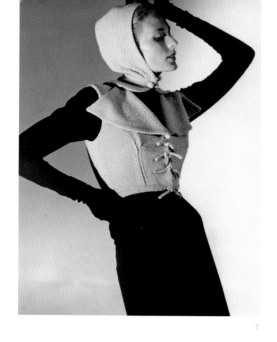

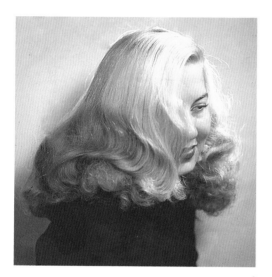

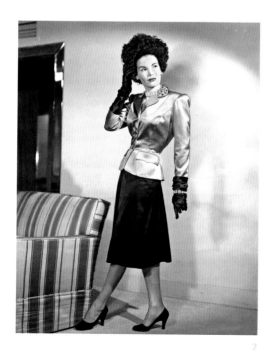

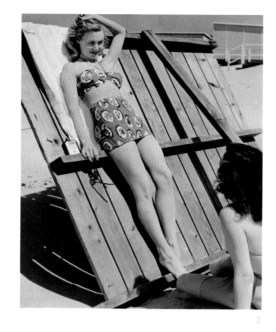

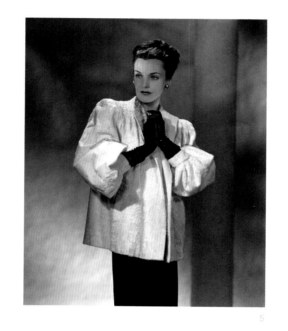

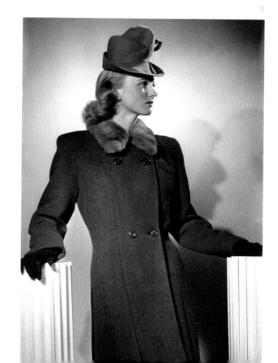

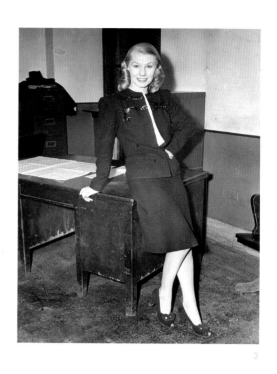

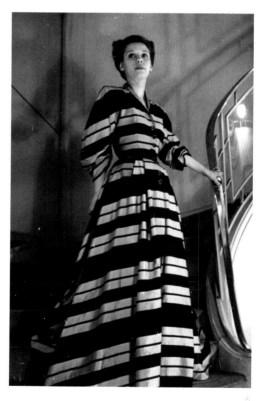

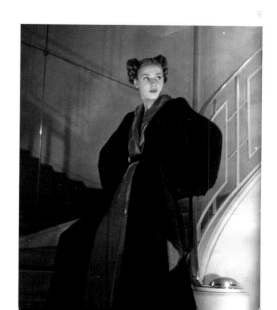

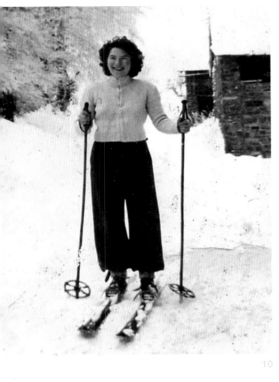

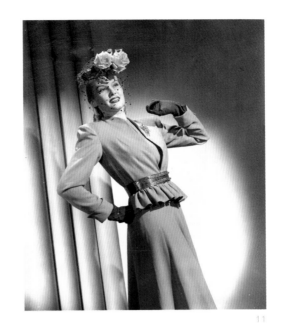

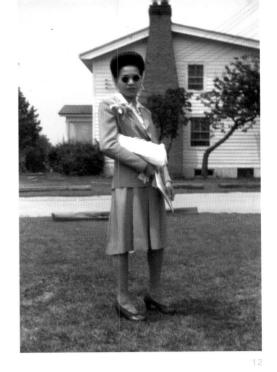

11

12

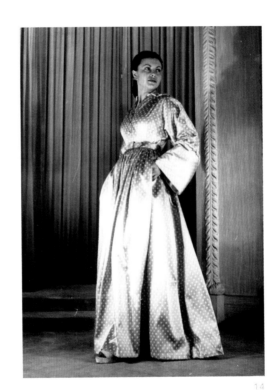

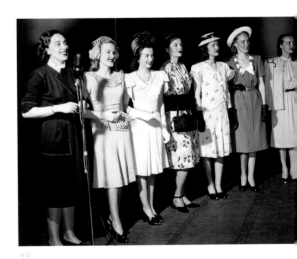

13

15

10

14

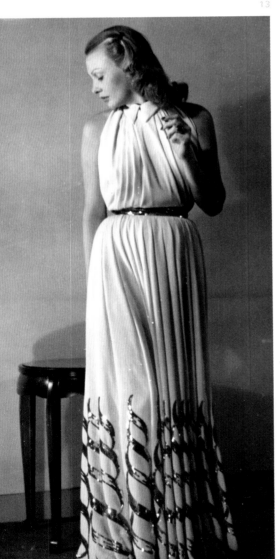

1945

Some of the first haute couture looks to emanate from liberated Paris include covered up and warm at-home gowns or robes d'interieur by Balenciaga in green and white wide stripes and Bruyère in green silk foulard with revers in rose silk foulard, both suitable for entertaining in chilly chateaux. A woman wears her hair in the style popularized by American film star Veronica Lake, the longest hair to be fashionable since before the 1920s.

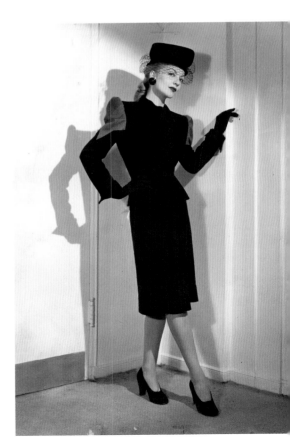

16

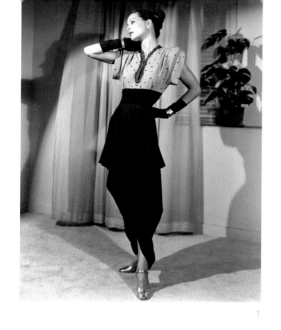

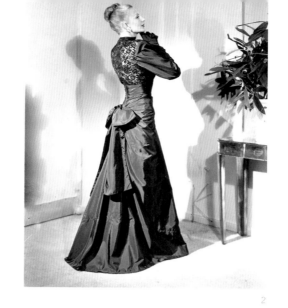

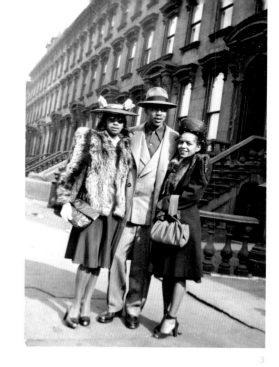

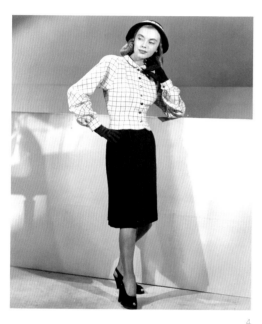

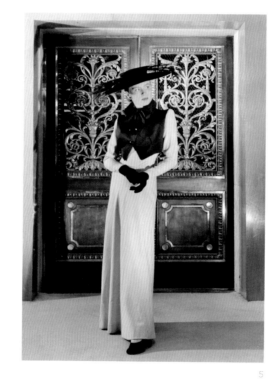

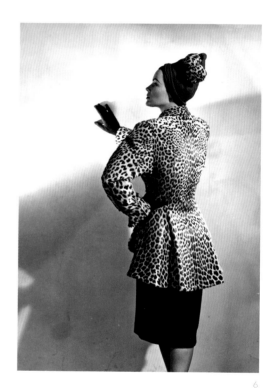

1946

American L-85 regulations are lifted and such features as drapery and bustles return to evening dresses. Postwar prosperity brings with it a passion for wearing fur, and examples of fur "chubbies" are shown here in Harlem (the leopard coat is from Gunther in New York).

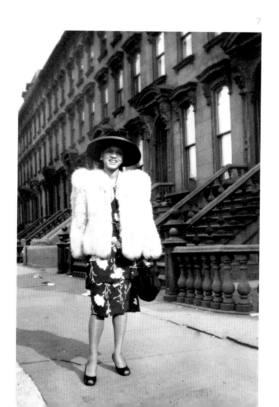

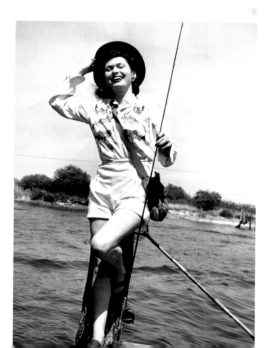

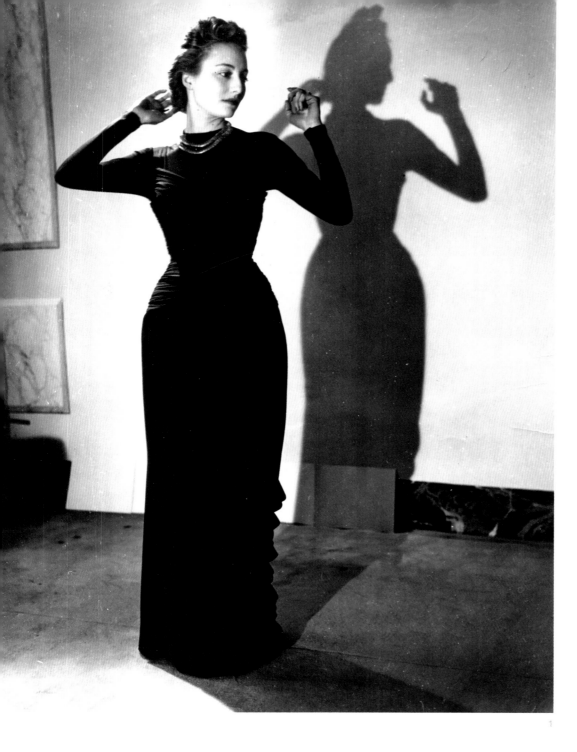

A NEW LOOK

In 1946, Marcel Rochas debuts his new guêpière waistline in two styles modeled by his young wife Héléne: a draped jersey long dress and a toile print evening gown. Balenciaga's short evening dress in heavy silk with self-belt and three dimensional jet embroidery is photographed in the Balenciaga atelier. On February 12, 1947, Christian Dior opens his couture house, and his silhouette with natural shoulders, fitted bodice, nipped in waist, and full, long skirts will be dubbed the New Look by Carmel Snow, editor of *Harper's Bazaar*. This silhouette will dominate the next decade.

1947

Postwar fashions would go in two directions: luxurious and casual. Hattie Carnegie shows an evening gown of net, trimmed with bands of lace, and a Persian lamb bolero coat with gigot sleeves. Du Pont develops a new type of plastic for sunglasses, and a waitress in a uniform that would remain in use for decades signs the back of her snapshot: *Lots of luck you little devil. And here's hoping you come back with a million and your upper bridge. Your friend Clio.*

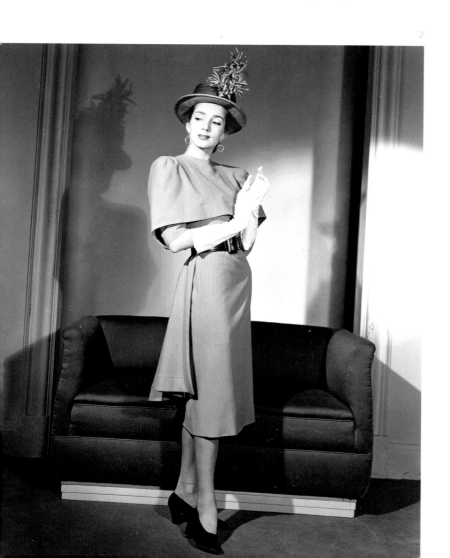

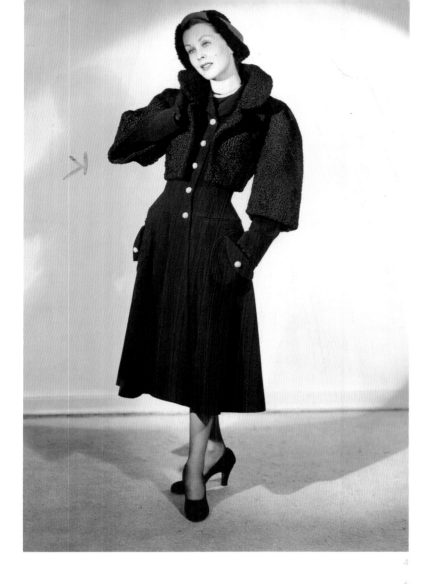

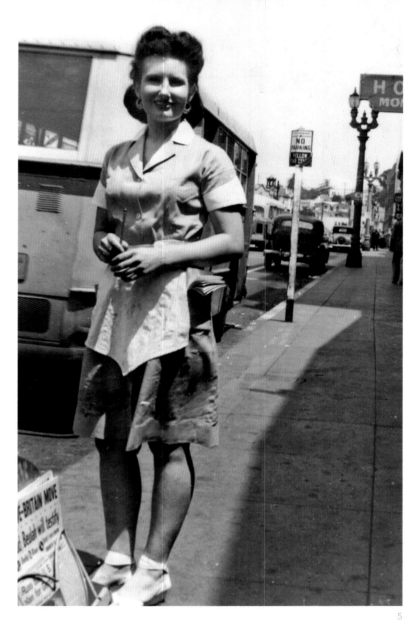

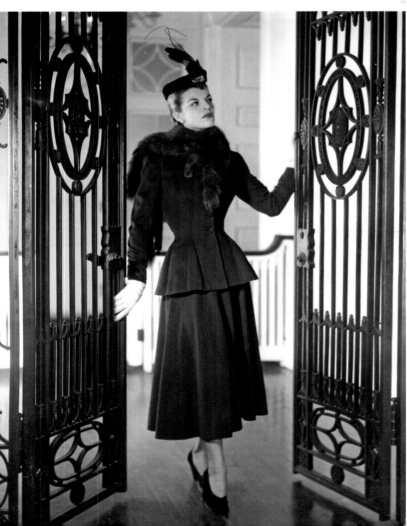

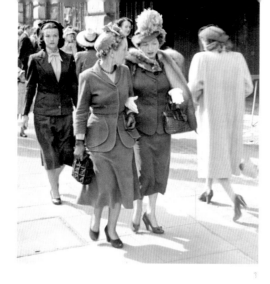

1948

Hemlines for day and afternoon have dropped. Black opera pumps are worn with dressy daytime, afternoon, and evening clothes. Short swing coats and the mink stole become popular.

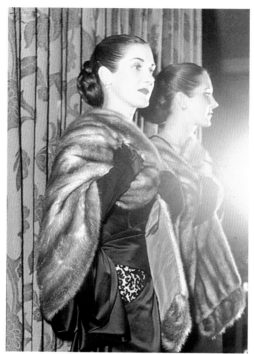

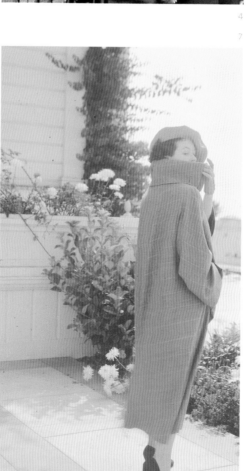

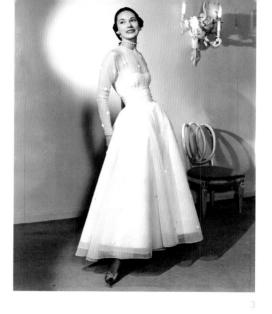

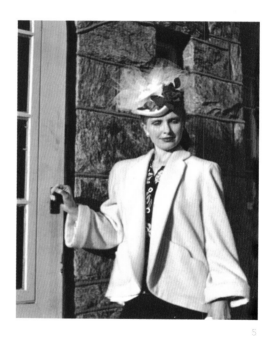

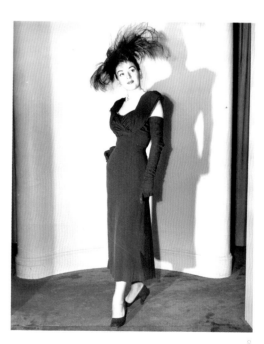

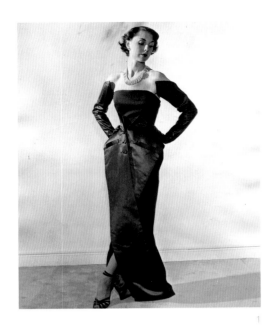

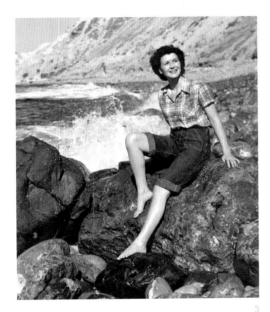

1949

Seen at Ascot, an afternoon dress with picture hat and a morning suit with top hat. Evening dresses include what will be quite popular for at least the next decade, the strapless tulle evening dress, and Christian Dior designs a gown in sapphire silk broadcloth and satin made with "scissor blades" crossing at the skirt. Gloves are worn with afternoon and evening clothes. A single strand pearl choker is worn high on the throat. A fashion editor advises that there should never be a single extraneous pearl.

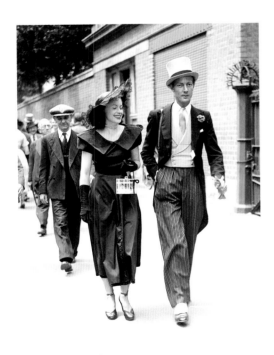

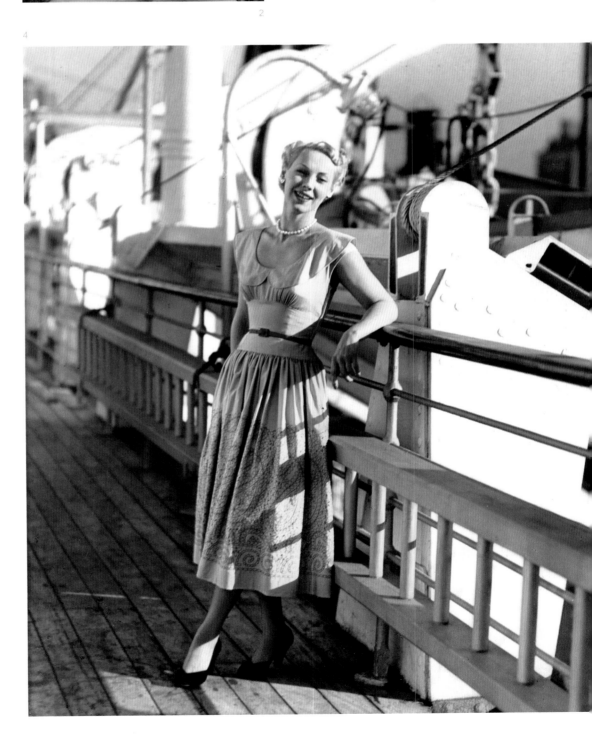

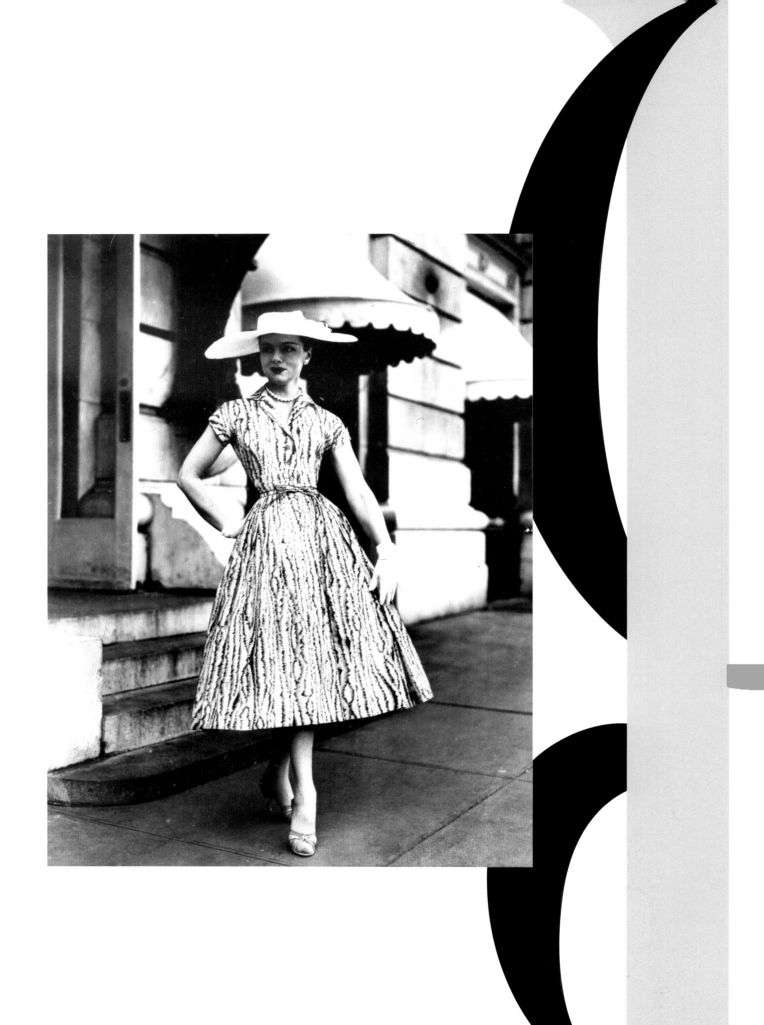

1950s

A fitted bodice, natural shoulders, tiny waist, and full skirt was a silhouette used for casual cotton shirtwaist dresses, elegant afternoon looks, cocktail dresses, and even short ball gown and wedding dresses. Nylon stockings would become sheerer than ever before, as they could now be made without reinforced toes. Bare high-heeled sandals come into play. Picture or cartwheel hats balance the silhouette, and gloves are proper to wear for all appearances outside the home.

1950

Pierre Balmain shows a haute couture plaid shirtwaist dress with narrow pleated skirt while Claire McCardell unveils one in "smudge" green with artichoke green top-stitching with brass buttons. Balenciaga is playing with volume in a suit of walnut wool with rounded jacket and melon sleeves.

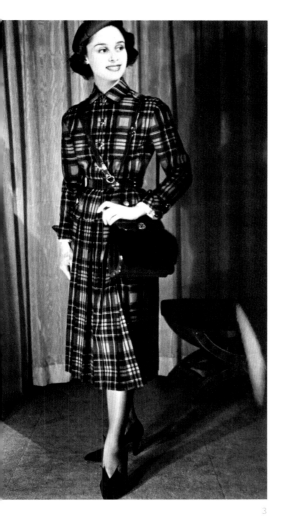

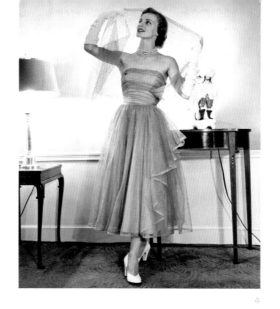

4

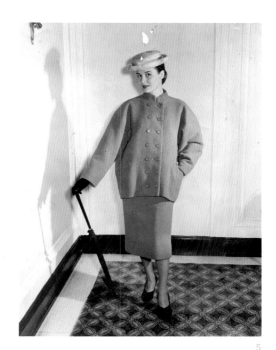

5

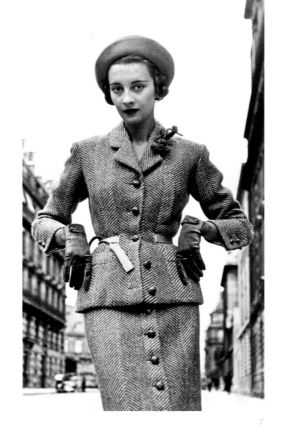

7

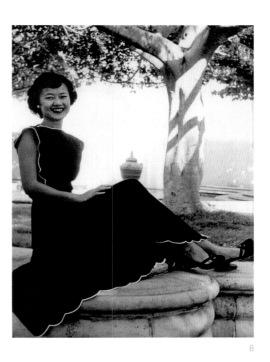

8

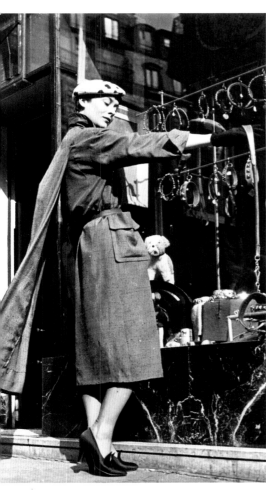

6

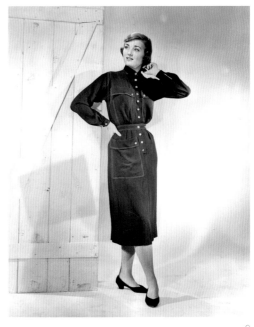

9

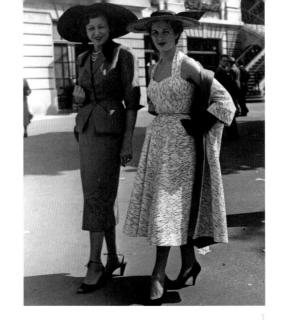

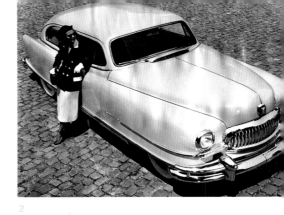

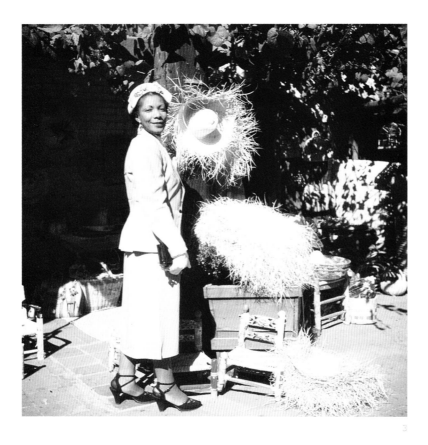

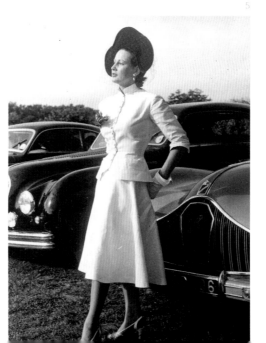

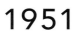

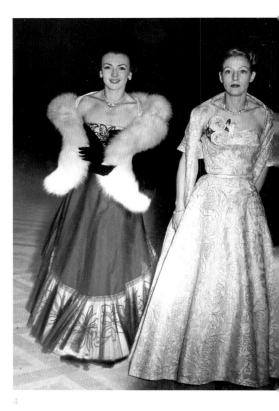

1951

Styles worn at the French races include a spring suit with short sleeves and a bare dress and coat ensemble. Jean Dessès and Jeanne Lanvin haute couture evening gowns are worn to a presentation of antique silks at the Louvre in Paris. Strapless nylon tulle ballet-length evening dresses are donned by two back-up singers.

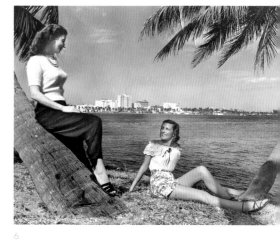

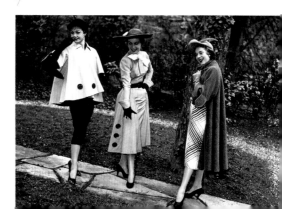

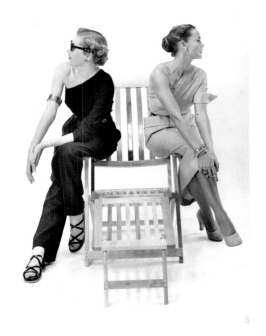

8

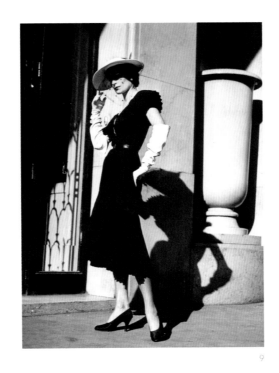

9

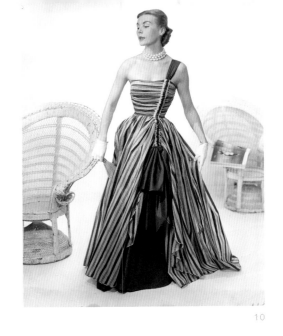

10

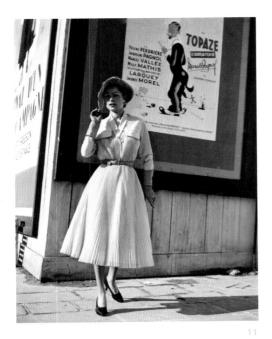

11

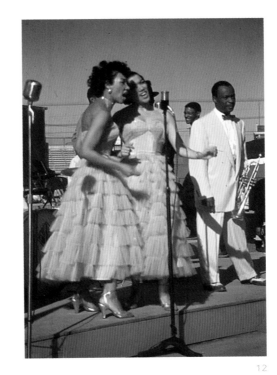

12

13

14

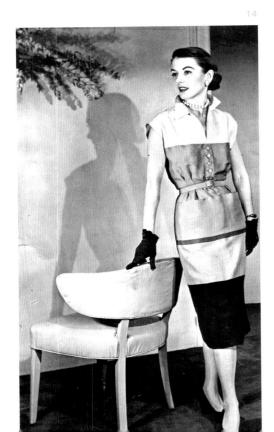

15

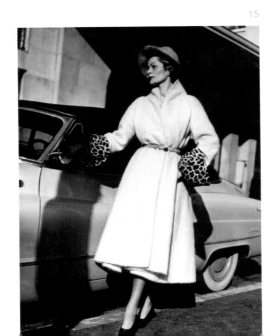

16

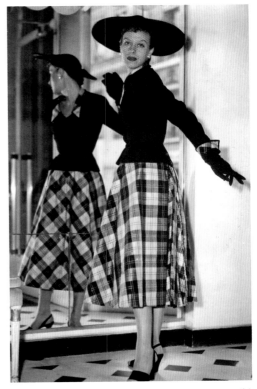

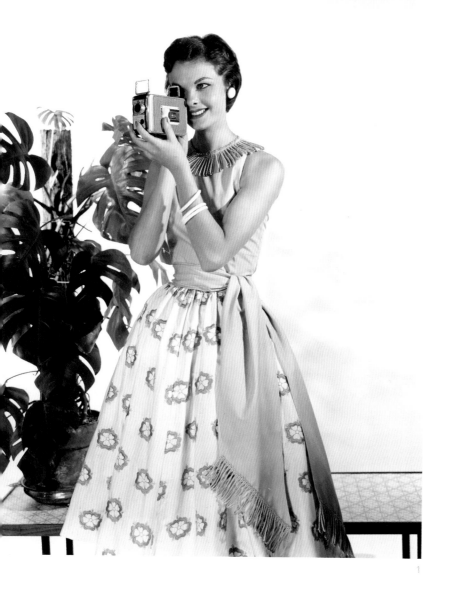

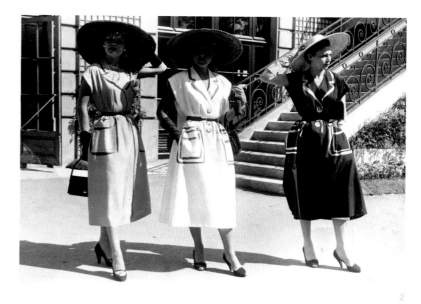

1952

Shawls, sable scarves, and fur stoles are coveted accessories. Carven designs a coin dot summer suit and, in a promotion linking cars and fashions, a "Motor-Mate" coat in two tones of wool coordinates with the new two-tone Ford Victoria model.

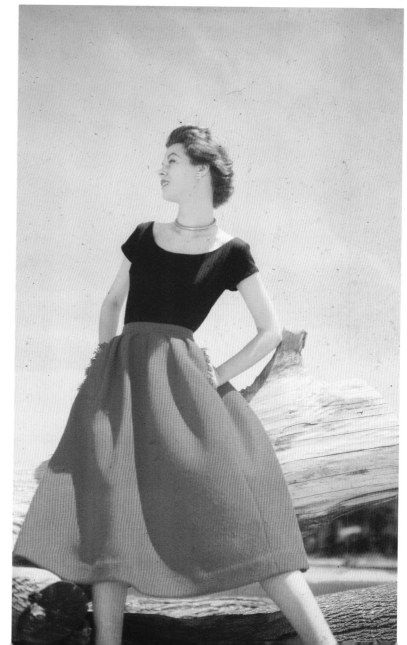

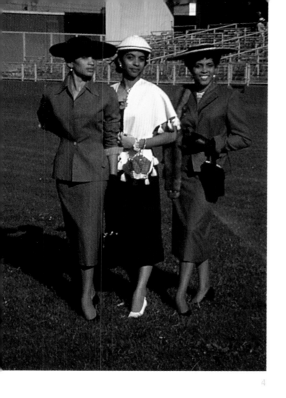

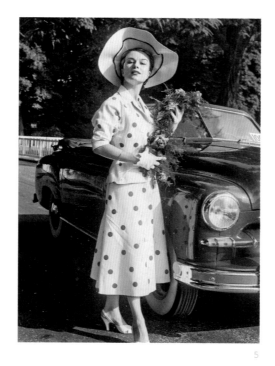

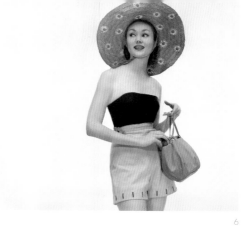

6

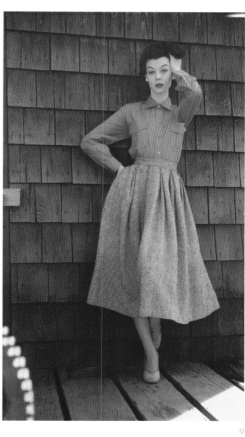

9

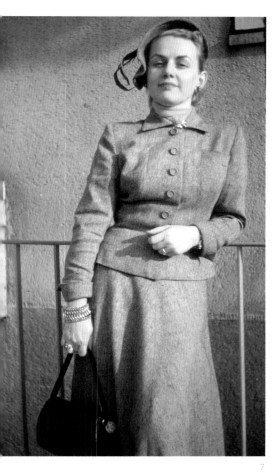

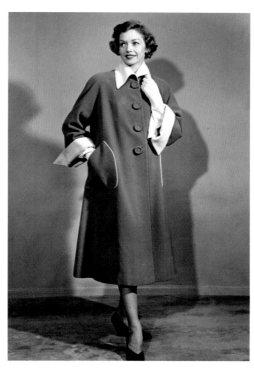

8

7

10

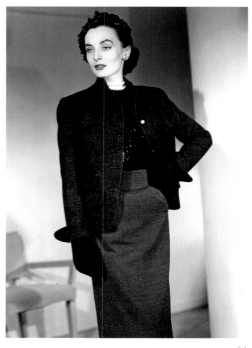

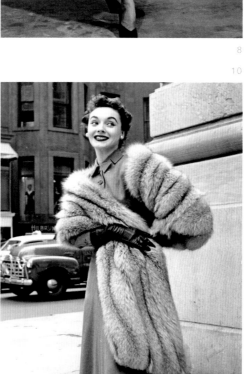

11

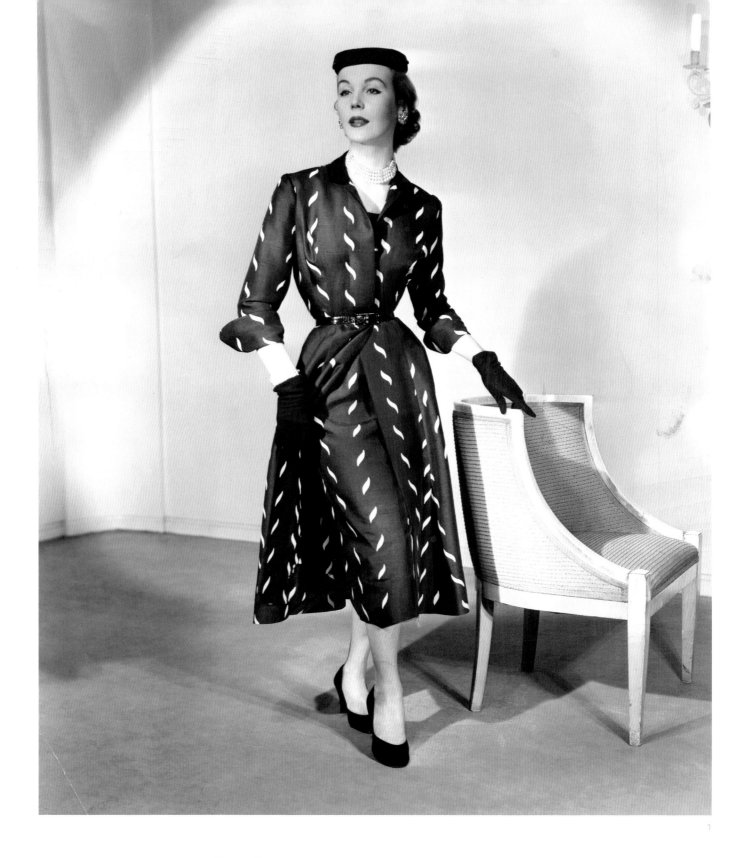

1953

Bathing suits are often boned so as to support the same kind of stay-up strapless bodices as evening dresses. A new style for at-home or casual evening is narrow pants in velvet worn with cashmere or wool cardigans embroidered with sequins or beads. Mrs. William Randolph Hearst, Jr., a former society columnist, wears a Charles James silk dress, diamond bow brooch, and gardenias in London with her husband to attend Queen Elizabeth's coronation.

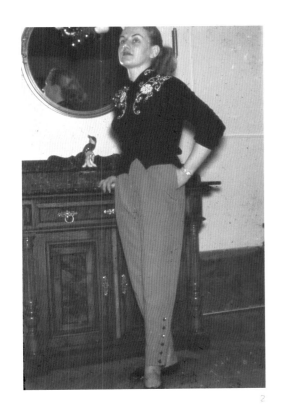

2

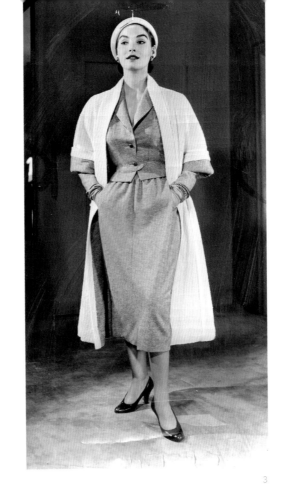

3

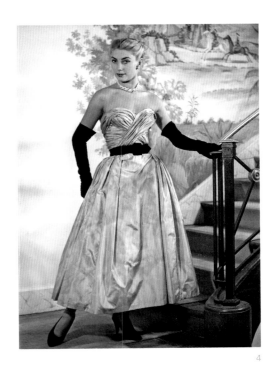

4

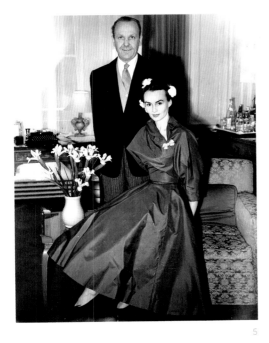

5

8

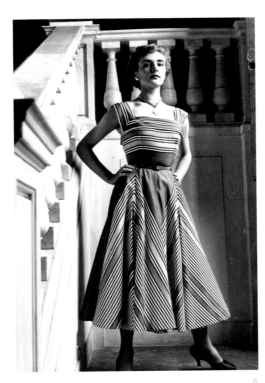

6

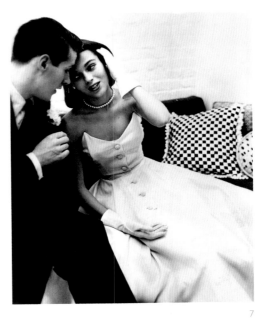

7

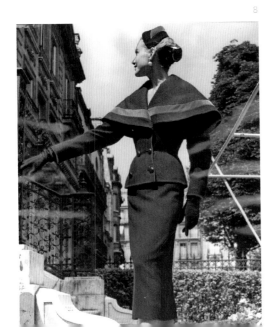

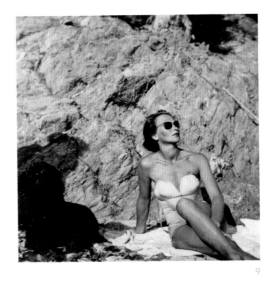

9

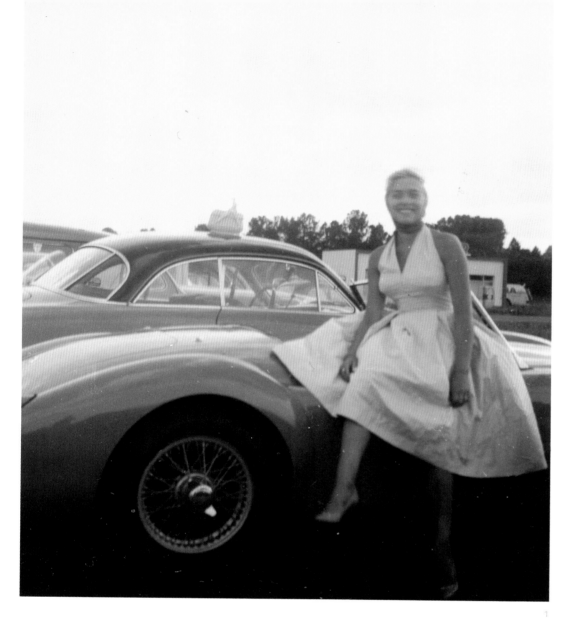

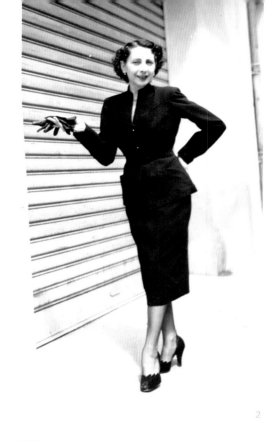

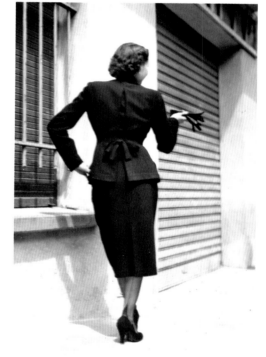

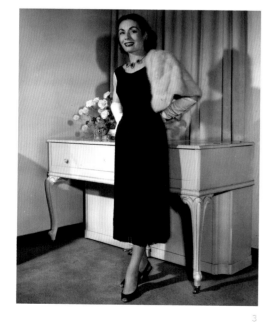

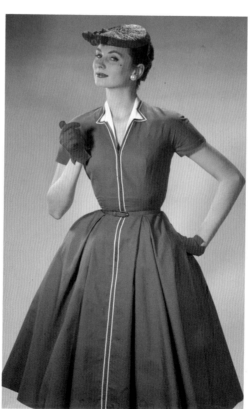

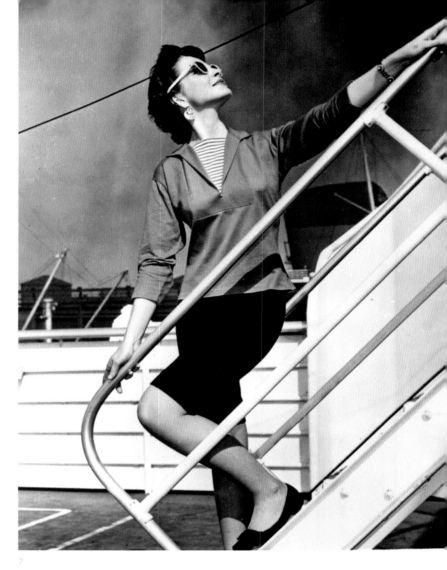

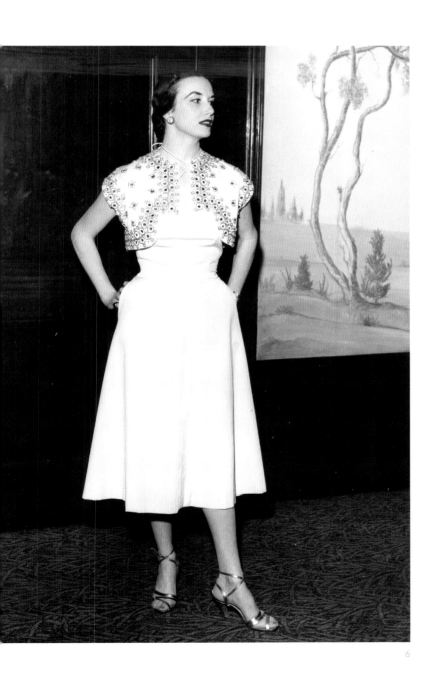

1954

A Frenchwoman poses front and back in Perpignan in a tailored suit with back self bow, worn with seamed stockings and peep-toe pumps. Cuban-born shooting champion Carola Mandel wears a short evening dress in black crepe by Leslie Morris of Bergdorf Goodman. Suzy Parker models a cotton shirtwaist dress by McKettrick.

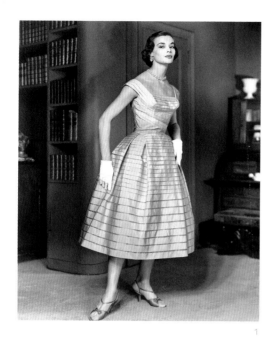

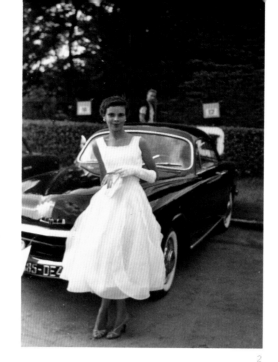

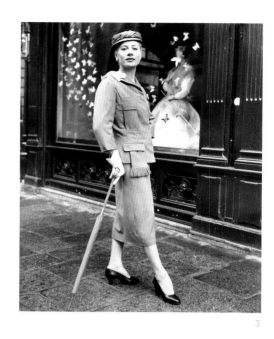

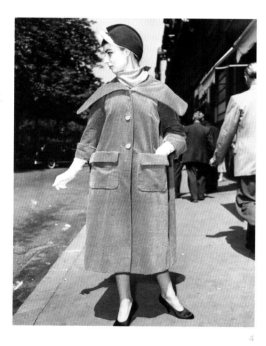

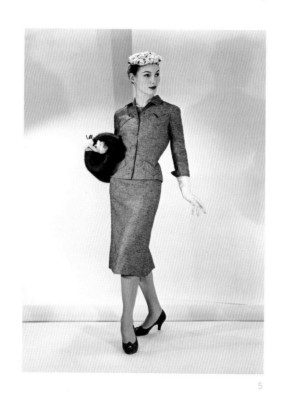

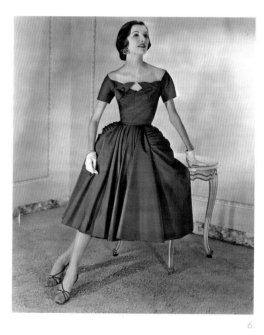

1955

Ceil Chapman's short evening dress is concocted of pink silk taffeta ribbons stitched onto silk organdie. A dress and jacket ensemble by Nettie Rosenstein is worn with small flower-covered hat by Emme. Balenciaga's town coat in wide-whaled caramel corduroy has an exaggerated cape collar and is worn with a hat shaped like a Phrygean bonnet.

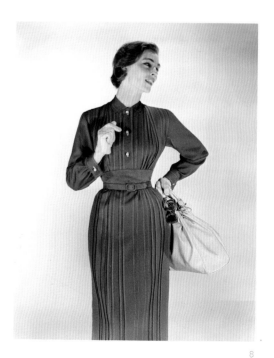

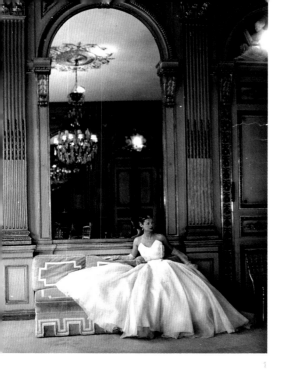

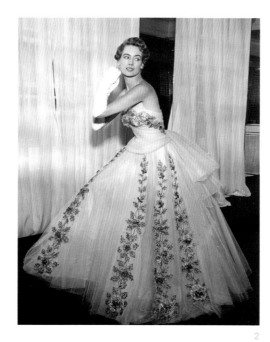

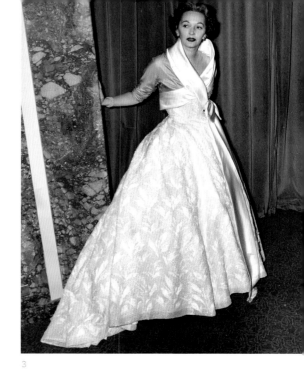

GRAND EVENING

As *Vogue* heralded: "Evening dresses are, to put it mildly, important. Not necessarily more expensive, but cut with a grand-entrance sweep, in salon—rather than restaurant—colors and materials, and crying out for safe deposit boxes (closed in '40) to be opened again" (*Vogue*, April 1, 1949).

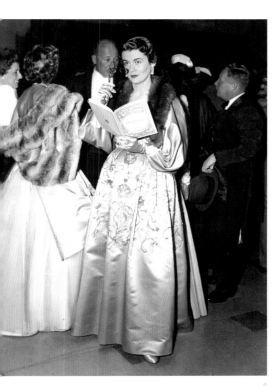

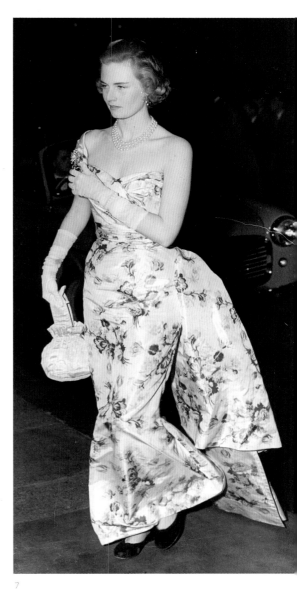

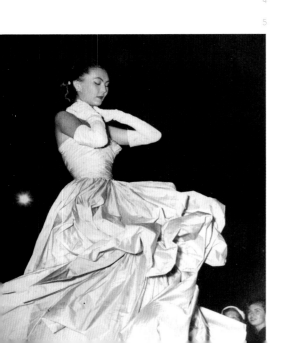

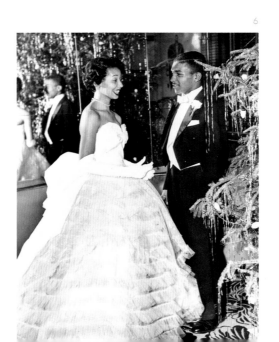

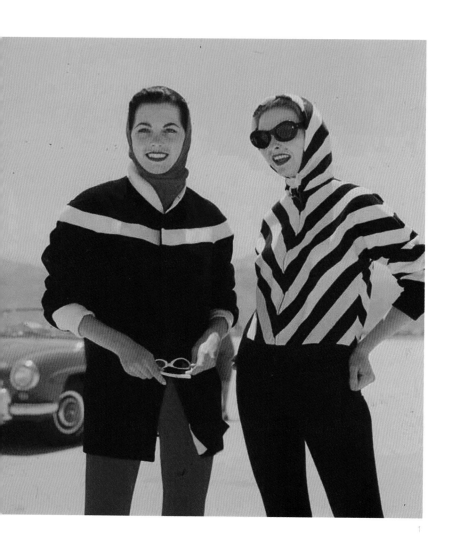

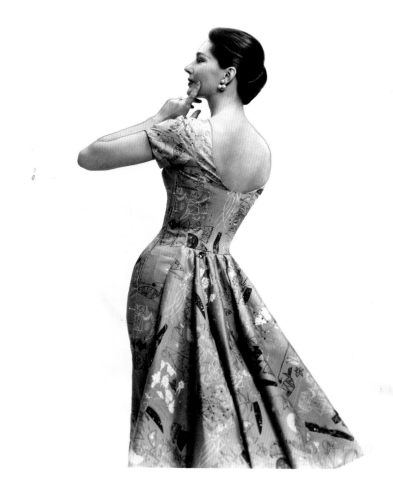

1956

A model channels Grace Kelly, the cynosure of all eyes during her 1956 wedding to Prince Rainier of Monaco. Car coats or toppers are popular new styles, and a cocktail dress is made from one of Modern Masters' specially-commissioned printed cottons. A woman sightsees wearing a travel shirtwaist with a permanent pleated skirt. Advertisements in fashion magazines tout fabric that "needs no travel iron, suds superbly" enticing busy housewives with such phrases as: "quick-drying," "crease-resistance," "washable," "Sag-No-Mor," and "ceaseless creaselessness."

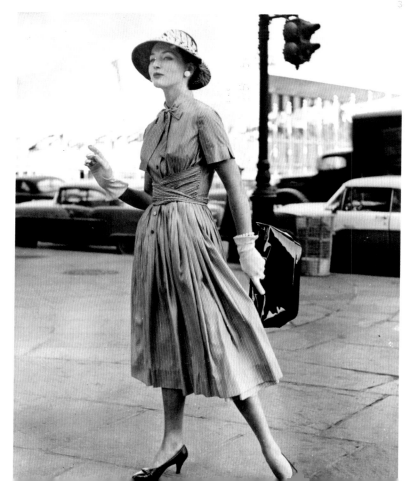

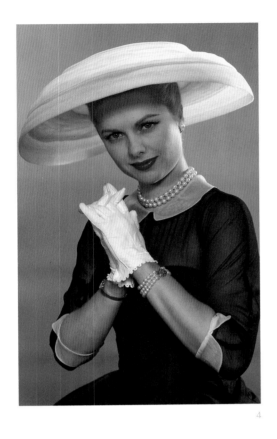

4

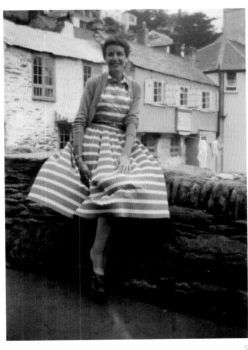

5

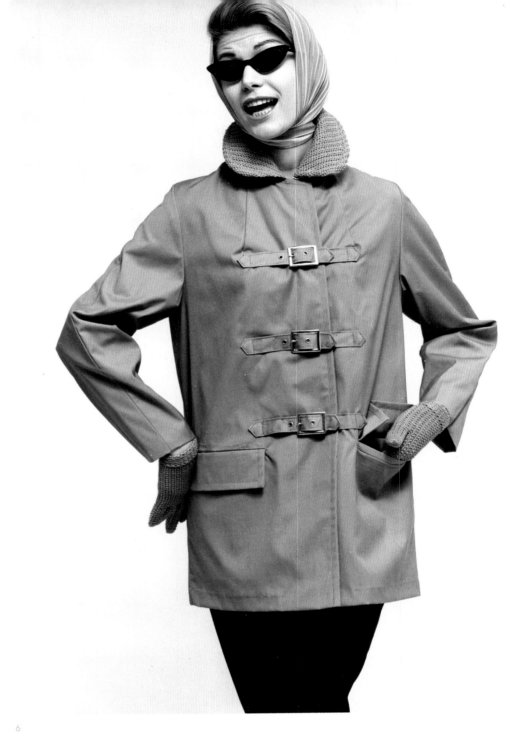

6

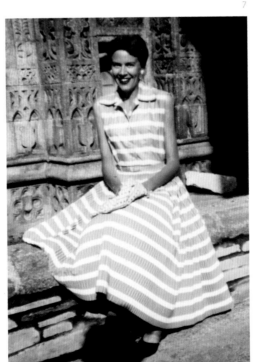

7

1957

Forward-looking shapes include the flared jacket over a pencil skirt in tweed and the overblouse of a sportswear evening look by Anne Klein of Junior Sophisticates. Nina Ricci shows a wedding gown in draped silk jersey while a bubble evening gown is modeled in Tokyo. A shirtwaist is worn in the California orange groves, madras in Palm Beach.

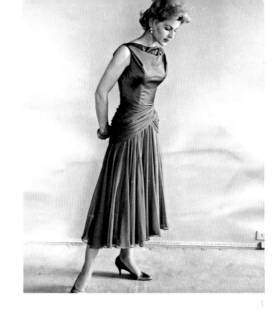

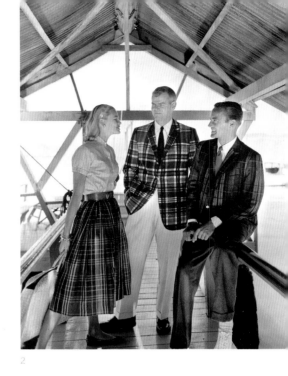

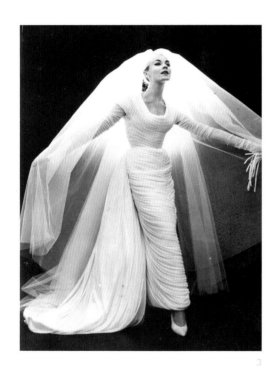

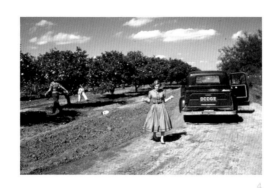

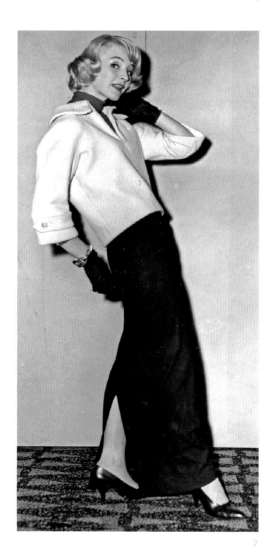

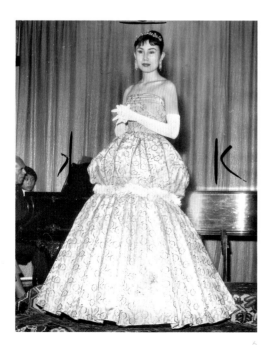

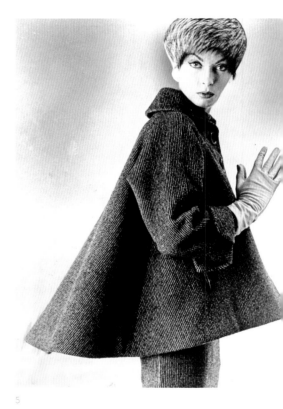

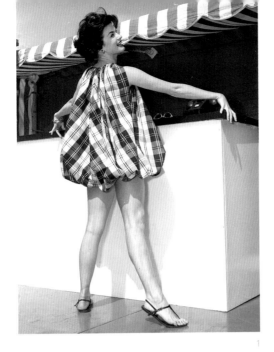

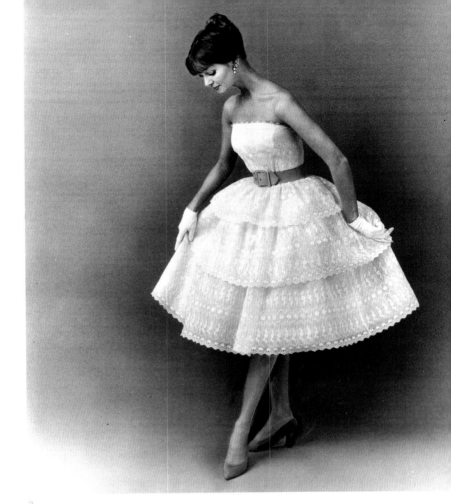

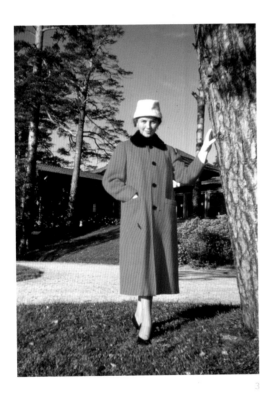

1958

Claire McCardell's bubble bathing suit is from her last collection for Townley before her death. Lanz of Salzburg makes a short evening dress in machine-embroidered organdy. A red coat with an easy shape is worn in Helsinki, and a model wears a version of the trapeze shape designed by Yves Saint Laurent for Christian Dior.

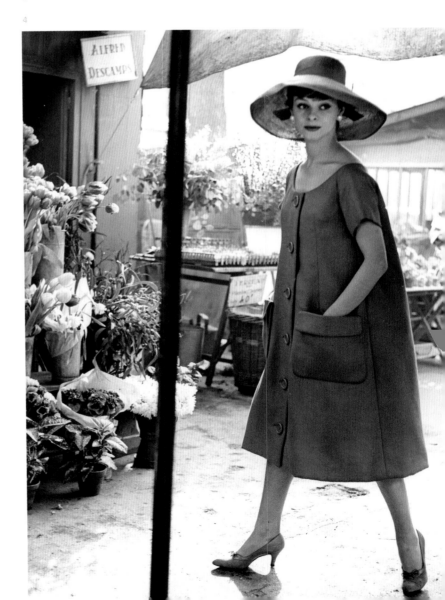

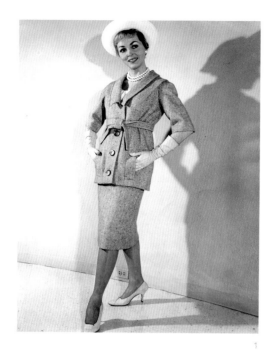

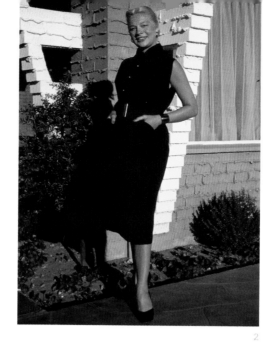

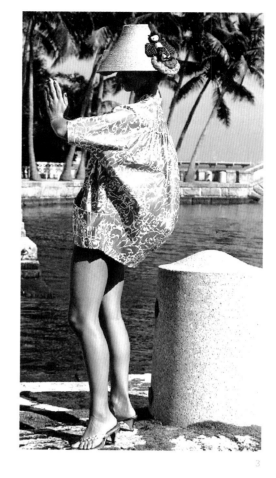

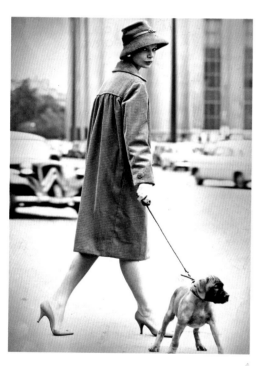

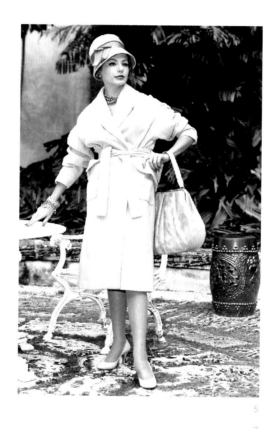

1959

There is an ease to the cut of a suit by California designer James Galanos in oatmeal tweed with raised waistline and self-tie belt, as well as the boxy jacket in faux broadtail by Sportwhirl and the balloon beach cover up by Sodi.

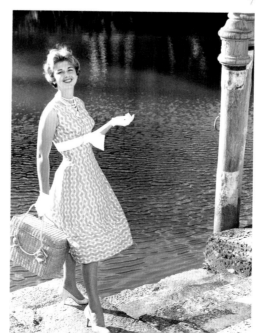

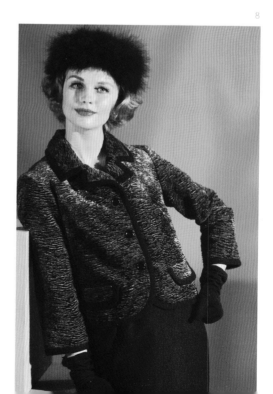

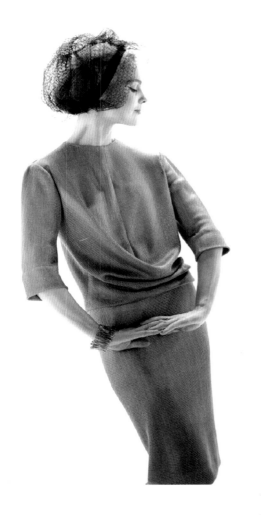

A
SILHOUETTE
SHIFT

In August 1955, *Women's Wear Daily* predicts: "Balenciaga's Easy Lines Lead the Way." By the end of the 1950s, numerous designers were following Balenciaga's lead and experimenting with looks that didn't involve a waistline and often featured extra volume in curved shapes. Models emphasized this new look by standing with their hips jutting forward and their shoulders back.

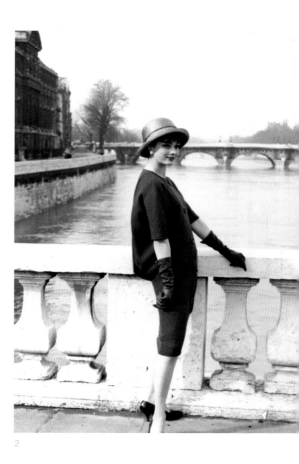

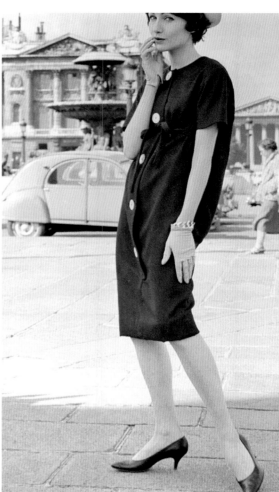

1960s

What Diana Vreeland would call a "youthquake" gave the 1960s its look and feel. The new American president and his wife were young marrieds, and Kennedy style synced the old—East Coast establishment, French culture, and haute couture—with the new—dancing the Twist at the White House. As the decade progressed, the youthfulness became ever younger, and teenagers were credited with popularizing such styles as mini skirts and bikinis. Bare legs and bare navels paved the way for further nude looks—potent visual expressions of a new sexual permissiveness.

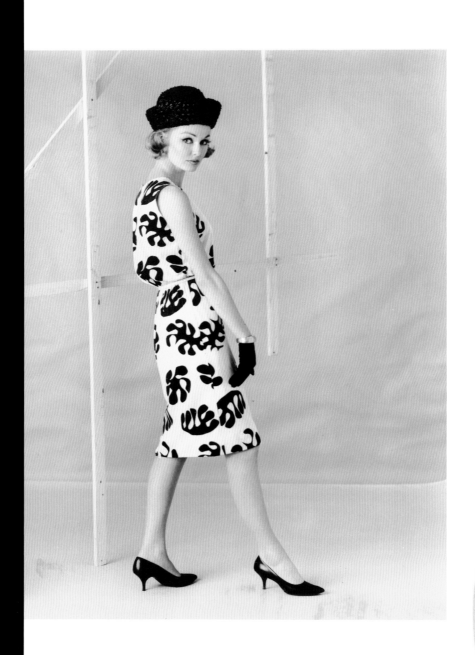

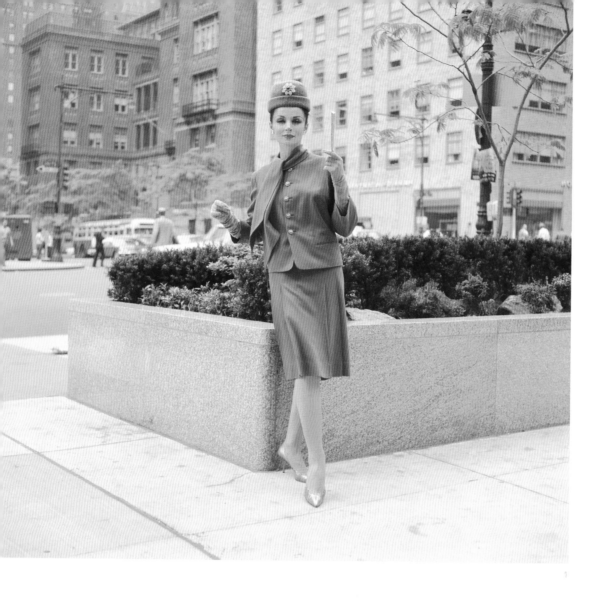

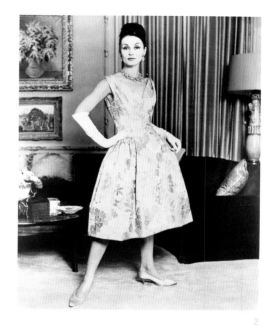

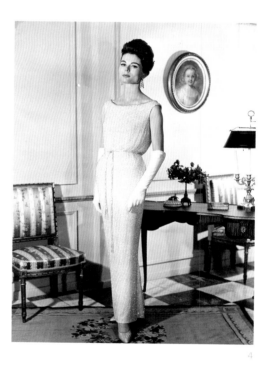

1960

A boxy fall suit is shown by ready-to-wear label Suburbia in gold wool. Shown here are rounded big coats by Pauline Trigère, Originala, and Arthur Jablow. A columnar evening gown is enlivened by overall sequins or bugle beads—two examples here by Ceil Chapman. Hair is now "set" on rollers, heated under a hood dryer. A young woman stands in a doorway holding the new invention of a travel hair dryer with bonnet in a fitted case.

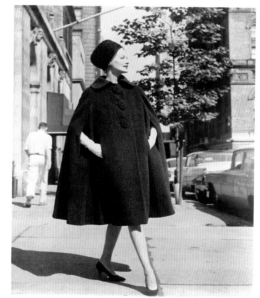

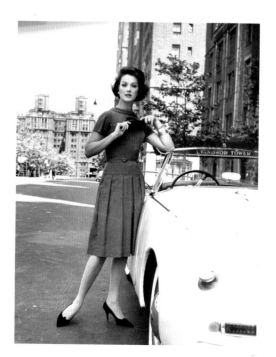

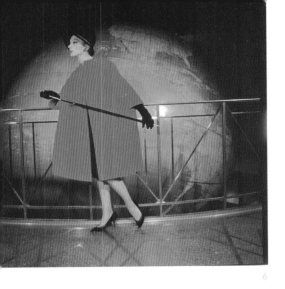

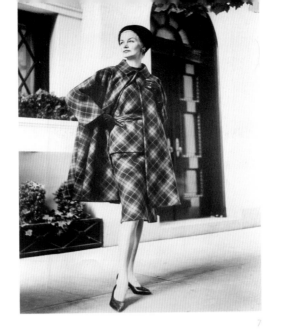

6

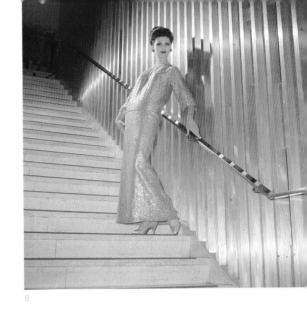

7

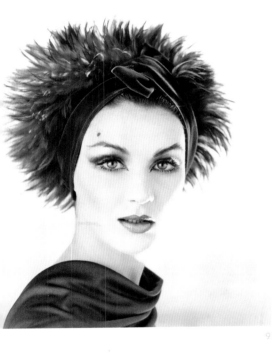

8

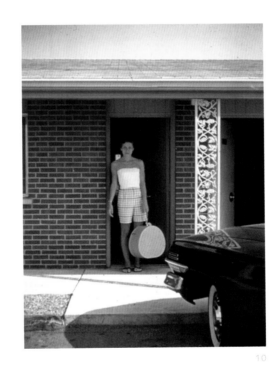

9

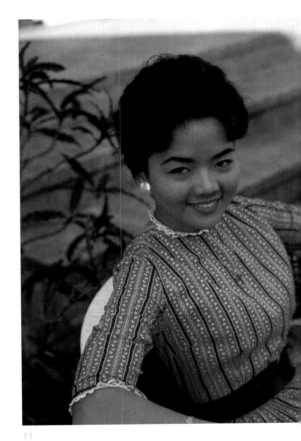

10

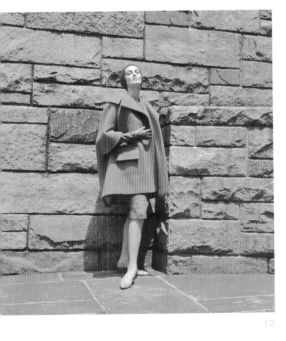

11

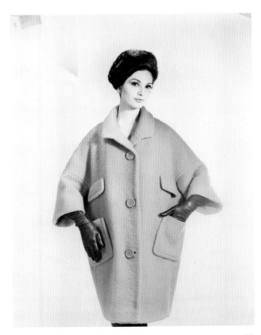

12

13

1961

Hemlines still cover the knee in a dress in shades of taupe, worn with a turquoise bib necklace, a dress, and short jacket in black and white diagonal tweed. A red wool one-piece dress with a two-piece look is by Italian designer Rapuano.

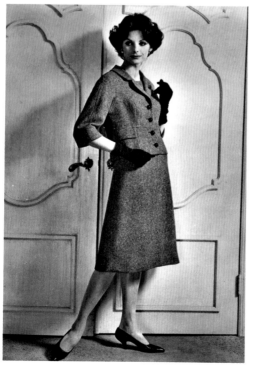

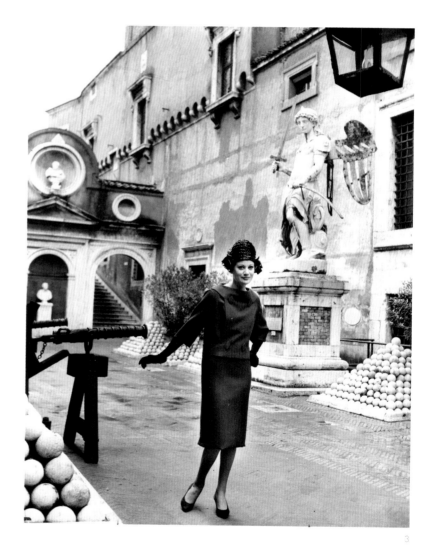

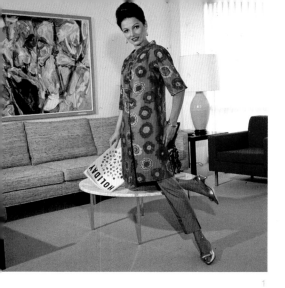

1962

A bride makes a fast getaway wearing Wellies in the snow. For après-ski, Jacques Tiffeau presents pants in textured gold wool worn with a black wool V-neck sleeveless overblouse and triangular scarf. A patterned Nehru coat and silk pants is the kind of look that becomes widespread for at-home while an evening gown features a stylized calligraphy print. The First Lady's influence can be seen in bright or pale suits with gently shaped skirts and slightly boxy jackets, short or bracelet length sleeves, and big buttons.

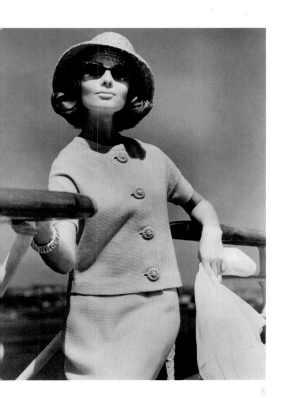

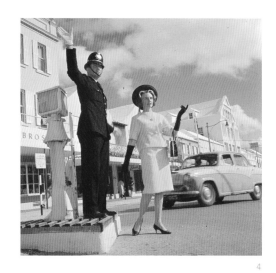

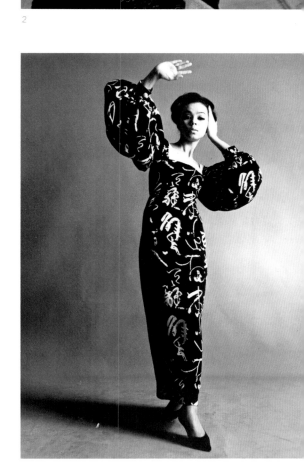

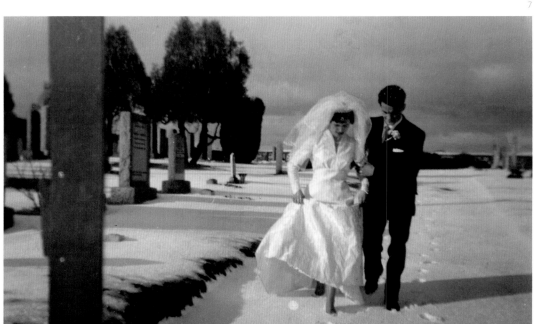

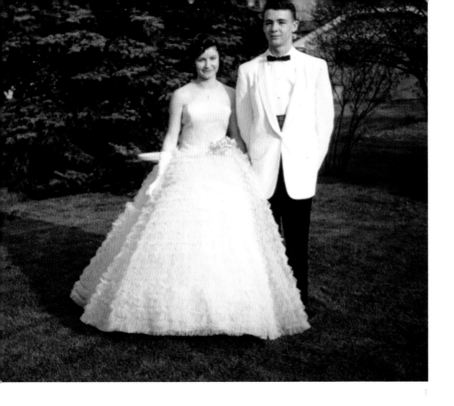

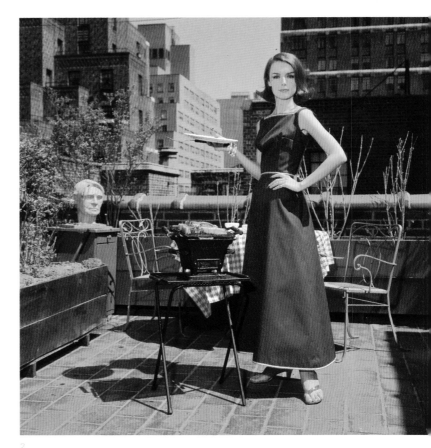

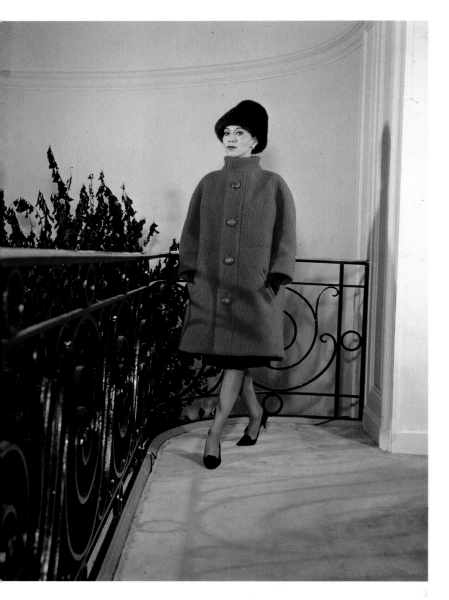

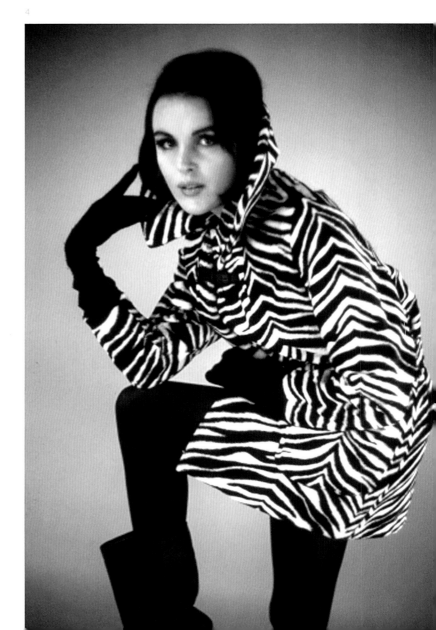

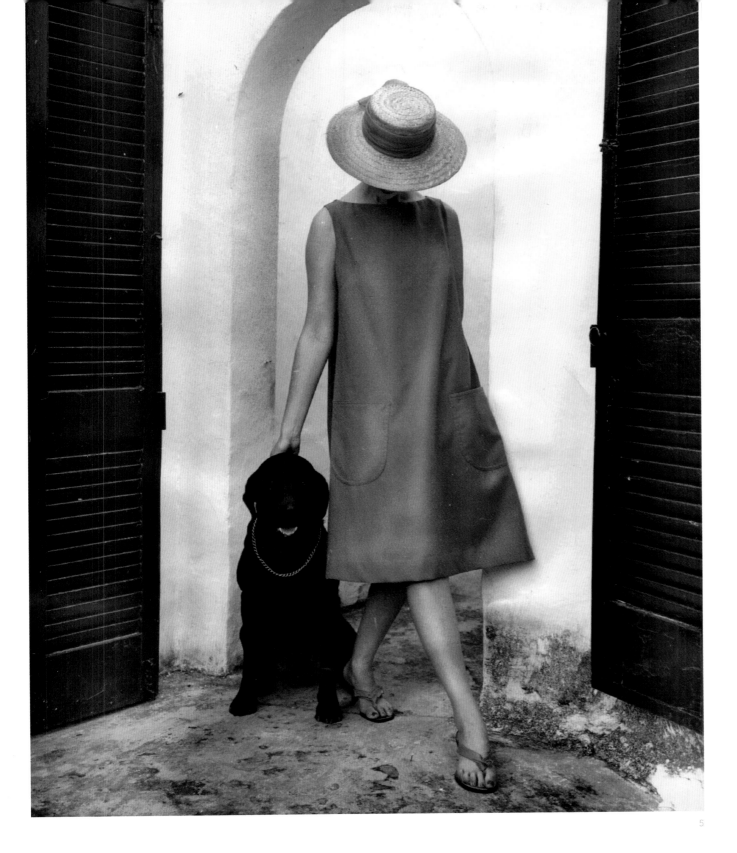

1963

Dressed for the prom in a strapless tulle gown and white dinner jacket. Casual summer evening dress is worn for a hibachi cookout on a New York terrace while a tiger stripe mini-trench is worn with black tights and ankle boots. Also shown here: a structured and curved haute couture look by Yves Saint Laurent and an unstructured tent dress in burnt orange sailcloth from The Villager—a ready-to-wear label specializing in separates for teens.

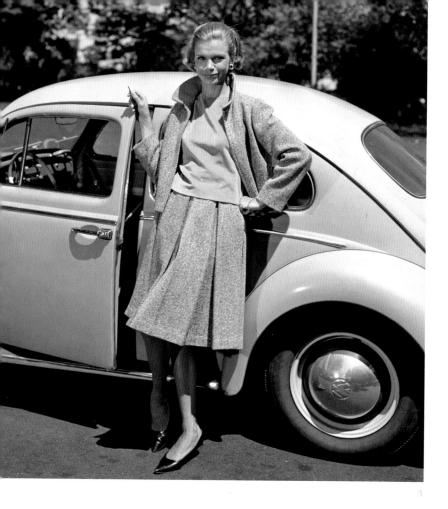

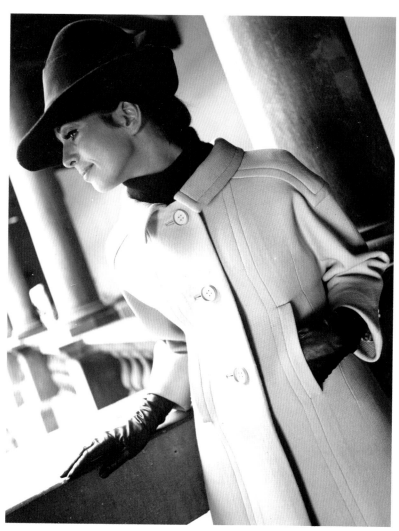

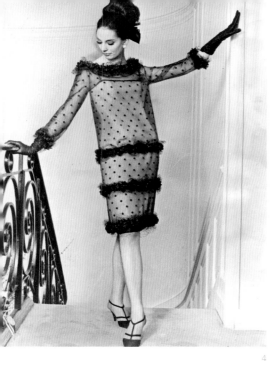

1964

Hemlines are creeping above the knee—shown here in two styles modeled by the same young woman in New York: a Henri Bendel two-piece ensemble of black and white textured wool and a Saks Fifth Avenue suit with double-breasted jacket cut away from the neck. Each at $185.00, both styles were expensive for youthful looks.

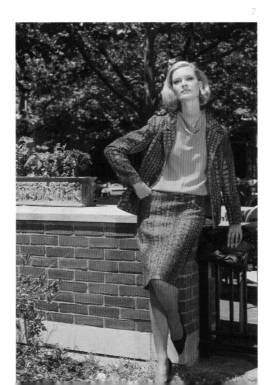

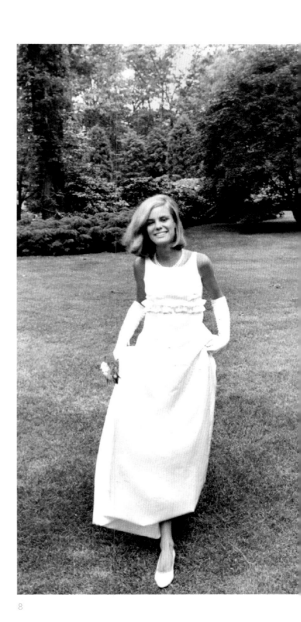

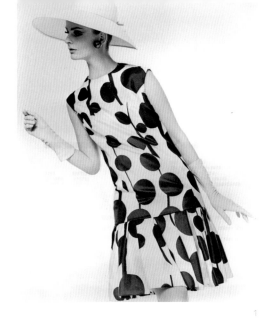

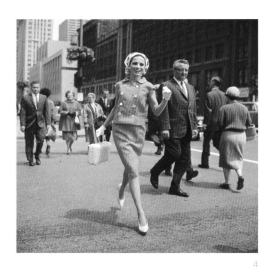

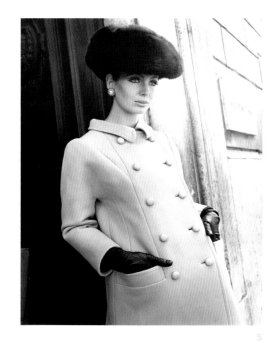

1965

Finger on the pulse designer Mary Quant wears her own knee-baring shift dress, patent double purse on long chain, and ankle strap low-heeled shoes while her husband Alexander Plunkett-Greene wears a suit with the mod touch of safari pockets and low boots. Mrs. Alfred Gwynne Vanderbilt (Jean) is at the Opera Ball wearing Balenciaga's gold brocade sari evening dress with jeweled edging, chandelier earrings, and Indian embroidered evening envelope. And 1960s "It" girl Mrs. Leonard (Baby Jane) Holzer, wearing a wool twill coatdress with fringed wool ruffled cuffs, chats with illustrator Joe Eula.

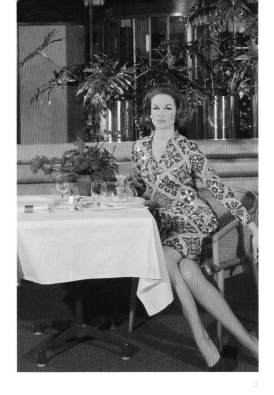

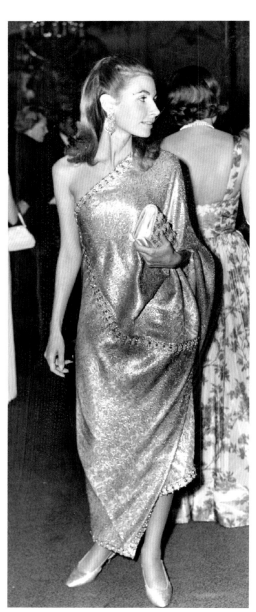

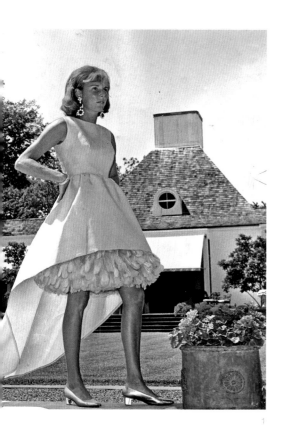

FREEWHEELING

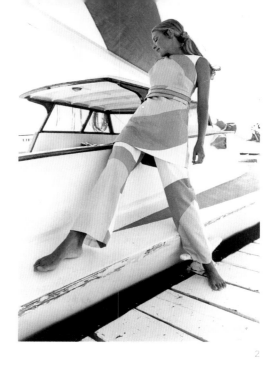

In September 1965, *Time* magazine comments on the new scene: "Not so long ago she might have gotten by with illustrious bones, a rumor of a bosom, reliable cosmetics, and a stomach that could settle on Ry-krisp and yoghurt, but fashions in fashion models change. These days the girl who can't perform a mean frug might just as well turn in her hatbox. It's a cinch that she will never make the scene." Freestyle 1960s dances called for freewheeling styles.

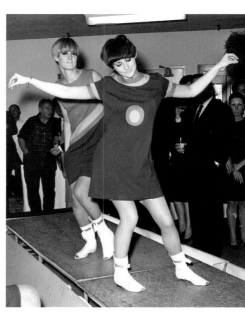

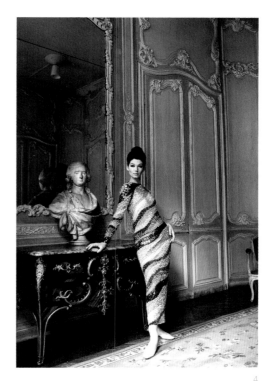

1966

Pierre Cardin gives an haute couture swing coat a space age helmet lined with luxurious fox fur. Rudi Gernreich makes a cheetah print head-to-toe ensemble, and Yves Saint Laurent is inspired by a visit to an American Army-Navy thrift shop to go nautical. New effects include clear vinyl used for a raincoat, the knitted technique called Malhia which involves weaving rather than embroidering sequins, and DuPont Orlon knits used for casual tops.

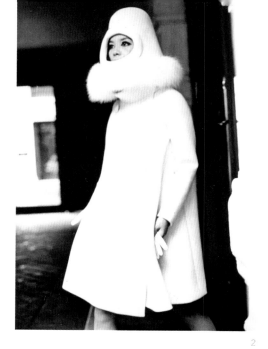

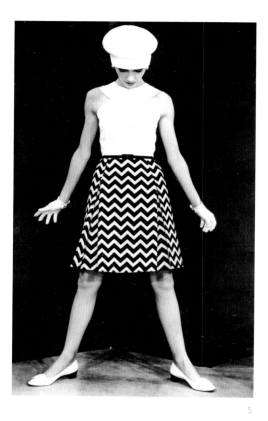

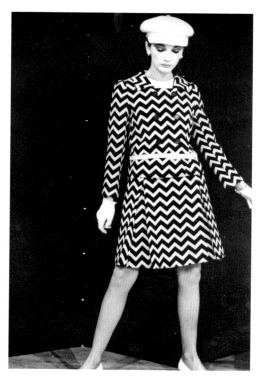

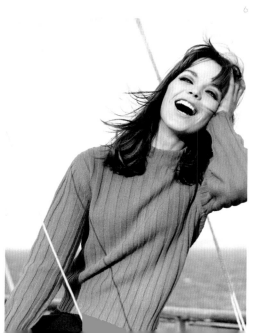

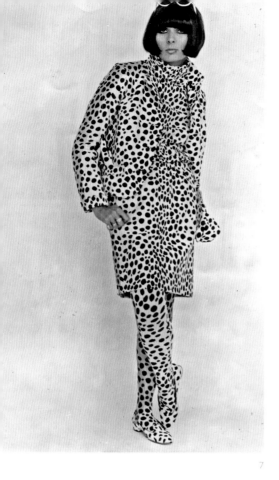

7

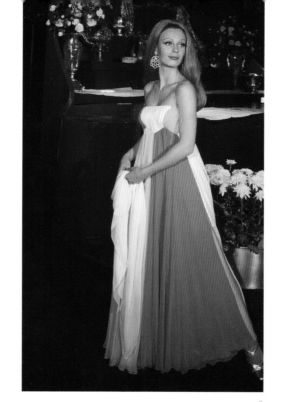

8

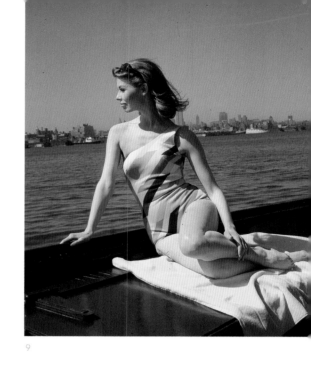

9

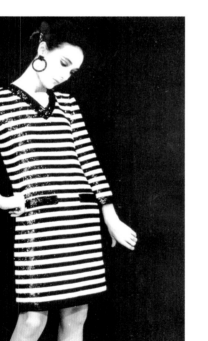

10

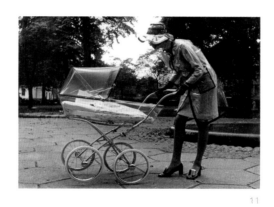

11

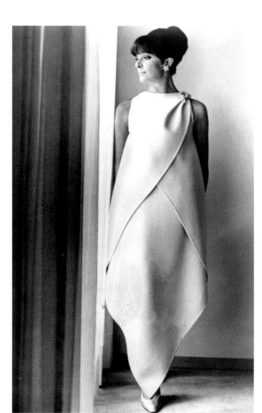

13

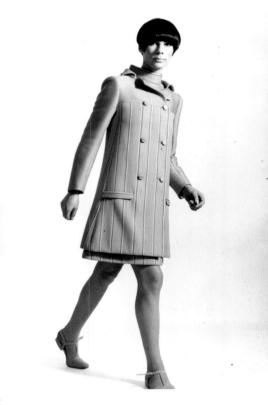

12

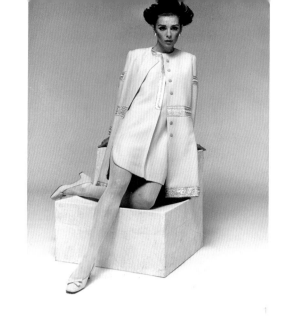

1967

Boutiques, young and up-to-the-moment, have become the place to shop. Models wearing an assortment of skirt lengths, all grounded by low-heeled boots, pose outside a new boutique in London's Chelsea.

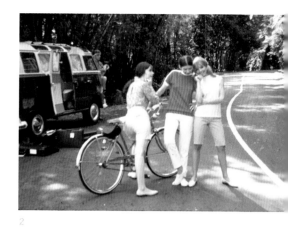

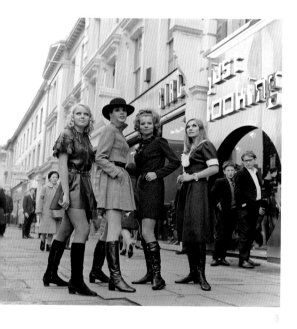

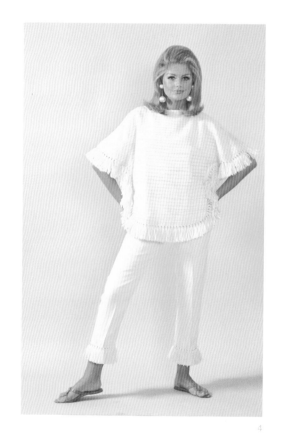

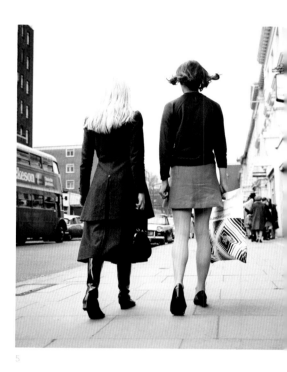

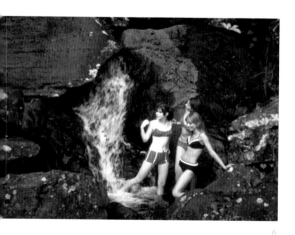

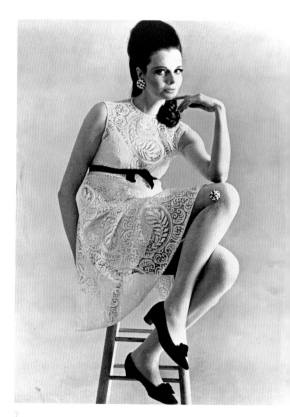

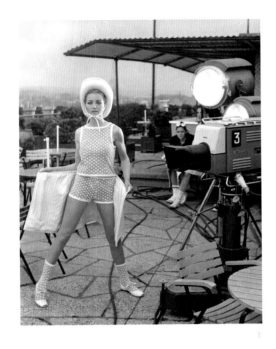

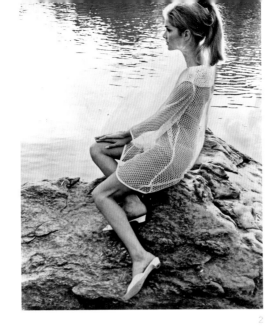

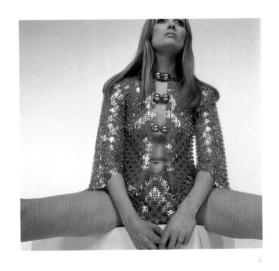

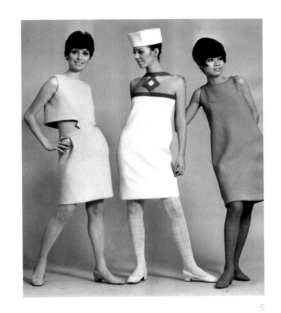

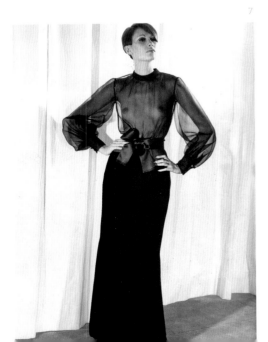

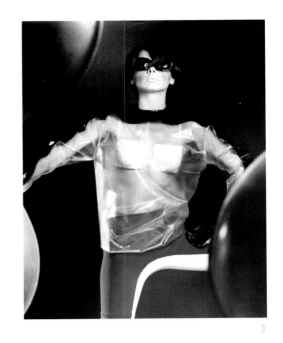

BARE MINIMUM

Nudity generates publicity and sales. Rudi Gernreich designs his topless bathing suit in 1964 as a statement about prudery, only to sell 3,000 of them. The following year, Cole of California introduces the Scandal suit with its décolleté mesh panel. Selling more than 200,000 of them, Cole buys a new factory to keep up with demand. Also pushing the nudity envelope are Sylvia de Gay for Robert Sloan's sportswear fishnet beach dress, Ruben Torres's clear and black patent vinyl overblouse and square bra top in lace, Paco Rabanne's celluloid acetate dress, Pierre Cardin short cutout dress, and Yves Saint Laurent's Fall/Winter 1968–1969 evening dress "75" in black velvet with transparent bodice of transparent black cigaline.

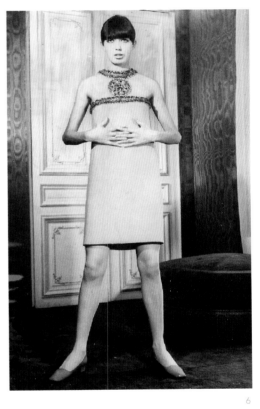

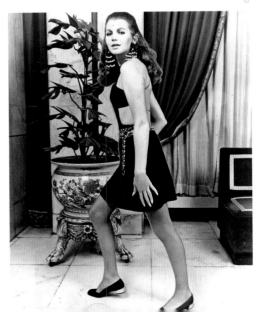

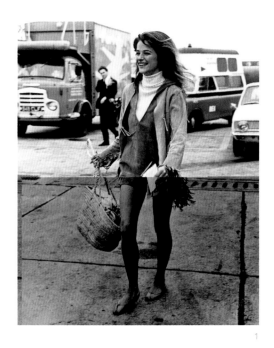

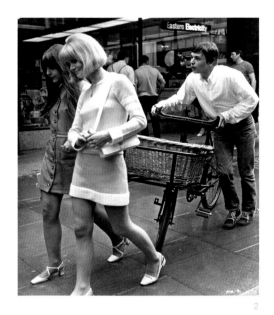

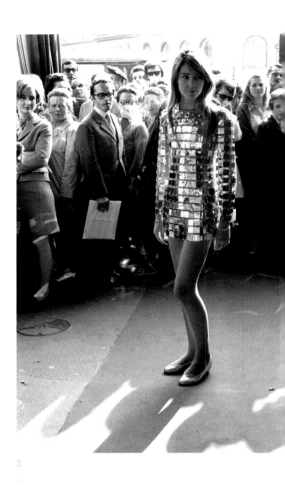

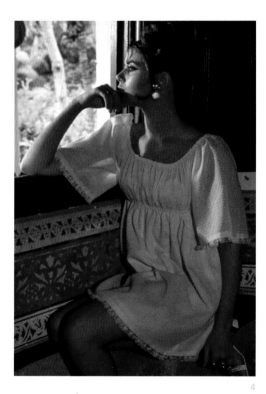

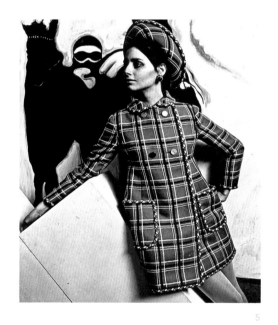

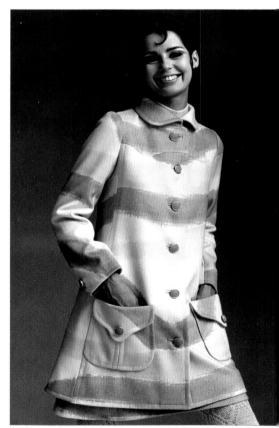

1968

The mini continues to rise thanks, in part, to new and improved pantyhose. Fringed suede mini dress and straw tote is worn by actress Charlotte Rampling while French singer Françoise Hardy wears a mini dress by Paco Rabanne. Mini skirts and sandals are worn by actresses Judy Geeson and Diane Keene in a scene from *Here We Go Round the Mulberry Bush* (1968). Shown here, an evening jumpsuit with bare midriff knotted bodice, foot jewelry, and multiple rings.

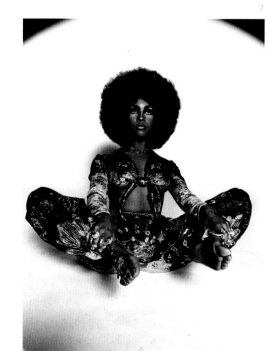

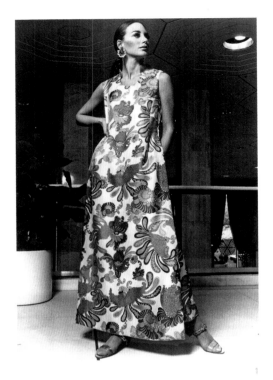

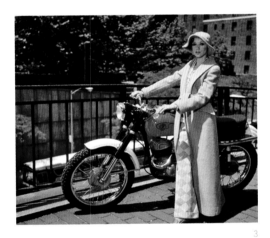

1969

Anxiety about hemlines produces commentary like this from September's *Harper's Bazaar*: "What every woman ought to know: the hemline has dropped. But don't panic. It hasn't dropped a bomb. Hemlines have come down. In Paris, the feeling for the longer skirt is up, up, up. But by day, Paris goes to every length. Hems brush the instep, tap the ankle, cover the calf, divide the calf, hit the knee bone or stay thigh-high."

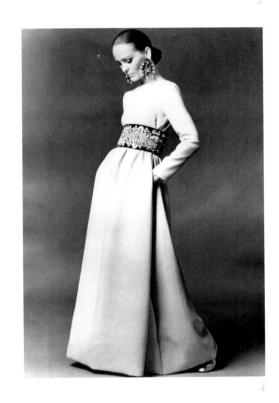

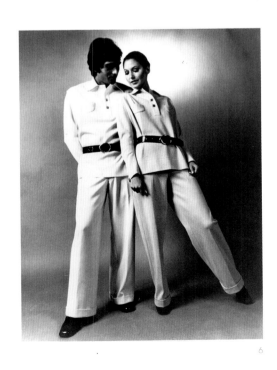

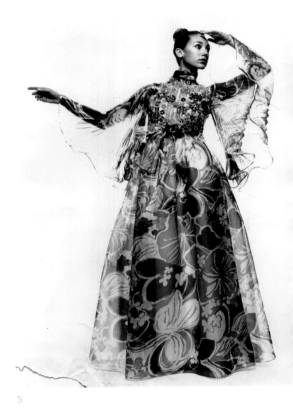

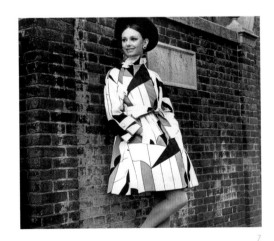

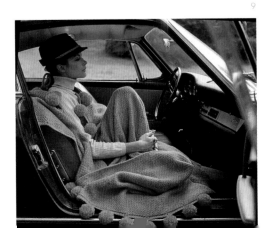

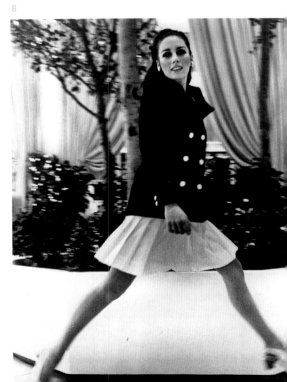

1970s

A new era in androgyny: unisex dressing. As Mary Quant put it: "Since the sexes live much the same sort of lives, they want the same sort of clothes to live them in." Both outfits are based on male attire but forward looking, supplanting the collared shirt and tie with a sweater or tunic.

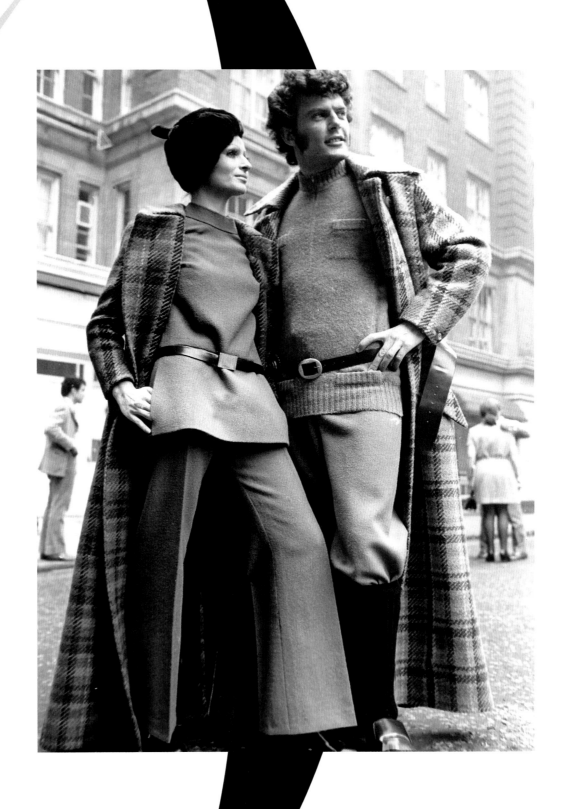

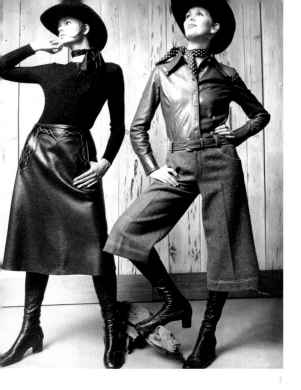

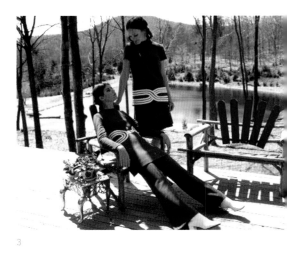

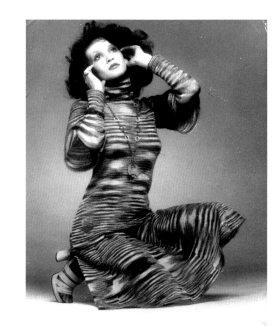

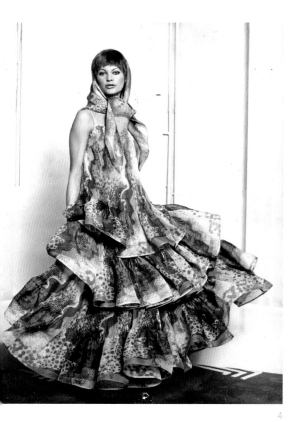

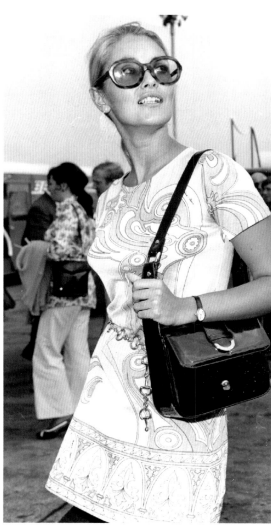

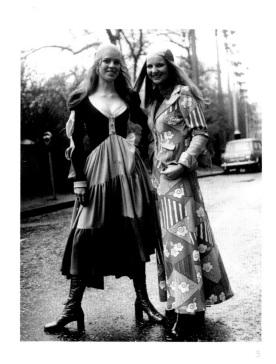

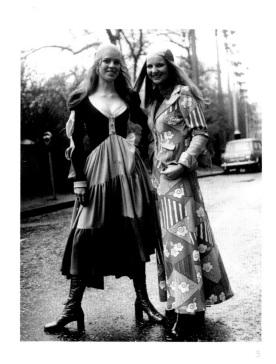

1970

"The Great Hemline Hassle" read the cover of a 1970 *Life* Magazine. Mini skirts could be interpreted as freeing for women (in the sense that they were useful for flouting convention), but there was also sexism in the common view that men didn't want to see them disappear. Designers offered new lengths, the midi and the maxi, as well as an increasing variety of pants. The end of conformity, its seeds planted during the revolutionary 1960s, was now assured.

8

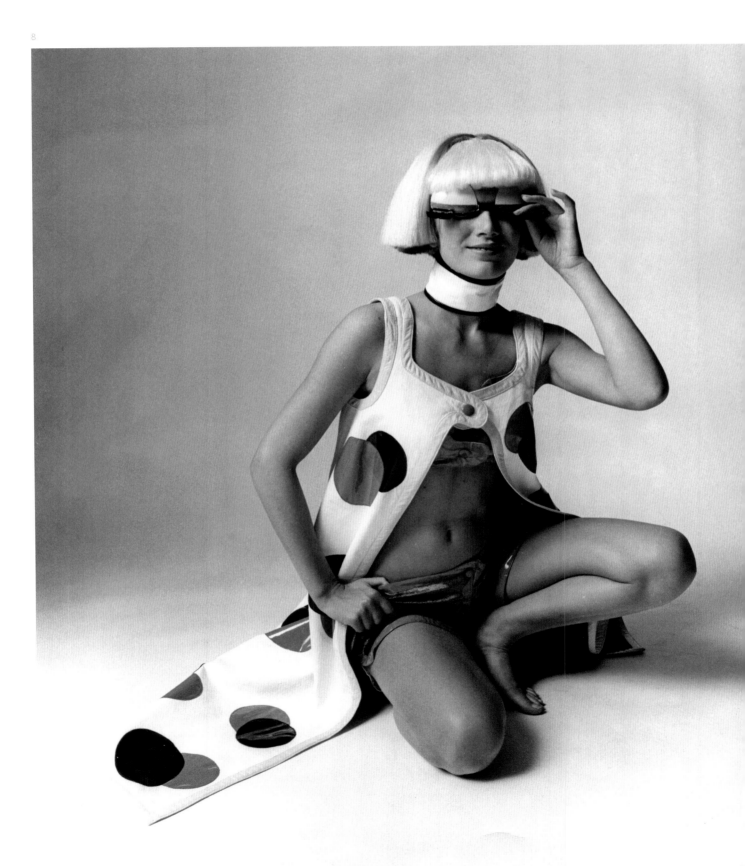

HIPPIE CHIC

The 1969 Woodstock music festival and its documentary released in 1970 brought wide attention to the counterculture, one aspect of which was dressing outside the system. This included DIY, like tie-dye, macramé, and crochet, as well as jeans (not at the time allowed in the workplace, on campus, or in many public places), and vintage clothes, which could be purchased for pennies or scavenged. The vintage clothes that were still widely available included true marvels: velvet opera cloaks, Edwardian lingerie dresses, 1920s beaded chemises, and 30s bias cut charmeuse dresses. And, perhaps unsurprisingly, how these clothes were worn inspired mainstream fashion designers.

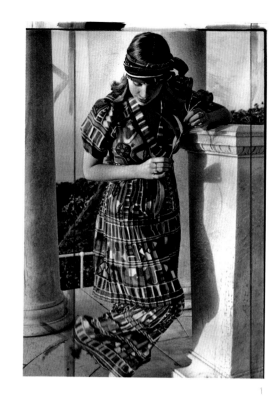

1

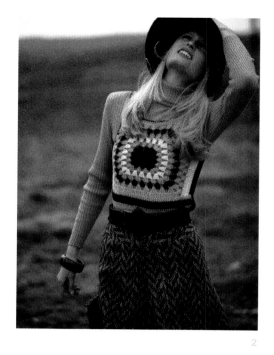

2

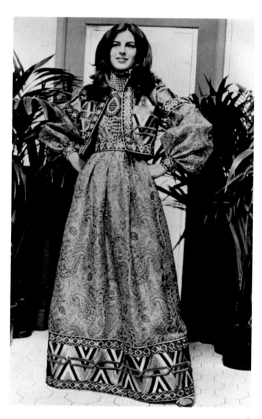

4

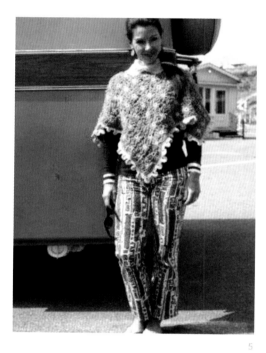

5

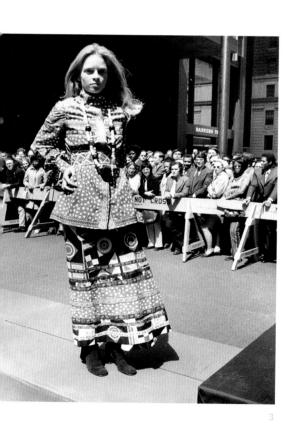

3

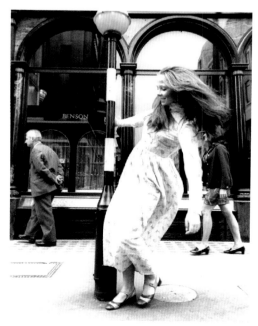

6

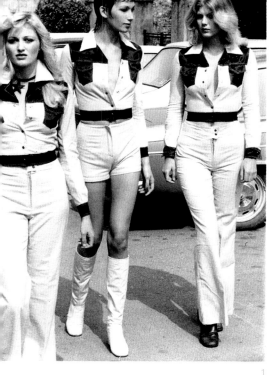

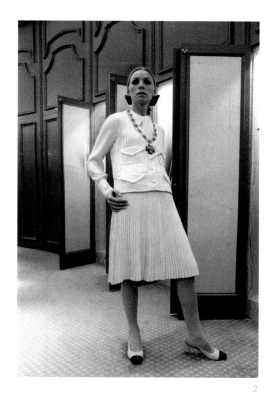

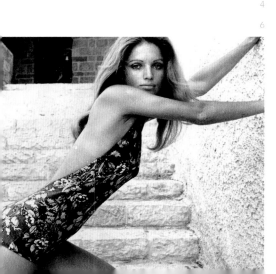

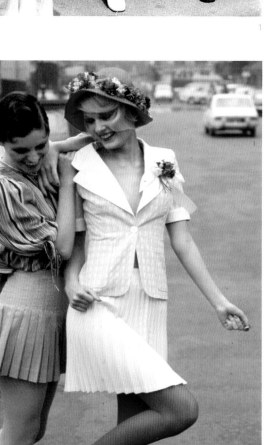

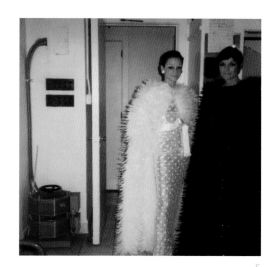

1971

Hot pants arrived just in time to allay anxiety about the disappearance of the mini. Short shorts were seen in St. Tropez worn with boots and peeked out from underneath a long skirt slit to the waist, like these looks shown by Elinor Simmons for Malcolm Starr. Ossie Clark shows an ankle length party dress, and in Paris, two lengths of pleated skirts are shown with bright tights while a Chanel suit from her last collection features a skirt arriving just below the knee.

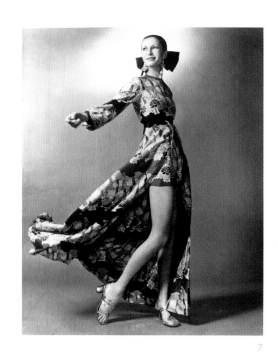

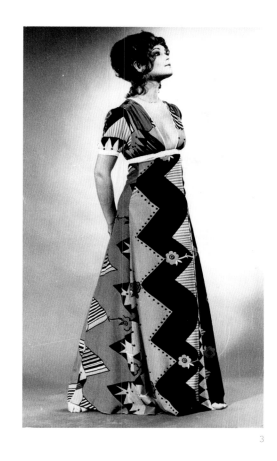

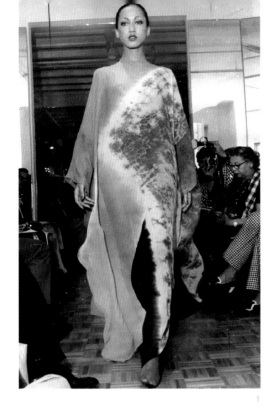

1972

Hippie meets high fashion in a Halston tie-dyed caftan, modeled by Pat Cleveland. A variety of pants styles abounds: A black crepe halter bra by Chloé worn with black and white pajama pants, a coat and matching pants by Anne Klein, and a pants ensemble with pleated peplum tunic top in printed cotton with a border by Cacharel. Geoffrey Beene makes an evening dress as casual as a T-shirt in blue-and-white striped chiffon. Also shown a woman dresses for Royal Ascot in a marabou chubby jacket with an Edwardian vintage purse.

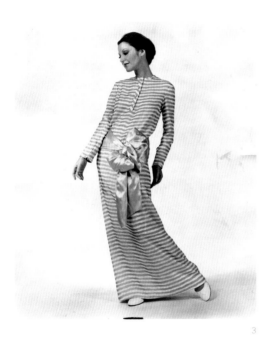

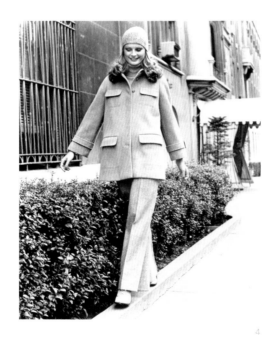

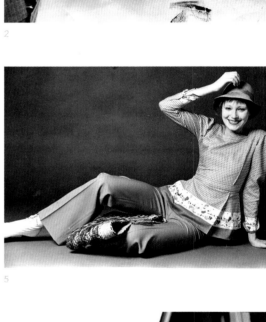

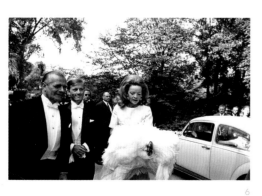

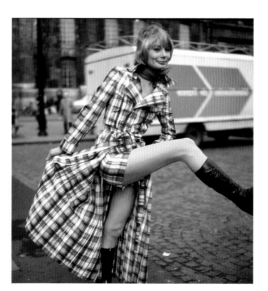

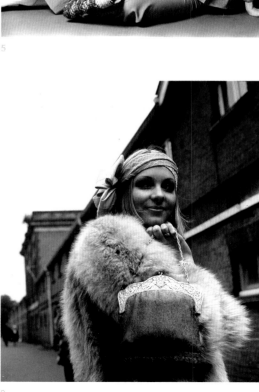

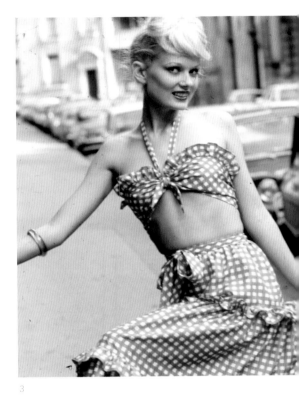

ROMANTIC PEASANT

The peasant (or poet's) blouse and the dirndl—elements of vintage chic—become their own category of dressing. Bill Blass designs the evening look of a poet's blouse in silk with a flowing long skirt, and Kristin Clothilde Darnell models a tartan evening dress. Yves Saint Laurent designs many variations of what will come to be known as the rich peasant look: some were famously Russian inspired, others Spanish, as in the corselet bodice worn with a ruffled taffeta skirt.

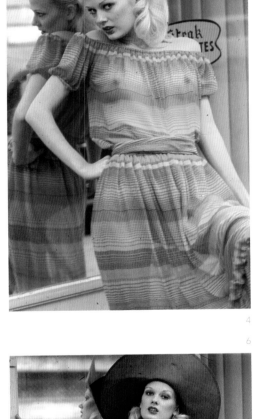

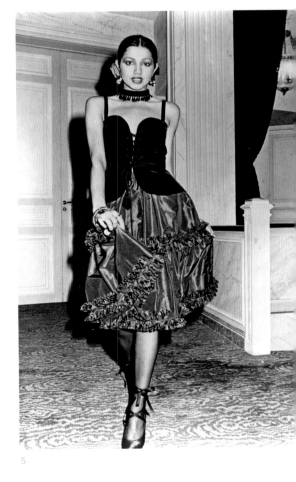

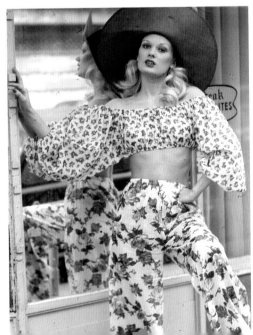

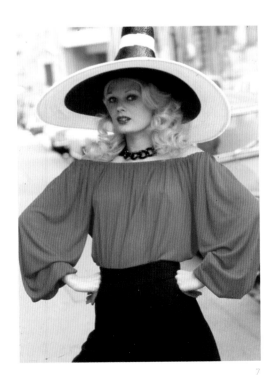

1973

Pucci prints, reflective of a jet-set vibe, remain popular even as neutral tones and natural textures and fibers become more prevalent. A chunky, ribbed knit sweater is worn with tweed skirt and boots. Ralph Lauren shows a poplin trench coat with wide lapels, button-out camel hair lining, and Loulou de la Falaise models Yves Saint Laurent's man-tailored turnout softened with smock jacket and print blouse.

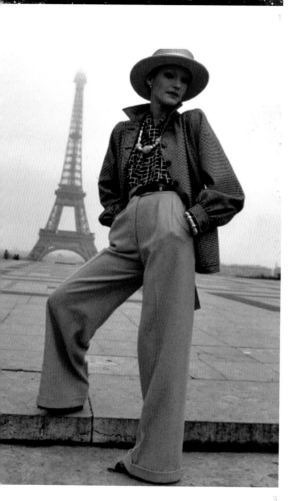

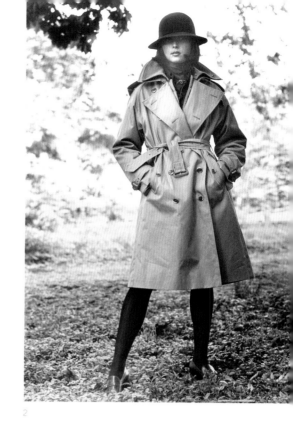

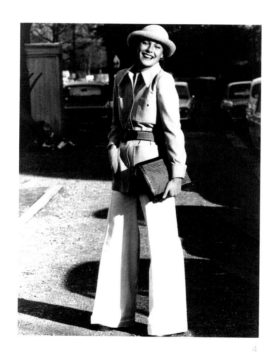

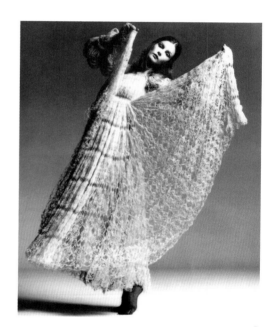

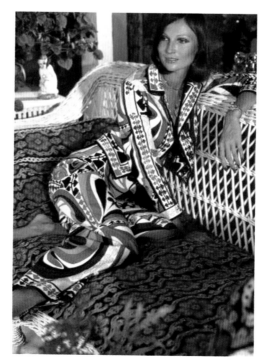

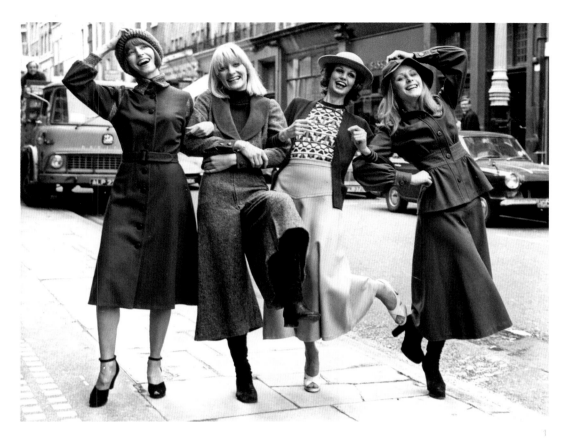

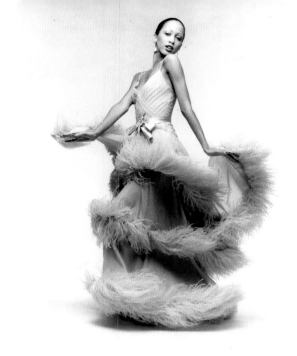

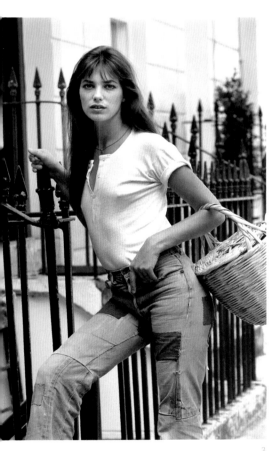

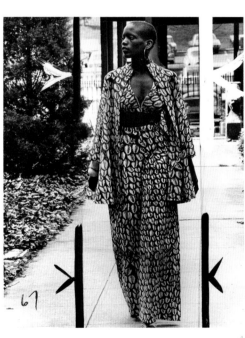

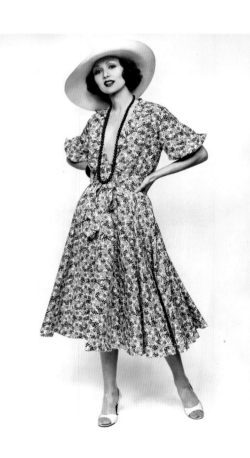

1974

Mary Quant offers a variety of skirt lengths and gaucho styles for spring, as Valentino shows a 1930s revival evening dress with Ginger Rogers' worthy ostrich trim. African-American designer Willi Smith shows a party outfit of pants, bra, and jacket in a print referencing African cowrie shells. However, the most lasting style is the simple white T-shirt without a bra worn by Jane Birkin.

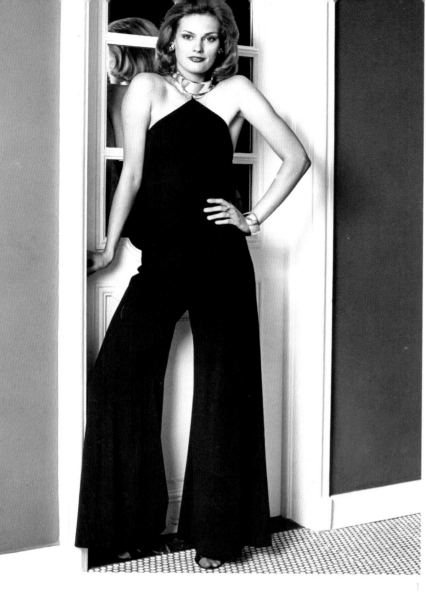

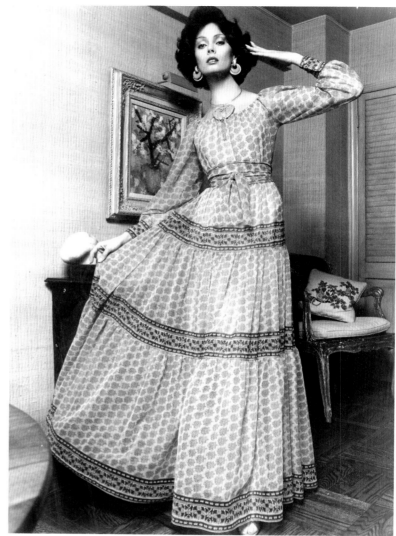

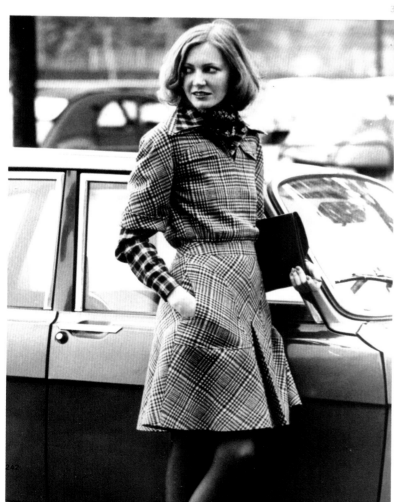

1975

Rudi Gernreich shows a black jersey evening pajama with silver choker, Albert Capraro for Jerry Guttenberg Ltd. makes a peasant evening dress in peach and brown printed chiffon, and Cacharel shows a tailored short dress in Prince of Wales plaid wool layered over another plaid shirt.

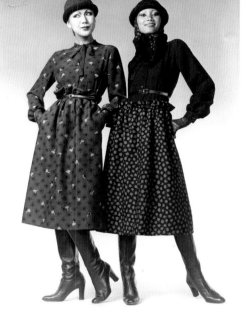

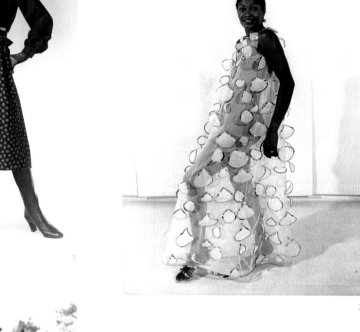

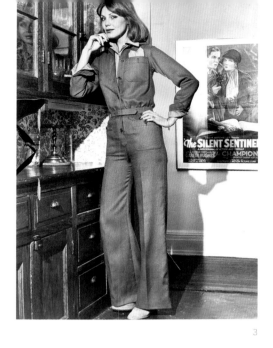

1976

A below-the-knee-length hem is seen in Givenchy haute couture dresses in wool challis with paper bag waists. A buttoned, big, cowl-neck sweater and flared corduroy skirt with suede cropped jacket and jodhpurs is shown by Donna Karan and Louis dell'Olio for Anne Klein & Co. In an influential collection, Yves Saint Laurent looks to China for an evening ensemble of velvet jacket trimmed with metallic piping worn over jacquard silk tunic and velvet pants and velvet hat with tassels. Barely there underwear was required for the narrow lines of 1970s clothing.

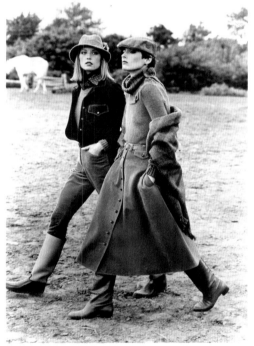

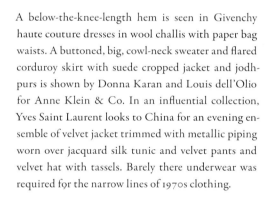

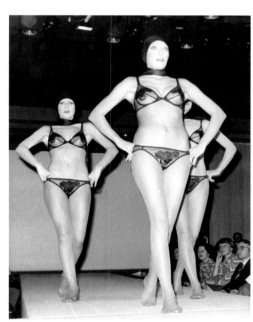

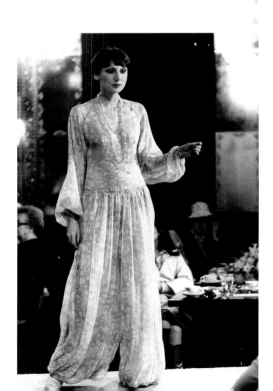

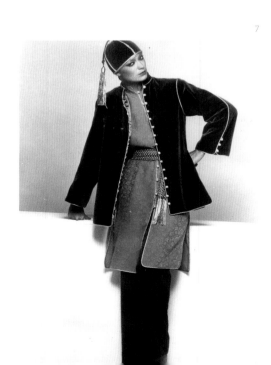

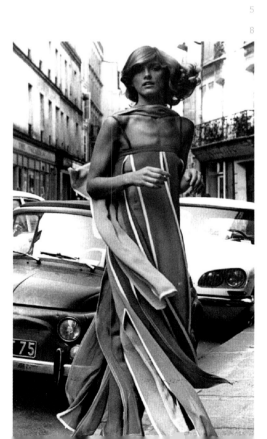

1977

In February, *Vogue* extols: "The breeze of skirts all over the place—fuller skirts, sometimes dirndl-full. Not pushing pants out of the picture, just adding a new—more romantic—dimension! Sexiest (in a sneaky way): sliding necklines . . . sliding open, sliding closed Sexiest (in a not so sneaky way): the look of great legs through slit-skirts . . . and high-heeled sandals. . . ."

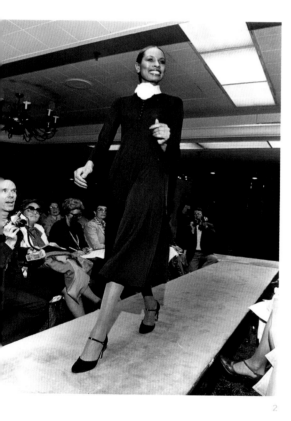

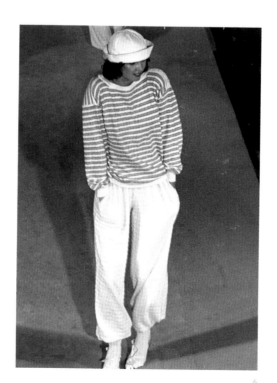

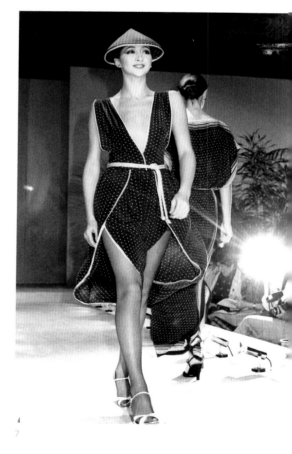

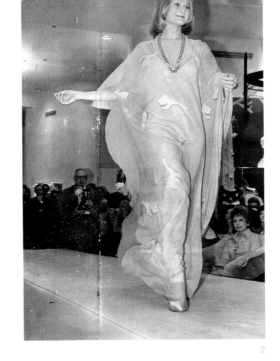

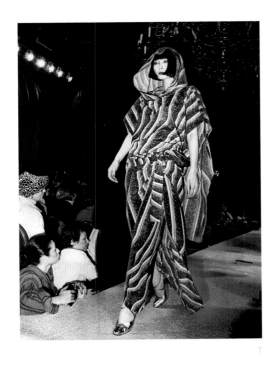

FLOW

Supple materials like silk chiffon, jersey, charmeuse and DuPont's Qiana are used for caftans, jumpsuits, and pajama and peasant styles shown here by Stephen Burrows, Kansai Yamamoto, and Halston.

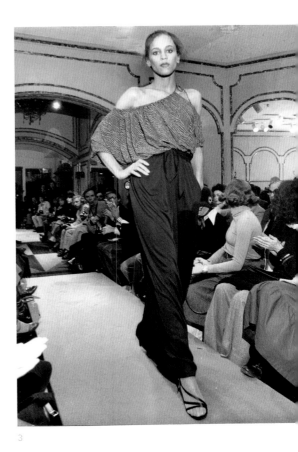

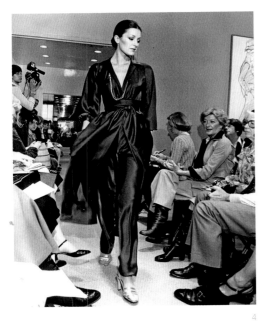

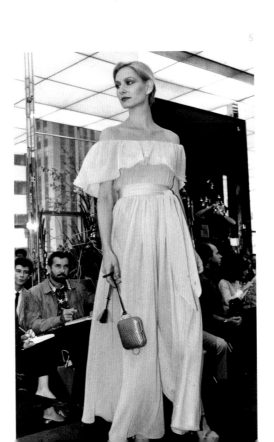

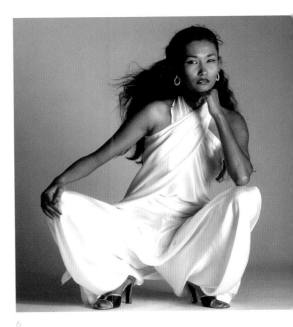

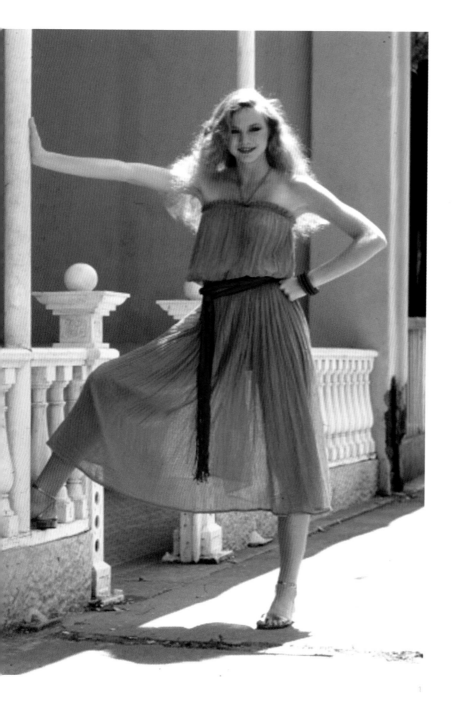

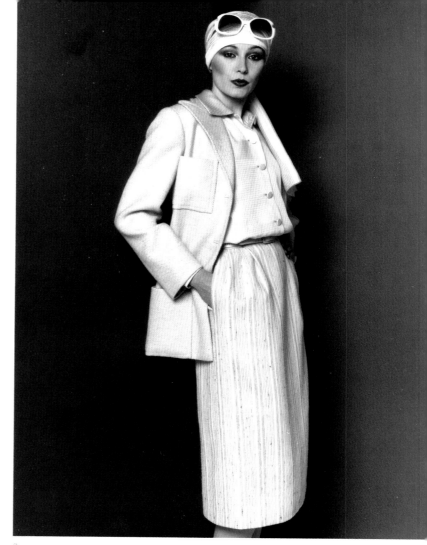

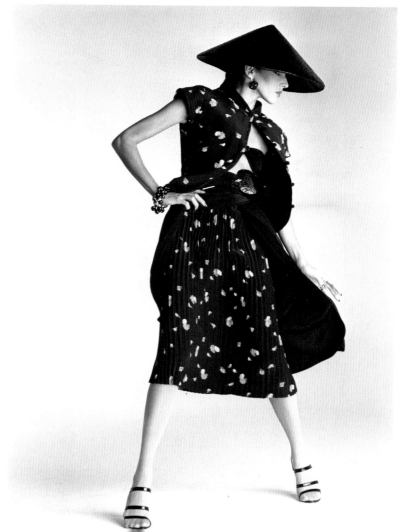

1978

A crinkle gauze sundress with self-piping halter is typical of a casual 1970s vibe. Looking ahead towards the 1980s are a formal skirt suit by Balmain in shades of beige and a dressy Valentino Boutique sunbathing ensemble "à la Japonaise."

1979

The disco era, fully underway with the opening of Studio 54 in New York City in 1977, calls for attention-getting sexy styles dressed up with metallics for nighttime. There is a new opulence to such styles as Nina Ricci's gray flannel skirt worn with lunarine mink jacket, Pierre Cardin strapless jumpsuit with pleated overskirt, and Valentino's haute couture strapless ball gown and shawl. For Chloé, Karl Lagerfeld shows textured minis.

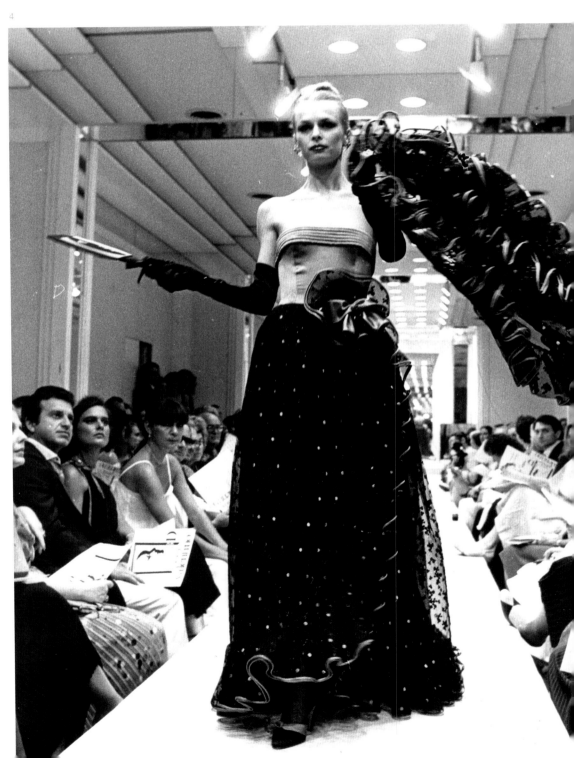

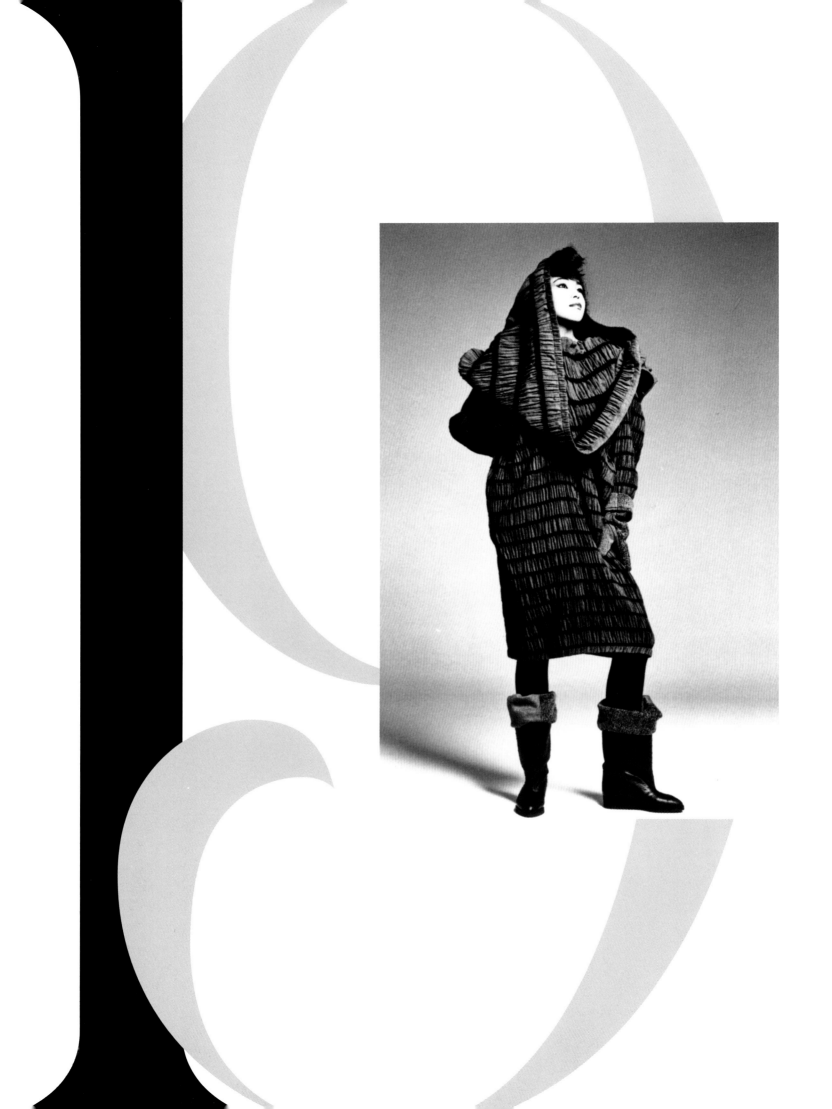

1980s

It is ground-breaking when a gallery at M.I.T. includes works by Issey Miyake (along with seven other designers) in an installation called "Intimate Architecture: Contemporary Clothing Design" in 1982. Fashion has previously been seen in a museum setting primarily as an enormously decorative historical artifact, and Miyake's works are now being considered as woven objects that blur the lines among technology, craft, and art. There is an intellectual heft to such clothes and a greater sense of actual volume, too. It is a new way of thinking about and designing clothes.

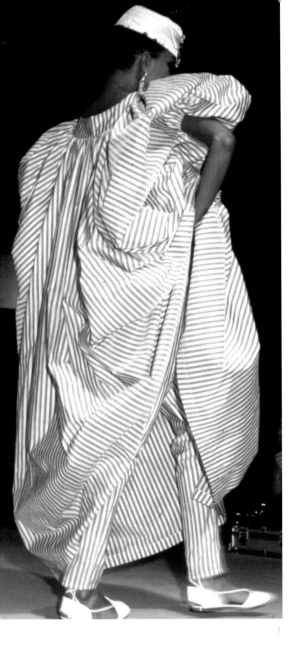

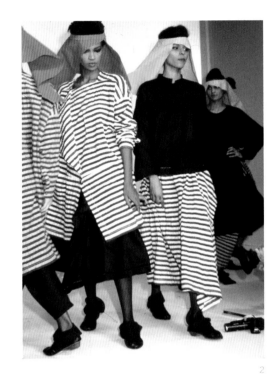

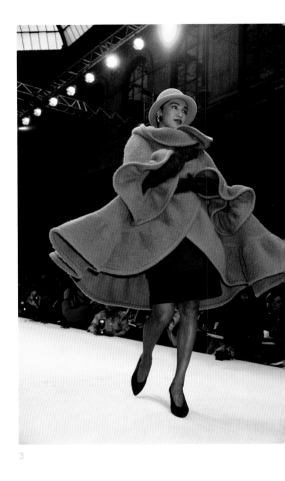

VOLUME

Fashion inflates during the 1980s—not just shoulders (bolstered generally by shoulder pads) but the overall scale. Even hair gets big and is worn with gel and mousse to stand out from the head. Kenzo shows a billowing striped dress over stovepipe pants, and Issey Miyake comes out with striped separates. A purple flared coat worn over a suit is a haute couture design by Gerard Pipart for Nina Ricci. Perry Ellis's oversized linen blazers are striped and worn with just-above-the-ankle pleated skirts with pale stockings and dainty pumps particular to the early 1980s. Giorgio Armani shows a jacket in plaid with strong shoulders, and Karl Lagerfeld's roomy coat with oversize collar and pockets is worn with opaque black stockings and slouchy boots.

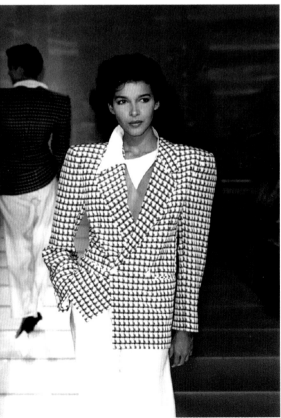

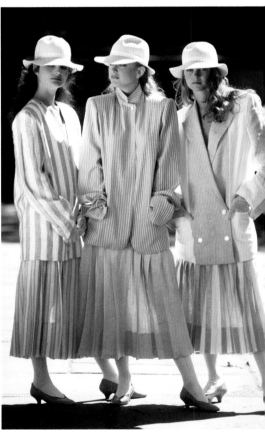

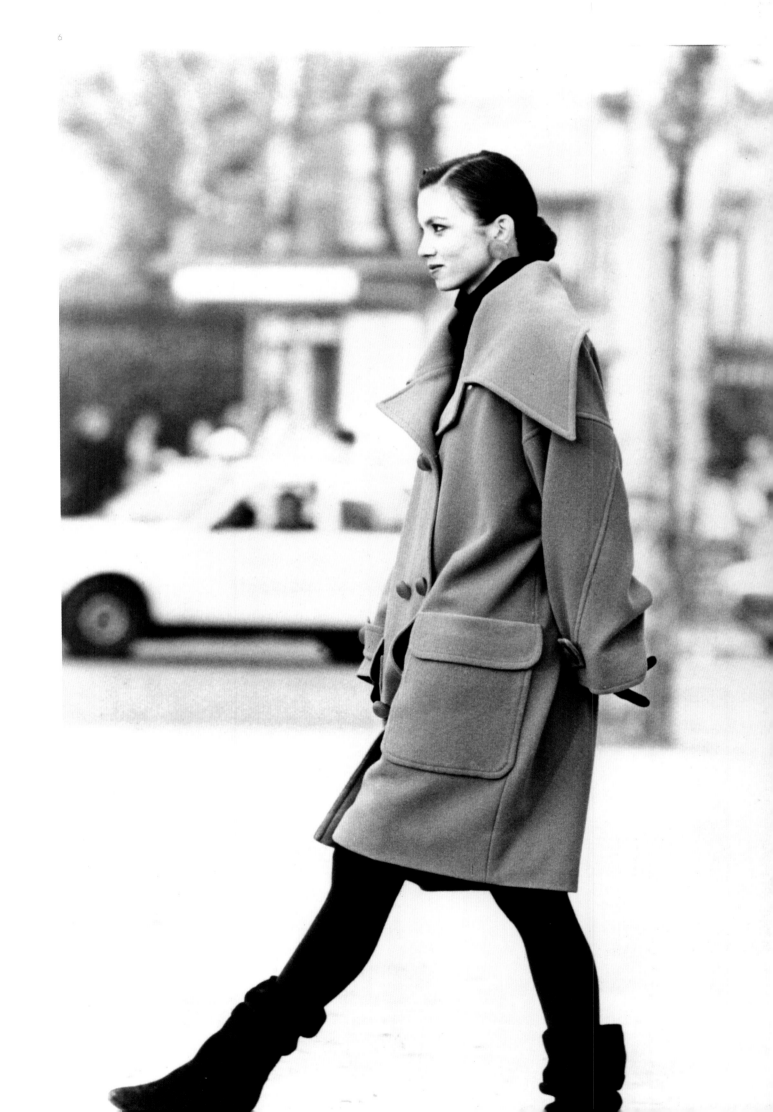

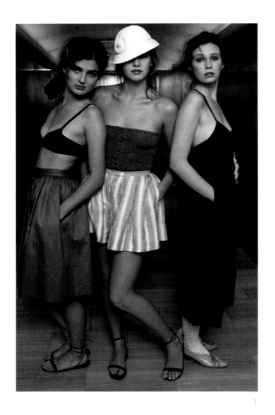

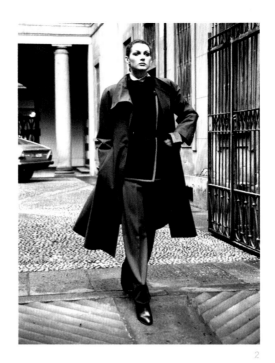

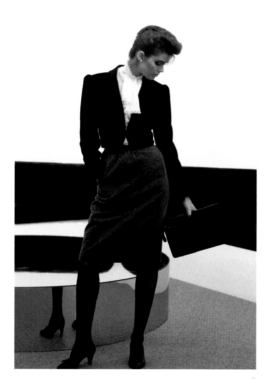

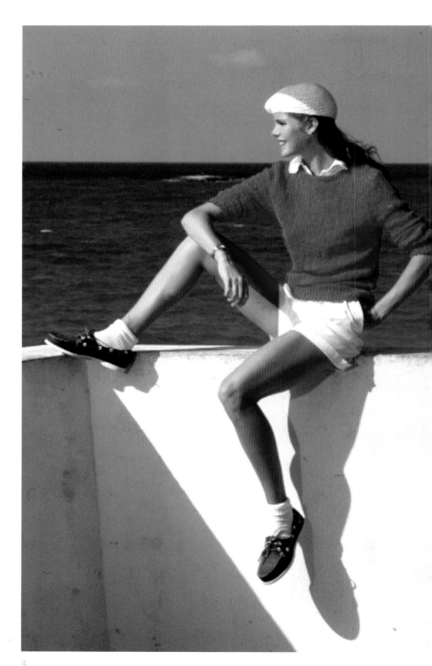

1980

The suit is the dominant look for working women, a group in the United States now nearly 50 million strong. At the high end, designers present coordinated ensembles rather than matching pieces. Gianfranco Ferré shows a double-faced raincoat over a mohair sweater/jacket and flannel pants while Oscar de la Renta creates a cropped black velvet jacket, white silk, and lace blouse ensemble with knee-length gray flannel skirt. Work and play continue to be distinctly separate—play clothes are clean cut and a bit preppy.

1981

Although an American preppy look had existed for most of the century, during the 1980s, it became high fashion. Ralph Lauren specialized in mining the traditional looks of the landed gentry, and here he shows an English countryside ensemble of tweed shooting jacket, checked camp shirt, and sweater vest. Emanuel Ungaro pairs a traditional wool challis skirt with a long leather jacket—the navy and burgundy meet in a line of flames. For vacation wear a bikini top is worn with harem pants and Callaghan jungle print draped pants and blouson top with center slit. Classic jeans and jeans jackets are seen in London.

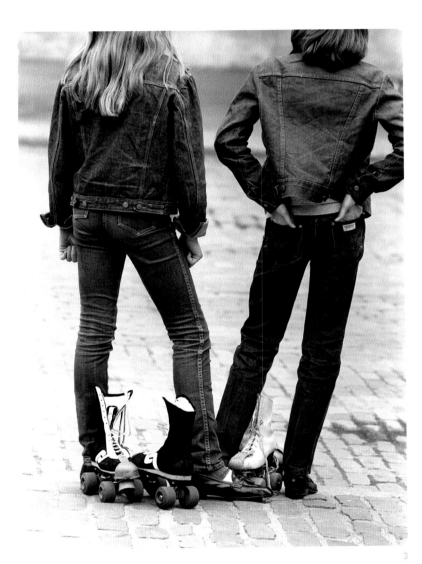

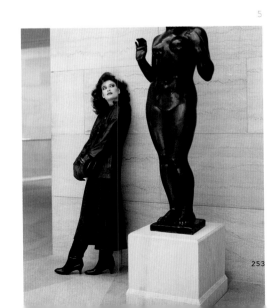

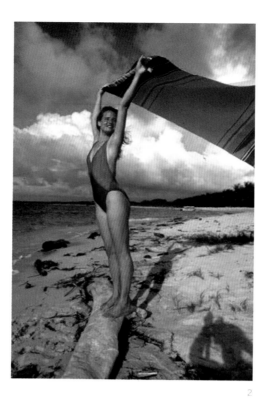

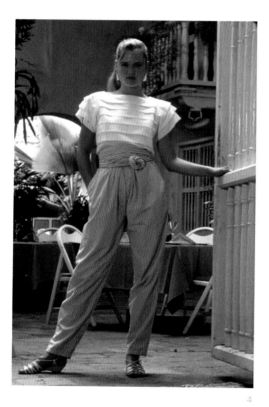

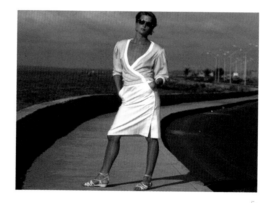

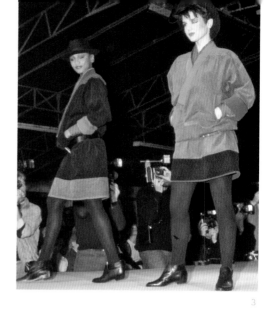

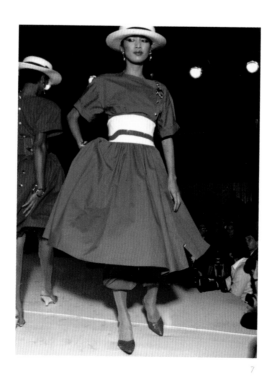

1982

Working out gives women leaner but also noticeably stronger bodices, and bathing suits are cut high on the leg to showcase a toned figure. Cobalt blue is just one of the new bright colors worn during the day.

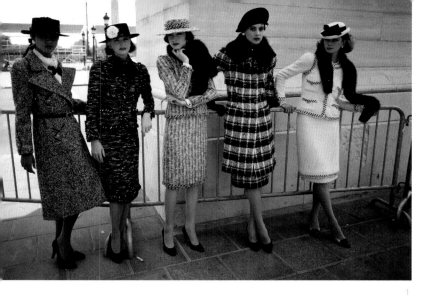

1983

Dominating the world of tailoring is Giorgio Armani, who has provided both men and women with suits based on a jacket draped semi-casually with a powerfully insouciant swagger. Karl Lagerfeld shows his first collection for the house of Chanel in 1983. He tells *Women's Wear Daily* that he hoped to make the Chanel idiom "modern and chic-sexy, not Las Vegas-sexy" (January 19, 1983). Sticking to a palette of navy, black-and-white, and red, he gives new life to tweeds, tweed trim, black satin ribbon bows, and gardenias. The Chanel revival, wildly successful, will whet a growing appetite for the luxury logo.

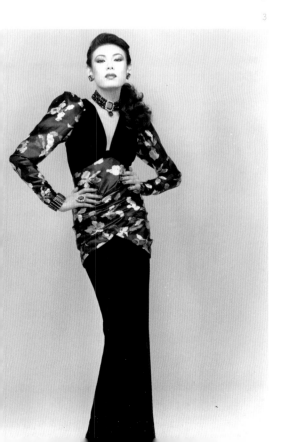

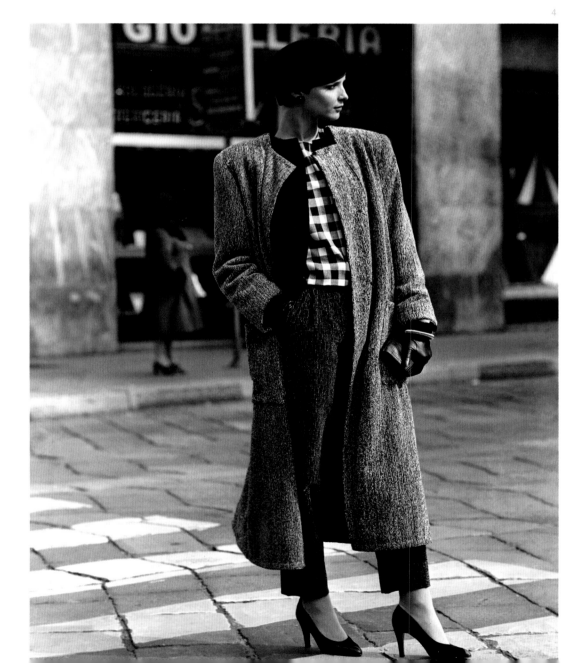

1984

In Paris, a number of silhouettes are shown: Kenzo's voluminous plaid dress tops two-tone pants; Karl Lagerfeld looks to the 1930s for Chloé's elongated looks; Christian Dior tops a suit with a topcoat 1940s style; and Lanvin makes a geometric chemise. American sweats make for cheerful athleticism, and Gene Ewing for Bis makes a tie-dye top, textured leggings and mesh vest and skirt ensemble. At the Costume Institute benefit, Tina Chow poses with her husband Michael Chow wearing a subdued evening look from Chanel.

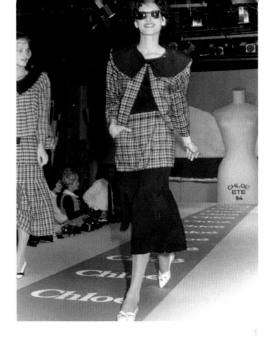

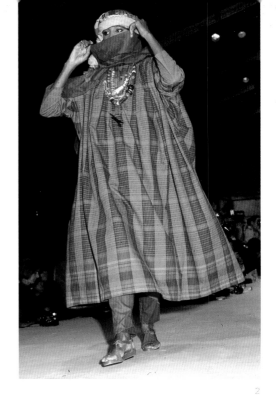

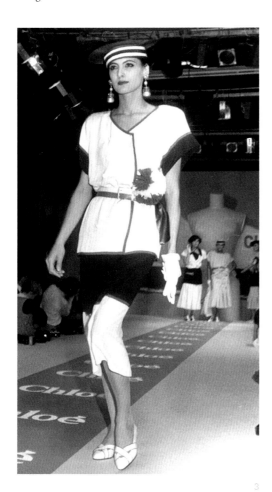

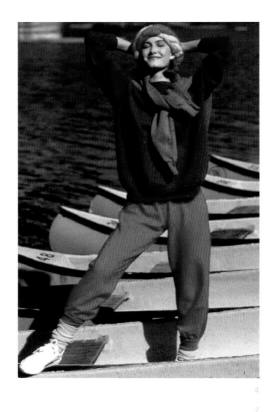

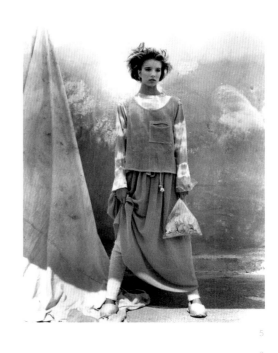

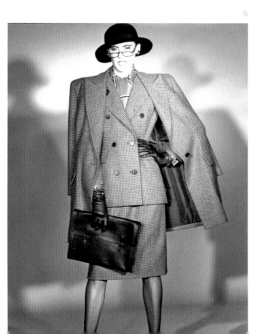

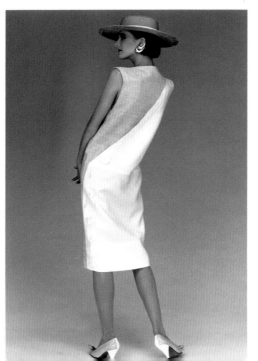

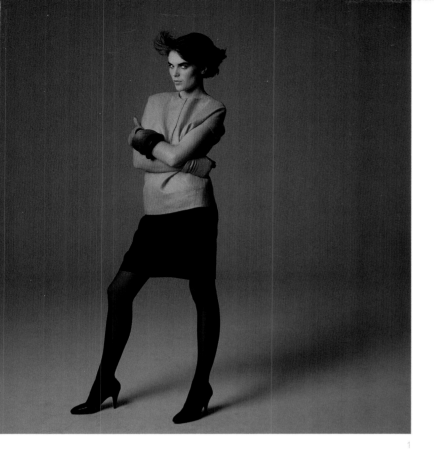

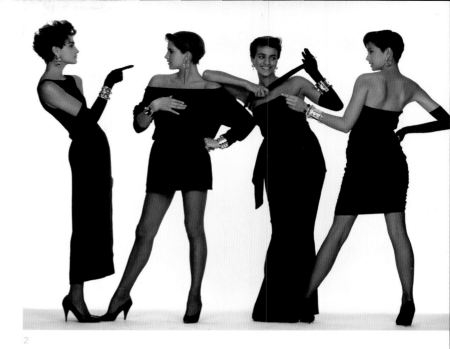

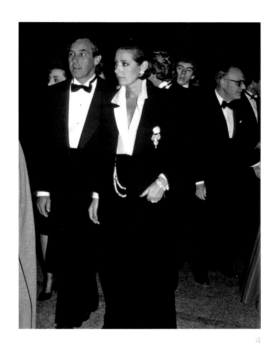

1985

The stance is bolder and sharper. Alaïa's denim jacket with melon sleeves and careful seams is an example of what *Elle* Magazine called his "dangerously sharp curves." Donna Karan, who has just started designing under her own name, wears her version of a smoking jacket to the Costume Institute benefit.

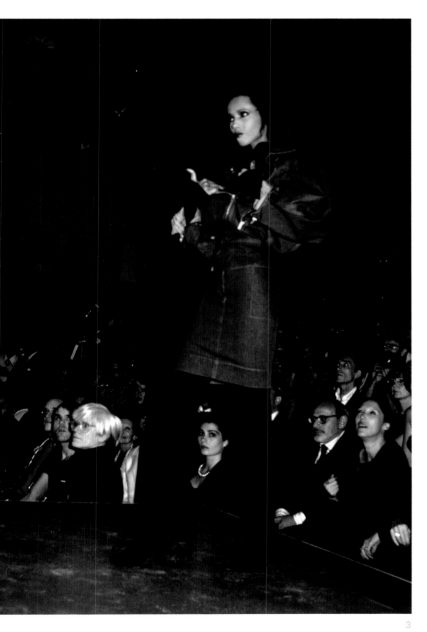

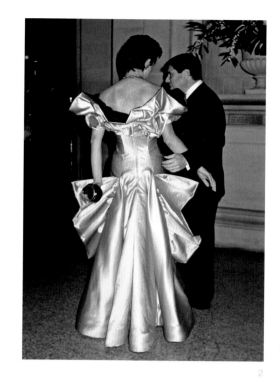

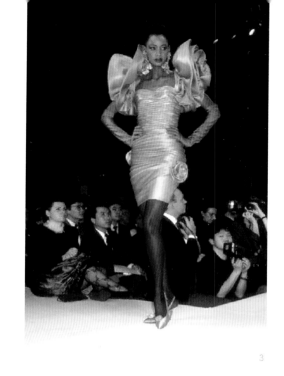

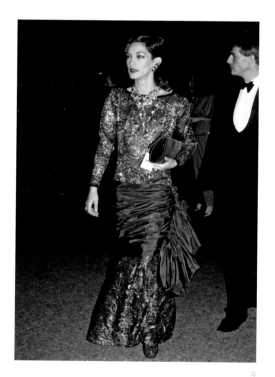

OPULENCE

1980s fashion magazines used such words for evening as "swirling," "glamorous," "drama," "fantasy," "extravagance," "whimsy," "glimmer," "gleam," and even "nuovi flash." Taffeta, satin, and gilded lace are arranged in ruffles, poufs, and especially shirring.

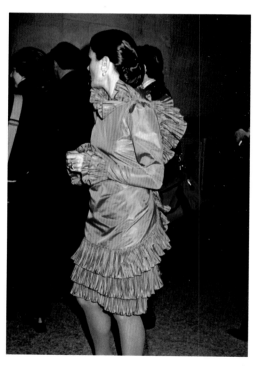

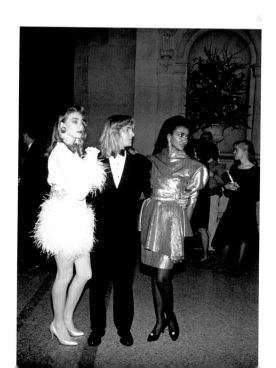

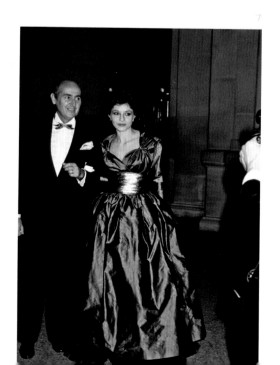

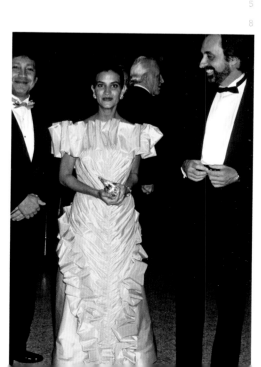

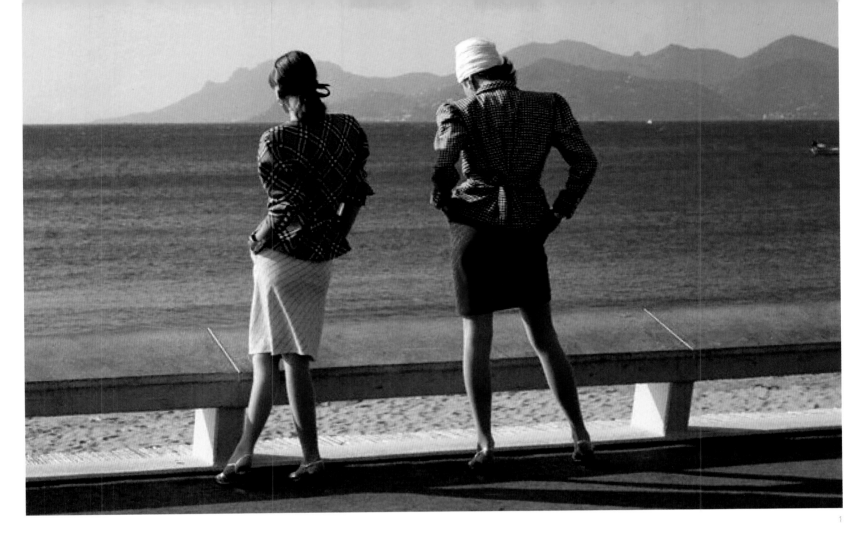

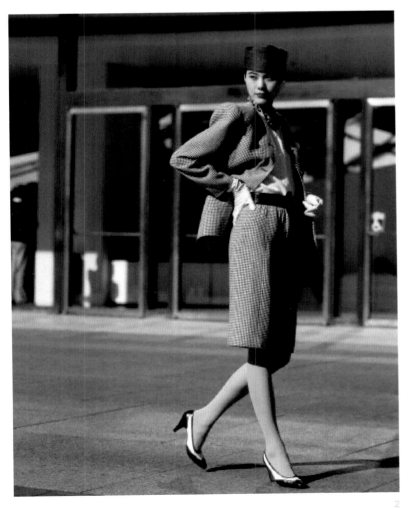

1986

Shown here are Emanuel Ungaro mismatched suits—the jackets with full sleeves— Oscar de la Renta's checked wool skirt suit—worn with silk cloqué blouse, pillbox hat, and spectator pumps— and a black one-shouldered jumpsuit in jersey.

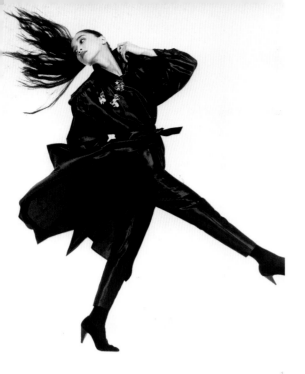

1987

Cathy Hardwick shows an evening coat and narrow pants ensemble in embossed taffeta while Aquascutum offers a swing coat in black-and-white Glencheck wool tweed. Guy Laroche's short evening dress is in black Calais lace with flounces and bow of black and fuchsia taffeta. Yves Saint Laurent presents a haute couture dinner suit in bright orange satin, and Carolyne Roehm's strapless short evening dress is accented at the neckline and hemline with bands of velvet hem.

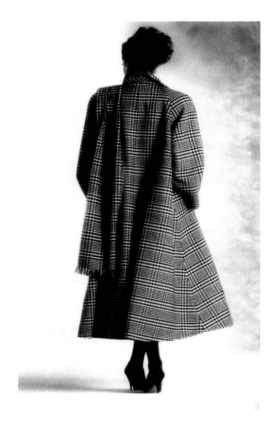

1988

Rei Kawakubo for Comme des Garçons' ensemble juxtaposes delicate organza with utilitarian anorak-like details. Emanuel Ungaro supersizes a swing jacket over coordinated sarong skirt and print blouse.

1989

Two versions of an Arnold Scaasi flowered dress parade the runway at The Plaza Hotel, and Patrick Kelly decorates a strapless cocktail dress with miniature versions of the Mona Lisa. A haute couture evening ensemble by Christian Lacroix features a jacket in black satin embroidered by Lesage with a Byzantine cross and a draped black, silk chiffon dress. Jacqueline de Ribes designs an evening gown with daring décolleté in black velvet with black Chantilly lace. Suits with straight knee-length skirts and boxy jackets are worn to an evening event in New York City and to attend the couture showings in Paris.

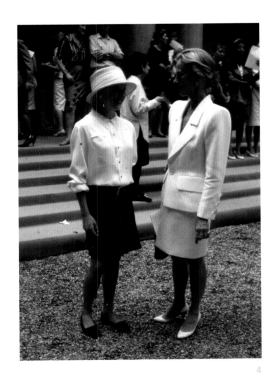

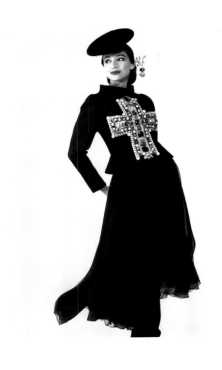

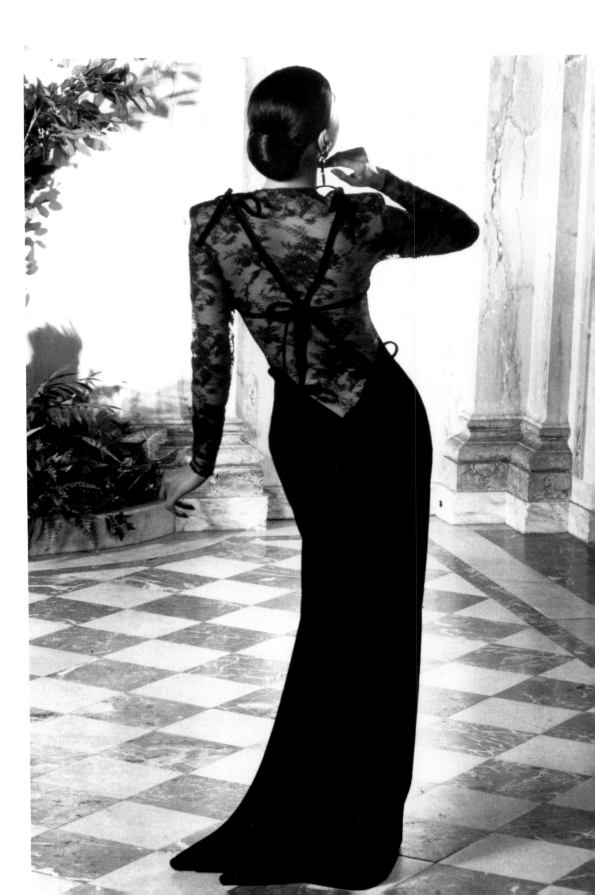

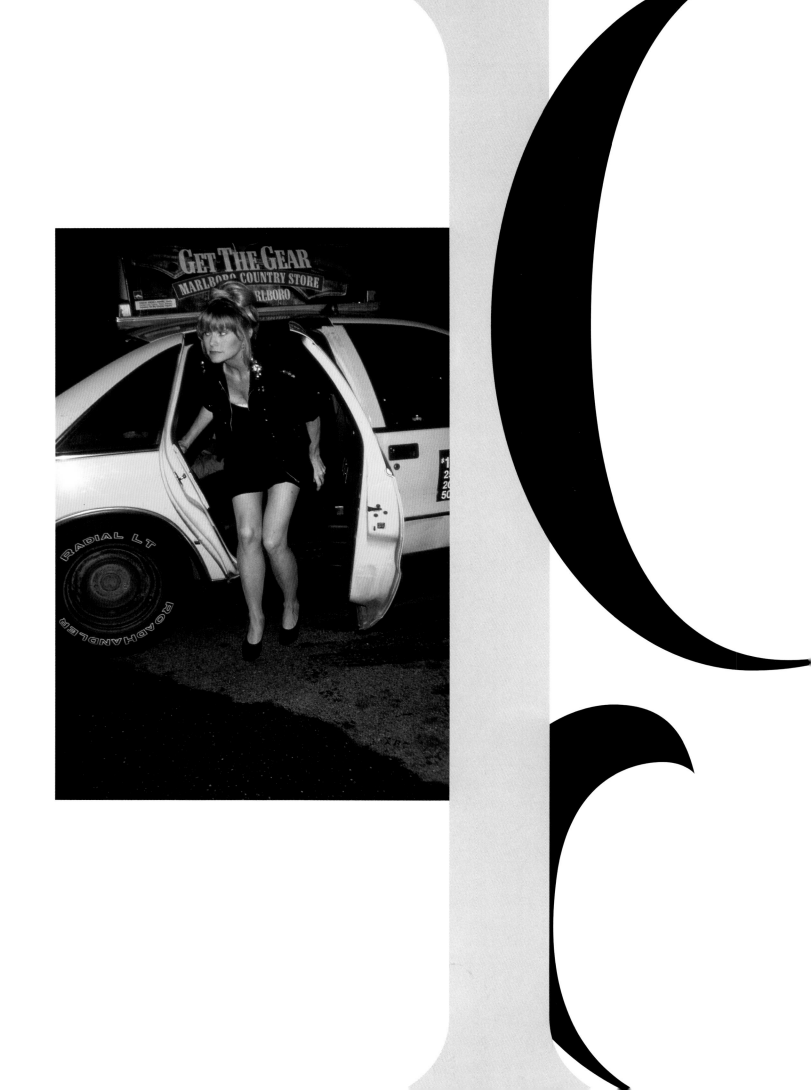

1990s

Looking back at the 1990s from the vantage point of 1996, in January Katharine Betts wrote for *Vogue*: "The 90s have veered from Pucci to Gucci with everything from biker chic and baby dolls to grunge and glamour in between. That's a lot of looks for a 'minimalist' decade."

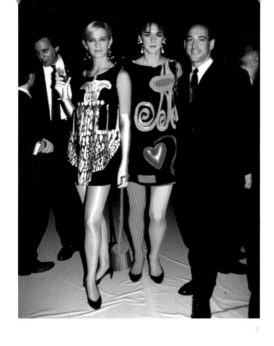

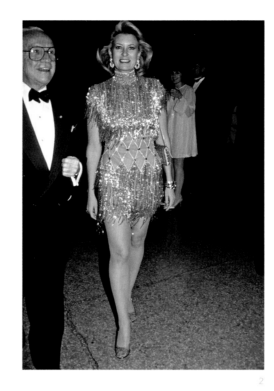

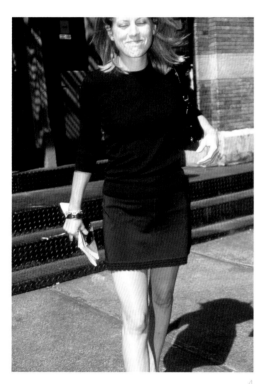

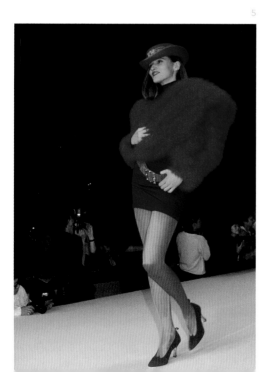

LEGGY

In May 1997, *Vogue* advises, "Get back on the stair master. High hems are now in high gear." Never before have such short skirts been worn with such high heels. Stockings are on their way out, legs acquire a professionally groomed gloss.

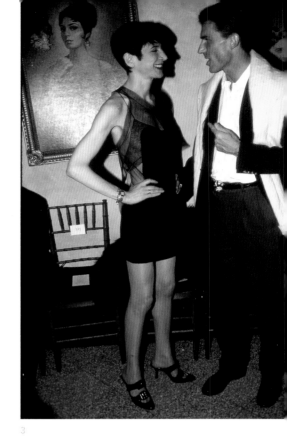

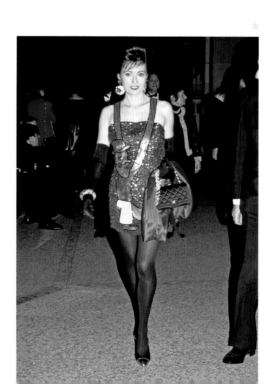

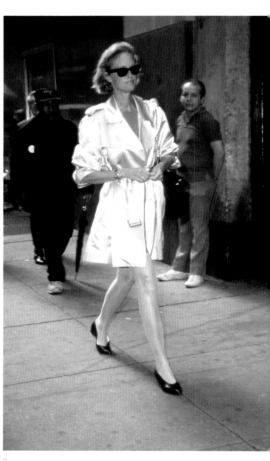

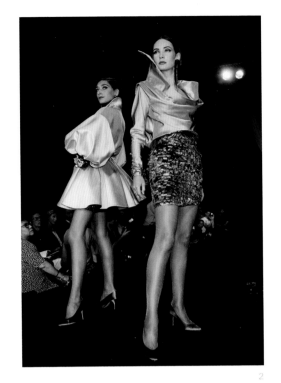

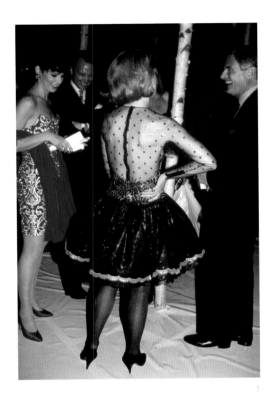

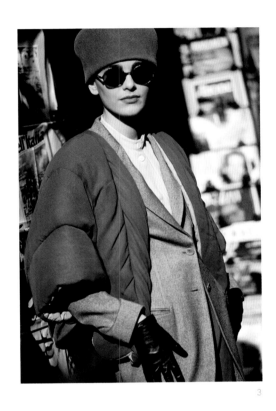

1990

Backs are the focus of short evening looks from Geoffrey Beene (point d'esprit) and Bill Blass (faux pearls tied in a bow). Claude Montana shows evening looks with sculptural blouses; Armani tops a suit with an elegant twist on a down jacket; Gianfranco for Dior shows a skirt suit and a pant suit in Dior gray; and Paloma Picasso pairs her own jewelry designs with an embroidered evening jacket by Yves Saint Laurent.

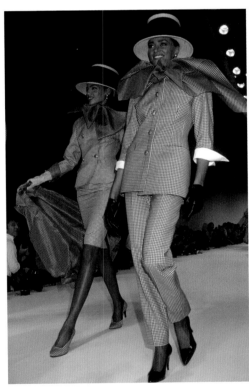

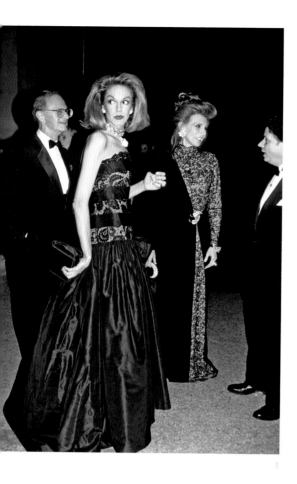

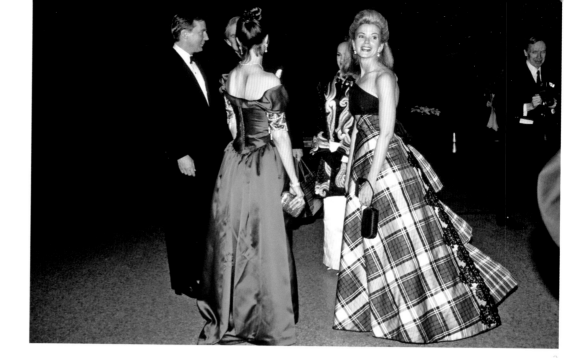

1991

Ball gowns worn at the Costume Institute benefit include Christian Lacroix's sweeping dress of tartan and lace. At the Volpi ball in Venice, a woman is swathed in tulle, and Sonia Rykiel shows models in high fashion hoodies. Short haute couture day looks include a Karl Lagerfeld for Chanel tweed suit with paneled skirt and red dress with fringed scarf by Emanuel Ungaro.

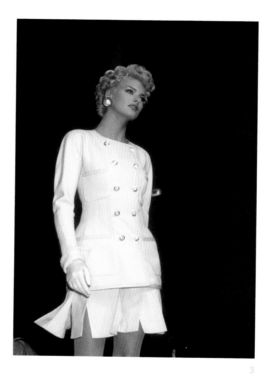

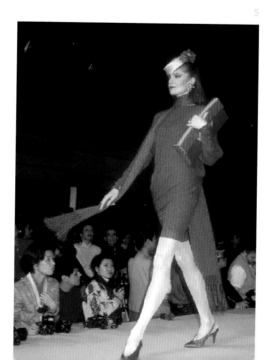

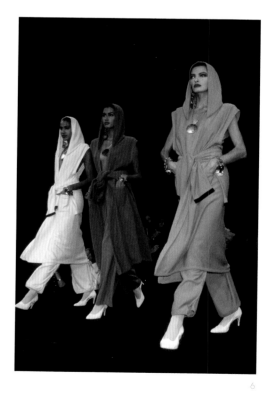

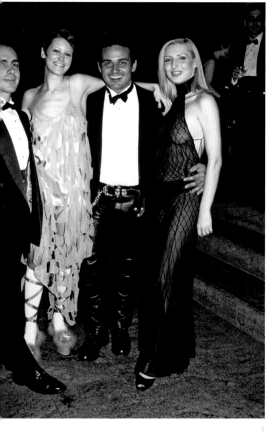

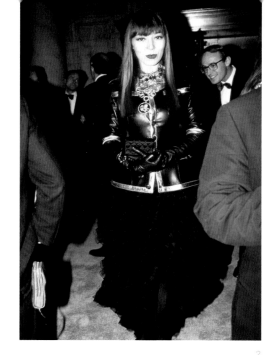

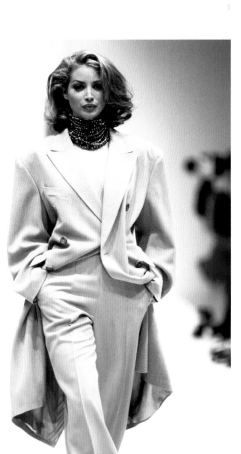

1992

For even the grandest of black tie events, anything now goes—from artfully arranged tatters and sheer fishnet to a Winterhalter worthy tulle ball gown crossed with bands of lace.

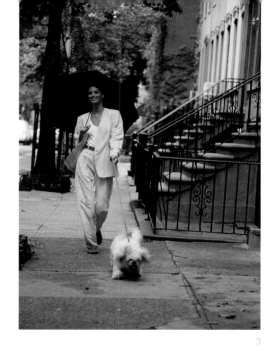

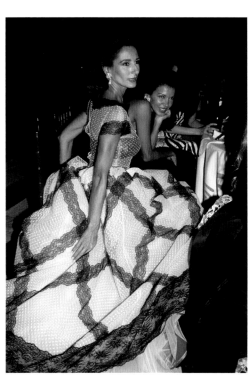

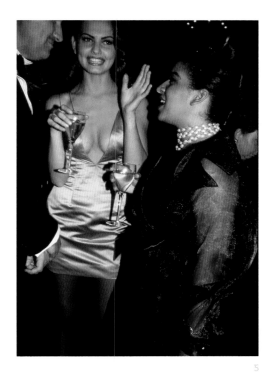

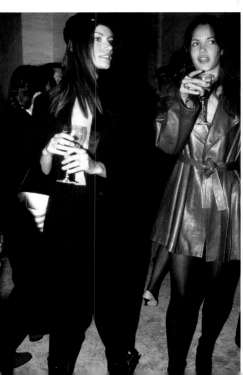

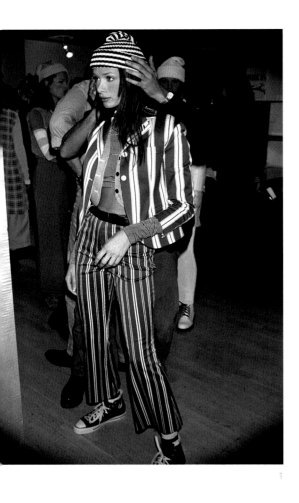

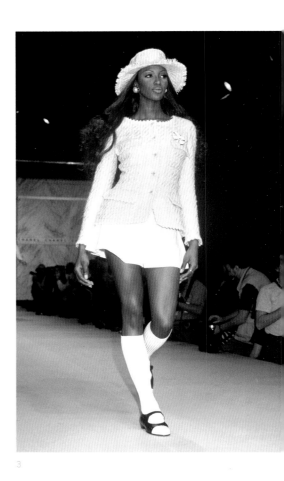

1993

A Marc Jacobs for Perry Ellis grunge outfit of mismatched stripes is seen backstage on Carla Bruni. Although this collection was savaged by critics, it embodied '90s values of thinking outside the box, pushing the envelope, and breaking the rules.

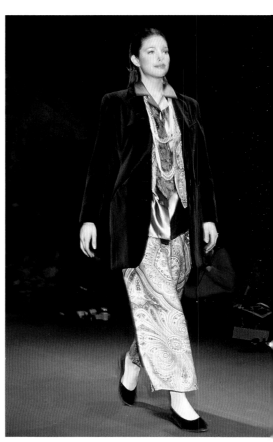

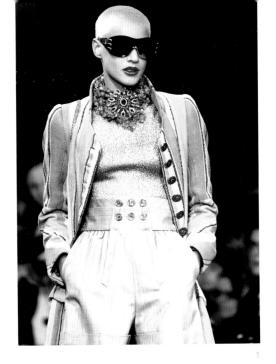

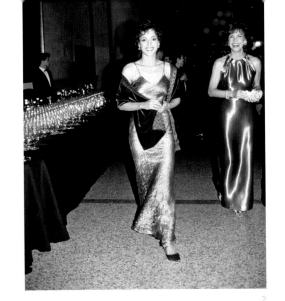

1994

A mix of patterns are seen in an ensemble by Christian Lacroix and a dress by Dries van Noten. Karl Lagerfeld looks to ancient Greece for a Chloé collection, and Sonia Rykiel makes a wrap bra top while Vivienne Westwood shows a manic Anglo fur trimmed coat. Narrow lines are seen in metallic dresses and in a John Galliano dress with train.

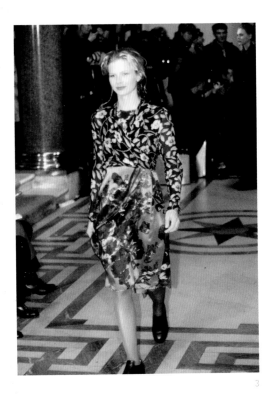

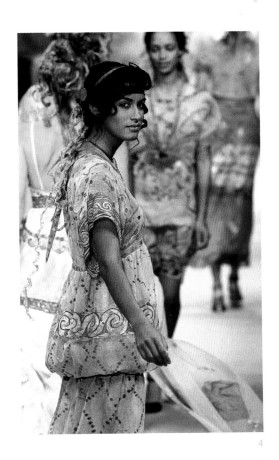

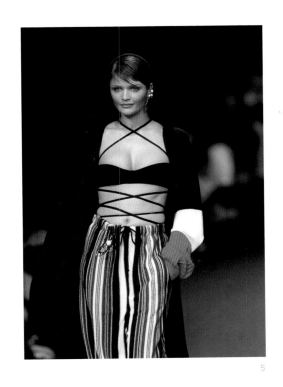

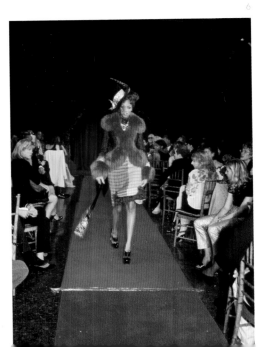

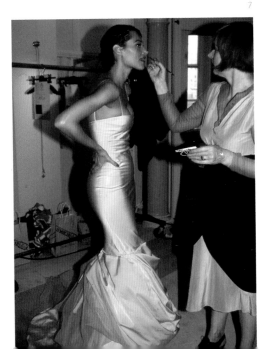

1995

Karl Lagerfeld gives a suit jacket a redingote air while Ralph Lauren's suit with topcoat has a 1940s look. In Soho, a woman wears resort white in the city. John Galliano's bustier is teamed with a bandage tight high-waisted skirt, and Alexander McQueen inc[...] [...]ress with tartan sle[...] [...]ing and thought pr[...] [...]ape."

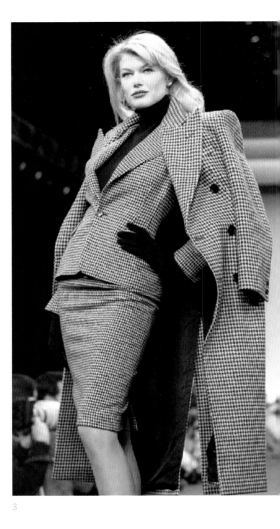

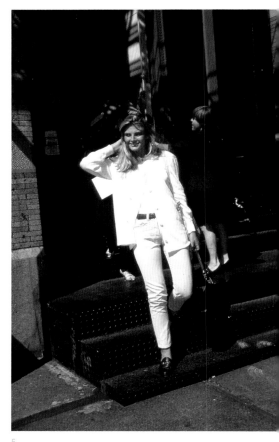

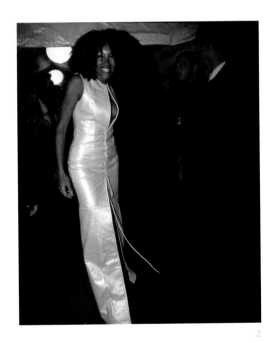

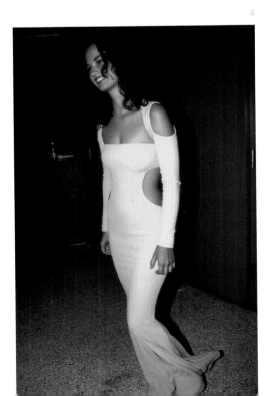

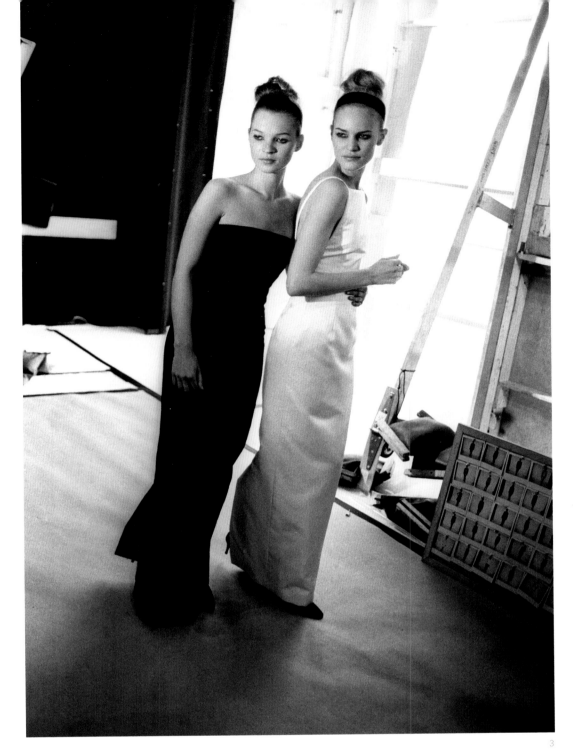

MINIMALISM

Minimalism highlights bodily perfection—all the
more possible with surgery now added to the arsenal
of diet and exercise. For minimalist day and evening
looks, accessories are practically non-existent.

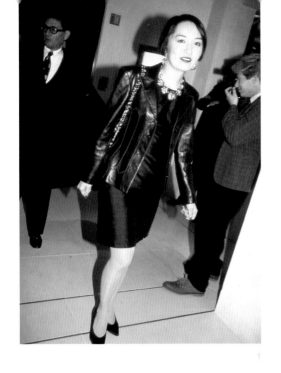

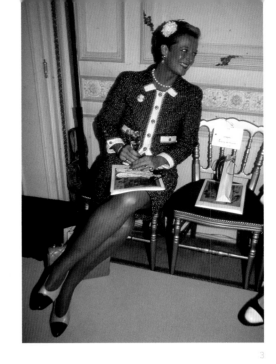

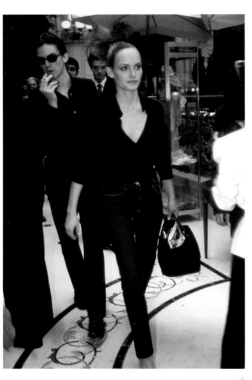

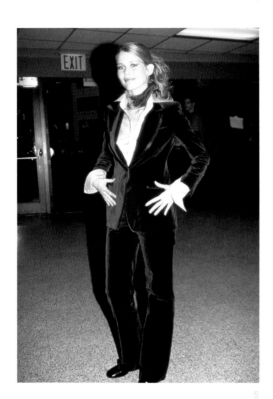

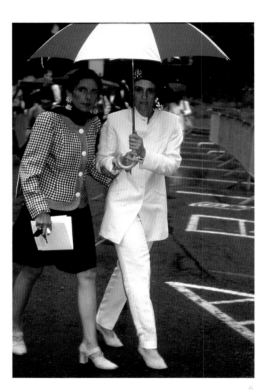

1996

Clients attending haute couture shows wear tailored day clothes: a coatdress, a Chanel suit, a skirt or pantsuit, and polished leather. Tom Ford for Gucci's velvet pantsuit is seen at the VH1 music awards.

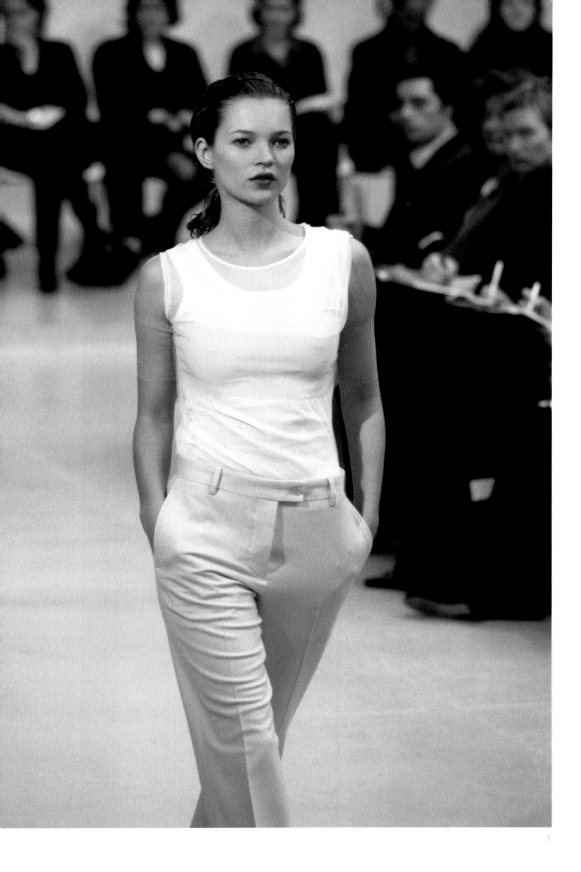

1997

Radically casual fashion becomes runway fodder. Helmut Lang layers white tank tops with a band of pink tulle, worn with chinos and modeled by Kate Moss.

1998

"I can remodel a body" said Hervé Léger referring to his bandage dresses—a new item in the vocabulary of fashion. Anna Wintour described an antidote to such body conscious silhouettes as "square, geometrical clothes, a look pioneered by Prada" (*Vogue*, Nov. 1998). Amber Valleta wears a Prada chemise on the runway.

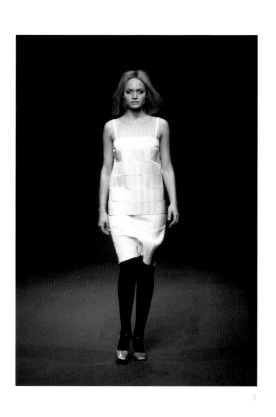

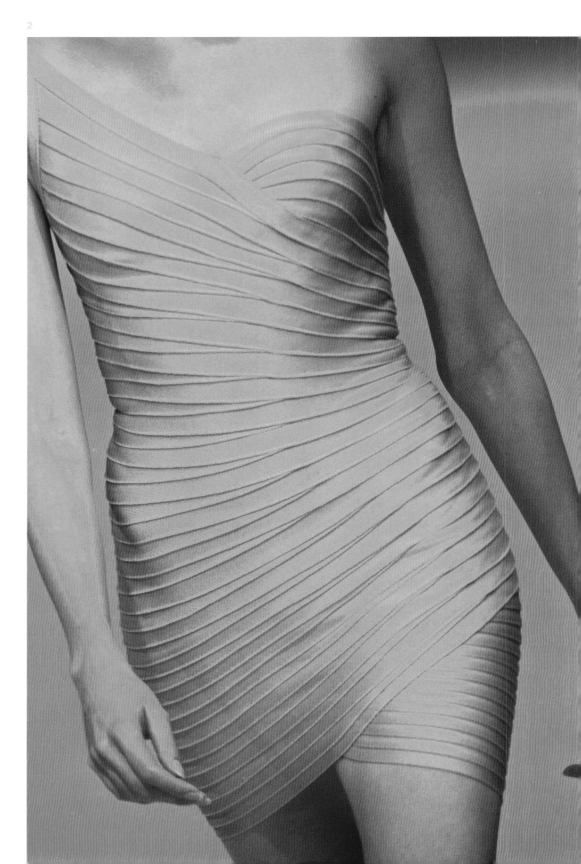

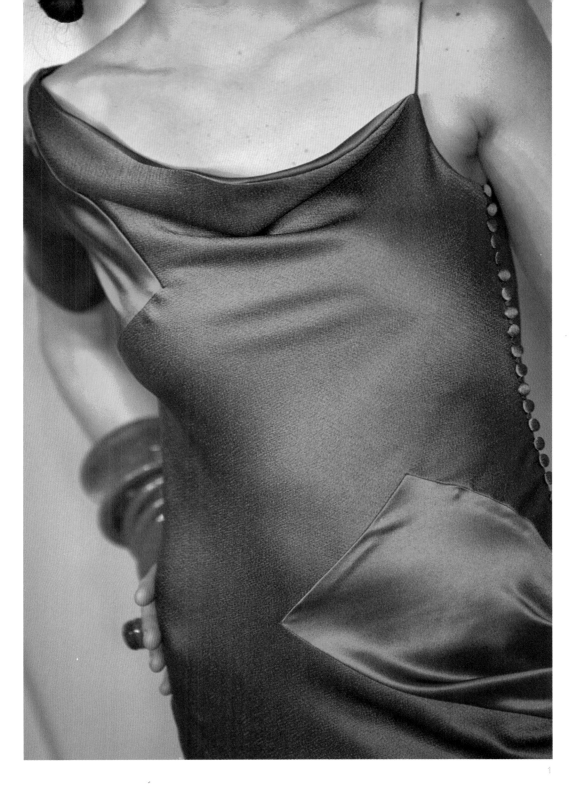

1999

Slip dresses suited the minimalist mood, this bias version with its row of vintage lingerie or wedding dress buttons was a signature of John Galliano's. Mugler gives edgy elegance to a dress with carefully revealing bands.

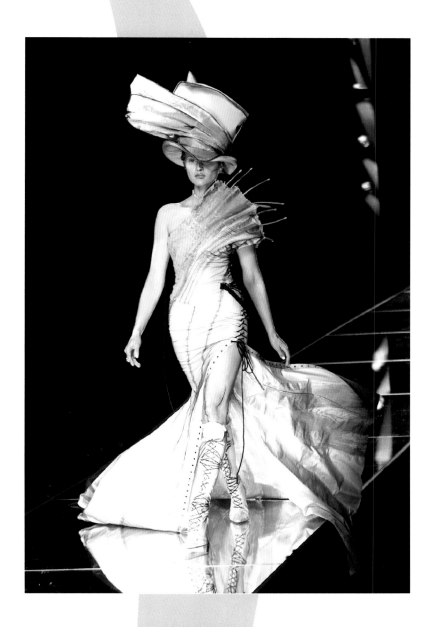

2000s

John Galliano for Christian Dior haute couture twisted corset gown—its stays exploding from the shoulder. Fashion shows are a category of performance art all their own. The growing expectation is for provocation with every detail exquisitely rendered. Here, the theme is "La Belle et le Clochard," a translation into French of the seemingly innocuous Disney film title "The Lady and the Tramp." This haute couture rendering of a dress that might be worn by a homeless woman predates Thomas Piketty's *Capital* by more than a decade.

IT BAG

As the new millennium dawned, dress codes no longer existed. Fashion abhors a vacuum when it comes to display, and as more and more people wear more and more jeans, carrying the very latest bag is de rigeur.

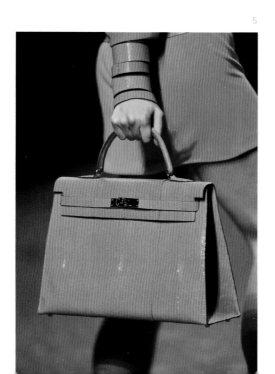

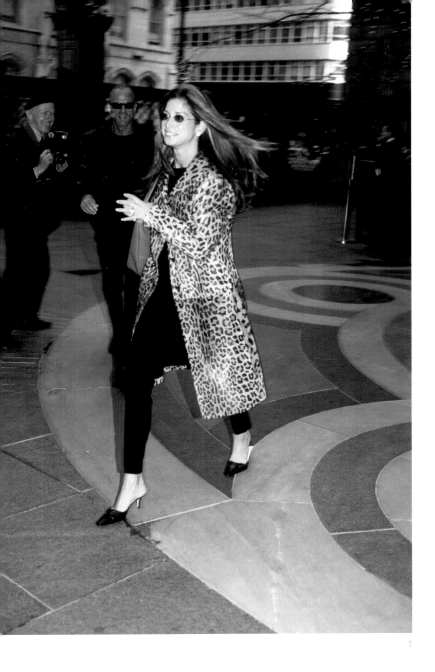

2000

The pace of city life accelerates. Leopard-printed ponyskin for a city coat is worn with mules and Elle Macpherson wears evening gown of strategic bareness by Valentino.

2

1

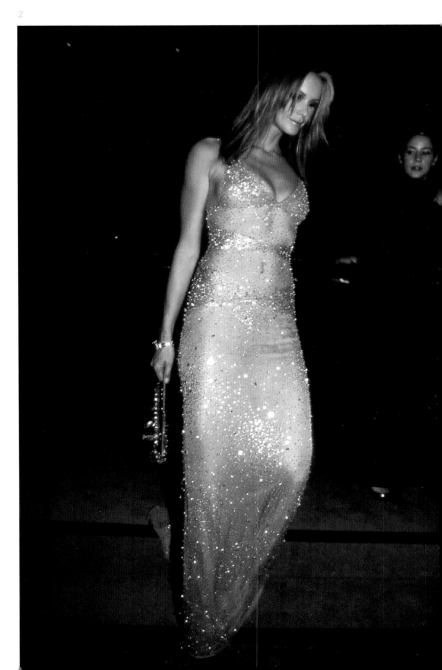

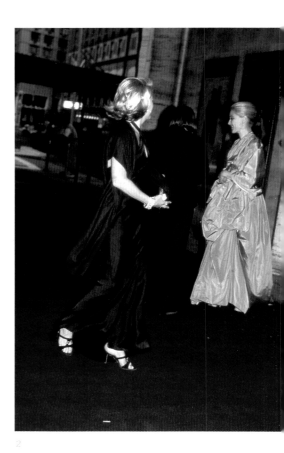

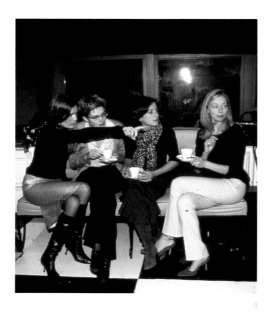

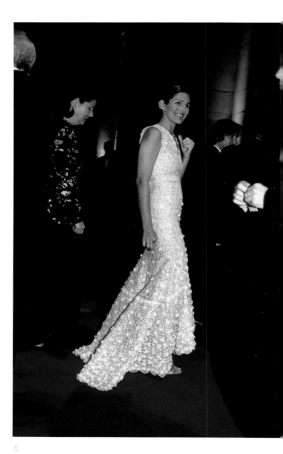

2001

At the same time that the day uniform becomes simpler, evening clothes become more glamorous. Trains are indispensable.

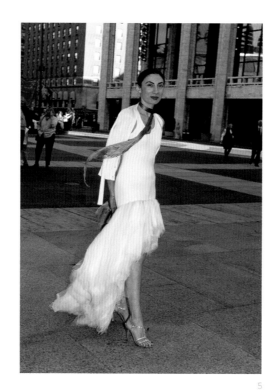

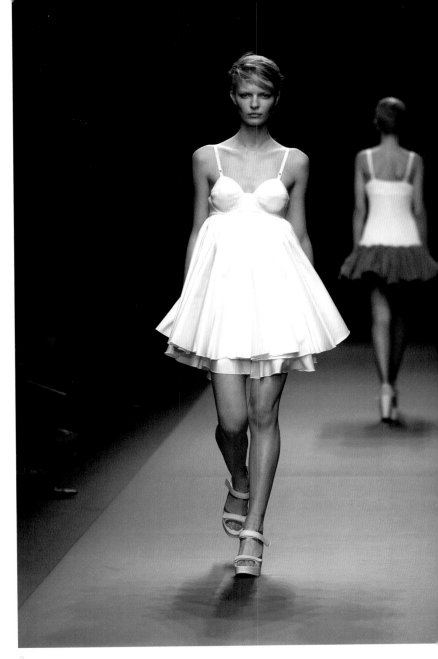

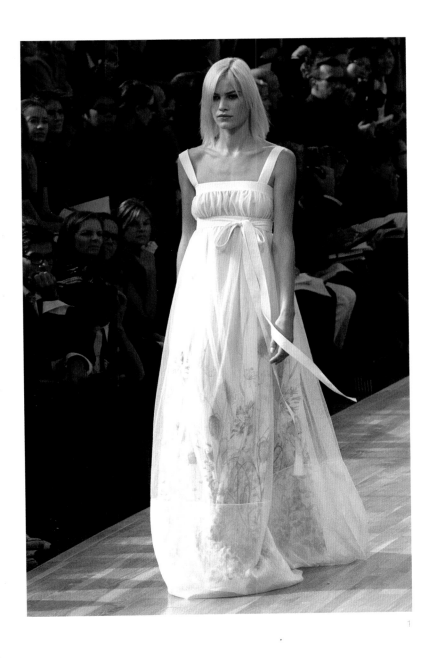

2002

Miuccia Prada for Miu Miu and Marc Jacobs for Louis Vuitton both show innocent looks—a bra-top babydoll dress for Miu Miu and an empire waist evening gown in a soft floral print silk for Louis Vuitton.

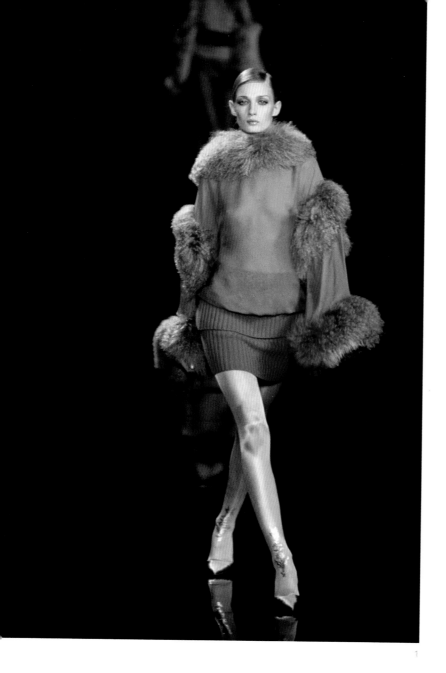

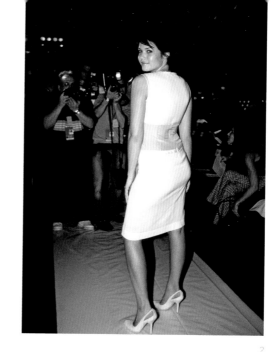

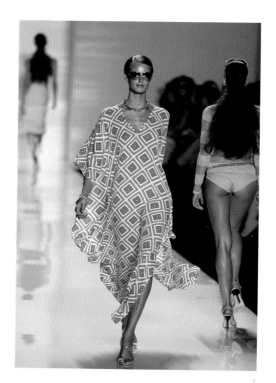

2003

Bareness is a mainstay of the catwalk. Transparency for day is shown by Valentino, and Michael Kors designs a resort caftan. The resort vibe is now worn all year and everywhere.

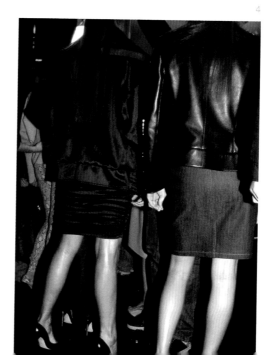

2004

Common stances at events: the ready-to-be-photographed descent, a pause in the passiegiata of gowns, checking a phone. The model in Alexander McQueen's runway show is dazedly dancing in a re-enactment of *They Shoot Horses Don't They?*

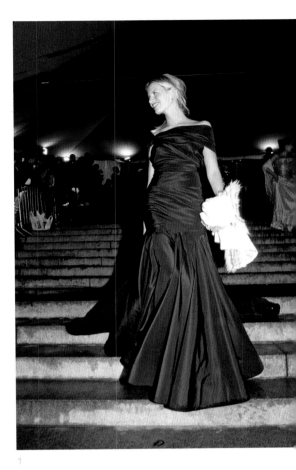

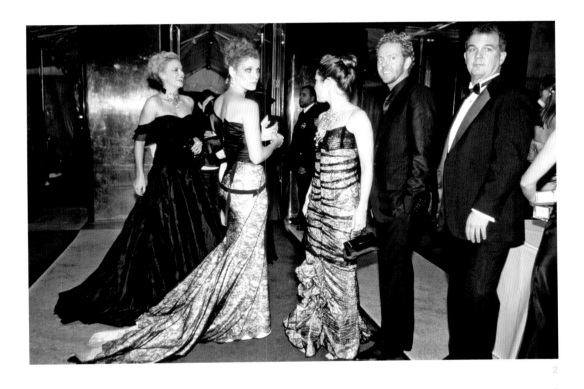

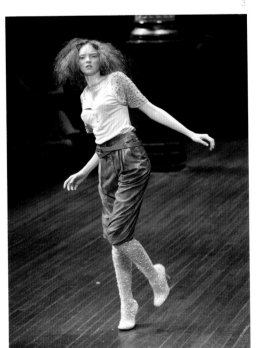

2005

At luxury goods companies, designers tweak signatures: Marc Jacobs translates the Louis Vuitton monogram into denim, and Christian Lacroix infuses Pucci with exuberance.

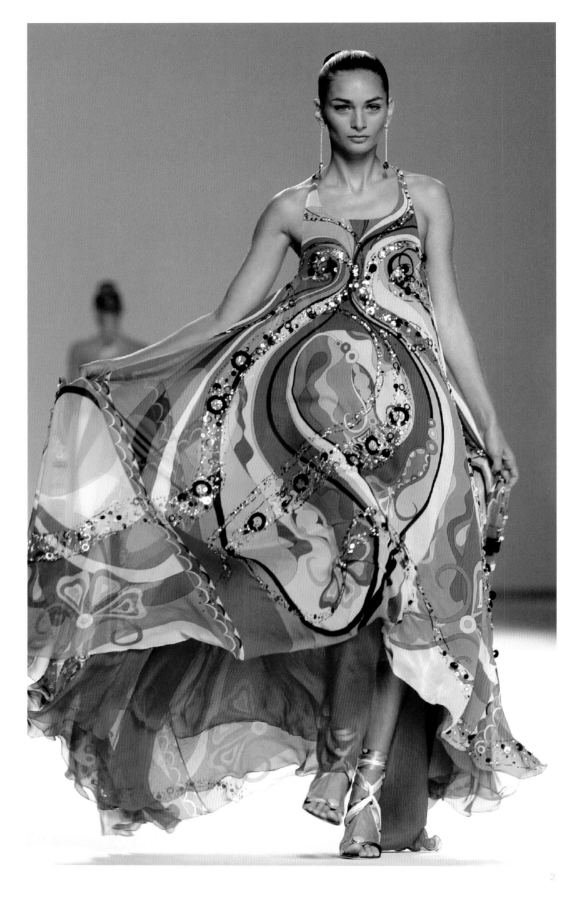

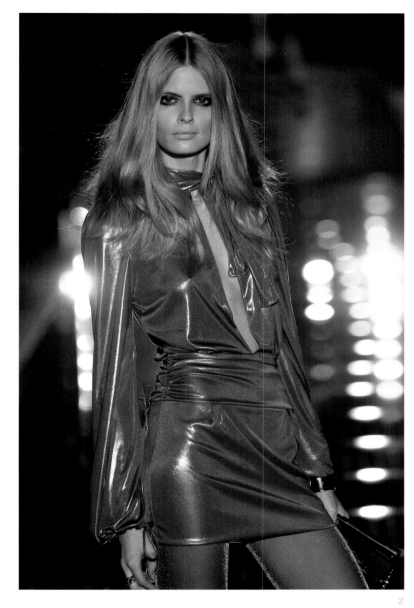

2006

Sexiness reigns. Carine Roitfeld wears gladiator sandals and shows a bit of leg at fashion week. Frida Giannini for Gucci shows a décolleté blouse and mini while Versace shows an ice blue one-shouldered evening gown with high slit skirt.

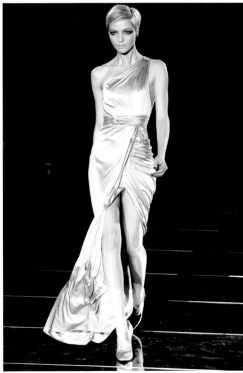

2007

New elements of the anytime, anywhere fashion vocabulary include the romper, the flat shoe, and the stand alone blouse. Chaiken pairs this bow blouse with tuxedo cummerbund pants. A new pose is the legs crossed over.

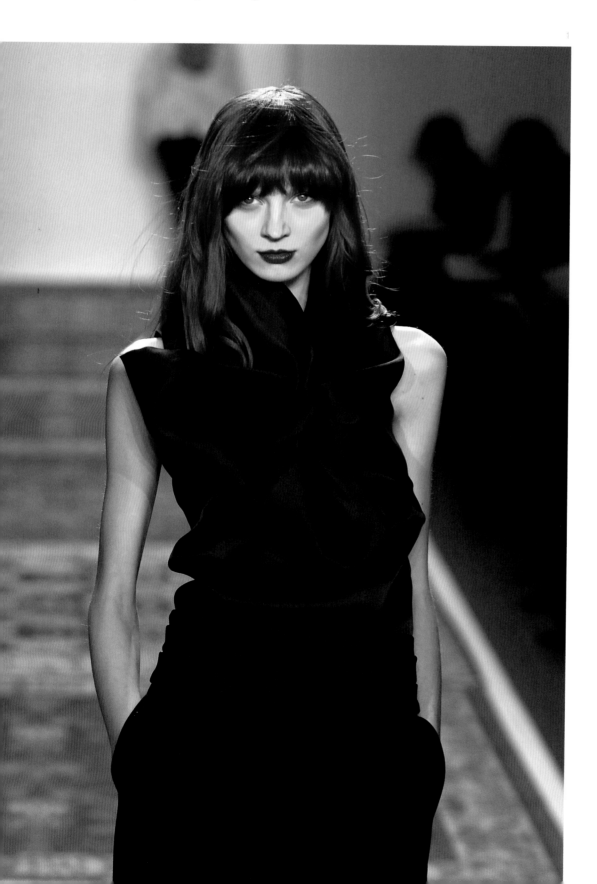

2008

Thom Browne's suits have changed the way men dress. A woman wearing his sort of suit is a twenty-first century garçonne.

2009

Into the void left by the power suit comes the toned-arm-baring dress. Alber Elbaz for Lanvin gives a dress a gentle volume that speaks louder than skin tight. Milla Jovovich wears a floaty version of a Galliano slip dress to his fashion show.

2010

Daphne Guinness exemplifies a tradition of dressing as an art form dating back as far as the Countess de Castiglione. Challenging shoes have become the most designed and coveted of accessories. Separates *composée* on the runway: Dries Van Noten shows an overblouse with sailor collar and shaped hem over print shorts, and Nicholas Ghesquière for Balenciaga shows a pullover with coordinated skirt.

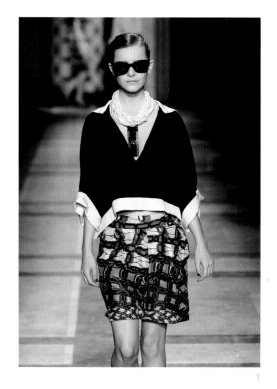

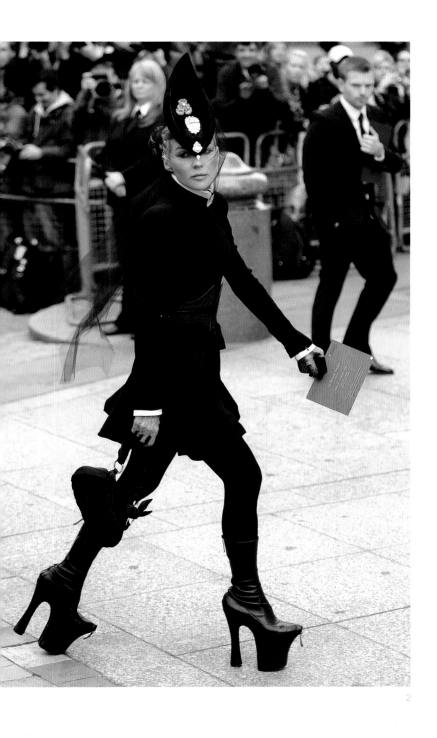

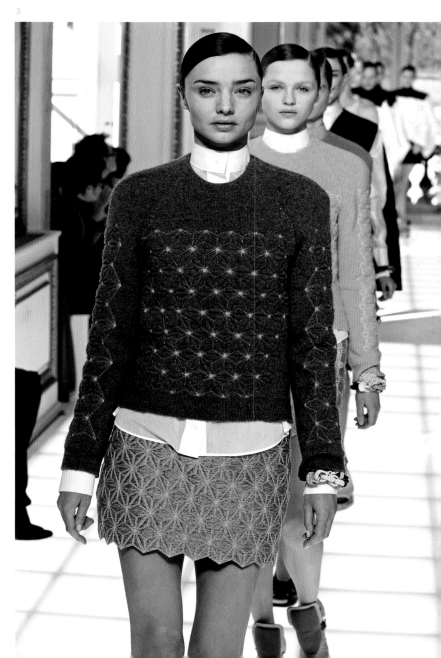

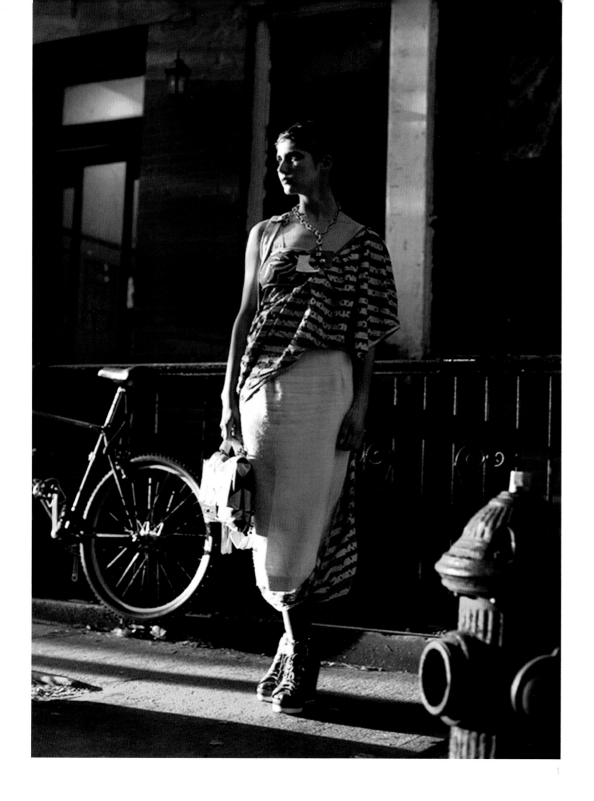

2011

The grace of moments captured *en plain air* provide an antidote to fashion spreads peopled with cyborg celebrities.

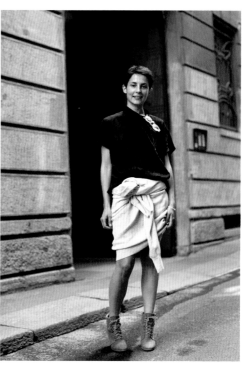

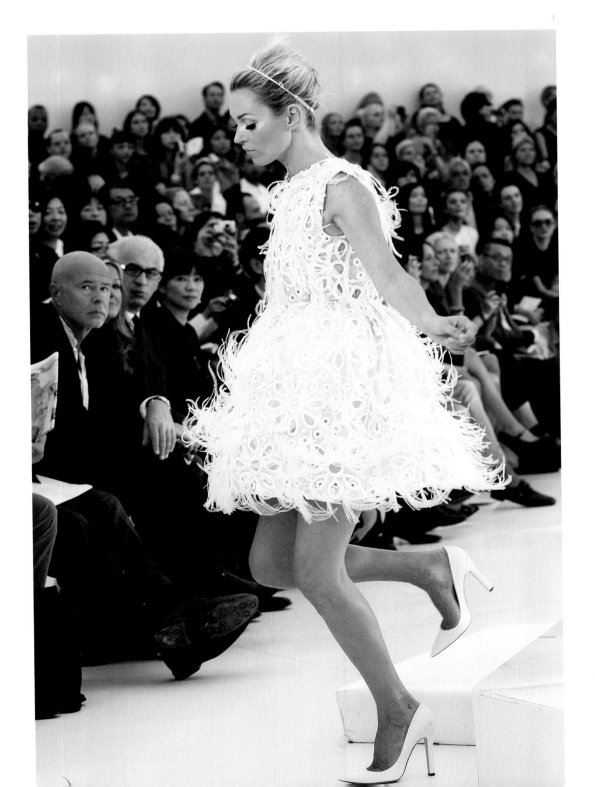

2012

Feathers decorate an eyelet dress by Marc Jacobs for Louis Vuitton, and Isabel Marant pairs cropped, fringe pants with faux fur.

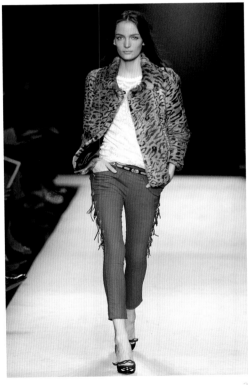

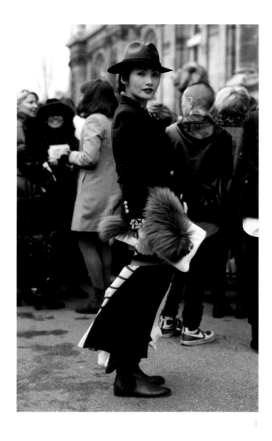

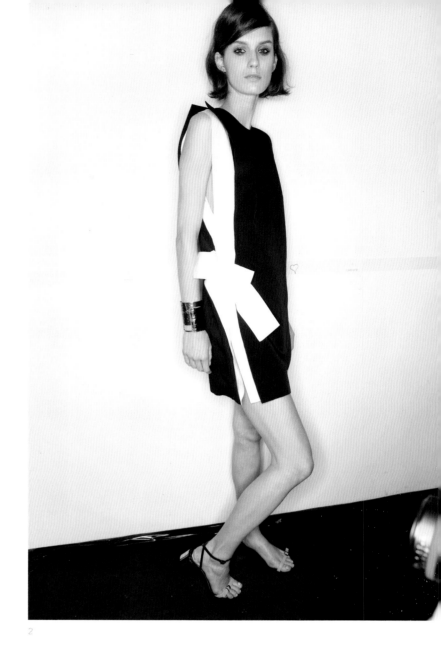

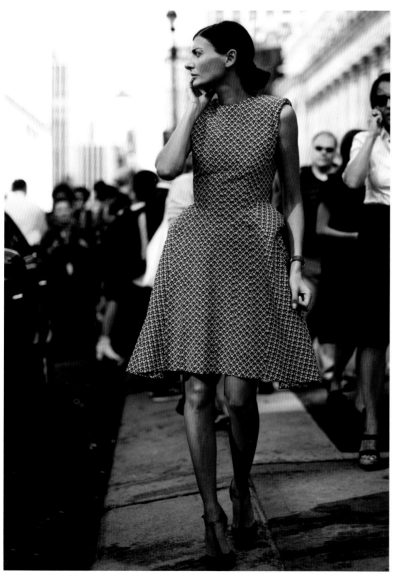

2013

An elegantly composed ensemble, and the dress goes on. Giovanna Battaglia wears a New Look silhouette for day.

2014

The whole is greater than the sum of its parts: penny loafers, a falling down sock, a corduroy skirt with drawstring hem extended, and a beanie give a young woman an uncontrived allure. A woman dresses down a crisp matelasse shift dress with a utilitarian army jacket.

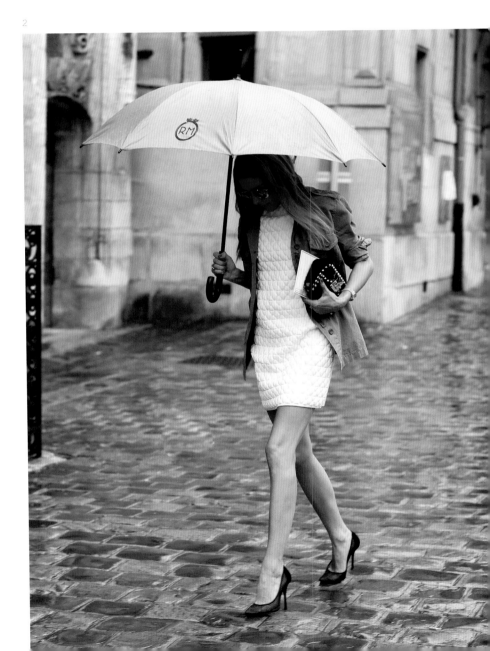

2015

Women of style with internet presence. Instagramming Italian model Virginia Mugnaioni wears a white jacket, black full trousers, blush fur, and Celine bag during Milan Fashion Week. Shirttail, sweater, jeans, heels, and Chanel cross body bag is worn by Boutique owner and blogger Golestaneh Mayer-Uellner at Berlin Mercedes-Benz Fashion Week.

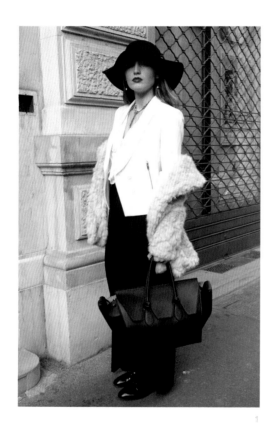

1

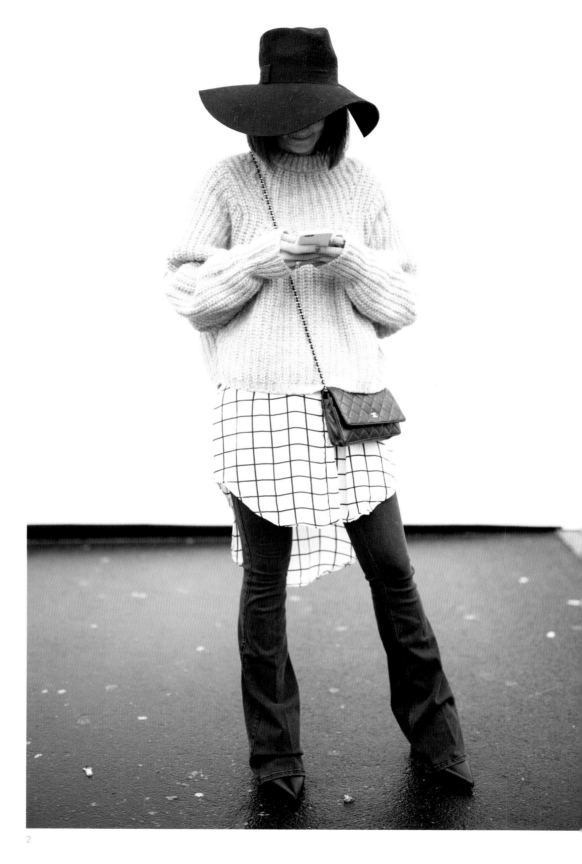

2

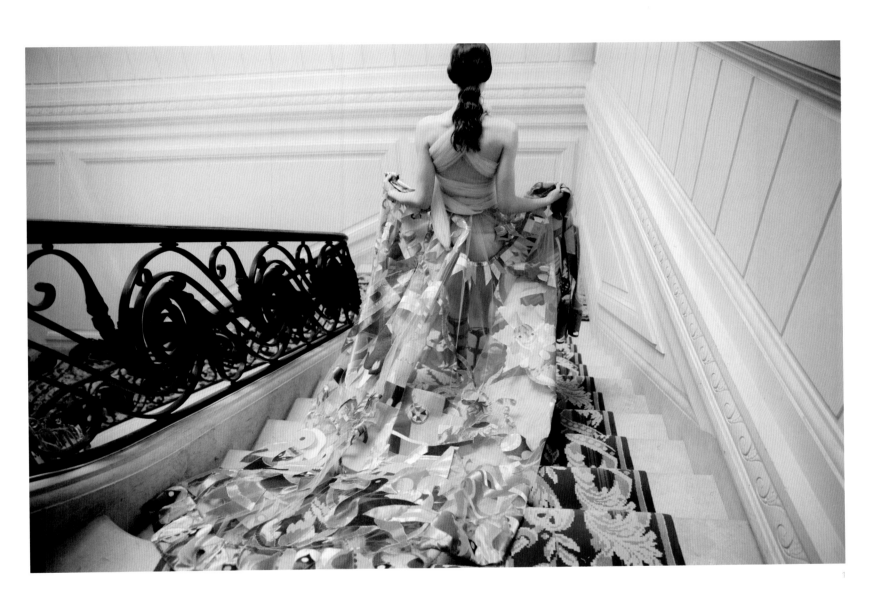

CONVERGENCE

Red carpet display has assumed many characteristics of long ago presentations to royalty. Court presentation required a very definite set of rules: for women in England it was plumes in the hair, inherited jewels, deep décolleté, long gloves, fan, and a long dress, usually white, with a train. Ladies and gentlemen waited outside the palace in a line of carriages or cars and then began their procession through an enfilade of state rooms to a throne room, once making a deep curtsey to a king or queen, they proceeded straight to a court photographer, open late at night solely to record the ensembles for posterity.

1. Day dress of wool printed with a pattern of dots and stripes. Daguerrotype photo by unknown (United States). Circa 1850s.

2. Dark dress in an earlier style worn with lace collar, white tie, and lace-edged under sleeves with several bracelets. Daguerrotype photo by unknown. Inscription: *1856.*

3. Dress with tiered skirt of silk woven à la disposition; high bonnet with wide ribbon strings. Unknown photographer (United States). Circa 1859.

4. Silk day dress with striped three-tier skirt, the bodice with appliquéd bands. Photo by Sée Photographs de l'Ecole Imperiale Polytechnique (Paris). Circa 1855–56.

5. Silk taffeta evening dress with hand made lace bertha collar and lace-edged short sleeves trimmed with two types of patterned ribbons. The little boy wears a tartan dress. Daguerrotype photo by unknown (United States). Circa 1850s.

6. Day dress in printed silk à la disposition woven with chiné flowers, stripes, and plaid with cape effect at the yoke, tiered sleeves, and tiered skirt; the hair arranged in a snood. Photo by Fratelli d'Alessandri (Rome). Inscription: *la Duchesse de Gramont, née MacKinnon, Ambassadrice de France.* Circa 1857 (the year her husband became ambassador to Rome).

7. Day dress with tiered skirt and sleeves in silk woven with velvet stripes. The bodice is trimmed with beads. Simple cotton lawn collar and undersleeves. Photo by Deliaraz. Inscription: *Mme. Vartet St. Once. 1858.*

8, 9, & 10. Three views of the Empress Eugenie: Empress Eugenie wearing a dress of black taffeta trimmed with velvet and lace, a lace wrap, and bonnet with wide ribbon strings, holding a sunshade (8); Empress Eugenie wearing a dress of black taffeta trimmed with velvet and lace, posed here to highlight the way the skirt is somewhat fuller in back and jutting out at the waist (9); Empress Eugenie with her husband Emperor Napoleon III and their son the Prince Imperial. André-Adolphe-Eugène Disdéri & Cie (Paris). Circa 1862.

11. The most elegant woman in France, Princess Pauline de Metternich, looking effortlessly chic in a black silk dress with trained skirt, black velvet bolero with black bead trim, a long strand of oversized black beads and astrakhan muff. Photo by Legé & Bergeron (Paris). Circa 1865.

12. Taffeta dress trimmed with wide bands of patterned silk worn by Amina Boschetti, a ballerina who made her debut at the Paris Opéra in 1864. Photo by Disderi (unsigned). Inscription: *Anima Boschetti Opéra-Danse 1863.*

13. Cora Pearl, courtesan extraordinaire, in a dress with basque bodice and tiered skirt of heavy silk with a design of reticella lace. (In a full-length image from this sitting she wears high-buttoned boots with attention getting checkered spats). Photo by Disdéri (Paris). 1867.

14. Silk dress trimmed with passementerie and elaborate coiffure worn by Lady Susan Vane-Tempest, née Susan Charlotte Catherine Pelham-Clinton, married to Lord Adolphus Vane-Tempest, son of Marquis of Londonderry. This photograph was taken around the time of her affair with the Prince of Wales. Photo by Disdéri (Paris). 1867.

15. *Comme il faut* day dress in plaid, batiste collar and undersleeves, braid trim on the bodice and sleeves. Photo by Dubordieu. Circa 1860.

16. Empress Eugenie in a dress, possibly by Charles Frederick Worth, with trained skirt, in two tones of taffeta with pinked edged ruffles; the tailored bodice with white collar and black bow tie, narrow ruffles flanking a central row of buttons; wrap in black cut velvet, satin, or silk and lace. Photo by Georges Spingler (Paris). 1862.

17. Lucy Gwin, daughter of U.S. Senator William M. Gwin, wearing a day dress of silk trimmed in the same way as the dress worn below by the Duchesse d'Albe but with a more ornately trimmed bodice and sleeves, white collar and undersleeves, brooch, wide brimmed hat with coq feathers. Photo by Matthew Brady, unsigned. 1860.

18. Princess Anna Murat, close friend of the Empress Eugenie, wearing a day dress in taffeta trimmed with bands of velvet at the turned back cuffs and above the hem flounce; the bands edged with taffeta pleated ruffles. She married Antoine de Noailles, Duc de Mouchy in December 1865 and was one of the ladies at court invited to the Dinner of the Twenty Beauties given at the Tuileries by the Empress for her husband. Photo by Disdéri (Paris). Inscription: *Duchesse de Mouchy.* Circa 1862.

19. Princess Anna Murat and her mother Princess Caroline Murat (nee Caroline Georgina Fraser of Charleston, South Carolina), both wearing day dresses trimmed similarly. Photo by Disdéri (Paris). Circa 1862.

20. Duchesse d'Albe, sister of Empress Eugenie, wearing a day dress of black silk with deep flounce of silk woven or appliquéd with velvet stripes and velvet scalloped edging; simple white collar and undersleeves, black velvet bowtie. Photo by Disdéri (Paris). Circa 1859.

21. Seen at the races: wool jersey dress with surplice bodice, worn with cape, miniature hat in velvet with point d'esprit bow. Photo by Paris-Soir. Inscription: *Mode aux Courses.* 1941.

22. Professional model, or possibly a mannequin, posing while at the races, wearing a hobble skirt dress with tunic overskirt trimmed with a ruffle matching the blouse underneath the bib front bodice; capelet with fur, bag with tassel, hat with extended crown sprouting bird-of-paradise feathers, elbow-length gloves and several strands of pearls in varying sizes. Photo by Agié. Circa 1914.

23. Actress (and mistress of Baron Foy) Suzanne Orlandi striking a flirtatious pose at the races in a white silk dress with over-vest; worn with a wide brimmed hat trimmed with feathers and scattered coin dots, elbow-length gloves. The gentlemen wear suits and bowlers, or "chapeaux melons." Unknown photographer (France). Circa 1903–1905.

24. A shift in how to dress for the street: casually, sun glasses of paramount importance, jacket worn over the shoulders, loafer style walking shoes with horse bits. Unknown photographer (Europe). 1960.

25. The shape of a European woman's upturned hat mirrors that of the utilitarian basket worn on the head of the boy walking behind her. Unknown photographer. Circa 1900.

26. Fringed sashed coat and egret feather hat worn for touring the Piazzo San Marco. He wears a double-breasted suit. Photo postcard. Unknown photographer. Addressed to *Madame, Monsieur Charles Bauce, Boulogne, from Ginette and Jean.* Printed date: *21 Agosto 24.*

27. Facing the phalanx of photographers, an evening gown in red, trimmed with self ruffles and worn with red rosettes in the hair. Photo by Mary Hilliard. 1987.

28. Model being photographed outside a fashion show, New York. Photo by Mary Hilliard. 2009.

1860s

13: Striped silk dress with button-down front, shaped band at the hem, trimmed with geometric bands of sheer silk edged with lace; lace-edged shawl; dangling earrings and oval brooch; velvet- and jet-trimmed hat; sunshade with striped edging. He wears a frock coat with matching vest and checked trousers with a stripe down the outside leg. Photo by S. Bureau (Paris). Circa 1860.

14–15: 1860

1. The soft white evening gown with bare bodice and bouffant skirt is the direct ancestor of the mid-twentieth-century prom dress. An example in white tulle with white flowers worn by Lady Diana Beauclerk (née de Vere, circa 1842–1905), descended from Charles II's affair with Nell Gwyn, daughter of the 9th Duke of St. Albans, born in 1842 and probably dressed for presentation at court. She would be the author of two books (*True Love* and *A Summer and Winter in Norway*) and at age thirty-one married barrister Sir John Walter Huddleston. Photo by F. R. Window (London). Circa 1860.

2. The height of mid-nineteenth-century propriety: dark dress in a luxurious fabric worn by Madame de Pettolas, Lyon, France. Brocaded taffeta dress with long, fitted bodice trimmed with lace; bertha; dangling brooch; lace headdress. One of six photographs from an album of photographs from Lyon, identified sitters including de Pettolas, White, Dyons de Champ, Doulot, and Pierce. Photo by P. Durand. Inscription: *M. de Pettolas* [?] *Lyon 29 Juillet 1860.*

3. Plaid silk taffeta dress worn with paletot with pagoda sleeves, pleated self-ruffle edging; hair ribbon worn to one side. Photo by Mayer & Pierson. Inscription: *Mlle. Evelina Bordier 1860.*

4. Dress and paletot ensemble trimmed with narrow bands and matching covered buttons; black ribbon necktie with cameo brooch. Photo by Maujean (Paris). Circa 1860 (based on photographer advertising an 1860 relocation on back of card).

5. Brocaded taffeta dress, skirt with six flounces; flower-trimmed bonnet with wide ribbon strings; lace bavolet; black lace shawl. One of six photographs from an album of photographs from Lyon, identified sitters including de Pettolas, White, Dyons de Champ, Doulot, and Pierce. Unknown photographer. Inscription: *15 Juin 1860. Madame* [illegible] *White.*

6. Dress of moiré antique with trimming of tassels and bands of lace, white lace collar and undersleeves; large brooch, possibly a micromosaic. Unknown photographer. Inscription: *Miss Laura Knapp. 19 Juin 1860.*

7. Dress with flounced skirt, each tier edged with narrow braid; black lace shawl; bonnet with wide ribbon strings trimmed with interior brim with flowers. One of six photographs from an album of photographs from Lyon, identified sitters including de Pettolas, White, Dyons de Champ, Doulot, and Pierce. Unknown photographer. Inscription: *Wife Caroline Pierce with sincere respects le 15 Juin 1860.*

8. Summer dress of striped voile with pagoda sleeves, flounced skirt, striped ribbon belt, white collar and undersleeves; dangling earrings; headdress. Photo by André-Adolphe-Eugène Disdéri & Cie (Paris). Inscription: *Mad de Anjat. 28 Juin 1860.*

16: PRINCESS CUT DRESSES

1. Princess cut dress in striped taffeta decorated with self-covered buttons in different sizes, plain white collar, lace-edged undersleeves, drop earrings, chain, and brooch; snood. Unknown photographer. Circa 1860.

2. Princess cut dress with scalloped hem and scalloped bands of velvet. Photo by Laignelot Peintre & Photographe (Montpellier, France). Circa 1864.

3. Princess cut gown with Elizabethan-style sleeves, probably white silk with black flocked-velvet floral sprays, trim of black handmade lace; flower and lace lappet headdress; fan with brisé sticks and guards. Photo by Adler (Cheltenham, UK). Circa 1865.

4. Princess cut dress in patterned silk, scalloped hem with pleated under ruffle, a simple, almost masculine collar with necktie, sleeves with turned-back cuffs. Photo by Franck (Bordeaux). Circa 1864.

5. Princess cut dress in checked silk with shirred bands of solid silk. Photo by Pierre Petit (Paris). Circa 1864.

17: WALKING SKIRTS

1. Walking dress in small checked fabric, bodice made as vest effect in front, cutaway jacket effect in back, military braid at the cuffs, underskirt in same fabric trimmed with cartridge pleating; hat with upturned brim and ostrich plumes. Photo by François-Joseph Delintraz (Paris). Circa 1863.

2. Pauline de Metternich (1836–1921) wearing a walking ensemble of taffeta and velvet trimmed with self-ruching and pleats, white cuffs and jabot; ankle boots; hat edged with curly ostrich plumes. Photo by Levitsky (Paris). Inscription: *p.cesse de Metternich.* Circa 1863.

3. Elaborate walking dress in striped satin with overdress of contrasting solid silk trimmed with bobble fringe; pillbox hat with cockade. Photo by Eugene Hallier (Paris). Inscription: *Mauvois.* Circa 1863.

4. Shooting ensemble: Garibaldi shirt, named in honor of the Italian war hero, paired with a walking skirt, gathered overskirt, and flat-topped toque. Unknown photographer (France). Circa 1863.

5. Walking dress of striped fitted jacket and striped overskirt, worn over solid short skirt, bodice decorated with black braided passementerie; toque with feather. Photo by Penabert (Paris). Circa 1863.

6. Walking ensemble with wool cape with ruffle at collar, plaid shirtwaist, taffeta skirt trimmed with pinked-edged ruffles and gathered up over a checked petticoat; gaiters, straw hat with velvet trim; walking stick. Photo by Britton & Sons (Barnstaple, England). Circa 1863.

7. Walking ensembles with striped skirts and striped decorated paletots; long strings of gutta-percha beads; toques with Stars of David and fur tails. Photo by Ed Wettstein Fils (Verviers, Belgium). Circa 1865.

18–19: 1861

1. Day dress with button trim, short jacket with pagoda sleeves; pair of cuff bracelets; snood; worn by teenage girl. Photo by C. T. Newcombe (London). Pencil inscription: *Isabel Crawshay December 1861 aged 16 last May.*

2. Dress in taffeta woven with a small figure, lace collar, batiste undersleeves; brooch and chain emerging from buttoned bodice. One of six photographs from an album of photographs from Lyon, identified sitters including de Pettolas, White, Dyons de Champ, Doulot, and Pierce. Unknown photographer. Inscription: *Lyn 27 Mai, 1861. Son Mari Capitaine.*

3. Taffeta dress with tiered skirt, the uppermost tier raised to one side with a sash, cavalier cuffs; lace headdress. Photo by Victoire Lyon. Inscription: *Lyon 22 Mai 1861 and Madame Dyons de Champ.*

4. Princess cut day dress in wool, velvet trim and buttons, pocket with decorative edging. Photo by Charles D. Fredericks & Co. (New York). Pencil inscription: *May Anderson, Feb 8, 1861.*

5. Queen Victoria poses in grand court attire: an evening gown in silk moiré, one of the most luxurious fabrics then available, with long court train attached at the waist; crown jewels. Photo by C. Clifford (Madrid; published by A. Marion & Co., London). Inscription: *November 14, 1861.*

6. Moiré dress with skirt arranged in soft folds rather than a full bell-shaped crinoline, decorated with crossed bands of moiré edged with velvet and sewn with velvet-covered buttons; self-covered belt edged with velvet. Photo by Trinquart (Paris). Inscription: *A mon ami Grange bon souvenir de 1861. N. Martine.*

7. Taffeta dress with rows of shirring giving a bell shape to the skirt, trim of velvet bands and velvet buttons, narrowed and curved sleeves; velvet ribbon choker with charm; long chain; snood. Photo by Groom & Co. Photographers (Plymouth and Exeter, UK). Pencil inscription: *September 23rd 1861 and Emily Michelmore.*

8. Moiré dress with back fullness and wide sleeves with wide cuffs, military braid at the bodice front. Unknown photographer. Inscription: *Souvenir d'amitié de Angelica Palacios a son ami M. Eugene Conneau. Août 19/1861.*

9. Striped silk dress, not closely fitted, with self-ruched bands, white collar, and undersleeves; long chain; straw hat with velvet trim; snood. Possibly the mother of Emily Michelmore (see 1861, no. 7), photographed the same day. Photo by Groom & Co. Photographers (Plymouth and Exeter, UK). Pencil inscription: *September 23rd. 1861.*

10. Striped dress with pointed waist, plain bands of contrasting fabric as trimming, simple white collar and cuffs. Posing is Fanny Melchoir, a student of the painter Franz Xavier Winterhalter (1805–1873). Photo by Fratelli Alinari (Florence). Inscription: *Fanny Melchoir Francaise.*

11. Black taffeta dress with pinked-edged flounces, fitted long coat in wool with trimming of quilted taffeta, pagoda sleeves, simple white collar and undersleeves; worn by a vicomtesse. Photo by Ost & Neumann (Vienna, AU). Inscription: *La Vicomtesse de Santa Quinteria 1861.*

12. Taffeta day dress with double pointed bodice, velvet trim, unusual pleated ribbon; silk flower coronet. Photo by A. Ken (Paris). Inscription: *Mme. Leon Mowben Paris, Juin 1861.*

20–21: 1862

1. Light silk dress decorated all over with appliqués edged with black lace; large black lace shawl; small brooch; chignon wrapped with braids. Photo by John Mayall (London). Circa 1862.

2. Lady Emma Dacres, wife of Admiral Sir Sidney Dacres, married in 1840, wearing a crinoline dress made from satin-striped taffeta à la disposition, in this case designed to be used as tiers in a skirt. Photo by J. Perkins (Bath, UK). Inscription: *Mrs. Dacres 1862.*

3. Black taffeta dress with passementerie trim at the bodice and pagoda sleeves, tiered skirt. Photo by Delintraz (Paris). Inscription: *Mme. Veronique Larsi Janvier 1862.*

4. Day dress of silk trimmed with cartridge-pleated self-ruffles. Photo by Gustave (Le Mans, France).

5. Countess Walewska in a dress of dark silk with fullness at the back of the skirt. The countess was a client of Charles Worth's. Worth is known to have wanted to banish the enormous crinoline skirt prevalent at the time, which in his designs by drawing the fullness around to the back. Photo by Disdéri & Cie (Paris).

6. Dress in small checked fabric with rosette ornaments, Swiss belt, lawn collar, undersleeves. Unknown photographer. Pencil inscription: *Fanny Mills 1862.*

7. Velvet dress with tunic overdress in striped material trimmed with velvet, braid, and lace; black lace shawl; white bonnet; worn by Julie Obrenović (Countess Julia Hunyady de Kéthely [1831–1919]), wife of Serbian Prince Mihailo Obrenović. Photo by L'Angerer.

8. Striped silk day dress trimmed with flat bands of silk with mitred corners, with buttons covered in the same silk as the bands, sleeves decorated similarly; black lace necktie; dangling earrings; hair comb. Photo by Disdéri & Cie (Paris). Inscription: *Mme. Eric Lefret Coinfit & Marie Anne.*

9. Silk ball gown with puffed sleeves, button-front bodice, black lace edging at the neckline, black velvet sash; worn by Eugénie Fiocre (1845–1908), a principal dancer with the Paris Opéra, painted by Edgar Degas in Saint-Leon's ballet *La Source* and a popular performer *en travesti* so as best to display her exquisite legs. Possibly the same dress as worn by her sister in an image possibly from the same sitting. Photo by probably Disdéri & Cie (Paris). Inscription: *Eugénie Fiocre Opera-Danse.*

10. Grid plaid day dress with pleated ruffle at the sleeve; striped coat. Photo by Jh. Contini & Bussi (Cannes). Inscription: *Decembre 1862.*

11. Silk ball gown with puffed sleeves, button-front bodice, black lace edging at the neckline, black velvet sash; worn by Louise Fiocre, also a dancer with the Paris Opéra. Photo by probably Disdéri & Cie (Paris). Inscription: *Louise Fiocre Opera-Danse.*

12. Another view of the silk ball gown with puffed sleeves, button-front bodice, black lace edging at the neckline, black velvet sash; worn by Eugénie Fiocre. Photo by probably Disdéri & Cie (Paris). Inscription: *Eugénie Fiocre Opera-Danse.*

13. Dark silk dresses with pagoda sleeves. The older woman wears a dress dating from a few years earlier, when flounces were all the rage. Photo by Denisse & Cie (Bordeaux). Inscription: *Mars 1862.*

22–23: 1863

1. Black heavy silk dress with black chenille fringe trim, small tailcoat effect at the back of the waist, white collar and undersleeves; headdress. Infant dress in white. Photo by T & J (Harrogate, UK). Circa 1863.

2. Sprigged cotton summer dress with long sleeves arranged in puffs. Photo by Bayard & Bertall (Paris). Inscription: *Ctesse de Noé et Jeanne 31 Juillet 1863.*

3. Dress and paletot worn for a garden stroll. Unknown photographer. Circa 1863.

4. Striped dress with tiered skirt; lace jabot and lace shawl. Photo by Dagron &

Cie (Paris). Inscription: *Madame Fourmier. La Rochelle – Janvier 63.*

5. Taffeta dress with paisley shawl arranged as a cloak. Photo by Adèle (Vienna).

6. Summer attire. Unknown photographer. Album page inscription: *Penga 1863.*

7. Colonial family in garden, West Bengal, India. Unknown photographer. Album page inscription: *Penga 1863.*

8. Striped dress, pointed waist, sleeves edged with box-pleated self-ruffle, batiste undersleeves, white collar with ribbon bow tie, belt with ornamental buckle; in one hand the sitter holds a flower, in the other a hat with a brim, lace face veil, and ribbon strings. Photo by Durand (Lyon, France). Inscription: *Claire 1863.*

9. Moiré ball gown with pointed waist, pleated skirt, lace pelerine sewn with narrow bands of black velvet; silk lace shawl. Photo by V. Plumier (Paris). Inscription: *Mlle. J. Arrecher 1863.*

10. Striped silk dress; sacque jacket with passementerie trim; hat with slightly turned up brim at the side. Unknown photographer. Pencil inscription: *Juin 1863.*

24–25: THE WORTH THAT LAUNCHED A THOUSAND COPIES

1. Pauline Metternich wearing a day dress by Charles Frederick Worth, probably in silk faille. The dress, which has a slight train, features a double row of buttons down the front of the bodice, striped gauntlet cuffs, and a scalloped hem applied with bands of velvet. Photo by Disdéri & Cie (Paris). Circa 1863.

2. Pauline Metternich wearing a day dress by Charles Frederick Worth, probably in silk faille, possibly yellow. The dress features a double row of buttons down the front of the bodice, striped gauntlet cuffs, and a scalloped hem applied with bands of ribbon. Photo by Disdéri & Cie (Paris). Circa 1863.

3. Silk dress with scalloped hem applied with bands of striped ribbon, elaborate cuffs; worn by an actress named Nelly. Unknown photographer, possibly Disdéri & Cie (Paris). Circa 1864.

4. Silk taffeta dress trimmed with bands of black velvet, turned back cuffs, wide sash. Photo by F. Deron (Brussels). Circa 1864.

5. Boy's suit with velvet trim. Photo by De Rheda. Circa 1865.

6. Walking dress with trimmed with velvet bands; worn by Belgian Comtesse Hermine van der Burch (1850–1924). Photo by G. Velloni & Cie. Photographes (Brussels). Pencil inscription: *Sirschott Csse van der Burch.* Circa 1864.

7. Day dress trimmed with velvet bands, plain collar with black lace bowtie; hat worn tipped forward trimmed with ostrich plumes and lace; worn by Queen Victoria's third child, Princess Louis of Hesse (born 1843, married 1862), shown holding her infant daughter Princess Victoria, born April 5, 1863. Photo by A. Marion & Co. (London). 1863.

8. Silk day dress trimmed with arrow-notched velvet ribbon bands at the top of the sleeves, cuffs, bodice, and hem, also trimmed with fringe and, at the hem, ruching *a la vieille*; mourning jewelry including a bracelet with medallion. Photo by E. Robinet (Paris). Circa 1864.

9. Girl's dress with puffed sleeves, velvet details, and pointed waistband. Photo by Ulric Grob (Paris). Circa 1865.

10. Detail of 1 and 2.

26–27: 1864

1. Adelaide Ristori, tragic actress (1822–1906), wearing a dress of silk taffeta with velvet appliqués outlined with satin piping, scalloped trim at the neckline and hem. Unknown photographer, possibly Disdéri & Cie (Paris). Inscription: *Adelaide Ristori. 1864.*

2. Ball gown with sheer silk sleeves, shirred panels at the skirt. Photo by HB (Paris). Inscription: *Charlotte Derthier in 1864.*

3. Court presentation ball gown with train, white silk decorated in eighteenth-century taste with self-scrolling bands and rosettes; tiara and requisite Prince of Wales plumes. Unknown photographer. Circa 1864.

4. Summer paletot with passementerie, plaid skirt with scalloped hem; worn by Countese de Noé. The Noé family included the well-known illustrator and caricaturist Charles Amédée de Noé, known as Cham (1818–1879). Photo by Bayard & Bertall (Paris). Inscription: *Septembre 1864.*

5. Identical silk dresses with self-ruching trim, similar silk paletots; similar dark straw hats; young man's jacket and vest worn with light pants, bowler hat. Unknown photographer (Sussex, UK). 1864.

6. Dress with passementerie trim; large bead bracelet; headdress. Photo by L. Nonat (Provins, France). Inscription: *Mille. Emile Borguelat Juin 1864.*

7. Ball gown in taffeta with pleating at the off-the-shoulder neckline, ruched, pinked-edged, and ruffled trimming in a contrasting shade of taffeta; handmade lace bertha; black lace shawl. Photo by Witz & Cie (Rouen). Inscription: *Mme. Verdiel. Tante de moi oncle.* In pencil: *1864.*

8. Ball gown with taffeta bodice trimmed with patterned ribbon, puffed sleeves, pointed waist, and long, trained skirt of velvet; necklace with coral pendant; chignon with braid. Photo by J. Hawke (Devon, UK). Circa 1864.

9. Silk dress with black lace appliqués; black lace shawl; black bead necklace; braided coronet coiffure. Photo by F. A. Renards & Fils (Bourbonne-les-Bains, France). Inscription: *Juillet 1864.*

10. Silk paletot with lace trim over a plaid dress. Photo by Pierre Petit (Paris). Inscription: *M. Andren 1864.*

11. Day dress of dark figured fabric, possibly wool challis, broderie anglaise collar, unusual undersleeves in that the material contrasts with the dress. Photo by Keely (Philadelphia, PA, United States). Inscription: *Taken about 1864.*

28: 1865

1. Sprigged dress trimmed with scalloped bands of pleated flat ruffles; worn by actress Albertine Liné, whose hairdo is unusual for the time, loosely curled or perhaps even short. Photo by Adèle (Vienna). Printed date: *1865.*

2. Plaid cotton dress with scrolling braid trim on the sleeve. Photo by G. K. Proctor's Gallery (Salem, MA, United States). Tax stamp: *1865.*

3. Silk taffeta dress with double-pointed bodice. Photo by G. W. Weiser (Steubenville, OH, United States). Pencil inscription: *Caroline.* Inscription: *July 19, 1865.*

4. White summer dress with sash and pale wool three-piece suit worn by engaged couple Countess Julie Hoyos Stichenstein and Prince Filippo Orsini, 18th Duke of Gravina. Photo by L. Angerer (Vienna).

Inscription: *La Prince D. Philippe Orsini et la Julie Hoyos comme fiancées en 1865.*

29: ALTERNATE DRESS

1. Bloomer ensemble with military-style tunic, military-style belt, short full skirt, ankle-length bloomers; shoes with spats; military-style hat. Photo by C. F. Linge & Co. (Stockholm). Circa 1860s.

2. Athletic bloomer costume with plaid tab appliqués, belt, and pocket. In 1864, *Godey's Lady's Book* described similar athletic attire made by Mme. Demorest of New York: "the most suitable and admired of these costumes are made in French flannel, and consist of a Garibaldi, Turkish pants and short skirt, which leaves the limbs free for exercise." Photo by Schoonmaker (Troy, NY, United States). Circa September 1864–August 1866 (based on hand-canceled two-cent stamp).

3. Compromise feminine ensemble as worn by French painter Rosa Bonheur. Bonheur, a realist painter, particularly of animals, was the first woman to receive the Legion d'honneur. She wore her hair short, parted on the side, and her typical dress consisted of adaptations of men's clothing; for riding she wore baggy knee breeches, for painting a smock and trousers, and was described by the painter Paul Chardin as having a particular costume for receiving guests or for visiting Paris: "a sort of black velvet cloak, half cassock, with a rather masculine cut, beneath which showed a kind of velvet waistcoat which was buttoned straight up." Photo by Disdéri & Cie. (Paris). Circa 1858–1862.

4. Wool day dress and trouser ensemble worn by Dr. Mary Walker, surgeon and early feminist who wore various versions of pants ensembles her entire life. Photo by Elliott & Fry (London). Circa 1866 (based in part on when Walker received her medal, which she wore daily for the rest of her life).

30–31: 1866

1. Tailored day dresses, two with trimming at the bodices, one with deep hem box-pleated flounce. Unknown photographer. Tax two-cent stamp: *FEB 22 1866 Columbus.*

2. Ball gown with ruched trimming; black handmade lace shawl; necklaces with pendants; hair with ringlets; headdress. Photo by Dr. Reid & Ronninger (Vienna). Inscription: *To my Kind Friend* [illegible] *Cook in kind remembrance from Caroline* [illegible] *London 23 66.*

3. Court presentation: ball gown of white shirred tulle with camellia corsage, white silk and tulle train; headdress with white ostrich and veiling; worn by Miss Lloyd. Photo by Camille Silvy (London). Inscription: *Dear Mrs. Parry from Floreline* [sic]. Printed date: *1866.*

4. Black dress with bead trim and train, possibly a mourning dress; black beads with cross pendant. Photo by Levitsky (Paris). Inscription: *Mrs. Hunt with M.* [illegible]*'s love. Sept. 15th 1866.*

5. Taffeta two-piece dress, jacket bodice with tails, skirt with some increased back fullness, appliquéd with looped bands of narrow ribbon; snood. Photo by Eugene Hallier (Paris). Inscription: *Marie Renault 1866.*

6. Tailored skirt, shirtwaist; black velvet bolero. Photo by Dubordieu Photographe (Rue de la Gare Valence). Inscription: *Renbido en Mexico. El 4 de Augusto 1866.*

7. Day dress in pale or white silk, with trained skirt, worn by Eugénie Fiocre (1845–1908), principal dancer with the Paris Opéra and muse to Edgar Degas

and Jean-Baptiste Carpeaux. Unknown photographer, possibly Disdéri & Cie (Paris). Inscription: *Eugenie Fiocre Opéra – (danse) 1866.*

8. Silk day dress with fullness to the back of the skirt, flat braid or ribbon trim, ornamental pocket. Photo by H. Daubray (London). Inscription: *17 years old taken in 1866.*

9. Dark pinstriped silk dress with train, satin trim at the sleeve; belt; long chain; worn by a member of the German aristocracy. Unknown photographer. Partially legible pencil inscription with identification and date: *S. A. la de Saxe Meiningen Hildburghauser 1866 nee Princesse a Saxe Allenbourg.* Note: Feodora de Hohenlohe-Langenbourg (1839–1872) married Georges II de Saxe-Meiningen-Hildburghauser in 1858.

10. Garibaldi-type blouse, belt with decorative stitching, contrasting long skirt. Photo by The West London Photo Company (London). Inscription: *Theresa Young* [illegible]. Circa 1866.

11. Day dress of silk woven with velvet floral sprays, wide belt, trimmed with jet fringes, edged at hem with a box-pleated ruffle. Photo by A. Ken (Paris). Circa 1866.

12. Dress with off-the-shoulder neckline; ankle boots; worn by an eleven-year-old girl. Photo by Rob Hayward (London). Inscription: *August – 1866 – 11 years old.*

32–33: 1867

1 & 4. Two views of Mrs. Bates: seated, in a taffeta dress with jet embroidery, her black lace shawl and flower-trimmed hat on the table; and standing, in taffeta dress with taffeta paletot with velvet trim, flat hat worn tilted over her brow. Photo no. 2 by De Jongh (Vevey, Switzerland). Inscription: *Mrs. Bates November 11th, 1867.* Photo no. 3 by F. Randegger (Vevey, Switzerland). Inscription: *Dec. 15th, 1867.*

2. Christina Nilsson (1843–1921), renowned Swedish opera singer, in an ensemble of fitted jacket and crinoline projetée in striped silk trimmed with bands of silk with circles and diagonal lines. Photo by Ch. Reutlinger (Paris). Circa 1867.

3. Velvet dress with pleats at the back and train; worn by great beauty Georgina Elizabeth Ward, Countess Dudley, née Moncreiffe (1846–1929, married in 1865). Photo by F. C. Earl (Worcester, UK). A copy of this photograph, along with another from the same sitting, is in the collection of the National Portrait Gallery, London. Circa 1867.

5. Black dress trimmed with wide bands of mourning crape, paletot with crape trimming. Photo by Claude Bossoli (London). Inscription: *June 1867.*

6. Garibaldi blouse and dark skirt. Photo by AG Tod (Cheltenham, UK). Inscription: *Oct. 1867.*

7. Dress of moiré antique woven with small square figure, trimming of velvet and jet bead fringes; black lace shawl. Photo by Mathieu-Deroche (Paris). 1867 (based on silver medal date printed on photograph).

8. Velvet bodice with military braid detail, taffeta skirt with fullness in back and train. Photo by Milner & Son (Ilkley, UK). Circa 1867.

9. Dark taffeta dress, narrow sleeves, small collar and cuffs; parasol; belt with buckle; dangling earrings, brooch, long chain. Photo by Américaine Brevetée (Rome). Inscription: *Mde. Colona. Rome. 1867.*

10. Silk dress with triangular decorations of brocaded ribbon and lace; short vel-

vet jacket with embroidery; turban hat with fringed sash ends in back. Photo by Aptiopa (Russia). Stamped: Collection Marcel Bovis. Inscription: *Mademoiselle Letitia Marlini June 3/67*.

11. Striped trained dress with velvet wrap; frock coat; checked pants; brooch; gloves. Unknown photographer. Pencil inscription: *2 Aug 67*.

12. Summer scene outside a garden house: Garibaldi shirtwaists and skirts; belts; bolero or paletot jackets. Unknown photographer (Switzerland). 1867.

34: 1868

1. Bolero jacket trimmed with pompon fringe, braid, and fringe; shirt with full sleeves and long cuffs, trained taffeta skirt with wide waistband, skirt held up to reveal embroidered underskirt or petticoat; dangling earrings and dangling brooch at waist; hat with feather trim; coiffure with braid coronet. Photo by Guipet (Dijon, France). Pencil inscription: *Madame de Cardonade Sandrano, nee de Bereson. Dijon, Juin 1868*.

2. Silk dress with gored skirt with slight train, narrow box-pleated ruffle trim; necklace with cross pendant. Photo by Bonnefon (Corbeil, France). Inscription: *le 19th, 9th, 1868 (22 ans!)*.

3. Gored silk day dress with self-fabric trimmings, train. Photo by H. Chala (Rennes, France).

4. Summer ensembles won by two sets of sisters: dresses; jackets, blouses and skirts; hats and wraps. Photo by J. O'Neil (New York). Pencil inscription: *Emma Seyfert, Marie Seyfert, The Misses Jones*.

5. Black taffeta evening gown with puffed sleeves, point d'esprit long undersleeves, bodice; ribbon-trimmed bolero; mourning jewelry including gutta-percha link bracelet with pendant. Photo by Carl Kroh (Vienna). Inscription: *Mariette Wilmar, 1 November 1868*.

6. Mourning attire: silk jacket trimmed with wide bands of crape, black necklace and black dress with slight train. Photo by H. T. Reed & Co. (London). Circa 1868.

7. Patterned silk dress with train, beaded passementerie epaulets and trim, ribbon sash; half-up, half-down coiffure with coronet. Photo by Schembouche, Fot (Turin and Florence). Inscription: *28 Juigno 1868. Carolina Gantanchiotti [illegible]*.

8. Dinner gown with yoke and sleeves of point d'esprit woven or trimmed with bands of lace, heavy braid and bobble trim at the yoke and sash; ribbon choker with locket, dangling earrings and bracelets, hair ornament. Photo by Ch. Reutlinger (Paris). Inscription (trimmed and thus mostly illegible) and date: *1868*.

35: 1869

1. Dark silk dress with train, sash; necklace of large beads; coiffure with long ringlet. Photo by J. E. Thompson (Bath, UK). Inscription: *M. Jackson 20th May 1869*.

2. Evening gown of black satin overlaid with black lace; bib necklace. Photo by J. Geiser (Algiers). Inscription: *Madame Chalanqui – 1869*.

3. Reception gown of silk faille with basque bodice and trained skirt with center pane worked with ruching and points. Photo by A. Rae & Son (Banff, Scotland). Inscription: *Mrs. Garden-Campbell of Troup & c. 1869*.

4. Velvet dress trimmed with passementerie, ruffled collar, undersleeves. Photo by Barthélemy (Nancy, France). Inscription: *Mme. Emile Guérin Lunéville 1869*.

5. Striped dress with shirred overskirt; braided coiffure with ringlet. Photo by F. E. Hesselbach (Würzburg, Germany). Inscription: *69 [illegible]*.

6. Silk dress with wide bands of black lace, satin bands and ribbon bows, high small bustle, train; black bead necklace. Photo by Fratelli Gregori (Piacenza, Italy). Inscription: *Miss Mary Adail Wikersham Piacenza Agotto 1869*.

7. Dress with braid trimming at the lapels, vest insert, apron overskirt and hem; demi-parure and long chain; fan. Photo by Fratelli Gregori (Piacenza, Italy). Inscription: *Virginia Settembre 1869 Piacenza*.

8. Silk skirt with overskirt, shirtwaist with shirred yoke, ribbon beading. Photo by Hanns Hanfstaengl (Dresden). Inscription: *Margaret L. A. Camp July Dresden 1869*.

1870s

36: Two-tone reception dress rimmed with pleated ruffles. Photo by Appleton & Co. (Bradford, UK). 1872.

38: 1870

1. Dress with tiered skirt and pointed overskirt in light wool trimmed with embroidered scalloped bands in contrasting tones. Photo by Mrs. E. Higgins (Stamford, UK). Circa 1870.

2. Bride in white dress with train, marabou-feather trim; tulle veil; bouquet and lace-trimmed handkerchief. Groom in white tie and tails. Photo by Angelina Trouillet (Paris). Pencil inscription: *en Avril 1870*.

3. Walking or visiting toilette: wool dress with cape and apron overskirt, trimmed with self-ruffles; velvet hat trimmed with ostrich plumes worn low on the brow; umbrella. Photo by Emil Rothe (Cassel, Germany). Printed date: *1870*.

4. Patterned silk ball gown with shirred tulle inner bodice; worn by burlesque actress and impresario Ada Richmond. Photo by Howell (New York). Inscription: *Ada Richmond - To His Nibs*. Circa 1870.

5. Silk dress trimmed with pleated fringe-edged bands; braided chignon. Photo by Southwell Brothers (London). Inscription: *For dear Carrie with love, May 2nd 1870*.

6. Silk day dress with apron overskirt, trimmed with self-bands, pleating, and rosettes; worn by a young woman leafing through an album of cartes des visites. Photo by J. Milner (Leeds, UK). Inscription: *Taken 1870*.

7. Empress Eugénie departing the Tuileries in September 1870. Composite image possibly using earlier images by photographer E. Flamant (Paris).

39: 1871

1. Faille, velvet, and lace dress with apron overskirt; ornate belt buckle; velvet neck ribbon with pendant and earrings; elaborately braided coiffure with hairnet. Unknown photographer. Inscription: *Bristol 1871. Mrs. Lee*.

2. Satin ball gown trimmed with bands of bead embroidery and lace; pendant suspended from ribbon choker, dangling brooch, and bracelets; fan. Photo by J. & L. Allgeyer (Karlsruhe, Germany). Inscription: *Freiburg. Sept. 71*.

3. Evening gown in black velvet and silk taffeta trimmed with black lace, sheer point d'esprit yoke and long sleeves; pearl bib necklace; elaborate coiffure worn with a comb. Photo by William Heath (Plymouth, UK).

4. Day dress for a seventeen-year-old: striped material with self-trim. Photo by D. J. Ryan. Savannah, GA, United States). Inscription: *Janie Tison 17 in 1871*.

5. Satin bustle dress trimmed with black binche lace; drop earrings; coiffure with braided coronet. Photo by Sarony (New York). Entered according to act of Congress in the year 1871 by N. Sarony in the office of the Librarian of Congress of Washington.

6. Girl's dress in wool, ribbed stockings; ankle boots. The length of the dress illustrates the *Godey's Lady's Book* dictum of June 1870: "Girls of twelve years and less wear their skirt short enough to show two or three inches of white stocking above the boot, but drawers, no matter how handsomely trimmed, must not appear below the dress." Photo by Burgaud et Cie (Rochefort, France). Inscription: *Marie Allez 5 ans ½ 1871*.

7. Dress pulled up showing a pantaloons-clad leg. The intention behind this photograph is unclear; other images of the time show similar line-ups of people sitting on a ramp with the inference being that they are miners. Inscription: *"Champs" Sept. 1 1871*.

8. Day dress trimmed with self-ruffles, belt, white collar, ribbon bow; pendant on chain. Photo by Alfred Perlat (Poitiers, France). Inscription: *A. Blanchard Juillet 1871*.

40: 1872

1. Dress and overskirt trimmed with ruffles. Photo by T. Cognacq (La Rochelle, France).

2. Velvet dress with soft fur trim; necklace of large beads; elaborate coiffure. Photo by S. H. Parsons (Harbour Grace, Canada). Inscription: *11th Oct 1872*.

3. Bustle-backed dress of black silk with velvet trim; braided coiffure. Photo by Fratelli Marco Giovanni Contarini (Venice, Italy).

4. Taffeta ensemble with apron overskirt, bustle, trim including fringe, pinked edges. Photo by Le Jeune (Paris). Inscription: *Mme. Alin Brice 1872*.

5. Pale bustle dress, black short jacket with wide sleeves trimmed with bands of black satin and fringe; flower-trimmed hat with ribbon strings. Photo by London Portrait Rooms (Dunedin, New Zealand). Inscription: *Augt 1872. Mrs. A. Hepburn*.

6. Dark dress trimmed at the shoulders with braid. Girls' dresses with self-ruffles. Photo by Delaporte (Vincennes, Paris). Stamp: *1872*.

7. Alexandra, Princess of Wales (1844–1925), wearing a tailored daytime ensemble with draped bustle-back skirt, holding a pet parrot. Photo by H. J. Whitlock (Birmingham, UK).

41: 1873

1. Dress trimmed with self-ruffles; coiffure with high crown and ringlets. Photo by C. Hawkins (Brighton, UK). Inscription: *Florence Davis. July '73. 19 years old*.

2. Summer dress of striped sheer cotton trimmed with self-ruffles and ruched or gathered bands matching the stripes; drop earrings; braided coiffure. Photo by Sunderland (Birmingham, UK). Pencil inscription: *1873*.

3. Woman on left wearing dress with scalloped edged overskirt and hem, sheared fur-trimmed jacket. Woman on right wearing black dress with apron overskirt trimmed with self-ruffles and bands of wool braid; hat with feathers. Unknown photographer. Inscription: *Con Muriel & 'Bill" Weedon April 1873*.

4. Dress with trimming of black binche lace, jabot edged with Valenciennes; parure of coral; loosely braided coiffure. Photo by Coleman & Remington (Providence, RI, United States). Inscription: *Mintie P. Summer May 26th, '73*.

5. Taffeta dresses trimmed with self-ruching and ruffles. Photo by Robbes (Rennes, France). Inscription: *Magdelene et Mathilde de Monfoy – Mathilde a 17 ans. x73*.

6. Black dresses with velvet bodices and ruff collars. Photo by Jungmann & Albert (Bodenbach, Germany). Stamp: *1873*.

7. Bustle-back formal daytime dress, possibly for mourning, in black trimmed with self-piping, black lace, bows. Photo by E. Bieber Hofphotographin (Hamburg, Germany). 1873 (based on most recent of six dates on the back of the card indicating prizes won by the photographer).

42-43: 1874

1. Dark silk dress with apron overskirt and wide revers trimmed with a narrow band of box-pleated self-ruffles; dangling earrings; hair comb. Photo by Marius (Paris). Inscription: *1874*.

2. Reception gown in in silk faille with self-trimming, bustle, and train. Photo by A. L. Graham (Leamington).

3. Summer dress of broderie anglaise with foliate sprigs, overskirt edged with Battenberg lace; velvet necktie with cameo; velvet and lace headdress. Photo by Hills & Saunders (Eton, UK). Inscription: *Mrs. Griffith-Jones. 1874*.

4. Elaborate reception gown in black silk sewn with bands of jet embroidery and black lace, apron overskirt in black satin striped mesh embroidered with vermicelli lines in beads, neck ruffle of black beaded lace over white pleated ruffle, wrist ruffles of pleated sheer black lace over white; worn by the Countess of Dudley, née Georgina Moncrieffe (1846–1929), wife of William Ward, 1st Earl of Dudley. Married at St. Paul's Church in 1865, wearing a rich dress with a tunic and bodice of French lace originally intended for the Empress Eugénie and valued at the time at £2,000. Among her wedding presents, as reported in the press, were five strands of pearls presented by her husband before heading to the altar. Countess Dudley was known for her beauty and her taste in fashion and furnishings. Among her admirers was the Prince of Wales, who "lent" her for life a residence at Pembroke Lodge. Photo by Adèle (Vienna). Printed date: *1874* (note that other photographs from this sitting are dated 1875).

5. Walking attire: dress and jacket; walking stick; beret. Photo by Allan Hamilton (Bristol, UK). Inscription: *W.K.T. Nov. 12 1874* (photograph also marked: *Hay Photo. Oban*).

6. Eighteenth-century-style theater costume adapted with up-to-date bustle; worn by Miss Ada Cavendish (1839–1935) in the role of Lady Clancarty in the play *My Lady Clancarty*. Photo by Window & Grove (London). Inscription: *Miss Ada Cavendish as "Lady Elizabeth Clancarty." Got at No. 8 Sloane Street, the 10th day of July 1874*.

7. Woman's tailored costume with cuirasse jacket and skirt with apron overskirt; riding crop; straw hat tilted over the brow. Unknown photographer. Circa 1874.

8. Bustle dress in silk faille with self-piping and narrow ruffle, black lace shawl.

Photo by Frank E. Pearsall (Brooklyn, NY, United States). Inscription: *Hattie Bull. 1874-75-76*.

9. Redingote inspired jacket over matching skirt. Photo by: Allan Hamilton. (1 Stanley Terrace. Woolcott Park, Bristol. Ink inscription: *W.K.T. Nov. 12 1874*.

10. Velvet dress with trapunto quilted yoke and cuffs, satin-edged scalloped apron overskirt. Unknown photographer (UK). Inscription: *Miss A. McKay 1874*.

11. Day dress with sailor collar, diamond shaped buttons. Photo by Le Jeune (Paris). Inscription: *Berthe Defresne. Mme. Pernet. 18 Mai 1874*. Circa 1874.

44-45: 1875

1. Ball gown in black or dark silk trimmed with bands of lace, black-bead floral vine embroidery around the waistband, artificial flowers matching those worn in the hair; triple-strand necklace; fan. Photo by Prod'hom & Fils (Bône [now Annaba], Algeria). Inscription: *28 Juin 1875*.

2. Two-toned bustle dress. Photo by Elliott & Fry (London). Inscription: *G. Sanderson, Miss Hutchinson. 15 Copies. 1875*.

3. Mother in dress with military tailoring, ruched sleeves, ruffled collar, and ribbon bow. Seven-month-old boy in dress of broderie anglaise; kid shoes. The mother is Lady Madeline Seymour, who died two years after this photograph was taken; her son, Hubert, became Major Crichton and died in the Great War. Inscription: *Lady Madeline Crichton and Hubert, 7 months old. 1875*.

4. Black dress with trimmings of knife-pleated ruffles, black velvet, black lace, and overskirt of sheer black material; hat with trimmed with velvet. Photo by Sarony (New York). Inscription: *Carrie S. Hanna Ft. Wayne, Ind. Aug. 7th, 75*.

5. Bustle dress with redingote and underskirt effect, the redingote edged with jet, the skirt with shirring, ruffles, and pleats. Photo by Wm. Klauser (New York). Inscription: *For Fanny. Taken May 28th, 1875*.

6. Reception dress trimmed with self-ruffles, lace collar; pendant on ribbon. Photo by Gustave (Le Mans, France). Inscription: *Souvenier a mon amie Lucie le 26 Novembre 1875*.

7. Velvet hat worn with black silk cape or capelet. Photo by E. P. Dunshee (Boston, MA, United States). Inscription: *1875*.

8. Plaid dress with solid trimmings. Photo by Carl Westendorp (Cologne). Circa 1875.

9. Light wool bustle-back dress decorated with bands and bows of dark velvet; velvet ribbon choker; velvet hat with ostrich plumes. Photo by W. & A. H. Fry (Brighton, UK).

10. Woman draped in a Spanish (Chinese by way of Manila, Philippines) shawl, silk crepe self-embroidered with flowers, lacy fringe. Photo by E. Courret (Lima, Peru). Inscription: *Mrs. Steele*.

11. Woman wearing tailored jacket, bustle-back skirt; high crown hat with ostrich feather; braided coiffure. Man wearing braided edged cutaway coat; striped bowtie; cane or walking stick; stovepipe hat. Photo by W. Durrant (Torquay, UK). Inscription: *May 1875*.

12. Plaid dress with basque bodice, contrast trim at the edges and pocket, bustled skirt. Photo by Rodgers (Hartford, CN, United States). Circa 1875.

46–47: 1876

1. Dinner or reception gown with jet embroidery; chatelaine at waist with several objects, including a magnifying glass; high braided coronet. Photo by H. Webster & Son (London). Inscription: *S. Hargreaves Taken 1876.*

2. Reception gown à la polonaise; triple-strand pearls and numerous bracelets; ostrich-plume-trimmed hat; worn by Elizabeth Harriet Grosvenor, née Leveson-Gower, Marchioness of Ormonde (1857–1928), an aristocratic beauty, possibly photographed around the time of her wedding in 1876. Photo by Elliot & Fry (London). Circa 1876.

3. Mother's dress in wool with self-ruffled detail, pocket; black jewelry; braided coiffure. Child's dress in velvet with high button boots. Photo by M. Konarsky (Moscow). Inscription: *à notre cher [illegible] Maris et mama Satowevry. le 12 Decembre 1876 Moscow.*

4. Mrs. Henry Tranger of San Francisco wearing a day ensemble with glazed fabric bodice, underskirt, wool overskirt trimmed with velvet, lace-edged jabot; long necklace. Mr. Henry Tranger wearing three-piece wool suit. Photo by John D. Goedus (San Francisco). Inscription: *14 APRIL '76.*

5. Dress with bustle and train in white with black trim. Photo by A. J. Melhuish (London). Inscription: *Jan 1876.*

6. Matelassé wrap with pagoda sleeves trimmed with fur; fur muff; felt hat trimmed with velvet and ostrich plumes. Photo by Emile Mourtin (Paris). Inscription: *a Mon. Abler Souvenir Paula Brown. 17876.*

7. Velvet reception gown, narrow pleated ruffles at the neckline and cuffs, bow-trimmed train. Photo by M. Scherer & H. Engler (Dresden, Germany). Printed: *Munchen (medal won at Exposition) 1876.*

8. Tailored dress with white collar and ribbon bow at the neck; cross pendant and dangling earrings; hair comb. Photo by Hri. Badie (Paris). Inscription: *Juillet 1876.*

48–49: 1877

1. Dinner gown in white-on-white striped silk and lace, U-neck with ruffles, lace sleeves; paisley wrap and fan; worn by Mrs. Arthur Sassoon, née Louise Perugia (1854–1943), one of the leaders of Anglo-Jewish society. Born into an old Italian Jewish family, she married Arthur Sassoon in 1873. Her sister married into the Rothschild family in 1881, the first Jewish wedding attended by the Prince of Wales, who was also a friend and houseguest of the Sassoons'. Louise Sassoon's pre-Raphaelite beauty was captured by painter George Frederic Watts in 1882. Circa 1877.

2. Dress with draped skirt ending in pointed, tasseled folds over a dark pleated underskirt. Photo by A.B. Cross (Salem, MA, United States). Printed date: *1877.*

3. Velvet hat with upturned brim; slide necklace. Photo by E. S. Dunshee (Boston, MA, United States). Stamp: *1877.*

4. One-piece silk dress with slight bustle, trimmed with self-pleated ruffles, self-bows; lace scarf. Photo by John Owen (Newtown, UK). Inscription: *M.E.P.G. 1877.*

5. Walking or visiting dress in black silk faille trimmed with lace, narrowly pleated ruffles, white ruffle at the collar and cuffs. Unknown photographer. Inscription: *Frannie B. H. 1877.*

6. Taffeta and velvet dress with lace trim. Photo by H. G. Smith (Boston, MA, United States). Inscription: *Mr. and Mrs. Stearns with compliments of one of "the boys." June 15th, '77.*

50–51: 1878

1. Dark silk tailored ensemble with fitted jacket bodice and bustle skirt, beaded embroidered medallions at the skirt and the sleeve cuffs, lace jabot and cuff ruffles; gloves; umbrella and hat with ostrich plume. Photo by Sarony (New York).

2. Dark striped wool dress with trimmings of ribbed velvet. Photo by E. Villette (Paris).

3. Striped satin dress with train, trimmed with satin, pointed petaled hem; fringed hair ornament. Photo by H. Lambert (Bath, UK). Inscription: *1878.*

4. Two-piece dress in silk, cut velvet with trimming of bows and cords; chain with medallion; matching bracelets; worn by concert pianist and composer Julie Rivé-King (1854–1937). Photo by Gentile (Chicago). Inscribed: *to F.D. Nutting from Julie Rivé-King. March 7, 1878.*

5. Two street costumes with trains; feathered trimmed hats; braided chignons. Photo by Hammersly (St. Louis, MO, United States). Inscription: *Emma H. Rose, Hattie R. Whittier Dec. 11 1878.*

6. Black dress with white ruffled collar; blackened metal chain necklace. Photo by Taylor & Preston (Salem, MA, United States). Inscription: *1878.*

7 & 8. Two views of a princess dress with bustle-back details, embroidered with cornflowers, sewn with rows of buttons, side pocket. Photo by Adams & Stilliard (Southampton, UK). Stamp: *Jan. 1878.*

52: PRINCESS DRESSES

1. Fitted princess dress in striped fabric, draped overskirt, underskirt trimmed with striped petals, pleating. Photo by J. Loeffler (Staten Island, NY, United States). Circa 1878.

2. Day dress with low bustle detail and train, zigzag-edged shaped panel down the front, corresponding pointed trim above the pleated hem, ruffled jabot. Photo by William J. Sandry (Camborne, UK). Circa 1878.

3. Velvet-trimmed day dress. Children's coats with velvet collar and cuffs. Photo by Eugen Kegel (Cassel, Germany). Printed date: *Dec. 1878.*

4. Dresses trimmed with black velvet bows; braided coiffures. Photo by Nadar (Paris). Circa 1878.

5. Princess dress with velvet used for the sleeves, back, and possibly front panel, buttons and other trim. Photo by J. E. Shaw (Huddersfield, UK). Circa 1878.

53: 1879

1. Dark silk reception dress with train, decorated with self-bands, ruched bands, wide tucks, and narrow pleats. Photo by Edy Brothers (Ontario, Canada). Inscription: *7th May 1879. Caroline Macklin.*

2. Wedding dress of white satin trimmed with wax orange blossoms; veil of Honiton lace; diamond brooches and diamond bracelet; diamond fringe necklace and tiara; worn by Princess Louise Margaret (1860–1917), who, upon marriage to the third son of Queen Victoria in 1839, became the Duchess of Connaught and Strathearn. Photo by W & D. Downey (London).

3. Satin wedding gown with narrow skirt arranged in chevron bands, train; tulle veil; wax orange blossoms. Photo by M. & W. Garrett (Wilmington, DE, United States). Inscription: *Mary Bates Harrington. 1879. To Mia Hilthropp Harrington.*

4. Princess dresses with different placement of buttons, draping of skirt, hem trim; coiffures with decorative combs. Photo by A. H. Bell & Bro. (Bloomington, IL, United States). Stamp: *1879.*

1880s

55: Visiting dress with contrasting fabric of flocked dotted velvet. Tintype by unknown photographer (United States). Circa 1886.

56: 1880

1. Fur cape or cape collar; toque gathered into velvet band; braided chignon. Photo by Barry & Co. (Hull, UK). Inscription: *Kate Hutchinson 1880.*

2. Princess-cut evening gown in satin with fringed trim; marabou-feather-edged fan; ostrich-plumed-headdress. Photo by H. Rocher (Chicago). Circa 1880.

3. Jockey dress, with jockey cap and riding crop, possible fancy dress. Photo by B. Kisch (Durban, South Africa). Pencil inscription: *Flossie [illegible] 1880.*

4. Evening gown trimmed with handmade point lace; drop earrings and necklace; fitted kid gloves; Chinese fan with pierced sandalwood sticks and guards; hair ornament. Photo by Baldwin (Chicago). Pencil inscription: *Chicago 1880* (possibly added later and unreliable as a firm date).

5. Trained dress in heavy silk, probably faille, with trimmings of turned-back satin linings, the basque edged with knotted fringes, lace jabot and cuffs. Photo by E. L. Eaton Photographic Gallery. Printed date: *1880.*

6. Velvet ensemble of basque jacket with cutaway front, velvet bustle-back skirt with satin draped apron; gloves and large handbag; velvet hat. Photo by Partridge (Boston, MA, United States).

57: TUMBLING TRAINS

1. Ball gown in white or very pale pastel silk, probably taffeta, cuirasse bodice edged with beaded fringes, narrow skirt with overskirt of beadwork, bustle, and ruffled train; pearls; just-over-the-elbow-length kid gloves. Photo by Portrait Promenade. Circa 1880.

2. Bare evening dress with cuirasse bodice featuring little bands of piping sewn with puffs or bows standing in for sleeves, ruffle outlined neckline, Watteau train; sheer long fingerless gloves; worn by actress Edith Kingdon (1864–1921), who married George Gould, son of railroad tycoon Jay Gould. Photo by Gehrig (Chicago). Circa 1885.

3. Trained dinner gown in velvet with foliate embroidery or appliqué, underdress and train in contrasting color; worn by actress Kate Claxton (1848–1924). Photo by Mora (New York). Circa 1888.

58: 1881

1. Daytime ensemble with princess-cut long overdress, underdress with pleated ruffle, velvet trim, lace jabot. Photo by H. Buchholm (Springfield, MA, United States). Inscription: *Jennie Clapp Horey.*

2. Tailored dress in checked fabric, shirred collar and cuffs, shirred at the sides of the overskirt. Photo by W. W. Winter (Derby, UK). Inscription: *Rose Montford, Sep 5, 1881.*

3. Dress with patterned bodice and solid, draped skirt, jabot-collared shirt; turban. Photo by Brigham (Scarborough, UK). Inscription: *Mary H. Walker April 1881.*

4. Two-tone tailored dress fastening down the front with buttons, trimmed with ruching and narrowly pleated ruffles, white collar and jabot; silk flower corsage. Photo by Castellani (Rome). Inscription: *Gignio 1881.*

5. Floral woven silk two-piece dress with cuirasse bodice and draped skirt, trimming of lace and ribbon tabs; worn by Charlotte of Prussia (1860–1919), granddaughter of Queen Victoria. Photo by Theodor Prumm (Berlin). Stamp: *188[illegible].*

6. Summer dress with train. Photo-Portraits and Landscapes. (New Jersey, United States). Inscription: *18 August 1881.*

7 Dress with long cuirasse bodice and shirred bustle-backed skirt; worn by a young woman holding a carte de visite, possibly from the album resting on the chair back. Photo by Victor Franck (Saint-Dié-Des-Vosges, France). Inscription: *Almandine Ostertag. Dec. 1881.*

8. Summer dresses trimmed with bands of floral fabric, lace ruffles, ribbons. Photo by Barry (Plymouth, UK). Inscription: *Plymouth 1881.*

59: SHIRRING

1. Bustle-backed dress with basque bodice, bands of shirrings alternating with puffs. Photo by Brown, Barnes & Bell Photographers (London). Circa 1883.

2. Two-tone dress with double-pointed basque bodices, puffed sleeves, panels of shirring. Photo by A. E. Withington (Danielsville, CT, United States). Circa 1881.

3. Ten-year-old girl's dress with shirring and scalloped trim; silk sunshade and ankle-high strapped shoes in glacé leather; straw hat trimmed with ribbons. Photo by McComy Branson (Knoxville, TN, United States). Inscription: *Respectfully Ella W. Franz, born August 10.1871. 1881.*

60: 1882

1. Silk faille evening dress with train, trimmed with shirred bands, smocking, self-ruffles and black bead embroidery, lace collar and jabot. Photo by U. C. Moulton (Fitchburg, MA, United States). Inscription: *To Louis & Hattie from Mother. Christmas, Dec. 25, 1882.*

2. Checked wool three-piece single-breasted suit; bowler hat. Photo by The Toronto Photograph Company (Toronto, Canada). Inscription: *W. G. Vaughburrn 1882.*

3. Evening toilettes made in silk woven or embroidered or painted with large sprays of flowers. On the left is gown with short sleeves, black lace shawl; coiffure with hairpiece and spit curls. On the right is fitted bodice with lace-trimmed sleeves, trained skirt trimmed with ball fringe. Photo by Krueger & Co. (New York). Circa 1882.

4. Bustle dress trimmed with moiré, wide bands of moiré ribbon, smocking. Photo by W. Perry (Sandgate, UK). Inscription: *E. McLaughlin 1882.*

5. Formal bustle-backed dress and trained skirt in dark silk trimmed with dark lace; lace-edged fichu shawl. Photo by Charlie

E. Orr (Sandwich, IL, United States). Inscription: *1882.*

6. Black dress with velvet collar and shaped velvet center panel, draped skirt with flared underskirt, ruched trim, white ruffled collar and cuffs. Photo by G. P. Jacobsen (Odense, Denmark). Inscription: *1882.*

7. Wedding gown in white satin draped in lace and trimmed with wax orange blossoms; bouquet with lace ruffles, headdress of orange blossoms. Photo by W. W. Winter (Derby, UK). Inscription: *Lily Woodforde as she appeared "positively for the last time only" May 9, 1882.*

8. Girl's day dress in wool trimmed with shirring and with pleated satin panel, lace collar and cuffs, flat ribbon bow at the neck; hair bow and earrings. Photo by Rykert (Buffalo, NY, United States). Inscription: *1882.*

9. Velvet coat trimmed with sheared fur, frog closures. Photo by Vail (Poughkeepsie, NY, United States). Circa 1882.

10. White dress trimmed with tucks and bands of lace, draped apron overskirt and bustle; white mesh mitts; coiffure with curled bangs and long ponytail. Photo by Warwick Brooke (Manchester, UK). Circa 1882 (based on the printed statement on the back of the photograph that Brooke had been established eighteen years and on information in his obituary that he opened his business around 1864).

11. Dinner dress with cuirasse bodice and narrow skirt trimmed with bands of braid and fringe, lace sleeves; necklace and matching earrings. Photo by W. & D. Downey (London). Inscription: *April 15th, 1882.*

12. Dark silk bustle dress, probably black, basque bodice edged with triple row of piping trimmed with jet and black lace, moiré ribbons, ruched panels in the skirt. Photo by Taylor & Preston (Salem, MA, United States). Inscription: *1882.*

13. Striped silk street dress, basque bodice with pleated self-ruffle at the sleeves, apron draped overskirt, solid silk underskirt trimmed with pleated rosettes. Photo by Fernando Dessaur (New York). Inscription: *1882.*

62–63: 1883

1. Tailored day ensemble, wool fitted tunic jacket with braided knots and toggles, draped skirt over pleated underskirt; leather ankle boots; bar pin; fur muff; velvet flower bonnet worn back on the head. Photo by Th. Prümm (Berlin). Printed date: *1883.*

2. Formal daytime attire worn by extended family or house party gathering. Photo by L. Sauvager (Fontainebleau, France). Printed date: *1883.*

3. Day dress with cuirasse bodice, shirring at the shoulders and torso, draped satin at the hem, skirt with three kinds of pleats. Photo by F. Calmel (Pau, France). Inscription: *Célina Giron 1883.*

4. Ball gown of velvet cut to silk in a pattern of large leaves, underskirt of satin trimmed with self-bands, sleeves and trim of black lace embroidered with black beads. Photo by W. & D. Downey (London). Inscription: *Mrs. Helzer Dec. 10th [?] 1883.*

5. Day dress with delicate embroidery; brooch and lorgnette chain. Photo by Walter G. Lewis (Bath, UK). Inscription: *Robina C. Arnott. Taken July 16.83. For Louie.*

6. Tailored dress with smocked yoke, ruffled collar and cuffs; tennis racket. Photo

by W. W. Winter (Derby, UK). Inscription: *Blanche Montford, June 19th, 1883.*

7. Formal wedding attire. Photo by Langhans Praha (Prague). Inscription: *6. Februar. 1883. Prag Böhnmess.*

8. Fur-trimmed velvet dress with matching muff, distinctive large buttons down the front of the dress, frilled collar; bar brooch; leather gloves; velvet hat with ostrich-feather trim. Photo by C. Theo Cain (Owensboro, KY, United States). Printed date: *1883.*

9. Dark silk dress with double row of buttons; pale kid gloves; Gainsborough hat with curved brim trimmed with ostrich feathers. Photo by Conant (Portland, ME, United States).

10. Tailored dress trimmed with bands of velvet ribbons; heavy chain with locket pendant and chain link bracelet; long cord with monocle (?). Photo by Gaythier (Vienne, France). Inscription: *14 Octobre 1883.*

11. Silk dress with inserts of moiré, trimming of black silk lace over blonde silk lace; oval brooch. Photo by W. & D. Downey Studios (London). Pencil inscription: *Nov 14/83.*

64-65: 1884

1. Black dress with smocking, puffed long sleeves; black mesh mitts. Photo by Schemboche (Florence). Inscription: *Daisy's photograph with much love Xmas 1884.*

2. Tailored day dress in Glen plaid, apron trimmed with broderie anglaise. Unknown photographer. Inscription: *31 Decembre 1884. Gabrielle a cher Elodie.*

3. Ball gown in white satin with white tulle bustle trimmed with scattered faux pearls; rivière with pendant, stomacher, brooch and bracelet, diamond tiara; worn by Theresa, Marchioness of Londonderry (1856–1919), a formidable political wife and part of the Prince and Princess of Wales's set. The character Lady Roehampton in Vita Sackville West's *The Edwardians* was based on her. Another photograph of the dress reveals that the narrow draped skirt was embroidered with scattered motifs, almost like paisleys in faux pearls. Photo by W. & D. Downey (London).

4. Silk bustle-backed day dress with puffed skirt, pleated underskirt, Elizabethan frill collar; long chain with slide. Photo by Charles Hunt Photographer (Rockville, IN, United States). Circa 1884.

5. Bustle dress with velvet trim. Photo by Charles (Bordeaux, France). Circa 1884.

6. Reception dress in velvet-cut-to satin foliate floral pattern; diamond earrings; lace-trimmed patterned silk sunshade and dark kid gloves; velvet bonnet with bird wings. Photo by Taber (San Francisco). Stamp: *Apr 1 1884.*

7. Bustle dress in silk, possibly faille, trimmed with cut velvet bands. Photo by Charles (Bordeaux, France). Inscription: *Alice 20 Juin 1884.*

8. Tweed long fitted coat with self-covered buttons; umbrella; hat with rolled brim and bird-of-paradise feathers. Unknown photographer (France). Inscription: *Jane de Gaudemaris (1858–1890) 1884.*

66-67: 1885

1. Family portrait showing woman in faille and velvet dress with velvet chenille trim down the front, around the hem and at the cuffs, skirt with alternating shirred bands of velvet with pleated ruffles of faille. The menfolk wear new-looking dark wool clothing and the youngest son is wearing what would become known in the early twentieth century as a "Buster Brown suit," named after a comic strip character. Photo by Carter (Worcester, MA, United States). Pencil inscription: *March 4th, 1885.*

2. Dark dress with high collar and jabot; fresh violets; bar brooch and earrings, owl-shaped clasps or buttons; coiffure with tightly curled bangs. Photo by F. Glenton (Nashua, NH, United States). Printed date: *1885.*

3. Floral-patterned tailored dress; sprig of lilies-of-the-valley. Photo by Th. Boulanger (Mulhouse, France). Inscription: *M.S. 1885.*

4. Lillie Langtry (1853–1929) in a satin and lace evening dress; pearl choker with jeweled pendant and jeweled ornament, stickpin. Other photographs from this sitting show the long pointed bodice and a bustle skirt of lace and satin. Photo by W. & D. Downey (London).

5. Lillie Langtry in a bustle-backed ball gown, bodice of embroidered satin edged with shirred white mousseline, skirt of satin, satin ribbon, and lace; pearl choker; ostrich fan. Photo by Henry Van der Weyde (London). 1885 (based on date of same photograph found on the Internet).

6. Woman with a bird, wearing a formal day dress in silk brocade trimmed with lace. Photo by W. & D. Downey (London). Circa 1885.

7. Seaside or yachting costume: white belted jacket trimmed with braid, shirt with high collar and neck scarf, skirt with patterned silk apron edged with lace; bar pin; hat with veiling. Photo by Heath & Bullingham (Plymouth, UK). Inscription: [illegible] *79372.* Circa 1885.

8. Tailored daytime costume in tweed. Photo by P. E. Chillman (Philadelphia, PA, United States). Pencil inscription: *"Susie" 1885.*

9. Princess Henry of Battenberg (1857–1944), youngest daughter of Queen Victoria, dressed for her wedding to Prince Henry of Battenberg on July 23, 1885. Her Honiton lace veil and the draped apron panel on her skirt had been worn by Queen Victoria at her own wedding. Photo by W. & D. Downey (London).

10. Dark patterned silk tailored dress with ruffled collar and cuffs, tulle and flower-trimmed bonnet; worn by Miss Frances Paget. Photo by Elliott & Fry (London). Pencil inscription: *1885.*

11. Dress of wool and velvet, lace jabot; floral corsage; long chain. Unknown photographer. Inscription: *Dollie M. Gilliland and Mechanicsville. Cedar Co., Iowa. Feb. 10, 1886.* Pencil inscription: *Eva Age 24 years 1885.*

12. Dark silk dress with gathered bodice, ruff collar, silk flowers at the neck. Photo by Furman (Rochester, NY, United States). Inscription: *Lucy Underwood July 4th, 1885.*

68-69: CORSET DETAILING

1. Reception gown of white trimmed with ruching and white lace, basque bodice with double row of self-buttons, ruched chiffon trim in a darker color at neck; delicate bracelet worn on each wrist, double-strand choker of artificial pearls; fitted kid gloves. Photo by D.A. Bowman (Mahanoy City, PA, United States). Circa 1882–83.

2. Dinner dress with corset-laced bodice, yoke and sleeve insert of embroidered net, ruff collar with beaded circlet, rosebud corsage; long silk liste mitts; handkerchief and fan. Photo by United States Portrait Co. (Brooklyn, NY, United States). Circa 1885.

3. Black dress with corset-laced cuirasse bodice, draped skirt. Photo by Debenham & Gould (Bournemouth, UK). Circa 1884.

4. Black dress with corset-laced bodice, edged with braid, tasseled braided belt. Photo by T. C. Turner (London). Circa 1885.

5. Day dress with corset-laced bodice, plastron, ruched bands of tartan silk. Photo by J. C. Schaarwächter (Berlin). Circa 1885.

6. Wool dress with gathered plastron, draped panier on one side and pleating, corselet and skirt panel of velvet. Photo by Miller (Minneapolis, MN, United States). Circa 1888–90.

7. Actress Edith Kingdon (1865–1921) in bare evening dress with cuirasse bodice, ruffle outlined neckline, Watteau train; the bare bodice featuring little bands of piping sewn with puffs or bows standing in for sleeves; sheer long fingerless gloves. Photo by Gehrig (Chicago). Circa 1885.

8. Dress with sleeveless cuirasse bodice, lace, velvet standup collar, bustle skirt with moiré ribbons. Photo by Aimé Dupont (New York). Inscription: [illegible] *K. C. Goodward.* Circa 1885 (based on photographer's Harlem address, where he set up shop in 1884 before moving early in 1886 to 574 Fifth Avenue).

9. Satin ball gown with corset-laced back, decorations of shaped satin bands with chenille and other embroidery and appliqué, silk lace ruffle trim; drop earrings; braided chignon; worn by Frances "Fanny" Work (1857–1947), a daughter of a New York banker who married James Boothby Burke Roche, a son of Baron Fermoy of Ireland, in 1880. She divorced in 1891, married again in 1905, and divorced again. She was a great-grandmother of Diana, Princess of Wales. Photo by Downey (London). Printed title: Mrs. Roche. Copyright. Waterlow & Sons Ltd. Circa 1885.

70: 1886

1. Wool tailored dress with apron overskirt, fan-pleated bodice, trimming of striped cut velvet; bar pin, double-strand bead necklace, and bracelet. Photo by Otto Schulz. (Osnabrük, Germany). Inscription: *Berta Heilmann Osnabruck 1886.*

2. Day dress with boteh appliqués in velvet, lace jabot; lorgnette without a chain; hat with ostrich plumes. Unknown photographer. Inscription: *Dollie M. Gilliland and Mechanicsville. Cedar Co., Iowa. Feb. 10, 1886.*

3. Black satin tailored dress, apron overskirt, pleated underskirt, frill collar. Photo by Elite (Chicago).

4. Lady Randolph Churchill (1854–1921) in a black dinner dress, underskirt, lace bodice with soft ruffled collar, cuffs at the elbow-length sleeves, wide belt with jeweled buckle; pearl choker and bracelet of thin chain wrapped several times around the waist dangling a charm. Born Jennie Jerome in Brooklyn, she married Lord Randolph Churchill in 1874; her son Winston was born in 1874. Musically talented, she was a lover of Edward VII, a good friend of his wife, the Princess of Wales, and one of Charles Frederick Worth's "most valued customers." Worth made a fancy dress costume for her based on Empress Theodora. Photo by Nadar (Paris). Printed date: *1886.*

5. Tailored dress in cream embroidered with cream-colored flowering vines; dotted tulle scarf; large pearl choker; paste hair ornament. Photo by Dumshee (Philadelphia, PA, United States). Printed date: *1886.*

6. Similar dresses in black or dark silk with closely fitted cuirasse bodices, draped and pleated street-length skirts. Unknown photographer. Stamp: *Rec. Sep 28 1886.*

7. Young woman wearing lace-trimmed two-piece formal daytime dress. Bangor, Maine. Photo by F. C. Weston.

8. Similar eyelet dresses with tartan sashes; double strands of coral beads and earrings; matching hair styles. Photo by Alfred Lehmann (Berlin). Pencil inscription: *13/3 86.*

71: CUL DE PARIS

1. Ensemble with basque bodice and bustle-backed walking-length skirt in silk woven with sprays of leaves, velvet trim, high lace collar; lace-trimmed sunshade; Gainsborough wide-brimmed hat with ostrich plumes. Photo by Salisbury (Pawtucket, RI, United States). Circa 1884–87.

2. Wool day dress with velvet collar and cuffs, draped apron overskirt; coiffure with curled bangs. Photo by Numa Blanc fils Sucles (Monte Carlo, Monaco). Circa 1886.

3. Satin dress with bustle skirt; possibly a wedding photograph. Photo by Smaddara (Fall River, MA, United States). Circa 1886.

4. Ball gown in black satin, lace, and jet-bead-embroidered lace, black and white ribbon trim, black bead edging at the neckline and loop at the sleeve; cluster of small diamond brooches and black ribbon choker with a small brooch. Photo by Charles Smith Allen, The Excelsior Studio (Tenby, UK). Circa 1888.

5. Well-dressed family of three, with the mother's dress overlaid with black lace, the father holding a bowler hat. Photo by Hennies (Columbia, SC, United States). Circa 1886.

6. Tailored costume with bustle, high neck, white collar and cuffs; straw hat trimmed with artificial fruit. Photo by Smith (Cooperstown, NY, United States). Circa 1886.

72: 1887

1. Reception or dinner gown with train in silk and velvet trimmed with beaded tassels and lace ruffles. Photo by Gehry (Chicago). Inscription: *Isabelle A. Galt. 550 Dearborn Ave. 1887.*

2. Reception gown with raised Renaissance shawl collar, bobble trim, bustle, marabou-feather-edged fan. Photo by Jordan (Dubuque, IA, United States). Printed: *1887.*

3. Lingerie dress worn for high school graduation, broderie anglaise with tiered skirt, bustle. The graduate is holding her scrolled diploma. Along with the floral tributes on the table are books, including *Shakespeare's Works.* Photo by Bradford (Kendallville, IN, United States). Inscription: *Mary L. Lepper. H.S. Class '87* (and in another hand: *my namesake*).

4 & 7. Two views of a bathing costume with sailor collar and braid trim, espadrilles. Similar to a published image of bathing suits from a catalogue published in 1887 by Marshall & Snelgrove, an English department store. Pencil inscription: *Nelly Mercier 1887.*

5. Tailored dress of dark wool with stripes at the high collar, front bodice, cuffs of the long sleeves and at the skirt; earrings and necklace; fan. Photo by S. D. Kruger (Liverpool, UK). Inscription: *1887.*

6. Silk dress with basque bodice and bustle skirt with apron drapery, frilled collar and cuffs. Photo by Goodwin's Studio (Providence, RI, United States). Inscription on mat: *Nan 1887.*

8. Two-piece wool dress with passementerie trim; bar brooch. Photo by Gardner (Brookfield, MO, United States). Printed date: *1887.*

73: MENSWEAR FABRIC FOR WOMEN

1. Dress and jacket ensemble of Glen plaid wool, the dress with cuirasse bodice, sleeves with high puffs at the shoulder, overskirt and pleated underskirt, trimmed with black ribbon bows; ostrich-plume-trimmed Gainsborough hat. Boy wearing sailor suit with polka-dot bow. Photo by M. L. Winter (Vienna). Circa 1889.

2. Pinstripe wool dress, possibly one-piece, bustle drapery, plain collar and cuffs. Photo by Cox & Durrant (Torquay, UK). Circa 1887.

3. Two tailored ensembles, one in plaid with matching hat, the other with military braid down the front worn with a derby hat. Photo by Arthur Debenham (Sanddown, UK). Circa 1886.

74: 1888

1. Dark dress trimmed with flat braid, contrasting narrow placket; bracelet slide with charm and hair ornament. Photo by Rudolf Hermann (Leipzig, Germany). Inscription: *1888.*

2. Walking attire: tailored dress and jacket, the skirt drawn up to reveal a plaid underskirt, the jacket with striped revers; umbrella; coal-scuttle bonnet trimmed with flowers. Unknown photographer (France). From an album dated 1888.

3. Black ball gowns in lace and velvet with jet embroidery; worn by (right) society beauty Hermione Wilhelmina FitzGerald, née Duncombe, wife of the 5th Duke of Leinster and a lover of Hugo Charteris, Lord Wemyss, and, (left) her sister Helen Venetia Vincent Duncombe, who, upon marriage in 1890, would become Helen, Viscountess d'Abernon. She was a peeress, diarist, would be painted by Sargent and was connected with the social group The Souls. Photograph by Lafayette (Dublin).

4. Young woman wearing two-piece dress with draped skirt and military-inspired tailored jacket; hat with high crown. Photo by Hargrave & Gubelman Portraits (New York).

5. Dark tailored dresses worn by teachers or aspiring teachers during a math lesson. Unknown photographer (France). From an album dated 1888.

6. Tailored dress with apron effect and underskirt in wallpaper stripe; plaid parasol; wide-brimmed straw hat. Unknown photographer (France). From an album dated 1888.

7. Tailored dress in light wool with striped revers and covered buttons in a contrasting fabric. Photo by Constant Peigne (Saint-Nazaire, France). Inscription: *1888.*

8. Woman in bustle skirt with straw hat, fitted jacket bodice. Two children wearing beribboned hats. Unknown photographer (France). Inscription: *1888.*

9. Among the tailored dresses worn by the girls and women posing on this bridge are four sets of two matching dresses, worn with matching hats. Unknown photographer (France). From an album dated 1888.

10. Woman wearing dress with fringed jet appliqués and jet embroidery, fitted bodice with high collar, pleated street-length skirt with bustle. Man in cutaway and vest, striped trousers; watch chain

with slide. Photo by Decker & Arrasmith (South Walnut St.).

11. Tailored bustle dress with side front closure, Elizabethan ruff collar, hem edged with narrow self-box-pleated ruffle. Photo by Edgwick's (Zanesville, OH, United States). Printed date: 1888.

12. Dress with side closure, striped collar and cuffs; graduated bead necklace, possibly ivory; lace parasol; straw hat with wide ribbon trim. Photo by E. Queck (Weimar, Germany). Inscription: *M. Hunk 1/9/1888.*

13. Tailored day dress with pleated satin insert; kid gloves; high-crowned hat trimmed with foliage and ostrich plumes. Photo by F. Bennett & Son (Worcester, UK). Printed date: *1888.*

14. Among the tailored dresses worn by the girls and women posing in a French garden are three sets of two matching dresses. Unknown photographer (France). From an album dated 1888.

76–77: 1889

1. Court presentation gown with train, in patterned silk trimmed with metallic lace and pearl tassels; necklace with cross pendant; lily-of-the-valley bouquet; Prince of Wales ostrich plumes and veil. Unknown photographer. Inscription: *Margaret Chandodole May 3, 1889.*

2. Walking dress, cut in one piece at the back with bodice separate in front, narrow skirt draped over a striped underskirt, passementerie trim; silk sunshade; black hat and gloves. Unknown photographer. Circa 1889.

3. Adelina Patti (1843–1919), noted opera singer and client of Charles Frederick Worth's, wearing a printed velvet dress with beaded trim and satin draped bustle with satin bows; fur stole. Photo by Nadar (Paris).

4. Dark wool tailored day dress, foulard printed silk jabot and cuffs. Photo by A. C. Austin (Nashua, NH, United States). Inscription: *Cora L. Parker, 1889.*

5. An early example of a well-known person supporting fashion: Canada's First Lady, Lady Stanley of Preston, née Lady Constance Villiers (1840–1922), wears a moiré and lace evening gown in a photograph issued in conjunction with promoting the spring offerings of H. Shorey & Co., Montreal. She married Frederick Arthur Stanley in 1864; they had eight sons and two daughters. The Stanley family became ice hockey enthusiasts and Lord Stanley, 6th Governor General of Canada, initiated the Stanley Cup. Lady Stanley founded an Institute for Trained Nurses, the first nursing school in Ottawa. Caption (in part): *1889 Spring. In announcing the coming visit of our representative, with Samples for the Spring and Summer trade of 1889, we have every confidence that the efforts which we have put forth to obtain the very latest styles in materials and make, will be fully appreciated.*

6. Coat with fur collar; fur boa and muff. Photo by Hotchkiss (Norwich, NY, United States).

7. Day dress with draped overskirt worn by a member of the Michaux family, Metropolis, Illinois. Note: one of two photographs taken at the same time, the other inscribed: *Miss Ida Michaux.* Freed slaves Calvin Michaux and Bell Gough married in 1875, among their children were Ida (1876–1951) who became a schoolteacher and Oscar Micheaux (1884–1951) who added an "e" to his name and became a novelist as well as being regarded as the first African-American filmmaker. Photo by Henderson, Metropolis (Illinois, US).

8. Elegant riding attire: the husband wearing a frock coat with riding pants and riding boots, his wife wearing a sidesaddle habit. Unknown photographer (France). Inscription: *C. et Csse de Gaudemaris 1889.* (Note: René de Gardemaris married Jeanne Gabrielle Lacave in 1881.)

9. Embroidered organdy ball gown with puffed sleeves, draped skirt, wide sash of moiré, the neckline dipping slightly in back in an unusual way to show the Valenciennes lace edge of a corset cover; feather boa; pearls; worn by Daisy, Countess of Warwick, known as Lady Brooke or Frances Evelyn "Daisy" Greville, née Maynard (1861–1938). Daisy was a society figure of such allure that her friend author Elinor Glyn described her as an "It" girl, a term she coined. Despite marrying in 1881, among her romantic conquests was the Prince of Wales and her lack of discretion led to the nickname "Babbling Brooke." She wore designs by Charles Frederick Worth and Jacques Doucet. Later in life she became an activist and a socialist. Photo by Walery, published by Sampson Low & Co..

10. Summer leisure attire: women wearing wool dresses trimmed with passementerie, Scottish-style ensemble with deerstalker hat and sailor bodice and men wearing three and two-piece suits, striped jacket worn with solid trousers, striped ribbon belt, short neckties and bowlers, boaters and caps. Photo by F. W. Swift Wilders Arcade (Rochester, NY, United States). Caption: *Campers on Lake Erie August.*

11. Full mourning dress including Marie Stuart cap with long veil. Photo by Sylvestar. Circa 1889.

12. Wool tailored dress with velvet trim; leaf brooch. Photo by W. K. Munro (Edinburgh, UK). Inscription: *Elizabeth Stewart 6-5-89.*

13. Striped wool tailored dress trimmed with bands of ribbon and buttons; cross on a chain; wide-brimmed straw hat. Photo by Th. Kirsten (Dresden). Circa 1888–89.

14. Sidesaddle habit; striped cap. Photo by E. L. Temple (Milford, MA, United States). Pencil inscription: *MabelleAlbre, Octo. 5, 1889.*

15. Evening gown with layered puffed sleeves, crossed bands of ribbon forming an openwork neckline; bracelet; gloves and lace fan. Photo by Jancowski Studios (Louth, Ireland). Inscription: *Your loving Coz Ellie, April 1899.*

1890s

79: Ball gown in white trimmed with white lace ruffles and artificial roses; neck chain and matching bracelet of metal links and pearls. Photo by Fred Boissonnas (Geneva). Circa 1896.

80: 1890

1. Teenaged young man in a black jacket and vest, striped pants. Teenaged young woman in a tailored dress with jacket bodice; high-buttoned boots; holding a straw hat. Photo by W. J. Chapman (Dawlish, UK). Inscription: *26 Jun 90.*

2. Four tailored day dresses and four variations on the boater. Unknown photographer. Inscription: *Mrs. Reidy 1890.*

3. Princess-cut dinner gown of black velvet with facings of black faille, jet and lace trimmings. Photo by Lafayette (Glasgow). Circa 1890 (based on most recent of numerous prize medals listed on the reverse).

4. Black velvet dolman trimmed with heavy braid, bobble fringe, and black ostrich feathers; ostrich-feather-trimmed bonnet with face veiling. The bustle, though on the wane, was still in fashion in 1890. Photo by Graham (Leamington Spa, UK). Printed date: *1890.*

5. Sidesaddle riding habit in wool with kid leather vest; derby instead of a top hat. Photo by W. Whiteley (London). Inscription: *Muriel S. Daniel. October 1890.*

81: TAILORING

1. Tailored jacket with gigot sleeves and cape collar of sheared fur; sheared fur muff; boater hat with upstanding plaid ribbon bow. Unknown photographer. Inscription: *Mother Snyder.* Circa 1894.

2. Androgynous sidesaddle habit with fitted jacket made like a smoking jacket with shawl collar, wing-collared shirt, black tie. Photo by Lindbeborg (Jönköping, Sweden). Circa 1890.

3. Tailored costume with gigot sleeves; boater with veil. Photo by F. L. Matson (San Francisco). Circa 1894–95.

4. Wool coat trimmed with sheared fur; sable muff with tassels; lacquered, possibly straw hat with ostrich feather and ribbon trim. Photo by A. T. Osborne (Hull, UK). Circa 1895.

5. Unusual three-sided view of a woman wearing wool jacket with military braid trim and gigot sleeves; saucer hat with standup flower and bow trim. Photo by Browning (Exeter, UK). Circa 1894–96.

82–83: 1891

1. Woman in two-piece tailored dress. Groom in striped jacket and cap with brim. Man in light jacket and derby. Horses' names are Tramp, Spider, and Zulicka. Unknown photographer.

2. Wool dress with plaid insert and high collar; four-leaf clover brooch; velvet hat. Photo by Birdsall (Leavenworth, KS, United States). Inscription: *Taken Oct. '91.*

3. White dress trimmed with black, black sleeves; black ostrich-feather-trimmed hat and mitts. Unknown photographer (United States). Inscription: *The photos of J. M. Berry and S. S. Berry taken on their 20th wedding anniversary at LaGrande, Oregon, July 2nd 1891.*

4. Day dress in satin woven with a foliate design over stripes; white fur boa. Unknown photographer. Inscription: *in the Paseo, Sunday noon, March 91.*

5. Tailored daytime ensemble with fitted jacket and sleeves puffed high at the shoulders, shawl collar, blouse with scarf jabot; dangling lapel pin. The child on left in a suit with pintuck jacket; the child on the right in an infant's long dress. Photo by Angel Neosho (Missouri, United States). Inscription: *"Belle Christmas 1891."*

6. Plaid dress, passementerie trim at the cuff. Boy's dress in small plaid, ribbed wool stockings. Photo by Hofphot. G. Th. Hase & Sohn (Vienna). Inscription: *Mama and Richard 1891.*

7. Tailored suit with crenellated jacket hem, unusual folds at the top of the sleeves, fur trim. Unknown photographer (UK). Inscription: *"Retta" 1891.* Inscription on back of album page: [illegible] *anling-Hawkhill.*

8. Tailored two-piece dress with cadet-style bodice trimmed with bands of flat braid; handkerchief worn in bodice; guitar brooch and bracelet; kid gloves; flowers in hair. Photo by Photographic Company (London). Inscription: *For Mrs. Kemp L.S. May 1891.*

9. Three tailored dresses: (left) light wool with passementerie trim and watered silk high collar and insert, insert panels in the skirt; (middle) plaid wool with yoke ruffles tapering to a point at the bodice waist, the plaid cut the bias in the skirt; (right) striped dress with ball-fringe trim. Photo by J. B. Feilner (Hannover, Germany). Label on back: *Vom. 1. April 1891.*

10. Tailored day dresses with pleated skirts: (left) pleated skirt and self-bows; (right) trimmed with moiré ribbons, with pearl choker worn at the top of the high collar; children's clothes in wool and infant dress in white cotton. Photo by Lightly Bros. (Hartford City, IN, United States). Inscription: *Anna Maggie Leon, Florence Van Williams. Taken 1891 spring.*

11. Evening gown in pastel satin with surplice bodice and ribbon at the side of the waist; earrings, choker with pendants, jewel-set brooch, two different bracelets, and multiple rings; fan. Photo by E. Davey Lavender (London, UK). Inscription: *Ellen M. Ghewy 1891 and with love to dear Bessie from Nelly.*

84–85: 1892

1. Evening dresses with rounded square necklines in black with point d'esprit frills or in light colors with petaled or soft chiffon bertha collars; worn by the four sisters known as the Misses Dene, after their most famous member, born Ada Pullan, known as Dorothy Dene (1859–1899). A muse to such artists as Sir Frederic Leighton, Dene is conjectured to have been the inspiration for George Bernard's Shaw's *Pygmalion* (London). Photo by W. & D. Downey (London).

2. Tailored ensemble of jacket, skirt with slight train, boned bodice with vest effect. Photo by Benedetti &. Co. (London). Inscription: *With love to Maude and Bertie Oct. 20, 1892.*

3. Reception gown of silk woven with a broken stripe, trimmed with handmade lace and braid, gigot sleeves; worn by actress Olga Nethersole (1867–1951). Photo by W. & D. Downey (London).

4. Printed summer dresses: (left) floral print with velvet ribbon trim; (right) pattern of foliate medallions; half boots. Photo by Leonard Plattsmouth (Nebraska, United States). Inscription: *Jeanne Helps Bath – England Mia Gering Plattsmouth Neb 1892*

5. Tailored costume with velvet sleeves and revers fastening with buttons and piping loops, lace-trimmed bodice; boa of curly ostrich feathers; kid gloves; ostrich-feather-trimmed hat. Unknown photographer. Inscription: *Daisy Brown. May 21st, 1892.*

86–87: BOAS

1. Velvet-collared double-breasted wool coat; ostrich-feather boa; velvet and brocade hat with ostrich feathers and rhinestone button trim. Unknown photographer. Pencil inscription: *Aunt Martha.* Circa 1895.

2. Wool tailleurs with gigot sleeves; white feather boas; hats trimmed with bows and ostrich plumes. Photo by W. Wright (London). Circa 1895.

3. Friends dressed alike in wool tailored costumes with vests and trim of velvet; long fur boas; kid gloves; lacy hats trimmed with flowers. Photo by G. W. Wilson & Co. (Aberdeen, UK). Inscription: *Mother Gilbert and friend.* Circa 1891.

4. Striped suit, shirtwaist with ruffled jabot; fox-fur boa; umbrella; simple hat. Unknown photographer. Circa 1898.

5. Striped cotton shirtwaist, black silk cravat, white patterned belt, dark skirt; white feather boa; watch chain with slide; black straw boater with feathers. Photo by T. Rigg (Kendal, UK). Circa 1896.

88–89: 1893

1. Male and female teachers' and an assortment of students' attire at a public school. Von Humboldt School, Chicago, November 1893. Photo by Waterman.

2. Wool twill tailored dress with gigot sleeves and wide velvet revers, buttons and trim; bar pin; braided chignon. Photo by Lavender Gold Medalist (Kent, UK). Inscription: *J. Nicholas. Sept. 6th. 1893.*

3. Young artist's model formally dressed in striped silk dress with double puffed sleeves, embroidered waistband and ruffled hem. The painter wears a polka-dot silk shirtwaist with gigot sleeves and dark wool skirt; straw hat with flowers and ribbon. Unknown photographer (France). Caption: *Nice, chez Mme. F. Avril 1893.*

4. Dark day dresses with plaid trimmings, modified gigot sleeves; curled fringes. Photo by A. G. Arrasmith (Muncie, IN, United States). Inscription: *Kate M. Wheeling 2nd. Gertie Skinner Muncie. 1893.*

5. Impeccable daytime attire: sleeves puffed high at the shoulder, flat-brimmed hat with large bow. Man wears a cutaway jacket, waistcoat, striped trousers; holds gloves and a top hat. Photographer: J. Brown. 3, Kinmel St. Rhyl. Photographer: Ulric Grob (Paris). Inscription: *September 6th, 1893. Aunt Polly and husband.*

6. Fitted day dress of twill wool, machine-embroidered lace trim at the collar, cuffs and waist, attached lace vest, gigot sleeves; hat with lacy edging and ostrich feathers. Photo by A. Debenham (Cowes, UK).

7. Ball gown with bead or sequin embroidery and chiffon ruffles, long cape with tiered cape collar lined in and edged with fur; unusually simple hair style. Photo by Sarony (New York). Inscription: *C.M. May 1 '93.*

8. Patterned silk dress with gigot sleeves, self-ruffle trim. The man has taken off his boater and wears a daisy in his buttonhole. Unknown photographer. Inscription: *Juin 1893. Helene Pauly Edouard Garros.*

9. Mother's tailored dress in wool with velvet trim; heart-shaped brooch. Daughter in wool sailor dress with moiré bow. Father in suit with tweed or herringbone vest. Photo by Houser's South Side Gallery (Huntington, IN, United States). Inscription: *Dollie. Mear, Jake Straslin. Warre, Inc. 1893.*

10. Dress trimmed with metallic braid, cape; bar pin at the high collar; kid gloves; hat trimmed with flowers and ribbons. Photo by Douglas Pym (Streatham, UK).

11. Laura wearing a gingham pinafore and a boater hat; Helen in a dress with puffed sleeves and cap. Unknown photographer. Inscription: *Laura on Major. Helen and DFK on Nabob. '93.*

90: 1894

1. Wool twill tailored dress with gigot sleeves, braid trim, lace collar. Photo by G. Anthony Beales (Ipswich, UK). Inscription: *Doris (Cohen) when six months old. Dec. 1894.*

2. A sailor and his bride in a day dress with gigot sleeves, ruffled broderie anglaise collar and satin ribbon trim; saucer hat in straw. Photo by J. Harper (Fareham, UK). Circa 1894.

3. Tailleur with gigot sleeves, patterned silk waist with high collar; dangling pocket watch pin; worn by graduate. Photo by Gallant Sweetwater (Tennessee, United States). Inscription: *Vesta Sampile Jan 1894.*

4. Tailored suit and jacket in wool with velvet revers, ostrich feather boa; hat with bird wings. Photo by Mc. Isaac & Riddle (Oban, UK). Inscription: *Marie Hodge Christmas 1894.*

5. Bridal gown in white satin with lace trim, self-bows; tulle veil. Photo by Debenham & Smith. (1, Sussex Place. South Hampton). Circa 1894.

6. Gigot-sleeved ensembles with hats. Unknown photographer. Inscription: *St. Christol 1894.*

7. Maid's uniform of dark dress with white cuffs; apron; cap. Photo by C. F. Mathews, The Court Studio (London). Inscription: *with loving wishes, 1894 K[illegible] E[illegible]* (and on the front *E[illegible] "on Duty"*).

8. Fitted wool Chesterfield coat with gigot sleeves, wool skirt, shirtwaist, necktie; fedora-style hat. Photo by Hughes & Sandberg (Omaha, NE, United States). Circa 1894.

9. Patterned wool two-piece dress, belt with ornate buckle, contrasting bow at neck; hat trimmed with sprays of wheat. Photo by Bush (Henry, IL, United States). Stamp: *1894.*

92: GIGOT SLEEVES

1. Ribbed faille tailored dress with gigot sleeves and turned-back cuffs overlaid with lace; fresh violets as a corsage; hair comb. Photo by Webster (Birmingham, UK). Circa 1893.

2. Velvet evening gown with puffed sleeves, satin cummerbund, lace bertha collar; long gloves and fan. Unknown photographer (France). Inscription: *Madame Emile Cottu, nee Berthe Sollerou.* Circa 1894.

3. Satin ball gown with balloon sleeves, trimmed with lace and embroidered net, corset laced back. Unknown photographer. Circa 1894.

4. Tailleur with gigot sleeves, wing-collared shirtwaist and necktie, belt with filigree belt buckle. Photo by H. Vandyck (Notting Hill). Circa 1895.

5. Lingerie dress in white-on-white patterned organdy, ribbon trim. Photo by J. Ghibault (Fall River, MA, United States). Circa 1895.

6. Plaid shirtwaist with enormous gigot sleeves, rose-point lace collar. Photo by Masters (Princeton, IL, United States). Inscription: *Happy New Year!* Circa 1895.

7. Woman holding the reins of a horse-driven gig carriage, wearing a wool suit and boater, sitting under a plaid carriage blanket. Groom wears riding boots and top hat. Female servant in doorway wears a long apron. Unknown photographer (probably UK). Circa 1895.

8. Patterned silk evening gown with puffed sleeves, yoke trimmed with embroidered lawn ruffles and rosette bands. Unknown photographer. Circa 1896.

93: 1895

1. Velvet and lace dress with high collar, gigot sleeves, handmade lace handkerchief cuffs; holding a camellia. Photo by London Stereoscopic and Photographic Company, Ltd. (London). Inscription: *With the sincere thanks and good wishes of Weetman D. Pearson and A. Pearson. Feb. 1895.*

2. Woman wearing polka-dot dress; hat with feather ornament. Infant girl's long dress and sweater, and woman in right wearing striped skirt with shirtwaist and boater. Unknown photographer. Inscription: *Miss Fannie Peck. Mrs. S. N. Blake with baby Elizabeth. 1895.*

3. Two-piece tailored dress in wool and patterned silk, trimmed with jet-embroidered bands and with flat round marcasite buttons; hat with marcasite buckle, bow, and ostrich plumes. Photo by A. S. Ralph (Columbus). Inscription: *Christmas 1895.*

4. Tailored clothes for an outing in the country. Unknown photographer. Pencil inscription: *Buck Hill Oct. 1895.*

5. Gigot-sleeved long jacket, plain skirt; hat with upright curly ostrich plume. Photo by Green Studios (Boston, MA, United States).

6. Starched linen shirtwaist, enormous gigot sleeves, smooth flared skirt, black velvet ribbon bow trim. Photo by Banney & Dalk (Chicago). Circa 1895.

7. Cycling attire: wool jacket and bloomers; straw boater with upturned brim. Photo by Fondary de Beauvière, Albert Somme (Paris). Circa 1895.

8. Tailored ensembles photographed at the shore, Culross, Scotland; jacket and shirtwaist with various versions of gigot sleeves; small hats with flat or upturned brims, ribbon and other trim. Unknown photographer. Inscription: *Taken at Culross Aug 1895.*

94: 1896

1. Assorted daytime attire: tailored ladies' suits and dresses with gigot sleeves; tailored girl's dress worn with plaid stockings; hooded cape for a little girl. Unknown photographer (France). Inscription: *Monshimont August 12, 1896.*

2. Bride in white satin gown, self-trimming; tulle veil with top knot; fresh flowers and foliage from top knot to hem. The groom in white tie. Photo by K. & A. Vikner (Wenerborg, Sweden). 1896 (based on most recent prize awarded at Malmö).

3. Visiting dress trimmed with bands of brocaded ribbon; rings; gloves and sunshade; ornate hat with chin ties of tulle. Photo by C. Yuahckiu (Russia). 1896 (based on an award printed on the reverse. However, another photograph of this sitter is dated 1906).

4. Day dress with gigot sleeves, puffed silk plastron. Photo by F. Hansen (Kjobenhavn, Denmark). Inscription: *12/96.*

5. Walking and bike-riding attire: knickers, sailor tunic, dark dress with gigot sleeves, bowler hat and boater. Caption: *Rueil Malmaison. Septembre 1896. Fernand. Jean Pepin. Raymond. Daniel. Marguerite. L. Banias. Eva.*

6. Woman in floral sprigged dress and tailored suit with gigot sleeves; boater hat put aside. The young men somewhat informally dressed. Unknown photographer (United States). Inscription: *September 1896.*

7. Dresses with gigot sleeves. Unknown photographer. Inscription: *Villemomble le dimanche 5 Juillet 96. L. Cauvin.*

95: 1897

1. Shirtwaist, neckties, tailored skirts and boaters worn boating. Unknown photographer. Circa 1897.

2. Ice-skating attire: dark dress; plumed hat. Unknown photographer (France). Pencil inscription: *15 Avril 1897.*

3. Woman wearing tailored bodice with gigot sleeves, moiré revers, shirtwaist blouse with high ruffled collar; skates. Man in suit with double-breasted jacket; skates. On the right a tailored dress with gigot sleeves, plaid insert and cuffs, skirt trimmed with self-bands or tucks; skates. Unknown photographer (France). Circa 1897.

4. Mother wearing dress with lace trim at the yoke, modified gigot sleeves, high collar with pin. Daughter in dress with lace bertha. Photo by Karl Lambeck (Lennep, Germany). Stamp: *1897.*

5. Dotted silk trimmed with shirred chiffon and lace; long pearls; worn by Effie French at a New York State resort. Unknown photographer. Name and date from album dated 1897.

6. Ball gown with trained overskirt embroidered with flowers; graduated pearl-centered brooches; pearl and diamond tiara. Photo by Reutlinger (Paris). 1897 (based on latest award printed on back, the Gold Medal at Bruxelles, 1897).

7. Pinstripe suit with velvet collar; lapel watch; kid gloves; straw hat with high crown. Woman in the window wears patterned cotton summer dress. Unknown photographer. Inscription: *Mary Leonard and Nancy Hornby, Cliftonville 1897.*

8. Lingerie dresses and hats with veils; awning striped sunshade; worn by Effie French and her mother at a New York State resort. Unknown photographer. Name and date from album dated 1897.

96–97: 1898

1. Court presentation ball gown with puffed sleeves, draped corsage, long flared skirt, train; elbow-length kid gloves; pearls; bouquet of lilies-of-the-valley and roses; ostrich plumes and veil. Unknown photographer. Inscription: *Ada Feb. 1898.*

2. Plaid shirtwaist trimmed with solid ruffles; small hoop earrings; curled coiffure. Photo by Mesarvey (Portland, OR, United States). Inscription: *April 27, 1898. Myrtle.*

3. Skating attire: Woman wears shirtwaist with sleeves puffed at the shoulders, flared ankle-length velvet skirt; flower-trimmed hat. Man wears a single-breasted suit. Unknown photographer. Pencil inscription: *2 Avril 1898. France.*

4. Summer dress in linen or cotton with small floral print, ruffled high neck and yoke; plaid sunshade; straw hat trimmed with velvet roses. Unknown photographer.

5. Elegant country outdoor attire: Man in jacket and vest with tweed knickers. Woman in long coat with gigot sleeves, which were high style a few years earlier; boater hat with upright curled feathers. Photo by Bulls (Paignton, UK). Pencil inscription: *Iris. Done April 98.*

6. Dress of dark silk printed with small springs, trimmed with bands of braid, yoke and front placket of net; crescent brooch and dangling watch brooch. Photo by Bloomingdale Bros. (New York). Circa 1898.

7. Dress with elaborate evening bodice, striped silk double puffed sleeves, shirred tulle with coin dots, silk flowers, bead embroidered waistband, pointed peplum, textured skirt. Photo by Rockwood (New York). Stamp: *1898.*

8. Mother wearing lingerie dress with gigot sleeves and self-ruffles. Father wearing shirt with wing collar, bib front, and armbands. Photo by Lark's (Ruma, IL, United States). Circa 1898.

9. Textured wool dress worn with fur tippet; hat trimmed with faceted jet ornament and ostrich and other plumes. Photo by J. F. Gerrity (Bangor, ME, United States). Inscription: *Mother Dec. 1898.*

10. Tailleur trimmed with scrolled bands of flat braid, tulle jabot; hat with velvet cockade; worn by Emily Jay, née Astor Kane (1854–1881), posing with her two sons, including Peter A. Jay, who was painted by Sargent in 1880. The great-granddaughter of John Jacob Astor, she married in 1876, and her granddaughter was author Susan Mary Alsop. Photo by Otto (Paris). Inscription: *Emily Jay and her sons 1898.*

11. Tweed dress trimmed with fur, heavy machine lace appliqué, passementerie. Five-year-old boy wears a sailor outfit in wool. Photo by Lovell (Oswego, NY, United States). Inscription: *Mrs. Chas H. Pool and Chas. H. Pool, Jr. taken on Charles Jr. fifth birthday, March 17th, 1898.*

12. Hockey attire: Men and boys in wool shorts and white shirts, neckties, sweaters. Women in shirtwaists, neckties, long skirts, boaters. Unknown photographer. Circa 1898.

13. White-on-white striped cotton lingerie dress with lace-edged ruffled yoke, ribbon at the high collar, ribbon sash. Photo by Windeatt (Chicago). Inscription: *July 17th, 1898.*

98–99: 1899

1. Cycling ensemble: shirtwaist, ankle-length skirt, boater. Unknown photographer (United States). Inscription: *Oct. 23, 1899 Mabel Field Slater.*

2. Summer attire. Unknown photographer (France). Inscription: *Celte. Août 99.*

3. Velvet jacket with fur edging; umbrella; hat with flowerpot crown. Photo by R. Hahn (Viersen, Germany). Inscription: *[illegible] 99.*

4. Man dressed as a woman for a play, in a satin and lace ball gown of a style popular a few years before; worn by Fred A. Fetherwolf (sp) as Miss Plaiced, Muhlenberg College Play. Photo by Lindenmuth's Studio (Allentown, PA, United States).

5. Lingerie dress; black stockings and polished calf pumps; lace-trimmed fan dangling from a cord; white hat and parasol. Photo by Purdy (Boston, MA, United States). Inscription: *Grace Kellogg, Class of '99.*

6. Floral sprigged dress trimmed with ruched bands of ribbon; straw hat decorated with soft silk, flowers, and ribbon. Infant's long gown trimmed with tucks and lace; ruched bonnet. Photo by Thomas Bromwich & Kidderminster (Bridgnorth, UK). Inscription: *Ronald Branstove Heaton, aged three months.*

7. White dress with shirred yoke, long sleeves with puffs at the shoulders. Photo by Friedr Kolby (Herzogl, Germany). Printed date: *1899.*

8. Black lace shirtwaist, trimmed with narrow ruched bands of black chiffon; engagement ring and chain for lorgnette. Photo by Hansbury (Philadelphia, PA, United States). Inscription: *Josephine W. Dorr, 10/6/99.*

9. Feeding the chickens in gigot-sleeved dresses or shirtwaists. Unknown photographer. Inscription: *At Uncle Samuel's Farm, three miles from Middleboro.* From an album dated 1899.

10. Lingerie dress; sunshade and bouquet; boater. Unknown photographer. Inscription: *May – with love from Lillie. 7.7.99.*

11. Dress with gigot sleeves, decorations including shirred velvet, tucks, lace appliqué; hat covered with fabric, trimmed with ostrich and egret feathers. The boy holds a straw boater. Unknown photographer. Circa 1899.

12. Students in day dresses. Photo by George Hahn (Baden-Baden, Germany).

1900s

100: Daytime finery with trimmed hats and silk parasols. Photo by unknown (France). Circa 1904.

102: LINGERIE DRESSES

1. Lingerie dress in sheer white cotton woven with small bow-knots, inset with bands of lace and sewn with lace ruffles, high boned collar, elbow-length ruffled sleeves, shirred silk waistband; lace-trimmed parasol; winged hat. Photo by F. Faissat (Limoges, France). Circa 1903.

2. Lingerie dresses and flower-trimmed hats worn for a motor excursion. Photo by J. M. McClaure (Mineral Wells, TX, United States). Inscription: *August 9th, 1906.*

3. Summer frock in white linen worn for boating; straw hat with gingham plaid band. Photographer unknown. Pencil inscription: *Lizzie.* Circa 1905.

4. Lingerie dress that might be a tea gown but worn with stays and pearl earrings, necklace, and Greek key hair ornament. Posed in a relaxed yet formal style, the woman reclines in a Thonet-type bentwood rocking chair, a book on her lap. Photo by C. Cyora (Russia). 1905 (based on an award date printed on the reverse, although another photograph of this sitter in a ribbon-trimmed dress is dated 1896).

5. Lingerie dress with square neckline, trimmed with Irish crochet lace; straw hat tied with a scarf. Photographer unknown (probably France). Circa 1905.

6. Woman in a lingerie dress with a quail sitting on her lap and a dog posed next to her. Photo postcard. Photographer unknown (probably United States). Circa 1905.

7. Lingerie dress with short sleeves, sewn with wide bands of lace. Photo by unknown (United States). Pencil inscription: *Elizabeth Bonnell. Sep 1/3.* 1903.

8. Lingerie dresses; duster-like coats; wide-brimmed hats. Photographer unknown (probably Europe). Circa 1907.

103: 1900

1. A family in mourning wearing tailored black dresses trimmed with black crape; purses of black crape. Photographer unknown (France). Inscription: *Mme. Et Mlles. Nonnon 1900.*

2. Summer evening gown with bodice of floral-printed sheer silk and skirt of taffeta; long pearls and gold bracelets. Photo by Hermann Ernst (London). Inscription: *Daisy Koettgen. South Hampstead. 1900.*

3. Bride wearing high-collared bridal gown in white silk trimmed with cascading ruffles of lace; tulle veil; wax orange blossoms. Groom wearing tails and top hat. Photo by L. Devolder (Brussels). Inscription: *A mon cher Ann Albert Vandevelde en souvenir du Septembre 1900.*

4. Almost identical tailored suits; on the left a purse with flower appliqué. Unknown photographer (France). Inscription: *1900.*

5. A variety of clothing seen at a street market. Unknown photographer (Paris,

possibly near the location of the Paris Exposition).

6. Waist-length jacket with gigot sleeves, satin waist with high collar, bow tie. Unknown photographer (France). Inscription: *Coulou 1900.*

7. Silk crepe dress with smocking, shirring, scallop-edged yoke, ribbon sash tying in back with bow; straw hat trimmed with ostrich feathers. Photo by Rudolph Pause (Chemnitz, Germany). Inscription: *Dir Leibe Johanna* [illegible] *Hannah Schmitt 1900 Chemnitz.*

104: 1901

1. Day dress with scroll appliqué; ostrich-feather-trimmed hat. Photo postcard. Photo by Reutlinger (Paris). Printed date: *1901* (canceled stamp date: *Oct. 04*).

2. Dinner gown in net embroidered with foliate scrolls, trimmed with soft silk; brooch and chains; feather fan. Photo by A. Blankhorn (Mainz, Germany). Pencil inscription: *Betty Baier-Falk 1901.*

3. Queen Alexandria, Princess of Wales (1844–1925), became Queen-Empress consort to Edward VII upon the death of Queen Victoria wearing a daytime ensemble of wool with embroidered lapels and wide fur collar, signature high collar. Photo postcard. Photo by Lafayette (Dublin).

4. Shirtwaists, tailored skirts; hats; worn for a country excursion in Epping Forest, UK. Unknown photographer. Inscription: *September 1901.*

5. Day dress of cotton or linen printed with small nosegays, eyelet and ruffled yoke, ribbon high neck and waistband, rimless glasses. Photo by Purdy (Boston, MA, United States). Inscription: *Lottie W. Diaper. S.E.H.S. 1901.*

6. Lady with mandolin, wearing shirtwaist dress in linen printed with scattered dots, trimmed with self-tucks and rows of narrow braid or ribbon; hat with tulle and silk flowers. Photo by Teague (Lenoir, NC, United States). Inscription: *Florence L. Gall, Maiden, N.C. May 30, 1901.*

7. Two European women in dresses with checked sunshades and hats; behind them a black woman in a dress and headscarf. Unknown photographer. Inscription: *Maria et Elisa. St. Marceau. Mai 1901.*

105: 1902

1. Almost identical dresses in leaf-patterned fabric sewn with bands of black lace and sheer ribbon, lace yokes, faux kerchief ties in black or white. Photo by Cohen (Chicago). Pencil inscription: *July 31, 02, Sine Nielsen and Josephine Koehn.*

2. Striped satin dress with self-ruffle at the trained hem, dotted tulle sleeves. Unknown photographer. Inscription: *Willie w. Elsie in November. 1902.*

3. Formal daytime attire worn for a September wedding in Wisconsin: bride wearing a wool dress with lace at the yoke and cuffs of the long sleeves, floor-length tulle veil trimmed with orange blossoms and other flowers, holding a handkerchief, and groom wearing dark checked wool suit. Both have flowers in a boutonniere or a corsage. Unknown photographer (United States). Inscription: *Mr and Mrs Nelbert Nelson. Married September 20, 1902.*

4. Shirtwaist with striking printed design, plain wool flared long skirt; posed against floral patterned wallpaper with a gilt ballroom chair. Photo by A. Jos. Schmidt Reichenbach (Germany). Circa 1902.

5. Day dress with yoke, waistband and cuffs of Irish crochet lace. Photo by Thompson (Brooklyn, NY, United States). Inscription: *Anna Dahl. Augusti 5 – 1902.*

6. Day dress with high collar, yoke and trimming of machine lace, the sleeve sewn with tucks; bar pin and dangling pin. Photo by F. S. Robinson (London). 1902 (based on a photograph of the same sitter in the same dress, for another photographer, dated July 19, 1902).

7. White dress with lace trim and swansdown-edged cape. Photo by Hebensperger (Riga, Latvia). Stamp: *1902.*

8. Lingerie dress worn for graduation, voile trimmed with lace appliqué and self-ruffles; long chain; long white gloves. Photo by Randall (Hartford, CT, United States). Inscription: *Florence Kilbourne Elmore. June 5, 1902.*

106: SHIRTWAISTS AND SKIRTS

1. Shirtwaist and skirt worn for an outing in the hills, Texas. Photo postcard. Unknown photographer. Circa 1904.

2. Masculine shirtwaist with high collar, cuffs fastened with cuff links, natural linen skirt with bias flounce, soft silk paisley scarf worn instead of a necktie, leather belt; bangle bracelet; rimless eyeglasses; straw boater. Unknown photographer (Mt. Carmel, PA, United States). Circa 1900.

3. Unusual below-the-knee-length skirts, possibly with split backs over bloomers or breeches, shirtwaists; gaiters. Unknown photographer (Western United States). Circa 1905.

4. Striped shirtwaist with lace trim, worn with dark skirt. Photo by M. Frölich (Flensburg, Germany). Impressed date: 1908.

5. Shirtwaist, dark skirt; worn while hiking. Unknown photographer. Circa 1902.

6. Tennis attire: woman wears shirtwaist and flared skirt in white linen or cotton, ankle boots, and man wears white flannel trousers, shirt with soft collar, sports jacket. Unknown photographer (United States). Circa 1906.

7. Family portrait showing mother wearing shirtwaist with inserts of broderie anglaise and tucks, striped wool skirt, belt with buckle; wide-brimmed saucer straw hat trimmed with flowers. Father wearing three-piece tweed suit; gold watch chain. Daughter wearing white frock; dark socks and ankle boots. Photo by J. Goulson (Coalville, UK). Circa 1903.

107: TURN OF THE CENTURY TROUSERS

1. Basketball or gym suits with voluminous bloomers and middy collar blouses, large bows, dark stockings; lace-up ankle boots or shoes. Unknown photographer. Caption: *"Basket Ball" Rah, Rah, Rah.* Circa 1909.

2. Men dressed in a variety of levels of formality, one with knee breeches, at least two with neckties. Standing woman wearing a calico shirtwaist, calico bloomers tucked into ankle boots, a below-the-knee-length overskirt. Photographed at a summer outing, possibly a camping excursion in Mt. Weston, Oregon. Unknown photographer. Inscription: *Sarah Ware, Pasadena and in pencil: Mt. Weston.* Circa 1890.

3. Cycling costume of wool, bloomers with velvet yoke at the waist, jacket with modified gigot sleeves and velvet chesterfield collar; lace-up oxford shoes; hat trimmed with plaid taffeta ribbon. Photograph by F. Linck (Saint-Ouen, France). Circa 1895.

4. Bloomers, shirtwaist with stiff collar; straw boater hat. Unknown photographer. Circa 1900.

5. Trousers underneath a skirt, with heavy knit cardigan, belted; wide-brimmed hat with driving veil. Unknown photographer. Circa 1905.

108: 1903

1. Appropriate country outing attire: Man wearing knickers, thick socks, boots, tattersall vest, shirt with stiff collar and neck tie, tweed jacket, and woman wearing the ubiquitous shirtwaist, tailored skirt, boater. Unknown photographer. Inscription: *1903 Lulworth.*

2. Tailored ensemble of pale wool double-breasted jacket, dark skirt; locket pendant; hat trimmed with ribbon and ostrich feathers. Unknown photographer. Circa 1903.

3 & 6 (front and back view). Dressed for a summer walk. Unknown photographer (France). Inscription: *24 Juillet 1903.* Niederbronn.

4. Day dress in black wool with flared sleeves, tiered skirt, trimmed with lace, braid, tucks. Photo by Cyril Linden (Ryde, Isle of Wight, UK). Inscription: *Dec. 12th. 1903.*

5. S-bend silhouette dress in white linen trimmed with tucks and lace insertion, pigeon pouter waist; pince-nez; saucer hat. Photo by B. D. Durtha.

7. Plaid topcoat worn with bowler hat. Child in wool dress with tucks, white collar with black neck tie, pointed yoke panel, black stockings, ankle boots. Unknown photographer.

8. Dinner dress by Paris couturier Georges Doeuillet, of lace and silk. Photo by Boissonnas & Taponier, *Les Modes* (Paris), October 1903.

109: 1904

1. Day dress of wool with velvet yoke trimmed with lace appliqué, bow-tied jabot. Husband wearing a sack suit, mustache waxed. Photo by Hugo Mende (Remscheid, Germany). Stamp: *1904.*

2. Two spring dresses: (left) pastel day dress trimmed with lace and pin tucks; (right) white dress with unusual open shoulder neckline crossed with narrow bands of ribbon and edged with lace and fringe, the sleeves with elbow puffs. Photo by Atelier Gebu. Otto Oranienburg U. (Gransee, Germany). Pencil inscription: *18th April 1904.*

3. Tailored dress with braid trim, shirred dickey with high collar. Photo by S. Maass (Rostock, Germany). Inscription: *Anne Bennett Wien. 1907.*

4. Lillie Langtry wearing Paul Poiret "Révérend" cape with sable collar and lining with Chinese motifs, over a lingerie waist and hat trimmed with wings. Photo by Lafayette. Photo postcard. Cancelled stamp: *Dec. 23 '05.*

5. School uniforms: shirtwaist with stiff collars, narrow solid or dotted neckties; class pins; Gibson Girl hair. Photo by Cole & Holladay (Durham, NC, United States) Inscription: *"Tow-heads" "Co-eds" Trinity 1904.*

6. White silk shirtwaist with embroidered high collar and pigeon-pouter fullness, bishop sleeves, black satin flared skirt; brooch of entwined hearts and locket on a chain; worn by Grace Morgan. Photo by W. H. Fulton (Kingston, NY, United States). Inscription: *January 1904.*

7. Girl's black day dress; plaid silk sunshade; ankle boots; upturned hat; pho-

tographed at the Passage Pommeraye, Nantes, France. Unknown photographer. Inscription: *16 Juillet 1904.*

8. Dressed for a carriage outing near Paris. Photo by A.L. Inscription: *Noisy la 24 Juin 1904 Bon Papa et Bonne Maman DeFrance, leur fille tante Lucie Robert et son fils Gaston.*

9. Lingerie shirtwaist and hat with ostrich plumes. Infant wearing dress and booties. Unknown photographer (UK). Inscription: *Ethel and baby Alan, 3 month old, July 1904. Fareham.*

110–111: AT THE RACES

1. Lingerie dresses out in force at Auteuil, probably the day of the June Journée des Drags. Unknown photographer (France). Circa 1903–5.

2. Dressed for the races in Irish crochet lace coats over lingerie dresses, point d'esprit or tulle; hats piled with ostrich plumes or flowers. Unknown photographer (France). Inscription: *24 Juillet 1903.* Niederbronn.

3. Lace and appliqué trimmed dress; parasol and profile hat; worn by actress Gilda Darthy at the Auteuil Grand Steeplechase; taken at the Auteuil, probably the day of the June Journée des Drags. Unknown photographer (France). Circa 1903–5.

4. Typically frothy concoctions worn at Auteuil. Unknown photographer (France). Circa 1907.

5. Dressed for the races in striped dress with lace-trimmed yoke and hem, large black velvet buttons at the bodice, high boned lace collar; hat trimmed with puffs of chiffon, black velvet hatband, white face veil. Unknown photographer (France). Circa 1907.

6. Two actresses at the races: (left) a lingerie dress of bands of lace and bands of dark silk chiffon, taffeta girdle; (right) lingerie waist with smooth front, elbow-length puffed sleeves, floral taffeta girdle, white pleated linen skirt; both worn with elbow-length kid gloves. Unknown photographer (France). Circa 1903–5.

7. At left, satin dress with cutaway hem and narrow white underskirt; hat with wide white lace brim; black and domed parasols in black and white satin. Woman with her back to the camera wearing a satin tailleur with lace sailor collar. Photo by Meurisse (Paris). Circa 1908.

8. The pulchritudinous scene in the grandstands, Auteuil. Unknown photographer (France). Circa 1903–5.

112: 1905

1. Day dresses with protective aprons. Photo postcard. Unknown photographer (France). Cancelled stamp: *05.*

2. Striped summer suit, tucked shirtwaist with high collar; hat trimmed with feathers. Woman is reading a fashion magazine at an Art Nouveau chair and table. Photo by Carlos Vasquez (Lisbon). Inscription: *Le 8.7*

3. Shirtwaist with tucks, silk chiffon, dark skirt with flat braid *passementerie*; black kid gloves and handkerchief; hat with ostrich plumes. Unknown photographer. Inscription: *Aunt Lee 1905.*

4. Shirtwaist with lace jabot and coat with fur-trimmed collar; worn by Fay Davis, Boston-born actress (1873–1945). Photo by Rotary Photo Co. Ltd. (London). Circa 1905.

5. Wool dress with high collar trimmed with bands of velvet, braid and buttons, lacy insert. Photo by Alex. Möhlen (Han-

nover, Germany) Inscription: *Henni Brand 05.*

6. Women in shirtwaists and lingerie dresses. Men in shirts with armbands and stiff collars, boaters tossed on the ground. Unknown photographer. Inscription: *July 4, 1905.*

7. Formal daytime attire worn at a summer dance, the space decorated with paper lanterns and nautical flags. Unknown photographer (France). Circa 1905.

113: 1906

1. Outdoor wedding group, including a bride in her veil, wearing lace-trimmed day dresses and with flower-laden hats. Unknown photographer (France). Circa 1906.

2. Wool tailleur with long jacket and cape collar; hat with ostrich-feather trim. Girl's dress in white cotton worn with ankle boots. Photo by Genelli (St. Louis, MO, United States). Inscription: *Mrs. Julia Toliver and Bernice Toliver.* Circa 1906.

3. Tailored suit, shirtwaist, and white gloves. Photo by La Parisienne (Paris).

4. Seersucker textured dress with lace collar; long bead necklace; rough straw boater. Unknown photographer. Inscription: *1906.*

5. Tailored dress with sailor collar; worn for boating. Unknown photographer. Inscription: *Souvenir d'une canotiere. Georgette Lalanne. Septembre 1906.*

6. Wool tailleur worn with fur scarf and upturned hat with large buckle. Infant in large bonnet and boy in wool coat with sailor collar. Photo postcard. Unknown photographer (UK). Stamp: *My 6 06. Kenilworth.*

114: 1907

1. Dressed for a summer outing in shirtwaists, tailored skirts; beribboned hats. Gentlemen wearing three-piece suits and boaters. Photo postcard. Unknown photographer. Stamp: *4-8 07. St. Poncy.*

2. Lace-trimmed white dress; jewelry; sunshade; flower and ostrich-feather-laden saucer hat. Photo by C. Mull & Co. (Lucknow, India). Inscription: *For Bro Warner from Sis Porter with kind regards 17/16/07.*

3. Long double-breasted fitted coat with cape collar; upturned hat trimmed with flowers. Photo postcard celebrating a new year and a new German coin. Unknown photographer.

4. Woman wearing striped silk dress worn with jacket and scarf. Man wearing a sack suit, stiff rounded collar. Unknown photographer. Inscription: *Rotterdam bound, on the steamer "Rynda," of the Holland America Line. Sept. 10th 1907.*

5. Lingerie dress worn playing tennis by musical comedy sensation Miss Gertrude "Gertie" Millar (1879–1952), star of the Gaiety Theater, later Countess of Dudley. Miss Millar often wore designs by Lucile. Photo by Foulsham & Banfield. Rotary Photo Postcard. Circa 1907.

6. Afternoon gown in pale blue overlaid with point d'esprit and lace; silk sunshade; ostrich-feather-trimmed hat. Photo postcard. Photo by Henri Manuel (Paris). Circa 1907.

7. Tennis attire: lingerie shirtwaist and white pleated skirt; pendant brooch; wide-brimmed straw hat. Photo postcard. Unknown photographer (France). Circa 1907.

8. Lingerie dress with pleated yoke and skirt, puffed sleeves. Unknown photogra-

pher. Inscription: *1907 Rowena Chichester Rahway, NJ.*

115: 1908

1. Reception gown with train; hat trimmed with ostrich and egret feathers. Model at a custom or couture salon; on mannequins can be seen other wardrobe staples such as a lingerie dress and a tailored suit. Photo by George Grantham Bain, Bain News Service. Circa 1908.

2. Afternoon/dinner gown of mousseline embroidered with floral sprays, trimmed with bands of satin and tassels. Photo by Henri Manuel. Postcard titled "Les Reines de la Mode. Prince. Theatre de l'Athenee." Canceled stamp: *'08.*

3. Floral-printed cotton housedress with apron; worn for housework. Unknown photographer. Pencil inscription: *Chicago, Ill. 1908.*

4. Tea gown photographed outdoors. Unknown photographer (France). Circa 1908.

5. Dressed for a vernissage, Paris: pinstripe wool suit with appliquéd bands, shirtwaist with lace-trimmed jabot; fox scarf; flower-trimmed wide-brimmed hat with face veiling; short wool jacket decorated with tucks and embroidered bands; flower-trimmed basket hat. Photo by George Grantham Bain, Bain News Service. Inscription: *"Smart gowns worn to the Salon on 'Varnishing Day', Paris, May '08."*

6. Kimono jacket in wool with embroidered bands down the front, lingerie shirtwaist and long skirt in wool with passementerie; toque with veiling. Unknown photographer. Inscription: *A la villa en 1908.*

7. Tailleurs with pleated skirts, braid-trimmed jackets; wide-brimmed hats with chenille dotted face veils. Unknown photographer (probably United States).

8. Mothers in summer dresses holding infants in long gowns. Unknown photographer. Inscription: *7-16-08.*

116–117: 1909

1. An assortment of tailored daytime clothes as worn by men, women, and children of various ages, with an early motorized sightseeing vehicle. Unknown photographer (New York).

2. Young woman's dress in white with tucked side panels in the skirt; sunshade; straw hat with puffed organdy crown. Photo by E. Heide vorm. Inh. Herzogl. (Stottenburg, Germany).

3. Lingerie dress and wide-brimmed hat draped with chiffon and silk lilacs; worn for graduation from Sumner High, the first public high school for African Americans west of the Mississippi, founded in 1875. Photo by Maxwell (St. Louis, MO, United States). Inscription: *Mabel 1909, Sumner High.*

4. Suit in striped wool with satin trim, embroidered vest detail; pince-nez; wide-brimmed hat trimmed with ostrich feathers. Unknown photographer. Inscription: *Bessie A. Morris. March 1909.*

5. Woman wearing lingerie dress and patent leather boots. Men in sack suits and bouttonieres. Photo postcard. Unknown photographer (UK). Pencil inscription: *E.W.B., best man at wedding of Mr. and Mrs. Arnold Shackleton at Guiseley, near Leeds, Yorkshire, Eng. 1909.*

6. Shirtwaist with white belt, dark skirt; two leather bags; flower-laden saucer hat; worn for a summer walk. Unknown photographer (Massachusetts, possibly East

Bridgewater, United States). Date from album dated 1897.

7. Coat with embroidered collar and cuffs worn over a lingerie dress; metal mesh bag; wide-brimmed hat with ostrich plumes. Photo postcard. Unknown photographer (France). Stamp: *1909.*

8. Linen lingerie dress worn by a bride. Unknown photographer. Inscription: *Married July 4, 1909. at Bell Ranch, Streeter N. Dak. By Rev. Smith. Georges and Ruth Harris.*

9. Dressed for tennis: shirt and tie or athletic tank; rubber-soled shoes. Unknown photographer (United States).

10. Patterned dress with apron and pinafore-covered dresses. Unknown photographer. Inscription: *Août 1909.*

11. Shirtwaist and dark skirts, short aprons. Photo postcard. Unknown photographer (United States). Inscription: *4-11-1909. As others did see us. Ha! Mary Prasun and sister. (Lucas, Kaus-stone hotel)*

1910s

119: Lingerie dress inset with wide band of buratto lace and with zigzag bands of openwork, satin dress with embroidery; hat with upturned brim and bird-of-paradise feathers. Photo by Société de Nouveautés (Paris). Inscription: *Long. 20.6.12 503.* Circa 1912.

120: THE POIRET LOOK

1. Models posing in a park wearing (from left) white dress with striped waistband; white suit; dress in white with bow and skirt insert of striped material; wide-brimmed hats and shoulder bags with knotted cord long straps. Photo postcard. Photo by R. Duvau (Colombes, France). Circa 1910.

2. Printed silk day dress with empire waist, ruffles on below-the-elbow-length sleeves. Unknown photographer (France). Circa 1908.

3. Striped dress with empire waist, wide shawl collar of broderie anglaise; wide-brimmed hat with flowers. Unknown photographer (France). Circa 1908.

4. Day dress in checked cotton with high waist, tunic skirt and narrow underskirt, edged with narrow bands of contrasting material; shoulder bag with knotted cord strap; wide-brimmed hat of straw trimmed with velvet and striped ribbon. Photo by R. Duvau (Colombes, France). Circa 1910.

5. Day dress in checked fabric with bolero; wide-brimmed hat. Child's dress and bonnet in broderie anglaise. Photo postcard. Unknown photographer (France). Circa 1910.

6. Empire Revival dress, gathered neckline. Unknown photographer (probably France). Circa 1910.

122–123: 1910

1. Dot-patterned black dress with tucked net sleeves, satin and lace bands, velvet waistband fastening with a bow; hat with wide brim and deep crown trimmed with ostrich plumes. Photo postcard. Photo by Novelty Photo Studio (Richmond, VA, United States). Circa 1910.

2. Lingerie dress in broderie anglaise with tiered, flared skirt; string of pearls; wide hair ribbon. Photo postcard. Unknown photographer (Bayshore, NY, United States). Inscription: *1910 Summer.*

3. Woman wearing navy tailleur, blouse with ruffled jabot; gold mesh purse; floral corsage and long chain; wide-brimmed hat. Man wearing a three-piece suit, watch chain, boater hat; carries cane. Autochrome photo. Unknown photographer (France). Circa 1910.

4. Two married couples pose in daytime attire; the men in suits and topcoats, the women in shirtwaists, dark skirts, and stylish hats. Photo postcard. Unknown photographer. Inscription: *Received Aug. 13, 1910. From left to right: Mr. Ferley Stone, Mr. J. R. Clouting, Mrs. Maude Clouting, Mrs. Hetty Stone. To Wn. Clouting.*

5. Bride and groom in wedding gown and veil, white tie and tails. Photo by Ed. Rillon (London).

6. Evening gown with bodice of lace, tulle, metallic lace, embroidery and beads, slight train, fringed chiffon scarf; lacy fan; peach-basket bonnet. Photo postcard. Unknown photographer. Circa 1910.

7. Assorted swimming attire. Photo postcard. Photo by Tisdale's Studio (Old Orchard Beach, ME, United States). Inscription: *June 1910.*

124–125: 1911

1. Teens dressed for alpine sports: for skiing the boy wears knickers, knit sweater and hat and backpack; the girl wears knit cap, sweater, and a long wool skirt. Unknown photographer. Inscription: *Weihuachten 1911 (Christmas Day).*

2. Tailored coat with fur scarf and muff; wide-brimmed hat with silk chrysanthemum and rose. Child's winter attire including coat with curly lamb collar and gaiters. Photo postcard. Photo by Central-photographie. Cancelled stamp: *7.1.11.*

3. Lingerie dress. Photo by G. Agié (Paris). Circa 1911–13.

4. Fashions at the races: dresses with elements of embroidery and eyelet, hems with bands of sheer silk; handbag with fringe; sunshade; large hats trimmed with egret or ostrich feathers. Photo by Meurisse (Paris).

5. Tailleur with blouse with ruffled collar; hat with asymmetrical brim. Unknown photographer (probably France). Circa 1911.

6. Fashions at the races: dresses with elements of embroidery and eyelet; handbags in watered silk with fringe or beads; large flower- or feather-laden hats. Photo by Meurisse (Paris).

7. Dress by Paris couturier Buzenet in white-and-rose-pink-striped silk voile with a fichu of white linen embroidered in rose; worn by actress Lillian Greuze. Photograph by Reutlinger. Circa 1911.

8. *Déshabillé* in the garden: *combinaison* or nightgown held up as if bloomers; rustic straw hat. Unknown photographer (possibly Southern United States). Inscription: *Summer 1911.*

9. Wedding party in France. The groom is Joseph Wachter, an American photographer. Unknown photographer.

10. Gingham checked dress with self-covered buttons; wide-brimmed hat with dotted organdy-like fabric. Photo postcard. Photo by Falk Studios (Perth, Australia). Inscription: *Norah, June 1911.*

11. Empire-waist dress with lace undersleeves and pointed sheer silk overskirt edged with a satin band. Photo by M. Appel (Berlin). Stamp: *1911.*

12. White-on-white striped dress with lace insertion. Photo by Atelier Strauss & Co. (Vienna). Inscription: *Eveline 11.8.1911.*

126–127: JUPE-CULOTTE

1. This is the satin jupe-culotte ensemble worn by a model to the opening races at Auteuil that was reported as inciting near riots; it would be years before newspapers around the world lost interest in designers creating trouser skirts and women wearing them. Photo by H. Weilamann (New York). 1911.

2. *La mode nouvelle*: Jupe-culotte with harem pant legs underneath a tunic with uneven hem, trimmed with fringe at the bodice and the hem; wide-brimmed velvet hat trimmed with ostrich plumes. Photo postcard. Unknown photographer. Cancelled stamp: *9 VI 12.* 1912.

3. Paul Poiret jupe-culotte or pantaloon gown, high waist with two-tone sash, surplice neckline with buttons along one edge, underblouse of dotted swiss or white material gathered into a round neckline, center and side panels of gingham plaid cut on the bias; black patent pumps with bows; wide-brimmed hat with bird-of-paradise plume. Photo by Old George Grantham Bain, Bain News Service. Stamp: *February 28, 1911.*

4. Postcards depicting jupe-culottes were immediately issued, one was even sent by a niece to poet T.S. Eliot who responded "I have not seen this costume on the street and I don't think it will be a success." This example features a robe pantaloon in satin with sailor collar, self-covered button and button loop details, and turban with egret feather. Photo by: Henri Manuel. Photo postcard. Photo by Henri Manuel. Cancelled stamp: *11-12 -13. 1913.*

5. Seen at the races: jupe-culotte with pant legs of contrasting wide tucks underneath a tunic with surplice bodice, soft chiffon blouse with sailor collar; corsage of silk roses; long gloves; ostrich-feather fan; toque with sprays of bird-of-paradise feathers. Unknown photographer. Circa 1912.

6. Another view of the wool jupe-culotte ensemble. Photo postcard. Photo by Henri Manuel. Stamp: *1911.*

7. Jupe-culotte tailored ensemble: wool with revers trimmed with flat braid, lingerie shirtwaist with jabot; purse with long shoulder strap; shaped toque with plume. Not only is this woman daringly sporting pantaloons, but she is also applying lipstick. Photo postcard. Photo by Henri Manuel. Stamp: *1911.*

8. Two examples of jupe-culottes photographed in Paris. Photo by George Grantham Bain, Bain News Service. Stamp: *Feb 27 1911.*

128–129: 1912

1. Worn at Auteuil: dress with delicate floral print overlaid with black net worked with pin tucks with decorative edging, the skirt with panels of Irish crochet lace under black tulle; wide-brimmed hat with a white and a black rose. Photo by Société de Nouveautés (Paris). Inscription: *Auteuil 26.6.12.*

2. Dress with white tunic worked with scrolling foliate embroidery and edged with bobble-fringe; hat with face veiling. Unknown photographer, Société de Nouveautés (Paris). Inscription: *Auteuil 21.7.12*

3. Tailored suit worn for beachcombing; long chain with pendant, possibly a watch; hat with ostrich plume. Unknown photographer (New England, United States).

4. White dress with floral chiffon tunic edged with white bobble fringe; hat trimmed with ostrich feathers. Unknown photographer. Inscription: *Gwen Phillips.* Circa 1912.

5. Wool suit with cutaway hem; wide-brimmed hat trimmed with ostrich feathers. Unknown photographer (United States). Circa 1912.

6. Woman at center wearing satin dress with empire waistline, embroidered scallops down sides and at the hem of a long tunic, pointed bertha and skirt embroidered with three-dimensional satin stitch and with scrolling braid, knotted rope belt with tassel; wide-brimmed hat with egret feathers. Her fellow racegoers wearing frock coat, pinstriped trousers, and bowler hat; and a tailored woman's suit in pinstriped wool with embroidery. Worn at Longchamps, April 24, 1912. Photo by Société de Nouveautés (Paris).

7. Daytime dress with embroidered braid trim, lace, embroidery. Photo by Heinrich Wagner. 1912 (based on date of award printed on the back of the photograph).

8. Lingerie dresses, one curvier than the other, trimmed with handmade lace; sunshade with embroidery; wide-brimmed straw hats with flowers and ostrich plumes, one with face veiling. Photo by L. Tresca (Paris). Circa 1912.

9. Tailored suit with contrasting revers, button holes and button edges; curly ostrich-feather boa, coin purse on long chain. Unknown photographer. Inscription: *Ima November 1912.*

10. Schoolgirl's school sweater with Cathedral of the Sacred Heart insignia, collared shirt, necktie, wool skirt, hair bow. Unknown photographer. Inscription: *Edna Schillinger, Ocean City, New Jersey.*

11. Styles seen at Longchamps in April: dress with elbow-length sleeves and narrow, draped skirt edged with a deep flounce of handmade rose-point lace; fur scarves; wide-brimmed hat with bird-of-paradise feathers; tailored suit with cutaway jacket with empire waist, skirt with tiered scalloped back panel; fur scarves; hat with upturned wide brim edged with grosgrain. Unknown photographer, Société de Nouveautés (Paris). Inscription: *Longchamps 14.4.12.*

12. Moirè dress with tiered skirt; flower-trimmed hat. Unknown photographer (probably United States). Circa 1912.

13. Dressed for races at Deauville, France in a tailored suit, possibly in ribbed pique, and lingerie dress in broderie anglaise with tartan sash; both ladies wearing veils drawn tightly against their faces. Photo by Société de Nouveautés (Paris). Inscription: *Deauville 6.8.12.*

130: 1913

1. Two tailleurs with Directoire elements; hats with bird-of-paradise feathers; photo taken in France. Photo by George Grantham Bain, Bain News Service. Stamp: *Jun. 4, 1913.*

2. Embroidered net dress with empire waist; worn with mob cap; taken in France. Photo by: George Grantham Bain, Bain News Service. Stamp: *July 1 1913.*

3. Pinstriped day dress with ribbon bowtie; sunshade; flower-trimmed hat. Unknown photographer. Pencil inscription: *July 1, 1913.*

4. Dress inset with wide bands of openwork, bright paisley narrow scarf tied low in back; hat with faux grapes. Photograph by George Grantham Bain, Bain News Service. Printed date: *JUN 8 1913.*

5. Evening dress with bodice of white net worked with pin tucks and self-ruffles, trained skirt overlaid with Irish crochet lace; headdress of white stripped feathers. Photo by Culbertson. Inscription: *For Mamma.*

6. Striped jacket over long satin finish skirt; hair loosely braided or twisted. At night, a woman wearing man's hat, shirt, necktie, and trousers. Unknown photographer. Inscription: *S. W. Green and May Fellows taken June 8th 1913.*

7. Watered silk tailored suit with embroidered lingerie shirtwaist; mesh purse. Photo by The Vaudeville Photograph & Press Bureau. Stamp: *Jan. 1913.*

8. Evening dress with typical "Teens" mélange of elements: bodice of embroidered net with lace insertions, faux pearl embroidered trim, cummerbund waist and overskirt of metallic brocade, underskirt of pleated silk chiffon with floral appliquè and hem band embroidered with a lattice of bugle and other beads; worn by Miss Hazel Bird Brown, fiancée of Capt. James Wainwright Flanagan. Photo by De Lux Studio (Denver, CO, United States). Stamp: *Dec. 10, 1913.*

131: DIRECTOIRE REVIVAL

1. Narrow cocoon coat in silk moiré, sailor collar with self-rosette at the back, narrow draped skirt and shirtwaist; suede and patent shoes with diamante bows; bag with tassel; angled profile hat with veil; worn at the races. Photo by G. Agié (Paris). Circa 1913–14.

2. Velvet coat with narrow bubble shape in the skirt, high collar trimmed underneath with fur; fox muff; hat with upturned brim and egret feathers. Photo by G. Agié (Paris). Circa 1913–14.

3. Velvet coat with fox-trimmed overskirt and narrow velvet under skirt; fox collar, cuffs, and muff; pumps with cut-steel buckles; upturned medium-brimmed hat with ostrich plume. Photo by G. Agié (Paris). Circa 1913–14.

4. Tailleur for spring with dark cutaway jacket and tattersall checked wool sarong-draped skirt; two-toned shoes; pouch shaped bag with tassel; medium-brimmed hat. Photo by G. Agié (Paris). Circa 1913–14.

5. Woman at the races wearing satin dress trimmed with narrow and wide bands of fur, self-covered buttons, flared skirt and narrow underskirt; walking shoes with spats; peaked toque with egret plumes. Seen from the back is a gentleman in Chesterfield coat, spats, and top hat. Photo by G. Agié (Paris). Circa 1913–14.

6. Dress in white silk and pale velvet, narrow skirt and overskirt in soft silk, tunic of net with delicate floral embroidery ending in back with beaded tassel, soft chiffon or tulle collar and cuffs at the elbow-length sleeves; pouch handbag; two-tone shoe with crossed straps; wide-brimmed hat in white with egret plume; worn at the races. Photo by G. Agié (Paris). Circa 1913–14.

7. Racegoer's ensemble with velvet cutaway jacket, fur collar, dress underneath with sash to match jacket ending in a large tassel; fur muff, purse with fringe, and medium-brimmed hat trimmed with egret feathers. Photo by G. Agié (Paris). Circa 1913–14.

8. Narrow cocoon coat in velvet with tucks; fur scarf; black suede shoes with diamante buckle; soft toque trimmed with ribbons. Photo by G. Agié (Paris). Circa 1913–14.

132: 1914

1. Side view of embroidered sheer silk dress with lace hem; ostrich-feather-trimmed hat and feather boa; worn at Longchamps. Photo postcard. Unknown photographer (France). 5/13/14 (date based on alternate photo of woman in same dress).

2. Back view of embroidered sheer silk dress with lace hem; ostrich-feather-trimmed hat and feather boa; worn at Longchamps. Photo postcard. Unknown photographer (France).

3. A feminine version of a gentleman's morning suit: draped striped skirt, blouse with winglike collar and waistcoat hem, dark jacket; white fur scarf and cane; veiled boater hat sprouting bird-of-paradise-feathers; worn probably at Longchamps. Photo postcard. Unknown photographer. Circa 1914.

4. Spring ensembles worn by models at the races: (left) a dress trimmed with buratto lace, mesh sailor collar, self-covered buttons, gold mesh purse; (right) a dress by Jenny, a designer known for dresses that were simple and typically Parisian in style, in white silk with low girdle sash and flared skirt looking ahead to 1915, long strand of pearls to upper thigh, black hat trimmed with bursts of egret feathers. Photo by: G. Agié (Paris). 1914 (based on a photograph of the Jenny dress appearing in *Les Modes*, July 1914).

5. Three afternoon dresses: (from left) embroidered lawn or batiste lingerie dress with ruffled hem, sunshade, elbow-length gloves, white walking shoes, wide-brimmed hat; striped dress with tiered skirt, gloves, white shoes with heels, medium-brimmed hat; dress with flowered panel at the skirt worn with dark accessories, from the band on the wide-brimmed hat to the belt, sunshade, handbag, and shoes. Photo by George Grantham Bain, Bain News Service. Stamp: *Paris Fashions July 1914.*

6. Soft suit, possibly knit, with white gilet, ruffled neckline, and belt; white silk knit gloves; shoes with multiple straps; feather-trimmed hat; probably worn at Longchamps. Photo postcard. Unknown photographer. Circa 1914.

7. Taffeta dress with surplice neckline and skirt gathered low over a narrower underskirt; spats-inspired two-tone boots; white-feather-trimmed black hat; worn by a woman photographed often by the Frères Seeberger, probably at Longchamps. Photo postcard. Unknown photographer. Circa 1914.

133: 1915

1. Elsie de Wolfe (1859?–1950) returning from inspection of American Ambulance Field Service at Versailles. Photo by George Grantham Bain, Bain News Service. Printed date: *Dec. 6 1915.*

2. Girl Guide in uniform, UK. Unknown photographer. Circa 1915.

3. White net dress with lace collar and trim, with the slightly raised waistline and narrow silhouette that was on its way out; small fan worn as a pendant. Photo by Polastri y Taramillo (Guayaquil, Ecuador). Inscription: *Ana Ma. San Lineast. X-13-1915.*

4. Dress with tiered pleated skirt, taffeta bolero jacket. Unknown photographer (probably United States). Inscription: *Yours lovingly Blanche Robb 12/25/15.*

5. Suit with belted jacket and flared mid-calf skirt; drawstring purse; lace-up boots; straw toque. Unknown photographer. Circa 1915

6. Lingerie dress worn by actress Mary Ryan in *The House of Glass*, New York. Photo by Ira L. Hill's Studio (New York).

134: 1916

1. Coat with tasseled belt; ankle boots; velvet-trimmed hat. Unknown photographer (probably United States). Inscription: *1916.*

2. Taffeta dress with taffeta vest, sewn at the side with a tassel; ankle boots. Photo by Photokunst (Dresden). Circa 1916.

3. Wartime wedding attire: white dress with orange blossom wreath and military uniform. Photo by Trois Bébés (35, Fg. St. Martin). Circa 1916.

4. Wool coat with velvet collar and half-belt; toque trimmed with grapes. Unknown photographer. Inscription: *May 17, 1916.*

5. Fur-trimmed evening coat with smocking details over metallic lace trimmed ankle-length dress; worn by actress Mary Servoss, appearing in *The Passion Play of Washington Square.* Photo by Apeda (New York). 1916 (based on performance run of the play).

6. Striped silk dress by Buzenet, Paris. Photo by Joel Feder (New York). Circa 1916.

7. Black satin dress and flower-trimmed hat. Child's bonnet, coat, dress, stockings, and shoes in white. Unknown photographer. Inscription: *Aug. 1916.*

8. Picnic attire: dress with striped bodice and peplum; Japanese paper parasol. Unknown photographer. 1916 (based on the US license plate).

135: 1917

1. Jersey costume of tunic and skirt by new designer Gabrielle Chanel. Although embroidered, the tunic is almost identical in style to the thick jerseys that were Chanel's first great success at Deauville, France, in 1913. Photo by Boissonnas et Caponier (Paris). Circa 1917.

2. Tiered dress in tulle; white stockings and pumps. Unknown photographer.

3. Light silk summer dress, dark skirt, and lingerie shirtwaist. Boy wearing shorts outfit in white with floppy bowtie. Unknown photographer. Inscription: *What do you think of this one? Alice. 1917.*

4. Lingerie dress, wide leather belt; cuff bracelet and metal mesh purse; leather ankle boots; large black hat. Unknown photographer. Inscription: *Taken at Hillside Park.*

5. Dressed for skating in a wool tailleur with flared skirt; sable scarf and fur stole; ankle boots; wide-brimmed hat. Unknown photographer (probably Europe). Circa 1917.

6. Tailored walking suits; fur scarves, large astrakhan muffs; ankle boots; medium-brimmed hats. Unknown photographer. Inscription: *1917.*

7. Suit with peplum; chain-mesh purse; medium-brimmed hat. Unknown photographer. Circa 1917.

136: 1918

1. Woman wearing fur-trimmed coat belted over a dress; ankle boots. Man wearing a suit, cuffed pants, newsboy cap. Unknown photographer. Pencil inscription: *April, 1918.*

2. Evening gown by Lucile, a couturiére with salons in London, Paris, New York, and Chicago, in black satin with train, rolled collar of skunk, tie, sleeve ruffles and "modestie" of real lace. Photo by Bachrach Studio. 1918 (based on a drawing of this dress appearing in *Vogue*, November 15, 1918, dating the dress as fall/winter 1918/19).

3. Lace-up ankle boots in leather with stacked heels worn by actress Vera Steadman (1900–1966). Unknown photographer (probably United States). Inscription: *Restlessness Vera Steadman.*

4. Smock, breeches; felt hat worn for painting. Unknown photographer. Pencil inscription: *1918.*

5. Tailleur by Hickson, a good quality custom and import store in New York and Boston, of black oxford cloth with ivory waistcoat; hat of faille with star points. Photo by The International Film Service, Hickson & Co., New York. Circa 1918.

6. For gym class: wool bloomers and middy blouses. Unknown photographer. Inscription: *1918.*

7. Twill tailor suit with satin collar and corded bands; hat with wings of woven straw. Photo by George Grantham Bain, Bain News Service. Printed date: *Spring 1918.*

8. Suit with tiered cape collar, self-belt, flared skirt, blouse with shaped collar, chrysanthemum boutonniere; lace-up ankle boots; wide-brimmed hat. Unknown photographer (France). Inscription: *Je quitte Calais pour Vence avec chacun un gros baiser pour vous tous. Suzanne. Calais 9 Juillet 1918.*

137: 1919

1. Tulle evening dress with sequin embroidery; long necklace of small pearls. Photo by The Parker Studios (Morristown, NJ, United States). Pencil inscription: *Parker 1919.*

2. Black satin dress with tunic effect embroidered in gold, high collar of black tulle tied in a bow at the back; shaped toque of black straw with a spray of stripped feathers. Photo by Central News Photo Service. Stamp: *Feb 1 1919.*

3. Short-sleeved wool knit bathing costumes and swim caps. Unknown photographer (Dawlish, UK). Pencil inscription: *Dawlish, UK 1919.*

4. Evening gown of pale green gauze over silver cloth with sheer overcoat of black gauze, the under dress embroidered in silver, the black gauze embroidered with flowers in black, a squared black satin train lined with yellow and embellished with tiny French flowers. Photo by Steffens (Chicago). Stamp: *Dec. 11 1919.*

5. Dark dress with embroidered overskirt, white collar. Unknown photographer. Pencil inscription: *19.*

6. Sisters wearing their new French finery aboard ship returning home: one wears a furry dress and coat ensemble; the other wears a plush wrap coat. Photo by Keystone Press Agency. Stamp: *Dec. 1 1919.*

7. Tailored day dresses and suits, most with embroidered details. Unknown photographer. (California, United States). Inscription: *Donovans at Santa Barbara 11-2-1919.*

8. Linen jodpur suit, worn by musical comedy actress Francine Larrimore (1898–1975). Photo by Moffett (Chicago). Stamp: *1919.*

1920s

139: Elegant summer attire worn at the races at Deauville, France: afternoon frocks and medium-brimmed hats for the women and light trousers for the gentlemen. Photo by Henri Manuel. Inscription: *Lot mensuel* [monthly allotment] *No. 4. Les Courses de Deauville.* Circa 1923.

140: ANDROGYNY

1. Gym bloomers and blouse with sailor collar; dark stockings; striped knit hat. Unknown photographer. Circa 1920.

2. Unisex bathing costumes in black-and-white striped wool jersey. Photo by Keystone Press Agency. 1924.

3. Artists' smocks and berets worn as fancy dress costumes. Unknown photographer (France). Circa 1925.

4. Knee breeches, gaiters, corduroy coat or cardigan and shirts with neckties worn in a hen house. Photo postcard. Unknown photographer. Inscription: *Charteris. 1922.*

5. Unisex bathing costumes in black-and-white striped wool jersey. Photo by Keystone Press Agency. 1924.

6. Superbly- tailored ensemble of pin-striped wool skirt suit with double-breasted jacket, shirt with collar pin and necktie; bar pin; handbag and pocket square; oxford walking shoes; closely fitting hat composed of circles with dotted veil; photographed at the races, France. Unknown photographer. 1928.

7. Dapper young man. Unknown photographer. Inscription: *Herbert Burke.* 1925.

8. Pajama nightwear, one of a group of snapshots taken on a trip to Egypt. Unknown photographer. 1922.

9. Letter sweater and gym bloomers; ribbed knee socks and high-topped canvas sports shoes. Unknown photographer. Inscription: *1928 May.*

10. Knickers, V-neck pullover sweater, collared shirt, narrow necktie; wide headband; worn by a flapper. Unknown photographer. Printed date: *July 1925.*

11. Jodpurs, tailored jackets; boots and/or gaiters. Unknown photographer. 1930.

12. Dressed for alpine hiking in knickers worn with camp shirt and tie; heavy wool socks and ankle boots. Unknown photographer. (Europe). Circa 1925.

13. Knickers and overalls. Unknown photographer (Baraboo, WI). Printed date: *July 1922.*

142-143: 1920

1. Dress with simple bodice, cowl neck and tiered, tulle skirt; lace-up pumps. Man wearing three-piece suit, stiff collar. Unknown photographer (Nanterre, France). Circa 1920.

2. Dress with simple bodice, cowl neck, and tiered, tulle skirt; lace-up pumps. Man wearing three-piece suit and stiff collar. Unknown photographer (Nanterre, France). Circa 1920.

3. Glamorous lesbian actress Alla Nazimova (1879–1945), in a scene from the film *Stronger Than Death* (1920), wearing a tea gown of silk mousseline with metallic embroidery; necklace of large faux pearls. Photo by Screen Classics Inc. Stamp: *Feb 20 1920.*

4. Evening gown with camisole bodice embroidered with iridescent sequins, full skirt with fur trim; worn by actress Nancy Fair promoting the play *No More Blondes* in 1920. Photo by Sarony (New York).

5. Coat and skirt ensemble; long chain; black wide-brimmed hat. Unknown photographer. Inscribed: *Madelaine Nicoloeff May 1920.*

6. Afternoon frock by Rosemary, an American ready-to-wear label, in satin with a tunic overdress, collar of pin-tucked net and lace. Photograph by D-international. Stamp: *10-6-20.*

7. Three women in winter coats, all with distinctive buttons; two with fur scarves and flower trimmed hats, one wearing a boater. Unknown photographer. Pencil inscription: *3/30/20.*

8. American socialite Rita de Acosta Lydig (1875–1929) in profile wearing a high collar of antique lace, her pose and collar reminiscent of the portrait bust of her in alabaster by Malvina Hoffman. Over her wool dress she wears a taffeta jacket edged with embroidery; a fur scarf and pearls; and a straw hat with bird-of-paradise feathers as well as simple versions of her signature shoes by Yantorny. Photo by "International." Stamp: *May 7, 1920.*

9. Bathing costumes with bobbed hair and bandeaux. Unknown photographer. Inscription: *High Island 1920.*

10. Family photographed on a pier, the mother in tailored coat or coatdress with trimming of floral pattern material with fur collar. Unknown photographer. (United States). Circa 1920.

11. Black taffeta dress trimmed with two rows of self-pleated ruffles, slightly barrel-shaped skirt. Unknown photographer. Inscription: *Summer 1920.*

12. Striped wool knickers; belted long jacket with flared skirt; shirt with narrow tie run through a slot; striped wool socks and oxford shoes; hat with narrow brim. Unknown photographer. Circa 1920.

13. Lord Charles Hardinge (1858–1954), just appointed ambassador to France from England, wearing a three-piece suit, and his daughter the Honorable Diamond Hardinge, wearing a striped wool dress with a slightly barrel-shaped skirt. Photo by Henri Manuel.

14. Silk dress with Art Nouveau embroidery at the neck, tucks at the skirt. Photo postcard. Unknown photographer (Lewiston, ME, United States). Inscribed: *1920.*

15. Satin dress with side-buttoning tunic; wristwatch. Infant wearing knitted booties and dress with lace and cotton lawn collar. Photo by Mayadon Rabkine (Paris). Pencil inscription: *Souvener de Mogir pour ses 5 mois. 17 Fevrier 1920.*

16. Middy blouse, plaid skirt; black stockings and white walking shoes; feather-trimmed hat. Unknown photographer. Inscription: *Ella Marquette, Oct. 17, 20. Devil's Lake.*

144: 1921

1. Intentionally Bohemian in a dress of batik-dyed velvet; worn by Miss Ethel Wallace, who did the batik herself. Unknown photographer. Stamp: *Mar 21 1921.*

2. Knee-length shorts, shirt with tie; belted wool knicker suit and white dress with tiered skirt, hair ribbon. Unknown photographer. Inscription: *Herbert, Rowland and Lois. July 1921.*

3. Chenille dot woven suit trimmed with flat bands of silk; lingerie blouse with pin tucks and lace; straw hat with wide ribbon hatband; probably photographed at a charity sale. Photo by Irving Allen Fox.

4. Mother in a gauzy lingerie dress and child in a sailor hat. Unknown photographer (probably United States). Pencil inscription: *1921.*

5. Robe de style with petaled hem, circular motifs embroidered with sequins with teardrop tassels; metallic brocade T-strap sandals; hat in metallic cloth; worn by actress Elsie Bartlett, chorus player in a 1921 revival of *The Merry Widow.* Photo by White Studio (New York).

6. Spring frock in cloud gray "tallyho" silk, three-quarter-length sleeves, high collar, self-covered belt. Photograph by Joel Feder. Copyright J.A. Migel Inc. Stamp: *Apr 30 1921.*

7. Evening dress with beaded appliqué and velvet flower. Boy's romper with embroidered detail at the sleeves, ankle boots. Unknown photographer. Inscription: *Xmas 1921.*

8. Paul Poiret afternoon gown in black velvet and coral chiffon, sleeves embroidered in coral beads and silver thread; fur scarf; satin and lace hat. Unknown photographer. Stamp: *Nov 2 1921.*

145: EAST-WEST

1. "Smoking suit" for "milady's boudoir": yellow and orange satin with quilting. Caption: *Modernistic motifs in soft yellow are quilted onto the orange satin background of a spring smoking suit for milady's boudoir.* Photo by Acme Newspictures. Printed date: *Dec. 29 1927.*

2. Chinese jacket in embroidered silk jacquard, pants in embroidered cuffs; embroidered shoes; modeled by an actress. Unknown photographer. Stamp: *Sep 7 1921.*

3. Gown made from Chinese riding skirt; black satin jacket and hat. Photo by International. Circa 1925.

4. Countess Ludwig Salm von Hoogstraeten, better known as Millicent Rogers (1902–1953), wearing a sari. Photo by Pacific & Atlantic Photos. Pencil inscription: *1-14-24.*

5. Fancy dress in Near Eastern taste. Unknown photographer (probably United States). Inscription: *with love Jessie Xmas 1923.*

6. Costume with Near Eastern touches: tunic with bloomers; turban with attached earrings. Photo postcard. Unknown photographer. Pencil inscription: *1925.*

146: 1922

1. Dress and cape ensemble by Melnotte Simonin, Paris, a small couture house, in white marocain and navy satin: dress with sapphire and bead belt; cape with side fastening and cowl collar; navy georgette hat. Photo by General Photographic Agency (London). Stamp: *Jul 24 1922.*

2. Striped sailor dress worn by Miss Mathilda McCormick. Photo by News Photo.

3. Three-piece suit by New York ready-to-wear label Mayer, of black matelassé trimmed with white caracul and beaded fringes; velvet hat with ostrich feathers. Photograph by Underwood & Underwood (New York). Stamp: *10/22/22.*

4. Paul Poiret walking costume of jade velour, made entirely of straight pieces of material, the skirt folded down at the top to form an overskirt, another piece folded to form a cape with tassels, silver brocade fitted girdle and vestee front; small hat of jade velour trimmed with silver roses. Photo by Underwood & Underwood (New York). Stamp: *11/13/22.*

5. Woman wearing wool suit with open jacket worn over a satin tunic trimmed with tucks. Boy in wool coat, and girl wearing a cape with fur collar and matching muff. Unknown photographer (United States). Inscription: *Edgar Mom Betty 1922.*

6. Sport frock with belted cardigan; white stockings and shoes; medium-brimmed hat. Unknown photographer. Inscription: *Morecambe 1922.*

7. Styles seen at Longchamp including a black dress with strands of red and white beads. Unknown photographer. Stamp: *May 19 1922.*

8. Summer dress with high waist and peplum; tulle hat with wire brim. Unknown photographer. Inscription: *From one of the four with good wishes, Alexandria 1922.*

147: 1923

1. Striped wool suit with cardigan jacket and silk blouse, embroidered hat with embroidered veil, carved pendant (possibly jade) worn on a Chinese knotted cord; worn by textile designer Hazel Burnham Slaughter, who had recently won the Tutankh-amen scholarship established by Cheney Brothers for the study of ancient and present-day Egyptian art; photographed on the *Amsterdam* just before leaving New York for Egypt. Photo by Pictorial Press Photos (New York).

2. Lingerie frock with V neck, short sleeves, self-covered belt at the natural waist, lace insertions; wide-brimmed hat of rough straw; worn by American film and stage actress Pauline Frederick (1883–1938). Photo by Paul Grenbeaux.

3. Dress of printed and solid silk with horizontal bands of opaque and sheer silk layered over the print, fastening with self-covered buttons; checkerboard-patterned silk purse; tricorn hat; photographed at the races, probably Longchamps. Photo by G. B. Odone (Genoa). Stamp: *2 Nov 1923.*

4. Fashion at the races: afternoon dress in black satin, tunic dress with embroidered bands; cloche hat. Photo by Le Journal Service des Illustrations. Stamp: *1 Nov. 1923.*

5. Coat with fox collar and cuffs, single oversize button closure; hat with feathers. Unknown photographer (United States). 1923 (based on license plate of car).

6. Jean Patou dress in blue gabardine with "new" short skirt, bateau neckline, monogram on the sleeve embroidered in white beads; mushroom hat of brown felt with long "sheik" veil; worn by Mrs. Aubrey L. Eads, neé Peggy Hoyt, described in the news caption as the best-dressed woman in the country. Photo by Wide World Photos. Stamp: *1/29/23.*

148: 1924

1. Chanel-style silk frock with embroidery inspired by eastern or northern European peasant blouses; gloves with checkerboard cuffs; metal mesh handbag; simple cloche hat; worn at the races in France. Photo by H. Weilamann (New York). Circa 1924.

2. Afternoon dress with shaded floral embroidery, bias-cut circular skirt; picture hat trimmed with ostrich feathers. Press photo. Unknown photographer (United States). Stamp: *Jul 7 1924.*

3. Dress of silk charmeuse trimmed with tapered, curved bands of paler crepe de chine, sleeves with tiered cuffs; five-strand necklace of graduated pearls; handbag and walking stick; cloche with upturned brim; worn at the races, probably Longchamps. Photo by G. B. Odone (Genoa). Stamp: *Apr [illegible]4.*

4. Chic mother and baby in the Place Vendôme, Paris, wearing wool coat with sheared fur cape collar; low-heeled walking shoes; wide-brimmed hat. Unknown photographer. Pencil inscription: *Maman me promenade a Paris. 1924.*

5. Countess Ludwig Salm von Hoogstraeten, neé Millicent Rogers, dressed for travel in a checked wool suit, foulard scarf; kid gloves; envelope purse; pumps with cut steel buckles; cloche hat. Photo by Pacific & Atlantic Photos. Pencil inscription: *1-14-24.*

6. Full-skirted robe de style, a style for which couturier Jeanne Lanvin was particularly known: this example in white organdy trimmed with concentric circle appliqués. Modeled by Lillian Greuze. Lanvin press photo. Stamp: *Jun 25 1924.*

7. Summer chemise dress with patterned hem and pocket trim worn by Miss Helen Wills (1905–1998), renowned tennis player also known for her style. Unknown photographer. Stamp: *Aug 26 1924.*

8. Street dress in blue gabardine with a fitted bodice worked with pin tucks in a diamond grid and knife-pleated skirt, French-embroidered collar, hip ornament of moiré ribbon and composition rings; sable scarf; cloisonne bangles and gemset bar pin; hat with diamante pin; worn by film actress Helene Chadwick (1897–1940). Photo by Pacific & Atlantic.

149: 1925

1. Woman in somber dress contrasting with the summer frocks and parasols of the others. Unknown photographer (Europe). Date from album dated 1925.

2. Plaid coat with fur collar, narrow suede belt; long striped scarf; medium-brimmed cloche. Unknown photographer. Inscription: *Miss Ward 6-6.* Circa 1925.

3. Afternoon frock with scrolling floral design at the skirt; white shoes and stockings; wide-brimmed hat. Photo by Charrier (Vichy, France). Circa 1925.

4. Going-away clothes. Unknown photographer. Inscription: *Us off for the Honeymoon. 1925.*

5. Jean Patou beaded evening dress with transparent black décolleté; sable-trimmed wrap draped on the chair. Photo by Bonney. Stamp: *Mar 10 1925.*

6. Lace evening dress with inset godet panels of silk, embroidered with sequins or rhinestones. Unknown photographer. Stamp: *Mar 24 1925.*

7. Worn shopping, coat with striped border on the sleeves and at the hem. Photo postcard. Unknown photographer (United States). Inscription: *Calais, Me. 1925.*

8. Casually dressed couple, probably students. He is wearing a boxy "Norfolk" jacket and a hat with a flat crown. She is wearing a plaid skirt, cardigan that is belted low; fur piece; medium-brimmed hat. Unknown photographer. Circa 1925.

150: 1926

1. A dashing bride, her bouquet almost entirely obscuring her organdy dress with petaled hem; tulle veil with circlet of wax orange blossoms. Photo postcard. Unknown photographer (probably Europe). Circa 1926.

2. Plush wrap coat with fur collar and cuffs; cloche. Unknown photographer. Inscription: *Belle Isle 1926.*

3. Robe de style dress, a Hickson copy of a Goupy original, white taffeta with silver net; modeled by Boston area pretty young thing and future novelist Nancy Hale. Photo by Acme Newspictures (New York).

4. Textured knit pullover and plain knit box-pleated skirt, wide suede belt; pearl necklace; soft clutch purse; ankle strap shoes; worn by Mrs. Mona Wainwright at White Sulphur Springs, WV, United States. Photo by P & A Photos. Stamp: *10-05-26.*

5. Lucien Lelong dress of red satin made using both the matte and shiny sides of the fabric; worn by Mrs. Chandler Hall, a fashion critic, while examining the new fabric designs of lacquer artist Jean Dunand in his studio. She also wears a lacquered straw cloche and a wristwatch. Photo by Acme Newspictures (New York). Stamp: *Jul 26 1926.*

6. Sonia Delauney silk two-piece dress worn by Soviet expert Ruth Epperson Kennell. Born in 1893 in the United States, she and her husband joined the American colony Kuzbas in Siberia; she worked at the International library in Moscow and as secretary to Theodore Dreiser during his time in Russia. Rumor had it that she was his lover. Back in the States she wrote articles, short stories, and books extolling Soviet Russia. Photo by Maude Jay Wilson (Palo Alto, CA, United States). Circa 1926.

7. Helen Wills photographed at an art class in California, wearing sports costume of pleated skirt, blouse, and striped cardigan, probably by Jean Patou, who made most of her clothes, both on the courts and off. Photo by Photo by Acme Newspictures (New York). Stamp: *Sep 8 1926.*

151: 1927

1. Dressed for touring Stonehenge: coats and summer dresses; white stockings and shoes; cloche hats. Unknown photographer. Date based from album dated 1927.

2. Breton striped top and pleated skirt worn by Mrs. Freda Dudley Ward, society beauty and one-time lover of the Prince of Wales, shown with two daughters. Photo by Henry Miller News Picture Service. Circa 1927.

3. Spring dress and cape ensemble in flowered mousseline dress in shades of blue with the ostrich-feather trimming that was popular at the time; metallic shoes. Photo by Underwood & Underwood (New York). Stamp: *Nov. 1926.*

4. Sporty ensembles worn at Auteuil: (left) possibly a two-piece frock with striped knit top and matching cardigan with fur collar; (right) a pullover and coordinated pleated skirt with newly fashionable shoulder scarf. Photo by Underwood & Underwood (New York). Stamp: *Recibida 17 Ago 1927.*

5. Day/afternoon dress of floral printed silk with contrasting solid silk, finely pleated; straw hat; photographed at the races in the Bois de Boulogne. Photo by Meurisse. Stamp: *"The Times" London Copyright. Aug 23 1927.*

6. Leather coats worn with cloche hats and sports frocks by participants in a fashion show in Greenwich, Connecticut. Caption: *Members of Society stage fashion show and revue. Miss Dorothy Fuller (left) and Miss Virginia Cutter (right), both of Greenwich, Conn., who took part in the "Greenwich Fashions and Follies" staged by members of society at Greenwich, Conn. (Social Register).* Photo by Acme Newspictures (New York). Stamp: *Dec. 31, 1927.*

7. Coat and dress ensemble by Jeanne Lanvin, Paris, of beige and brown wool, the coat partially lined to match the dress, the coat with sheared beaver collar and cuffs. Photo by Scaioni (Paris) for Lanvin. Stamp: *Nov 30 1927.*

152-153: 1928

1. Afternoon frock with narrowly pleated skirt, grid-tucked bodice, trimming of patterned bands; long pearl necklace with small pearl spacer beads, Art Deco crystal centered pin; envelope purse; pumps;

medium-brimmed straw hat with ribbon trim and rosettes. Unknown photographer. Circa 1928.

2. Worn riding a camel in fox-fur trimmed coat and skirt ensemble and cloche with relatively wide brim. Unknown photographer (Egypt). Circa 1928.

3. Wedding gown with uneven hem and bolero-effect bodice in floral silk or rayon lace; tulle veil with wax orange blossoms trim. Photo by Don Diego. Stamp: *May 25 28.*

4. Two beach ensembles; pirate head wraps; sandals or beach shoes. Photo by George Grantham Bain, Bain News Service. Stamp: *July 3, 1928.*

5. Sporty sweater, skirt; wool stockings; cloche; worn for shooting. Unknown photographer. Date from album dated 1928.

6. Jean Patou capitalized on the craze for cocktails in more ways than one: not only was there a cocktail bar in his couture house, where a client or her benefactor could seek fortification for the selection of a frock, but he also named a perfume "Cocktail." Photo by Luigi Diaz. Stamp: *Dec. 27 28.*

7. Dress with tiered skirt; T-strap shoes; cloche hat. Unknown photographer. Inscription: *Monette. 12-4-28.*

8. Mousseline afternoon dress and wide-brimmed straw hat; worn by the wife of the Japanese naval attaché, Mme. Tsuneyoshi Sakano. Photo by Harris & Ewing. Copyright by Harris & Ewing. Stamp: *Central Press Association. Jul 23-28. Reference Dept.*

9. Silk day dress with white collar and cuffs; leather handbag; sheer stockings and shoes; medium-brim cloche; worn at Ventnor, Isle of Wight. Unknown photographer. Inscription: *Emmeline at Ventnor, July 1928.*

10. Woman wearing leopard coat with sable collar and cuffs; cloche/helmet hat. Man wearing a double-breasted greatcoat and a bowler. Unknown photographer. 1928 (based on Wisconsin license plate expiration date).

11. Little black dress and unusual pearl sautoir with tassel; turban/cloche; photographed at the races, France. Unknown photographer. Inscription: *28.5.28.*

12. Jean Patou dress of wool in "*flower jaune*," with white collar and cuffs; worn by Miss Helen Wills, photographed at home in Paris. Photo by Luigi Diaz. Stamp: *Jun 21 28.*

13. Two tailored costumes for the races in France: (left) silk tunic and pleated skirt with contrasting band decoration; fox scarves; felt hat; (right) skirt and coat ensemble with striped knit pullover, narrow belt; alligator bag; felt hat. Unknown photographer.

154: BEACH AND OTHER PAJAMAS

1. Beach pajamas by New York ready-to-wear house William Bloom in linen, sleeveless jacket in orange, blouse in melon, wide pleated trousers in lime yellow; sandals by Delman. Photo by Charmante Studio, Inc. (New York). Stamp: *Apr 30 1931.*

2. Paris-designed resort ensemble of navy flannel pajamas tied with two scarves; photographed at the French Fashion Fête on the Lido, Venice. Photo by Associated Press. Stamp: *9/14/28.*

3. Lucien Lelong "Fonceur" evening pajamas, the tunic blouse in gold and rose lamé with bands of black crepe de chine, pants in black crepe de chine; worn by a model with hair that is unusually short for the

time. Photo by Scaioni (Paris). Stamp: *Mar 5 1927.*

155: 1929

1. From Henri Bendel, one of New York's top specialty shops specializing in custom and imported designs, a coat of caracul lavishly trimmed with silver fox; velvet turban imported from Caroline Reboux of Paris. Unknown photographer. Stamp: *Oct. 15 29.*

2. Dress with pleated side panel; silver fox scarf; silk stockings and patent leather pumps. Unknown photographer. Circa 1929.

3. Sonia Delauney beach robe. Photo by Underwood & Underwood (New York). Circa 1929.

4. Evening gown with handkerchief hem by Drecoll-Beer, a Paris couture house formed in 1929 by the merger of Drecoll and Beer, in white silk mousseline embroidered with dull and brilliant white beads. Photo by Acme Newspictures. Stamp: *May 31, 29.*

5. Lucien Lelong evening gown of white silk chiffon embroidered with rhinestones, irregular hemline of floating panels; modeled by actress Claire Luce (1903–1989). Photo by Wilfred Sketch (Paris) for Lucien Lelong. Inscription: *12-29.*

6. Dotted silk ensemble worn to the races at Longchamp, Paris. Unknown photographer. Stamp: *9/15/1929.*

7. Paris couturier Lucile Paray evening dress in white satin; necklace and pin in coral and jade. Photo by Underwood & Underwood (New York). Circa 1929.

8. Lucien Lelong "Ramona" afternoon coat in black marocain, worn with profile hat. Photo by Scaioni (Paris) for Lucien Lelong.

1930s

156: Back and front view of a white crepe evening gown with low back décolleté, back sailor collar, floating arm panels. Photo by unknown (United States). Circa 1931.

158–159: 1930

1. Beach pajamas worn by Mrs. Kitty Conway and Miss Muriel Lodge while strolling in Palm Beach. Photo by Acme Newspictures. Stamp: *April 19 1930.*

2. Flowered silk chiffon day dress; string of pearls; horsehair hat. Unknown photographer. Circa 1930.

3. Jean Patou golf blouson and hat, pull-over jacket with knit collar, cuffs, and hem, featuring an early example of the zipper pull. Photo by Luigi Diaz (Paris). Stamp: *Feb. 4 1930.*

4. Jean Patou evening gown in white silk georgette with uneven hem and double loop at low back décolleté. Photo by Luigi Diaz (Paris). Stamp: *Jan 23 1930.*

5. Above-the-ankle-length coat with fur collar and trim at the sleeves; cloche with clip; worn at Longchamps. Photo by Agence Rol. Inscription: *La Mode aux Courses Paris Fashion Longchamp.*

6. Sheared rabbit coat with shawl collar, self-covered buttons, by Stern brothers, a New York department store; brown felt cloche; pumps. Unknown photographer. Inscription: *October 13, 1930.*

7. Men in suits holding bouquets of daisies. Unknown photographer (United States). Circa 1930s.

8. The Whigham family dressed for the royal enclosure at Ascot. Ethel Margaret Whigham (1912–1993) was a society beauty, debutante of the year in 1930, and, once married, the Mrs. Sweeny cited in the British adaptation of Cole Porter's *You're the Top.* Her hat "all made of tulle, it was so beautiful" according to the inscription on the back of the photo, is by British couturier Norman Hartnell, who would design her wedding gown. Photo by Keystone Press Agency. Inscription: *Circa 1930.*

9. Cloche hats and fur-trimmed coats worn by flappers riding in a rumble seat. Unknown photographer. Inscribed: *Spring 1930.*

10. Jean Patou pajamas in Patou's own "Jypécrepe" in light green, bias ruffle neckline; silk high-heeled mules. Photo by Luigi Diaz (Paris). Stamp: *Aug 25 1930.*

11. Spring suit from the French couture house of Redfern, of blue and white tweed in a diagonal stripe. Caption: *simply cut and youthful-looking in the extreme. The hat is of matching blue felt and the bag of the same material as the ensemble.* French press photo. Stamp: *Feb. 27 1930.*

12. Model in a tailored suit being photographed next to the statue of Prometheus at Rockefeller Center, New York. Unknown photographer. Circa early 1930s.

160: 1931

1. Coat with cape collar lined in contrasting material; gauntlet gloves in kid decorated with punchwork; hat with veil. Unknown photographer. Circa 1931.

2. From Bonwit Teller, an elegant New York department store, red and white knitted dress with matching beret, from their new shop of made-to-order knitted frocks and coats in any color combination. Photo by Pagano, for Bonwit Teller, New York. Stamp: *Dec 2 1931.*

3. Black velvet evening gown with tunic lines and long panels attached at the shoulders; white kid gloves; clutch of Art Deco bracelets; worn by Peggy Hamilton, official hostess of the county of Los Angeles during the festivities of the Los Angeles Sesquicentennial and the Olympic Games, February 1931. Unknown photographer.

4. Day dress with flame-shaped appliqués. Unknown photographer (France). Circa 1931.

5. Accessories from Jay-Thorpe, a posh New York specialty shop, worn with a tweed knit ensemble: white polka dotted scarf; blue umbrella with handle of leather and ebony; blue leather bag with silver metal trim; pigskin gloves; blue knitted "roll-your-own" cap. Photo by Stadler (New York). Stamp: *Mar 19 1931.*

6. At the races in France, coat with fur collar, worn with asymmetrical hat and quilted envelope purse, ankle bracelet, Art deco shoe ornament. Photo by Agence ROL (France).

7. Brown corduroy suit with a yellow angora blouse for wear in the country, designed by Elizabeth Hawes, Vassar-educated New York custom designer and author of *Fashion Is Spinach* and other books. Photograph by Acme Newspictures. Original caption date: *10/26/31.*

8. Hostess gown in pale pink from Jay-Thorpe. Unknown photographer. Benjamin Sonnenberg, Press Representative (New York). Stamp: *Aug 29 1931.*

161: SPORTS CLOTHES

1. Chic lesbian actress Lilyan Tashman (1896–1934) wearing a backless bathing suit with linen pinafore cover-up; espadrilles knit hat. Photo by International News Photo. Inscription: *Tashman – Lilyan Artista 8-7-33.*

2. Resort pants ensemble; choker; two-tone shoes; beret. Unknown photographer. Inscription: *Deauville Casino Aout 19 '33.*

3. Beach styles: floral print bathing suit with halter neck, apron front and bloomer legs; foliate-printed beach coat with shorts underneath; modeled by Isa Vollner and Katharine Aldridge. Unknown photographer. Stamp: *11-9-38.*

4. Hawaiian-style shirt, possibly a man's, worn knotted at the waist, pleated shorts in linen; ankle socks and lace-up rubber-soled shoes. Unknown photographer. Circa 1935

5. White pants worn with one-shoulder halter revealing a tanned shoulder and a sliver of bare midriff; white turban. Unknown photographer. Circa 1935.

6. Athletic playsuit, possibly wool jersey. Unknown photographer. Circa 1940.

7. Red ski suit by Burberry worn in St. Moritz by Ethel Margaret Whigham, future Mrs. Charles Sweeny and the Duchess of Argyll. The suit was donated to the Victoria & Albert Museum. Photo by Sport General Press Agency, Ltd. Inscription: *One of our many Xmases in St. Moritz it was most beautiful there, as the snow stays hard, it is never slushy as here, it always freezes after Sundown.* Circa 1931.

8. Sleeveless white dresses worn for a dog-training session. Unknown photographer (Europe). Circa 1933.

162: STRICTLY TAILORED

1. American fashion designer Sally Milgrim wearing her own design of an evening ensemble based on a "mess" jacket. Photo by Wide World Photos. Stamp: *2/8/35.* 1935.

2. Suit with belted jacket; walking shoes; tilted beret. Unknown photographer. Inscription: *Champs Élysées. 22 Mai 31. 1931.*

3. Suit with short-sleeved jacket, pleated sleeves, peplum and hem, ruffled jabot in white lace; photographed at Longchamps. Photo by France Presse. Original caption date: *13/5/34.*

4. In 1937 Lady Mendl, née Elsie de Wolfe (c. 1859?–1950), and Madame Mirablau participated in a Paris dog show in which the elegance and ensembles of the dog owners were judged along with the dogs. Mme. Mirablau wears an all-white suit and brown accessories to match her brown poodles. Lady Mendl wears a suit (most likely by Mainbocher) of ribbed wool with scroll appliqués with a lingerie blouse and is showing off a dwarf smoke-blue schnauzer and a rare Tibetan poodle called "Train Bleu." Photo by Acme Newspictures (Paris). Original caption date: *July 3, 1937.*

5. Suit by Paris couture house Zhendre in cinnamon rough jersey with triple row of buttons, patch pockets; green felt sports hat with brown grosgrain ribbon by Eneley Soeurs. Photo by Associated Press. 1937.

6. Odette Myrtil, French musical comedy star, wearing a "smoking" skirt suit with satin lapels and besom pockets in lieu of bow tie; diamond and cabochon double clip brooch; carnation boutonniere. Stamp: *NBC Photo.* Original caption date: *1935.*

7. Traveling ensemble by American-in-Paris couturier Main Rousseau Bocher, better known as Mainbocher: coat of black tweed over a dress of red flat crepe with tiny white polka dots ("you've heard how smart dots are this season"); stitched wool crepe soft hat. Photo by Joel Feder. Stamp: *Apr 12 1932.*

8. Best-selling Gabrielle Chanel suit in black moiré with vest blouse of white silk piqué; Chanel hat of black silk straw faced with the same white silk piqué. French press photo. Photo by Charles Portraitiste, Acme Newspictures (Paris). Stamp: *4-5-37.*

163: 1932

1. Silk dress; two-tone sandals; close-fitting hat. Unknown photographer (France). Inscription: *Mai 32.*

2. Chanel summer evening dress in striped cotton organdy, worn with mesh gloves and a straw hat. Photo by Joel Feder. Courtesy Cotton-Textile Institute, (New York). Stamp: *Sep 3 1932.*

3. Model about to open the door of a Frigidaire refrigerator wearing a crepe dress with long undersleeves, scarf trim; pumps with bows; knit cap with rhinestone clip. Unknown photographer.

4. Summer dress with short sleeves; wide-brimmed hat; worn at the coast, at the border of France and Spain. Unknown photographer. Inscription: *Herndaye Plage. One vers le sud. Au fond la cote espagnole.*

5. Jeanne Lanvin "La Coupole" dinner frock of black marocain with diamond cutouts sewn to tulle; wide-brimmed hat of black straw with a black peau d'ange ribbon. French press photo. Unknown photographer. Stamp: *May 21 1932.*

6. Dress with ruffled Letty Lynton–inspired sleeves, named after the Adrian-designed movie *Letty Lynton,* starring Joan Crawford. Unknown photographer (United States). Circa 1932.

7. From B. Altman & Co., a New York department store: sports ensemble in Briella, a suede-finished synthetic jersey made from the new dull finish Acele; accessories also by B. Altman & Co. Without the jacket, it made a practical sports frock. With the jacket, could be made into a smart street costume. In addition to the slight ribbed surface as shown, the fabric came in other piques, drop-stitch effects, and in a variety of fancy cords. Photo by Joel Feder. Stamp: *Jun 25 1932.*

8. Suit in white ribbed cotton by Paris couture house Maggy Rouff, hand-knit scarf in yellow wool; hat by Paris milliner Agnès of angora wool knitted straw trimmed with a hand-knitted band of tangerine wool. Unknown photographer, French press photo. Stamp: *Maggy Rouff. Jun 21 1932.*

164: 1933

1. Mr. and Mrs. Sweeny, née Ethel Margaret Whigman, in Paris. She wears a mink coat with generous shawl collar, handbag personalized with her new initials, opera pumps, hat with diamond clip. Mr. Sweeny wears a tweed topcoat, pinstripe suit, wingtips. Photo by Associated Press of Great Britain Ltd. Circa 1933.

2. Comedian Robert Woolsey (1888–1938) and actress and future consumer advocate Betty Furness (1916–1944) wearing double-breasted skirt suits in Hollywood. Photo by International News Photo.

3. Wrap coat in wool with caracul sleeves and trim of the self-scarf; hydrangea and fern corsage; tilted cap; worn at Longchamps. Photo by Acme Newspictures (Paris). Caption: *Latest summer fashions*

seen at the opening of the Longchamps Race Track April 2nd, 1933.

4. Wool coat with sheared fur at the collar and cuffs; felt hat with quill from Lord & Taylor. Unknown photographer. Courtesy Lord & Taylor, New York, N.Y. Stamp: *9-24-33*.

5. Mr. and Mrs. Sweeny at their wedding: the former Ethel Margaret Whigham wears a Norman Hartnell wedding gown made in medieval style, of white satin embroidered with star-shaped flowers outlined in pearls, sleeves to the floor; matching veil held in place by a circlet of wire strung with pearls and wax orange blossoms. The dress took thirty-three seamstresses six weeks to make and cost £52, a sum the bride found exorbitant. The dress and veil are now in the collection of the Victoria & Albert Museum. Photo by Portnam Press Bureau.

6. Dress and jacket ensemble with bias-cut scalloped tiers; fox collar; straw hat; worn at opening day at Longchamps. Photo by Acme Newspictures (Paris). Stamp: *April 2nd 1933*.

7. From B. Altman: knit dress with diagonal stripe and knit bouclé suit with cardigan jacket; hats worn fashionably tilted. Photo by Frederick Bradley. Pencil inscription: *B. Altman, New York. Proofs go to Florence King, 16 Park Ave., NYC.* Stamp: *May 27 1933*.

165: 1934

1. Seen at Longchamps: checked suit with checked blouse; silk carnations; handbag and binoculars; pumps; panama straw hat. France Presse Société. Original caption date: *28/5/34*.

2. Dress in "Shangola" rayon crepe from DuPont with yoke of silver-threaded silk net, dots in silver; fingernails painted with moons and tips left blank; jersey hat worn at a tilt and trimmed with a flower. Photo by Forbath & Rejane (New York). Stamp: *Jan 11 1934*.

3. Dark dress and coat ensemble worn with a beret-style hat; printed silk dress with long jacket. Unknown photographer. Caption: *Montmartre, summer 1934*.

4. Striped dress. Unknown photographer. Stamp: *14 Jun 1934*.

5. 1934 Spring suits seen at the races: (from left) dark suit worn with white stock-tied blouse, silk carnation corsage; unusual short-sleeved tailored dress with fox trim; suit with nautical striped revers, blouse or placket; gauntlets. Photo by Henri Manuel (Paris). Stamp: *April 9, 1933*.

6. Silk dress with self-tie neckline, velvet jacket with trapunto shoulders; velvet hat trimmed with stripped feathers. Photo by Henri Manuel (Paris). Inscription: *La Mode aux Courses. October 14, 1934*.

7. Lucien Lelong dinner suit: black uncrushable velvet, jacket bloused in back, blouse of black-and-white-striped cravat silk. Photo by Wide World Photo.

8. Jeanne Lanvin tailored suit; beret worn at a tilt. Unknown photographer. Inscription: *Pl. Vendome. 12 Mai '34. "Lanvin."*

166-167: 1935

1. Airline stewardess uniform: (left) skirt suit, shirt and necktie; (right) summer travel dress in plaid, low-heeled sandals, white hat. Photo by Ralph Morgan.

2. Paris couturier Jacques Heim "Pirate" evening dress: wrapped halter bodice of green velvet, skirt of linen printed with green and white "*les fruits d'Europe*" Raoul Dufy design. Photo by The Velvet Guild, Inc.

3. Paris couture house Martial et Armand Spring evening dress of silk faille woven with dots. Photo by France-Presse. Stamp: *31/10/1934*.

4. Dressy spring ensembles worn to the races, hats all worn at the same angle: (from left) black dress with silk flower sleeves and belt trim; long dress in organdy; geometric eyelet dress and jacket ensemble trimmed with fur; white suit and hat trimmed with white monkey fur. Caption: *Le Grand Steeplechase d'Auteuil in the presence this afternoon of M. Albert Lebrun. June 24, 1935.* Photo by Henri Manuel (Paris).

5. Polka-dot pajamas and robe ensemble. Unknown photographer (United States). Inscription: *21 March 1935*.

6. Couturier Mainbocher with a vendeuse and two models wearing dinner styles of metallic brocade jacket over long black dress and dress in specialty crepe with draped wrap. Unknown photographer. Stamp: *Nov 24 1935*.

7. Evening dress with shirred velvet yoke and matching muff. Unknown photographer. Inscription: *Merry Christmas to Mama and Pappa Frits from Winifred 1935*.

8. Alpine hiking ensemble: plus fours with sailor-pants-style buttoning at the sides of the hips, plaid revers and matching scarf; tilted beret. Unknown photographer. Inscription: *Briancon. 1935*.

168: 1936

1. Paris couturier Jean Patou afternoon dress in black wool with shirring at the bodice, modified gigot sleeves, linen collar. Photo by Luigi Diaz (Paris). Stamp: *2-20-36*.

2. Sports suit from Bonwit Teller in green, brown, and cream nubby herringbone tweed with brown linen blouse; green felt sailor beret (jacket: $29.75; hat $5). Photo by Charmante Studio (New York). Stamp: *10-16-36*.

3. Ensembles shown at the International Week Fall Fashions show, which was presented daily by the shops at Rockefeller Center: (left) three-quarter-length jacket of hunter's green tweed fitted at the waist, broad shouldered and double-breasted, with skirt of pumpkin tweed, buttoning onto a green velveteen blouse, by Valle Modes, Inc., green felt modified beret trimmed with lacquered quills of a dark copper from the Barry Hat Shop (blouse: $24.50; beret: $6.75); (right) soft nubby tweed suit in bright autumn green with trimming of natural lynx to the hem of the seven-eighths-length coat, matching dress with square gold buttons and gold link belt, from Dana de Paris, hat of crushed green soleil with quills, also from Dana de Paris (dress: $149.50; hat $12.50). Rockefeller Center International Week press release. Photo by Paul D'Ome Photography (New York). Stamp: *9-25-36*.

4. Afternoon ensemble by British-born Paris couturier Molyneux: brown silk with white floral appliqué; brown straw saucer hat with flat crown and bandeau in matching fabric; worn by Madame Jean-Charles Napp. Photo by Acme Newspictures (Paris).

5. Diamond grid dress with leather belt; sheared fur coat; spectacles; beret. Unknown photographer (probably France). Inscription: *Fevrier 1936*.

6. Dark skirt, sweater; oxford shoes; beret; worn for golfing in Sutton-on-Sea, UK. Unknown photographer. 1936 (date and location based on photo album).

7. Jean Patou evening dress in white silk, two pleated panels at the bodice held in by sets of rhinestone bows, which also orna-ment the waist; diamond bracelet by Van Cleef & Arpels. The panels are stitched below the hipline in front of the skirt, where they are released. The back is plain and ends in a short train. Unknown photographer. Stamp: *10-9-36*.

169: LITTLE PRINTS

1. Floral-print silk dresses with puffed sleeves, self-ruffled hems; gauntlet gloves; spectator and black pumps; hats at a tilt. Photo postcard. Unknown photographer. Circa 1933.

2. Formal afternoon ensemble by Paris couturier Louiseboulanger in red, green, and ivory sheer silk. Photo by Scaioni. Oval stamp with details filled in: *Louiseboulanger Ete 1930 robe de diner mousseline imprime rouge – verte – ivoire. La nom Louiseboulanger devra obligatoirement accompagner toutes les reproductions to cette photo.* Stamp: *Jun 12 1930*.

3. Fashion at the races: floral-print silk dress with finely pleated self-ruffle; "pools of light" choker; cotton gloves; felt hat with asymmetric brim. Photo by Underwood & Underwood (New York). Circa 1934.

4. Printed silk spring ensembles. Photo by Henri Manuel (Paris). Stamp: *Mai 20 1934. La Mode a Longchamps*. 1934.

5. Ensemble by Paris couturier Marcel Rochas: coat in off-purple wool lined with the same brown-and-white leopard-printed crepe as the dress underneath; grosgrain toque by Maria Guy. Photo by Georges Saad. Stamp: *4-21-37*. 1937.

6. Summer dresses, on the left with sailor yoke in white, worn with white pumps. Unknown photographer. Inscription: *1937*.

7. Floral-printed dress with puffed sleeves. Unknown photographer. Inscription: *July 1937*.

170-171: 1937

1. Coat by Paris couturier Francevramant, newly full, in dark green plush wool; brown felt hat by Paris milliner Suzy. Photograph by Dorvyne (Paris), Associated Press. Stamp: *10-10-37*.

2. Black corded silk coat lavishly trimmed with silver fox; purse composed of several change purses slung together on a chain; hat of moiré ribbon by Maggy Rouff. Photo by Associated Press.

3. Woman wearing printed swim dress and sandals at Lincolnshire, Sutton-on-Sea, UK. Man wearing polo shirt and trousers. Unknown photographer. Circa 1937 (date and location based on photo album).

4. Paris couture house Bruyère street dress in dark green jersey with horizontal inverted pleats, skirt slightly flared on side with flat front and back, bodice fastened in back with tiny self-covered buttons, blouse trimmed at neck and cuffs with row of narrow white cable braid; hat of black Bengal straw with white piqué bow. Unknown photographer. Stamp: *Bruyère 8 Mar 1937*.

5. Jean Patou afternoon dress in black marocain, a ribbed crepe, with fan pleating at the bodice, cuffs and skirt and bow tie of white piqué; jaunty sailor cap in fine black straw with piqué ornaments and flowing veil in black net. French press photo. Unknown photographer. Stamp: *6-16-37*.

6. Paris couture house Germaine Lecomte evening dress in white floral lace on a sheer net ground, shoulder straps and belt of silver kid studded with faux emeralds, belt fastened with large faux emerald cab-ochon. Photo by Associated Press. Stamp: *SEP 1937*.

7. Balenciaga evening dress with hobble skirt in black lace with ciré sash. Photo by barnaba Photographs Corp. (New York). From caption: *The New Spanish house, Balenciaga, which opened with the fall collections, in Paris, created this formal evening gown for the Arden Shore Lace Ball in Chicago.* Stamp: *11-8-37*.

8. Organdy bolero with tiered sleeves over black evening gown; worn by Miss Elsie Quinby, Washington socialite. Photo by Harris & Harris.

9. Maillot with elaborate back; worn by Mrs. Poppleton in Lincolnshire, UK. Unknown photographer.

10. Marcel Rochas formal afternoon tailleur, the jacket in red edged with white grosgrain braid, skirt of black wool and blouse of pleated white mousseline; gloves of black antelope; mortarboard hat by Paris milliner Maria Guy. Photo by Georges Saad. Stamp: *3-8-37*.

11. Casual spectator suit by New York ready-to-wear designer Helen Cookman in nubby wool with self-trim. Photo by Lockhart International, Inc. Stamp: *9-10-37*.

12. Evening gown in the new silhouette of fitted bodice and flared or full skirt made with pleated bands of alternating sheer and opaque silk, the bodice inset with bands of sheer silk; large silk flower corsage. Photograph by Acme Newspictures (Paris). Stamp: *8-30-37*.

13. Kay Morrison bias-cut silk evening dress with self-knot at the back shoulder and waist. Unknown photographer. Stamp: *1-31-37*.

14. Black dress with white fox scarf; black hat. Photo by The Coleman Studio (Oakland, CA, United States). Stamp: *Sept 21 1937*.

172-173: 1938

1. Evening gown by Paris couturière Alix—known after World War II as Madame Grès—in white silk matte jersey; pâte de verre necklace and bracelet by Gripoix; worn by actress Mary Boland (1882–1965) in a publicity still for the movie *Artists and Models Abroad*. Unknown photographer.

2. Coat in red-and-green plaid from Lord & Taylor, a combination of straight lines with fullness in the front and back panels from the use of the plaid cut on the bias. The squared shoulders of the sleeves form part of the yoke. The collar is a quilted roll that descends into soft, unpressed revers. Stamp: *10-16-38*.

3. Suit from R. H. Macy & Co. in imported tweed woven in a plaid of wine red, brown, yellow, navy, and red (jacket: $16.98; skirt: $12.98). Photo by "barnaba".

4. Balenciaga evening gown in striped satin with fitted bodice, flared long skirt with slight train; worn by his favorite model, Colette. Photo by Dorvyne Studio.

5. Jean Patou ensemble of army green jersey with jacket of brown striped wool jersey, narrow belt in brown leather; halo felt hat in green to match the dress; seen at the races. Photo by Acme Newspictures (Paris). Original caption date: *6/10/38*.

6. Navy blue nubby wool coatdress with self-belt and white waffle piqué collar. Photo by J. Walker Grimm.

7. An early example of a strapless dress, this one in emerald-green velvet by Jean Patou worn with jewels of diamonds and emeralds by Mauboussin. French press photo. Unknown photographer. Stamp: *11-9-38*.

8. American ready-to-wear designer Claire McCardell evening pajamas in white with McCardell-designed belt and cuffs of pigskin with studs. Unknown photographer. Stamp: *1-1'39* (1938 date based on another image of this style).

9. Silk crepe dress with surplice bodice, short sleeves, fagoting details at the yoke; profile hat. Unknown photographer (United States). Stamp: *7-28-38*.

10. Evening gown by Paris couturière Alix, known after World War II as Madame Grès, in white matte jersey; worn in a New York charity fashion show by Miss Wetmore. Photo by Acme Newspictures (Paris). Original caption date: *3/25/38*.

174-175: 1939

1. Victorian-revival evening look from New York specialty shop Stein & Blaine: formal dinner suit in velvet with bustle detail and bolero, fitted bodice square décolletage and narrow straps underneath jacket. Unknown photographer. Courtesy Stein & Blaine. Stamp: *11-5-39*.

2. Trousers, belted jacket worn open, dark shirt and wide necktie; photographed in Dalat, Vietnam. Unknown photographer. 1939 (based on date and location inscribed on another photograph in its group).

3. Playsuit with bolero jacket worn with ankle socks and saddle shoes. Unknown photographer. Pencil inscription: *1939 – the year John and I met*.

4. Stein & Blaine evening gown and bolero in a stylized chrysanthemum print. Unknown photographer. Courtesy Stein & Blaine. Stamp: *7-9-39*.

5. Claire McCardell brown chiffon dinner gown with a long blue scarf to be worn on the head or draped from the neck at the back to float to ankles, shirred bodice, button-down front; worn by ballerina Vera Zorina (1917–2003). Unknown photographer, Fashion League Service. Original caption date: *FEB 4, 1939*.

6. At-home or dinner look by American ready-to-wear firm Kalmour of cummerbund-waist crepe "harem" pants with metallic short-sleeved blouse; bib necklace and dangling bead bracelet; sandals; metallic turban. Photo by Kallman & Morris, Inc. (New York). Inscription: *Oct. 21-39*.

7. American custom designer Muriel King evening gown in pink velveteen with cascading bustle back and train trimmed with black lace. Photo by Fashion League Service. Stamp: *August 22 1939*.

8. Mainbocher jacket with metal buttons and collar of coiled silk braid. The American-born Paris-based couturier moved his business to New York in 1940. French press photo. Unknown photographer. Stamp: *Mainbocher. Made in France. 2-14-39*.

9. Alpine sweater with elbow-length puffed sleeves. Photo postcard. Unknown photographer. Inscription: *San Martino di Castcozza. Febr. 1939*.

10. Claire McCardell suits: (right) gray gabardine with one of her characteristic free-swinging skirts with slit pockets, fitted jacket with gold buttons, turban; (left) suit in black wool with loose smock jacket, full circular skirt and tight blouse of white pique with black pin dots, hat with mesh veiling. Photo by Acme. Stamp: *2-10-39*.

11. Black satin cocktail dress with bustle panel; black antelope suede bag and gloves; draped turban. Photo by Frederick Bradley. Stamp: *9/17/39*.

12. Lucien Lelong evening gown with camisole bodice, lantern-pleated full skirt.

Photo by Agneta Fischer (Paris). Stamp: *2-14-39. Made in France.*

13. Evening "at-home" outfit by American ready-to-wear designer Florence Gainor, known for her sporty styles: black bengaline pants cut like a man's evening trousers with braid down the side, blouse in white acetate and silk, cummerbund in red. Photo by Charmante Studios Inc. (New York). Stamp: *11-19-39.*

14. Mother and daughter in Dalat, Vietnam, wearing summer dresses and sandals or shoes. Unknown photographer. Inscription: *Dans la chamber de l'hotel a Dalat. 28 Avril 1939.*

1940s

177: Windowpane-check suit worn with top coat and military-style cap; model posed near Washington Square Arch, New York. Photo by Zoltan S. Farkas. Circa 1940–44.

178-179: 1940

1. Spring suits, coats, jackets, and hats worn outside a church. Even with such a variety of styles and fabrics the hemlines are remarkably even in distance from the ground. Unknown photographer (UK). Inscription: *22/5/40.*

2. Shirtwaist dress in white piqué with openwork, grosgrain sash; designed by Harold Eisenberg, who started his ready-to-wear business in 1918 after serving in World War I. Photo by Ray Albert. Stamp: *6-2-40.*

3. Evening ensemble of yellow silk chiffon evening gown and emerald-green wool jacket with metallic floral embroidery; designed by New York ready-to-wear designer Rose Amado of Pattullo Modes, also known for having hired Jo Copeland as a designer. Photograph by J. Walter Thompson. Stamp: *2-6'40.*

4. Jacket of peacock-blue suede topping a dress of citron-yellow kasha jersey by David M. Goodstein Wholesale. Photo by Wide World Studio Photo (New York). Original caption date: *8/16/1940.*

5. Golf dress. Photo by Zoltan S. Farkas. Circa 1940.

6. Daringly bare midriff evening look designed by Arthur Falkenstein, New York custom designer, in white crepe, bodice with short sleeves and draped to fasten under the left arm, clips at the lower hem of the bodice; modeled by Rose Hobart. Photo by International News Photos. Original caption date: *5-12-40.*

7. Little black dress in crepe by New York–based designer Peg Newton; fox boa; clutch purse with monogrammed clasp; black suede pumps; wide-brimmed hat. Photo by Publicity Associates. Stamp: *6-7 '40.*

180-181: 1941

1. Dance dress of pale gray silk chiffon with wide girdle of yellow jersey and narrow band of powder-blue crepe down the front of skirt, yellow jersey cape; from Jenkins, a posh custom design house in New York. Photo by Wide World Photo. Original caption date: *4/4/41.*

2. Tailored clothes by American ready-to-wear designer B. H. Wragge, shown with furs: B. H. Wragge two-piece suit in hunting-green wool worn with Alaskan sealskin full-length coat, belted, by George J. Baruch; B. H. Wragge sports dress with dispatcher pocket on alligator belt worn with Alaskan sealskin coat by H. Scher

Corp. Photo by Acme Newspictures. Stamp: *6-12-41.*

3. Spotted at the Tuxedo Park Horse Show, Miss Lillian Talmage Mitchell wearing a summer dress with square shoulders, neckline, short sleeves, torso of wide stripes with embroidered motifs and slightly flared skirt. Photo by Bert Morgan, Morgan Photo Service. Stamp: *6-15-41.*

4. Spring dress in pink, "heaven" blue, "tendril" green, and "mist" gray with white collar and buttons, self-belt. Photo by *Detroit Times.* Stamp: *Feb 21 1941.*

5. Hunting jacket and jodhpurs; turban. Photo by Harold M. Lambert. Stamp: *11/41.*

6. Classic trench coat. Unknown photographer. (United States). Circa 1941.

7. Suit with tucked details at the broad shoulders; envelope clutch purse; suede gloves and shoes; coal-scuttle-brim hat; model photographed admiring a 1942 Nash car. Nash Motora Press Bureau press release. Photo by Pictorial Studio.

8. Dotted dress with fitted midriff; two-tone pumps. Unknown photographer (United States). Inscription: *Eva 1941.*

9. Elinor Jenkins dinner dress, bodice and matching pillbox hat in white velvet embroidered in gold and sequins, accordion-pleated skirt in stripes of royal blue, lipstick red, and brilliant green; worn by CBS actress Elizabeth Russell. Unknown photographer. Newspaper date: *Jan 14, 1941.*

10. From Bonwit Teller, a white tunic dinner dress with gold belt; bag; shoes; worn at a charity fashion show benefiting the American Red Cross at the Brazilian Embassy. Photo by Acme Newspictures. Original caption date: *3/27/41.*

11. White suit, hyacinth blouse; heart-shaped costume brooch; mesh gloves. Unknown photographer. Circa 1941.

12. Evening coat by New York custom and ready-to-wear designer Sally Milgrim, midnight-blue bengaline with metallic embroidery at the shoulders and slightly gigot sleeves; suede gloves with turned-back metallic leather cuffs. Photo by Acme Newspictures. Stamp: *9-03-41.*

13. From Hattie Carnegie, fine specialty store in New York known for both custom designs and imports, a dress in red-and-black printed wool jersey with red snakeskin belt; cape of Persian lamb lined with red wool; black chenille snood. Photo by Acme Newspictures. Original caption date: *9/9/41.*

14. Woman wearing navy-and-white print ensemble of short-sleeved dress and little shirred jacket; white gloves and bag; navy blue shoes; tiny white straw sailor trimmed with a large rose. Man wearing U.S. Army uniform. Photo by Acme Newspictures. Original caption date: *5/23/1941.*

15. Tailored suits with feminine details: hats with veiling, silk chrysanthemum corsage or ruffled jabot. Unknown photographer. Stamp: *3-2'41.*

16. Coat with self-covered button tab, fur collar; suede heels; calf envelope purse; tilted pillbox hat. Unknown photographer. Inscription: *Perpignan 26 Janvier 1941.*

182: 1942

1. To help with the war effort, Bonwit Teller introduced the "Walk and Carry" Victory Shoulder Sack, made of heavy paper and guaranteed to hold twenty-five pounds. The bag encouraged women to save gasoline by walking to do errands. The model is wearing a tweed suit with

gloves and shaped beret. Photo by Bonwit Teller. Original caption date: *November 28, 1942.*

2. Broad-shouldered coats in European street scene, possibly Germany. Photo postcard. Unknown photographer. Inscription: *18 Okt. 1942.*

3. Changing into a beach cover-up of culottes or skirt, Atlantic City. Unknown photographer. Inscription: *1942.* Stamp: *Aug. 1 1942.*

4. Ready-to-wear designer Adele Simpson café dining suit in wool (good for heat-rationed interiors) trimmed with sequins for glamour; hat by Mexican milliner Maria Luisa Le Blanc. Unknown photographer. Stamp: *10/23/42.*

5. "Homefront" uniform modeled by Miss Betty Bond. Photo by Acme Newspictures.

6. Dinner dress by New York–based designer Zoe de Salle in velveteen with jumper skirt, matching jacket and lamé blouse. Photo by Wide World Photos.

7. Woman's suit made according to the regulations issued by the War Production Board: jacket measuring 25 inches and skirt not more than 64 inches around, made in gray-and-white checked wool with flap pockets and mother-of-pearl buttons; matching cap, "V for Victory" gloves; worn by Joan Edwards of CBS's *Your Hit Parade.* Photo by Examiner Photo.

8. Jacquard wool ski ensemble by Catalina with silver metal buttons; modeled by actress "Jinx" Falkenburg (1919–2003). Press release. Photo by Catalina Sweater. Release reads: *Ski week-ends are on hand so get your shopping done early. New and gay is this jacquard wool sweater with a bright all-over pattern and silver buttons. Jinx Falkenburg, who will soon start work in the Columbia film, "Professional Model", wears it.* Stamp: *FEB 10 1942.*

183: 1943

1. Evening dress and capelet by American high-end ready-to-wear designer Jo Copeland in black rayon crepe, skirt shirred at the center and slit to just below the knee, low-cut bodice with rhinestone clip and held up by flesh-colored net, capelet with matching clip. Photo by Wide World Fashion Photos.

2. Claire McCardell separates outfits in black or brown matte jersey. The pieces could be combined to make two different day outfits and two different evening looks. Photo by AP Wirephoto. Original caption date: *July 22, 1943.*

3. Dressed for archery in A-line skirt and long fitted sweater. Unknown photographer (United States). Inscription: *Oct. 27, 1943.*

4. Striped swimsuit. Unknown photographer (United States). Inscription: *8-19-43.*

5. Suit and towering hat. Caption: *This slim suit with its broad shoulders and huge revers stems from a costume worn by Orson Welles in the 20th Century Fox Motion Picture Jane Eyre. Nettie Rosenstein, distinguished fashion designer, with a few deft touches creates a charmingly feminine 100% wool suit from a male costume. The blouse with its single ruffle takes "Rochester's" shirt right off his back.* Photo by International News Photo, a unit of King Features Synd., Inc.

6. Single-breasted suit by high-end American ready-to-wear designer Nettie Rosenstein in wool, with high, broad shoulders and exaggerated revers on the brief, fitted jacket; parure of metal jewelry worn on the hat, as earrings, and as clips; suede gloves; opera pumps. Photo by Interna-

tional News Photo, a unit of King Features Synd., Inc.

7. Primping before going onstage at one of Jack Benny's camp shows, actress Anna Lee wears a dark evening dress with a jeweled circlet for a hat. Pencil inscription: *This photograph released by the U.S. Army for publicity purposes. 1943 WWII show. Anna Lee, Jack Benny Camp Show.*

8. Rayon silk suit made in accordance with wartime utility regulations worn by Babs Beckwith with Verdura-style link bracelets at Apa Locka Air Station, Miami. Unknown photographer.

184: 1944

1. Wool or mink coats. Unknown photographer. Stamp: *Genuine Velox photo paper. Tupenny Snapshot Co., St. Louis, Mo. Summer 1944.*

2. Hattie Carnegie leopard-print fabric kerchief hat and gloves, the hat with top-stitched red lining. Photo by Acme Newspictures. Stamp: *9/12/44.*

3. Suit by New York ready-to-wear designer Anthony Blotta, in purple wool with fitted jacket with ruffled collar and peplum. Photo courtesy the New York Dress Institute, Eleanor Lambert Publicity. Stamp: *1-7-44.*

4. Wool flannel suit and topcoat, the coat lined with lamb's wool; dark cotton gloves; bow-trimmed hat. Photo by Kenneth Heilbron. Stamp: *Oct 3, 1944.*

5. Claire McCardell popover-style dress in navy or black, 100 percent virgin wool worn with bow-tied blouse. Retailed by the Town Shop, the dress sold for $25.00 and the blouse for $10.00. This is a fairly dressy version of McCardell's successful popover. Press photo. Unknown photographer. Stamp: *Feb 4 1944.*

6. Feminine evening hat with veiling. Photo by Larry Gordon. Stamp: *1-7-44.*

7. Dinner dress and jacket by Fira Benenson, New York custom designer, in gray wool crepe, narrow skirt with low drapery, jacket embroidered with beads. Photo by Acme Newspictures. Stamp: *9/15/44.*

8. Coat and skirt ensemble inspired by Napoléon Bonaparte by New York ready-to-wear designer Anthony Blott in suede-finish fabric with sleeves embroidered with sequins with Napoléon's imperial monogram, eagles, and bees. Unknown photographer.

185: CAMPUS STYLE

1. Wartime coed style: narrow wool plaid skirt; bracelets made out of garter clips; nails painted with half moons left unpainted; leotard tights and ballet slippers (which were not rationed). Unknown photographer. Circa 1943.

2. Winter resort wear: pine-tree knitted sweater and ski pants; bathing suit and bathing cap; worn at the outdoor pool at Sun Valley Resort, Idaho, United States. Unknown photographer. Stamp: *March 30, 1949.*

3. Casual pants ensemble: tunic with shirttail hem, pants with horsehoof hems; ballet slippers. Unknown photographer. Stamp: *9-14-46.*

4. Shorts with blouse and Shetland wool cardigan; coat and tie. Unknown photographer. Pencil inscription: *1941.*

5. Typical bobby-soxer wear: wool skirt and simple blouse; bobby socks and saddle shoes. Unknown photographer. Inscription: *Jane Eileen – 1946.*

6. Suit with matching topcoat. Photo by Zoltan S. Farkas. Circa 1944.

7. Worn for cycling: long pedal pushers with plaid blouse; suit with pleated (possibly divided) skirt. Photo by Zoltan S. Farkas. Circa 1945.

8. Suit with collarless jacket and jaunty hat. Photo by Zoltan S. Farkas. Circa 1943.

186-187: 1945

1. Arpad crusader hood and weskit in beige or pastel knit, from Jay-Thorpe. Photo by Rosemary Sheehan. Stamp: *12-19-45.*

2. American sportswear designer Carolyn Schnurer bathing suit with bandeau halter top and elasticized shirred fitted skirt bottom, brown cotton with a floral medallion print. Photo by J. Walter Thompson Co. Stamp: *5-24-45.*

3. Tailored suit embroidered with sequins; suede peep-toe pumps; modeled by Danish dancer Puk Paaris. Unknown photographer (United States).

4. The hairstyle made famous by American film actress Veronica Lake. Unknown photographer (United States). Circa 1945.

5. Jacket in white Indian broadtail with push-up sleeves by Dein-Bacher of the Waldorf-Astoria Hotel. Photo by Benedict Frenkel (New York). Press photo by Ted Saucier, The Waldorf-Astoria.

6. Balenciaga evening gown in green-and-white wide stripes, draped sleeves, button front. From a group of photographs illustrating an article by journalist Hélène Cingria entitled "Robes pour les fêtes de fin d'année."

7. Jo Copeland for Pattullo Modes cocktail suit, the jacket in cerise pink satin with jeweled collar. Photo courtesy the New York Dress Institute, Eleanor Lambert Publicity. Printed date: *July 18 (1945).*

8. Wool coat with fur collar, stitched chevron detail. Photo by Olofsdotter. Inscription: *H – 45.*

9. Paquin robe d'interieur in royal blue velvet inset with a panel of pervenche, or periwinkle, blue, belted in amarante, or purplish-red, velvet. From a group of photographs illustrating an article by journalist Hélène Cingria entitled "Robes pour les fetes de fin d'année."

10. Plus-fours and cardigan for skiing. Unknown photographer (Belgium). Inscription: *for Bud, to a swell guy I think a lot of Gale. 2 Feb 1945 Stavelot.*

11. Eisenberg dress and peplum jacket in pale blue, wide red reptile belt. Original caption: *The skirt has the new ease which marks fashions for spring 1945. Style 357, Eisenberg. Retails for around $110.* Photo by The Fashion League.

12. Spring suit with orchid corsage. Unknown photographer (United States). Circa 1945.

13. Jean Patou evening gown in white satin with low back décolleté embroidered with gold curved bands. From a group of photographs illustrating an article by journalist Hélène Cingria entitled "Robes pour les fetes de fin d'année."

14. Bruyère robe d'interieur in green silk foulard with revers in rose silk foulard. From a group of photographs illustrating an article by journalist Hélène Cingria entitled "Robes pour les fetes de fin d'année."

15. Participants in a fashion event called Fashion Rhapsody. The moderator wears a simple Claire McCardell dress, which stands out in contrast to the feminine flourishes on the other ensembles. Photo by Daily News Photo. Stamp: *March 20, 1945.*

16. Suit by New York ready-to-wear firm Fox-Brownie; hat with veil. Unknown photographer. Stamp: *JUL 22, 1945*.

188: 1946

1. Anna Miller dinner dress: bodice in "Zouave blue" wool, molded midriff in royal-blue crepe, skirt in "Renoir wine" crepe, sequin embroidery; metallic sandals. Photo courtesy the New York Dress Institute, Eleanor Lambert Publicity. Stamp: *Dec 1 1946*.

2. Fox-Brownie evening dress in ember-brown taffeta fitted about the hips, tied in a magnificent bustle-back bow beneath a sleek midriff, sequined lace top with high neckline, long sleeves of taffeta. Photo courtesy the New York Dress Institute, Eleanor Lambert Publicity. Stamp: *Dec. 1 1946*.

3. Photographed against a row of Harlem brownstones, New York: (from left) dark suit, chubby silver fox jacket, long clutch purse and peep-toe shoes, saucer hat with ribbon trim; double-breasted suit, dark shirt with no necktie, top coat, fedora; dark coat with trapunto details at the hip, fur boa, ankle-strap shoes, toque with dotted veil. Unknown photographer. 1946 (based on another photo in its group dated June 1946).

4. Suit with short jacket of tattersall checked wool paired with solid black skirt; black suede peep-toe platform slingbacks; hat with tattersall band. American press photo. Unknown photographer. Stamp: *46*.

5. Traina-Norell dinner dress of featherweight greige wool with vest of blue faille fastened with jet buttons; wide-brimmed restaurant hat; chosen as one of the ten most prophetic looks in the ninth annual Neiman-Marcus Fall Fashion Exposition. Photo by Wm. Langley. Underwood and Underwood Illustration Studios, Inc. Stamp: *9-26-46*.

6. Fitted leopard flared peplum jacket from Gunther, New York furrier. Unknown photographer, International News Photo.

7. Peplum dress printed with long-stemmed carnations, chubby fur jacket; peep-toe pumps; picture hat trimmed with velvet bow; photographed against a row of Harlem brownstones, New York. Unknown photographer. 1946 (based on another photo in its group dated June 1946).

8. Fishing outfit of fish-printed shirt, rolled-up shorts; flat sandals; worn by "Queen Bass" of the Rod & Gun Club Bass tournament, Alexandria Bay, New York. Photo by Hamilton Wright Co. Stamp: *6-14-46*.

189: A NEW LOOK

1. Marcel Rochas's new guêpière waistline in a draped jersey evening gown modeled by his young wife, Héléne. Press photo accompanying a typed draft of a fashion article describing the new silhouette. Unknown photographer. 1946.

2. Balenciaga short evening dress in heavy silk, self-belt with three-dimensional jet embroidery; tulle pillbox with draped cowl; photographed in the Balenciaga atelier. Press photo. Unknown photographer. Stamp: *11-1-46*.

3. Marcel Rochas's new guêpière waistline in a toile print evening gown modeled by his wife, Héléne. Press photo accompanying a typed draft of a fashion article describing the new silhouette. Unknown photographer. 1946.

190-191: 1947

1. Hattie Carnegie evening gown in net trimmed with bands of lace over a slip, deep round neckline, puffed sleeves to below the elbow; rhinestone choker. Associated Press Photo. Original caption date: *For release January 10, 1947*.

2. New York ready-to-wear designer Herbert Sondheim suit in stone-gray wool with bertha cape (stole ends may be worn as pictured or with the ends falling loose over the belt); elbow-length gloves showing a little below the bertha; hoop earrings and ankle bracelet; boater with stand-up ornament. Photo courtesy the New York Dress Institute, Eleanor Lambert Publicity. Original caption date: *For release Jan 7 1947*.

3. Plastic (probably laminate) eyeglass frames by DuPont. Photo by New York Office Du Pont Co. (New York). Stamp: *7-31-47*.

4. Hattie Carnegie coat with bolero of Persian lamb, gigot sleeves. Unknown photographer. Stamp: *Jul 23 1947*.

5. Waitress uniform with hoop earrings and wedge sandals. Unknown photographer (United States). Inscription: *Lots of luck you little devil. And here's hoping you come back with a million and your upper bridge. Your friend Clio.* 1947 (based on newspaper headline).

6. Suit with New Look silhouette; pillbox hat with stand-up ornament. Unknown photographer. Stamp: *10-1-47*.

192: 1948

1. London street scene showing dressy suits worn with feminine hats and purses. Still evident are some elements of wartime fashion, such as the squared shoulder of the coat shown from the rear. Unknown photographer. Inscription: *Regent Street. London. Oct. 1948*.

2. Winter coats and hats. Unknown photographer (United States). Stamp: *5-48*.

3. New York ready-to-wear designer Ben Reig evening dress in white marquisette over taffeta, with "fol-de-rol" hipline hooped out with a little waist-and-hip liner of taffeta and canvas worn underneath, embroidered with miniature snowballs in white sequins. Photo courtesy the New York Dress Institute, Eleanor Lambert Publicity.

4. Mink stole over evening dress. Photo by Walter Otto Wyss (Los Angeles). Circa 1948.

5. White swing jacket with scalloped pockets; hat trimmed with flowers and tulle. Unknown photographer (United States). Stamp: *5-48*.

6. Spring dress with yellow rosebud print, tie belt forming side panels; short cotton gloves; diamond earrings and pearl bracelets; opera pumps; wide-brimmed hat. Unknown photographer.

7. Plaid wool coat with high funnel collar; soft beret. Unknown photographer. Circa 1948.

8. Herbert Sondheim black tissue faille cocktail dress with a low-cut neckline, draped at the shoulder. Photo by Associated Press.

193: 1949

1. Christian Dior evening gown in sapphire silk broadcloth and satin made with "scissor blades" crossing at the skirt; elongated pointed kid gloves; rhinestone fringe collar. Photo by David S. Boyer, Acme Newspictures. Original caption date: *For release September 15, 1949*.

2. Strapless tulle evening dress in white sprinkled with rhinestones, black velvet sash; black long gloves. Unknown photographer (United States).

3. Rolled-up dungarees, plaid short-sleeved camp shirt. Unknown photographer. Pencil inscription: *Stella 10/5/49 near Manhattan Beach, California.*

4. Light blue dress with paisley embroidery in tomato red, red belt; black opera pumps; worn aboard the S.S. *Parthia* for a March of Dimes fashion show. Photo by B. Cleand. Inscription: *1/30/49*.

5. Formal attire for Ascot: woman wearing afternoon dress, lace hat, gloves, and man wearing a morning suit and top hat. Photo by Mirrorpix/Everett Collection.

1950s

194: Summer afternoon dress in brown-and-white moiré voile. Unknown photographer. Stamp: *May 22 1950*.

196: 1950

1. Man in double-breasted suit standing by airplane. Photo by Walter Otto Wyss (Los Angeles). Circa 1950s.

2. Showgirls primping. Photo by Walter Otto Wyss (Los Angeles). Circa 1950.

3. Pierre Balmain Summer haute couture plaid shirtwaist dress with narrow pleated skirt. Unknown photographer. Pierre Balmain (Paris).

4. Strapless short evening dress with attached stole in point d'esprit. Stamp: *'50*.

5. A different silhouette for a suit by Balenciaga: walnut rattine wool, rounded jacket with melon-cut sleeves and Chinese style collar; furry felt boater. Unknown photographer. Stamp: *September 11, 1950*.

6. Pierre Balmain Summer haute couture coatdress with flying back panel. Unknown photographer. Pierre Balmain (Paris).

7. Pierre Balmain Fall/Winter haute couture herringbone wool suit. Unknown photographer. Pierre Balmain (Paris).

8. Dress with tabard bodice, scalloping at bodice and hem of full skirt; black suede pumps. Unknown photographer (Hawaii [before statehood], United States). Circa 1950.

9. Claire McCardell casual shirtdress in "smudge" green with artichoke-green top-stitching outlining high standing collar and patch pockets, brass buttons. Photo by Raymond Smith (New York). Stamp: *SEP 22 1950*.

198-199: 1951

1. Spring suit and coat and dress ensemble worn at the races in France. Photo by Stella-Presse. Circa 1951.

2. Tailored suit with white details and white skirt; shoulder bag; ankle-strap shoes; beret and sunglasses. The model is standing beside the Nash Ambassador for 1951, photographed at the Cloisters, New York. Photo by Public Relations Department Nash Motors.

3. Spring suit accessorized with hat and ankle-strap sandals. Unknown photographer. Circa 1951.

4. Jean Dessès and Jeanne Lanvin haute couture evening gowns worn to a presentation of antique silks at the Louvre, Paris. Photo by Stella-Presse. Stamp: *30 April 51*.

5. White "Bagatelle" suit; white high-heeled sandals; profile hat with veiling; worn at the Concours d'Élégance en Automobile, Bois de Boulogne, Paris. Photo by Stella-Presse.

6. Angora pin-up girl sweater, slacks; peasant blouse with floral shorts. Photo by Palm Beach News Service.

7. Jacques Fath Spring/Summer haute couture looks: (from left) black dress with white piqué jacket fastening with large black buttons, black hat with veil; dress in a toile called Zyzy from Tissus Ramon with turned-back cuffs, floating skirt panels, large black buttons, wide-brimmed hat; dress and coat ensemble, the coat lined to match the dress in a plaid rayon called Shantella, hat stuck through with a single feather. Unknown photographer.

8. One-shouldered looks: jersey top with trousers, leather belt with metal decorations and strappy sandals; crisp one-shouldered dress with turned-up cuff. Photo by Kenneth Heilbron (Chicago). Circa 1951.

9. Jacques Fath haute couture afternoon or cocktail dress in black with fan pleating at the collar forming sleeves and at the skirt; elbow-length gloves; hat with point d'esprit veil. Unknown photographer.

10. Summer evening dress of awning-striped organdy over taffeta; choker of swirled glass or plastic ovoid beads, some with rhinestone spacers; wrist-length kid gloves, which were just becoming *de rigueur* day or night. Unknown photographer. Stamp: *Jan 9 1951*.

11. Jacques Fath dress with fan-pleated skirt, shawl collar with pearl stickpin, leather belt. Unknown photographer (France).

12. Singers wearing strapless ball-length evening dresses in pale blue tulle. Male musician in a yellow suit with spectator shoes. Photo by Walter Otto Wyss (Los Angeles). Circa 1951.

13. Dressed for work as a television interviewer in a dressmaker suit, pearls, clip, and pumps; worn by Robin Chandler on the set of her weekly CBS show *Meet Your Cover Girl*. Photo by Sun Magazine. Stamp: *Feb 25 1951*.

14. Herbert Sondheim ready-to-wear dress in silk linen in wide stripes of neutral, yellow, and black; high pearl choker; black scallop-edged cotton gloves; black opera pumps. Unknown photographer. Stamp: *Jan. 10, 1951*.

15. Jacques Fath haute couture wrap coat with turned-back cuffs in leopard, narrow calf belt. Unknown photographer (France).

16. Maggy Rouff haute couture ensemble with fitted jacket and plaid skirt pleated in the back, turned-back cuffs to match the skirt; sling-back sandals; wide-brimmed hat. Unknown photographer (France).

200-201: 1952

1. American sportswear designer Toni Owens separates for holiday: cotton sleeveless blouse in wrinkle-resistant cotton with high daisy neckline, embroidered skirt, and sash; Brownie movie camera (blouse: $7.95; skirt: $19.95; sash: $3.50). Unknown photographer.

2. Three versions of dresses with trompe l'oeil collars and pockets; modeled at the races in France. Photo by Stella-Presse.

3. Tweed dirndl worn with silk blouse with safari/camp shirt pockets; modeled by Gaby Sayers. Unknown photographer for Frances Gill Model Agency.

4. Three daytime ensembles: two gray suits and one black dress. Photo by Walter Otto Wyss (Los Angeles). Circa 1952.

5. Carven coin dot suit from Paris; picture hat by Paris milliner Jean Barthet. Photo by Stella-Presse. Stamp: *Summer 1952*.

6. Casual summer styles promoted by a button company: convertible shorts with buttonholes for add-on legs; convertible drawstring beach bag; straw hat with button-centered daisies. Prims Cover-Your-Own Buttons press release. Unknown photographer.

7. Tailored skirt suit in gray flannel worn with ochre scarf. Unknown photographer (Germany). Stamp: *Fashions of 52*.

8. "Motor-Mate" coat in two tones of Kalakina worsted designed to coordinate with the new two-tone Ford Victoria cars. Unknown photographer. Stamp: *Feb. 1, 1952*.

9. Tweed dirndl worn with silk camp shirt; modeled by Gaby Sayers. Unknown photographer for Frances Gill Model Agency.

10. Quintessential 1950s wrap: fur stole of silver fox worn with a tailored wool dress. Unknown photographer. Stamp: *Apr 7 1952*.

11. Capri Original Winter suit with a cut-away short coat in reversible Riviera red wool, sleeveless black sequined blouse, slim skirt with high midriff belt. Photo courtesy the New York Dress Institute, Eleanor Lambert Publicity. Stamp: *Jun 28 1952*.

202-201: 1953

1. Ben Reig spring coat and dress ensemble in black-and-white printed silk shantung. Unknown photographer. Stamp: *Jan 11, 1953*.

2. A well-loved look for casual evenings: embroidered cardigan or twin set, tapered pants. Unknown photographer (Germany). Stamp: *Fashions of 53*.

3. Monte-Sano Spring ready-to-wear suit in gray wool jersey, white linen coat lined in gray wool jersey. Press photo. Unknown photographer. Stamp: *Jan 11 1953*.

4. Pierre Balmain Fall/Winter haute couture strapless ballet-length cocktail or evening dress in pink and blue taffeta, accented with black suede belt and long gloves, faux pearl neckline and earrings. Photo by Creation Balmain, Keystone Press Agency.

5. Charles James taffeta dress, diamond bow brooch, and gardenias; worn by Austine Hearst (1920–1991), photographed with her husband, William Randolph Hearst, Jr. (1908–1993), in London, following Queen Elizabeth's coronation. Photo by Keystone Press Agency. Stamp: *8-6-53*.

6. Striped dress with mitred seams in the flared skirt, square neckline; modeled at the haute couture show held in the Sala Bianca of the Pitti Palace, Florence, Italy. Participants in the show included Simonetta, Schuberth, Fontana, Veneziani, Marucelli as well as boutique talents Pucci and Tessitrice. Photo by Keystone Press Agency, Keystoglobe Inc., and Publifoto Milano.

7. Strapless evening gown with button-down front considered suitable for a young bride's trousseau. Unknown photographer. Caption: *Fashions for June Brides*. Stamp: *Apr 28 53*.

8. Hubert de Givenchy double-breasted suit in black with wide shawl collar of charcoal wool flannel with a velvet band; modeled by Beryl. Givenchy had just opened his couture house in 1952. Photo by Tribune Paris Bureau. Stamp: *1953 Aug 26*.

9. Sun worshiping in swimsuit with décolleté bodice; sunglasses. Unknown photographer (France). Inscription: *1953.*

204–205: 1954

1. Halter-necked sundress. Unknown photographer (probably France).

2 & 5. Front and back view of tailored suit with back self-bow in back, worn with seamed stockings and peep-toe pumps. Unknown photographer. Inscribed: *29 Mai 1954, Perpignan.*

3. Short evening dress in black crepe by custom designer Leslie Morris of Bergdorf Goodman, embroidered with beads at the torso, fringed from the hip to the hem; white mink capelet; modeled by Carola Mandel. Born in Cuba, Mandel was married to department store executive Leon Mandel and known for her style as well as her excellent marksmanship: she won numerous shooting championships and was captain of the All-American Women's Skeet Shooting Association. Photo by United Press Roto. Stamp: *12/3/54.*

4. Cotton shirtwaist dress by McKettrick, white collar and piping, narrow self-belt; red straw hat and cotton short gloves; modeled by Suzy Parker. Unknown photographer. Original caption date: *11/10/54.*

6. Pauline Trigère cocktail dress and bolero in cotton made from Wamsutta Mills, New Bedford, Massachusetts. Unknown photographer. Caption: *High Fashions from New England Textiles will be featured at the 100th annual meeting of the National Association of Cotton Manufacturers in Boston in May. Hart model Pat Harris shows a dress especially designed by Pauline Trigère from fabrics made by Wamsutta Mills, New Bedford Mass. An exciting collection of dresses created from New England cotton and man-made fibre textiles is currently in preparation by top-flight international designers for fashion, a high point of the two-day meeting.* Stamp: *Mar 31 1954.*

7. Long shorts worn with middy blouse top. Unknown photographer. Stamp: *Nov. 23, '54.*

206: 1955

1. Short evening dress by American ready-to-wear designer Ceil Chapman composed of pink silk taffeta ribbons stitched onto silk organdie, midriff swathed with ombred matching taffeta; rhinestone jewelry by Bogoff; evening sandals by Palter de Liso. Photo courtesy the New York Dress Institute, Eleanor Lambert Publicity.

2. Organdy short evening dress with skirt arranged in overlapping petals; elbow-length gloves; high-heeled sandals. Unknown photographer (France). Stamp: *10 Aout 1955.*

3. Antonio Castillo of Lanvin follows the straight and narrow line in a spring suit in coral wool: straight, unfitted jacket with straight, cuffless sleeves, straight and narrow skirt with longer hemline. The suit has an interesting asymmetrical point in the self-fringed scarf threaded through the pockets on the right side. Note the lapel butterfly, Castillo's signature trim for spring 1955. Photo by Stephen Tavoularis. United Press. Stamp: *2/25/1955.*

4. Balenciaga town coat with cape collar in caramel corduroy; hat shaped like a Phrygian bonnet. Photo by United Press Photo. Original caption date: *For release Thursday, September 1, 1955.*

5. Nettie Rosenstein beige and navy silk tweed dress and jacket ensemble, the sleeveless dress with rear kick pleat; fur piece by Ritter; shoes by I. Miller; hat

by Emme. Photo courtesy the New York Dress Institute, Eleanor Lambert Publicity. Circa 1955.

6. Oleg Cassini cocktail dress with "gondolier" skirt in sapphire silk taffeta. Photo courtesy the New York Dress Institute, Eleanor Lambert Publicity. Original caption date: *Fall and Winter 1955-56.*

7. Audrey Wayne in the three-wheel Powerdrive microcar. Photo by Chris Ware. Circa 1955.

8. Claire McCardell shirt dress in green worsted, stitched front and back, green suede cummerbund belt; bag by Smart Set; faux tortoise sunglasses by Claire McCardell. Unknown photographer. Photo courtesy the New York Dress Institute, Eleanor Lambert Publicity. Original caption date: *spring 1955.*

207: GRAND EVENING

1. Christian Dior strapless ball gown in white with button detail and tightly cinched self-belt. Unknown photographer. Pencil inscription: *Dior Juillet '51.*

2. British couturier Digby Morton haute couture ball gown of pale pink tulle embroidered with widening floral bands of sequins and metallic thread. Photograph by P. A. Reuter Photos Ltd. (London). Stamp: *SEP 27, 1953.*

3. Hubert de Givenchy ball gown in white and gold lily-of-the-valley-patterned silk, ground embroidered with beads, topped with a bolero of gold satin bordered in white satin; modeled by Mrs. James Downey for the April in Paris Ball, New York. Photo by United Press Association. Stamp: *4/18/1953.*

4. Evening gown and wrap by Christian Dior in topaz satin with embroidery and sable; dangling diamond earrings; jeweled lorgnette; worn by Mrs. Francis Joseph Klimley for an evening at the opera. Unknown photographer. 1955.

5. Christian Dior "Pavane" strapless ball gown in taffeta; worn at a charity fashion show benefiting the Red Cross in Stockholm. Photo by AGIP, Robert Cohen. Stamp: *Octobre 1953.*

6. Dressed for a debutante ball in white ball gown and white tie: the strapless dress in tulle, embroidered tulle, and taffeta worn by debutante Doris Anne Shropshear at the Royal Coterie of Snakes Debutante Ball, Chicago. The Royal Coterie of Snakes was an elite social club on Chicago's South Side. William Lester, Jr., future scientist and author, is her escort. Unknown photographer. Stamp: *DEC 28 1955.*

7. One-shouldered Chiné taffeta ball gown, narrow skirt with side panels; diamond spray earrings and triple-strand pearl necklace; silk pouch evening bag and fabric gloves; ballet slippers; worn by Viscountess Norwich as she attended the twenty-first birthday party of Miss Katherine Smith, sister of Lord Hambledon, at the Savoy, London. Photo by Keystone Press Agency. 1954.

208–209: 1956

1. Two casual sportswear styles: car coat and striped hooded sweatshirt. Unknown photographer.

2. Summer cocktail dress made from printed cotton by Modern Masters, D. B. Fuller & Co. This particular fabric design is possibly by Joan Miró. Photo by United Press Photo. Stamp: *2/2/56.*

3. Pinstriped cotton shirtwaist dress with wrapped waist in style of Claire McCardell; white cotton gloves; black patent leather handbag; medium-brimmed hat

with striped hatband. Caption: *Summer fashions for 1956.* Stamp: *Jun 12 '56.*

4. Ladylike ensemble perhaps intentionally invoking the newly married Princess Grace: afternoon dress in organdy with sheer yoke, white Peter Pan collar and cuffs; double-strand pearl choker, triple-strand bracelet with ruby set catch, pearl and diamond earrings; white kid short gloves; white wide-brimmed hat; modeled by Martha Hyer. Unknown photographer. Inscription: *7/11/56.*

5 and 7. Two views of striped shirtwaist with permanent pleated skirt; one with cardigan, one with wrist-length gloves; worn sightseeing in Cornwall. Unknown photographer. Inscription: *Mary Magdalene Launceston (Cornwall). 56 or Polperro Harbour, Cornwall 1956.*

6. Fireman-style combination rain jacket and car coat with knit collar; string gloves; sunglasses. Unknown photographer. Circa 1956.

210: 1957

1. Ceil Chapman cocktail dress with green satin bodice and green chiffon skirt. Unknown photographer. Courtesy New York Dress Institute. Stamp: *6/25/57.*

2. Madras, or hand-dyed, hand-loomed "Bengali" skirt and jackets. Woman wearing narrow leather belt with metal decorations and carrying a straw tote. Men wearing narrow ties, khaki pants or gray flannels, loafers and tennis shoes. Unknown photographer (Palm Beach, FL). Stamp: *Mar 19 1957.*

3. Nina Ricci Fall/Winter haute couture wedding dress in draped white jersey tulle veil with headpiece of white camellias. Photo by Keystone Press Agency for Nina Ricci. Original caption date: *27, August 1957.*

4. Shirtwaist dress. Unknown photographer. Inscription: *Bev in the orange grove, Los Fresnos, Texas. November 1957.*

5. Tweed suit with flared jacket over pencil skirt; feathered hat with a touch of veiling. Unknown photographer. Stamp: *Cleveland Press Aug 26 1957.*

6. Strapless ball gown with bubble skirt, a Japanese design modeled by Tadako Kondon in Tokyo. Photo by UPI.

7. Junior Sophisticates ensemble with white chinchilla cloth overblouse, brilliant red cravat, black evening skirt; modeled by Merrill at a showing of American fashions, the Washington Hotel, London. Photo by Keystone Press Agency. Original caption date: *9-9-57.*

211: 1958

1. Claire McCardell Spring/Summer bubble bathing suit from her last collection for Townley before her death. Unknown photographer.

2. Lanz of Salzburg short strapless evening dress in machine-embroidered organdy, contrast belt, full tiered skirt. Unknown photographer, copyright 1958 Lanz Originals, Inc. Stamp: *Feb 5 1959.*

3. Red coat worn with white toque. Unknown photographer (Helsinki).

4. A version of a trapeze day dress designed by Yves Saint Laurent for Christian Dior. Unknown photographer (France).

212: 1959

1. Suit by California couture designer Galanos in oatmeal tweed, raised waistline with self-tie belt, elbow-length sleeves; double-strand faux pearls; kid

gloves; straw hat. Photo by Charles Gekler for a Chicago newspaper. Stamp: *FEB 17 1959.*

2. Sleeveless sheath dress. Unknown photographer (United States). Circa 1959.

3. Matching swimsuit and balloon jacket by Sodi. Photo by Florida State News Bureau.

4. Plaid textured velvet coat; furry textured felt hat. Photo by Louis R. Astre, Sporvel. Inscription: *1/59.*

5. An apricot cashmere coat by Sue-Preem-Maid, very casual with a relaxed resort air, belt in rear with large buttons at either side over full-cut back. Photo by Florida State News Bureau. Circa 1959.

6. Shorts and Keds sneakers; worn by model feeding a fawn. Unknown photographer. Inscription: *Bev feeding deer. June 1959.* Stamp: *Jun 59.*

7. Simple empire sheath in cotton print by Harmony Fashions. Photo by Florida State News Bureau.

8. Cabaret singer Hildegarde models a brown faux broadtail jacket by Sportwhirl; ostrich hat by Sally Victor. Unknown photographer. Printed date: *6/1959.*

213: A SILHOUETTE SHIFT

1. Dress with blouson bodice; point d'esprit hat. Unknown photographer. Circa 1958.

2. A version of a sack dress, narrow with balloon back. Unknown photographer (Paris). Circa 1958.

3. Black capri pants, white sleeveless blouse; black high-heeled mule sandals. Unknown photographer (United States). Stamp: *JUN 58.*

4. Christian Dior "New York" dress in light gray wool and silk flannel; Dior hat and gloves; modeled by Mabel Glemby. Unknown photographer, Metro Group Editorial Service. Stamp: *Dec. 2, 1956.*

5. Sack dress with suggestion of empire waistline; Verdura-style gold link bracelet; short gloves. Photo by Kenneth Heilbron. Circa 1958.

1960s

214: Dress printed with Matisse cut-outs; blouson bodice; lacquered straw sailor hat. Unknown photographer. Circa 1961–62.

216–217: 1960

1. Fall suit by ready-to-wear label Suburbia in gold wool; toque with jeweled pin; modeled by Pauline Kienan. Unknown photographer (New York).

2. Adele Simpson dress of pale-toned rich silk brocade with cartridge pleating at the hipline. Unknown photographer. Photo courtesy the New York Dress Institute, Eleanor Lambert Publicity. Original caption date: *July 19, 1960.*

3. Pauline Trigère cape coat of pitch-gray plush fleece with slim front enveloped by back fullness. Unknown photographer. Photo courtesy the New York Dress Institute, Eleanor Lambert Publicity. Original caption date: *July 17, 1960.*

4. Ceil Chapman columnar evening gown in white sheer silk embroidered with silver bugle beads, bugle-bead rope belt; jewelry by Trifari; shoes by Evin; photographed at Gracie Towers Apartments in New York. Unknown photographer. Photo courtesy the New York Dress Institute, Eleanor

Lambert Publicity. Original caption date: *Fall, 1960.*

5. Day dress with fitted torso and pleated skirt; modeled by Betsy Pickering. Unknown photographer. Stamp: *Jul 29 '60.*

6. Red wool coat; modeled by Toni Terrace in the lobby of the News Building at 220 E 42nd Street. Unknown photographer.

7. Pauline Trigère overblouse dress and full, flaring seven-eighths-length coat in an amaranth wool plaid with undertones of green. Photo courtesy the New York Dress Institute, Eleanor Lambert Publicity. Original caption date: *July 17, 1960.*

8. Ceil Chapman Fall sequined evening dress; modeled by Isabella Acbonico in a New York bank. Unknown photographer.

9. Adolfo of Emme hat from Cirque d'Hiver Fall collection of flaming red coq feathers, headband of matching velvet. Photo courtesy the New York Dress Institute, Eleanor Lambert Publicity. Original caption date: *Fall, 1960.*

10. Blue plaid shorts and strapless top; travel case, possibly fitted with a lady Sunbeam hair dryer and bonnet. Unknown photographer. Inscription: *St. Louis Labor Day.* Stamp: *Sep. 60.*

11. Calico printed dress with eyelet edging. Unknown photographer. Inscription: *M. L. Chun. Student Center. 11/21/60.*

12. Arthur Jablow Fall cape coat ensemble; modeled by Carmen. Unknown photographer.

13. Originala's red "chinchilla fleece" three-quarter-length coat, widened silhouette narrowing at the hem. Unknown photographer. Photo courtesy the New York Dress Institute, Eleanor Lambert Publicity. Original caption date: *Fall, 1960.*

218: 1961

1. Dress in shades of taupe; turquoise bib necklace. Kodachrome slide. Unknown photographer (United States). Stamp: *Apr 61.*

2. Dress and short jacket in black-and-white diagonal tweed. Unknown photographer. Stamp: *Oct. 2. '61.*

3. Red wool one-piece dress with two-piece look by Italian designer Rapuano. Unknown photographer, UPI.

219: 1962

1. At-home outfit of Nehru coat and silk pants ($69.95). Photo by Charles Gekler for *Chicago Sun-Times Midwest Magazine.*

2. Hat for fall from Lemington, Inc. Unknown photographer for *Chicago Sun-Times Midwest Magazine.* Printed date: *August 5, 1962.*

3. Jacques Tiffeau suit for après-ski in textured gold wool, black wool V-neck sleeveless overblouse, triangular scarf; modeled by Joyce Kramer at the O'Hare Inn. Photograph by Charles Gekler for *Chicago Sun-Times Midwest Magazine.* Circa 1962.

4. Monte-Sano nubby textured wool short-sleeved suit available at Bonwit Teller ($250). Photo by Charles Gekler for *Chicago Sun-Times Midwest Magazine.* Original caption date: *March 25, 1962.*

5. Evening dress printed with calligraphy. Unknown photographer. Circa 1962.

6. Pique textured knit suit with short-sleeved jacket, crocheted buttons. Unknown photographer. Stamp: *1962 NOV 5 Cruise Knits.*

7. Wedding gown and rubber boots. Unknown photographer. Inscription:

220–221: 1963

1. Dressed for the prom: strapless tulle gown and white dinner jacket. Unknown photographer (United States). Stamp: *JUN 1963*.

2. Casual summer evening dress in blue with touches of red and white; modeled by Cynthia O'Neal. Unknown photographer. Printed date: *5/1966*.

3. Yves Saint Laurent haute couture orange wool coat with shaped stand-up collar; mink toque. Associated Press Photo (France). Printed date: *2/8/63*.

4. Tiger-stripe mini-trench; black tights and ankle boots; modeled by Ariana. Kodachrome transparency. Unknown photographer. Stamp: *OCT 63*.

5. A-line shift for resort wear in Crompton's burnt-orange sailcloth, patch pockets, from the Villager, a ready-to-wear label specializing in separates for teens and co-eds; photographed in Bermuda. Photo by UPI Photo. Stamp: *1/30/63*.

222–223: 1964

1. Tweed suit with boxy jacket and pleated skirt, solid shell top; modeled by Gunilla Riva at Tavern on the Green, Central Park, New York. Unknown photographer.

2. Henri Bendel two-piece ensemble of black and white textured wool ($185); modeled by Suzannah Hornberg. Photograph by Joe Engels for *New York Herald Tribune*. Stamp: *Jul 26 1964*.

3. A Sleek City coat in pure worsted gabardine, its two vertical pockets, raglan sleeves, and shoulder details emphasized by skillful seaming. International Wool Service photo. Unknown photographer. Inscription: *Aug.18, 1964*.

4. Yves Saint Laurent Spring/Summer haute couture cocktail dress in dotted tulle with point d'esprit ruffled trim; T-strap satin evening shoes. Unknown photographer. Stamp: *Feb. 24, 1964*.

5. White leather single-breasted coat; modeled by Gunilla Riva at Tavern on the Green, Central Park, New York. Unknown photographer. Printed date: *7/1964*.

6. Saks Fifth Avenue suit with double-breasted jacket cut away from the neck ($185); modeled by Suzannah Hornberg. Photograph by Joe Engels for *New York Herald Tribune*. Stamp: *Jul 26 1964*.

7. Crocodile-patterned suit with cowl-necked blouse; modeled by Christa Fiedler at Tavern on the Green, Central Park, New York. Unknown photographer. Printed date: *7/7/1964*.

8. Debutante look of pearls, long white dress, and gloves: white peau de soie dress made to order by Cestaro of Lashack in Locust Valley; worn by Joan Townsend about to make her debut at Piping Rock Club, Locust Valley, New York. Photo by Frances McLaughlin-Glll.

224: 1965

1. Ceil Chapman for Miss Winston printed silk drop-waist dress; earrings by Kenneth Jay Lane; gloves by Kislav; hat by Halston. Unknown photographer. Courtesy International Silk Association (United States). Circa 1965.

2. Mary Quant wearing her own knee-baring shift dress; patent double purse on long chain; ankle-strap low-heeled shoes. Her husband, Alexander Plunkett-Greene, wearing suit with mod touch of safari

pockets; low boots. Photo by Dwight Miller for the *Minneapolis Tribune*. August 26, 1965.

3. Printed dress with ruffled neckline, self-tie belt; modeled by Elinor Rowley at the LaGuardia Terrace Restaurant, LaGuardia Airport, New York. Unknown photographer. Printed date: *2/2/65*.

4. Barberini two-piece linen dress with white buttons and cap sleeves. Photo by Charles Gekler for *Chicago Sun-Times Midwest Magazine*.

5. Valentino haute couture coat in beige double-faced wool gabardine by Nattier with raglan sleeves. Unknown photographer, International Wool Fashion Office. Original caption date: *August 31, 1965*.

6. Mrs. Leonard ("Baby Jane") Holzer (1940–), chatting with illustrator Joe Eula, wearing wool twill coatdress with fringed wool ruffled cuffs. Photo by Stan Papich.

7. Mrs. Alfred Gwynne Vanderbilt, née Jean Harvey, at the Opera Ball wearing a Balenciaga gold brocade sari evening dress with jeweled edging; Indian embroidered evening envelope; chandelier earrings. Photo by Charles Krejesi. Stamp: *Daily News October 9, 1965*.

225: FREEWHEELING

1. Mrs. Potter Palmer modeling an Elizabeth Arden ball gown with uneven hem and train at a preview party benefit for Children's Memorial Hospital. Photo by Carmen Reporto for *Chicago Sun-Times*. Stamp: *Sun-Times Aug 19 1968*.

2. Malia of Hawaii pantsuit in splash colors of "moonshot" ($40). Unknown photographer. Circa 1969.

3. Pierre Cardin mini/maxidress with carwash fringe ending in circles. Unknown photographer. 1969.

4. Pierre Cardin Fall/Winter sequined and jeweled evening dress. Pierre Cardin press photo. Unknown photographer. 1965.

5. Two models dancing at a Best & Co. fashion show wearing Mary Quant jersey dresses with Piet Mondrian and Serge Poliakoff designs; white ankle boots styled after Courrèges. The dances demonstrated included the Frug, the Jerk, the Monkey, and the Twist. Photo by UPI. 1965.

226: 1966

1. Widely copied Pierre Cardin ensemble: orange and black wool with orange-dyed fox fur; patterned stockings and square-toe low-heeled pumps; domed riding helmet–shaped hat; hair and makeup by Carita. Pierre Cardin press photo. Original caption date: *27 Aout 1966*.

2. Pierre Cardin white wool coat and space-helmet hat trimmed with white fox. Unknown photographer. Stamp: *Aug 28 1966*.

3. DuPont "Orlon" lightweight knit top; modeled by Loosveldt-Van Goethem. Photo by Stephan. Courtesy Du Pont Information Service, Geneva, Switzerland.

4. Yves Saint Laurent Spring/Summer haute couture dress and jacket ensemble in chevron striped Lesur wool, part of a collection inspired by mariners; Roger Vivier for Yves Saint Laurent shoes with pilgrim buckle; worn with white cap similar in shape to one Yves Saint Laurent was wearing at the time. Press photo. Unknown photographer. Pencil note: *sent to Globe*.

5. Yves Saint Laurent Spring/Summer haute couture dress, part of a dress and jacket ensemble, in Lesur wool; Roger

Vivier for Yves Saint Laurent shoes with pilgrim buckle; white cap similar in shape to one Yves Saint Laurent was wearing at the time. Press photo. Unknown photographer. Pencil note: *sent to Herald*.

6. Ribbed sweater in Du Pont "Orlon." Photo by Stephan. Courtesy Du Pont Information Service. (Geneva, Switzerland).

7. Rudi Gernreich total look: cheetah-stenciled pony-skin suit, nylon jersey cheetah-print T-shirt; matching tights by Capezio; pony-skin flats by Capezio; matching fur "glittens," combination gloves/mittens (suit: $550; T-shirt $40); modeled by Leon Bing. Unknown photographer. Photo by Rudi Gernreich, Inc. Original caption date: *July 10, 1966*.

8. Strapless dress in draped chiffon; chandelier earrings by Kenneth Jay Lane; modeled by Carlotta Greiner at the Rainbow Room, New York. Unknown photographer. Original caption date: *10/20/1966*.

9. One-shouldered bathing suit in diagonal stripes of yellow, black, and gray; worn by Marita Lindholm. Unknown photographer. Printed date: *3/29/1966*.

10. Yves Saint Laurent Spring/Summer haute couture cocktail dress made out of a technique called Malhia that involved weaving rather than embroidering sequins; part of a collection inspired by mariners and described by *L'Officiel* as a sensation. Probably press photo. Unknown photographer. Pencil inscription: *sent to Globe*.

11. Clear vinyl raincoat and pram. Photo by Keystone Press Agency. Circa 1966.

12. Ungaro's two-piece in green-and-shocking-pink vertically striped wool satin by Nattier. Unknown photographer, courtesy International Wool Fashion Office. Stamp: *2/28/1966*.

13. Irene Galitzine haute couture evening gown in double-faced silk crepe, pale blue over beige, formed of two rounded triangles that overlap. Newspaper caption: *Most beautiful evening dress in Rome, according to Eleanor Lambert*. Unknown photographer. Stamp: *Aug 15 1966*.

228: 1967

1. Coat and dress by Lanvin of Paris in wool barathea by Lesur, trimmed with silver braid. Unknown photographer. Courtesy International Wool Fashion Office. Stamp: *2/25/1967*.

2. Cycling outfits of shorts or capri pants; worn for a fashion shoot in Puerto Rico, photographic equipment seen to the side. Inscription: *Puerto Rico Rain Forest Models for Teen Magazine*. Stamp: *Nov 1967*.

3. Models wearing an assortment of skirt lengths, all grounded by low-heeled boots, posing outside a new boutique in London's Chelsea. Everett Collection. Caption: *Just Looking*.

4. Fringed poncho and matching clamdiggers. Unknown photographer (United States). Printed date: *1/1967*.

5. Midi- and miniskirts seen together on the King's Road, Chelsea. Mirrorpix/Everett Collection.

6. Bikinis in red and white or red, white, and blue; worn for a photo shoot in Puerto Rico, the photographer or photographer's assistant seen to the side giving instructions. Inscription: *Puerto Rico Rain Forest Models for Teen Magazine*. Stamp: *Nov 1967*.

7. Lace short evening dress with high waist; polka-dot earrings; mesh stockings; low-heeled pumps with self-bow. Unknown photographer. Stamp: *"Apr 21 1967"*.

229: BARE MINIMUM

1. André Courrèges shorts turnout with wrap skirt; Mary Jane version of his famous space boots; cowboy-style hat. Photo by Keystone Press Agency. Original caption: *American T.V. viewers could see direct transmission of a Paris fashion show thanks to The Early Bird. A mannequin modeled beach fashions before a T. V. Camera on the roof of a department store. May 4/65*. 1965.

2. Sylvia de Gay for Robert Sloan sportswear fishnet beach dress worn over Warner's "Bodystocking" in bare nude Nylon stretch (beachdress: $35; bodystocking: $11). Unknown photographer, Margaret Hodge Co., Public Relations. Stamp: *Dec 29 1964*.

3. Futuristic and sporty ensemble by Ruben Torres of stretch two-tone shorts, clear and black patent vinyl overblouse, square bra top in lace; dark sunglasses. Caption: *Lace square bra is one of the highlights of the Torres collection. Panty is in Air Force blue*. Unknown photographer. Stamp: *Jan 2 66*. 1966.

4. Paco Rabanne dress in rhodoid celluloid acetate plaques. Photo by Studio Press (Holland, The Netherlands). Circa 1967.

5. Pierre Cardin short dresses in pink, white with green border, or nasturtium; matching textured or clear stockings; low-heeled pumps by Charles Jourdan. Photograph by Ghislain Broulard. Stamp: *Mar 23 1966*.

6. Pierre Cardin minidress with jeweled halter. Unknown photographer, Press International. Stamp: *Mar 1 1966*.

7. Yves Saint Laurent Fall/Winter "75" evening dress in black velvet with transparent bodice of transparent black cigaline, little collar and large sleeves, bow-tied belt of black satin ribbon. Photo by Agence France Presse (Paris). Original caption date: *2.08.1968*.

8. Bare midriff minidress with chain straps in back, chain belt; chandelier earrings; satin low-heeled evening pumps with diamante heels. Unknown photographer (United States). Inscription: *1/3/69*.

230: 1968

1. Fringed suede minidress and straw tote worn by actress Charlotte Rampling. ©AGIP/AD/Everett Collection.

2. Miniskirts and sandals worn by actresses Judy Geeson and Diane Keen in a scene from *Here We Go Round the Mulberry Bush*. Press photo. Unknown photographer.

3. French singer Françoise Hardy wearing a minidress by Paco Rabanne, May 15 1968. © AGIP/AD/Everett Collection.

4. Minidress in dotted swiss with elasticized empire waistline and neckline, lace edging; modeled by actress Katharine Ross (1940–). Kodachrome slide. Photo by Joe Santoro. Inscription: *Yes Nov. 68*. Stamp: *Nov 68. Fashion Women Location*.

5. Plaid coat and hat. Photo by *San Francisco Examiner Pictorial Living*. Stamp: *1-14-68*.

6. Ungaro's 9/10-length coat and matching skirt in worsted wool broadcloth by Nattier with watercolor stripes in shades of sand, small turned-down collar, large pockets, deep inverted pleat up the back with a high martingale; diamond-patterned stockings. Unknown photographer. Courtesy International Wool Fashion Office. Printed date: *August 24th 1968*.

7. Evening jumpsuit with bare midriff, knotted bodice; foot jewelry and multiple rings; modeled by African American model with Afro coiffure. Photo by Condé Nast Ltd - Harri Peccinotti / Trunk Archive.

231: 1969

1. B. H. Wragge "sundowner" dress splashed with color, slashed sides showing twin print beneath (style #1762: $200). Photograph by B. H. Wragge (New York). Original caption date: *For release: Jan. 2, 1969*.

2. Yellow minidress and beige sandals; long sautoir. Kodachrome slide. Photo by Joe Santoro. Inscription: *Fashion Women Location. India. Yes*. Printed date: *Nov 69*.

3. Floor-length reefer coat worn with man-tailored trousers in gray argyle; modeled by Catherine Dahmen. Unknown photographer.

4. Oscar de la Renta evening gown in chartreuse silk with purple cummerbund embroidered Indian-style with gold beading. Press photo. Unknown photographer. Stamp: *SUN-TIMES FEB 2 1969*.

5. Oscar de la Renta evening dress in flowered silk organza with bolero of crystal beads; modeled by Marisa Berenson. Unknown photographer. Photo courtesy the New York Dress Institute, Eleanor Lambert Publicity. Stamp: *Sun-Times DEC 8 1969*.

6. Geoffrey Beene unisex pantsuits in jersey with tunics and cuffed pants, "G" and "B" buttons on the tunics. Press photo. Unknown photographer. Stamp: *Daily News Jan-8 1969*.

7. Originala raincoat in a wild abstract print. Photo by The New York Couture Business Council, Inc.

8. B. H. Wragge navy jersey blazer suit with white Arnel skirt ($200). B. H. Wragge press photo. Unknown photographer.

9. Hot pink poncho edged with giant pom-pons. Circa 1969.

1970s

233: Unisex outfits, modeled by Marion Lane and Richard Asman, anchored by plaid wool greatcoats: she wears wide-legged pants with a textured wool tunic; he wears pants of the textured wool tucked into knee socks with a turtleneck. Photo by Mirrorpix/Courtesy Everett Collection. Circa 1970.

234–235: 1970

1. Western-inspired designs by Anne Klein including a lace-up black sweater and black leather skirt with saddle stitching, wool gaucho pants, leather shirt. Photo by Field Enterprises, Inc. Stamp: *Chicago Daily News. Dec 16 1970*.

2. Missoni two-piece dress in shades of green mohair; green enamel and mother-of-pearl pendant, ivory flower ring, green enamel and silver bracelet; green tights and pale gray suede strappy high-heeled sandals. Photo by David Anthony for Camera Press London, Keystone Press Agency Press. Stamp: *Circa 1970*.

3. Tunic pantsuit or minidress in purple with white. Kodachrome slide. Photo by Joe Santoro. Inscription: *Yes. April 70. Fashion Women Location*. Stamp: *Apr 70*.

4. Lanvin silk organza evening peasant dress. Photo for Jeanne Lanvin. Stamp: *Sun-Times Apr 29 1970*.

5. Two styles modeled at the Berkeley Debutante Dress show held at the Savoy

Hotel. Photo by Keystone Press Agency. Original caption date: *April 12th, 1970.*

6. Actress Alexandra Bastedo at Heathrow Airport wearing Pucci-inspired print mini and Gucci belt. Photo by Popperfoto. Original caption date: *1st September, 1970.*

7. Zandra Rhodes caftans made from her original Indian Feathers print. Photo by Norman Eales for Camera Press London.

8. André Courrèges two-piece bathing suit in violet terry-cloth trimmed with red vinyl, under a long, sleeveless cotton coat with vinyl discs; yellow and mauve sunglasses with eyelashes; black and white vinyl dog-collar-style necklace; red and white wig. Photo by Herman Leonard for Camera Press London. Stamp: *27 Feb 1970.*

236: HIPPIE CHIC

1. The 1940s look gone Eastern: Thea Porter bold tunic dress in Thea Porter printed silk georgette with pleated overskirt; matching headband. Photo by Thea Porter Couture. Stamp: *DEC 5 1971.*

2. Model wears an orange and brown crocheted vest over an orange ribbed turtleneck sweater, a brown herringbone skirt all by Miss Pat, a brown leather belt by Odyssey, a Kenneth J. Lane bracelet, and brown hat by Madcaps. Photo by J.P. Zachariasen, © Corbis. Circa 1971.

3. Giorgio di Sant'Angelo ensemble; modeled by Jan Cushing in the Pan American Fashion Show, April 1971. Photo by Pescatore. Stamp: *Apr 13 1971.*

4. Paisley organza dress bordered with tapestry to match the short-sleeved jacket by Donald Brooks. Photo by Henry Herr Gill (New York). Stamp: *Daily News Oct 14 1970.*

5. Crocheted poncho. 1971.

6. Penelope Tree wearing a Victorian-inspired "granny" dress in cotton printed with small sprays of flowers. In the background, a more typical look of 1969 featuring a miniskirt. Unknown photographer. Stamp: *JUL 15 1969.*

237: 1971

1. Seen in St. Tropez: hot pants and boots or high-waisted flare-legged jean-style pants, abbreviated snap-front jeans-style jackets. Photo by Rex USA/ Everett Collection.

2. From Chanel's last collection before her death: a cocktail suit in narrowly pleated white silk crepe, with narrowly pleated skirt; signature Maltese cross pendant on ornate chain; beige and black slingback shoes; black hair bow. Press photo. Stamp: *Mar 6 1971.*

3. Ossie Clark ankle-length party dress. Photo by Jorgen Sperling, © Politickens Press Photo (Copenhagen). Original caption date: *22/1/71.*

4. Pleated minis worn with bright tights: (left) striped peasant top; (right) 1930s-revival short-sleeved jacket. Photo by Gunnar Larsen, Agencia Europeia de Imprensa (Paris).

5. Norman Norell sequined dresses with floor-length feather coats; worn by models backstage at one of his fashion shows. Press photo. Stamp: *Jan 71R.*

6. Halter-neck swimsuit in exotic floral print from Gottex, one of Israel's best-known beachwear firms. Photo by Ben Lamm for the *Chicago Sun-Times.* Original caption date: *Oct. 25, 1971.*

7. Elinor Simmons for Malcolm Starr dinner dress in multicolored print silk with hot pants under slashed skirt, rhinestone and sequin embroidery on the waist and

shorts; jewelry by Kenneth Jay Lane; sandals by Bernardo. Photo courtesy the New York Dress Institute, Eleanor Lambert Publicity. Stamp: *Jun 25 1971.*

238: 1972

1. Halston tie-dyed caftan modeled by Pat Cleveland. Press photo. Stamp: *Jul. 5 1972.*

2. Black crepe halter by Chloé worn with black-and-white pajama or palazzo pants and matching shawl. Examiner Photo Library. Stamp: *Received Jul 6 1972.*

3. Geoffrey Beene T-shirt dress in blue-and-white striped chiffon. Photo courtesy the New York Dress Institute, Eleanor Lambert Publicity. Stamp: *1/5/1972.*

4. Anne Klein coat and matching pants. Press photo by Field Entertainment, Inc. Hand written; *Anne Klein, Topper-1972.* Stamp: *Mar 1973.*

5. Cacharel tunic top with pleated peplum in printed cotton with border reminiscent of child's nursery wallpaper, shown with pastel wool gabardine pants. Photo by *Chicago Sun-Times.* Original caption date: *Feb 10 1972.*

6. Arriving at a white-tie event: covered-up white ball gown; pearl-drop earrings; white ostrich; enormous hair. Photo by Peterhofen (Hamburg). Hand written date: *Sept 23/72.*

7. Plaid shorts with matching trench coatdress; photographed in Paris. Photo by Gunnar Larsen, Agencia Europa de Imprensa (Paris).

8. Vintage-inspired marabou "chubby" jacket; turn-of-the-last-century bag with molded silver frame and chain; photographed at Royal Ascot. Mirrorpix/Courtesy Everett Collection.

239: ROMANTIC PEASANT

1. Bill Blass evening look of poet's blouse, silk flower at the waist, flowing long skirt; modeled by Carla LaMonte. Press photo. Stamp: *June 74.*

2. Tartan evening dress; modeled by Kristin Clothilde Darnell. Kodachrome slide. Inscription: *Cover Dock. Yes. July 77. Fashion Location.* Stamp: *Oct 77.*

3. Yves Saint Laurent Rive Gauche gingham check bare-midriff look. Photo by Gunnar Larsen (Paris). 1972.

4. Sheer look for spring: striped silk dress with peasant top. Photo by Gunnar Larsen (Paris). 1972.

5. Yves Saint Laurent Spring/Summer Spanish collection: velvet-laced corselet, taffeta skirt with self-ruffles; ankle-wrapped evening shoes. Photo by Guy Marineau for *Women's Wear Daily.* Stamp: *Jan 16, 1977.*

6. Bare midriff ensemble: off-the-shoulder peasant blouse, flowing pants with elasticized waist; cartwheel hat. Photo by Gunnar Larsen (Paris). 1972.

7. Yves Saint Laurent Rive Gauche peasant blouse and high-waisted trousers; lacquered straw hat. Photo by Gunnar Larsen (Paris). 1972.

240: 1973

1. Chunky ribbed knit sweater; tweed skirt and boots. Photo by Mary Evans/ Peter Akehurst/ Everett Collection.

2. Polo by Ralph Lauren poplin trench coat with wide lapels, button-out cam-el-hair lining. Press photo. Stamp: *For release: On or after Saturday-Sunday, June 16-17, 1973.*

3. Loulou de la Falaise modeling Yves Saint Laurent ensemble of smock jacket, print blouse, man-tailored trousers; bold beads and bangle; boater. Kodachrome slide. Photo by Joe Santoro. Inscription: *Fashion Women Location. Yes. Feb 73.* Stamp: *Feb. 73.*

4. The pantsuit silhouette for spring: beige jacket, white pants; photographed in France. Photo by Keystone Press Agency. Printed date: *17/01/73.*

5. Lace dress with empire waistline and crystal pleated skirt by Carmini. Photo by Peter Akehurst, Everett Collection.

6. Pucci cropped jacket and wide legged pants; pendant by Pucci; modeled by Vivianne. Kodachrome slide. Photo by Joe Santoro. Stamp: *Aug. 73.*

241: 1974

1. Mary Quant Fall/Winter styles: (from left) Priscilla wearing bull's blood flared shirt-dress (£23.40); Sheryn in Donegal tweed suit (£35.90), with polo-neck ribbed sweater; Keryn in sweater, cardigan, flared skirt, priest's hat; Ulrika in woolen flared jacket with yoked skirt (£33.25). Photo by Press Association Photos. Sticker: *johnrogersarchive.* Original caption date: *April 22 1974.*

2. Pat Cleveland in Valentino evening gown in melon chiffon with matching ostrich feathers. Photo by *Daily News.* Stamp: *Nov 6 1974.*

3. Jane Birkin, braless in a T-shirt, patched jeans, carrying one of her signature straw totes, August 1974. Mirrorpix/ Everett Collection.

4. Willi Smith party outfit of pants, bra, jacket printed with cowrie shells and titled "Cowrie Shell." Design Works of Bedford Stuyvesant, Community Gallery, the Brooklyn Museum. Stamp: *May 12 74.*

5. Christian Dior Haute Couture Spring Summer 74 navy blue and orange "fruit" print beige crepe de Chine dress. Examiner Reference Library. Stamp: *Received Feb 15 1974.*

242: 1975

1. Rudi Gernreich black jersey evening pajamas with silver choker. Photo by Fred Stein, *Daily News.* Stamp: *Oct 9 1975.*

2. Albert Capraro for Jerry Guttenberg, Ltd., evening dress in peach and brown printed chiffon. This dress was among those chosen by First Lady Mrs. Gerald Ford. Press photo. Stamp: *Feb 10 1975.*

3. Cacharel Spring ready-to-wear dress in Prince of Wales plaid wool in blue, white, green, and wine red. Photo by Keystone Press Agency. Original caption date: *22 03 75.*

243: 1976

1. Hubert du Givenchy Fall/Winter haute couture wool challis dresses in black and red or shades of brown and orange, paper bag waists; boots by Mancini for Givenchy; accessories by Givenchy. Photo by Jean-Louis Guegan, Givenchy press photo. Release date printed: *25 August 1976.*

2. André Courrèges Fall/Winter evening dress in white organza with teardrops of organza edged with gold paillettes. Photo by Keystone Press Agency. Original caption date: *21/07/76.*

3. Narrow fitted jumpsuit; espadrilles. Stamp: *Mar 4 1976.*

4. Donna Karan and Louis dell'Olio for Anne Klein & Co. ensembles: (left) rust suede cropped jacket with knit waistband,

ribbed olive crew, paisley blouse, camel corduroy jodhpurs; (right) buttoned, big-cowled pumpkin sweater, flared corduroy skirt. Photo for Anne Klein & Co. Release date printed: *On or after June 19-20, 1976.*

5. "Barely there" underwear was required for the narrow lines of 1970s clothing. Photo by Keystone Press Agency. Original caption date: *10/02/76.*

6. Galanos evening pajama in champagne and gray floral print silk. Photo by Perry C. Riddle, *Daily News.* Stamp: *Mar 10 1976.*

7. China-inspired style for Fall/Winter by Yves Saint Laurent: velvet jacket trimmed with metallic piping worn over jacquard silk tunic and velvet pants; velvet hat with tassel. Photo by Keystone Press Agency. Original caption date: *29/06/76.*

8. Dress in blue viscose trimmed in white from a collection of "prêt-a-danser" clothing designed by Régine, the singer famous for Serge Gainsbourg's song "*Les P'tits papiers,*" in collaboration with Marinelli of Nice. Photo by Keystone Press Agency. Original caption date: *23/06/76.*

244: 1977

1. Daniel Hechter "Homelle" sweatshirt with boat neck, 100 percent cotton (F179). Photo by Daniel Hechter, Jacqueline Edouard Press Service. Collection Daniel Hechter, Summer 1977.

2. Bill Cunningham at the Dominic Rompollo fashion show; model wearing a black jersey dress with white collar and camellia at the throat. Press photo. Stamp: *Jun 26 '77.*

3. Textured linen bomber jacket, bias skirt. Kodachrome slide. Photograph by Joe Santoro. Stamp: *Nov. 77.*

4. Model walking up brick steps near the tennis villas at the Casa de Campo resort, in the Dominican Republic, wearing a black camisole, unlined white jacket, and a crepe de chine print skirt with printed silk shawl around the hips, by Complice. Photo by Kourkebn Pakchanian, © Condé Nast Archive/Corbis.

5. White silk V-neck jumpsuit; wedge sandals. Photo by Mary Evans/Peter Akehurst/Everett Collection.

6. Daniel Hechter cotton seersucker "Honoraire" pullover in navy and ecru stripes, training pants in ecru (pullover: F135; pants: F150). Photo by Daniel Hechter, Jacqueline Edouard Press Service. Collection Daniel Hechter, Summer 1977.

7. Heinz Riva diaper-wrapped summer dress in pin dots; matching hat. Photo by Massimo Turchetti, © Agenzia Giornalistica Italia S.p.A. Original caption date: *14/10/1977.*

245: FLOW

1. Kansai Yamamoto hooded caftan with hip sash. Photo by Jean Jacques Levy. Stamp: *Apr 7 1976.*

2. Pale gold and ivory version of hand-painted chiffon caftan that some Halston devotees have bought by the dozen. Examiner Photo Library. Stamp: *Received Feb 21 1973.*

3. Stephen Burrows relaxed evening look in jersey, peasant blouse with asymmetric off-the-shoulder neckline. Press photo. Stamp: *Jul 10 1977.*

4. Halston dress with cummerbund over soft pajamas; Elsa Peretti "diamonds by the yard"; metallic high-heeled sandals; photographed at fashion show held at Halston's Seventh Avenue showroom. Press photo. Stamp: *Aug 26 1977.*

5. Halston palazzo pajama in chartreuse silk georgette; metal minaudiere purse suspended from a braided cord; metallic sandals. Photo by Frederic Stein. *Chicago Sun-Times.* Stamp: *November 7, 1979.*

6. White charmeuse wrapped halter-neck jumpsuit. A model wears a simple white silk halter neck dress. Photo by Mary Evans/Peter Akehurst/Everett Collection. 1974.

246: 1978

1. Crinkle gauze sundress with self-piping halter. Kodachrome slide. Photo by Joseph Santoro. Inscription: *Yes. Fashion Women Location.* Stamp: *Nov. 78.*

2. Pierre Balmain Spring/Summer haute couture beige tweed jacket, beige striped tweed skirt, beige silk blouse. Photo by Jean-Pierre Ledos.

3. Valentino Boutique Spring/Summer sunbathing ensemble *à la Japonaise* in black silk printed with fuchsia flowers, pleated double skirt; belt fibula; sandals by Rene Caovilla for Valentino; hat in black lacquered straw; coiffure by Alexandre Zouari for Maurice Frank. Valentino Boutique Collection, Spring/Summer 1979. Stamp: *Nov 1 1978.*

247: 1979

1. Lamé bustier and jacket worn with disco metallic stretch pants. Kodachrome slide. Photo by Joseph Santoro. Stamp: *Jul 79.*

2. Nina Ricci three-quarter-length jacket of lunaraine mink; gray flannel skirt and blouse, gray satin pouf; velvet beret. Press photo. Circa 1979–80.

3. Karl Lagerfeld for Chloé textured mini-dress. Press photo. Stamp: *Oct 30 1979.*

4. Valentino haute couture strapless ball gown and shawl. Photo by Agenzia Ansa (Rome).

5. Pierre Cardin strapless jumpsuit with pleated overskirt. Press photo. Inscription: *1979.*

1980s

248: Issey Miyake Fall shirred dress with oversize cowl neck. Issey Miyake press photo. 1983. Inscription: *F 1983.*

250: VOLUME

1. Kenzo Spring/Summer billowing striped dress over stovepipe pants. Kenzo press photo. Inscription: *1984.*

2. Striped separates by Issey Miyake. Issey Miyake press photo. Inscription: *1983.*

3. Gerard Pipart for Nina Ricci Fall/Winter haute couture flared ruffled coat worn over a suit. Photo by Pierre Vauthey (Paris), © Corbis. 1987.

4. Giorgio Armani broad-shouldered jacket in plaid. Armani press photo. Hand written inscription: *Armani 1984.*

5. Perry Ellis Chariots of Fire collection: oversize blazers in striped linen worn with pleated skirts that fall to just above the ankle; white stockings and low-heeled pumps. Photo by Dustin Pittman (New York), © Condé Nast Archive/Corbis. Spring/summer 1984.

6. Karl Lagerfeld roomy coat with oversize collar and pockets; opaque black stockings and slouchy boots. Stamp: *Apr 7 1985.*

252: 1980

1. Perry Ellis summer separates: bra top and dirndl; cable-knit tube top over mini culottes and camisole top. Photo by Dustin Pittman, © Corbis.

2. Gianfranco Ferré double-faced raincoat over mohair sweater-jacket and flannel pants. Milan, Italy. Photo by Tim Jenkins, © Corbis.

3. Oscar de la Renta suit with cropped black velvet jacket, white silk and lace blouse, knee-length gray flannel skirt. Photo by Denis Piel, © Condé Nast Archive/Corbis.

4. Christie Brinkley in red sweater, white shorts; two-tone deck shoes. Photo by Joseph Santoro. Stamp: *Oct 80*.

253: 1981

1. Ralph Lauren English countryside ensemble: tweed shooting jacket, checked camp shirt, sweater vest. Photo by Ernie Leyba, © Getty Images.

2. Bikini top, harem pants. Photo by Joe Santoro. Kodachrome slide mount stamped: *Nov 81*.

3. Jeans and jean jackets; photographed in London. Photo by Mirrorpix/ Everett Collection.

4. Jerry Hall in Callaghan Spring/Summer jungle-print draped pants and blouson top with center slit. © Agenzia Giornalistica Italia. Printed: *26/8/77*.

5. Rosemary McGrotha modeling by statue in Washington, DC, United States. Emanuel Ungaro ensemble: long, side-buttoned blue and burgundy jacket, wool challis skirt; bag by Susan Bennis/ Warren Edwards; boots by Charles Jourdan. Photo by Denis Piel, © Corbis.

254: 1982

1. Relaxed summer look: shirt knotted over tank top; straw bag; huarache sandals. Photo by Joe Santoro.

2. Halter maillot with high-cut legs. Photo by Joe Santoro.

3. Kenzo Fall/Winter skirts and blouson jackets. Kenzo press photo.

4. Seersucker draped pants with cummerbund waistline, rosette, top with tucks emphasizing broad shoulder line. Photo by Joe Santoro.

5. Knit top and side-buttoning skirt. Photo by Joe Santoro.

6. Chambray blouse and engineer striped pants. Photo by Joe Santoro.

7. Karl Lagerfeld for Chloé Spring/Summer "Taormina" dress and pantaloons. Chloé press photo.

8. Jacket with flame appliqués at the shoulder and calligraphy, scrunched-up boots. Photo by Joe Santoro.

255: 1983

1. For his first haute couture collection at Chanel, Karl Lagerfeld riffed on house signatures: tweed, bands of trimming, black satin bows, silk camellias, two-tone shoes, French cuffs. Photo by Guy Marineau (Paris), © Corbis.

2. Pierre Balmain haute couture ensemble with patent-leather skirt, jacket with fur cuffs and striped satin blouse with oversize jabot; hat with veil. Balmain press photo.

3. Givenchy Nouvelle Boutique Fall/Winter evening gown of black velvet with orchid print satin. Photo by Jean-Pierre Ledos. Givenchy Nouvelle Boutique press photo. Stamp: *1983–1984*.

4. Giorgio Armani ensemble of cardigan coat with broad shoulders, pant suit cropped at the ankles; photographed in Milan. Photo by Tom Jenkins, © Condé Nast Archive/Corbis.

256: 1984

1. Karl Lagerfeld for Chloé suit in solid and plaid with plaid peplum, wide layered Peter Pan collar. Chloé press photo.

2. Kenzo Spring/Summer billowing plaid dress over two-tone pants. Kenzo press photo. Inscription: *Kenzo 84*.

3. Inès de la Fressange in Karl Lagerfeld for Chloé silk dress; thimble earrings. Chloé press photo.

4. Colorful sweats dressing. Photo by Joe Santoro. Stamp: *Apr 1985*.

5. Gene Ewing for Bis tie-dye top, textured leggings, mesh vest and skirt ("crop top: approx. $50"; T-shirt: approx. $28; skirt: approx. $80"; leggings: approx. $50"). Photo courtesy the New York Dress Institute, Eleanor Lambert Publicity.

6. Christian Dior Fall/Winter 1984 suit with double-breasted blazer and topcoat in gray, black, and brown tweed, blouse in jacquard satin crepe printed black-and-gray check. Printed: *Christian Dior Fourrure*.

7. Lanvin sleeveless red-and-white linen dress; natural straw wide-brimmed boater trimmed with white grosgrain; pumps with conical heels. Photo by Jean-Pierre Ledos.

8. Tina Chow in Chanel at the Metropolitan Museum's Costume Institute Benefit, with her husband, Michael Chow, New York. Photo by Mary Hilliard.

257: 1985

1. Geoffrey Beene orange linen top over navy wool short skirt; wooden bracelets by Roy A. Heymann; hair styled by Bumble & Bumble. Photo by Denis Piel, © Condé Nast Archive/Corbis.

2. A myriad of looks in black for evening: (from left) Geoffrey Beene just-above-the-ankle-length dress; Calvin Klein off-the-shoulder minidress; Oscar de la Renta strapless, floor-length dress; Jackie Rogers strapless above-the-knee-length dress. Photo by Denis Piel, © Condé Nast Archive/Corbis.

3. Iman in Azzedine Alaïa denim suit, jacket with exuberant melon sleeves; photographed at a fashion show in New York. Photo by Rose Hartman, © Getty Images.

4. Donna Karan wearing her version of a man's smoking jacket at the Metropolitan Museum's Costume Institute Benefit, New York. Photo by Mary Hillard.

258: OPULENCE

1. Lacroix Fall/Winter evening bag in satin with gilded branch handle. Photo by Pierre Vauthey (Paris), © Corbis. 1987.

2. Arnold Scaasi ball gown worn by Gayfryd Steinberg at the Metropolitan Museum's Costume Institute Benefit, New York. Photo by Mary Hilliard. 1986.

3. Emanuel Ungaro Spring/Summer haute couture short evening dress with exuberant ruffled sleeves. Photo by Pierre Vauthey (Paris), © Corbis. 1988.

4. Loulou de la Falaise wearing Yves Saint Laurent gilded lace evening gown swathed in taffeta, at the Metropolitan Museum's Costume Institute Benefit, New York. 1983.

5. Hot-pink ruffled short dress worn at the Metropolitan Museum's Costume Insti-

tute Benefit, New York. Photo by Mary Hilliard. 1986.

6. Designer Marc Bouwer posing with women wearing short evening dress at the Metropolitan Museum's Costume Institute Benefit, New York. Photo by Mary Hilliard. 1986.

7. Joan Juliet Buck wearing olive taffeta ball gown worn at Metropolitan Museum's Costume Institute Benefit, New York. Photo by Mary Hilliard. 1986.

8. Yellow ruched satin gown worn at the Metropolitan Museum's Costume Institute Benefit, New York. Photo by Mary Hilliard. 1987.

259: 1986

1. Emanuel Ungaro mismatched suits; photographed at Cannes, France. Photo by Denis Piel, © Corbis.

2. Oscar de la Renta checked wool skirt suit with silk cloque blouse; spectator pumps; pillbox hat; photographed at Lincoln Center, New York. Photo by George Chinsee (New York), © Corbis.

3. Black one-shouldered jumpsuit in jersey. Stamp: *Sep 1986*.

260: 1987

1. Cathy Hardwick evening coat and narrow pants ensemble in embossed taffeta. Photo by David Hartman.

2. Guy Laroche prêt-à-porter short evening dress or cocktail dress in black Calais lace, flounces and bow of black and fuchsia taffeta; jeweled hoop earrings and wide bracelet; stretch satin gloves; coiffure by Agathe Segura; makeup by Vincent Lefeuvre. photographed at the Paris Country Club, Paris. Photo by Chantal Wolf, Relations Presses, Union Patronale Textile de la Region de Caudry. Circa 1987–88.

3. Aquascutum "Stowe" swing coat, in black-and-white Glencheck wool tweed. Aquascutum, Ltd. press photo.

4. Carolyne Roehm Fall/Winter 1987 collection: strapless short evening dress accented at the neckline and hem with bands of velvet. Photo by Jody Donohue Associates (New York).

5. Yves Saint Laurent Fall/Winter haute couture dinner suit in orange satin. Photo by Pierre Vauthey (Paris), © Corbis.

261: 1988

1. Emanuel Ungaro Spring/Summer collection ensemble: plaid swing jacket, sarong-draped skirt in black-and-white floral crepe, turtleneck blouse in turquoise crepe with square black dots. Emanuel Ungaro press photo. Photo by Guy Marineau.

2. Rei Kawakubo for Comme des Garçons Spring/Summer ensemble in anorak-detailed layers of organza. Photo by Pierre Vauthey (Paris), © Corbis.

262-263: 1989

1. Arnold Scaasi flowered dresses. Photo by Ron Galella, © Getty Images.

2. Miniature Chanel barrel bag, green suit. Photo by Mary Hilliard.

3. Patrick Kelly Spring/Summer strapless cocktail dress ornamented with miniature versions of the *Mona Lisa*. Photo by Pierre Vauthey (Paris), © Corbis.

4. Two women waiting outside the Christian Dior couture show in Paris. Photo by Mary Hilliard.

5. Christian Lacroix Fall/Winter haute couture evening dress in black satin embroidered by Lesage with Byzantine cross, dress of draped black silk chiffon; hat and chignon ornaments by Christian Lacroix. Lacroix press photo. Photo by Jean-Francois Gaté. Stamp: *Sun Jun 11 1989*.

6. Jacqueline de Ribes evening gown in black velvet with black Chantilly lace. Photo by Claus Ohm, Jody Donohue Associates (New York).

1990s

264: Getting out of a taxi in a short skirt, New York. Photo by Mary Hilliard. 1994.

266: LEGGY

1. Two minidresses by Michael Katz, one with jester tights, worn at the Metropolitan Museum's Costume Institute Benefit, New York. Photo by Mary Hilliard. 1990.

2. Gold beaded bare midriff minidress worn at the Metropolitan Museum's Costume Institute Benefit, New York. Photo by Mary Hilliard. 1990.

3. Amy Fine Collins at John Galliano fashion show. Photo by Mary Hilliard. 1995.

4. On the sidewalks of Soho, outside Isaac Mizrahi fashion show. Photo by Mary Hilliard. 1995.

5. Chantal Thomass Fall/Winter chubby jacket and mini, fuchsia stockings. Photo by Pierre Vauthey (Paris), © Corbis. 1990.

6. Michael Katz sequined minidress worn at the Metropolitan Museum's Costume Institute Benefit, New York. Photo by Mary Hilliard. 1991.

7. Martha Baker wearing a satin trench coat. Photo by Mary Hilliard. 1991.

267: 1990

1. Geoffrey Beene dress with point d'esprit bodice. Photo by Mary Hilliard.

2. Claude Montana for Lanvin Fall/Winter haute couture silver short coat with full sleeves and skirt, nipped-in waist, silver top with shaped collar. Photo by Pierre Vauthey (Paris), © Corbis.

3. Giorgio Armani suit and down jacket; sunglasses and gloves; toque. Milan, Italy. Photo by Art Streiber, © Corbis.

4. Paloma Picasso wearing her own jewelry and embroidered jacket by Yves Saint Laurent. Photo by Mary Hilliard.

5. Bill Blass minidress with back treatment of ropes of faux pearls caught with a black bow. Photo by Mary Hilliard.

6. Gianfranco Ferré for Christian Dior Spring/Summer skirt suit and pantsuit in shades of Dior gray. Photo by Pierre Vauthey (Paris), © Corbis.

268: 1991

1. Lace-trimmed ball gown worn by CeCe Kieselstein-Cord at the Metropolitan Museum's Costume Institute Benefit, New York. Photo by Mary Hilliard.

2. Christian Lacroix tartan ball gown with tiered ruffled back worn by Blaine Trump at the Metropolitan Museum's Costume Institute Benefit, New York. Photo by Mary Hilliard.

3. Linda Evangelista in Karl Lagerfeld for Chanel Spring/Summer haute couture suit in pale blue with paneled skirt. Photo by Pierre Vauthey (Paris), © Corbis.

4. White strapless ball gown, hot-pink shawl; worn at Count Volpi's ball in Venice. Photo by Mary Hilliard.

5. Emanuel Ungaro Spring/Summer haute couture red dress with fringed scarf; fuschia envelope bag; yellow pillbox hat. Photo by Pierre Vauthey (Paris), © Corbis.

6. Sonia Rykiel Fall/Winter ensembles with hooded sleeveless long jackets, wrapped at the waist with cardigans. Photo by Pierre Vauthey (Paris), © Corbis.

269: 1992

1. Distressed and see-through looks worn at the Metropolitan Museum's Costume Institute Benefit, New York. Photo by Mary Hilliard.

2. Victoire de Castellane wearing Chanel ensemble with gilt-edged leather jacket at *Vogue's* 100th anniversary party. Photo by Mary Hilliard.

3. Christy Turlington in Michael Kors pant suit on Charles Street, New York. Photo by Rose Hartman, © Getty Images.

4. Christy Turlington in Jil Sander beige suit with knee-length jacket worn with beaded choker. Milan, Italy. Photo by Art Streiber, © Corbis.

5. Décolleté yellow minidress worn at *Vogue's* 100th anniversary party. Photo by Mary Hilliard.

6. Nati Abascal y Romero-Toro in Valentino lace-trimmed ball gown with see-through bodice at the opening of the Valentino retrospective *Thirty Years of Magic* at the New York Armory. Guests were asked to wear black or white. Photo by Mary Hilliard.

7. Smoking jacket worn by Susan Holmes to *Vogue's* 100th anniversary party. Photo by Mary Hilliard.

270: 1993

1. Carla Bruni gets dressed backstage at the Marc Jacobs for Perry Ellis Spring/Summer show. "Grunge" outfit of mismatched stripes. Photo by Kyle Ericksen, © Condé Nast Archive/Corbis.

2. Vendela Kirsebom in perfectly faded jeans jacket arriving at the Los Angeles International Airport. Photo by Ron Galella, © Getty Images.

3. Karl Lagerfeld for Chanel Spring/Summer ready-to-wear suit: white skirt, pink tweed long jacket and matching hat. Photo by Bertrand Rindoff Petroff, © Getty Images.

4. Marina Schiano in red cocoon evening wrap and André Leon Talley in red military-style jacket at the Metropolitan Museum's Costume Institute Benefit, New York. Photo by Mary Hilliard.

5. Kenzo Spring/Summer ready-to-wear 1994 collection, Paris. Photo by Bertrand Rindoff Petroff, © Getty Images.

271: 1994

1. Christian Lacroix pants ensemble. Photo by Mirrorpix/ Everett Collection.

2. Two metallic blue narrow, fluid evening dresses worn at the Metropolitan Museum's Costume Institute Benefit, New York. Photo by Mary Hilliard.

3. Dries Van Noten dress in two autumnal foliate fabrics; brogues. Photo by Thierry Orban, © Corbis.

4. Karl Lagerfeld for Chloé Spring/Summer tunic dress, inspired by ancient Greece. Photo by Gerard Julien, © Getty Images.

5. Helena Christensen in Sonia Rykiel ensemble with wrapped bra top. Photo by Gerard Julien, © Getty Images.

6. Vivienne Westwood fur-trimmed ensemble modeled by Tyra Banks. Photo by Mary Hilliard.

7 & 8. Two views of narrow evening dress with train backstage at John Galliano fashion show. Photo by Mary Hilliard.

272: 1995

1. Karl Lagerfeld suit with miniature hat. Photo by Pierre Vauthey (Paris), © Corbis.

2. John Galliano bustier and high-waisted narrow skirt. Photo by Mary Hilliard.

3. Ralph Lauren checked wool skirt suit and matching top coat. Photo by Timothy Clary, © Getty Images.

4. Tartan and sheer foliate-patterned fabric in a dress from Alexander McQueen Fall/Winter 1995 "Highland Rape" collection. Photo by Charles Knight. Photo by Charles Knight / Rex USA/ Everett Collection .

5. White jeans turnout outside the Isaac Mizrahi fashion show. Photo by Mary Hilliard.

273: MINIMALISM

1. Narrow white long dress worn to a party at MOMA. Photo by Mary Hilliard. 1997.

2. Long silvery white dress worn at the VH1 awards. Photo by Mary Hilliard. 1998.

3. Calvin Klein strapless long dress in black, camisole neckline; long dress in white. Photo by Kyle Erickson, © Condé Nast Archive/Corbis. 1995.

4. Long stretch dress with cutouts worn at the VH1 awards. Photo by Mary Hilliard. 1998.

274: 1996

1. Photographed at Chanel haute couture show in Paris. Photo by Mary Hilliard.

2. Coat dress seen in Paris outside the couture shows. Photo by Mary Hilliard.

3. Chanel-clad patron waiting on a gilt ballroom chair for the Chanel haute couture show to begin. Photo by Mary Hilliard.

4. Amber Valletta at Balmain haute couture show, Paris. Photo by Mary Hilliard.

5. Tom Ford for Gucci velvet pantsuit worn to the VH1 awards. Photo by Mary Hilliard.

6. Sharing an umbrella outside the Paris couture shows: skirt suit and pant suit; statement earrings. Photo by Mary Hilliard.

7. Street scene outside Paris couture shows. Photo by Mary Hilliard.

275: 1997

1. Kate Moss in Helmut Lang Fall/Winter layered white tank tops with band of pink tulle, chinos. Photo by Giovanni Giannoni, © Corbis.

276: 1998

1. Amber Valletta in Prada Fall/Winter paneled chemise dress; black tights and white patent leather heels. Photo by Guy Marineau, © Corbis.

2. Herve Leger Spring/Summer one-shoulder bandage dress in saffron. Photo by Thierry Orban, © Corbis.

277: 1999

1. John Galliano for Christian Dior Fall/Winter bias-cut slip dress with row of self-covered buttons. Photo by Thierry Orban, © Corbis.

2. Thierry Mugler Fall/Winter dress with cutout design: © Corbis.

2000s

279: John Galliano for Christian Dior Spring/Summer haute couture "La Belle et le Clochard" collection: twisted Victorian gown sprouting its stays; Victorian lace-up boots; flanged hat. Photo by Mirrorpix/Courtesy Everett Collection.

280: IT BAG

1. Louis Vuitton monogram clutch. Photo by Mary Hilliard. 2000.

2. Louis Vuitton Stephen Sprouse Graffiti limited edition Alma horizontal handle bag, 2001. Photo by Pierre Vauthey (Paris), © Corbis. 2001.

3. Anti "It" bags during Fashion Week in New York. Photo by Mary Hilliard. 2009.

4. Fendi baguette during New York's Olympus Fashion Week. Photo by Astrid Stawiarz, © Getty Images. 2004.

5. John Paul Gaultier for Hermès bag. Photo by Stephane Cardinale. © Corbis. 2011.

6. Red crocodile handbag worn during Fashion Week in New York. Photo by Mary Hilliard. 2006.

281: 2000

1. Leopard-stenciled pony skin coat and mules. Photo by Mary Hilliard.

2. Elle Macpherson wearing sequined nude evening gown by Valentino to Valentino's 40th anniversary party in Los Angeles. Photo by Mary Hilliard.

282: 2001

1. Jean Paul Gaultier Spring/Summer openwork corset top. Photo by Pierre Vauthey, © Corbis.

2. Photographed outside the New York City Ballet Gala. Photo by Mary Hilliard.

3. Silver beaded fringed dance dress. Photo by Mary Hilliard.

4. Pants and skirts with high heels or boots worn at a Lulu Guinness tea party, New York. Photo by Mary Hilliard.

5. Anh Duong arriving at New York City Ballet Gala, New York. Photo by Mary Hilliard.

6. Oscar de la Renta evening dress worn at the Metropolitan Museum's Costume Institute Benefit, New York. Photo by Mary Hilliard.

283: 2002

1. Louis Vuitton Spring/Summer ready-to-wear empire-waist evening gown in floral print silk, Paris. Photo by Jean-Pierre Muller. © Getty Images.

2. Miuccia Prada for Miu Miu Spring bra-top baby-doll dress, worn with white and orange platform sandals by Ksenia Maximova during Milan Fashion Week. © Getty Images.

284: 2003

1. Valentino Fall/Winter sheer top edged with fur over a knit mini. Photo by Dominique Maitre, © Corbis.

2. Sheath dress with midriff panel. Photo by Mary Hilliard.

3. Michael Kors Spring/Summer caftan during New York Fashion Week. Photo by Petre Buzoianu, © Corbis.

4. The new bare leg seen at Fashion Week, New York. Photo by Mary Hilliard.

285: 2004

1. Ball gown descending the stairs at the Metropolitan Museum's Costume Institute Benefit, New York. Photo by Mary Hilliard.

2. Ball gowns with lace at New Yorkers For Children benefit, New York. Photo by Mary Hilliard.

3. Alexander McQueen Spring ready-to-wear pearl-embroidered bolero and tights, draped knickers, Paris. © Corbis.

4. Lavender slip dress seen at New Yorkers for Children benefit, New York. Photo by Mary Hilliard.

286: 2005

1. Marc Jacobs for Louis Vuitton Spring/Summer monogram denim shorts. © Corbis.

2. Christian Lacroix for Emilio Pucci Spring/Summer chiffon evening gown during Milan Fashion Week. Photo by Stefano Rellandini, © Corbis.

287: 2006

1. Carine Rotfield at New York Fashion Week. Photo by Mary Hilliard.

2. Frida Giannini for Gucci décolleté mini dress. Photo by Matteo Bazzi, © Corbis.

3. Versace Fall/Winter ice-blue one-shouldered evening gown, high slit skirt. Photo by Matteo Bazzi, © Corbis.

288: 2007

1. Chaiken knotted sleeveless blouse, tuxedo cummerbund pants; photographed in New York. Photo by Andreea Angelescu, © Corbis.

2. Black tailored romper worn by Elizabeth von Guttman; photographed in New York. Photo by Scott Schuman, The Sartorialist.

3. Pink dress with vertical and horizontal tucks worn with tennis shoes during New York Fashion Week. Photo by Mary Hilliard.

4. White shirt, print skirt, flats worn bicycling on Via Montenapoleone, Milan. Photo by Scott Schuman, The Sartorialist.

289: 2008

1. Charcoal wool pantsuit with shrunken fit, button-down collar shirt and black necktie; photographed on 36th Street, New York. Photo by Scott Schuman, The Sartorialist.

290: 2009

1. Milla Jovovich at John Galliano Fall/Winter ready-to-wear fashion show during Paris Fashion Week. Photo by Photo by Nicolas Khayat/Enigma / Rex USA, Courtesy Everett Collection.

2. Alber Elbaz for Lanvin Fall/Winter dress with cap sleeves, side draped skirt. © Corbis.

3. Shearling jacket, skinny jeans and fringed boots worn to Fashion Week, New York. Photo by Mary Hilliard.

291: 2010

1. Dries Van Noten Spring/Summer ready-to-wear overblouse with sailor collar and shaped hem over print shorts during Paris Fashion Week. © Corbis.

2. Daphne Guinness arriving at the memorial service for Alexander McQueen at St. Paul's Cathedral. Photo by Paul Hackett, © Corbis.

3. Nicholas Ghesquière for Balenciaga Fall ready-to-wear pullover with pointelle texture, zigzag-edged skirt in another version of the same design; modeled by Miranda Kerr in Paris. © Corbis.

292: 2011

1. Linen skirt worn with camisole top and draped panel in two crepuscular prints. Ninth Street, New York. June 9, 2011. Photo by Scott Schuman, The Sartorialist.

2. Folds of fabric reminiscent of the draperies in Baroque paintings: a sweatshirt knotted to form a skirt and a top pulled to the side by a pair of glasses. Milan. May 25, 2011. Photo by Scott Schuman, The Sartorialist.

293: 2012

1. Kate Moss in Marc Jacobs for Louis Vuitton Spring/Summer feather-trimmed eyelet dress. Photo by Stephane Cardinal, © Corbis.

2. Isabel Marant Fall/Winter turnout with leopard faux-fur jacket, fringed cropped pants at Couvent des Cordeliers, Paris. © Corbis.

294: 2013

1. Navy jacket, purple fox fur; riding boots; charcoal fedora; photographed in Paris. Photo by Scott Schuman, The Sartorialist.

2. Alber Elbaz for Lanvin chemise dress tied with a bow at the side; modeled by Marikka Juhler backstage in Paris. Photo by John Eduardo Anderson, © Corbis.

3. Giovanna Battaglia in full-skirted dress, T-strap shoes; photographed in Milan. Photo by Scott Schuman, The Sartorialist.

295: 2014

1. Penny loafers, ankle socks, corduroy skirt with drawstring hem, chunky cardigan, and knit Phrygian cap seen on Broadway, New York. Photo by Scott Schuman, The Sartorialist.

2. Army jacket over crisp matelasse dress worn with sheer black high heel. Fall/Winter fashion week, Paris. Photo by Lee Oliveira/ Trunk Archive.

296: 2015

1. White jacket, black full trousers, blush fur; bag by Celine; worn by Virginia Mugnaioni arriving at Ferragamo runway show, Milan. Photo by Paolo Diletto, © Corbis.

2. Shirttail, sweater, jeans; cross-body bag by Chanel; heels; worn by blogger Golestaneh Mayer-Uellner at Berlin Mercedes-Benz Fashion Week. © Corbis.

297: CONVERGENCE

1. Maria Grazia Chiuri and Pier Paolo Piccioli for Valentino Fall/Winter haute couture evening gown with "barely there" knotted bodice of pale beige tulle, long trained skirt of printed and sheer silk. 2014. Photo by Kevin Tachman/ Trunk Archive.

SELECTED BIBLIOGRAPHY

Arch, Nigel and Joanna Marschner. *Splendor at Court: Dressing for Royal Occasions since 1700.* London: Unwin Hyman, 1987.

Barwick, Sandra. *A Century of Style.* London: George Allen & Unwin, 1984.

Beaton, Cecil. *The Glass of Fashion.* New York: Rizzoli International Publications, Inc., 2014.

Blum, Stella, ed. *Victorian Fashions & Costumes from Harper's Bazaar: 1867-1898.* New York: Dover Publications, Inc., 1974.

Buxbaum, Gerda. *Icons of Fashion: The 20th Century.* Munich · London · New York: Prestel Verlag, 1999.

Churchill, Peregrine and Julian Mitchell. *Jennie, Lady Randolph Churchill: A Portrait with Letters.* New York: St. Martin's Press, 1974.

Cunnington, C. Willet. *English Women's Clothing in the Nineteenth Century: A Comprehensive Guide with 1,117 Illustrations.* New York: Dover Publications, Inc., 1990.

Deslandres, Yvonne and Florence Miller. *Histoire de la Mode au XXᵉ Siecle.* Paris: Editions SOMOGY, 1986.

Downey, Fairfax. *Portrait of an Era as Drawn by C. D. Gibson.* United States of America: Life Publishing Co., 1936.

Dunbar, Janet. *The Early Victorian Woman.* London: George G. Harrap & Co. Ltd., 1953.

Goldthorpe, Caroline. *From Queen to Empress: Victorian Dress 1837-1877.* New York: Metropolitan Museum of Art, 1988.

Groom, Gloria. *Impressionism, Fashion, & Modernity.* Chicago: The Art Institute of Chicago, 2012.

Hall-Duncan, Nancy. *The History of Fashion Photography.* New York: Alpine Book Company, Inc., Publishers, 1979.

Johnston, Lucy. *Nineteenth-Century Fashion in Detail.* London: V & A Publications, 2005.

Le Maux, Nicole. *Modes de Paris: Histoire du Chapeau féminin.* Paris: Éditions Charles Massin, 2000.

Milbank, Caroline Rennolds. *New York Fashion: The Evolution of American Style.* New York: Harry N. Abrams, Inc., 1989.

Olian, JoAnne, ed. *Victorian and Edwardian Fashions from "La Mode Illustrée."* New York: Dover Publications, Inc., 1998.

Perrot, Philippe. *Fashioning the Bourgeoisie: A History of Clothing in the Nineteenth Century.* Princeton: Princeton University Press, 1994.

Picken, Mary Brooks. *The Fashion Dictionary: Fabric, Sewing, and Apparel as expressed in the Language of Fashion: Revised and Enlarged.* New York: Funk & Wagnalls, 1973.

Sefrioui, Anne, ed. *Femmes fin de siècle: 1885-1895.* Paris: Éditions Paris Musées, 1990.

Severa, Joan L. *Dressed for the Photographer: Ordinary Americans & Fashion, 1840-1900.* Kent, Ohio: The Kent State University Press, 1995.

Severa, Joan L. *My Likeness Taken: Daguerreian Portraits in America.* Kent, Ohio: The Kent State University Press, 2005.

Steele, Valerie, ed. *Encyclopedia of Clothing and Fashion.* Michigan: Thomson Gale, 2005.

Studievic, Hélène, ed. *Sous L'Empire des Crinolines.* Musée Galliera. Paris Musées, 2008.

PUBLICATIONS

The Bystander, Charm, Elle, Femina, Frank Leslie's Weekly, Godey's Lady's Book, Harper's Bazaar, Life, The Modern Priscilla, les Modes, The New York Times, The New Yorker, Sports Illustrated, L'Officiel, Peterson's Magazine, Vanity Fair, Vogue, Weekly Vincennes Gazette, W, Women's Wear Daily.

ACKNOWLEDGMENTS

Watching this book take form has filled me with awe for the team at Rizzoli. Thanks to publisher Charles Miers, designers Jacob Wildschiødtz, Elina Asanti, Kayleigh Jankowski, copy editors Elisabeth Smith and Keith Meatto, and especially to editor Allison Power who embodies grace under pressure. Endless gratitude to Harold Koda, for his foreword and his friendship. Thank you to Anita Dickhuth for photo permissions.

This book was fortunate to have a circle of early responders; I was encouraged by the enthusiasm of: Deeda Blair, Margaret Rennolds Chace, Anne Goldrach, Nancy Hall-Duncan, Titi Halle, Phyllis Magidson, Michelle Majer, Jane Trapnell Marino, Alexandra Palmer, Clare Sauro, and Lynn Sellin.

Special thanks to archivist Dorota Liczbinska who took on every photograph related challenge and responded to every photograph emergency with alacrity; April Calahan at Special Collections and FIT Archives at Fashion Institute of Technology who facilitated finding photo needles in periodical haystacks and Mary Hilliard whose generosity with the archive of her work was inspiring.

For assembling the bibliography thanks to Rives Milbank and for being a paradigm of patience, Jerry.

First published in the United States of America in 2015
by Rizzoli International Publications, Inc.
300 Park Avenue South
New York, NY 10010
www.rizzoliusa.com

2015 2016 2017 2018 / 10 9 8 7 6 5 4 3 2 1

Printed in China

ISBN: 978-0-8478-4602-3

Library of Congress Catalog Control Number: 2015945049

Editor: Allison Power
Design: NR2154
Design Coordinator: Kayleigh Jankowski